THE BRITISH LIBRARY STUDIES IN MEDIEVAL CULTURE

The Egerton Genesis

THE EGERTON GENESIS

Mary Coker Joslin

and

Carolyn Coker Joslin Watson

THE BRITISH LIBRARY

AND

UNIVERSITY OF TORONTO PRESS

2001

First Published 2001 by
The British Library
96 Euston Road
London NW1 2DB

British Library Cataloguing in Publication Data
A catalogue record for this title is avaliable from The British Library

ISBN 0 7123 4648 1

Published in North America in 2001 by
University of Toronto Press Incorporated
Toronto and Buffalo

National Library of Canada Cataloguing in Publication Data
Joslin, Mary Coker, 1922–
The Egerton Genesis

(The British Library studies in medieval culture)
Co-published with the British Library
Includes bibliographical references and index
ISBN 0–8020–4758–0

1. Bible. O.T. Genesis–Illustrations. 2. Illumination of books and manuscripts, Medieval.
I. Watson, Carolyn Coker Joslin II. British Library III. Title. IV. Series.
ND3358.G4J67 2001 745.6'7'09023 C2001-901561-5

Design and typesetting by Hope Services (Abingdon) Ltd

Printed in Great Britain by St Edmundsbury Press

TO OUR MENTOR AND FRIEND
Jaroslav Folda

Contents

List of Plates

(Between pages 84 and 85)

List of Figures

Acknowledgements

We gratefully acknowledge the inestimable help of librarians and photographic directors in the institutions to whose collections we were granted access: the Biblioteca Apostolica Vaticana in Vatican City, the Biblioteca dell'Accademia dei Concordi in Rovigo, the Biblioteca Riccardiana in Florence, the Biblioteca Patriarcale di San Domenico in Bologna, the Bayerische Staatsbibliothek in Munich, the Bibliothèque Nationale in Paris, the Bibliothèque Royale Albert Ier in Brussels, the Bodleian Library in Oxford, The British Library in London, the Norfolk Record Office in Norwich, the Davis, Sloane, and Wilson Libraries at the University of North Carolina in Chapel Hill, North Carolina, the Fitzwilliam Library in Cambridge, the Furman University Library in Greenville, South Carolina, the John Rylands University Library in Manchester, the Kongelige Bibliotek in Copenhagen, the Koninklijke Bibliotheek in the Hague, the Library of Congress in Washington, the National Library of the Czech Republic in Prague, the Österreischische Nationalbibliothek in Vienna, the Museo Civico Archeologico in Bologna, the Pierpont Morgan Library in New York, the Robert W. Woodruff Library at Emory University in Atlanta, Georgia, the Rijksmuseum Meermanno-Westreenianum in the Hague, and the Walters Art Gallery in Baltimore.

Our sincerest thanks go to the many individuals who have generously helped us in various ways. For sharing with us much useful information about medieval Norwich, we thank Brian Ayers and Caroline Hull. We express our gratitude to James Govan, Joseph Hewitt, Philip Reese, Marcella Grendler, Rachel Fruh, and Michele Fletcher, who supported us generously in our work in the Chapel Hill libraries, and with libraries abroad, and to research assistants June Pitts and Heather Thornton at Furman University. We acknowledge the generous help of Susan Nutter, Director of Libraries at North Carolina State University. Our thanks go to Cynthia Killough, Karen Kletter, and Will Joslin for editorial and technical assistance. William Diebold willingly shared with us his paper on the Egerton Genesis delivered at Dumbarton Oaks. Vojtech Balik graciously allowed us the privilege of seeing the Velislav Bible in Prague. Frank Kraus, Olga Savelková, and Beth Sedberry helped to make possible our study in the Czech Republic. We thank Jerry Wager of the Rare Book and Special Collections Division of the Library of Congress for bibliographical information.

Nell Medlin most generously helped us with copy editing. James Joslin, Beth Joslin, Sarah Bond, Nell Medlin, and Helen Minter were quick to relieve us of domestic duties during our busiest days, thus freeing us to devote our best energy to this project. Jaroslav Folda, Paul Gilster, and Donald Edward Kennedy kindly read portions of our study and gave us helpful comments.

We are most grateful to the Administration of Furman University for granting Carolyn Watson two leaves of absence from teaching and for grants to assist with travel expenses and publishing costs.

We wish to thank Andrew Prescott, our editor, for his encouragement and most helpful advice, as well as David Way, Anne Young, Kathleen Houghton, and Lara Speicher of the British Library Publications Office for their belief in the value of our project and for their

understanding of our special needs. We thank our two Toronto readers for their careful attention to our manuscript.

We acknowledge with grateful affection the patience and generous understanding of our husbands, William Joslin and Randal Watson, throughout our years of work on this project. The unfailing and staunch support of our immediate family, our children, and our grandchildren and the prayers and encouragement of many friends made it possible for us to work with confidence. Knowing that we could not have accomplished this work on our own power, we both can say with J. S. Bach, *Soli Deo Gloria.*

Abbreviations

AB	*Art Bulletin*
BJRL	*Bulletin of the John Rylands University Library at Manchester*
EDAM	Early Drama Art and Music
EETS	Early English Text Society
ES	Early Series
GBA	*Gazette des Beaux Arts*
Ha	*Histoire ancienne jusqu'à César (Histoire ancienne)*
HS	*Historia Scholastica*
JWAG	*Journal of the Walters Art Gallery*
JWCI	*Journal of the Warburg and Courtauld Institutes*
LSE	*Leeds Studies in English*
MLN	*Modern Language Notes*
MLQ	*Modern Language Quarterly*
MLR	*Modern Language Review*
NS	New Series
OS	Original Series
PL	*Patrologia Latina*
PMLA	*Proceedings of the Modern Language Association*
REED	*Records of Early English Drama*
RORD	*Research Opportunities in Renaissance Drama*
SS	Second Series
SUNY	State University of New York
ULTM	University of Leeds Texts and Monographs

Introduction

THE PUZZLE

'It is the riddle of all medieval picture books'. 'I have been looking at it again, and it is the most puzzling book I have ever seen'.[1] These comments of Montague Rhodes James in letters to Eric Millar and Sydney Cockerell not long after he first saw in 1919 the British Library's Egerton Genesis, Egerton MS 1894, largely remain true of this curious fourteenth-century manuscript today. James's enthusiasm for this small codex is apparent from his almost immediate decision to produce the Roxburghe Club facsimile, which appeared in 1921.[2] This facsimile, so eagerly and quickly produced, is now eighty years old and difficult to obtain.

Though James identified the handwriting as English, or 'probably English' in the case of the first scribe, he could only guess at the nationality of the artist. James was astonished by the comic facial expressions and unconventional subject matter, expressed with superb mastery of line, and he judged this artist matchless among the illustrators of his time. Our study grapples with the aspects which baffled James: the identity of the artist, the source of his style, the environment in which he produced the Egerton Genesis.

We offer here a fresh examination of the images of the Egerton Genesis and a consideration of its artistic and cultural milieu, a study which is long overdue in light of the considerable scholarship published since James introduced to modern readers this vibrant, but very fragile small book. We offer as an Appendix a rereading of the text, the first English translation, comments on sources and on the relation of image to text. In five instances, we read textual passages differently from James. In our iconographical interpretation of the 149 scenes (Chapter 3), we differ from James in a number of cases. We offer this study as an aid to future understanding of this precious monument of fourteenth-century English culture.

PROVENANCE

The exact time and place of origin of this manuscript cannot be determined from direct textual evidence. James estimated the date to be around 1360.[3] Recent scholarship affirms it as English and dates it less precisely, as a product of the third quarter of the fourteenth century.[4] The provenance of the manuscript can be traced no further than shortly before its purchase by the British Museum on March 23, 1860, from the firm of Christie, Manson, and Woods, with

income of the Farnborough fund.[5] Several days earlier, Christie's had bought the book from Lowenstein Brothers of Frankfurt-am-Main, the agency handling the dissolution sale of items from the Schönfeld Technological Museum of Vienna.[6] Schönfeld acquired in the late eighteenth century the collection of the Emperors Maximilian I and his grandson Rudolph II. It is not at present possible to determine whether the manuscript was part of the Imperial Collection, originally housed in Prague, or whether Schönfeld himself acquired it from another source. The recent provenance of the volume thus offers no clue as to its nature and origin. In our effort to solve James's puzzle, we must depend on study of the manuscript itself.

HISTORY OF SCHOLARSHIP

In the introduction to his facsimile James discussed the manuscript's acquisition and its distinctive style. He transcribed all the texts, which he related to Peter Comestor and to the Vulgate, and described all the pictures. He was unable to go beyond conjecture as to origin and purpose. This manuscript received no attention in modern times before the facsimile of James, and little attention for some years afterward.[7] Since 1937, however, it has been the object of considerable scholarship, which confirmed its English origin and began to consider its connections to earlier English and continental traditions. In that year, Millar identified a psalter closely related to the Egerton Genesis. The calendar and artistic style of this psalter were unquestionably English. This manuscript, purchased through the efforts of Millar by James's friends as a memorial to him, entered the British Library as Additional MS 44949 in 1937.[8] In 1943, Wormald judged the Fitzwarin Psalter (Paris, Bibliothèque Nationale, MS lat. 765) to contain two miniatures so closely related to those of the Egerton Genesis as to suggest the work of the same artist.[9] He was the first to introduce the question of an artistic connection to Flanders, remarking that in the Fitzwarin Psalter 'the wild conglomeration of roofs and chimneys in some ways recalls Flemish MSS'.[10] The possibility of a Flemish connection continued to rise in scholarly discussion and dispute. Subsequent chapters will reveal it as a focus of the present study as well.

Otto Pächt, in his landmark article of 1943, added the Psalter of Stephen of Derby (Oxford, Bodleian Library, MS Rawlinson G. 185) to the list of manuscripts illuminated by the Egerton Genesis artist.[11] Pächt's wide-ranging consideration of influences, models, and sources began to indicate the manuscript's richness and complexity. He noted that the scenes of the Egerton Genesis do not always illustrate their superposed texts.[12] He considered the images to constitute a Bible Picture Book with added commentaries, comparable in their layout to that of the Paduan Bible, the Genesis section of which is in Rovigo, Biblioteca dell'Accademia dei Concordi, MS 212.[13] Repetition of settings with the same personages performing action in progress suggested to Pächt that one of the artist's prototypes could have been wall paintings.[14]

Pächt detected a revival of Anglo-Saxon and late antique traditions in the miniatures of the Egerton Genesis, finding there certain parallels to scenes of the San Marco mosaics and to

those in a copy of the *Histoire ancienne* (Vienna, Österreichische Nationalbibliothek, Cod. 2576) which is considered to be of the Cotton Genesis recension.[15] He noticed how the literal portrayal of pointing fingers and upward gazes sometimes link the narrative from one scene to the other, how the physical and psychological relations of the actors confer a unity within the scene. He compared the block-like figures of this dramatic visual narrative with the solid forms of Giotto.[16]

Noting that, even on the painted folios, tints contribute little to understanding the rhythmic, occasionally foreshortened forms and thick figures, Pächt considered the Egerton Genesis artist's line drawing a substitute for painting. The successful technique of outlining the heavy figures in this manuscript, otherwise similar in form to the painted forms of Giotto, prompted Pächt to affirm that the Egerton Genesis Master ingeniously linked linear skill with the solid forms observable in fourteenth-century Italian art.[17]

Rickert in 1954 expressed the view that the Egerton Genesis is not English in style, but rather French-Italian. She based her opinion on the 'technique of grisaille' found in French but not in English manuscripts of the third quarter of the fourteenth century.[18]

Like Pächt, Henderson in his article of 1962 found the Egerton Genesis to be a reservoir of elements from many sources and traditions. He noted resemblance to the 'Cædmon manuscript' (Oxford, Bodleian Library, Junius MS 11), to the manuscript of Ælfric's Paraphrase of the Hexateuch (London, British Library, Cotton MS Claudius B. IV) and also to late-antique picture cycle types.[19] The Egerton Genesis artist, according to Henderson, must have seen and copied San Marco mosaics, which he regarded as a modification of the Cotton Genesis tradition.[20] He proposed the influence upon the Egerton Genesis artist of Palermo and Monreale Genesis mosaic types, plus influence from two medieval English works – the miniature of Lot and the Sodomites of W. de Brailes, one of seven sheets formerly in the Georges Wildenstein Collection and now in the Musée Marmottan in Paris,[21] and the Embarkation in the Queen Mary Psalter (London, British Library, Royal MS 2 B VII).[22] He concluded that the inquiring mind of the Egerton Genesis master prompted him to borrow from many sources: Anglo-Saxon, English thirteenth- and early fourteenth-century, Jewish, contemporary Italian, Italo-Byzantine and even from the Cotton Genesis (London, British Library, Cotton MS Otho B. VI).[23]

The question of the relation of the Egerton Genesis to manuscripts of the Low Countries was reintroduced by Klemm in 1973. In her study of a twelfth-century Mosan Psalter fragment (Berlin, Kupferstichkabinett, MS 78 A 6), she compared two miniatures of this psalter, the punishment of Hagar on fol. 9ᵛ and the slaughter of the Shechemites on fol. 17ᵛ, with Egerton Genesis scenes.[24] She suggested a common dependence on elements from the Cotton Genesis tradition as a way to explain these parallels.

In a paper on the Egerton Genesis, presented at a seminar on the Cotton Genesis in 1980, Diebold returned to the question of antique sources.[25] He pointed out miniatures related to the Cotton Genesis and its recension members, the San Marco Genesis mosaics and the Vienna *Histoire ancienne*. Diebold suggested that the Egerton Genesis may belong to an older tradition, of which the Cotton Genesis represents a branch, one from which the Anglo-Saxon miniatures

of Junius 11 and the Ælfric manuscript may be traced, as well as those of other northern man-
uscripts such as the German Millstatt Genesis (Klagenfurt, Kärntner Landesarchiv, cod. 6/19)
and the Bohemian Velislav Bible (Prague, Prague University Library, MS XXIII C 124).[26]

The robust figures of the Egerton Genesis Master indicated to Simpson (1984), as to Pächt,
that the artist had probably trained in Italy.[27] She acknowledged most of the stylistic connec-
tions within the oeuvre associated with the Egerton Genesis by Millar, Wormald, and Pächt
and again considered the possibility of a Flemish connection, noting similarities between the
architecture and figure style of the Fitzwarin Psalter and those of a missal made in Ghent (The
Hague, Museum van het boek/Rijksmuseum Meermanno-Westreenianum, MS 10 A 14).[28]

In their study of the Cotton Genesis, published in 1986, Weitzmann and Kessler suggested
that the Egerton Genesis could be based on an early Christian model.[29] They proposed a com-
mon model with the Junius 11 and Ælfric manuscripts, but stated that where the two cycles
differ, the Egerton Genesis is more faithful to the Cotton Genesis.

In 1986, Sandler related the Egerton Genesis stylistically to Neapolitan-Angevin art, par-
ticularly the London Dante (British Library, Additional MS 19587), produced around 1370.[30]
She mentioned 'volumetric figures precisely contoured so that each is a coherent, single unit',
along with similarities in drapery and spatial qualities, as characteristics of the Dante illustra-
tions held in common with the Egerton Genesis. She believed that the latter also exhibits both
the English traits of vigorous gesture and facial caricature and northern architectural types not
found in the Dante.

Dennison made a significant attempt to expand the oeuvre of the Egerton Genesis master
in her dissertation of 1988. Her proposals would revise the traditional picture of this artist as
an anomalistic stylist and would place all his work, including his early bifolium in the
Fitzwarin Psalter, in the post-Plague era, extending his career into the 1390s and beyond.[31]
Dennison attributed to the Egerton Genesis master the illumination of a psalter of the 1380s
(Norfolk, Holkham Hall, Earl of Leicester MS 26), as well as a page from Higden's
Polychronicon (Oxford, Bodleian Library, MS Bodley 316), and part of a psalter-hours in
Dublin, Trinity College, MS B.3.2, all of which would postdate his work in the Egerton
Genesis and the other manuscripts heretofore associated with it. Dennison believed that the
Egerton Genesis master eventually abandoned most of the Italianisms which characterised his
earlier illumination and came under the influence of late fourteenth-century artists who
worked on the Carmelite Missal (London, British Library, Additional MS 29704-5) and the
Litlyngton Missal (London, Westminster Abbey, MS 37). His style thus became more English
and more painterly, she claimed, while retaining some of the figural monumentality of the ear-
lier work. In her discussion of the Egerton Genesis master's oeuvre, centering on the Derby
Psalter, she drew a number of parallels between figural elements in the Derby manuscript and
those of three later ones. She related borders in these four manuscripts, through various inter-
mediaries, to a common source: the Queen Mary Psalter group.

John Lowden, in 1992, questioned whether, given its unfinished state, Egerton 1894 may
indeed be called a Genesis.[32] He claimed it finds no context among other so-called Genesis
manuscripts. He believed that its fragmentary condition precluded deductions about what its

designers proposed to accomplish, and suggested that the Genesis miniatures of Egerton 1894 were perhaps intended as a prefatory cycle.

In remarking upon the subordination of text to image in the Egerton Genesis, Caroline Hull, in 1995, noted that inscriptions were added rather inexpertly, after the completion of the pictures, that they were 'of secondary importance'.[33] In commenting on the Holkham Bible Picture Book (London, British Library, Additional MS 47682), she noted that carelessness in identification of subjects and failure to estimate space needed for text indicates that the scribe composed as he wrote.[34]

In conclusion, we agree with Millar, Pächt, and Wormald that the hand of the Egerton Genesis artist is found in the illumination of the Fitzwarin, James Memorial, and Derby Psalters. Further discussion of these manuscripts in Chapter 6 qualifies our view. Unlike Dennison, we do not find the hand of the Egerton Genesis artist in illumination of the later decades of the fourteenth century. It appears, rather, that the Egerton Genesis is the work of a mature and experienced master, one whose career had developed during the two preceding decades. Suggestions that the Egerton Genesis is related to Flemish manuscripts have surfaced repeatedly in scholarship; we find these connections to be highly significant, as explained in subsequent chapters, especially Chapter 6. Italianisms, especially those derived from Tuscan and north Italian sources, have also presented themselves insistently to other scholars and to ourselves.

BIBLE PICTURE BOOKS

The so-called Bible Picture Book of the thirteenth and fourteenth centuries is a pictorial narrative of biblical events. Text was not the primary interest of the patron. Inscriptions were intended to be explanations of the pictures, a reversal of the usual case with medieval manuscripts, where images illustrative of the text introduce sections or stress typology implicit in the text. We shall not here attempt to review all manuscripts which might typify the Bible Picture Book. Indeed, this genre comprises examples which differ widely from each other.[35] Rather, we shall discuss selected works in order to illuminate similarities to and differences from the Egerton Genesis.

The rise of the genre of the Bible Picture Book correlates to a change in taste among Flemish patrons of the thirteenth century, who wished to possess chronological works in prose—some of which, like the *Histoire ancienne* and the *Bible historiale,* began with the biblical Genesis—rather than the verse romances so popular in the twelfth century.[36] A related taste for visual biblical narrative summoned such thirteenth-century visual expressions as the John Rylands Bible[37] and the Morgan Picture Book.[38] The genre includes fourteenth-century visual narrative sequences such as the prefatory pictures of the Queen Mary Psalter, the Holkham Bible Picture Book, the Egerton Genesis in England, the Paduan Bible in Rovigo, and the Bohemian Velislav Bible. The prefatory miniatures without text in the *Omne Bonum* in the British Library, an encyclopaedic compilation of medieval learning, can also be compared to a Bible Picture Book.[39]

Although much earlier in production, the John Rylands Bible (Manchester, John Rylands University Library, MS French 5) has several qualities in common with the Egerton Genesis. Short inscriptions in Anglo-Norman French, often almost titular, relate to the scenes depicted. These brief texts do not always correspond to the paintings they putatively explain. On fol. 27v, the text tells much more of the story than the illustration depicts; on fol. 37r, the explanation ignores the feast that the illustration portrays.[40] Like the Egerton Genesis, the Bible at Manchester is fragmentary. In its present state, it lacks illustrations in the Genesis for the third and sixth days of Creation, possibly for the Fall of Man before the Expulsion on fol. 6, and possibly for Jacob's ladder. In addition, two illustrations were probably omitted between Joseph's explanation of his dream (fol. 27v) and his sale to a potentate, Potiphar or Pharaoh (fol. 28r). On fol. 8r of the Bible at Manchester, as on the Sodomite scene of the Egerton Genesis, fol. 11r (10rJ), a moralist-scraper has been at work. Fawtier believed that the iconoclast mistook Abel for Cain and rubbed off the face of both Abel and God, ignorantly suspecting that the scene portrayed a preference by the Deity for the murderer Cain to his innocent brother Abel.[41] Cain's face is scraped in the image of his brother's murder on fol. 9v; the faces of Moses and of the Egyptian he murders are scraped on fol. 47v. Inscriptions were imposed after the miniatures. Indeed, seven of the Rylands Bible paintings were left without inscription until some time after the production of the manuscript.[42]

Having acknowledged these similarities to the Egerton Genesis, we note several obvious differences. The John Rylands Bible is a serious attempt to retell the Genesis story by single scenes per page. It respects the patriarchs. Sexual references are either omitted or depicted with decorum. The Deity is a standing figure in the Creation scenes and in the confrontation with Cain. Only once is the Deity shown as a face and blessing hand from a cloud, at upper right—in the sacrifice of Cain and Abel. In the rarity of representations of God, the Rylands Bible differs from the Egerton Genesis. Another contrast with the Egerton manuscript is that faces are similar in the Rylands Bible and bodily motion is restrained, though expressions and gesticulating hands enliven the action.

The Morgan Picture Book (New York, Pierpont Morgan Library, MS M. 638) has several characteristics in common with the Egerton Genesis. It presents an extensive visual Genesis narrative in fifty miniatures on its first seven folios with few typological references. There are usually four scenes to the page. The patron of the Morgan Picture Book, like the commissioner of the Egerton Genesis, was interested primarily in image rather than text; its bas-de-page Latin text in an Italian script was imposed about fifty years after the completion of the images in an attempt to explain them.[43] Cockerell conjectures that the codex went from Paris to Naples, where it received its inscriptions.[44] As in the text of the Egerton Genesis, biblical chronology is misinterpreted in some cases. The Joseph story affords an example of misinterpretation—on fol. 7r the burial of Joseph is the likely subject, whereas the Latin text identifies the scene as the burial of Jacob.[45] The Morgan Picture Book differs from the Egerton Genesis in that many of its Genesis illustrations stress kingship and the triumph of kingly figures in battle scenes.

The Holkham Bible Picture Book (London, British Library, Additional MS 47682) is an English work produced in the second quarter of the fourteenth century,[46] commissioned pri-

marily for pictures rather than for text.[47] Like the Egerton Genesis, the Holkham manuscript bears Anglo-Norman inscriptions, evidently imposed after the completion of the images. However, the Holkham Bible's scribe includes phrases of English and Latin, whereas the Egerton Genesis writers use Anglo-Norman throughout. The second Egerton Genesis scribe's technique of cramming text into available space left by the illustrator also characterises the Holkham Book.[48] The text of neither of the two manuscripts consistently explains the pictures appropriately: the writer sometimes includes more about the theme than is visually represented. However, the Holkham Bible's literary designer more nearly bears the relevant image in mind than does the Egerton Genesis writer, who in several instances includes details quite at variance with those in the subjoined images. Like those of the Egerton text, the inscriptions of the Holkham Bible Picture Book are drawn from both the Vulgate and the *Historia Scholastica* of Peter Comestor.[49]

Points of similarity and difference between the two manuscripts also occur in their use of colour, gold, and silver. Both manuscripts have tinted drawings, though opaque paint was also used in the Egerton Genesis. The Holkham manuscript seems to contain neither gold nor silver. The Egerton Genesis painter almost always outlines the clothing of important painted figures, such as Abraham and Sarah, with a fine gold line. He uses white or silver to mark the face and hands of the Deity or of an angelic messenger. Gold wash alone or in conjunction with silver emphasises royalty or divinity. Yet, judging by the limited use of such embellishments, neither manuscript was a luxury item.

Both designers have produced figures characterised by poses and actions reminiscent of the drama.[50] In contrast with Egerton Genesis figures, the Holkham figures are sprightly, even when they assume dramatic poses and forceful gestures. Though both the Holkham and Egerton manuscripts seek to entertain, and both manifest theatrical elements, the Holkham Picture Book, alone of the two, evinces the didactic purpose of instruction in piety, first noticed by James and Hassall,[51] a purpose shared by the Queen Mary Psalter and the Velislav Bible.

The late fourteenth-century Paduan Bible (Biblioteca dell'Accademia dei Concordi, MS 212 and London, British Library Additional MS 15277) has been coupled with the Egerton Genesis as a Bible Picture Book. Pächt considered this Italian Bible to be 'its closest parallel'.[52] The Paduan Bible's Genesis text, in Italian, is translated from the Vulgate and from Peter Comestor's *Historia Scholastica*, with some author-imposed details, as in the Egerton Genesis. Arensberg noted that 'the author of the text . . . sometimes contributed material himself to clarify historical events and make the biblical story more accessible to a fourteenth-century audience'.[53] These scribal additions are notable in the Egerton Genesis manuscript as well.[54] The Paduan Bible's inscriptions, like those in the Egerton Genesis, succeeded the layout of the miniatures.[55] As in most pages in the Egerton Genesis, there are four scenes to a page. The human forms of the Italian Bible are invariably ponderous, even heavier in appearance than the bulky, Giottesque figures of fol. 20ᵛ of the Egerton Genesis, remarked by Pächt (the seated brothers seen from the rear at Joseph's feast),[56] or the figures of workmen who construct the Tower of Babel (fol. 5ᵛ, fig. 23), or the superimposed forms of the brothers binding

sheaves of grain in the dream of Joseph (fol. 18ʳ). The Paduan Bible's artist, unlike the Egerton Genesis master, depicts sexually explicit Genesis scenes with restraint.[57]

The Velislav Bible (Prague, Prague University Library, MS XXIII C 124), dating from the middle third of the fourteenth century, includes a visual narration of Genesis, other books of the Old Testament, and cycles based on both the New Testament and the lives of Czech saints.[58] The figures in this codex have been compared to those of the Holkham Bible Picture Book.[59] The Velislav figures, however, lack the animation of the Holkham Bible figures and also the weighty quality of those of the Paduan Bible and certain Giottesque Egerton Genesis images. In the Velislav Bible, there are examples of trees with heart-shaped leaves comparable to the foliage in the Egerton Genesis.[60] Czech captions, imposed at the end of the fourteenth or beginning of the fifteenth century, supplement the brief Latin inscriptions. In the seventeenth century, German legends were added. Unlike the Egerton Genesis artist, the Velislav Bible's designer either ignores or treats by suggestion references in the book of Genesis to such events as circumcision, rape, and even birth. One scene of the circumcision of a child has been scraped by an offended owner, as is the case with certain scenes in the John Rylands Bible and the Egerton Genesis. Apparently the Prague Bible was intended for a pious clerical patron, perhaps a Canon of Prague.[61] Its colours are striking, as they are in the first gathering of the Egerton Genesis. Not merely decorative, colour has a role to play in the narrative: green for nature is predominant; flesh tones are golden beige; red is used for border, blood, sceptres, and lips; horses and other animals are often blue; purple is sometimes used for clothing (fol. 30ᵛ).

The Queen Mary Psalter (London, British Library, Royal MS 2 B. VII), of the early fourteenth century, though not a Bible Picture Book, is comparable to the Egerton Genesis: its prefatory miniatures begin with narration of the Genesis; its short texts in Anglo-Norman accompany the miniatures as titles or rubrics; its images receive primary attention; its text includes legendary material. Unlike the Egerton Genesis, the Genesis scenes of the Queen Mary Psalter were all carefully planned with inscriptions in view. These brief texts fit both between and below two-tiered tinted drawings on the page and aptly express the subject they describe.[62] Stanton thought that the manuscript was commissioned by Isabella for the instruction of her son, the future King Edward III. It was, according to Stanton, designed for devotional use, for instruction in biblical-historical narrative, and for training in regal behaviour.[63] These qualities establish its radical difference from the Egerton Genesis.

The *Omne Bonum* (London, British Library, Royal MSS 6 E. VI, 6 E. VII), a secular English encyclopaedia dated c. 1360, is the autograph of James Le Palmer, London Exchequer Clerk, and a unicum as well.[64] Its prefatory cycle comprises one hundred and nine outline-and-wash miniatures, generally four to a page. Twenty-seven of these drawings, on three folios, are of Genesis subjects. The artist lacks the superb skill of the Egerton Genesis artist. His stiff, elongated figures repeat the same gestures. No gold leaf embellishes the *Omne Bonum* Genesis scenes, but rather gold and silver wash, as in the Egerton Genesis. Crowns and haloes show evidence of gold wash; knives and swords are silvered. No text accompanies the prefatory paintings. Altogether, this manuscript has far fewer Genesis scenes than the Egerton Genesis.

Though there are similarities between the Egerton Genesis and certain other Bible Picture Books or prefatory visual narratives of the Genesis, the Egerton Genesis differs from the selected works described above to the point of eccentricity. Though designed by a more skilful artist, it lacks the serious iconic tone of Rylands Bible scenes. Unlike the Morgan Bible, the Egerton Genesis does not glorify kingly figures, but mocks the stupidity, lust, or venality of the powerful. The moral instruction and piety of the Holkham Bible imagery is lacking. Though sharing figural elegance and liveliness with the prefatory Genesis scenes of the Queen Mary Psalter, the earthy Egerton Genesis makes no effort to provide instruction in courtly behaviour. Its characters differ vastly from the ponderous, modest actors in the Paduan Bible's Genesis. The consistent dignity required by an ecclesiastical patron, notable in the Velislav Bible, finds no counterpart in the Egerton Genesis. Nor does the Egerton artist display the naïve seriousness of the Genesis scenes preceding the encyclopaedic *Omne Bonum,* but rather entertains the viewer with sparkling satire.[65]

The Egerton Genesis was meant for the entertainment of a middle-class patron and his friends. This patron relished the drama, made no pretence of scholarship or piety, and had an earthy sense of humour and a keen eye for human and societal defects. The manuscript de-emphasises theology, though figural references to the deity in the visual narrative are always reverential. The artist offers amusement to a secular patron at the expense of the revered Genesis characters; indeed, he revels in their sometimes irresponsible or tawdry behaviour. Aware of contemporary social conditions, the artist dramatises the problems of the beggar, the tithe payer, powerless women, and ordinary shepherds. The Egerton Genesis differs radically from other comparable Picture Books.

METHODS, OBJECTIVES, AND QUALIFICATIONS FOR THIS STUDY

Many problems surround the Egerton Genesis: problems of origin, of stylistic character, and of relationship with other manuscripts, problems associated with the poor condition of the manuscript, problems with the relation of text to pictures, uncertainties as to its original patron, purpose, and genre. In view of these difficulties, we choose to employ multiple, flexible methods in an effort to cast light upon this work, in some respects so vastly different from roughly contemporary English illuminated manuscripts. No attempt will be made to locate this work in a system of Genesis archetypes in recension. Rather, we consider the monument itself with respect to its artistic production and the social milieu in which it was produced.

We examine the Egerton Genesis as an artefact—a codex, misbound, fragmentary, and in various stages of completion with regard to painting, inscriptions, initials, and line drawing. We provide a brief palaeographic analysis of the two scribal hands. In the Appendix, we transcribe the text with only such punctuation changes as make for easier reading and translate the text as literally as is easily understandable. We describe and discuss the iconography of each image. We examine the manuscript as a visual narrative of the Genesis, with accompanying literary commentary. We pay attention to the iconography and style of the images as they

relate to other English manuscripts and visual arts and to Flemish and Italian art. We present evidence of the artist's interest in contemporary drama, of his other distinctive interests and of his psychology. We identify earlier works by the artist and locate his origins in Flanders. We situate the production of the Egerton Genesis in Norwich, a centre of rich manuscript production. The question of patronage will be considered in the light of what can be gleaned from the work itself.

The manuscript is an historical document, which gives valuable information of many sorts. We leave to future scholars the full examination of historical materials in archival records. Scholars such as Hull have demonstrated how fruitful such study can be. The Egerton Genesis is a vibrant reflection of fourteenth-century life—the life of an artist with ties to Flanders, and the life of the East Anglian city in which it was produced.

Notes

1 Richard William Pfaff, *Montague Rhodes James* (London: Scolar Press, 1980), pp. 307–308.

2 Montague Rhodes James, *Illustrations of the Book of Genesis: Being a Complete Reproduction in Facsimile of the Manuscript British Museum, Egerton 1894* (Oxford: Oxford University Press, Roxburghe Club, 1921).

3 James, *Illustrations*, p. 6.

4 Lucy Freeman Sandler, *Gothic Manuscripts 1285–1385*, 2 vols, in *A Survey of Manuscripts Illuminated in the British Isles*, V (London: Harvey Miller, 1986), II, 143; Lynda Eileen Dennison, 'The Stylistic Sources, Dating and Development of the Bohun Workshop, c. 1340-1400' (unpublished doctoral thesis, Westfield College, University of London, 1988), p. 65.

5 M. A. E. Nickson, *The British Library: Guide to the Catalogues and Indexes of the Department of Manuscripts* (London: British Library, 1978), p. 7; James, *Illustrations*, p. 1.

6 James, *Illustrations*, p. 1.

7 Pfaff, p. 308.

8 Eric G. Millar, 'The Egerton Genesis and the M. R. James Memorial MS', *Archaeologia*, 87 (1938), 1–5.

9 Francis Wormald, 'The Fitzwarin Psalter and Its Allies', *JWCI*, 6 (1943), 71–79 (p. 74).

10 Wormald, p. 72.

11 Otto Pächt, 'A Giottesque Episode in English Mediaeval Art', *JWCI*, 6 (1943), 51–70 (p. 69).

12 'Giottesque Episode', p. 58.

13 'Giottesque Episode', p. 61.

14 'Giottesque Episode', p. 59.

15 'Giottesque Episode', pp. 62, 65.

16 'Giottesque Episode', p. 68.

17 'Giottesque Episode', p. 68–69.

18 Margaret Rickert, *Painting in Britain: the Middle Ages* (Baltimore: Penguin, 1954), p. 243, n. 9.

19 George Henderson, 'Late Antique Influences in Some English Mediaeval Illustrations of Genesis', *JWCI*, 25 (1962), 172–198 (pp. 172, 173, 176).

20 'Late Antique Influences', p. 196.

21 Twenty-four of the de Brailes sheets in this collection are preserved as Baltimore, Walters Art Gallery, MS W. 106.

22 'Late Antique Influences', pp. 189–190, 196, figs 36c and 35d.

23 'Late Antique Influences', p. 197.

24 Elisabeth Klemm, *Ein romanischer Miniaturenzyklus aus dem Maasgebiet* (Vienna: Holzhausens, 1973), p. 35, pl. 4; p. 47, pl. 10.

25 William Diebold, 'The Egerton Genesis' (unpublished paper presented at Dumbarton Oaks, Washington D.C., 1980). The author has kindly shared this paper with us.

26 pp. 14–25.

27 Amanda Simpson, *The Connections between English and Bohemian Painting during the Second Half of the Fourteenth Century* (New York: Garland, 1984), p. 115.

28 pp. 115–118.

29 Kurt Weitzmann and Herbert L. Kessler, *The Cotton Genesis, British Library Codex Cotton Otho B VI* (Princeton: Princeton University Press, 1986), p. 25.

30 *Gothic Manuscripts*, II, 143.

31 'Stylistic Sources', pp. 65–66, 217–223.

32 John Lowden, 'Concerning the Cotton Genesis and Other Illustrated Manuscripts of Genesis', *Gesta*, 31 (1992), 40–50 (pp. 44–45).

33 Caroline S. Hull, 'Rylands MS French 5: the Form and Function of a Medieval Bible Picture Book', *BJRL*, 77.2 (1995), 3–24 (p. 13).

34 Hull, 'Rylands MS', p. 13, n. 33.

35 These books have been described by Hull, who remarks on the diversity among them. See Hull, 'Rylands MS', p. 7 and *passim*.

36 Brian Woledge and H. P. Clive, *Répertoire des plus anciens textes en prose française depuis 842 jusqu'aux premières années du XIIIe siècle* (Geneva: Droz, 1964), pp. 27–34. See also Gabrielle M. Spiegel, *The Past as Text: the Theory and Practice of Medieval Historiography* (Baltimore: Johns Hopkins University Press, 1997), pp. 189, 191–192.

37 Hull, 'Rylands MS', p. 3. For this manuscript, see also Robert Fawtier, *La Bible Historiée toute figuriée de la John Rylands Library* (Paris: pour les Trustees et Gouverneurs de la John Rylands Library, 1924).

38 For the approximate date of this manuscript, see Sydney C. Cockerell and John Plummer, *Old Testament Miniatures: a Medieval Picture Book with 283 Paintings from the Creation to the Story of David* (New York: Braziller, 1969), p. 6.

39 See Lucy Freeman Sandler, *'Omne Bonum': a Fourteenth-Century Encyclopedia of Universal Knowledge, British Library MSS Royal 6 E VI – 6 E VII*, 2 vols (London: Harvey Miller, 1996).

40 Fawtier, pl. XXXII, fol. 27ᵛ (45ᵛ under the image); pl. XXXVII, fol. 37ʳ.

41 Fawtier, p. 16.

42 Fawtier, p. 6.

43 Early in the seventeenth century, while the present Morgan manuscript was in the possession of Shah Abbas, marginal descriptions of the scenes in Persian were imposed. Hebrew transliterations, also inscribed in the seventeenth century, accompany most of these inscriptions added in Persian. See Cockerell and Plummer, pp. 15, 16.

44 Cockerell and Plummer, p. 6.

45 Cockerell and Plummer, p. 50.

46 Sandler, *Gothic Manuscripts*, II, 105.

47 F. P. Pickering, *The Anglo-Norman Text of the Holkham Bible Picture Book* (Oxford: Blackwell, for the Anglo-Norman Text Society, 1971), p. ix.

48 W. O. Hassall, *Holkham Bible Picture Book* (London: Dropmore, 1954), fols 16ʳ and 17ʳ.

49 Pickering, p. xviii.

50 Hassall, pp. 34–36.

51 M. R. James, 'An English Bible-Picture Book of the Fourteenth Century', *Walpole Society*, 11 (1922–23), 1–27 (p.5); Hassall, p. 48.

52 'Giottesque Episode', p. 61.

53 Susan Arensberg, 'The Padua Bible and the Late Medieval Biblical Picture Book' (unpublished doctoral dissertation, Johns Hopkins University, 1986), p. 100.

54 We describe them in our Appendix, below.

55 Arensberg, p. 52.

56 Pächt, 'Giottesque Episode', p. 67.

57 See Chapter 3 below, for comments on fols 9ᵛ, lower right, and 17ᵛ, upper left, scenes of circumcision in the Egerton Genesis.

58 See Karel Stejskal, ed., *Velislai Bibbia picta*, 2 vols (Prague: Pragopress, 1970); Antonin Matějček, *Velislavova Bible* (Prague [n.pub.], 1926); Jan Erazim Vocel, *Welislaws Bilderbibel aus dem dreizehnten Jahrhunderte in der Bibliothek Sr. Durchl. des Fürsten*

Georg Lobkowic in Prag (Prague: Verlag der königl. böhm. Gesellschaft der Wissenschaften. Druck von Dr. Eduard Grégr, 1871). See also Arensberg, p. 327, n. 36.

59 Stejskel, text vol., p. 21.

60 Examples of heart-shaped leaves are found on fols 62ʳ and 68ʳ of the Neapolitan Dante, as well.

61 Stejskal, text vol., p. 18.

62 See George Warner, *Queen Mary's Psalter: Miniatures and Drawings by an English Artist of the 14th Century* (London: British Museum, 1912), pls 1–28.

63 Anne Rudloff Stanton, 'The "Queen Mary Psalter": Narrative and Devotion in Gothic England' (unpublished doctoral dissertation, University of Texas at Austin, 1992), ch. V, especially pp. 198–199.

64 Lucy Freeman Sandler, 'Notes for the Illuminator: the Case of the *Omne bonum*', *AB*, 71 (1989), 551–564 (p. 552); Sandler, '*Omne Bonum*,' I, 93–94. See also Sandler, *Gothic Manuscripts*, II, 136–138.

65 Before leaving this brief discussion of fourteenth-century Bible Picture Books, we note the prefatory scenes of the mid-fourteenth-century Haggadah of Spanish origin in the Museum at Sarajevo. This fine codex is a virtual Bible Picture Book, with forty-two scenes illustrating the entire Genesis, from the Creation to the death of Joseph, followed by scenes from Exodus. See Cecil Roth, text, *The Sarajevo Haggadah and its Significance in the History of Art* (New York: Harcourt, Brace & World, 1963).

Description of the Manuscript, Textual Sources

THE MANUSCRIPT

1. Codicology

The Egerton Genesis is a pictorial narrative, in 149 scenes, of the biblical Genesis, supple-
mented by legendary material. Inscriptions in Anglo-Norman French accompany the scenes
on about half of the folios. It is a small quarto volume of twenty parchment leaves measuring
about 245 mm × 185 mm. Measurements vary somewhat because of marginal cropping during
rebinding. Though described as having a velvet cover at the time of its sale to the British
Museum,[1] the manuscript is presently bound in red leather, with the Egerton book seal on
both outside covers. On the spine is the following inscription: Pictorial Illustrations of the
Book of Genesis, XIV Cent. / Mus. Brit. Bibl. Egerton / Ex Legato Caroli Baron Farnborough
1894, Press 525.H.[2] Flyleaves A-H and I- may be described as follows: A^r has inner binding
pattern; on A^v at bottom—$.644.a, with a note beneath, Ex.MR,11.ff. 5^v-6, an indication that
the codex was to be opened at fols 5^v and 6 for exhibition in the British Museum[3]; B^r has an
attached list of published references; C^r (top)—E.G. 1894 (Farnb.); (centre, in a fine cursive
hand)—Purchased at Christie's 23rd March 1860. "Vienna Museum", Lot 1286';[4] D-G are
blank; H is a kind of title page with the following text: 'v. Schönfeldsches / Museum der
Technologie / zum / Vortheil des Gewerbstandes / errichtet / im Jahre 1799 / Französische
Urschrift / vom / neunten oder eilften Jahrhunderte'; beneath this, in penciled longhand—
'about 1310–1320 / F. M.';[5] at bottom is a dim heraldic device stamped in red. Flyleaf I^r has
'2off' written in pencil at centre page, I^v has the same heraldic red stamp found on fol H; J^r
has '2off' written in centre page; J^v-O^r are blank; O^v is the end page with a binding pattern.

Originally, the manuscript as we know it today consisted of three quaternions. The first
gathering, from which the original second leaf is missing, includes the present fols 1-7; the
second gathering includes fols 8-15; the third gathering comprises fols 16-20. The three final
leaves are missing. The 149 scenes illustrate 44 chapters of the Book of Genesis. If the excised
folio between folios 1 and 2 had been illustrated with eight scenes, four to a page, as are most
pages in the manuscript, the number of scenes would total 157, or between three and four
scenes per chapter.[6] Two folios are misbound; the seventh and eighth folded sheets are trans-
posed. Diebold pointed out that the misbinding is not of recent date, since fols 12^v (13^v J) and
13^r (12^r J)[7] of the present binding were at one time stuck together and subsequently roughly

separated, to the detriment of both pages, treatment that would not have occurred after the rebinding by the British Library. It is our observation that the misbinding, with which we must presently deal, was a primary error. The sheets of parchment in question apparently attained their present sequence before the ink was dry, as inkblot transfers suggest. Outlines or internal details were overdrawn in black ink as a folio neared completion. Before the ink dried, the artist overlaid the sheet with another, with resultant blotting of the wet ink. A few examples of the many inkblot transfers in the Egerton Genesis are cited here:

fol. 2v, upper right; transfer from head of Cain in fol. 3r, upper left

fol. 3v, upper left; transfer from the two doorways of the Ark on fol. 4r

fol. 3v, lower half, centre, transfer from foliage balls of central tree at bottom of fol. 4r

fol. 6v, upper right, between the heads of Lot and Sarah; transfer from hair of dark-complexioned figure in fol. 7r, upper left

fol. 10r (11rJ), upper right, numerous small transfers within a triangular area at the foot of the bed, from shading of Hagar's dress, fol. 9v, upper left

fol. 13v (12vJ), upper left, vertical smudge through figure of the attendant at right; a transfer from doorway, fol. 14r, upper left

fol. 13v (12vJ), upper right, two diagonal lines smudged above the heads of the camels; a transfer from the garment of Abimelech's attendant, fol. 14r, upper right

No transfers occur in the final gathering, which consists only of outline drawings, done with a fine-nibbed pen and probably quick-drying.

We have considered an alternative possibility for the origin of these spots: that they might be transfers created by pressure after the pages were dry. If pressure had caused the transfers, one might expect to see them more uniformly distributed over the pages of the book. One might also expect to see transfers of the heavier opaque pigments, as well as of the overdrawing. The absence of both conditions has led us to decline the hypothesis of pressure as a cause of inkblot transfers.

It is possible that the designer, who was both artist and scribe of the first folio, initially intended a larger page, about 22 mm wider and about 25 mm longer. This is suggested by horizontal and vertical rulings, which would have been at central points in the original sheet. Two ruled lines on both recto and verso, at the top of the lower quadrants where text may originally have been imposed, were scraped in order to reduce the size of the sheet. The economic use of materials, evident in many aspects of this unfinished manuscript, may thus have begun on the first page.

The manuscript is now fragmentary. As indicated above, four folios have been lost. That the folio after the first leaf was cut is evidenced by the quarter-inch stub which remains. It probably depicted the fall, the expulsion, and the fratricide. The missing three folios at the end, which would have continued the Joseph story, are absent without trace. Any sign of remaining stubs is concealed in the binding. Images following Judah's intercession for Benjamin (Genesis 44), the last miniature of fol. 20, through the death and burial of Joseph (Genesis 50) would have completed the narrative of the Genesis. As noted before, it has been suggested that a

completed Genesis may not have been all that was originally planned.[8] The unfinished condition of this manuscript compounds the difficulty caused by the loss of folios and by misbinding.

The Egerton Genesis is extremely fragile. Badly mistreated in the past, it is rubbed, stained, torn, split, and even scraped, with attempts made at patching. On fol. 1, the lower margin and right corner are missing; the corner has been patched, making both the scene of the fourth day of Creation and the creation of Eve on the verso difficult to decipher. Fol. 15 is torn at the lower corner, so that the sleeping Jacob in the scene of the heavenly ladder on the recto and a large part of Jacob's encounter with Rachel at the well on the verso are missing. The artist initially ruled the central vertical border of fol. 15r too far to the left. He moved it to the right by about 12 or 13 mm, but never erased his mistake. As already noted, fols 12v (13vJ) and 13r (12rJ) are badly defaced because they were stuck together and pulled apart, making the scenes of the sacrifice of Isaac and of Isaac's prosperity difficult to read. The colour of fol. 15v, upper left, is damaged by scraping and chipping. Patches, holes, marginal splits, even a mid-page split can be found. Lower right areas on several folios are rubbed and faded. In describing the rubbed and torn outer edge of fol. 1 of the Holkham Bible Picture Book, Hassall suggested that for a considerable time the book had no cover, and seemed to have been 'in the hands of owners who did not appreciate it as a work of art, although they did not destroy it but used it.'[9] This may have been the case with the Egerton Genesis, as the codex was obviously much and carelessly used. Unfinished, undervalued, this manuscript was badly treated, probably for a considerable time. By a happy chance, it has survived to our day.

2. Working practices and stages of completion of the work

Much in the Egerton Genesis gives a sense of organic process in the work of artist and scribes. However, there are also many indications that time and money were short. Various elements of the manuscript's scribal and artistic work remain incomplete at different points. Initially the artist was probably also the scribe.[10] Scribe I, who was also the artist, ceases writing on fol. 2v, after he inscribes the upper right scene of this folio, the events of which, curiously enough, chronologically precede in the source those narrated on the quadrant to the left. Scribe II narrates this adjacent left quadrant, as well as the lower half of the folio and all scenes thereafter until the inscriptions cease. His work, of a lower quality than that of his predecessor, was probably less expensive for the patron.

This reversal of chronology coupled with a change in scribal hands may provide evidence of a brief episode of training to prepare the new scribe to assume his duties. The two scribes sat down with the folio spread before them. Scribe I, who was right-handed, took up the pen to demonstrate the proper procedure for inscribing a scene to his successor seated at his left. He inscribed events with chronological priority in the right quadrant, rather than in the left, where we would normally expect him to begin, so that his writing hand might not obscure his colleague's view of this important process. Because of the unusual composition in these two quadrants, which are not strictly subdivided into two discrete scenes, Hand I deemed this handling of the inscriptions for these quadrants acceptable.

In the first gathering, there are two full-page scenes, the debarkation, fol. 4ʳ, and the building of the Tower of Babel, fol. 5ᵛ, and two half-page scenes, the embarkation, fol. 3ʳ, and the destruction of the Tower of Babel, fol. 6ʳ. In the second gathering, there is one half-page scene, that of Lot, Abraham, and the Sodomites at the bottom of fol. 11ʳ(10ʳJ). Unlike the first two gatherings, the final gathering has neither full- nor half-page scenes. Presumably, the larger more compositionally complex scenes required more time to design. The progressive reduction in the number of such scenes suggests an effort to save time.

At the second gathering, beginning at fol. 8ʳ, the tinting of the borders ceases. Inscriptions and initials are missing on fol. 8ʳ, but inscriptions continue on fol. 9 and through the upper half of fol. 11ʳ (10ʳJ). Thereafter, inscriptions are lacking.

Beginning with the first leaf in the second gathering, the border strips between miniatures are no longer tinted pale yellow. This is perhaps evidence of a small economy of money, or more probably, of time. In addition, the two-line initials, blue flourished with vermilion, drop out at this point, just where vermilion reappears in the miniatures. It is interesting to consider the reasons for the shift in the use of this pigment at this point. Vermilion was used on fol. 1 to shade the gold-wash cloak of the Deity in the Creation scenes and on fols 1 and 2 to flourish initials. On fol. 2ᵛ, upper half, it colours the lining of Zillah's cloak and the red-hot iron on Tubal-cain's forge. After that, it disappears from the miniatures but continues to be used in the decoration of initials through fol. 7ᵛ.

The disappearance of vermilion from the miniatures happens just at the point where the second scribal hand takes over. The following scenario is possible: There was a single pot of vermilion. The Egerton Genesis artist (Scribe I) used it both in colouring the miniatures and in flourishing the initials in the accompanying inscriptions on fols 1 and 2. When in the middle of fol. 2ᵛ, he relinquished both the job of scribe and the pot of vermilion to Hand II, so that this second author-scribe could decorate the initials. (Evidence that each scribe decorated his own initials is provided by the fact that scribal hands and the type of decoration applied to initials change on the same folio, fol. 2ᵛ.) On fol. 8ʳ, the first leaf of the second gathering, the vermilion reappears in the miniatures. This colour is found also on fol. 15, the conjoint leaf of fol. 8. The reappearance of this colour is on the very leaf on which initialling disappears; no longer needed by the initialler, the pot of vermilion has passed back to the artist.

Painted initials drop out on fol. 9ʳ, though on the eight scenes of fol. 9ʳ and 9ᵛ and on the upper half of 11ʳ (10ʳJ) small prompting initials are pencilled within the two-line initial boxes. Thus, since fol. 8 lacks all inscriptions and initials, after fol. 7ᵛ there are no painted initials.

At the end of the first gathering (fol. 7ᵛ), there is a change from the more complicated scalloped cloud, from which the divine figure speaks, to the simple serrated cloud which took less time to execute. In the third gathering, beginning at fol. 16ʳ, the heavenly cloud drops out, except for a small one at lower left on fol. 17ᵛ. Also, the number of tiers of the serrated clouds diminishes from eight to two in the second gathering. There are eight on fol. 8ʳ, five on 9ᵛ, four on 10ᵛ (11ᵛJ), three on 13ᵛ (12ᵛJ) and only two on 14ʳ, the last appearance of the cloud in this gathering.

The reduction in the use of colour is more difficult to assess, because of the role played by misbinding and rough handling. Although the first nine folios were painted in a combination of wash and opaque paints, the latter have been much rubbed; as a result, the wash medium seems now to predominate, more than was originally the case. There is full colour for conjoint leaves 8 and 15 and conjoint leaves 9 and 14. Full colour is reduced to green and blue for fols 10 (11J), 11(10J), 12 (13J), and 13 (12J).

Penwork shading starts to decrease on fol. 10r (11rJ). Scenes of the last gathering, on fols 16-20, are simple line drawings where the artist's masterful graphic skill is clearly apparent. In the final gathering, the artist often renders hands in a time-saving, formulaic way which is apparently of north Italian origin. The hand appears as a lancet-shaped form with fingers indicated by parallel lines. The hand of Rachel on fol. 16r, lower right, and the hands of Rachel and Laban on fol. 16v, lower left, are only three among numerous examples.

The question of the missing final three leaves of the manuscript and of the unillustrated chapters of Genesis must be considered also. In the extant manuscript, in which 149 scenes illustrate 44 chapters of Genesis, the density of illustration averages three and a half scenes per chapter. Six chapters, Genesis 45-50, lack illustration. Had they been illustrated in conformity with the rest of the manuscript, these chapters would have been depicted in 21 scenes. This number would have filled just over five pages, requiring three leaves, and would have brought the total number of scenes to 178, including the eight scenes hypothesised for the excised leaf. We cannot, of course, be sure that the now-missing three leaves were ever completed in this fashion, nor that the original commission was only for the Book of Genesis, but these hypotheses are not unreasonable ones.

Study of the stages of completion of the manuscript yields evidence of the stages in its production. The only aspect of the manuscript that is complete on all extant leaves is the drawing. Throughout the manuscript, drawing is consistently high in quality, is fine in detail, and is nearly uniform in style. Consistency in these features suggests that the drawing was executed in a single campaign.

The second gathering, fols 8-15, discloses most about shading and colouring executed during the next stage of production. Shading and colouring required at least two steps, each of which involved the gathering and its bifolium sheets, rather than the page, as the working unit. The first step, represented by the sheets with fols 10 (11J)/13 (12J) and 11 (10J)/12 (13J), entailed washing large areas of translucent colour and adding penwork shading, mainly to areas which would appear as grisaille on the finished page. On these two sheets, trees and grass are washed with large areas of green and blue respectively. Green is more carefully applied than blue. Both trees and grass lack internal articulation, the drawing of individual leaves and blades of grass which characterises finished pages of the manuscript. On fol. 11r (10rJ) garments, hair, and architecture are all extensively shaded; on the other pages of the two unfinished sheets, shading, not carried to completion, is confined mainly to hair and beards; exceptions are Abraham's coat on fol. 10r (11rJ), upper left, and Rebecca's coverlet on fol. 12v (13vJ), upper left.

Shading and colouring are complete on the two remaining sheets of the second gathering, fols 8/15 and 9/14, as noted above. Comparing the unfinished to the finished sheets, one sees

that the second step in colouring required the application of colour to the linings of garments, to skin, sometimes to hair, architecture, and the caparisons of horses. Much of this colour is opaque and hence was not applied to areas previously shaded with penwork. This same step entailed adding internal articulation to the landscape washes and to architecture—the overlay of white or black strokes to create blades of grass, the lines to define leaves within the foliage balls of trees, the blackening of doorways and windows. Hair and the creases of garments sometimes received reinforcing touches of black ink as part of this step. Ink applied at this stage creates almost all the inkblot transfers.

This proposed sequence could be summarised as follows. The artist determined the number of sheets he would need and assembled them into gatherings. He then ruled his sheets and proceeded with the drawing, scene by scene, in a sequence following that of the Genesis story, through all gatherings. The program required 178 drawings, a number large enough to kindle an eagerness to finish as the artist found himself *in medias res*. Time-saving procedures and formulas, such as elimination of full-page scenes, adoption of the serrated cloud and the lancet-shaped hand, were introduced as the drawing proceeded, to hasten completion of this initial phase of work.

Having completed the drawing, the artist turned to colouring, which he applied in two steps. To begin with, he took the first gathering and worked sheet by sheet, applying translucent colour washes to landscape areas on all drawings of each sheet in turn. He also shaded with penwork areas that had not received a colour wash and that, in the main, would not be touched with colour later, creating at this stage the extensive grisaille effects of the Egerton Genesis.

After the colour wash dried, the artist applied the second step of colour, chiefly opaque touches to figures and garments, articulation to grass and trees, and some final overdrawing, to each sheet in turn. Sometimes he placed a still-wet sheet on top of the stack as he turned to another sheet. After the sheets dried and were reassembled into the gathering, they were ready for the scribe, whose working unit was, logically, the page rather than the sheet. Only for the first gathering did the artist and scribe complete all stages of production: drawing, colouring, shading, and inscription. As the artist worked on the first step of colouring in the second gathering, he realised time might be short; first he stopped tinting the borders; then he cut back on the time-consuming penwork shading in this gathering.

We have already seen evidence of close collaboration between the artist and Scribe II in their shared use of vermilion and in the episode of training on fol. 2v. Fols 8 through 11 (10J) furnish additional evidence that artist and Scribe II worked closely together in a vain attempt to finish work on the second gathering. The scenes on fol. 8 have no inscriptions, perhaps because the subject matter is difficult to interpret and because several quadrants offer limited space for inscriptions. Perhaps this combination of obstacles prompted the scribe to skip fol. 8, with the intention, never fulfilled, of returning to it after consultation with the artist. Fol. 9, whose subjects are more comprehensible and whose space is less obstructed, has inscriptions. Fol. 10 (11J) bears no inscriptions, but the upper scenes of fol. 11r (10rJ) are inscribed, even though the sheet is not completely coloured. If normally inscriptions were applied after

the colouring was complete, what has happened here? And is it only coincidental that this deviation in scribal practice occurs at the point where two sheets have been switched? It may be that the pressure of an unexpected deadline forced the artist to pass to the scribe for inscriptions a sheet which he had not had time to colour completely. Further study of this confusing portion of the manuscript is needed to sort out the sequence of work on these folios. In any case the inkblot transfers from fol. 9ᵛ onto fol. 11ʳ (10ʳJ) indicate that the order of the last two sheets in the gathering was reversed before the ink was dry.

In the Egerton Genesis, there seems to be a progressive effort to save expense and time on all aspects of the work—inscriptions, painting, and drawing. As the narrative progresses, scribe and artist hasten to complete their work, a goal they never reach.

3. Palaeography

The Egerton Genesis text shows the work of at least two scribal hands, as first identified by James.[11] Hand I, probably that of the artist himself, is responsible for the text of fols 1ʳ, 1ᵛ, and 2ʳ, as well as for the inscription on the scene at upper right on fol. 2ᵛ and for the names inscribed above the heads of Adah (Oda), Lamech, and Zillah (Sella). Hand II is responsible for the remainder of the text—three scenes on fol. 2ᵛ, plus all other inscriptions from fol. 3 through the upper half of fol. 11ʳ (10ʳJ). The ink changes colour from black to brown on fol. 2ᵛ. On this transitional folio, both hands use the brown ink, as though the inkwell were passed from one scribe to the other. In comparison to the first scribal hand, with his neatly fitted texts, the second scribe adapted his lengthier inscription less thoughtfully to the space provided and the subjects depicted. We note little difference between the language of the scribes. The writers employed similar grammar and orthography. The language of Hand I, describing the Creation and the descendants of Adam (on fols 1 and 2) is spare, largely translated from the biblical Genesis. Hand II includes more than the Vulgate. Still, we notice in common the Anglo-Norman -ier (pier[e]), the -au- (graunt) and the -ei- for -oi- (ordeina, purreit, devereit). Hand I prefers to introduce inscriptions with Coment, Come, Cest or Cestui. Hand II uses Adonqes most frequently to introduce his text. Hand II always uses comaunda or a variant, rather than the abbreviated ꝯ maunda of Hand I. Hand I uses a neatly written gothic book hand, small, but not tightly compressed. He lifted his pen more often between strokes than Hand II. The script of the first hand resembles Textualis Quadrata, but has no footed minims.[12] Letters are usually separated. Biting is rare, though **d** and **e** usually have a stroke in common. Examples of **d** and **e** biting are as follows: or∂eina (1ᵛ, upper left); ∂ebron (1ᵛ, upper right); ∂emeigne (1ᵛ, lower left). Also, there may be a common stroke with **o**, as in ∂nc (1ᵛ lower left), repposa (1ᵛ, lower right). Round **r** is always used; **a** does not extend above the level of other round vowels. There is one example of the suspension stroke after the -**k** (donkꝭ). This otiose stroke is more common in the second scribe's text.

The second hand uses a strongly cursive English script, perhaps that of a scrivener trained for public or secretarial writing. This writing, used for less expensive books, resembles both fourteenth-century documentary script and Bastard Anglicana of the fifteenth century, while

differing from both.[13] In most cases the writing of Hand II is clearly legible where not worn or rubbed, not noticeably rushed or compressed, and with easily resolvable abbreviations. The long **r** (Γ) is much used. The writing style alone affirms that the text is fourteenth century in origin.

4. Penwork flourishes

The most prominent penwork flourishes in the Egerton Genesis are associated with the initials of Hand I, on fol. 2r, where there are eighteen flourished initials (figs 1, 3). This decoration enlivens the tiresome genealogical text of fol. 2r for the reader, while embellishing the text for the casual viewer. However, even fol. 1, which is badly rubbed, contains the remnants of the flourisher's pearlised forms and descending loops with corkscrew finials delicately drawn in red ink. This is especially visible at upper right on fol. 1v.

The initial on fol. 2r, which introduces the figure of Adam, and the initial at lower left on the upper right side of the quadrant, which announces *La generacion de Cain,* are exuberant (figs 3, 1). Adam's initial is decorated in brown, rather than red. It extends upward and to the right only. The **C** directly above Adam's initial is also flourished in brown. An even larger initial, five lines high, which begins the genealogy of Cain (third paragraph from the left on the lower left quadrant) is infilled with spirals and a decorative device which we shall call pearl strings. This large initial is more elegantly decorated than the smaller ones.

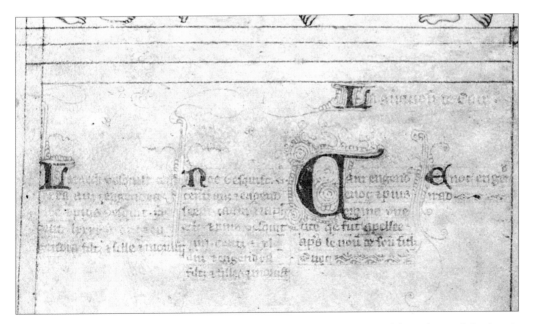

Fig. 1: Egerton Genesis. London, British Library, Egerton MS 1894, fol. 2r, lower left, detail: Text and penwork flourishing (Photo: British Library, London)

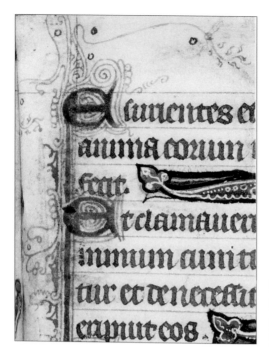

Fig. 2: Psalter. Oxford, Bodleian Library, MS Douce 6, fol. 67r, detail: Line initials with penwork flourishing (Photo: Bodleian Library, Oxford)

Most of the extensions above the small initials on fol. 2r end in a fan, or corrugated bulb, from which a large loop with three-petalled flower finials emerges.[14] Between the higher loops above the text and the text itself are shorter curved flourishes, terminating alternately in spiral and corkscrew forms. Below the text, the long stalk divides and ends with either two or three loops ending in simple spirals or corkscrews. These initial patterns alternate with the successive six-line texts above each figure. Between these loops and the text, one or two additional shorter loops branch off from the main stem, as described above, and end in spirals or corkscrews, in patterns which usually alternate from initial to initial within each quadrant. In the lower left quadrant, there is no room for loops below the first three paragraphs. The last paragraph has three loops, which end in spirals, with two shorter ones above.

The overall artistic effect of these flourishes is a refined balance between pattern and invention. The viewer senses pattern in alternation and symmetry. Invention emerges in deliberate slight departures from the symmetry: in the variable lengths of lines, in the use of both clockwise and counter-clockwise spirals, and in a preference for diagonals in the alignment of single elements as components of a larger design, especially in sections of flourishing below the text lines.

On fol. 2r, pearl strings are a prominent component closely associated with the initial itself (figs 3, 1). Sometimes there is a short pearl string to the right of the initial, connecting the two horizontals, as with the **I** or **J** of Jared (2nd from left on the upper right quadrant). Where there is no room for adequate treatment of the initials, the flourisher uses his ingenuity to decorate the initial: the flourish may extend upward obliquely to the right (in the case of the first para-

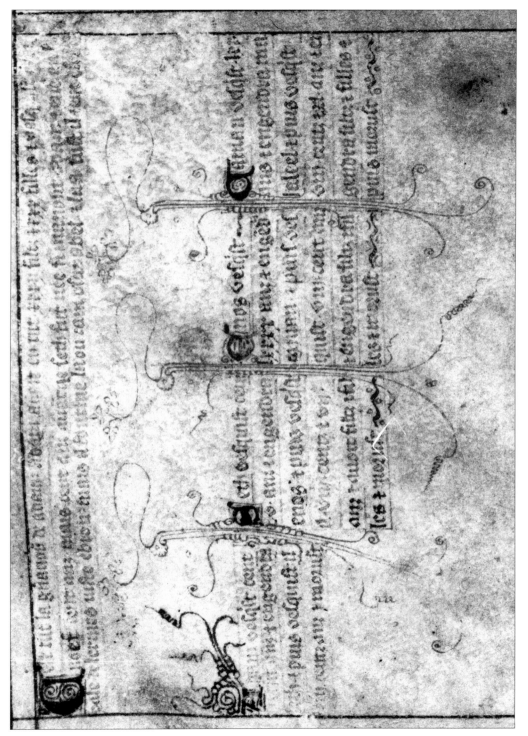

FIG. 3: Egerton Genesis. London, British Library, Egerton MS 1894, fol. 2ʳ, upper left, detail: Text and penwork flourishing (Photo: British Library, London)

graph of the upper left quadrant) or it may hug the left margin, extending vertically (as in the first paragraph of the upper right quadrant), or it may rise upward above the letter, turning sharply to the right (as in the case of the far left paragraph of the lower left quadrant). Above and at right in the lower left quadrant ('La generacion de Cain'), where there is insufficient room either above or below the initial, the decoration extends almost horizontally leftward, with two rising loops.

A special case is the large **C** of the lower left quadrant, where the genealogy of Cain begins (fig. 1). Here, there are four relatively large spirals, two at left above and below the initial and two as infilling for the initial **C**, which is closed by a vertical bar at right. All around the initial **C** are pearl strings. Below the lower spiral and even within it, there is an attempt to pearlise. This is the most lavishly flourished initial of the entire manuscript. As will be shown in Chapter 6, there are similarities in flourishing between the Egerton Genesis and flourishing as practised in Ghent in the 1330s.

Fol. 2r is the only page in the Egerton Genesis on which line-fillers are used: to fill out the final line in paragraphs two, three, and four of the upper left quadrant (fig. 3); to fill out the first paragraph of the upper right quadrant; to complete the final line of paragraphs three and four of the lower left quadrant (fig. 1); to complete the second (and final) line of the first paragraph in the lower right quadrant. These line-fillers vary. Forms are as follows:[15]

After the text of Hand II begins, the style of flourishing changes markedly. The blue two-line initials in Hand II's text are surrounded by delicate flourishes in red which, unlike those of Hand I, always rest within the initial box. Those on fol. 7 are clearly visible. In many cases the red pen decorations of the small initials are badly faded. Coordination of the change in script with that in flourishing indicates that each scribe flourished his own initials.

5. Mise-en-page: inscriptions

The space provided by two ruled lines on fols 1r and 1v is completely filled by Hand I's succinct translation of the biblical text. When the space is divided in order to provide for the genealogical explanations on fol. 2r, one above the head of each of the four figures in each quadrant, the scribe completely fills the ruled lines with text or line fillers. But on the lower half of the page, two lines are ruled but left entirely empty at the top of each quadrant, although the shorter ruled lines just above the heads are filled. Inconsistencies such as this characterise other aspects of this artist-scribe's work. In the image at upper right on fol. 2v, Hand I is careful not to encroach on the margins, in contrast with Hand II, who is responsible for the remainder of the verso. Hand I, presumably also the flourisher, decorates the first explanation and all the interstices on fol. 2r with the penwork mentioned in the previous section.

Hand II has no such flourishes attached to his writing. This second scribe frequently has more ruled lines than he can fill with text. On fol. 2v, writing begins on the central margin of the two lower illustrations, seemingly because the scribe was unsure of sufficient space below.

On fols 9 and 11ʳ (10ʳJ), the spaces left for initials remain blank. Neither initial box nor ruling appears on pages without any inscriptions. This may indicate that the artist was no longer concerned with the imposition of the text after it was turned over to Hand II, considering it secondary in importance to the images, which the patron evidently preferred. The inscriptions following fols 1ʳ, 1ᵛ, and 2ʳ seem to have been imposed after the images were drawn and at least partially coloured, as an effort to interpret the action depicted in the scene. Blank spaces left for four names at lower right on fol. 4ᵛ suggest that the background was added after the line drawing and that name spaces were left at this time.

On the folios inscribed by Hand II, placement of inscriptions was poorly designed. On fol. 5ᵛ, the text squeezes into the interstices at the top of the Tower of Babel, around the heads and arms of the masons. On fol. 6ʳ, left and fol. 6ᵛ, lower left, the text crowds most of the available space around the celestial heads in the upper part of both scenes. The inscription claims most of the available space in the scene of Hagar and the angel (fol. 9ᵛ, upper right). In other cases, there is too much space for the text. Ruled unused lines are found on fol. 3ᵛ, lower half; fol. 4ᵛ, lower right; fol. 5ʳ, upper right; right side of fol. 6ʳ; fol. 6ᵛ, three quadrants; all quadrants of fol. 9ʳ; left side of fol. 9ᵛ; upper left of fol. 11ʳ (10ʳJ). One has the strong impression that images and text were not co-ordinated after the artist surrendered his role as scribe to another.[16]

TEXTUAL SOURCES[17]

In this manuscript, in which images clearly have primacy over text and in which many economies are in evidence, each scribe probably composed his own section of the text, rather on an ad hoc basis, drawing on familiar sources to explain the images. James states that the text of the Egerton Genesis is 'taken partly from the Bible, but to a larger extent from the *Historia Scholastica* of Petrus Comestor'.[18] He cites extracts from the *Historia* to demonstrate how closely related the Egerton Genesis text is to Comestor's Genesis. However, he does not indicate the proportionate use of the two sources. The authors of the Egerton text have depended on the *Historia* for certain non-biblical details: identification of Naamah as the first weaver of cloth (Naamah as Lamech's daughter is merely mentioned by name in Genesis 4. 22); details about Lamech's murder of his ancestor Cain and subsequently of the child guide; explanation of the relation between Noah, Nimrod and Jonitus. At times, it seems that the Vulgate text alone has been rendered into Anglo-Norman. However, an examination of each inscribed folio reveals a more complicated text than that suggested by James, for here there are passages from the *Historia Scholastica*, which themselves include biblical text, translated into Anglo-Norman and enriched by the author with additional translated excerpts from the Vulgate.

In our opinion, James is right in ruling out Guyart Desmoulins as a source for the Egerton Genesis texts.[19] Guyart's *Bible historiale* of the late thirteenth century is loosely based on the *Historia Scholastica*, but is by no means a French translation of that work. Berger comments that

the *Bible historiale* of Guyart Desmoulins is actually quite different from a simple translation of the work of Comestor, that Guyart was inspired by the spirit of the *Historia Scholastica*, for, while he translates, he distances himself, adds and subtracts unscrupulously and everywhere translates freely.[20] McGerr calls the *Bible historiale* 'not so much a translation as a transformation of a Latin schoolbook into a vernacular text . . . Along with change in language came changes in form and content geared to a new type of reader'.[21]

Lacking a critical edition of both the *Historia Scholastica* and Guyart's *Bible historiale*, and working from the selected versions of Migne (*PL* 198) and Paris, Bibliothèque Nationale, MS fr. 155, respectively, we can make only general observations. A comparison of three Genesis narratives in Guyart Desmoulins and the Egerton Genesis reveals the following:

1. In the story of Lamech, his wives and family (Genesis 4. 19-22), Guyart's text (fol. 6r, col. 2) is close to that of Peter Comestor (ch. 28, col. 1079). He omits one passage, which may have been a gloss, about the invention attributed to Pythagoras. Both Egerton Genesis writers apparently use selections directly from Peter Comestor, using only what is necessary to explicate the scene on fol. 2v.

2. In the story of Abraham, Sarah, and the lustful Pharaoh, Guyart's version (fol. 9r, cols 2 and 3) is more like the Vulgate narrative than that of Peter Comestor (ch. 45, col. 1093). Guyart has translated almost directly the biblical narrative (Genesis 12. 10-20). The long narrative on fols 6v, 7r and 7v of the Egerton Genesis has little in common with comparable passages of Peter Comestor and Guyart. The writer is telling the story for himself, adapting his explanation to the dramatic visual narrative below his text.

3. In the story of Abraham and the Heavenly Visitors, Guyart's version (fol. 10v, cols 1 and 2) is a French translation of the biblical text (Genesis 18), with five references to Peter Comestor, 'li .m. en histoir' (ch. 51. cols 1098, 1099) for added details. The Egerton Genesis version is closer to that of Peter Comestor than is Guyart.

There is nothing to indicate that the Egerton Genesis text is dependent on Guyart's French text; rather, both seem independently to render material from Peter Comestor and the Bible into French, with the second scribe of the Egerton Genesis occasionally using his own description. In telling the same story, that of the visitors to Abraham of Genesis 18, the Egerton Genesis writer uses language quite different from that of Guyart. A juxtaposition of phrases, which convey the same information from the two writers, demonstrates this divergence:

Egerton Genesis (fol. 11r [10rJ])	*Guyart Desmoulins (BNF fr. MS 155 (10v)*
vist treis damisel	li apparurent .iii. homes
Abraham lui fist honurer	si aoura en terre
la viaunde estoit consumee en lour bouche	la viande quil pristrent s'anienti en machant

Sara rist, pur ceo quils Sara...rist. . . .car il estoient
estoient treveux endui viel et ancien
 a Sare faillies ses fleurs

The second author-scribe of the Egerton Genesis not infrequently introduces his own comments into his source material in an effort to explain or expand upon the images. This writer is at times unsuccessful in his attempt to explicate the narrative as expressed in the image it accompanies; sometimes he is carried away by his source to include more or different details from those expressed in the illustration. Remembered details, perhaps considered common knowledge, are included, information not found in Peter Comestor or the biblical narrative. Familiar versions of Genesis, such as that of the popular *Histoire ancienne*, exhibit parallels with text and scenes in the Egerton Genesis which are described neither in Peter Comestor nor the biblical account. As examples, we note the following: On fol. 3r of the Egerton Genesis, Lamech's grief is twice expressed as he becomes aware that he has committed two murders. In the *Histoire ancienne*, Lamech's grief is called 'paine . . . en doble maniere'.[22] Again on fol. 3r, the lower half, the Egerton Genesis text describes the animals entering the ark by divine nod, rather than by human labour. The verb *metre*, used in the *Histoire ancienne* Genesis,[23] is more appropriate for this scene on fol. 3r of the Egerton Genesis, in which Noah and his family carry the animals into the ark on their backs, than to the adjacent text. For examples of scenes not described in the main sources, but with parallels in the *Histoire ancienne* text, see our comments on fols 5r, 5v, and 17r, in Chapter 3 herein.

Scribe II has greater difficulty co-ordinating text and image and less skill in laying out space for his text than does his predecessor, probably himself the artist. The second scribe was assigned to provide the reader with a text to accompany the existing visual narrative. Though united with the artist in time and place, this writer apparently had minimal supervision from him. He relied heavily on the traditional interpretation of the well-known 'Master of History', Peter Comestor, upon whom so many had called for interpretation of the Genesis narrative, both before and after their visual images were designed. Not always understanding the iconography himself, this second scribe clings to well-known explanations, even when these were at variance with the images. He felt free to interpose remarks of his own as well. The unusual nature of some of the scenes on fol. 8r, plus the small amount of space left above two scenes on the verso, may have caused the scribe to postpone the imposition of a text until after the project was abandoned, when he no longer had to wrestle with the meaning of these images.

As noted before, we present a detailed discussion of textual sources for all inscribed images in the Appendix, in comments following the transcription and translation of each text. We also discuss in these comments how each inscription relates to the image beneath it.

Notes

1 James, *Illustrations*, p. 2.

2 This tooled pressmark on the spine means that the manuscript was in the Map and Egerton Room at Bloomsbury, which would have been the position of the MS after its purchase, before the Select Lobby and press 644 were built.

3 The inscription $644.a means that this manuscript was designated 'Select' at Great Russell Street and that it was in press 644 on shelf A. The dollar sign has been used to designate select manuscripts in the Department of Manuscripts since earlier in the 20th century. The manuscript has retained this press mark since its move to St Pancras (although the detail of the pressmarking system at St Pancras is slightly different from that at Bloomsbury). The note beneath the pressmark means that the manuscript was exhibited in case 11 in the Middle Room, the room latterly used for exhibition of illuminated manuscripts at Bloomsbury, at the opening indicated. A careful look at flyleaf Av reveals that the old pressmark, 525.H, was written in pencil and has been erased and replaced with the 644.a pressmark. (We thank Dr Andrew Prescott for interpreting for us these inscriptions on the spine and on flyleaf Av.)

4 Dr Prescott identifies this fine hand as that of Sir Frederick Madden, Keeper of Manuscripts from 1837 to 1866.

5 James identified this penciled note as that of Sir Frederick Madden. *Illustrations*, p. 1.

6 Later in this chapter, we conjecture that 178 scenes would be needed to carry Genesis to completion at the density of illustration in the surviving manuscript.

7 Throughout this study, when referring to scenes on the misbound sheets (seventh and eighth), we give first the folio number now in the manuscript as misbound, followed in parentheses by James's foliation number which reflects the chronology of the biblical account.

8 Pächt, 'Giottesque Episode', p. 58; Lowden, p. 45.

9 Hassall, *Holkham Bible*, p. 2.

10 See the discussion of penwork flourishes in this Chapter and in Chapter 6.

11 *Illustrations*, p. 2.

12 Michelle P. Brown, *A Guide to Western Historical Scripts from Antiquity to 1600* (London: British Library and Toronto: University of Toronto Press, 1990), p. 84, pl. 29.

13 Brown, *Guide*, p. 96, pl. 35, and p. 100, pl. 37.

14 Terms include those coined by Sonia Scott-Fleming, *The Analysis of Pen Flourishing in Thirteenth-Century Manuscripts* (Leiden: Brill, 1989), *passim*.

15 On fol. 204r of the Douai Psalter, Douai, Bibliothèque Municipale, MS 171, there is a line ending like the second one here in the upper left quadrant of fol. 2r of the Egerton Genesis. See Caroline S. Hull, 'The Douai Psalter and Related Manuscripts' 2 vols (unpublished doctoral dissertation, Yale University, 1994), II, pl. 12.

16 On the placement of text on the folio with the image in the Egerton Genesis, see Hull, 'Rylands MS French 5', p. 13.

17 See comments following the transcription and translation of each text in the Appendix for a detailed discussion of textual sources for all inscribed images.

18 James, *Illustrations*, p. 7. For *HS* of Peter Comestor, see *PL* 198. This twelfth-century narrative of biblical history, used in the Schools, was a source for many medieval writers. For precise references, see comments on sources in our Appendix.

19 James, *Illustrations*, p. 7, n.1.

20 Samuel Berger, *La Bible française au moyen âge* (Paris: [n.pub.] 1884; repr. Geneva: Slatkine, 1967), pp. 157, 178.

21 Rosemarie Potz McGerr, 'Guyart Desmoulins, the Vernacular Master of Histories, and His Bible historiale', *Viator*, 14 (1983), 211–244 (p. 213).

22 Mary Coker Joslin, *The Heard Word: a Moralized History* (University, MS: Romance Monographs, 45, 1986), p. 92, l. 17.

23 Joslin, *Heard Word*, p. 95.

CHAPTER THREE

Iconography: Description of Miniatures and Commentary

INTRODUCTION

The images of the Egerton Genesis are drawn in exquisite detail, much of it requiring magnification and careful examination for full resolution. We provide below a detailed description of each of the 149 scenes in the manuscript in the hopes of facilitating further study of this startlingly rich and copious iconography, first studied by James in 1921.[1] The comments following our descriptions remark connections with the iconography of other manuscripts and works of art and iconographical sources in, or parallels with, the Bible, the *Historia Scholastica*, legends, familiar oral accounts of Genesis, and the religious drama. The reader is referred to Chapter 4 for a much fuller discussion of the relationship to the medieval drama and to the Appendix for a discussion of the relationship of the iconography to the inscriptions. We have formulated several questions which define our major interests in the study of the iconography: 1. What is distinctive about the iconography of the Egerton Genesis? 2. What does the iconography reveal about the patronage or purpose of this manuscript? 3. How is the Egerton Genesis related to other fourteenth-century Genesis illustrations? In considering this question we have included as comparisons chiefly fourteenth-century Genesis picture books and a few other manuscripts with extensive Genesis illustration, mostly English. The Holkham Bible Picture Book; the Queen Mary Psalter; the St Omer Psalter (London, British Library, Additional MS 39810); the Isabella Psalter (Munich, Bayerische Staatsbibliothek, MS gall. 16); the Paduan Bible in Rovigo; and the Mosan Psalter fragment furnish most of the comparisons. 4. How does the Egerton Genesis fit into the broader picture of illumination and of visual culture, especially that of the first half of the fourteenth century? 5. Where was this manuscript produced? 6. Where did the artist originate?

No attempt has been made to catalogue subjects or motifs or to connect the illustrations of the Egerton Genesis to iconographical recensions. Rather our efforts have been directed toward contextualising this manuscript, so long regarded as an isolated phenomenon. In order to keep this focus, we have limited iconographical comparisons to those which are either closely related or seem especially relevant for some reason. When a scene in the Egerton Genesis is significantly different from the same scene as rendered elsewhere, we sometimes include contrasting references.

MINIATURES AND COMMENTARY

Folio 1^r

1. Fol. 1^r, upper left: First day of Creation (Genesis 1. 1–2, pl. III)
DESCRIPTION: The Creator sits on a rainbow. His cloak, fastened by a morse, conceals his feet, giving an oddly truncated look to the bottom of the figure. He extends his right hand downward in a gesture of command, while his left hand clasps a codex resting on the left thigh. Below the rainbow is the darkened, wave-covered circle of the earth, rimmed with grey scalloped clouds and inscribed with a semicircle.

Colour is much worn. Hair and beard were originally silvered. The clasp was green and the robe an intense, highly saturated blue; the cloak, gold wash. The colour of the codex, very black, is not abraded.

COMMENTS: The Lord seated on a rainbow above the circle of the earth is apparently unique in Creation iconography. The cosmic sphere is common in Creation images but not in conjunction with the rainbow-seat. In the late fourteenth-century Paduan Bible in Rovigo, fols 1^r–2^r, the Creator sits among angels above and to the left of a cosmic sphere of concentric circles, feet covered by his garment, as in the Egerton Genesis.[2]

The rainbow is used rarely in Creation scenes. In the Creation illustration on p. 6 of the 'Cædmon manuscript' (Oxford, Bodleian Library, Junius MS 11), the Creator sits on a rainbow-like arc as he separates light from darkness (fig. 4)[3]. The rainbow as seat of the Deity occurs

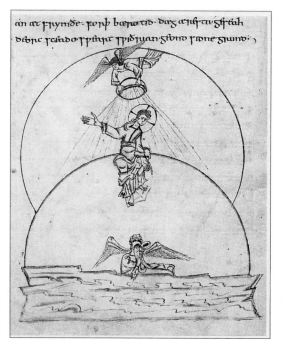

FIG. 4: Anglo-Saxon Genesis. Oxford, Bodleian Library, Junius MS 11, p. 6, detail: The Creator separates light from darkness. (Photo: Bodleian Library, Oxford)

in Last Judgement and Majesty iconography of English and Flemish manuscripts of the first half of the fourteenth century, but not in combination with the cosmic sphere. The most striking English parallel is in the St Omer Psalter, datable between c. 1335 and 1340, or later: the Christ in the Last Judgement on fol. 120[r] (fig. 5) is enthroned on a rainbow that spans a wide space like that in the Egerton Genesis.[4] The St Omer Last Judgement, whose Italianate spatial qualities were noted by Pächt, has striking antecedents in Flemish manuscripts, such as the Last Judgement in the psalter Oxford, Bodleian Library, MSS Douce 5–6, fol. 78[v] of Douce 6 (fig. 6).[5]

Several fourteenth-century English manuscripts include images, more or less related to the Creation in subject, of God enthroned on or above the cosmic sphere. In the Holkham Bible Picture Book, fol. 2[r], God, enthroned on the cosmic sphere within the circle of Heaven, is holding his compass.[6] In the Queen Mary Psalter the image of the fall of Lucifer, fol. 1[v], depicts God again holding his compass and enthroned within and on interlocking spheres.[7] The theological illustration of the Sphere of John of Peckham in the Psalter of Robert de Lisle (London, British Library, Arundel MS 83 II, fol. 123[v]), depicts the Deity enthroned directly above the cosmic sphere but not on a rainbow.[8]

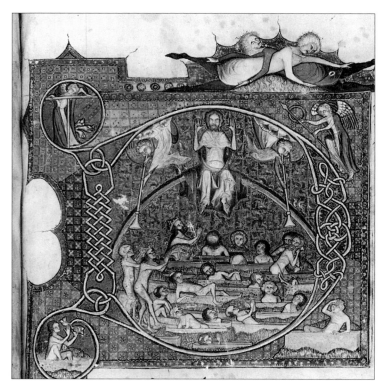

FIG. 5: St Omer Psalter. London, British Library, Additional MS 39810, fol. 120[r], detail: Initial D for Psalm 109, with Last Judgement (Photo: British Library, London)

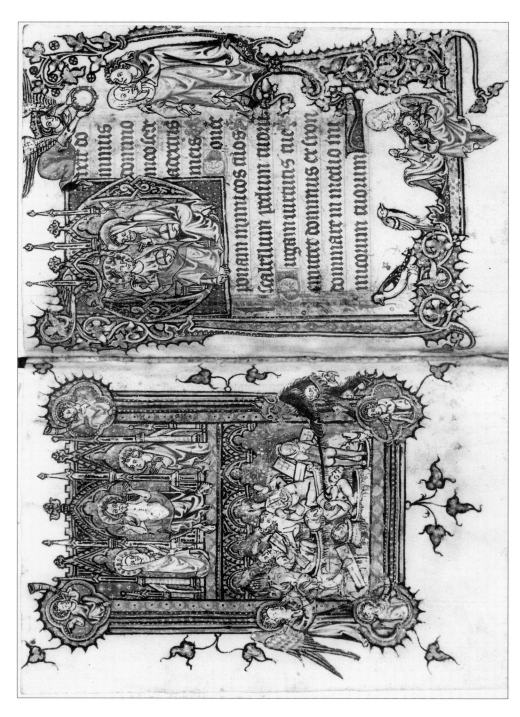

FIG. 6: Psalter. Oxford, Bodleian Library, MS Douce 6, fols 78ᵛ–79ʳ: Last Judgement and Psalm 109 (Photo: Bodleian Library, Oxford)

The silvered hair and beard are reminiscent of the silvered masks worn by actors playing the Deity, and the rainbow as a seat for the Deity was also a prop in medieval drama. See Chapter 4 for further discussion of these elements.

2. Fol. 1ʳ, upper right: Second day of Creation (Genesis 1. 6–8, pl. III)
DESCRIPTION: The pose, attire, and colouring of the Creator are those of the preceding miniature. His head inclines at a slightly greater angle and he is seated further to the right.

The firmament mentioned in the text is a large green crescent dividing the waters above from those below, separated from the latter by an uncoloured crescent. The waters are green. Colour is again much worn.

3. Fol. 1ʳ, lower left: Third day of Creation (Genesis 1. 9–13, pl. III)
DESCRIPTION: The Creator is depicted as in the preceding two miniatures. In the centre of the sphere below, the earth appears as a green semicircle on which grow five fruit-bearing trees with lopped branches. Foliage is a compact ball of dark green; the fruits, three on the middle tree and two on the others, are yellow.

COMMENTS: The trees are of a generic northern European type, but the colouring, in which high values in the centre of the foliage ball grade to low values at the edges, is suggestive of trees in certain Bolognese manuscripts of the 1320s to the 1340s, such as those in a gradual in Bologna, Convento di San Domenico, graduale 21, fol. 111ʳ (fig. 7).[9]

4. Fol. 1ʳ, lower right: Fourth day of Creation (Genesis 1. 14–19, pl. III)
DESCRIPTION: The Creator is depicted as in the preceding three miniatures. The sphere of the earth is as in the image of the third day.

COMMENTS: This miniature has suffered even more than the others on this very worn page. The bottom and lower right corner have been cropped, and the colour is greatly rubbed. Of the sun, moon, and stars mentioned in the text, not a trace is to be seen, neither in the space between the rainbow and the sphere, nor in the space between the firmament and the earth. Though they may have been omitted originally, it is also quite possible that abrasion has obliterated them.

Folio 1ᵛ

5. Fol. 1ᵛ, upper left: Fifth day of Creation (Genesis 1. 20–23, pl. IV)
DESCRIPTION: The Creator is depicted as in the preceding miniatures, seated slightly to the right of centre on the rainbow. In the sphere below (fig. 8), four birds of different species perch on the trees. One rests on the ground below. They may be identified, from left to right, as a crow or raven, a parrot, a jay, and a wren above and a snipe or woodcock below. Fruit on the five trees is less evident than previously. In the waters below are two large fish and at least five small ones.

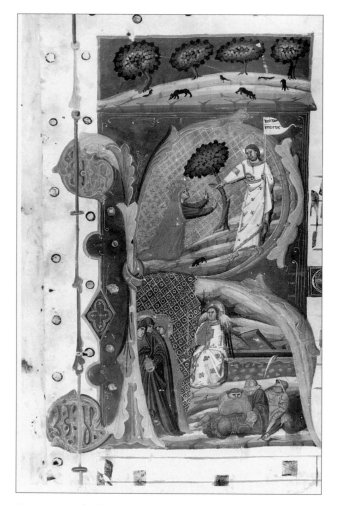

Fig. 7: Gradual. Bologna, Convento di San Domenico, graduale 21, fol. 111ʳ, detail: Initial R, with *Noli me tangere* and Three Marys at the Tomb (Photo: Convento di San Domenico, Bologna)

More colour remains than in the miniatures on 1ʳ. Some silver remains on God's hair, and some shading in rosy red penwork is apparent in the gold-wash cloak. Green on the preceding page, the firmament is now blue.

COMMENTS: Red is used to shade gold-wash garments in earlier illumination from the region of Ghent, in the only surviving copy of Jacob van Maerlant's *Spiegel historiael* (The Hague, Koninklijke Bibliotheek, Koninklijke Akademie MS XX),[10] dated to the second or third decade of the fourteenth century, as in the cloak of John in the Crucifixion, fol. 64ʳ.

6. Fol. 1ᵛ, upper right: Sixth day of Creation (Genesis 1. 24–25, pl. IV)
DESCRIPTION: The Creator is depicted as in the preceding miniatures, but his head is more inclined so that it is rendered with some foreshortening. In the sphere below, the earth has broadened and flattened and the *bestes de terre* are depicted. A squirrel and a monkey perch on two treetops facing each other. The central tree has been replaced by the head of a horned stag. Below appear also a ram, a bear, a water buffalo, a lion, and a lowing ox.

Colour is moderately well preserved; the hair, beard, and face of the Creator retain some silver. Rosy penwork shading is again apparent in the cloak, and the firmament is blue, as in the miniature to the left. The blue and yellow of the rainbow are more in evidence than in the preceding miniatures.

7. Fol. 1ᵛ, lower left: Sixth day of Creation (Genesis 1. 26–27; 2. 21–22, pl. IV)
DESCRIPTION: The scene is set in front of a grassy knoll on which grows a grove of conventional trees with lopped branches. The number of foliage balls does not match the number of tree trunks. The Creator bends forward, extending both hands toward Eve. His cloak hangs from his broad figure in statuesque vertical folds. The upper half of Eve's body emerges from

Fɪɢ. 8: Egerton Genesis. London, British Library, Egerton MS 1894, fol. 1ᵛ, upper left, Fifth Day of Creation, detail: Sphere of the earth (Photo: British Library, London)

a cleft in Adam's side, her hands together in a gesture of prayer. Only the left shoulder, hip and leg of the recumbent Adam are visible above the cropped borders of the miniature.

Rosy penwork shades the gold-wash cloak. Most foliage balls are coloured in the Italianate manner—dark green with higher value and more golden coloration in the centre, giving the effect of three-dimensionality through shading. Some are more northern in coloration—a nearly uniform light green undercoat with linear internal detailing overlaid in black.

COMMENTS: The miniature has suffered much damage; colour is badly rubbed, as is drawing in places. The face of God and the foliage of several trees are almost obliterated.

The iconography of this miniature is much more conventional than that of the preceding six days of Creation. Numerous other English and continental manuscripts depict Eve emerging from the side of a slumbering Adam at the command of a standing Creator. In many English examples the figure of Eve is three-quarters or full length. Examples include the St Omer Psalter fol. 7r;[11] the Holkham Bible Picture Book, fol. 3r; and the Queen Mary Psalter, fol. 3r. In the Isabella Psalter, fol. 9v, bas-de-page, she is half-length, as in the Egerton Genesis.

8. Fol. 1v, lower right: Seventh day of Creation (Genesis 2. 2, pl. IV)
DESCRIPTION: Resting after his labours, the Creator reclines in a grassy meadow—here blue, not green—strewn with white and blue flowers. He is attired as in the preceding miniatures; his bare feet are visible. He is proportionately larger than before. Behind him are two hills, separated by a valley. Ten trees climb the hill on the left and six the hill on the right. Many have Italianate shading, leaves in the centre being higher in value than those on the periphery. A single large tree grows in the valley, positioned directly behind the Creator's abdomen. In the Creator's gold-wash cloak, penwork shading and some internal lines are in red. The lining of the cloak has some black penwork shading.

COMMENTS: Colour is badly rubbed from the Creator's blue robe and from some trees. The unusual image of the reclining, slumbering Creator with the tree behind him is, to our knowledge, unique among miniatures of the seventh day of Creation. This imagery is probably an adaptation from iconography of the tree of Jesse, as found in the *Beatus* initials of many fourteenth-century English psalters.[12] The artist's originality shows in his ability to make visual associations between different subjects. The anomalous use of blue, rather than green, for the ground is one of many instances in which the Egerton Genesis artist deviates from usual practice, either in his work or in the larger artistic traditions. Use of blue here prepares the viewer for the exclusive use of blue as the underwash for grass on fols 10r (11rJ)–13v (12vJ).

Folio 2r

9–12: Fol. 2r, all quadrants: Descendants of Adam (Genesis 5. 3–29; 4. 17–18, pl. V)
DESCRIPTION: These four images depict Adam and fifteen of his descendants, about each of whom information can be read in the corresponding text block.[13] No setting, either indoor

or outdoor, is included. The figures are read as a continuous sequence, divided by the necessities of formatting into two horizontal rows. The vertical dividers between miniatures are integrated into the spaces of the sequence, causing little visual interruption. In fact, the figure of Irad at the left edge of the lower right miniature overlaps the divider.

Adam is the first figure in the miniature at upper left. He is followed by Seth, his third son, and eight of Seth's descendants, ending with Noah, second from the left in the miniature at lower left. After Noah, the genealogy picks up with Cain, Adam's first son, and presents five of Cain's descendants, ending with Lamech, the last figure at lower right. By depicting the descendants of Seth (Genesis 5) before those of Cain (Genesis 4), the artist reverses the biblical chronology.

All are bearded except Enoch, translated early in life, fourth in the lower row. All are garbed in the traditional long robe and mantle, generally the dress of patriarchs and the high-born in the Egerton Genesis. They are shown in a variety of poses—frontal, three-quarters, profile, and back view, no two alike. The gestures and expressions are lively and varied, avoiding the monotony to which a repetitive arrangement easily lends itself. Adam points to Seth and looks at him; Seth gestures toward his son Enosh but looks back at Adam. Enosh points to his father Seth but looks toward Kenan, and so on. Jared, sixth in the top row, bends his left arm vertically at the elbow and points backward over his shoulder. Methuselah, last in the top row, is seen from behind, his hands and feet in odd foreshortened views. Lamech, first in the bottom row, points diagonally up and across the page to indicate that his predecessor is Methuselah. The counterposed gestures of Irad, fifth in the lower row, have a quirky, staged effect.

Colour is used sparingly and elegantly. The figures are predominantly in grisaille on this page and on succeeding folios in this gathering. Robes and mantles, shaded with penwork, are mostly uncoloured; the blue cloak of Methuselah, last in the top row, is an exception. However the linings of many mantles are coloured a peachy pink or green. Traces of opaque peachy orange can be seen on the faces and hands of some figures, including Adam, first in the top row, and Lamech, Cain, and Mehujael, first, third, and sixth in the bottom row. Several figures also have blue hair, with black penwork shading, including Adam and Seth in the top row and Noah in the bottom row. Enoch and Lamech, fourth and last in the bottom row, have brown hair.

COMMENTS: Like the Egerton Genesis, the Paduan Bible in Rovigo, fol. 4r, devotes a full page (four miniatures) to the descendants of Adam (fig. 9). Three of these miniatures contain triads of frontal, standing patriarchs, clad in fringed, sleeveless tunics and each holding a scroll and a staff. The other miniature shows the translation of Enoch, an event omitted, though suggested, in the Egerton Genesis. The patriarchs in the Paduan Bible are much more staid and self-contained than those in the English manuscript, but the completely unspecified setting is the same in both. Less closely related are the Queen Mary Psalter's two pages of gesturing figures who hold scrolls, each pair a prophet and an apostle (fols 69v-70r). These pages follow the psalter's extensive prefatory Old Testament cycle. Perhaps also worth noting by way of comparison are the images of paired standing saints, expressively interacting, depicted in a

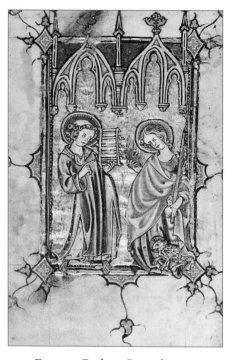

FIG. 9: Paduan Bible. Rovigo, Biblioteca dell'Accademia dei Concordi, MS 212, fol. 4ʳ: Descendants of Adam (Photo: Biblioteca dell'Accademia dei Concordi, Rovigo/Neri Pozza, Venice)

FIG. 10: Psalter. Copenhagen, Kongelige Bibliotek, Gammel kongelig Samling, MS 3384,8°, fol. 52ᵛ: Saint Lawrence and Saint Agnes (Photo: Kongelige Bibliotek, Copenhagen)

number of full-page miniatures in a psalter of the late 1330s in Copenhagen, Kongelige Bibliotek, Gammel kongelig Samling, MS 3384,8°, a manuscript from Ghent. See fol. 3ᵛ (pl. II) and fol. 52ᵛ (fig. 10).[14]

The stage-like display of patriarchs in the Egerton Genesis and the theatricality of their gestures are reminiscent of the medieval prophets plays, which themselves have characteristics of Jesse Tree iconography, already mentioned in reference to the recumbent Creator at the bottom of the preceding page. (Originally, a now-missing folio would have separated these two leaves.)

Folio 2ᵛ

13. Fol. 2ᵛ, upper register: Lamech with his two wives and children (Genesis 4. 19–22, pl. VI)
DESCRIPTION: This scene expands across the entire upper register; it seems to have been laid out before the vertical ruling, the lower third of which is preempted by the figures of Adah

(Odah) and Lamech. In the centre Lamech stands between his two wives, Adah and Zillah (Sella), who vie for his attention and gesture toward their respective offspring. Names of the three central figures are inscribed above their heads in the neat script of the first hand, and are outlined first in blue rectangles, then in red rectangles with trefoil finials.

At the far left is Jubal, the first master of music. He stands behind a harpist, seated on a tiered throne whose upper stages are decorated with arches. The base of the instrument rests in a bag on his lap. A roofed, wheeled cart of boards is between Jubal and his brother Jabal, to the right. In its doorway, a beardless shepherd in fringed trousers and a brimmed hat leans on his crook. Jabal gestures toward his mother. Jubal, Jabal, and the harpist are all bearded and clothed in long mantles.

To the right of Zillah, and behind her, is her son Tubal-cain, garbed as a blacksmith in an apron and boots. His apron is pinned at the chest with a penannular brooch. He works at a cylindrical anvil, hammering a piece of red-hot metal held with tongs. At the far right his sister Naamah works at her loom, complete with heddles and peddles. Inscriptions over the heads of Jubal, Jabal, Tubal-cain, and Naamah, written in the second hand, are without outlines.

Garments seem to have been mostly uncoloured with delicate penwork shading, giving the effect of grisaille; linings are blue, green, and red. Zillah's kerchief was washed a very light sienna. The cart is green with a blue-green roof and sienna wheels; the loom also is sienna. Touches of sienna on Naamah's shoulder and arm suggest that her garment was more fully coloured originally. No grass or trees are included.

COMMENTS: This scene has a stage-like quality, as if depicting a comical moment from a Genesis play. Lamech was characterized as a bigamist and *tresmauvais* in the text on the preceding page. Here, doubly henpecked and woebegone, he reaps the fruits of his folly. Circumflex eyebrows give a look of distress to his heavy-lidded eyes, which he directs toward the viewer as though to solicit sympathy for his domestic predicament.

Images of blacksmiths occur fairly often in English and Flemish manuscripts of the first half of the fourteenth century.[15] A blacksmith and his assistant appear in the bas-de-page of fol. 154[v] of the Gorleston Psalter (London, British Library, Additional MS 49622).[16] The Flemish *Romance of Alexander* (part 1 of Oxford, Bodleian Library, MS Bodley 264), illuminated between 1339 and 1344 by Jehan de Grise, has a number of images of blacksmithing, as in the bas-de-page on fols 84[r], 165[r], and 171[v].[17] On fol. 60[r] of Gl kgl. Saml. 3384,8°, a marginal line-ending is a blacksmith grasping a pair of figure-eight-shaped pliers similar to those in the Egerton Genesis. Tubal-cain appears less frequently in manuscript illumination. Two images of Tubal-cain at the forge appear in the lower margin of fol. 19[v] of the Isabella Psalter. Even more unusual, Naamah at her loom appears in the lower margin of fol. 20[v] of the same manuscript.[18] A book of hours from Ghent or St-Omer-Thérouanne, probably from the third or fourth decade of the fourteenth century and currently divided between London and New York, London, British Library, Additional MS 36684/New York, Pierpont Morgan Library, MS M. 754, has two marginal images of weavers, fols 22[v] and 60[v] of the New York manuscript.[19]

14. Fol. 2ᵛ, lower left: God commands Noah to build the ark. (Genesis 5. 14-16, pl. VI)
DESCRIPTION: The nimbed Deity, clothed as usual in blue robe and gold-wash mantle, instructs Noah and his wife Phuarphara to build the ark. As is usually the case in the Egerton Genesis, Noah is bald with a short beard. Holding an axe, he wears the tunic and the stirrup leggings of a labourer. Phuarphara, in a kerchief of light sienna wash and a mantle lined with red, holds three nails. Two sawhorses supporting a squared log indicate that work has already begun. The sawhorses appear to float in the air before Phuarphara. Nails, sawhorses, and log are sienna in colour. Noah's tunic is edged at the neck with a thin line of gold wash. No grass or trees are included.

The names of Noah and Phuarphara are written above the heads of the respective figures by the second scribal hand, which is responsible for all writing, both text and inscriptions, on succeeding folios.

COMMENTS: The positions and gestures of Noah and God bear comparison with those of Noah and the angel in this scene on fol. 5ᵛ of the Queen Mary Psalter.

15. Fol. 2ᵛ, lower right: The construction of the Ark (Genesis 5. 22, pl. VI)
DESCRIPTION: Attired as in the preceding scene but with a more stubbly beard, Noah bends over the sawhorse near him and slices a strip from the log with his axe. His right leg is in a spatially impossible position with respect to the boat and its supporting trestle. The hull of the ark beside him is complete, but its superstructure is only framed. One of Noah's sons approaches carrying a basket of wooden pins on his head. He is a squat figure with short, frizzy hair, clad in a tunic. Behind grows a grove of trees with lopped branches. All have the conventional foliage balls with individual leaves drawn internally. Oak, maple, and heart-shaped leaves are found on different trees. Outlines of fourteen foliage balls are detectable, though there are only twelve tree trunks and two stumps of felled trees.

Noah's sleeves and the neck of his garment are edged with a gold-wash line. The ark and nails are sienna. Six of the trees have dark green foliage which grades to a higher value brown in the centre of the foliage ball, showing Italianate influence. The colour of the remaining trees is badly rubbed, and little remains but a light green stain, with flecks of dark green. There is no grass.

COMMENTS: In this same scene in the Queen Mary Psalter, fol. 5ᵛ, sawhorses support both the log on which Noah works with an axe and the hull of the boat, as in the Egerton Genesis.

Folio 3ʳ

16. Fol. 3ʳ, upper left: Death of Cain (non-biblical, pl. VII)
DESCRIPTION: At left, the blind Lamech, having just released the arrow, holds out his bow. He is presented in a highly accomplished Italianate back view with the shoulders well drawn and the face as a lost profile. Cain stands at right with closed eyes, transfixed through the neck

by the arrow. The boy guide looks up at Lamech and touches him with his right hand, while pointing to the stricken Cain with his left. All wear tunics; the boy wears stirrup leggings as well. The setting is a grassy strip with trees. Between Lamech and Cain stands a tall tree with lopped branches. A heavy branch with three foliage balls bends to the left, in Lamech's direction, as though trying vainly to deflect the fatal arrow. Behind Cain is a clump of trees (four trunks, three tops) with lens-shaped foliage silhouettes.

The bow and the feathers of the arrow are sienna. A splotch of the same colour is on Lamech's left leg. Curiously, the latter seems to be inscribed with a letter—*u* or *v*—in black ink. Bright red blood drips from the wound in Cain's neck. Grass is green overlaid with vertical strokes in black penwork and foliage is of the northern type.

COMMENTS: The story is apocryphal. Here it interrupts the story of Noah, begun on fol. 2ᵛ and continues in the lower register of fol. 3ʳ. The *Historia Scholastica*, a major source for the text of the Egerton Genesis, recounts this legend but places it before the Noah story. Pächt noted that this scene and the adjacent scene of the death of the boy guide can be read as a continuation of the Lamech story which begins in the upper register of the facing page. He proposed that the adoption of this sweeping horizontal format might indicate the influence of wall painting on the artist.[20] The interrupted chronology, however, might be explained better with reference to drama.

The death of Cain is depicted in the St Omer Psalter, fol. 7ʳ (fig. 11); in the Isabella Psalter on fol. 15ᵛ, bas-de-page; and in the Holkham Bible Picture Book on fol. 6ᵛ.

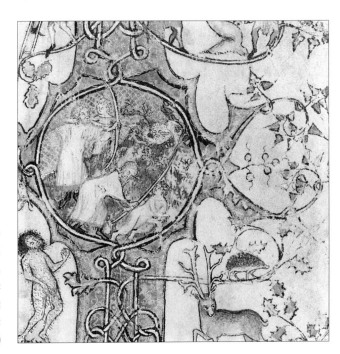

FIG. 11: St Omer Psalter. London, British Library, Additional MS 39810, fol. 7ʳ, right border, fourth roundel: Deaths of Cain and boy guide; nude bristle man below (Photo: British Library, London)

17. Fol. 3ʳ, upper right: Death of the boy guide (non-biblical, pl. VII)

DESCRIPTION: Lamech, at left, beats the prone boy guide with his bow. The boy is viewed from behind, his body slightly twisted. His head is rendered as a lost profile and his stiff right leg presents a rear view of the foot. He holds up his left hand to ward off the blows. As in the previous scene the setting is a grassy area in front of a grove of trees, which are even more expressive than before. A tree directly behind the dying boy has two branches which cross over the trunk and intertwine with each other, as though to express the anguish and confusion of the scene. Other trees have lenticular or ovoid foliage silhouettes. Spatial positioning of the tree between Lamech and the boy is uncertain.

Colour is much as in the preceding scene; trees and grass are green, the former with black penwork internal detailing and the latter with an overlay of white vertical strokes. The bow is sienna. An ink droplet of indeterminate origin on the tree above the boy's head has blotted onto the facing folio.

COMMENTS: The figure of the boy guide is very like that of the dying Abel in the Paduan Bible in Rovigo, fol. 3ᵛ, upper left (fig. 12). The subject is depicted in the St Omer Psalter, fol. 7ʳ in the same roundel as the death of Cain (fig. 11); in the Isabella Psalter on fol. 15ᵛ, bas-de-page, next to the scene of the death of Cain; and in the Holkham Bible Picture Book in two

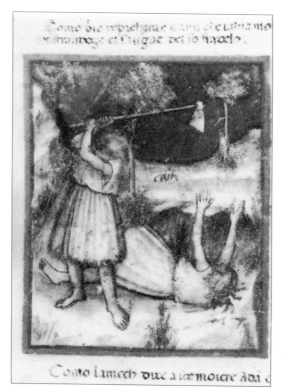

FIG. 12: Paduan Bible. Rovigo, Biblioteca dell'Accademia dei Concordi, MS 212, fol. 3ᵛ, upper left: Death of Abel (Photo: Biblioteca dell'Accademia dei Concordi, Rovigo/Neri Pozza, Venice)

vignettes on fol. 7ʳ. The depiction in the St Omer Psalter, where the boy guide is prone, is closest to the Egerton Genesis.

18. Fol. 3ʳ, lower register: The embarkation (Genesis 7. 7-9, pl. VII)
DESCRIPTION: The ark rests on a grassy hillside in front of a grove of conventional trees, of alternating Italianate and northern foliage, with lopped branches. There are fifteen trunks but only twelve tops. Noah and his wife approach carrying animals on their backs. She carries a small bull and he a ram. Noah leans on a curious staff with a spiked tip. Three ladders, providing entry for Noah's three sons, lean against the ark. The first son carries two bears on his back, as the double outline indicates; the second carries two monkeys; the third comically drags a reluctant lion by its hind legs. The sons' wives assist from aboard the ark. Heavily lidded eyes, hooked noses, and receding chins impart an element of caricature to the faces of the sons and their wives. Noah and his sons wear tunics; Phuarphara wears a kerchief and a long robe.

Hues are limited, as in the preceding miniatures on this folio. The coloured linings which add interest to many other pages of this manuscript are lacking here. In addition to the greens and sienna of trees, grass, and ark, there are touches of peachy orange on Phuarphara's kerchief; a gold-wash line edges her kerchief, Noah's sleeves, and the edge of his tunic. Noah's hair is tinted blue.

COMMENTS: The stiff, inert creatures, forcibly carried onto the ark, are unusual. (The scribe implicitly corrects the image here, stating that the animals came to the ark more by the will of God than by skill or force of man.) These animals are suggestive of the figures of animals painted on boards used in Noah plays.

A close parallel to the Egerton Genesis is provided by the St Omer Psalter, fol. 7ʳ. One of the marginal roundels shows a son of Noah mounting a ladder and carrying an animal piggyback (fig. 13). In the Holkham Bible Picture Book, fol. 7ᵛ, Noah carries a basket of animals, slung on his back; his family members carry birds in their arms. In the Queen Mary Psalter, fol. 6ᵛ, Noah, curiously, carries one of his sons piggyback as he climbs a ladder. Two of the fifteenth-century roof bosses of the nave of Norwich Cathedral, second bay from the east, are carved with images of animals physically carried into the ark.[21] One shows a man carrying an ewe under his right arm and a ram over his left shoulder; the other, a woman carrying a basket of fowl over her head.

Folio 3ᵛ

19. Fol. 3ᵛ, upper left: Noah releases the raven. (Genesis 8. 6–7, pl. VIII)
DESCRIPTION: The ark looks much as in the preceding scene, except that its superstructure is shorter with only one window. It floats on the water, depicted as a series of superimposed green undulating strips, colour greatly rubbed. Noah's head and arms appear at the window. From his outstretched hands he releases the black raven, seen as from above, with fully spread wings.

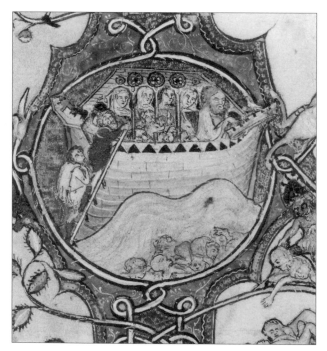

Fig. 13: St Omer Psalter. London, British Library,
Additional MS 39810, fol. 7ʳ, right border, second
roundel: Embarkation (Photo: British Library, London)

Noah's left sleeve is edged with a gold-wash line. Hue is largely restricted on this folio, as on the preceding page, to sienna and green, with only minor touches of other hues.

COMMENTS: In the Holkham Bible Picture Book, fol. 8ʳ, and in the Queen Mary Psalter, fol. 7ʳ, the release of the raven is conflated with scenes of the raven pecking a corpse and of the release and reception of the dove.

20. Fol. 3ᵛ, upper right: Noah releases the dove. (Genesis 8. 8, or 8. 10, pl. VIII)
DESCRIPTION: The scene is very similar to the preceding one except that the dove, painted white, is seen in profile with wings at the downbeat. A gold-wash line again edges Noah's sleeve.

21. Fol. 3ᵛ, lower register: The dove plucks an olive branch and returns after the second release. (Genesis 8. 10–11, pl. VIII)
DESCRIPTION: Noah's head appears at the window of the ark, as in the miniatures above. The dove, depicted in profile, approaches the window, an olive twig in its beak. At left the dove is depicted again, perched on the forked crown of a tall tree, one of a group whose tops emerge from the receding waters.

Trees are of both Italianate and northern colouring; the waters are depicted with the same parallel wavy green lines as in the scenes above.

COMMENTS: The image gives evidence of a change in the page's design while it was under execution. The wavy waters at bottom and the text at top are continuous across the register, but the trees and ark respect the division of the page. One foliage ball is sliced neatly in half where vertical ruling would be expected. Traces of this ruling are in fact detectable between the amputated foliage ball and the prow of the ark. Apparently, the artist's initial plan to divide the register into two scenes was modified in favour of a single scene. Once again, there is evidence of hasty work. Before fol. 4ʳ was completely dry, it was laid on top of fol. 3ᵛ; ink smudges above the prow of the ark and adjacent trees are transferred from the tree with three foliage balls on the page opposite.

On fol. 165ʳ of the Gorleston Psalter, top margin, Noah receives the dove, a spray of foliage in its beak.[22] Noah's head and arms emerge from the doorway of the ark.

Folio 4ʳ

22. Fol. 4ʳ: The debarkation, the delight of the animals, and the rainbow (Genesis 8. 15–19; 9. 12–16, pl. IX)
DESCRIPTION: As Henderson noted, this scene combines elements of three biblical episodes, Noah ordered to leave the ark, the debarkation, and the covenant.[23] The full-page format of this scene conveys a feeling of monumentality. The ark rests on a grassy hilltop, articulated as a green wash with an overlay of rows of white vertical strokes. Two of Noah's sons and one of the wives clamber out of the ark, without the help of the ladders used in the embarkation. One son is viewed in profile, the other three-quarters from behind, the bottom of his right foot visible and the tip of his nose as an addition to the lost profile view of his face. Both wear the tunics in which men of lower rank are often attired in the Egerton Genesis and one wears stirrup leggings. Phuarphara, distinguished from her daughter-in-law by her kerchief, lowers a ram to the ground by its hind legs. Hands together in a gesture of prayer, Noah looks from the window toward the rainbow and the figure of the Deity, whose face and arm emerge from a cloud in the corner as he instructs Noah.

To the left of the ark, eight conventional trees descend an adjacent hillside, four with Italianate colouring and round leaves, and four with northern colouring and heart-shaped leaves. The rainbow spans the space from the trees to the ark.

On the hillside below, the animals cavort and rejoice. A horned cow bellows at right; a pair of long-woolled rams butt one another below a backward-looking ram with tightly curled wool. Other animals include a monkey, a dog, a stag, a horse, a fox or wolf, a hedgehog, a lion, and a bear. A rampant long-haired goat tries to graze from a tree at bottom centre. A bat-winged dragon flies from the ark at centre under the rainbow.

In addition to the sienna and green of the preceding folio, there is blue in the sleeve of the Deity and a peachy orange in the kerchief of Phuarphara and in touches on the bodies of the horse and bear.

COMMENTS: This image has a sense of a spacious design and largely conceived compositional units—the ark, the grove, the hillside with animals—balanced and distributed evenly over the page. The monumental effect is suggestive of wall painting. As noted above in our comments on the Lamech story, Pächt proposed that a lost cycle of wall paintings was one source for the Egerton Genesis artist.[24] Another possibility is that the Egerton Genesis artist himself may have learned techniques of monumental design from working in some medium more monumental than manuscripts, perhaps in wall painting.

Elements in the iconography of this scene have been related to the Cotton Genesis tradition as exemplified in the mosaics of San Marco, to the twelfth-century mosaics of Sicily, and to English traditions as exemplified by the Queen Mary Psalter.[25] The closest overall comparisons are with English traditions, as Henderson has pointed out. It is unnecessary to postulate, as Pächt did, either a trip to north Italy by the artist or his dependence on a late-antique manuscript of the Cotton Genesis recension. Connections are neither compelling nor numerous, and details that link the Egerton Genesis to this tradition could have been picked up second-hand from other sources.

Butting rams are a commonplace in English, Flemish, and French manuscripts of the late thirteenth and fourteenth centuries. Randall lists over two dozen examples from as many manuscripts.[26] Long- and short-woolled sheep appear together in the Holkham Bible Picture Book, fol. 5ᵛ; both were important in the English medieval wool industry.

The dragon, whose flight from the ark suggests the survival of evil after the flood, is not unknown in earlier English iconography of the flood. In the scene of the embarkation on fol. 6ᵛ of the Queen Mary Psalter, a dragon is one of the animals on the hillside below the ark. Legends of the devil riding out the flood on the ark and escaping from it afterwards to roam the earth again are also reflected in the Queen Mary Psalter, on fol. 7ʳ, where the devil is shown escaping from a hole in the hull.

Given the biblical identification of the devil with the dragon, the meaning may be close to that of the Egerton Genesis scene. However, the debarking dragon of the Egerton Genesis may be connected also to iconography of the legendary Mélusine, who as the fée-wife of Raimond, Count of Forez, had the power to change into a winged dragon on Saturdays. Upon being discovered partially metamorphosised in her bath, she escaped as a dragon from Raimond's castle, never to return as a woman. Mélusine is depicted as a dragon flying from an ark-like castle in a fifteenth-century verse version of *Le Roman de Mélusine*, Paris, Bibliothèque Nationale, MS fr. 12575, fol. 86ʳ (fig. 14). An earlier prose version of the romance was composed in 1392–1393 by Jean d'Arras for Jean, Duc de Berry, who claimed lineage from Mélusine. In the *Très Riches Heures*, a manuscript of the Duc de Berry, her image appears on fol. 3ᵛ, as a dragon in flight above the Château de Lusignan.[27] The roots of this romance are in older folkloric material.[28] Connected with human fertility, with settling new lands, and with destruction by flooding,[29] Mélusine could have been associated visually and thematically with new beginnings in the post-diluvian age.

In the embarkation illustration of an early fifteenth-century Franco-Flemish book of hours, Baltimore, Walters Art Gallery, MS W. 292, fol. 50ᵛ (fig. 15), a golden, bat-winged dragon flies

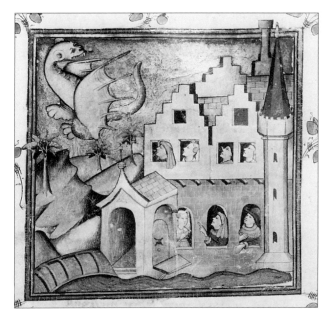

FIG. 14: *Le Roman de Mélusine.* Paris, Bibliothèque Nationale, MS fr. 12575, fol. 86ʳ, miniature: Mélusine flies as a dragon from the castle (Photo: Bibliothèque Nationale, Paris)

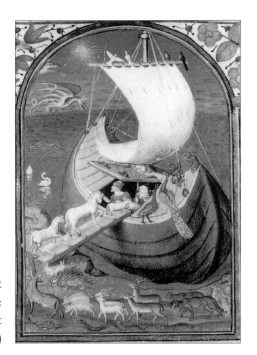

FIG. 15: Book of hours. Baltimore, Walters Art Gallery, MS W. 292, fol. 50ᵛ, detail: Embarkation (Photo: Walters Art Gallery, Baltimore)

toward the ark accompanied by its mate. The probable implication here, as with the disembarking dragon of the Egerton Genesis, is that evil will outlive the Deluge. This curious variant suggests that the male and female dragons intend to survive and reproduce, as will the other survivors of the ark.

Dragons in flight are also found in several earlier Flemish manuscripts, including Bodley 264, as in the miniature on fol. 65ʳ (fig. 16). The dragon in the initial on fol. 97ᵛ has a thin tail with stem-like projections, most ending in leaves but some ending as stubs, as in the Egerton Genesis.

Folio 4ᵛ

23. Fol. 4ᵛ, upper left: Ham sees the nakedness of the drunken Noah. (Genesis 20. 20–22, pl. X)

DESCRIPTION: Grinning gleefully, Ham (Caam) points to the slumbering Noah with his right hand as he taps Shem (Sem) on the shoulder with his left, crossing his arms in front of his body. Shem extends his left arm backward in a gesture of refusal while shielding his eyes with his right hand. Both sons wear tunics and stirrup leggings. At right, Noah reclines in drunken sleep, pillowing his head on his folded arms. His tunic parts to reveal his legs and carefully drawn genitals. A fold of his mantle is drawn around his head. Beside him is a large wine jug with a shallow cup inverted over its mouth. Behind Noah grow six gnarled grapevines, no two alike, each trained to a stake and bearing grapes in pendulous clusters.

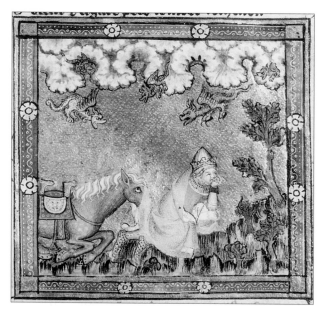

FIG. 16: *Romance of Alexander.* Oxford, Bodleian Library, MS Bodley 264, fol. 65ʳ, miniature (Photo: Bodleian Library, Oxford)

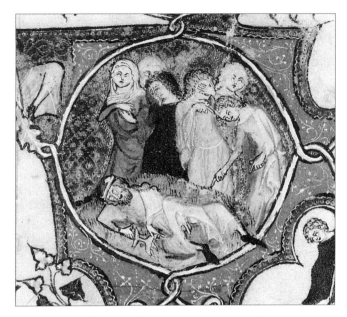

Fig. 17: St Omer Psalter. London, British Library,
Additional MS 39810, fol. 7ʳ, right border, first roundel:
Ham sees the nakedness of the drunken Noah. (Photo:
British Library, London)

The grassy hillside site is articulated as a green wash with an overlay of black strokes in a diagonal grid of squares, some of which contain smaller squares of the same configuration. Grapes are red; the lining of Noah's cloak, a deep pink. Noah's cloak is edged with a gold-wash line. Shem's tunic is edged with a white line.

COMMENTS: The subject of Ham mocking the nakedness of the drunken Noah is also depicted in the Holkham Bible Picture Book, fol. 9ʳ; in the Isabella Psalter, fol. 23ᵛ (where Noah's genitals appear to have been erased); in a marginal roundel of the St Omer Psalter, fol. 7ʳ (fig. 17); and in the Paduan Bible in Rovigo on fol. 6ʳ, lower left. In the Holkham Bible Picture Book and the Isabella Psalter, the scene is conflated with the episode of the covering of Noah's nakedness. In none of the English manuscripts is the scene depicted in quite the exaggerated burlesque fashion of the Egerton Genesis. In the Paduan Bible, Noah is transformed into a stately classical nude; Ham's gestures and expression are dignified. However the emphasis on the genitalia of the slumbering patriarch has a precedent in the *Spiegel historiael* from Ghent. On fol. 4ᵛ, in the scene of the creation of Eve, the genitals of the nude, slumbering Adam are large and carefully rendered (fig. 18). English Psalters which depict the genitalia of Adam, such as the Queen Mary Psalter, fols 3ʳ,ᵛ, and the Ramsey Psalter, Carinthia, St. Paul in Lavantthal, Stiftsbibliothek Cod. XXV/2, 19, fol. 1ʳ, do so in a markedly more understated fashion.[30]

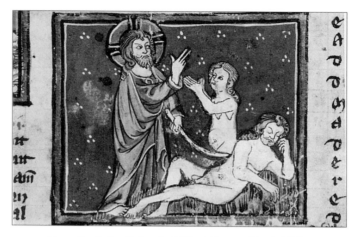

Fig. 18: *Spiegel historiael.* The Hague, Koninklijke Bibliotheek, Koninklijke Akademie MS XX, fol. 4ᵛ, miniature: Creation of Eve (Photo: Koninklijke Bibliotheek, The Hague. Copyright: Koninklijke Bibliotheek, The Hague)

Grass is articulated in a pattern similar to that on some folios of Bodley 264, as on fol. 42ᵛ, in a diamond-shaped repeating pattern of black strokes. Here, though, the design is less systematically executed.

24. Fol. 4ᵛ, upper right: Shem covers Noah. (Genesis 9. 23, pl. X)
DESCRIPTION: Shem walks backward, holding a drape with which to cover his father's nakedness. The cloak hangs in ample vertical folds. At left, Ham grins and points to Noah, who is depicted at right as in the preceding miniature. The scene again includes the wine jug and cup. Eight staked grapevines with dangling clusters of fruit grow on a hillside like that in the adjacent scene.

The grass is articulated as in the preceding scene, and colouring is also similar. One bunch of grapes is uncoloured, presumably an oversight, and Shem's drape is lined with sienna.

COMMENTS: The phenomenon here of sequential actions against a repetitive backdrop is discussed in Chapter 4 as possibly related to the drama.

25. Fol. 4ᵛ, lower left: Noah curses Canaan. (Genesis 9. 25-27, pl. X)
DESCRIPTION: Noah's three sons, Japheth, Ham, and Shem, stand before their father Noah, now covered and reclining with his head propped on his left hand. Japheth points to Ham's head with his left hand and touches him with his right. Ham and Shem stand with arms folded. Between the sons and Noah stands Ham's son Canaan, a curiously squat figure with thick torso and legs and small head. His fingers are interlaced. The sons wear tunics and stir-

rup leggings; Canaan wears a short tunic and fringed leggings; and Noah wears the more dig-
nified long robe and mantle.

Grass and colouring are as in the two scenes above, except that Noah's mantle has touches
of orange on the outside, as well as the line in gold wash along the edge. Orange seems to be
applied only to raised folds that have no penwork shading—a sort of highlighting in hue
rather than in value.

COMMENTS: Canaan is one of a number of figures in the Egerton Genesis with short, stocky
torsos and thick legs, sometimes verging on the elephantine. These figures relate primarily to
those in Bolognese and Franco-Flemish manuscripts rather than to figures in English manu-
scripts, as noted in Chapter 5.

26. Fol. 4ᵛ, lower right: The ancestry of Nimrod (Genesis 10. 8-9, pl. X)
DESCRIPTION: The descendants of Shem's son Aram (Hiron) on the left, and those of Ham,
in the centre, discuss the ancestry of Nimrod (Nemrot). The crowns of many heads can be seen
behind the various profile, three-quarters, and full-view faces in the front row, suggesting a
large crowd. Six faces at left are arranged to suggest a semi-circle in depth, but the figures'
bodies do not maintain this rational articulation of space. One of the two women at the right
touches the elbow of the giant Nimrod, who, standing by a river labeled *lacus*, holds a knobby
club tipped with a metal band and spike. Men and women in long robes and mantles stand
beside a huge, tunic-clad Nimrod. The setting is a grassy meadow in front of two hills. Grass
is rendered in the now-familiar diagonal grid pattern of vertical lines over green wash, but
with some loosening of the pattern on the hilltops. On the hilltop at left grow three small trees
which are variants of the northern type. These have short trunks which divide at the top, each
branch terminating in a cluster of heart-shaped leaves. This sort of tree appears again on fol.
7ᵛ, at upper right and lower right.

Mantles are lined with red, blue, and green. Nimrod's tunic is modelled with a sienna wash.
The river is blue. Ham's cloak is edged with a gold-wash line.

COMMENTS: No river is mentioned in the Egerton text, but the *Historia Scholastica*, with
which the artist seems to have been acquainted, states that Shem's descendants lived beyond
the Euphrates. Captions are written in rectangular spaces reserved from the background. This
is evidence that the artist, whose work certainly preceded the scribe's, planned for at least a
minimal text.

Nimrod's spiked club is a variant of the type Mann identifies as a *godendag*.[31] The tip of such
a club appears on fols 16ᵛ and 29ʳ of the Holkham Bible Picture Book. A *godendag* without
knobs but with the encircling metal band and projecting spike appears on fol. 118ʳ of Gl kgl.
Saml. 3384,8° (fig. 19).

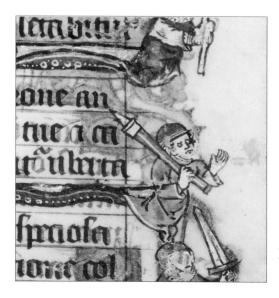

FIG. 19: Psalter. Copenhagen, Kongelige Bibliotek, Gammel kongelig Samling, MS 3384,8°, fol. 118ʳ, detail: Figural line-ending with a spiked club (Photo: Kongelige Bibliotek, Copenhagen)

Folio 5ʳ

27. Fol. 5ʳ, upper left: Nimrod forces the people to worship fire. (non-biblical. Historia Scholastica, ch. 37, col. 1088, pl. XI)

DESCRIPTION: In a gesture of command and threat, the giant Nimrod extends his spiked club over the heads of six of his subjects. Five men are kneeling in worship before a fire, articulated as six wavy flames in a triangular configuration edged with an aura of softer, shorter flames. One man stands with hands raised in protest, as though to ward off a blow.

Nimrod is brown-skinned, and his hair is washed with blue; his tunic is shaded with brown penwork. Several of the subjects have skin washed with brown. The standing figure wears a tunic shaded with both black and brown penwork and fringed leggings. His beard and one lock of hair are drawn but not coloured, perhaps signifying the partial greying of middle age. Tunics of the kneeling worshippers are brown, red, and blue-grey. This miniature and the next two lack all background elements, such as grass and trees.

COMMENTS: Dark-skinned persons are uncommon in early fourteenth-century English manuscripts. The identification of the fool on fol. 57ᵛ of the St Omer Psalter as a black man is dubious.[32] However, dark-skinned persons do appear in earlier Flemish works: On fol. 63ʳ of Douce 6 a figural line-ending playing the triangle has reddish-brown skin (fig. 20); on fol. 69ʳ of Gl kgl. Saml. 3384,8° a grotesque line-ending has dark skin; fol. 88ᵛ of the same manuscript has a figural line-ending with dark face, but blonde hair. In the margin on fol. 197ʳ of a psalter-hours from Ghent, Baltimore, Walters Art Gallery, MS W. 82, a dark-faced entertainer tosses up bowls with sticks (fig. 21).[33] On fol. 61ʳ of MS Bodley 264 three dark-skinned Indians are depicted in a miniature of Alexander fighting King Porus.

Nimrod strongly suggests the raging tyrant of medieval theatre, discussed in Chapter 4.

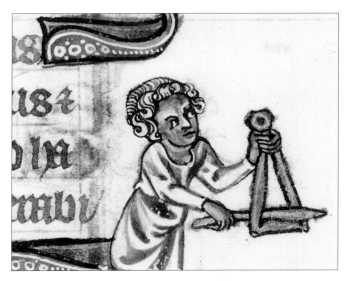

FIG. 20: Psalter. Oxford, Bodleian Library, MS Douce 6, fol. 63ʳ, detail: Figural line-ending with dark skin (Photo: Bodleian Library, Oxford)

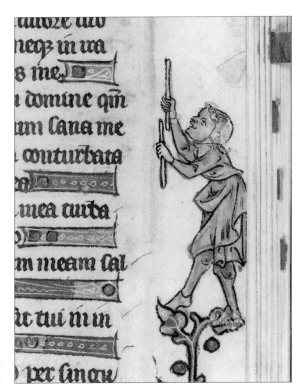

FIG. 21: Psalter-hours. Baltimore, Walters Art Gallery, MS W. 82, fol. 197ʳ, detail, right margin: Dark-faced entertainer (Photo: Walters Art Gallery, Baltimore)

28. Fol. 5ʳ, upper right: Descendants of Ham (Genesis 10. 6–20, pl. XI)

DESCRIPTION: Twelve male figures, some visible only as faces, completely fill the width of this miniature. Three pairs are in conversation; one figure gestures vigorously upward and to the left, toward an indeterminate object of attention. Five faces and some hands and feet are dark; the inscription states that Ham or his people occupied Africa. All garments are the long robes and mantles generally worn by patriarchs and persons of status.

Hair is blue or peachy orange. In addition to grisaille, garments are coloured with brown, orange-brown, and blue. Some linings are pink or blue. Ham's name (*Cam*) is inscribed above his head.

COMMENTS: The alternation of orange and blue occurs also in some scenes in Ælfric's Paraphrase of the Hexateuch of the eleventh century, as in the scene of Moses addressing the Israelites on fol. 136ᵛ.[34] Perhaps the colouring of the Egerton Genesis reflects older English traditions.

29. Fol. 5ʳ, lower left: Descendants of Japheth (Genesis 10. 2–5, pl. XI)

DESCRIPTION: Three groups of men, all garbed in long robes and mantles and some visible only as partial faces, are engaged in lively conversation. Profile faces occupy the spaces between groups and between the third group and the border. Altogether, fourteen or fifteen figures are represented. The distribution of profile, three-quarters, and full-view faces within each group gives the effect of a three-dimensional, semicircular grouping; but, as in the scene of the ancestry of Nimrod on the preceding page, the bodies convey the effect of depth less successfully.

Skin is mostly uncoloured; a few faces and feet bear minimal traces of orange or sienna. The inscription states that the descendants of Japheth inhabited Europe. Considerable traces of peachy orange remain on the projecting surfaces of folds, as though the artist had originally highlighted in hue. Linings are green, blue, and red. A gold-wash line edges the cloak of the first figure at left and that of Japheth, whose name is inscribed above his head.

30. Fol. 5ʳ, lower right: Jonitus, son of Noah, instructs Nimrod. (non-biblical; Historia Scholastica, ch. 37, col. 1088, pl. XI)

DESCRIPTION: After omitting the setting in the preceding miniatures on this page, the artist here depicts a grassy slope crowned with trees of the type on fol. 4ᵛ, lower right, and a river. At left Noah stands beside a river and points across it with his thumb, as though ceding the transriverine land to Jonitus, already standing on the opposite bank. The figure of Jonitus is immediately repeated, this time turned toward his kinsman Nimrod, whom he instructs in astronomy. Both men point upward toward the scalloped cloud which occupies a narrow space between the inscription and the upper border. Nimrod carries the same spiked club as in his previous appearances.

Colour is badly rubbed, especially at left. Grass is articulated in a new variant. Green wash is laid down, not as heretofore in a continuous carpet of colour but as zigzagging diagonals

with uncoloured areas of parchment between. The green is lightly overlaid with vertical strokes in black. The river is uncoloured. Noah's long cloak is blue, lined with peachy pink; his robe is represented in grisaille. Jonitus's robe is blue; his mantle in grisaille is lined with the same peachy pink. Any colour originally applied to the figure of Nimrod has rubbed off.

COMMENTS: Jonitus is rarely encountered in medieval Genesis iconography. The iconography of this scene suggests that the artist, independently of the scribe, was acquainted with literary sources. The inscription, based on the *Historia Scholastica*, does not mention the river, so prominently featured in the miniature. See the Appendix for further discussion of the relation between inscription and image.

Folio 5ᵛ

31. Fol. 5ᵛ, Building of the Tower of Babel (Genesis 11. 4, pl. XII)
DESCRIPTION: In this monumental, full-page scene, the Tower of Babel rises to four storeys as construction busily continues. The tower is an Italianate cylinder with round-arched openings. The first features three wall buttresses and a doorway with raised portcullis, through which a stairway is visible. A horizontal moulding divides the first storey from the second, articulated by two mullioned windows and three corbels which support a wickerwork scaffolding. A worker stands on the scaffolding which supports two ladders. The third storey has one mullioned window. Another wickerwork scaffolding marks the beginning of a gabled fourth level, where walls are under construction.

Masons are busy at many tasks. Below left, two men mix mortar with long-handled paddles, while a third stoops forward to fill his basin. The highly accomplished, strongly foreshortened view of this third figure is striking. A wickerwork ladder with raised triangular treads rises at left. Its front surface is tilted toward the picture plane, so that it seems to be unstable. Four workmen, all viewed three-quarters from behind, ascend the ladder. The two lower figures carry a litter laden with tiles. The two men above them support large triangular stone blocks borne on their shoulders with the help of sticks. On the scaffolding at the third level a mason, also viewed three-quarters from the rear, holds a trowel with curved handle above his head, in an attempt to protect himself from a large block which is falling from the storey above. Beside him a man on a second, shorter ladder descends, carrying a block on his shoulders in the manner described above.

Atop the structure a mason at left lays ashlar blocks (fig. 22); at centre, a workman checks a plumb bob. He bends forward and twists to the side in a complex and successfully foreshortened pose. A man at right makes a measurement, pulling a line taut with his raised right hand, curiously squared in silhouette. The Giottesque workers, short and stocky, are clad in tunics. One descending the ladder also wears fringed leggings. At right below, Nimrod, in his usual attire, consults with a group of his kinsmen, garbed in long robes and mantles. These could be either the leading men of Noah's lineage, *'le plus rour du saunk Noe'* mentioned in the

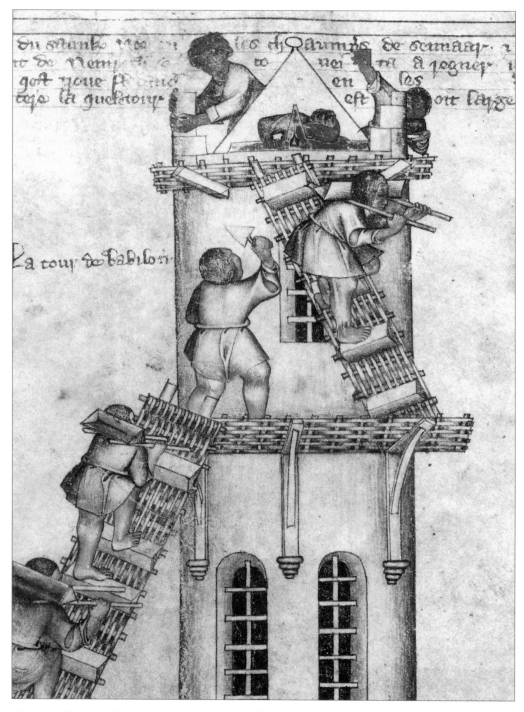

Fɪɢ. 22: Egerton Genesis. London, British Library, Egerton MS 1894, fol. 5ᵛ, detail: Masons at work on the Tower of Babel (Photo: British Library, London)

inscription, or possibly the wise men of Nimrod's lineage, '*li sage home dou lignage cestui Nembroth*', who in the *Histoire ancienne* come to advise Nimrod against the project because of God's wrath.[35]

The skin of all figures is darkened with sienna and black penwork. Hues are limited and subdued; most of the workers' tunics are in grisaille; the tunic of the one with the trowel is partially blue. Blue appears in the hair of the workman with the plumb bob and in that of the elder closest to Nimrod. Two cloaks are lined with touches of orange. The figures at the top have silvered faces and hands, perhaps to indicate their ambition to build the tower to Heaven. A gold-wash line edges the cloaks of the two elders beside Nimrod.

COMMENTS: Italianate elements are numerous in this image. The stocky figures, multiple back views, and foreshortenings are strongly Italianate in feeling. Scholars have pointed out similarities between this scene and the scene of the building of the Tower of Babel in the mosaics of San Marco.[36] There are indeed some similar elements, but substantial differences in the architecture of the tower and in the number and activities of the workmen distinguish the Egerton Genesis image from the comparable one at San Marco. The foreshortened workman holding a basin, at lower left in the manuscript's image, is strikingly similar to a figure in the same scene on fol. 7ʳ, upper left, in the Paduan Bible in Rovigo (fig. 23). The image in the Paduan Bible also includes, in a view from behind, a workman carrying a square basin full of stones on his shoulder. Nevertheless, differences in the two images outnumber similarities. The activities of the workmen and the disposition of men and ladders are different, and the

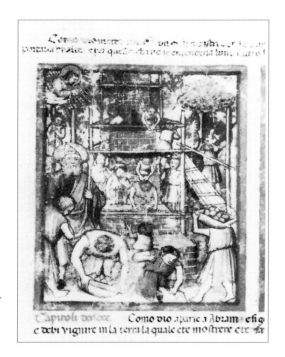

FIG. 23: Paduan Bible. Rovigo, Biblioteca dell'Accademia dei Concordi, MS 212, fol. 7ʳ, upper left: Building of the Tower of Babel (Photo: Biblioteca dell'Accademia dei Concordi, Rovigo/Neri Pozza, Venice)

architecture of the round tower in the Egerton Genesis is unlike the squared structure with multiple setbacks in the Paduan Bible. It is possible that the Egerton Genesis artist had access to some as yet unidentified North Italian pictorial source illustrated with Genesis material. A fourteenth-century North Italian Bible manuscript like the Paduan Bible (itself too late to be the source for the Egerton Genesis) is certainly one possibility. Nevertheless, such a manuscript could only be one source among many, rather than a model in any strict sense. The artist may also have seen the plain cylindrical towers which were part of municipal fortifications in four-teenth-century England.

Images of the building of the Tower of Babel as depicted in English fourteenth-century manuscripts such as that in the bas-de-page on fol. 24v of the Isabella Psalter, are not close iconographically to this scene in the Egerton Genesis. More interesting are the connections of the Egerton Genesis image to certain Flemish manuscripts with depictions of masons, many as line-ending vignettes. Fol. 36r of Gl kgl. Saml. 3384,8° depicts two such masons (fig. 24). One works on a section of wall with an implement (pliers?). His left hand has the same dis-tinctive squared silhouette as that of the mason checking a measurement in the Egerton Genesis Tower of Babel (fig. 22). The second mason carries on his shoulders an ovoid basin of mortar comparable to the one depicted at bottom left in the Egerton Genesis scene. On fol. 114r of the same manuscript, two masons work on the upper levels of a multi-storied Gothic tower. One hammers, the other adjusts the spire of the tallest pinnacle. In Douce 6, fol. 95r, three masons work on a Gothic tower with hammers and chisels. In MS Bodley 264, fol. 67v, upper right, a mason climbs a ladder, carrying stone blocks on a frame supported by two long-handled sticks that rest on his shoulders, rather like the device for portage in the Egerton Genesis.

Fig. 24: Psalter. Copenhagen, Kongelige Bibliotek, Gammel kongelig Samling, MS 3384,8°, fol. 36r, detail: Figural line-endings as masons (Photo: Kongelige Bibliotek, Copenhagen)

Folio 6ʳ

32. Fol. 6ʳ, left: Destruction of the Tower of Babel (non-biblical; Historia Scholastica, ch. 38, col. 1089, pl. XIII)

DESCRIPTION: This tall, thin image occupies the left half of the page. God's head and left arm appear from a scalloped cloud of five tiers in the upper right corner. He directs the four angelic winds whose winged heads appear from a second five-tiered scalloped cloud. The winds from their mouths are articulated as multiple penwork lines, which begin straight and become wavier toward their ends. Under the force of this atmospheric onslaught the tower breaks up into a shower of small rectangular fragments; the upper storeys have disintegrated and the second storey is under demolition. The standing portion of the structure looks much as in the preceding miniature, except for the absence of corbels.

God's face and hand and the cross of his nimbus are silvered, as are the wings of the angels. There may be some silver in the clouds as well. His sleeve is blue as is the nimbus. The portcullis is reddish brown; otherwise the image is in grisaille.

COMMENTS: The text is crammed between the winds and the figure of God at the top; clearly text was added after the image. Winds, or atmospheric forces, articulated as multiple lines issuing from the mouths of heads at the base of scalloped clouds, are also found in the Canonici Apocalypse, Oxford, Bodleian Library, Canonici biblical MS 62, fol. 29ʳ.[37] Again it is apparent that the artist was familiar with Peter Comestor, who is the source for this non-biblical image of winds destroying the Tower of Babel.

33. Fol. 6ʳ, upper right: Descendants of Shem (Genesis 11. 10-25, pl. XIII)

DESCRIPTION: Fifteen of Shem's male descendants, many arranged as conversing pairs, completely fill the miniature. Three-quarters and profile views predominate, but a frontal view, a back view, and a lost profile are also included. Nine are identified by inscriptions. They stand on a strip of grass, colour much abraded. The setting is otherwise unspecified. Their hair comprises variants of conventional Gothic types—sweeping, wavy locks and repeated short curls, sometimes arranged in sausage-like rows.

Figures and garments, long robes, and mantles, are in grisaille. Some mantles and sleeves have coloured linings in sienna, blue, red, and green. A gold line edges part of Shem's cloak (first figure at left in front row).

COMMENTS: This is another convivial scene, with lively gesturing hands, expressive glances and subtle variations in poses and in the configurations of drapery. It is strongly suggestive of the theatre.

34. Fol. 6ʳ, lower right: Abraham, his brothers and nephews (Genesis 11. 26–27, pl. XIII)[38]

DESCRIPTION: This scene continues the depiction of genealogy of Abraham, begun above. Three of the five figures in this scene are identified as Abraham and his brothers Nahor (Nacor)

and Haran (Aran) by inscriptions. Abraham and Nahor are not mentioned in the text of the miniature but are mentioned in that of the miniature directly above. Inscriptions over the heads of the two men at right are illegible; they may be identified as Haran's sons, Lot and Iscah, mentioned in the text of the miniature. Abraham, in profile at left, gestures with pointing finger, as though instructing his relatives, all of whom look at him. All wear long robes and mantles and all except Iscah are bearded. They stand on a strip of grass in an otherwise unspecified setting.

Colour and drawing are much rubbed; grisaille predominates. Mantles are lined, left to right, with blue, dull red, sienna, green, and pink. Abraham's robe is edged with a gold-wash line. The green wash of the grass is reduced to a faint stain.

Folio 6ᵛ

35. Fol. 6ᵛ, upper left: The marriage of Nahor and Milcah and of Abraham and Sarah (Genesis 11. 29, pl. XIV)

DESCRIPTION: Nahor takes Milcah as wife, joining his right hand with hers; Abraham like-wise takes Sarah, whose left arm overlaps the border. All are identified by inscriptions. All wear long robes and mantles, and the women wear kerchiefs.

The scene is set on a strip of grass, green wash overlaid with two or three rows of vertical strokes in white, perhaps with some black as well. The kerchiefs are coloured an intense white; mantles are lined with pink, deep sienna, and blue. Abraham's and Sarah's mantles are edged with a gold-wash line, which Nahor's and Milcah's lack. Otherwise the figures are in grisaille. Touches of the intense white used for the kerchiefs seem to be employed also on some pro-jecting folds of the garments of Abraham and Sarah, enhancing the modelling and the sense of three-dimensionality in their figures.

COMMENTS: The Queen Mary Psalter, fol. 8ᵛ, depicts the marriage of Abraham and Sarah in a minimal image, but the iconography of the double marriage does not occur, to our knowl-edge, in manuscripts other than the Egerton Genesis. This scene could well be the artist's own composition from a reading of the first part of Genesis 11. 29, which it closely follows. The text, on the other hand, follows Peter Comestor; this is only one of many instances in which the second author-scribe did not fully adapt his text to the pre-existing image.

36. Fol. 6ᵛ, upper right: Terah, Abraham, Sarah, and Lot journey to Harran. (Genesis 11. 31, pl. XIV)
DESCRIPTION: Terah leads his son Abraham by the hand. Sarah, her figure a graceful S-curve, follows Abraham, while Lot touches her shoulder from behind. Setting is the generic grassy strip that has appeared in the previous three scenes. All wear long robes and mantles. Lot is beardless.

Mantles are lined, left to right, with greenish-blue, blue, and sienna. Sarah's kerchief is a brilliant white. White highlighting on projecting folds of the robes enhances the sense of three-dimensional form. The mantles of all but Lot are edged with a gold-wash line.

37. Fol. 6ᵛ, lower left: God appears to Abraham at Shechem. (Genesis 12.6–7, pl. XIV)

DESCRIPTION: Having left Harran in response to God's command, Abraham, his head covered, worships before the altar he has built at Shechem. Beside and behind him stand Sarah and Lot, the latter cut off by the border. The setting is a strongly waved grassy strip. The Lord appears from a scalloped cloud in the upper right corner of the miniature, gesturing with both hands, as though to indicate the gift of the land to Abraham's descendants. The altar is shown in a strongly tilted perspective, with no attempt at the convergence of orthogonals. It is covered with a white cloth and is edged on the front with a beaded border and fringe and on the side with a linear border and fringe. Front and side are not aligned at the corner.

God's garment is the intense cerulean blue of fol. 1. His sleeves are edged with a gold-wash line. The face of the Deity is whitened rather than silvered as elsewhere. Abraham's mantle is lined with a dull orange-red. Sarah's kerchief is white, with a splotch of peachy orange on top. A gold-wash line edges Sarah's kerchief and cloak as well as Abraham's cloak.

COMMENTS: Indifference to the convergence of orthogonals is typical of the Egerton Genesis artist. His architecture is usually constructed using a rationalized version of northern layering rather than imitating Italianate efforts toward an empirical one-point perspective.

Abraham's first altar at Shechem, relatively uncommon in medieval Genesis iconography, is depicted on fol. 7ʳ, lower right, in the Paduan Bible in Rovigo and may be depicted on fol. 9ʳ of the Queen Mary Psalter.[39] In the Italian example the diagonally oriented altar and the inclusion of minimal accessories are points of resemblance with the same scene in the Egerton Genesis.

38. Fol. 6ᵛ, lower right: Abraham and Sarah journey toward Egypt. (Genesis 12. 10–13, pl. XIV)

DESCRIPTION: Equipped with knobbed walking sticks, Abraham and Sarah walk toward the right. Their names are inscribed above their heads. Abraham turns back to look at Sarah and touches her stick, perhaps instructing her to pretend she is his sister. She raises her hand in a gesture of acquiescence or acknowledgement. The setting is a grassy strip, scalloped in shape, like that of the preceding scene.

Sarah's kerchief is white; her mantle, lined with blue. Abraham's mantle is lined with sienna; both mantles and Sarah's kerchief are edged with a gold-wash line. Grass is dark green wash with an overlay of white strokes. Otherwise grisaille predominates.

COMMENTS: This scene, and the five succeeding, illustrate Genesis 12. 10–20. These six scenes of Abraham's sojourn in Egypt constitute exceptionally dense illustration of a ten-verse passage of scripture. The episode is a particularly colourful and dramatic one of cowardice and deception, lust, and divine rescue and retribution. It reads almost as a self-contained play within a play.

Folio 7ʳ

39. Fol. 7ʳ, upper left: Pharaoh's courtiers discover Sarah. (Genesis 12. 14, pl. XV)
DESCRIPTION: Sarah and Abraham are surrounded by four Egyptians, one with dark skin; two more converse at the right. One Egyptian grasps Abraham's left elbow and points to Sarah, whom another Egyptian holds by the right arm, to escort her to Pharaoh. Abraham points to Sarah, probably declaring, as the text in the preceding image relates, that she is his sister. The scene has no setting. Intense, peering faces and gesturing hands animate this vignette.

Abraham's hair is blue; otherwise colour is restricted to the linings of garments: blue, dull red, green, and a light sienna. A gold-wash line edges Sarah's kerchief and the cloaks of Abraham and Sarah. Most other cloaks are edged with a white line.

COMMENTS: The content of this scene is united with that of the scene succeeding. Courtiers in the next scene gesture back to Sarah depicted here.

40. Fol. 7ʳ, upper right: The courtiers tell Pharaoh about Sarah. (Genesis 12. 15a, pl. XV)
DESCRIPTION: Five eager courtiers are gathered before the crowned Pharaoh, who, holding a large sceptre, is seated on a draped, backless throne. His black shoe contrasts with the bare feet of the others. The courtier closest to the king genuflects. Hands gesture emphatically back toward Sarah and forward toward the king. The swinging curves of cloaks underscore the activity and excitement. Pharaoh, responding with a comically lecherous leer, gestures his desire to see Sarah. There is no indication of setting except for the throne.

Colour is once again mostly grisaille. Light sienna, blue, brown, and green line the cloaks. Pharaoh's hose are light sienna and his crown and sceptre are gold wash.

41. Fol. 7ʳ, lower left: Sarah is brought before Pharaoh. (Genesis 12. 15b, pl. XV)
DESCRIPTION: With 'groundelande contenance', Sarah is literally shoved into the presence of Pharaoh (fig. 25). She protests vigorously with upflung hands. The concave lines of her cloak and posture underscore her attitude of resistance, while the opposing curves of her escort's garments bespeak his determination to present her to Pharaoh. The king sits once again on his throne, here articulated with mouldings and two tiers of perforations. His shoe is patterned black and white. He grasps Sarah's left wrist with one hand and her cloak with the other and pulls her close. At the far left, Abraham acquiesces fearfully to a courtier who threatens him with a raised fist. As in the scene preceding, the throne is the only indication of setting.

Green, blue, and light sienna line the cloaks; Pharaoh's crown is coloured with gold wash. A gold-wash line edges the kerchief of Sarah and the cloaks of Abraham, Sarah, and Pharaoh.

42. Fol. 7ʳ, lower right: Pharaoh is stricken with illness. (Genesis 12. 17, pl. XV)
DESCRIPTION: Pharaoh reclines on a bed with a pleated coverlet, his head supported by his left hand. Slanting eyebrows and half-closed eyes express his distress. Behind his head is his

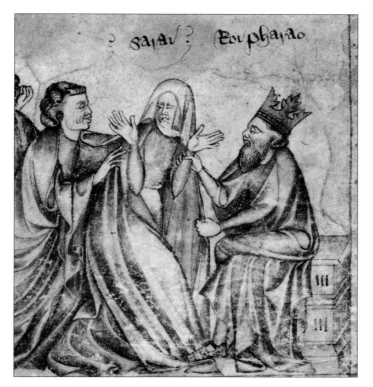

FIG. 25: Egerton Genesis. London, British Library, Egerton MS
1894, fol. 7ʳ, lower left, detail: Sarah, Pharaoh, and a courtier
(Photo: British Library, London)

crown, seemingly suspended in space. At the side of the bed Sarah regards the sick king with
compassion, while praying for him with folded hands. Her cloak is fastened with a circular
brooch. Three tonsured priests have gathered at the foot of the bed; one kneels and two stand.
One indicates Sarah as the source of the king's problem while the other two gesture with long,
curved forefingers.

Colour is minimal, in keeping with the other three scenes on this page: cloaks are lined with
blue, green, and light sienna; the crown is gold wash; a gold-wash line edges Sarah's kerchief
and the cloaks of Sarah and Pharaoh.

COMMENTS: This episode and the similar one on fol. 10ʳ (11ʳJ) of the ill Abimelech, the con-
cerned Rebecca, and the doctors, bring to mind the popular English folk play, described by
Tiddy, which included death by wounding and cure by a doctor.[40] Here the priests of the ill
Pharaoh are of no avail. It is truth which heals.

Long, curved, pointing forefingers, like those of the two priests, occur frequently in the
work of the Egerton Genesis artist.

Folio 7ᵛ

43. Fol. 7ᵛ, upper left: Pharaoh tells Abraham to leave Egypt. (Genesis 12. 18–20, pl. XVI)
DESCRIPTION: His health now much improved, Pharaoh sits up in bed, once again wearing his crown. Beside the bed are Abraham, Sarah, and four soldiers. Pharaoh's averted head and downcast eyes express his discomfiture and displeasure, as he directs the officer in charge to escort Abraham and Sarah out of Egypt. Sarah's glance and gesture indicate her concern for the monarch, but Abraham grasps her arm, eager to be off.

The soldiers at left and right wear chain mail *haubergeon*s over a quilted undergarment, iden-tifiable by its vertical rows of stitching. Over this is the sleeveless fitted surcoat. The knight at left wears as a helmet a ridged bascinet. The soldiers at left wear *chapels de fer*. Plate mail greaves and poleyns (knee-guards) protect the leg of the soldier at far right. The soldier in the centre, viewed from behind, wears a bascinet without a crest. Weapons are a double-flanged glaive, a poleaxe, and a spear.

Pharaoh's cloak, and Sarah's, are lined with rosy peach. Abraham's is lined with green. Weapons and poleyns are silvered. The crown is gold wash, and the usual gold-wash lines are applied to the edges of the garments of Pharaoh, Abraham, and Sarah.

44. Fol. 7ᵛ, upper right: Abraham's herdsmen fight with those of Lot. (Genesis 13. 7, pl. XVI)
DESCRIPTION: Three pairs of herdsmen are in combat over scarce pasturage. At left, one whose face is concealed grasps the hair of his adversary while striking his nose. Two other pairs wrestle with arms and legs interlocked. The pair in the immediate foreground wear hel-mets and eye protectors, having prepared in advance for the conflict. All wear short tunics; some wear leggings. The back views, twisted poses, and foreshortenings are well handled. At right stand the herds of livestock—sheep and goats, a cow, and a donkey. All but one long-haired sheep are oriented parallel to the picture plane. The setting is a grassy meadow, much rubbed. Three short trees with lopped branches grow in the background. Foliage of the two at left is divided into two balls; in each, heart-shaped leaves are drawn in black over green wash. The centre tree grows atop a curious hillock of flamelike, zigzagging projections.

Beside the green wash of the grass and leaves, the only colours are peach and grey splotches on the herds at right and touches of white on the eye protectors and on some animals.

COMMENTS: Vignettes of wrestlers are commonly encountered in the margins of early four-teenth-century manuscripts. This scene is reminiscent of wrestling matches associated with medieval drama, both as interludes and as integral to the drama itself. Conflict over grazing rights would have been a familiar theme in the wool-raising regions of fourteenth-century England.

The zigzagging hillock resembles the more patternized and linear version of the ground that appears in many miniatures of a *Rijmbijbel* in The Hague, Museum van het boek/Rijksmuseum Meermanno-Westreenianum, MS 10 B 21, as in the Creation scenes on fol. 1ᵛ (fig. 26).[41]

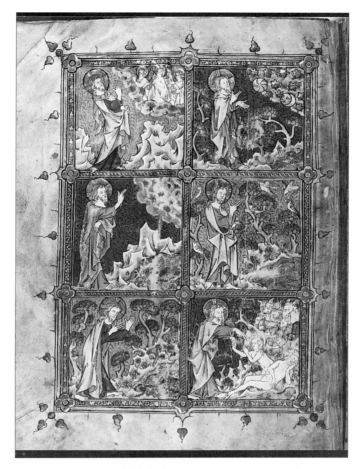

Fig. 26: *Rijmbijbel.* The Hague, Museum van het
boek/Rijksmuseum Meermanno-Westreenianum, MS 10 B
21, fol. 1ᵛ: Six days of Creation (Photo: Museum van het
boek/Rijksmuseum Meermanno-Westreenianum,
The Hague)

Pächt cited 'the perspective rendering of masses of figures or animals by means of multiple repetition at short intervals of the furthermost outlines' as one of 'the most patent signs of late-antique stylistic influence in the Egerton Genesis'.[42] This convention is employed on several folios, including fols 8ʳ, lower left; 18ʳ, lower right; and 20ʳ, upper left. However, it is not necessary to look to late antique models for the prototype. Close parallels in the Paduan Bible in Rovigo, as in the scene of Jacob questioning the herdsmen of Laban on fol. 20ᵛ, upper right (fig. 27); or in the scene of Jacob's return to Canaan, fol. 23ʳ, upper left, indicate that this convention for rendering masses of animals in depth had been assimilated into fourteenth-century Italian art.

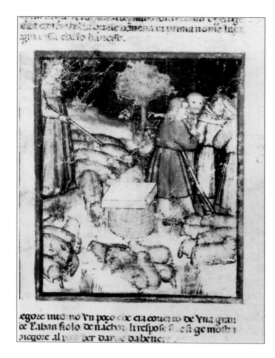

FIG. 27: Paduan Bible. Rovigo, Biblioteca dell'Accademia dei Concordi, MS 212, fol. 20ᵛ, upper right: Jacob questions the herdsmen of Laban. (Photo: Biblioteca dell'Accademia dei Concordi, Rovigo/ Neri Pozza, Venice)

45. Fol. 7ᵛ, lower left: Abraham's herdsmen report to him. (nonbiblical; source uncertain, pl. XVI)

DESCRIPTION: Seated together on a throne rendered in a tilted perspective, Abraham and Sarah listen to three herdsmen whose grimaces and gestures tell the woeful tale of conflict with Lot's herdsmen. All three gesture obliquely upward, toward the image which depicts the wrestling match; one points to his head, perhaps to indicate an injury sustained in the brawl. At least two wear long cloaks. Abraham looks grieved; he holds Sarah's hand, and she lays a comforting hand on his shoulder. His cloak is fastened with a circular brooch like that worn by Sarah on the preceding page, bottom right. A curious ringlet is on the side of his head. An oddity in this scene is the blank trapezoidal shape between Abraham and the shepherds. It cannot be read as a section of a garment, nor as a part of the seat, nor as an empty space.

Abraham's cloak is lined with green; his brooch is beige. Sarah's kerchief and her dress are splotched with an opaque orange-brown, largely rubbed off. Is the colour which encroaches on her neck intentional? Abraham's brooch is touched with gold wash, and a gold-wash line edges the cloaks of Abraham and Sarah.

46. Fol. 7ᵛ, lower right: The parting of Abraham and Lot, scene 1 (Genesis 13. 11, pl. XVI)
DESCRIPTION: At left stands a beardless young Lot with his wife and household, the latter represented by a partial figure seen three-quarters from the rear beside Lot. A small section of

an additional head is seen between Lot and his wife. The positioning of Lot's feet is questionable with respect to the stance of his upper body. Lot and his companion gesture in parting toward Abraham and Sarah, who stand with a member of their household at the right. Abraham's swaying stance and emphatic gesture toward Lot heighten the expressive quality imparted by the heavy eyes and down-turned mouths of the four principals. Clearly the moment is painful. In the centre of the image, the divided foliage ball of a tall tree with lopped branches, traditionally northern in type, re-emphasizes the theme of division and parting. The flocks of both households crowd the space around the base of the tree, leaving only a little space for the depiction of grass, much rubbed.

The foliage is green, as are the linings of Abraham's and Lot's cloaks. The grass is blue, as in the scene of the Creator resting on fol. 1ᵛ, lower right. The herds and the lower parts of Abraham's and Lot's garments are splotched with orangey-brown. Kerchiefs of Sarah and Lot's wife are white. A gold-wash line edges Sarah's kerchief, her robe and cloak, and those of her husband.

Folio 8ʳ

(This first folio of the second gathering is without inscriptions.)

47. Fol. 8ʳ, upper left: The parting of Abraham and Lot, scene 2 (Genesis 13. 11, pl. XVII)
DESCRIPTION: Having said their good-byes in the previous image, Abraham and Lot move in opposite directions, accompanied by their households. Lot is now bearded. His household includes four diminutive children. Two in short tunics have very thick legs; one holds a staff in his right hand and grasps a fold of the cloak of a nearby adult with his left. Eight adults in two rows accompany Lot; a woman at the rear turns to look back. Abraham, at the far right, casts a backward glance toward Lot's company; he is with Sarah and three other adults.

The setting is a grassy strip, articulated as green wash overlaid with vertical strokes of white in three horizontal rows. Two cloaks, those of one man in each company, are lined with an intense blue. Sarah's cloak and that of one woman in Lot's company are lined with an intense vermilion, a colour which appears in the illuminations for the first time since fol. 2ᵛ. Abraham's and Sarah's cloaks and Sarah's kerchief are edged with a gold-wash line.

COMMENTS: The inclusion of two scenes of the parting of Abraham and Lot is most unusual. This episode was apparently depicted twice in the glass of an apse window at Bury Saint Edmunds, probably in Simon de Luton's thirteenth-century Lady Chapel.[43]

48. Fol. 8ʳ, upper right: God promises the land to Abraham and his descendants. (Genesis 13. 14–16, pl. XVII)
DESCRIPTION: Abraham kneels on a grassy strip, his hands together in prayer. He looks toward the Lord, whose head and forearms appear between the second and third tiers of a magnificent cloud. Each tier is notched and serrated.

The grass is a wavy green strip overlaid with two rows of vertical white strokes. God's sleeves are blue, edged with a gold-wash line. His face, halo, and hands are silvered, and there is possibly some silver in the cloud as well. Abraham's cloak is lined with vermilion.

COMMENTS: This is the first of three scenes in which God promises progeny to Abraham. On fol. 9ʳ, lower left, the promise of Genesis 15. 1–4 is depicted; and on fol. 9ᵛ, lower left, the promise of Genesis 17. 1–5.

49. Fol. 8ʳ, lower left: Abraham walks the land and views the stars. (Genesis 13. 16, 17; 15. 5, pl. XVII)
DESCRIPTION: At left walks a bearded figure in a short tunic, a hooded cape, fringed leggings, and gloves. The gold-wash line edging his tunic and cape strongly suggests that this is no ordinary shepherd but rather Abraham, since gold wash is generally reserved in the Egerton Genesis for figures of distinction. He holds a stick with a curved end like a shepherd's staff in his right hand and shields his eyes with his left as he looks toward the sky. In front of Abraham is a herd of animals—cattle, sheep, goats, horses. On a hill behind him sit three men, all looking upward and apparently engaged in a game of skill (fig. 28). The man in the centre, his head

FIG. 28: Egerton Genesis. London, British Library, Egerton MS 1894, fol. 8ʳ, lower left, detail: Three herdsmen, the one at centre balancing a stick on his nose, with ball above (Photo: British Library, London)

depicted in drastic foreshortening, crosses his arms over his chest and balances a three-pronged stick on his nose. Above the stick is suspended a ball. The other two men watch the ball.

The hillside is covered with grass articulated as a green wash overlaid with black vertical strokes in the diaper pattern employed on fol. 4ᵛ. Three trees whose foliage balls are flattened into disks grow on the hillside. Grass and foliage are green; the hooded figure's cape is lined with orange-brown; his tunic and cape are edged with a gold-wash line. A few spots of peachy brown are on his leggings and the skirt of his tunic as well as on the herds to his right.

COMMENTS: This is one of the most mystifying scenes in the Egerton Genesis, because it seems to draw from multiple textual and visual sources. The textual sources seem to be a conflation of Genesis 13. 17: 'Arise, walk through the length and breadth of the land, for I will give it to you', (Revised Standard Version) and Genesis 15. 5: 'And He brought him outside and said, "Look toward heaven and number the stars, if you are able to number them" ' (Revised Standard Version). The figure at left is both walking and looking up toward the sky, as though to see the stars.

However, the visual sources of the iconography lead in entirely different directions. First, there are references to traditional images of the Annunciation to the Shepherds, which often feature one or more shepherds seated on a hillside entertaining themselves with musical instruments while a standing shepherd, at the base of the hill, leans on a staff and gazes up at the angel or the star. As is apparent from Randall's catalogue, Flemish, English, and French examples from the first half of the fourteenth century are numerous. Here the Annunciation iconography would refer to God's promise to Abraham of numerous progeny through Isaac's advent. Second, the balancing game played and watched by the men on the hill relates to many marginal images in Flemish, English, and French manuscripts of the first half of the fourteenth century. In Baltimore, Walters Art Gallery, MS W. 88, an early fourteenth-century book of hours from the Diocese of Cambrai, fol. 70ʳ, a man balances on his shoulder a stick with a curved flange, in which is cradled a ball.[44] Examples will not be multiplied here; many are illustrated by Randall.[45]

Pächt tentatively identified the three seated figures as Mamre, Aner, and Eschol, *les trois friers avauntditz* mentioned in the text on fol. 9ʳ, upper left. He suggested that their upward glances are intended to connect this scene with the parting of Abraham and Lot directly above and may show the influence of wall painting on the Egerton Genesis artist.[46] However, the fact that they are playing a game would suggest that they are figures of lower rank, perhaps the herdsmen of the flock below. Shepherds are sometimes depicted as engaged in frivolous pursuits, as in the Hours of Jeanne de Navarre, Paris, Bibliothèque Nationale, MS Nouv. acq. lat. 3145, fol. 53ʳ, bas-de-page, produced in Paris after 1336.[47]

This scene is also connected with the medieval shepherds' plays. Ruston considered the clowning of the ignorant shepherds before their vision of the annunciatory angel in the *Second Shepherd's Play* of the Wakefield cycle as 'typifying the people who walked in darkness before they saw a great light'.[48]

This image remains to be fully explained; at present it would seem to be composed of heterogeneous elements all in some way associated, some closely and some very loosely, with the biblical idea of a promised heir.

The mushroom-shaped flattened trees in this image were cited by Pächt as evidence of influence by an early Christian manuscript such as the Vienna Genesis.[49] However, there are parallels much closer in time and place of origin. Bodley 264 includes a number of flattened, mushroom- or umbrella-shaped trees, as in the bas-de-page of fols 121ᵛ, 122ᵛ (fig. 29), and 123ʳ.

FIG. 29: *Romance of Alexander*. Oxford, Bodleian Library, MS Bodley 264, fol. 122ᵛ, bas-de-page: Hunting scene with flattened tree (Photo: Bodleian Library, Oxford)

50. Fol. 8ʳ, lower right: Abraham and Sarah build the altar at Hebron. (Genesis 13. 18, pl. XVII)
DESCRIPTION: Sarah, at left, and Abraham, a slice of whose head is visible at right, arrange the cloth on the altar at Hebron. The cloth is fringed along its front side and is further ornamented with three fringed rectangular panels.

Two sculptors, viewed from behind in foreshortening, are at work on the superstructure. The figure at the left bends sideways and exhibits a skilfully rendered lost profile. The figure at the right, bent backwards with upraised arms, presents a radically foreshortened head, also well rendered. The architectural superstructure is supported by four slender columns set at the corners of the altar. Three of these columns are seen to be capped by pinnacles surmounted by a ball finial and a small cross. An ogival arch, enclosing five lobes and ornamented with a large foliate finial, connects the two columns closest to the picture plane. A similar arch, whose profile does not appear to be ogival, is seen at an angle connecting the two columns in front of Sarah. These arches (one presumably connecting each pair of columns) support segments of wall with battlements, behind which rise, in two tiers, slender sections of roofed walls pierced with thin lancets and adorned with numerous pinnacles, each having a ball finial topped with a small cross. The setting is a grassy strip, of whose original green colour only a faint wash remains.

The fringe of the altar cloth is coloured in blocks of green alternating with red and brown. The pinnacles and roofs of the superstructure are coloured red, blue, green, and peach, with gold wash (?) on the ribs and finials. The altar cloth and panels are splotched with peach and peachy brown, and the battlements are partly washed with peach as well. Sarah's kerchief is edged with a gold-wash line.

COMMENTS: Fringed and panelled altar cloths are generally found in manuscripts of the Low Countries, especially those associated with Ghent, rather than in English manuscripts. Often the fringe is coloured in blocks of two or three alternating colours. Comparable to the cloth in the Egerton Genesis are the fringed and panelled altar cloths on fols 31[r] and 48[r] (fig. 30) of the *Rijmbijbel* and that on fol. 147[r] of a psalter in The Hague, Koninklijke Bibliotheek, MS 135 E 15 (pl. Ia).[50] Other examples include the cloth in Gl kgl. Saml. 3384,8°, fol. 2[v], which has a striped fringe, as does that of the Egerton Genesis; the cloths in a missal in The Hague, Museum van het boek/Rijksmuseum Meermanno-Westreenianum, MS 10 A 14, in the miniature on fol. 144[r], and in the historiated initial on fol. 167[r]; the cloths in the so-called Missal of Louis de Male, Brussels, Bibliothèque Royale Albert 1er, MS 9217, in the initial on fol. 109[r], and in the initial on fol. 116[r] (fig. 31).

In both East Anglian and Flemish manuscripts of the second quarter of the fourteenth century, Italianate views of the undersides of vaults are depicted with varying degrees of success (figs 32, 33) as is noted in Chapter 5.

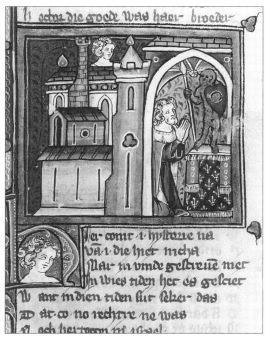

FIG. 30: *Rijmbijbel.* The Hague, Museum van het boek/Rijksmuseum Meermanno-Westreenianum, MS 10 B 21, fol. 48[r], miniature: Micah kneels at his shrine. (Photo: Museum van het boek/Rijksmuseum Meermanno-Westreenianum, The Hague)

71

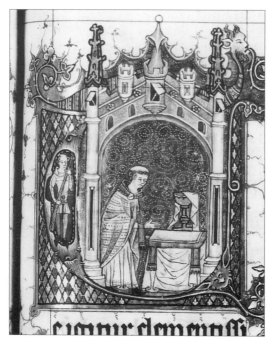

FIG. 31: Missal. Brussels, Bibliothèque Royale Albert 1er, MS 9217, fol. 116ʳ, detail: Initial T, with priest celebrating Mass (Photo: Bibliothèque Royale Albert 1er, Brussels)

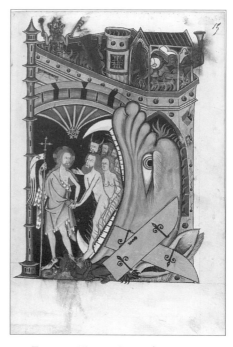

FIG. 32: Fitzwarin Psalter. Paris, Bibliothèque Nationale, MS lat. 765, fol. 15ʳ: Descent into Limbo (Photo: Bibliothèque Nationale, Paris)

Folio 8ᵛ

(This folio is without inscriptions.)

51. Fol. 8ᵛ, upper left: The battle between the four kings and the five kings (Genesis 14. 3–10, pl. XVIII)
DESCRIPTION: In this vigorous and gory battle scene, set on grassy ground, the four mounted attacking kings lean forward with heads down. They are clearly vanquishing the forces of the five kings, the latter appearing in the background at right, not engaged in combat. Serious injuries, including a cleft head and skewered shoulder, are inflicted on the soldiers of the losing side. At far right, a knight falls beneath the sword of the foremost of the four kings. The winning side is apparently unscathed.

The scene, densely packed with figures, horses, and weapons, is animated by the actions of the soldiers and the flying caparisons of the horses. Weapons include swords, spears, battle axes, a *godendag*, and one blade with a hooked tip and bayonet. Saddles feature leg protectors, most fully visible on the saddle of the foremost mounted king. The armour features a fitted outer garment laced up the sides and a number of plate reinforcements for the arms and legs. Chain mail hoods, or camails, are visible at the neck beneath the helmets, which include

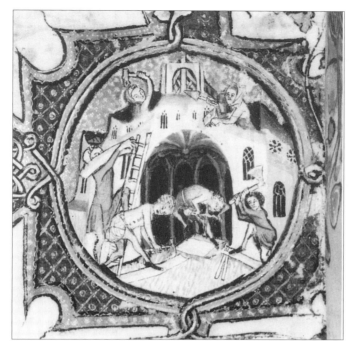

FIG. 33: St Omer Psalter. London, British Library, Additional
MS 39810, fol. 70ᵛ, lower border, fourth roundel: Building
of Solomon's Temple (Photo: British Library, London)

bascinets, *chapels de fer*, and a helmet of four tiered circles. The kings wear crowns over their
helmets.

This page is one of the most colourful in the second gathering. A bright vermilion is used
in a number of ways: in a sunburst pattern and in the lining of the caparison of the foremost
horse; at the edge of the same horse's saddlecloth; on the swordbelt and reverse side of the
shield and at the elbows of this horse's rider; on the undergarment of the second of the four
kings; in the reins and on the caparison of the horse directly behind the first king; in the blood
issuing from the wound of the soldier with cleft head. Blue appears in the first king's under-
garment and in the lining of a caparison visible beneath the first horse. Green is used in the
grass and in other touches, as on the scabbard and at the elbows of the first king, in the reins
and girth of his horse, and in the third king's undergarment. Sienna colours the legs of a horse.
Brown is used in the fourth king's undergarment, in the legs of several horses, and in one
caparison. Splotches of brown and peachy beige occur in several places, on outer garments and
on the foremost horse. Black and silver colour many weapons, helmets, and *épaulières*; and gold
wash is used on the nine crowns.

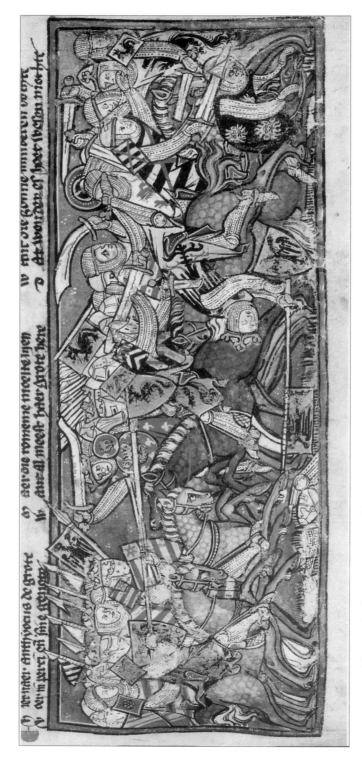

FIG. 34: *Spiegel historiael*. The Hague, Koninklijke Bibliotheek, Koninklijke Akademie MS XX, fol. 42ʳ, miniature: Battle Between Hannibal and the Romans (Photo: Koninklijke Bibliotheek, The Hague. Copyright: Koninklijke Bibliotheek, The Hague)

COMMENTS: Violent battle scenes are a familiar feature in English and Flemish manuscripts of the first half of the fourteenth century. The scenes in the Egerton Genesis are notable for their dense but rational composition in multiple layers parallel to the picture plane and for the depiction of rows of neatly aligned spears and swords which visually help to organise the combatants into distinct opposing groups. In spite of the neatness of design, the gory hacking and skewering are not underplayed, neither in this scene nor in the battle scene in the lower right quadrant of this folio.

The relationship of the two battle scenes on this page to the iconography of such scenes in contemporary illumination bears further investigation, but a few comments may be ventured. A number of features relate this battle scene to those in the *Spiegel historiael*. Scenes such as that depicting the battle between Alexander and Darius, fol. 32ᵛ, and the Battle between Hannibal and the Romans, fol. 42ʳ (fig. 34), include groups of horses with overlapping bodies, many equine legs, weapons clustered in parallel rows, and an organization predominantly parallel to the picture plane. The battle scenes in the *Spiegel historiael* and in the Egerton Genesis are also more graphic than those in some other manuscripts, such as Bodley 264 and the Queen Mary Psalter.

James noted that saddles with leg protectors are found mostly in examples from east of the Rhine.[51]

52. Fol. 8ᵛ, upper right: The four kings capture Lot and his possessions. (Genesis 14. 12, pl. XVIII)
DESCRIPTION: Hands behind his back as though bound, a bearded Lot walks toward the left, accompanied by a boy and by his herds of diminutive cattle and horses. Lot and the child wear short tunics, and the youth wears fringed leggings. Both turn back to look at the four mounted and armed kings who ride behind with their men-at-arms. The setting is a grassy strip.

Green is used in the grass, on the scabbard of the foremost king, and on the girth and reins of his horse. Vermilion red is used in the lining of his horse's caparison and in the starburst designs which decorate it, as well as at the edge of the saddle. Touches of red occur also at elbows and at the edges of helmets. The foremost horse is an intense white. Crowns are gold, as is the stirrup and spur of the foremost king; and there may be some touches of silver in the black of spearheads, helmets, *épaulières,* and elbow-guards.

COMMENTS: The child may have been included because the artist misread Genesis 14. 12: '*Tulerunt . . . necnon et Lot et substantiam eius, filium fratris Abram, qui habitabat in Sodomis*'. ('They took also Lot, the son of Abram's brother, who lived in Sodom, and his goods'.)

53. Fol. 8ᵛ, lower left: Messengers tell Abraham that Lot has been captured. (Genesis 14. 13, pl. XVIII)
DESCRIPTION: Two messengers who escaped tell Abraham about the capture of Lot. One, dressed in long garments, kneels before Abraham and gestures with his left hand toward the preceding scene of capture. A second fugitive, clad in a short tunic and leaning on a long staff, stands behind the first. His legs are thick. Both messengers are beardless with short, frizzy

hair. Abraham sits on the steps of his dwelling and wrings his hands in distress. His attitude is like that of Jacob viewing the bloodied coat of Joseph on fol. 18ᵛ, lower left. Behind him stands Sarah in the doorway of an elegant castle, not by the oaks of Mamre specified in the text. This building is like the castle on fol. 11ʳ (10ʳJ), upper half, from the doorway of which Abraham emerges to greet his three visitors. The setting is a grassy strip, much abraded.

The grass and the lining of the kneeling messenger's cloak are green. Vermilion lines Abraham's cloak. Sarah's kerchief is splotched with peachy pink, which also appears on some of the architectural elements, such as the corbelled bay windows above Abraham's head and on the first tier of battlements. Some roofs and the conical caps of the turrets are blue. Abraham's cloak and Sarah's kerchief are edged with a gold-wash line.

54. Fol. 8ᵛ, lower right: Abraham's forces defeat the four kings. (Genesis 14. 14–15, pl. XVIII)
DESCRIPTION: Mounted and heavily armed, Abraham's forces at left rout those of the four kings at right (fig. 35). The setting is a grassy field. Abraham demonstrates his prowess by simultaneously skewering two fleeing enemy soldiers with his lance. At Abraham's left a visored knight slices through the shield of an opponent and another knight decapitates an enemy. A fallen knight, trampled underfoot by the defeated forces, holds a shield in the form of a huge bearded face.

Colours are the much the same as those used in the preceding battle scene. Vermilion is especially striking in the linings of the flying caparisons of the horses at right. It appears also in the blood flowing from wounds, in the undergarments of several knights, in touches at elbows, and on a shield at left. A less intense rosy red colours a shield at right and the lining of the caparison of Abraham's horse. The grass is green, as are Abraham's saddle, his shield, and the caparison of his horse. Green also appears in a cloven shield and in the outer garment of a knight on the opposing side. Blue is used in one outer garment and two undergarments, in a gaunt, and on the helmets of several knights clustered on the right. Sienna and brown occur on horses' legs, and brown is used in some helmets. Weapons and a gaunt at left are silvered. Gold wash is used in the crowns of the fleeing kings and in Abraham's spur, stirrup, and reins.

COMMENTS: Like the battle scene in the upper left quadrant of this folio, this one is organised with multiple overlapping silhouettes of men and horses arranged parallel to the picture plane, many repetitive horses' legs, and many weapons grouped as repeated parallel lines. The same episode is depicted in the twelfth-century Mosan psalter fragment, fol. 1ᵛ.[52] There are a number of parallels between this scene and that in the Egerton Genesis, in the grouping of combatants and the arrangement of weapons.

Folio 9ʳ (Inscriptions resume on this folio and continue on 9ᵛ.)

55. Fol. 9ʳ, upper left: Abraham encounters the King of Sodom. (Genesis 14. 17, pl. XIX)
DESCRIPTION: Still dressed in his battle armour and accompanied by his knights, Abraham, at right, greets the King of Sodom, at left. The king wears simple court attire and removes his

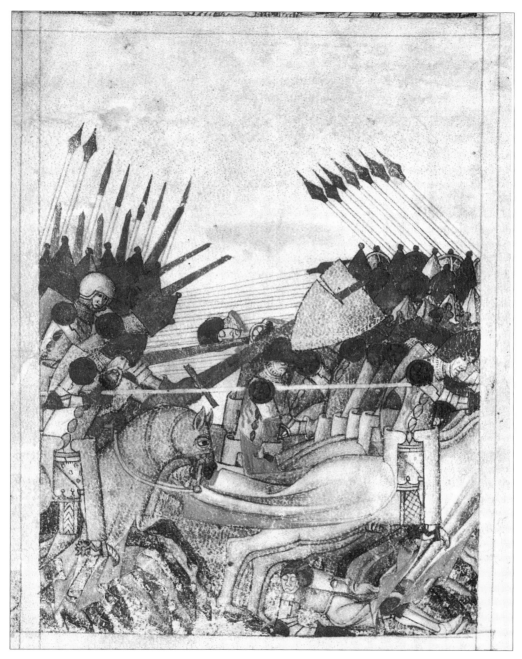

FIG. 35: Egerton Genesis. London, British Library, Egerton MS 1894, fol. 8ᵛ, lower right: Abraham's forces defeat the four kings. (Photo: British Library, London)

crown in a gesture of respect. His horse seems to bow to Abraham's mount. He is accompa-
nied by four beardless men with short, fuzzy hair, almost African in appearance.

The setting is an abraded, wavy strip of grass seemingly articulated with black and white
vertical strokes over green wash. Green is used in Abraham's saddle and in the caparison of his
horse. His reins and the lining of the caparison are orange. The bridle, reins, and stirrup of the
King of Sodom's horse are a rosy plum. Helmets are greyish sienna and blue. Gold wash is
used on Abraham's spur and stirrup, on the spur and crown of the King of Sodom, and as a
line edging his short cape.

56. Fol. 9ʳ, upper right: Abraham and Melchisedek (Genesis 14. 18–20, pl. XIX)
DESCRIPTION: Still dressed in his battle armour, Abraham kneels at the centre of a grassy
strip and extends his veiled hands to receive the elements of the Eucharist from Melchisedek
(fig. 36). The cloth between Abraham's arms is full of coins, the tithe mentioned in Genesis 14.
20. Melchisedek, on horseback, is both tonsured priest and king. He carries his crown like a
large bracelet over his right arm as he bends forward to extend the bread and wine to
Abraham. His retinue includes at least four men. Still barefooted and wearing the short tunic

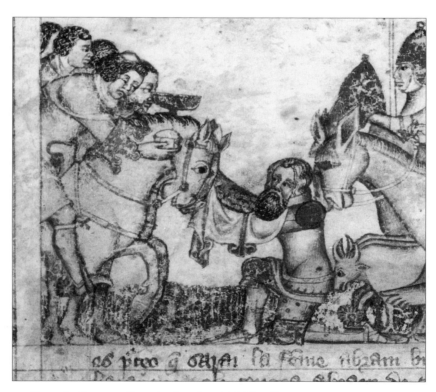

FIG. 36: Egerton Genesis. London, British Library, Egerton MS 1894,
fol. 9ʳ, upper right: Abraham and Melchisedek (Photo: British Library,
London)

of his capture, Lot sits behind Abraham holding the reins of his uncle's horse. A helmeted squire on a mount beside Lot holds Abraham's helmet and spear. The helmets and spears of the additional knights are visible behind Lot and the squire. The herds, moving forward among the mounted men, are an integral part of Abraham's contingent.

The grass and the caparison of Abraham's horse are green. The caparison is lined with orange-brown, and the reins of Abraham's horse, which Lot holds, are a rosy plum. Helmets are an opaque greyish sienna, perhaps with some silver and blue; and the reins and bridle of Melchisedek's horse are orange. The chalice, crown, and coins are gold wash.

COMMENTS: The juxtaposition of Abraham's gold coins with the Eucharistic bread and wine is striking. The artist would seem to be aware that receiving the sacred elements often involved a considerable outlay on the part of the communicant in the Church of his day. The scene may also refer to the paying of the tithe, to which there was an increased resistance in the fourteenth century.[53] The artist was probably acquainted with the *Somme le Roi* which was widely read in France and England and was particularly popular in the Low Countries. The sin of buying and selling the Eucharist is designated as among the greatest of the deadly sins in this moralising work.[54]

The motif of the crown held like a bracelet is found elsewhere, not in scenes of Abraham and Melchisedek but in scenes of the Adoration of the Magi. Examples may be found in two Fenland manuscripts, the Peterborough Psalter in Brussels (Bibliothèque Royale Albert 1er, MS 9961–62, fol. 12ʳ), and the Barlow Psalter (Oxford, Bodleian Library, MS Barlow 22, fol. 12ᵛ).[55]

Abraham's armour features a plate-metal collar and a skirted jupon, features which link it to the Hastings Brass in Elsing, Norfolk, of 1347.

57. Fol. 9ʳ, lower left: God's second promise of an heir to Abraham (Genesis 15. 1, pl. XIX)
DESCRIPTION: Though kneeling in the scene of the first promise on fol. 8ʳ, upper right, here Abraham is seated in a pose with classical associations. He holds both hands to his head; the left hand, in a beautifully foreshortened side view, shields his eyes from the vision of God, whose face, left arm, and gesturing hand emerge from a six-tiered notched and scalloped cloud in the upper right corner of the image.

A grassy setting is articulated as a green wash overlaid with black vertical strokes in a diagonally oriented grid pattern, much as in the scenes on fol. 4ᵛ. Abraham's cloak is lined with an orangish red of medium intensity. The pleats of the cloak fanning out below the figure are touched with a similar or slightly browner colour. The right sleeve also has a brownish splotch. God's face and hands are white, and his sleeve is an intense blue. The tiers of the cloud are alternately purplish red and greyish blue. A gold-wash line edges God's sleeve and Abraham's sleeves and cloak.

COMMENTS: This minimal image, explicable by a single verse, Genesis 15. 1, has a lengthy inscription which gives far more information than the image demands. The pose of Abraham

Fig. 37: Decretals of Gregory IX. Vatican City, Biblioteca Apostolica Vaticana, MS
Vat. lat. 1389, fol. 4ʳ, miniature: Adoration of the Trinity, above; scenes from the
life of a hermit, below (Photo: Biblioteca Apostolica Vaticana, Vatican City)

may be derived from images in Bolognese manuscripts, such as the seated hermit in the border in a Decretals of Gregory IX of the late 1330s or 1340s, Vatican City, Biblioteca Apostolica Vaticana, MS Vat. lat. 1389, fol. 4ʳ (fig. 37).[56]

58. Fol. 9ʳ, lower right: Sarah gives Hagar to Abraham. (Genesis 16. 1–2, pl. XIX)
DESCRIPTION: Sarah, depicted in a three-quarters back view with face in profile, looks at Abraham; both gesture toward Hagar, who stands apart at right. Abraham's expression, pose, and gesture communicate some diffidence, as though he foresees trouble from the suggested arrangement. Hagar seems ambivalent. Sarah wears the kerchief of the married woman while Hagar is bareheaded with circumferential braids. The setting is a grassy strip, now almost obliterated.

Abraham's cloak is lined with orange; a similar colour is applied to Sarah's kerchief. Her cloak is lined with green. A gold-wash line edges the cloaks of Abraham and Sarah and the necks of their robes. Hagar's figure is entirely in grisaille.

Folio 9ᵛ

59. Fol. 9ᵛ, upper left: Sarah treats Hagar harshly. (Genesis 16. 6, pl. XX)
DESCRIPTION: Sarah strikes at Hagar with the pointed end of her distaff; and Hagar, bending away from her mistress while looking back at her, raises her arms to protest and to protect herself. The faces express anger and fear. Names are inscribed 'in a late hand' above the two figures.[57]

The setting is a green-washed grassy strip, overlaid with vertical white strokes in three rows. Sarah's kerchief is completely coloured with an opaque peachy brown. The same colour appears on her right sleeve and in strips at the edges of the pleats of her skirt. The wool on her spindle is a peachy orange, bound with a plum-coloured cord. Her face has touches of both peachy brown and peachy orange. Hagar's face and dress are touched with a few spots of orange. A gold-wash line edges Sarah's kerchief and the neck of her dress.

COMMENTS: Sarah and Hagar are here clearly comic characters, perhaps with connections to the drama. The twelfth-century Mosan Psalter fragment in Berlin, fol. 2ᵛ, depicts Sarah beating a fallen Hagar with a rod as Abraham watches passively.[58] In the Isabella Psalter, fol. 26ᵛ, bas-de-page, Sarah, brandishing a long rod, threatens Hagar, who raises her hands in self-defense.

60. Fol. 9ᵛ, upper right: The angel speaks to Hagar in the wilderness. (Genesis 16. 7–12, pl. XX)
DESCRIPTION: Hagar, clad and coiffed as in the two previous scenes, prays with clasped hands, an agonised expression on her face. In the upper right corner, the head, forearm, and wings of an angel appear from a five-tiered notched and scalloped cloud. At Hagar's feet is the spring of water on the way to Shur, mentioned in Genesis 16. 7. The spring, seen in tilted perspective, issues from a grassy mound on which grow two trees with lopped branches, the

larger of the two with a knothole in its base. The smaller tree bends, as if in sympathy, toward Hagar.

Trees are of the traditional northern type, with heart-shaped leaves drawn in black over a green foliage ball. Grass immediately to the left and right of Hagar is articulated as a green wash with an overlay of white vertical strokes. Around the spring and trees the articulation changes to a diagonal grid or zigzag pattern of black strokes, now greatly rubbed, over green wash. The tiers of the cloud are alternately greyish blue and purplish red. An intense blue colours the angel's sleeve; silver, his face. Wings are gold wash with red stripes. The figure of Hagar is entirely in grisaille.

COMMENTS: The text, which contains far more information than the image requires, is fitted around the cloud and the angel. In the Paduan Bible in Rovigo, fol. 9ᵛ, upper right, Hagar encounters the angel at a well, rendered in tilted perspective and located on a tree-shaded hillside, as in the Egerton Genesis. The gestures and positions of Hagar and the angel are somewhat comparable in the two manuscripts.

61. Fol. 9ᵛ, lower left: God's third promise of an heir to Abraham (Genesis 17. 1–21, pl. XX)
DESCRIPTION: Abraham reclines face down on a grassy slope before God, whose face, forearm, and hand appear from a five-tiered cloud above. His posture reflects Genesis 17. 17, which in the Vulgate says '*cecedit Abraham in faciem suam*'. His countenance expresses not the laughter mentioned in the text, but rather concern or remonstrance.

Abraham's cloak is lined with a slightly orangish red of medium intensity, and his face is touched with the same colour. His cloak is splotched with a peachy orange and is edged with a gold-wash line. His right hand has a spot of grey or silver. Grass, much abraded, is a green wash overlaid with black strokes, apparently in a zigzag pattern. God's face and hand are orange, overlaid with some silver. His nimbus has an orange cross on a cerulean blue background, and his garment is of the same blue, with a gold-wash line edging the sleeve. The tiers of the cloud are alternately blue and red, in the same shades as in the cloud of the preceding miniature.

COMMENTS: Three of the four images on this page, and three on the preceding page, relate to the theme of agreements between God and humanity or between human beings. Perhaps this theme, which is sounded many times in the iconography of the Egerton Genesis, reflects in some respect the interests or *métier* of the patron.

62. Fol. 9ᵛ, lower right: Abraham and the men of his household are circumcised. (Genesis 17. 23–27, pl. XX)
DESCRIPTION: Abraham sits at left and parts his skirt, exposing his large sexual organs. His mouth is pursed as he watches a curly-headed servant circumcise him, performing the operation over a pan which catches the blood. In the centre and at right two more men with short fuzzy hair pull back their skirts; the figure in the centre is shown with strongly foreshortened

head. The man at right is, like Abraham, under the knife, and his face registers a grimace. A small figure beside him addresses him with a look of inquiry or comfort. The setting is a patch of grass.

Colour is minimal in this scene. Grass is green wash overlaid with strokes of white, still visible at right. There are orange splotches on the faces and garments of several figures. A thread of bright red blood emerges from the wounds inflicted by the circumcising knives. Abraham's garment is edged, not with gold wash but with a white line. Curiously, the gold-wash line is reserved for the skirt of the servant who circumcises the patriarch.

COMMENTS: The artist plays up the circumcision scene as an almost grotesquely comic interlude, complete with large sexual organs, bloody knives, woeful expressions, and much peering and poking. It is difficult to find comparable treatment of this rarely illustrated scene in medieval Genesis iconography. The scene is elsewhere depicted with reserve, as in the Millstatt Genesis, fol. 27r, where Abraham's genitals are only suggested below a fold of his parted skirt.

In the Paduan Bible in Rovigo this scene is rendered as two episodes, both treating the material with more restraint than does the Egerton Genesis. On fol. 9v, lower right, Abraham discreetly circumcises himself alone, behind a shed. On fol. 10r, upper left, Abraham circumcises the men of his household, who sit quietly in chairs or stools arranged in a semicircle. Several have skirts parted to reveal their genitals, of unremarkable size. In the *Omne Bonum*, fol. 3r, lower left, Abraham reclines nude on an altar; the knife is visible, but his genitals are not. One antecedent for a seemingly unnecessary emphasis on genitalia in a biblical scene can be found in the miniature of the creation of Eve in the Flemish *Spiegel historiael*, fol. 4v (fig. 18); here the slumbering Adam is depicted with large sexual organs clearly in view.

Folio 11r (10rJ).
(The last two inscriptions of the manuscripts are on the two upper scenes of the recto.)

DESCRIPTION: *63. Fol. 11r (10rJ), upper left: Abraham receives the three heavenly visitors. (Genesis 18. 1–3, pl. XXI)*
Abraham, with Sarah behind him, crouches at the entrance of a castle-like structure, which closely resembles the one on fol. 8v, lower left. The architecture features two tiers of windowed walls, the first crenellated, which enclose three roofed structures with cylindrical chimneys. The oven-like structure at left foreground is repeated directly above. The entryway is crowned by a cantilevered square tower with pitched roof in two storeys. Water flows from a vaulted culvert in the masonry balustrade beside Abraham. With extended hands, the left larger than the right, the patriarch humbly invites his visitors to stay. The visitors are without wings, though the first has a cross nimbus. His beard is white, his ears or curled locks strangely shaped. The second visitor has a short beard with a longer mustache; the third has a stubbly beard and short hair. First and second visitors point to Abraham with identical gestures—crooked wrists, pointing index fingers, other fingers curled.

A tree with lopped branches and green foliage ball is beside the doorway, and blue grass can be seen between the building and the visitors and around the feet of the latter. Except for the colour applied to the tree and grass, the scene is in grisaille.

COMMENTS: Medieval vaulted culverts, for water supply or drains, have been excavated in Norwich.[59] On this folio and on the next three, all grass is blue instead of green. Blue grass appeared earlier on fol. 1ᵛ, lower right. This page appears less finished than preceding ones in several respects. Grass and foliage are wash only, without the overlay of detailing in black and white which articulates blades of grass and leaves on the preceding folios. Black ink is not applied to the openings of all windows and doorways, as it is on fol. 8ᵛ, lower left, or in the architecture of the Tower of Babel on fols 5ᵛ and 6ʳ. These economies in execution would suggest that either time or money was at a premium.

64. Fol. 11ʳ (10ʳJ), upper right: The three heavenly visitors dine and promise a son to Abraham and Sarah. (Genesis 18. 8–10, pl. XXI)
DESCRIPTION: The three visitors are seated at a table draped with a cloth. On the table are a chalice, a bowl with scalloped interior, two triangular objects (the cakes mentioned in Genesis 18. 6?), and a rectangular object resembling a small codex. Both the visitor with cross nimbus, seated in the centre, and the visitor on the left point toward Abraham, standing at left. The third visitor, here with longer hair and without the stubbly beard of the preceding scene, drinks from a bowl; he appears oblivious of his companion's announcement. Abraham points back over his shoulder toward Sarah, who is listening in the doorway; less of the building is visible than in the scene at left. A servant crouches on all fours in front of the table, blowing on and poking at a fire beneath a cooking pot supported on a tripod stand. The central visitor's brooch resembles those on fols 2ʳ, 7ʳ and 7ᵛ, not the elaborate morse of the Creator on fol. 1. Colour is applied much as in the scene preceding.

COMMENTS: Peter Comestor mentions a divine spokesman, here the figure in the centre. Cooking pots supported on tripods are very commonly depicted in manuscripts of the first half of the fourteenth century, but the motif of a man blowing on the fire beneath a pot is less common. One such a vignette occurs in Gl kgl. Saml. 3384,8° on fol. 18ᵛ in the lower margin, where a figural line-ending blows through a tube onto a fire beneath a cooking pot supported on a tripod (fig. 38).

65. Fol. 11ʳ (10ʳJ), lower half: Abraham intercedes for Sodom and the angels encounter Lot. (Genesis 18. 22–19. 3, pl. XXI)
DESCRIPTION: This half-page scene includes four episodes. (1) At right, below, Abraham converses with God, depicted as in the scene above with cross nimbus and cloak pinned with a brooch. His left hand on the shoulder of the divine figure, Abraham beseeches him to spare Sodom, toward which God points with his right hand. (2) In the centre, Lot bows before two angels with tight short curls and magnificent feathered wings; he clutches their robes with one

THE PLATES

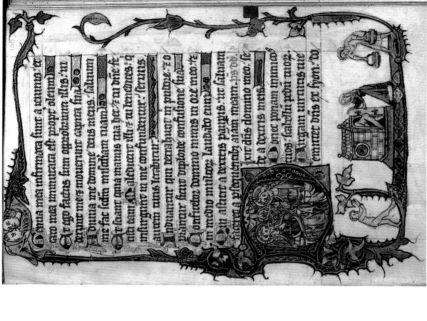

PLATE I: a. Psalter. The Hague, Koninklijke Bibliotheek, MS 135 E 15, fol. 147ʳ: Initial D for Psalm 101, with David at prayer (Photo: Koninklijke Bibliotheek, The Hague. Copyright: Koninklijke Bibliotheek, The Hague)

b. Psalter-hours. Baltimore, Walters Art Gallery, MS W. 82, fol. 100ʳ: Psalm 109 (Photo: Walters Art Gallery, Baltimore)

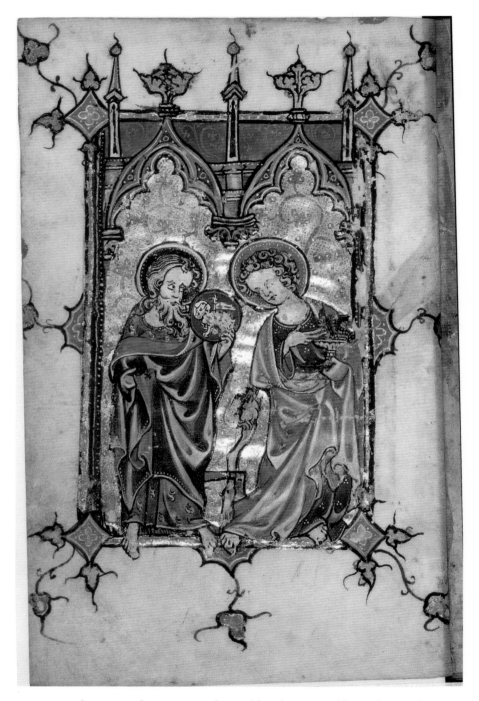

PLATE II: Psalter. Copenhagen, Kongelige Bibliotek, Gammel kongelig Samling, MS 3384,8°, fol. 3ᵛ: St John the Baptist and St John the Evangelist (Photo: Kongelige Bibliotek, Copenhagen)

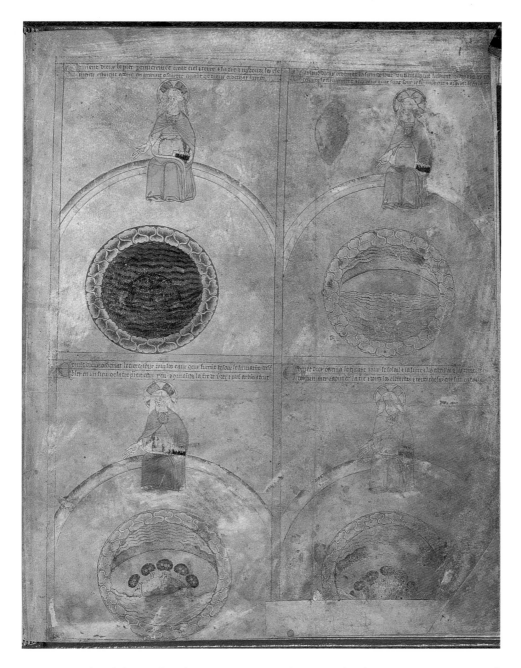

PLATE III: Fol. 1^r (Photos for Plates III–XLII: London, British Library, Egerton MS 1894)

 1. Upper left: First day of Creation

 2. Upper right: Second day of Creation

 3. Lower left: Third day of Creation

 4. Lower right: Fourth day of Creation

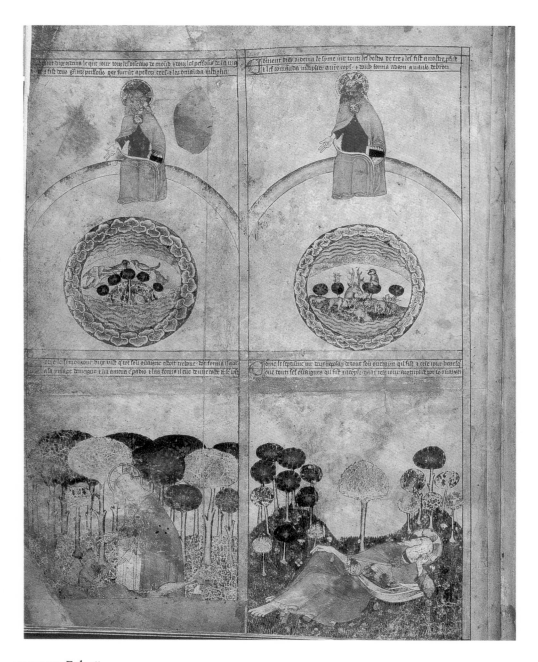

PLATE IV: Fol. I^v

5. Upper left: Fifth day of Creation
6. Upper right: Sixth day of Creation
7. Lower left: Sixth day of Creation
8. Lower right: Seventh day of Creation

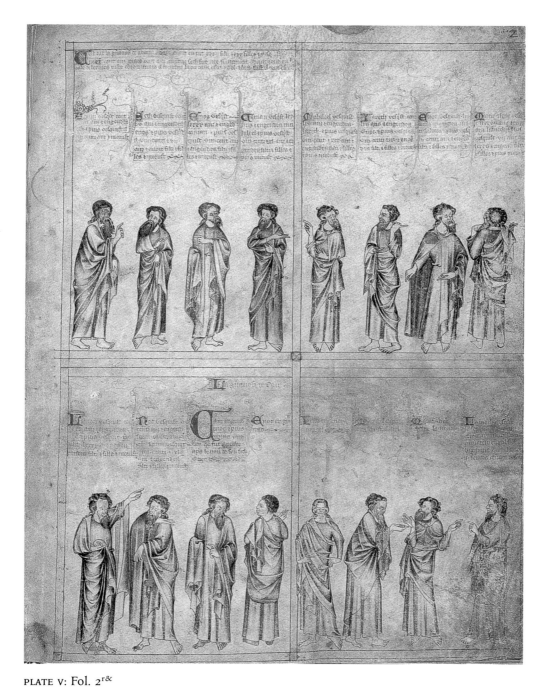

9–12. All quadrants: Descendants of Adam

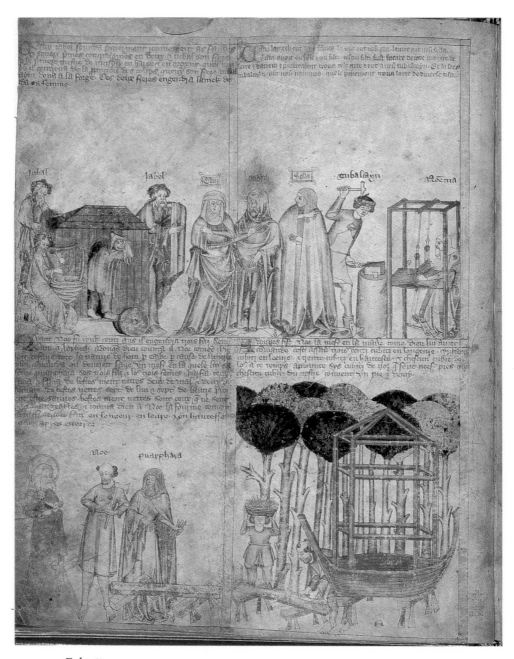

PLATE VI: Fol. 2ᵛ

 13. Upper register: Lamech with his two wives and children

 14. Lower left: God commands Noah to build the ark

 15. Lower right: The construction of the ark

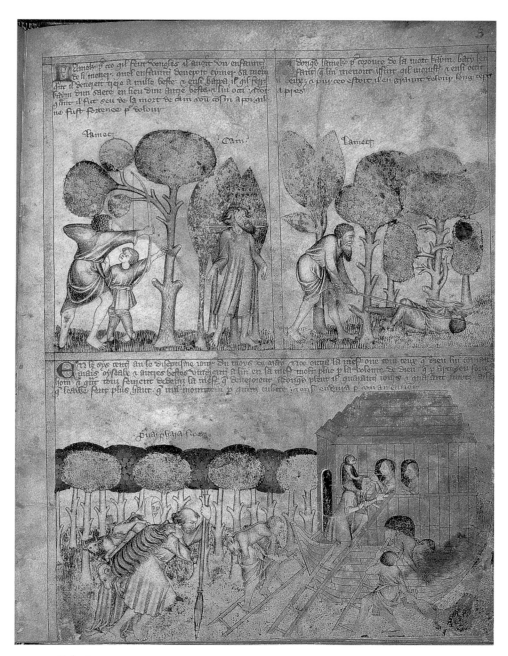

PLATE VII: Fol. 3ʳ

 16. Upper left: Death of Cain

 17. Upper right: Death of the boy guide

 18. Lower register: The embarkation

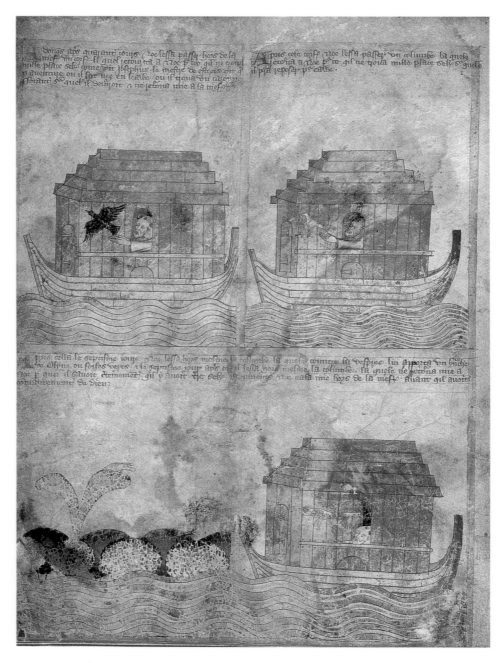

PLATE VIII: Fol. 3v

19. Upper left: Noah releases the raven

20. Upper right: Noah releases the dove

21. Lower register: The dove plucks an olive branch and returns after the second release

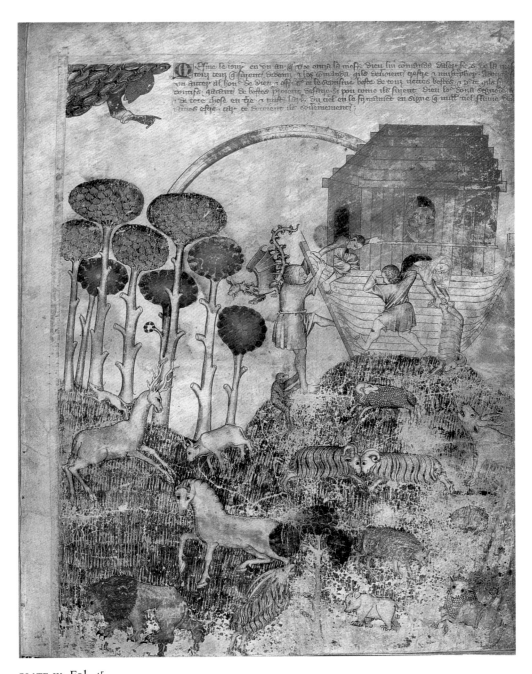

22. The debarkation, the delight of the animals, and the rainbow

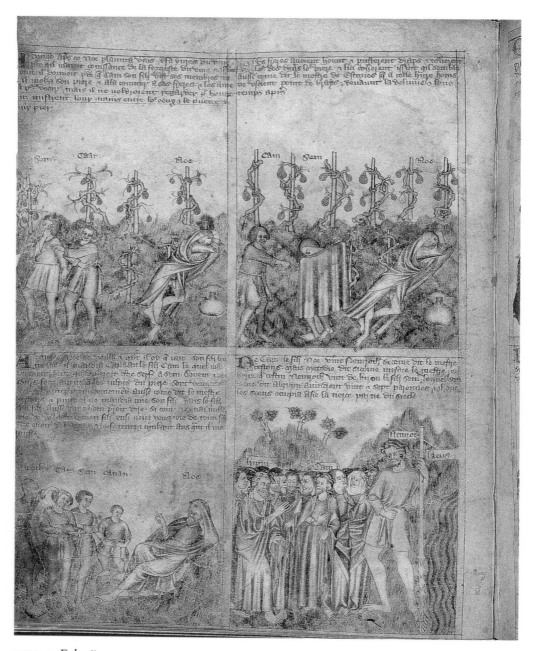

PLATE X: Fol. 4ᵛ

23. Upper left: Ham sees the nakedness of the drunken Noah
24. Upper right: Shem covers Noah
25. Lower left: Noah curses Canaan
26. Lower right: The ancestry of Nimrod

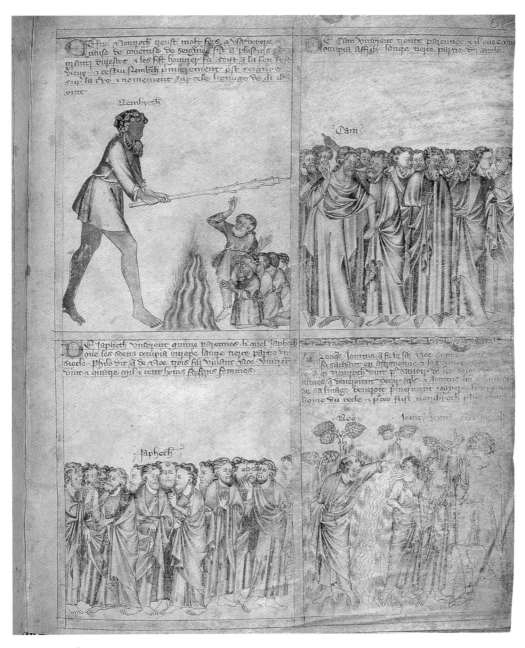

PLATE XI: Fol. 5 ʳ

27. Upper left: Nimrod forces the people to worship fire

28. Upper right: Descendants of Ham

29. Lower left: Descendants of Japheth

30. Lower right: Jonitus, son of Noah, instructs Nimrod

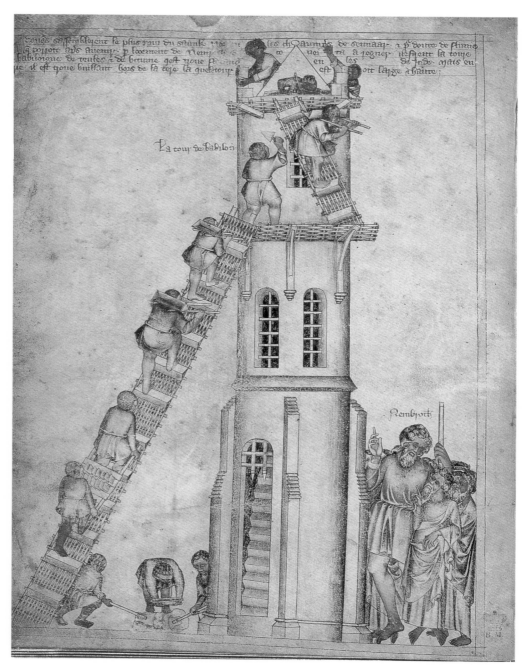

PLATE XII: Fol. 5ᵛ31.

Building of the Tower of Babel

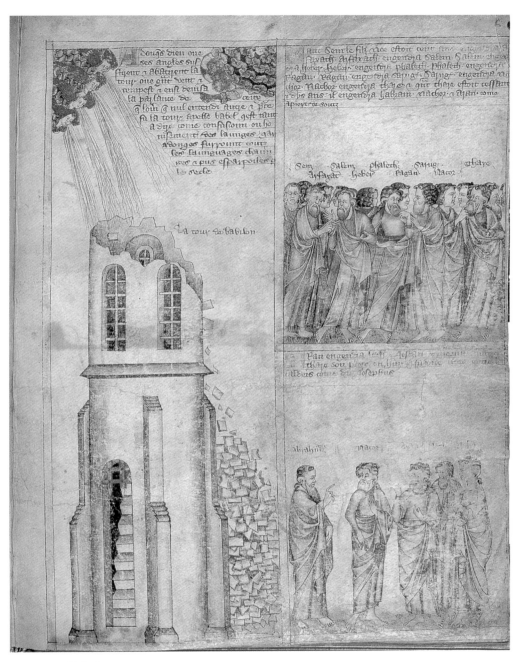

PLATE XIII: Fol. 6ʳ

32. Left: Destruction of the Tower of Babel

33. Upper right: Descendants of Shem

34. Lower right: Abraham, his brothers and nephews

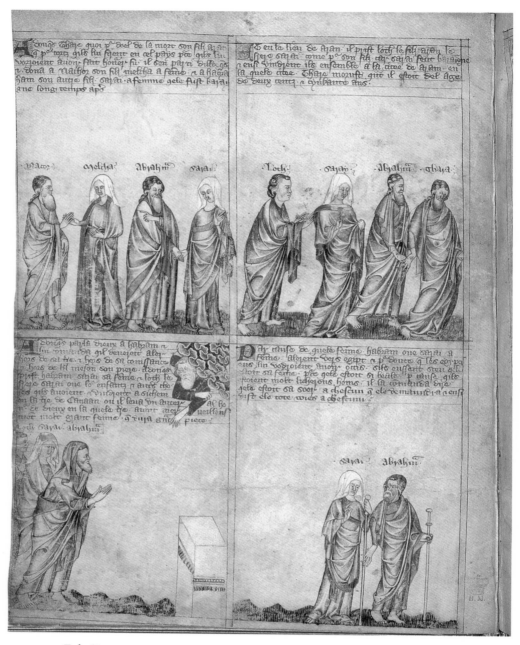

PLATE XIV: Fol. 6ᵛ

35. Upper left: The marriage of Nahor and Milcah and of Abraham and Sarah

36. Upper right: Terah, Abraham, Sarah, and Lot journey to Harran

37. Lower left: God appears to Abraham at Shechem

38. Lower right: Abraham and Sarah journey toward Egypt

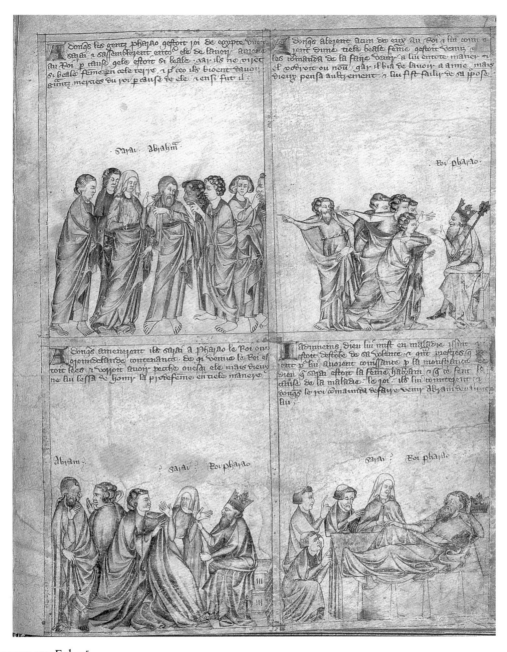

PLATE XV: Fol. 7r

39. Upper left: Pharaoh's courtiers discover Sarah

40. Upper right: The courtiers tell Pharaoh about Sarah

41. Lower left: Sarah is brought before Pharaoh

42. Lower right: Pharaoh is stricken with illness

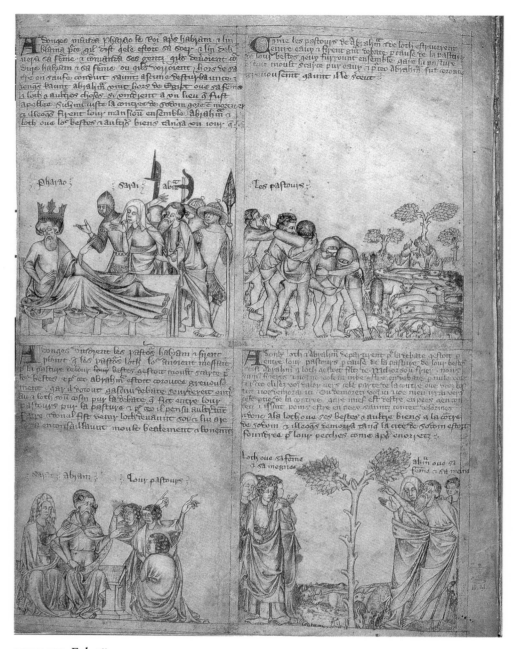

PLATE XVI: Fol. 7ᵛ

43. Upper left: Pharaoh tells Abraham to leave Egypt

44. Upper right: Abraham's herdsmen fight with those of Lot

45. Lower left: Abraham's herdsmen report to him

46. Lower right: The parting of Abraham and Lot, scene 1

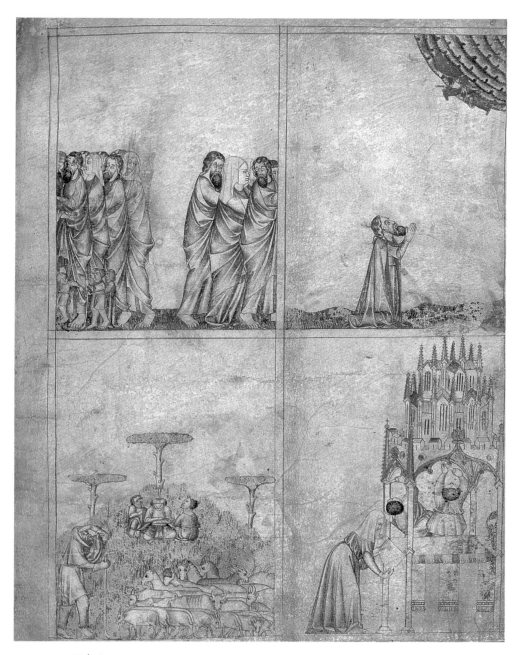

PLATE XVII: Fol. 8ʳ

> 47. Upper left: The parting of Abraham and Lot, scene 2
> 48. Upper right: God promises the land to Abraham and his descendants
> 49. Lower left: Abraham walks the land and views the stars
> 50. Lower right: Abraham and Sarah build the altar at Hebron

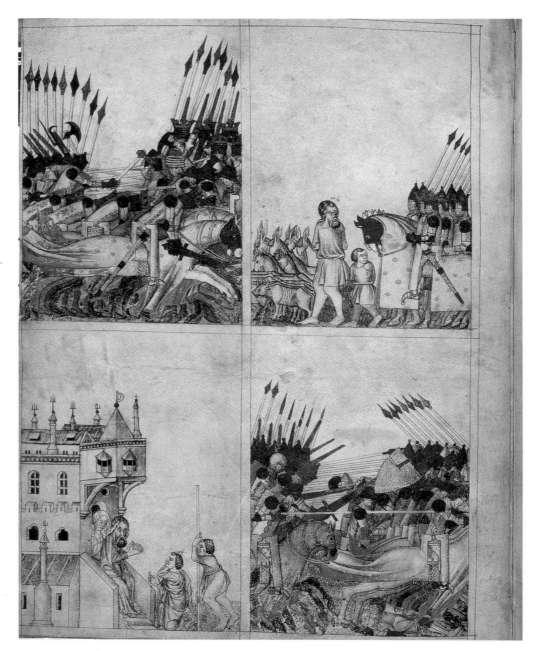

PLATE XVIII: Fol. 8ᵛ

 51. Upper left: The battle between the four kings and the five kings

 52. Upper right: The four kings capture Lot and his possessions

 53. Lower left: Messengers tell Abraham that Lot has been captured

 54. Lower right: Abraham's forces defeat the four kings

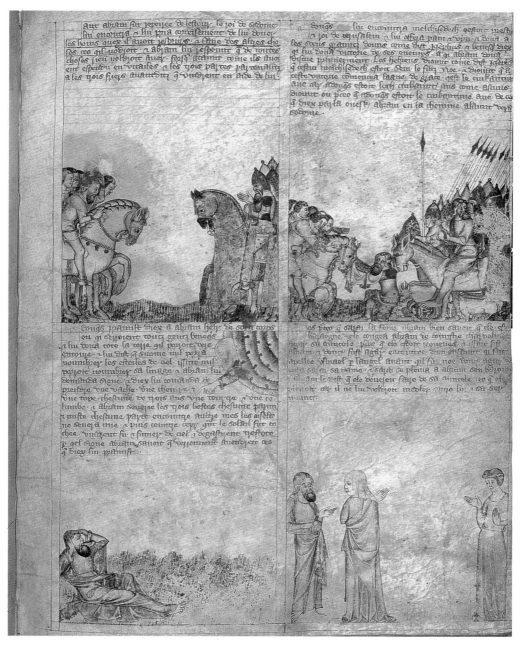

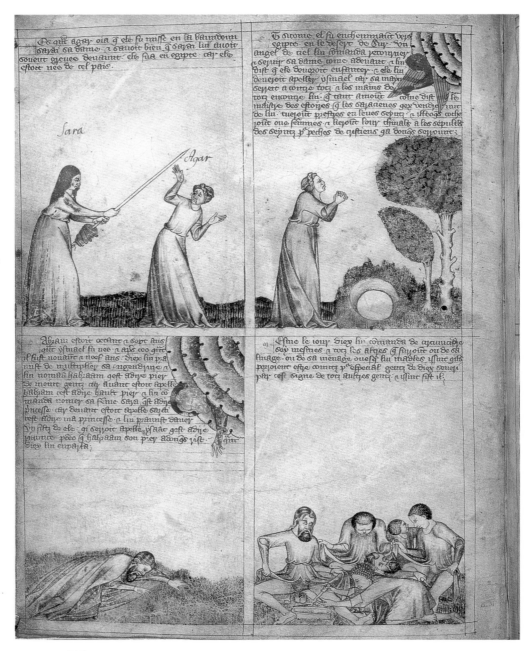

PLATE XX: Fol. 9ᵛ

 59. Upper left: Sarah treats Hagar harshly

 60. Upper right: The angel speaks to Hagar in the wilderness

 61. Lower left: God's third promise of an heir to Abraham

 62. Lower right: Abraham and the men of his household are circumcised

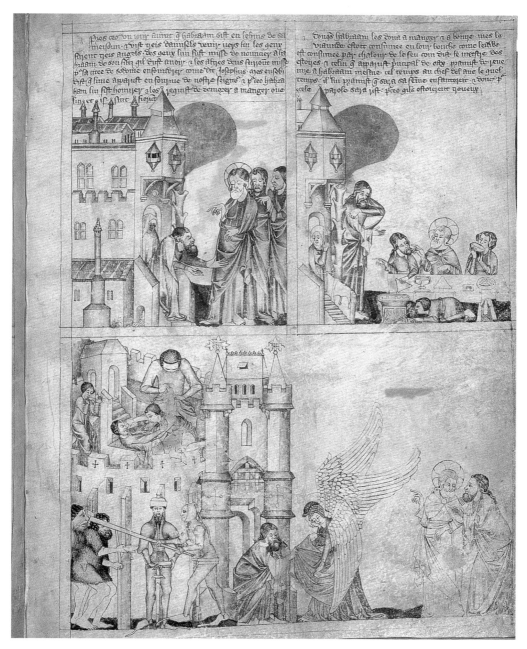

PLATE XXI: Fol. 11ʳ (10ʳJ)

> 63. Upper left: Abraham receives the three heavenly visitors
> 64. Upper right: The three heavenly visitors dine and promise a son to Abraham and Sarah
> 65. Lower half: Abraham intercedes for Sodom and the angels encounter Lot

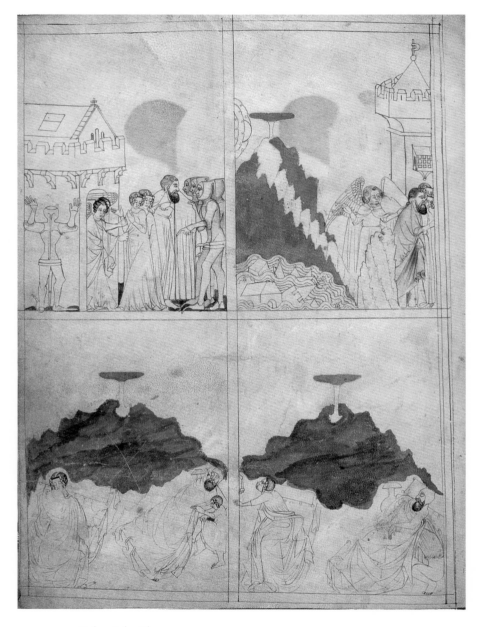

PLATE XXII: Fol. 11ᵛ (10ᵛJ)

66. Upper left: Lot offers his daughters to the Sodomites. The Sodomites are struck blind

67. Upper right: Sodom is destroyed. Lot and his daughters flee to Zoar. Lot's wife becomes a pillar of salt

68. Lower left: Lot's older daughter enters his bed

69. Lower right: Lot's younger daughter disrobes and enters his bed

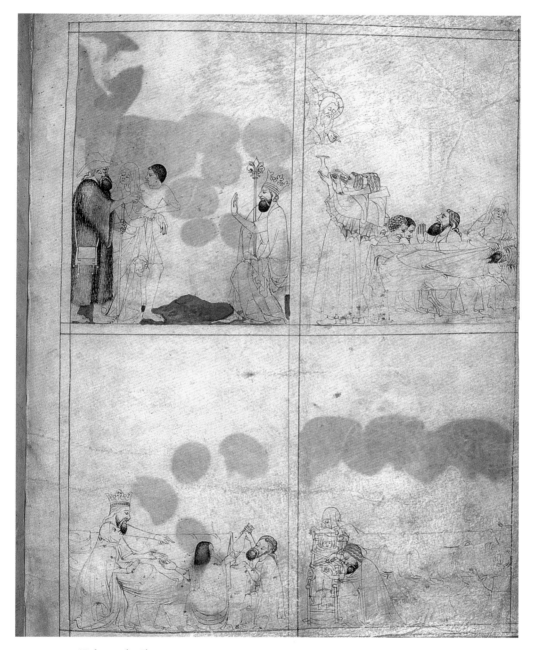

PLATE XXIII: Fol. 10ʳ (11ʳJ)

 70. Upper left: Sarah is brought before Abimelech.

 71. Upper right: Abimelech languishes.

 72. Lower left: Abimelech dismisses Abraham and Sarah.

 73. Lower right: Isaac is circumcised.

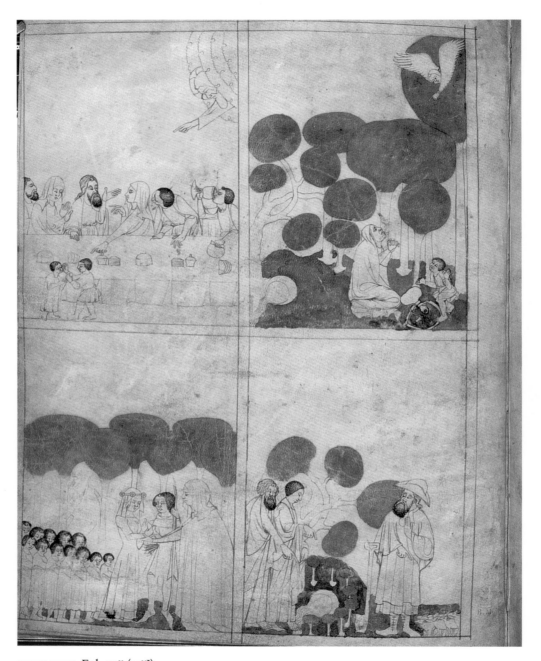

PLATE XXIV: Fol. 10ᵛ (11ᵛJ)

74. Upper left: Ishmael attacks Isaac at the feast for the weaning of Isaac
75. Upper right: Hagar and Ishmael encounter the angel in the wilderness
76. Lower left: The marriage of Ishmael
77. Lower right: The agreement between Abraham and Abimelech

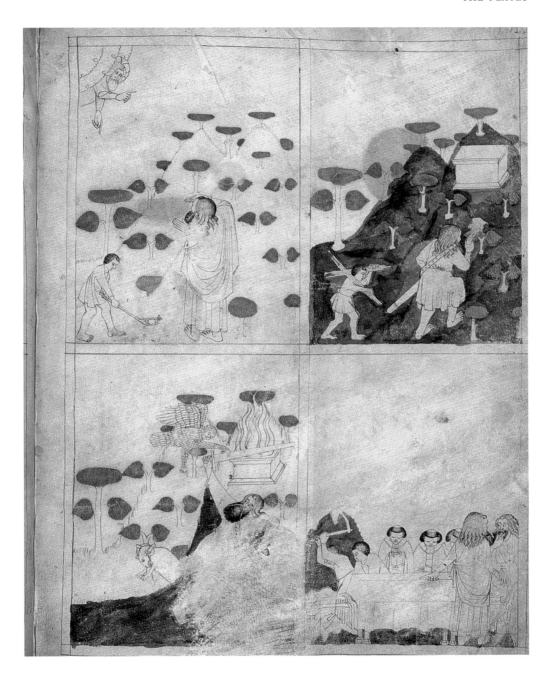

PLATE XXV: Fol. 13r (12rJ)

 78. Upper left: God commands Abraham to sacrifice Isaac

 79. Upper right: Abraham and Isaac ascend the mountain

 80. Lower left: The angel halts the sacrifice of Isaac

 81. Lower right: The burial of Sarah

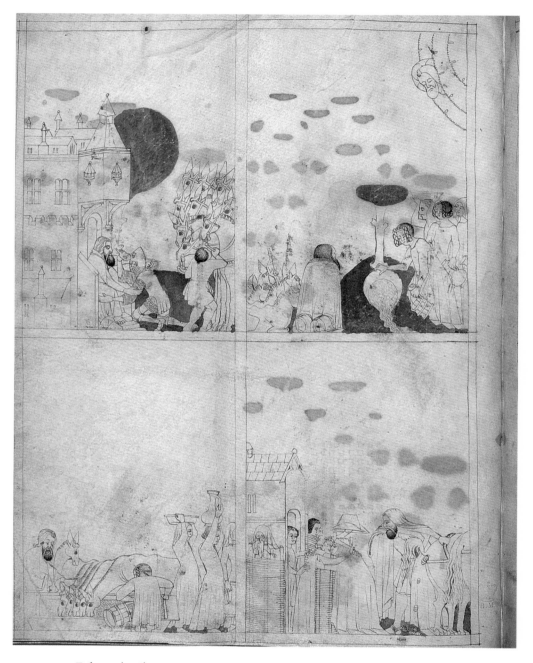

PLATE XXVI: Fol. 13ᵛ (12ᵛJ)

82. Upper left: Abraham's servant is commissioned to seek a wife for Isaac

83. Upper right: Abraham's servant meets Rebecca at the well

84. Lower left: Rebecca waters the camels of Abraham's servant

85. Lower right: Rebecca takes leave of her family

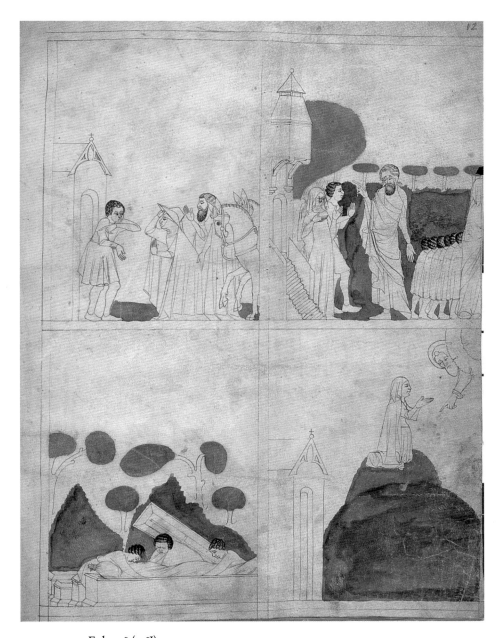

PLATE XXVII: Fol. 12ʳ (13ʳ])
 86. Upper left: Abraham's servant presents Rebecca to Isaac
 87. Upper right: Abraham welcomes Isaac and Rebecca while exiling Keturah and her children
 88. Lower left: The burial of Abraham
 89. Lower right: Rebecca consults God

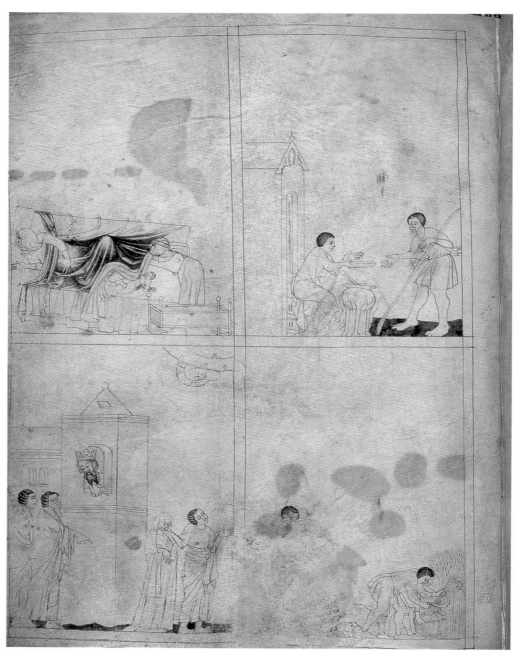

PLATE XXVIII: Fol. 12ᵛ (13ᵛJ)

90. Upper left: The birth of Esau and Jacob

91. Upper right: Esau sells his birthright

92. Lower left: Abimelech sees Isaac caressing Rebecca

93. Lower right: Isaac prospers

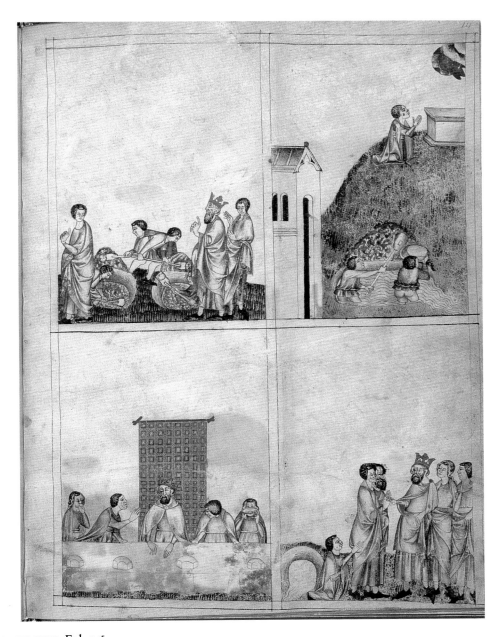

PLATE XXIX: Fol. 14ʳ

94. Upper left: Isaac's conflict with the Philistines over the wells, his subsequent alliance with Abimelech

95. Upper right: Isaac is told of his future descendants; a well is excavated

96. Lower left: Isaac's feast for Abimelech

97. Lower right: The oath between Isaac and Abimelech and the discovery of water at Beersheba

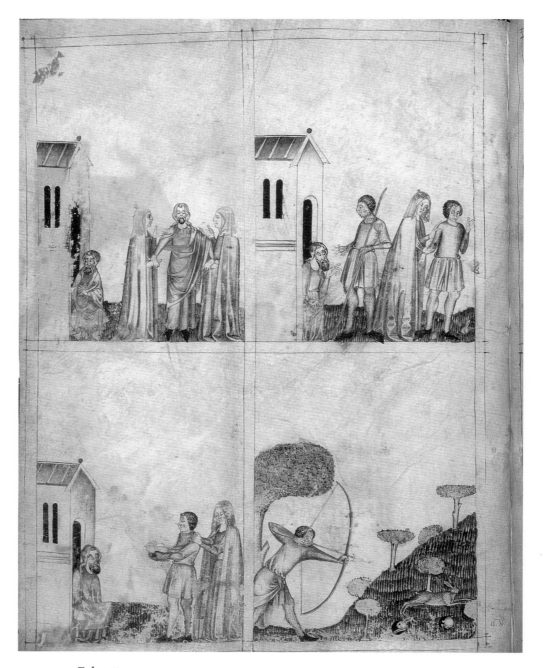

PLATE XXX: Fol. 14ᵛ

 98. Upper left: Esau's Hittite wives

 99. Upper right: Esau is sent to hunt game

 100. Lower left: Jacob approaches Isaac for the blessing

 101. Lower right: Esau hunting

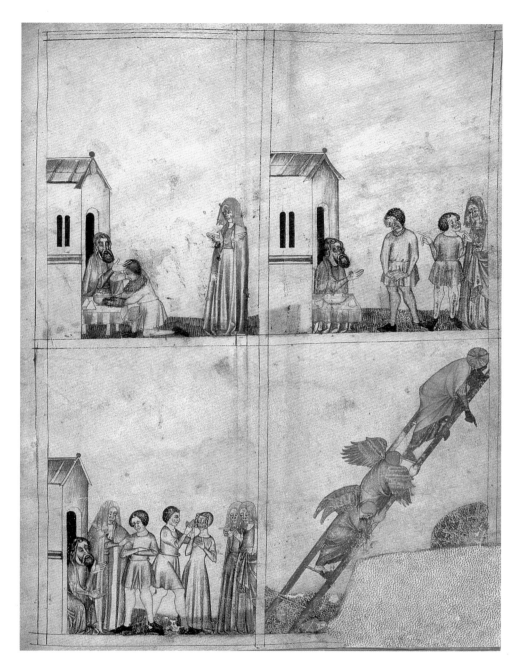

PLATE XXXI: Fol. 15ʳ

 102. Upper left: Jacob receives his father's blessing

 103. Upper right: Isaac refuses to bless Esau

 104. Lower left: Isaac sends Jacob to Paddan-aram; Esau marries Mahalath

 105. Lower right: Jacob's ladder

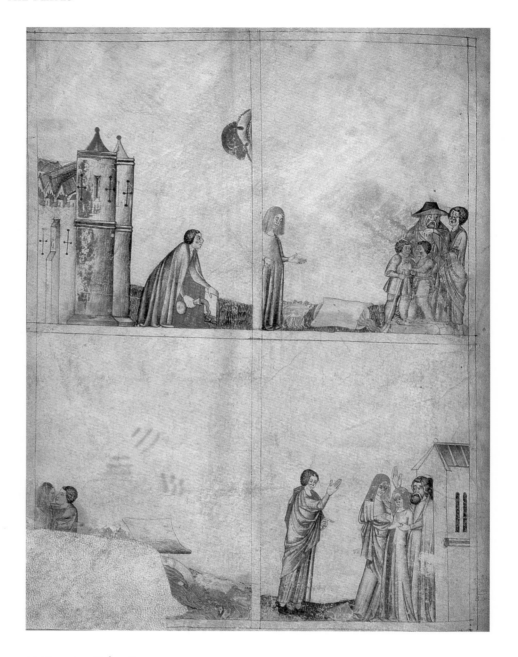

PLATE XXXII: Fol. 15ᵛ

 106. Upper left: Jacob anoints the stone used for a pillow in the dream of the ladder

 107. Upper right: Jacob at the well; Rachel's approach

 108. Lower left: Jacob greets Rachel

 109. Lower right: Jacob at Laban's house

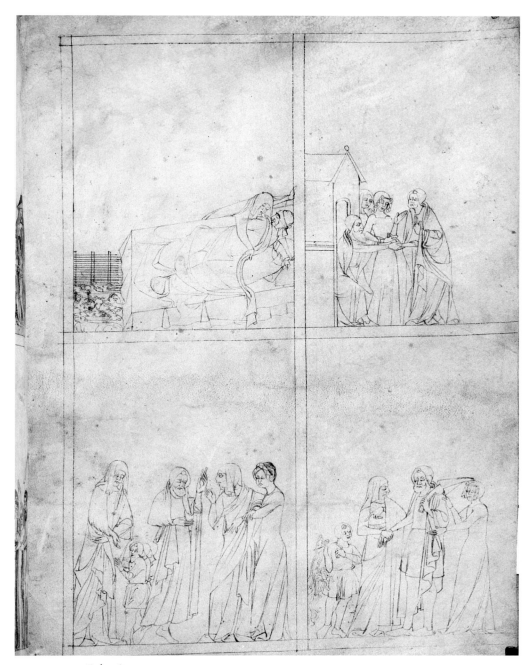

PLATE XXXIII: Fol. 16ʳ

 110. Upper left: The Deception of Jacob with Leah

 111. Upper right: Rachel is given to Jacob

 112. Lower left: Rachel presents Bilhah to Jacob

 113. Lower right: Rachel, Leah, Jacob, and the mandrakes

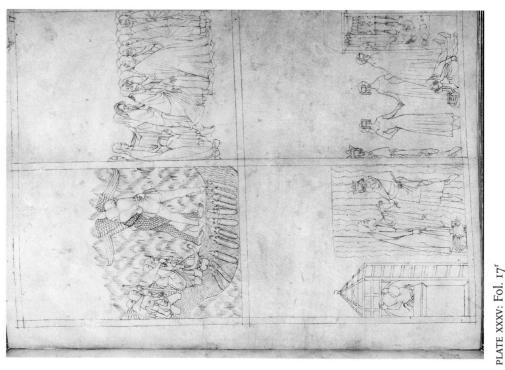
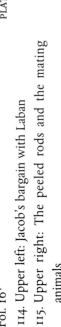

PLATE XXXV: Fol. 17ᵣ

118. Upper left: Jacob wrestles with the angel
119. Upper right: The reconciliation of Jacob and Esau
120. Lower left: Jacob buys land and builds an altar at
Shechem
121. Lower right: Dinah visits the women of Shechem

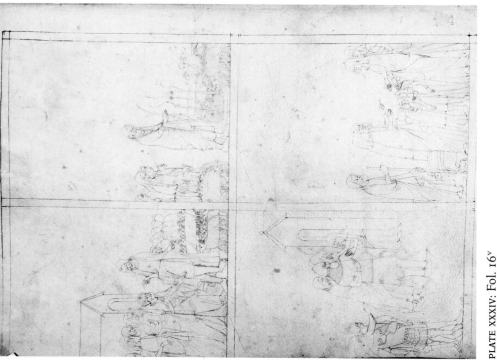

PLATE XXXIV: Fol. 16ᵛ

114. Upper left: Jacob's bargain with Laban
115. Upper right: The peeled rods and the mating
animals
116. Lower left: Laban's search for his stolen gods
117. Lower right: The division of Jacob's household

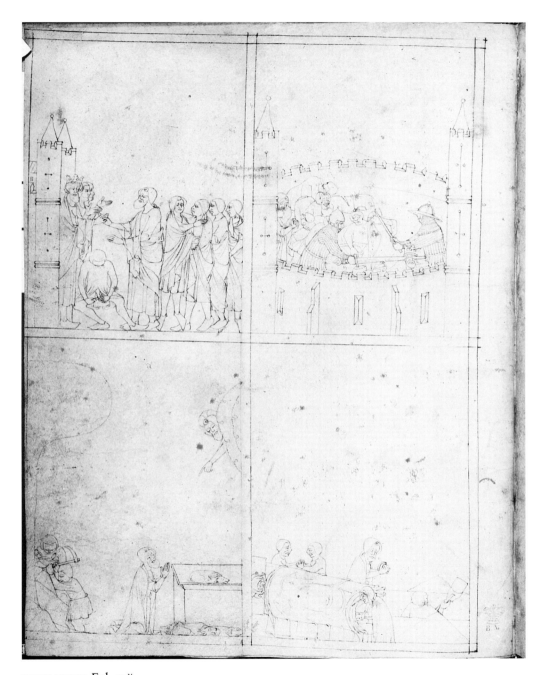

PLATE XXXVI: Fol. 17ᵛ

 122. Upper left: The treacherous agreement with the Shechemites

 123. Upper right: The slaughter of the Shechemites

 124. Lower left: Jacob's altar at Bethel; the burial of the pagan gods

 125. Lower right: The death and burial of Rachel

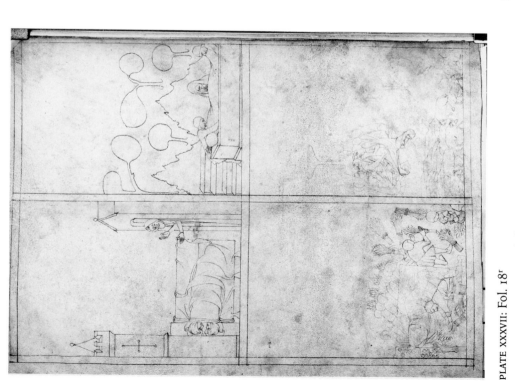

PLATE XXXVII: Fol. 18ʳ

126. Upper left: Reuben lies with his father's
concubine

127. Upper right: The burial of Isaac

128. Lower left: The dream of Joseph

129. Lower right: Joseph's arrival in Dothan

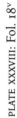

PLATE XXXVIII: Fol. 18ᵛ

130. Upper left: Joseph is stripped; his coat is stained

131. Upper right: Joseph is sold to the Ishmaelites

132. Lower left: Jacob learns the news of the loss of
Joseph

133. Lower right: Tamar's exile upon the death of

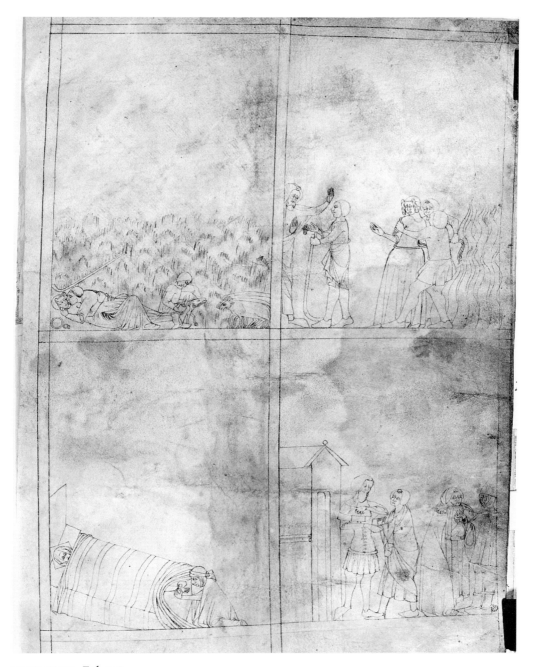

PLATE XXXIX: Fol. 19ʳ

 134. Upper left: Judah takes Tamar for a prostitute

 135. Upper right: Tamar is saved by the articles of the pledge

 136. Lower left: The birth of Perez and Zerah, Tamar's twins

 137. Lower right: The sale of Joseph to Potiphar

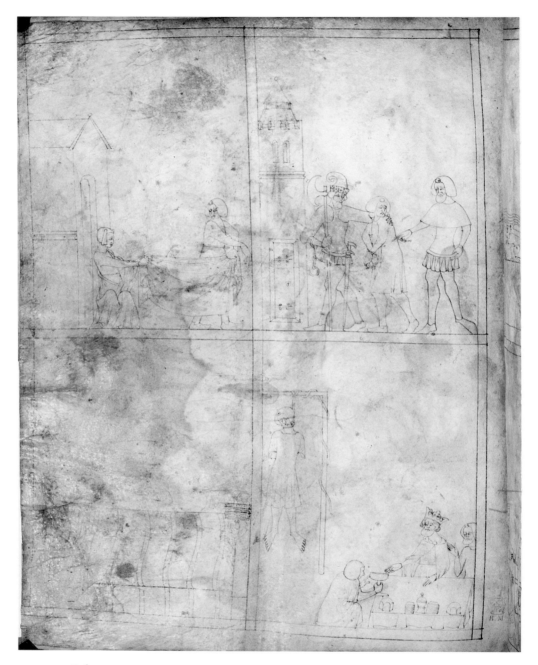

PLATE XL: Fol. 19v

138. Upper left: Joseph escapes from Potiphar's wife
139. Upper right: Joseph is thrown into prison
140. Lower left: The dreams of the baker and the wine steward
141. Lower right: The fulfillment of the dreams

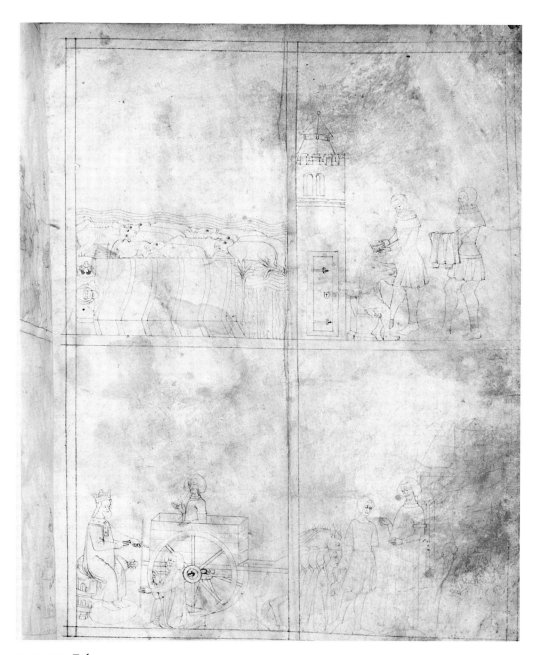

PLATE XLI: Fol. 20ʳ

142. Upper left: The dream of Pharaoh
143. Upper right: Joseph is prepared to appear before Pharaoh to interpret his dreams
144. Lower left: Joseph's commission; Joseph in the chariot of honour
145. Lower right: Simeon is held as hostage and the grain sacks are filled

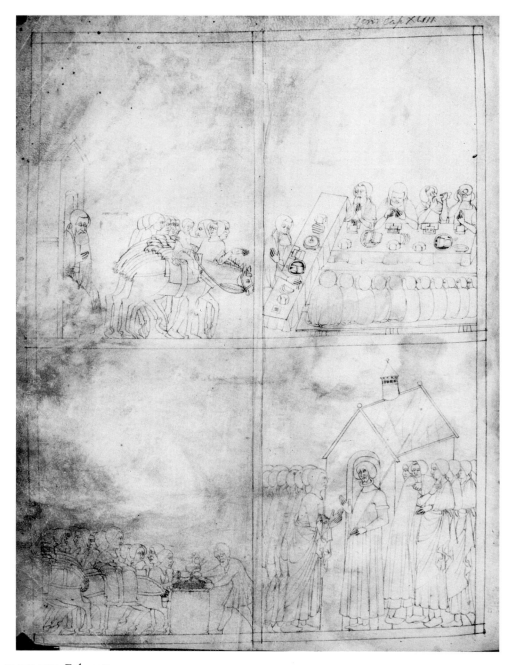

PLATE XLII: Fol. 20ᵛ

146. Upper left: The brothers prepare to take Benjamin to Egypt
147. Upper right: The banquet for Joseph's brothers
148. Lower left: Joseph's cup is found in Benjamin's sack
149. Lower right: Judah pleads for Benjamin's life

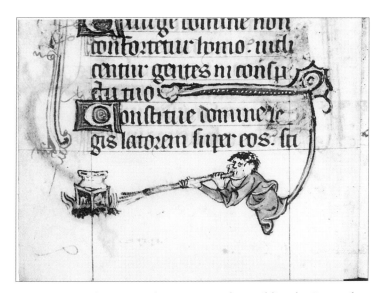

FIG. 38: Psalter. Copenhagen, Kongelige Bibliotek, Gammel kongelig Samling, MS 3384,8°, fol. 18ᵛ, detail, lower margin: Figural line-ending as a man blowing through a tube (Photo: Kongelige Bibliotek, Copenhagen)

hand and gestures over his shoulder toward the city gate with the other. His insistence reflects the text in Genesis 19. 3. Flanked by cylindrical towers with conical roofs topped by elaborate tri-partite finials, the city gate is equipped with a portcullis and a doorway within a doorway. Sodom is depicted as a crenellated and buttressed wall encircling a rooftop area with small structures. (3) On the rooftop two men prepare to engage in sodomy while a third, very large in size, lifts his skirt to examine his private parts, his head shown in strong foreshortening. At left a fourth man eats greedily. (4) Below, outside the city wall, a Sodomite mistreats two beggars who wear short garments of fur (fig. 39). There is a tear in the garment of the foremost. The face of the beggar at right expresses his misery as he is poked or struck with a long stick held by a Sodomite. The aggressive Sodomite wears a tight costume with a double roll around the hips and a phallic projection at the groin. His hood has a liripipe at back and his shoes have long pointed toes. Another bearded man in similar costume with a different headdress faces the viewer. He watches the cruelty with indifference, his hand on his sword, resting on the ground in front of him. His soft, pointed shoes curl over the border of the lower margin.

The left and central figures are more heavily shaded than the two figures at the right. The only colour is the blue of the ground.

COMMENTS: Following the story in the biblical Genesis and in the *Historia Scholastica*, the two visitors who arrive at Lot's door have become angels, possibly one angel with two heads.

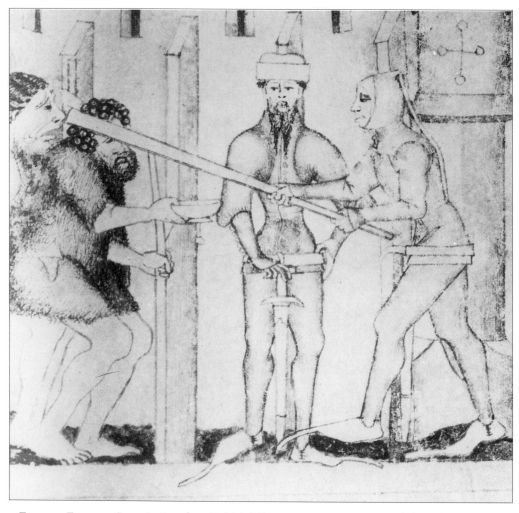

Fɪɢ. 39: Egerton Genesis. London, British Library, Egerton MS 1894, fol. 11ʳ (10ʳJ), lower half, detail: Sodomite beating two beggars (Photo: British Library, London)

The scene of the descent into Limbo in the Fitzwarin Psalter, fol. 15ʳ, depicts a rooftop enclosure with much demonic activity (fig. 32). The hell mouth and the rooftop demons in this image suggest connections with the hell of the medieval drama,[60] associations perhaps carried over into the Egerton Genesis.

We know of no other scenes of men engaging in anal intercourse in fourteenth-century manuscripts. In the book of hours from the Diocese of Cambrai in Baltimore, Walters 88, fol. 80ʳ, a man is depicted touching another man's genitals.

The importunate Lot, bending and gesturing over his shoulder, resembles the figure of Abraham greeting the angels in the scene of Abraham and the three heavenly visitors on fol. 11ʳ of the Queen Mary Psalter.

86

The costumes of the Sodomites suggest the fool/vice of medieval drama; see Chapter 4 for further discussion of this iconography. The sword between the legs of the Sodomite may have phallic associations, as in similar images in the *Omne Bonum*, fol. 58[v], and in the Ormesby Psalter (Oxford, Bodleian Library, MS Douce 366, fol. 131[r]).[61]

Beggars are found in English manuscripts such as in the Douai Psalter (Douai, Bibliothèque Municipale, MS 171), fol. 51[v], where a recipient of alms wears a hair garment like that in the Egerton Genesis.[62] They are more numerous in the margins of French and Flemish manuscripts.[63] In Bodley 264, fol. 109[r], bas-de-page, maimed beggars fighting with crutches and stools are well-dressed comic play-actors whose depiction lacks the element of social commentary in the Egerton Genesis. In several other Flemish manuscripts, beggars are depicted more nearly as in the Egerton Genesis, with a sharp eye for their misery as well as with some humour. Examples include Walters 82, fol. 193[v], lower margin; Gl kgl. Saml. 3384,8°, fol. 126[v], in which the beggar approaching St Elizabeth wears a ragged tunic and has hair in disarray; Douce 6, fol. 110[v], upper margin and bas-de-page, in which three beggars, one with fingerless hands and stumps for legs, approach a well-dressed bishop (fig. 40).

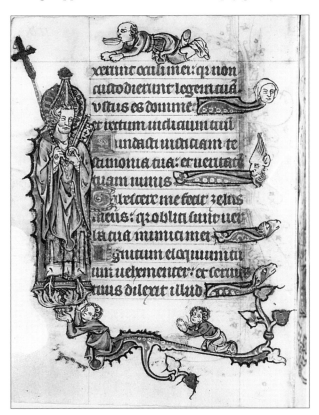

FIG. 40: Psalter. Oxford, Bodleian Library, MS Douce 6,
fol. 110[v]: Beggars in upper margin and bas-de-page
(Photo: Bodleian Library, Oxford)

Folio 11ᵛ (10ᵛJ)

66. Fol. 11ᵛ (10ᵛJ), upper left: Lot offers his daughters to the Sodomites. The Sodomites are struck blind. (Genesis 19. 6–11, pl. XXII)

DESCRIPTION: The setting has changed from the gates of Sodom to the house of Lot, topped with a corbelled, crenellated wall and a gabled roof with ventilator panel. At right Lot presents his two daughters to four Sodomites, dressed much as in the preceding scene. Lot points toward his daughters; the foremost Sodomite repeats his gesture. The daughters, turning toward the doorway, look fearfully at the phallic protrusions on the costumes of the Sodomites. The left hand of the daughter at front is unfinished. A single angel with two heads grasps the dress and arm of the closer daughter to pull her back into the house. The upper hand, which clutches the hand of this daughter, was begun as a right hand, then changed to a left, as though the artist first planned for two clutching angels and then revised it to one. At left a spread-eagled, blinded Sodomite, seen from the rear, feels his way along the walls of the house. His sword hangs between his legs as in the previous scene.

There is no penwork shading in the garments on this page (and very little on the next two folios), but the Sodomites are shaded lightly with monochrome wash. Touches of blue wash on the ground provide the only colour.

COMMENTS: The rendering of the angel suggests the Trinitarian type of the three-headed angel. Henderson compares this miniature to the de Brailes representation of Lot and the Sodomites formerly in the Wildenstein Collection and now in the Musée Marmottan in Paris.[64] Unlike the account in Genesis 19 and in ch. 53 of the *Historia Scholastica*, the two angels have become one with a double head. In this scene, as in the previous three on the recto, the artist is uncertain as to the nature of the visitors and as to their number. The artist may be trying to make sense of a confusing text.

67. Fol. 11ᵛ (10ᵛJ), upper right: Sodom is destroyed. Lot and his daughters flee to Zoar. Lot's wife becomes a pillar of salt. (Genesis 19. 17-25, pl. XXII)

DESCRIPTION: At the right, an unwilling Lot, his two daughters partially visible beyond him, is pushed toward the town of Zoar by an angel, who gestures back toward a tall green hill crowned by a flat-topped tree. This would seem to be a reference to the hills to which Lot is enjoined to flee in Genesis 19. 17. The hill is oddly cleft by a zigzagging diagonal, like a bolt of divine lightning. The bottom of this bolt contacts the base of the pillar of salt, likewise articulated with diagonal zigzags and surmounted by a human profile. At the base of the hill, topsy-turvy buildings, towers, and steeples are awash in a wavy pool of brimstone. The town of Zoar features a cantilevered, crenellated wall and a conical tower with a ball-and-pennant finial. At the extreme left, beside the tree, three scalloped tiers of a divine cloud are partially visible. A segment of a disk between two of the tiers may be either the unfinished head of the Deity or the rising sun mentioned in Genesis 19. 23.

The angel's left wing is unfinished. The green hill and flattened foliage ball of the tree are the only colour. Lot's cloak has some wash shading.

COMMENTS:

The depiction of the buildings of Sodom in topsy-turvy segments may relate to props used in the drama, 'some pasteboard simulacrum of disaster, pulled apart by strings', as Anderson has suggested of similar depictions in the Doomsday window in All Saints, North Street, York, and in a boss of the cloister at Norwich.[65] The zigzagging diagonal is comparable to the angular, diagonal rivers of fiery sulphur depicted in the scene of the destruction of the cities in the Paduan Bible in Rovigo, fol. 11r, lower right.

As in the Egerton Genesis image, Lot's wife of the de Brailes Sheets (Baltimore, Walters Art Gallery, MS W. 106), fol. 4r, has become a hard white mound (fig. 41). De Brailes attempted to show an uneven surface, as in the jagged pillar of the Egerton Genesis. The de Brailes depiction shows the head, unchanged, attached to the top of the mound, like a bust on a pedestal, rather than merged with the mound as in the Egerton Genesis. The depiction of Lot's wife in the Chapter House at Salisbury Cathedral, also somewhat like that of the Egerton Genesis, is a 'human-headed "pillar of salt" '.[66] A more common version of this scene is that of a pale woman or stiff white human form, as in the Peterborough Psalter in Brussels, fol. 12r;[67] the Isabella Psalter, fol. 25v, bas-de-page; and the John Rylands Bible, fol. 20r, in which image she is nude.

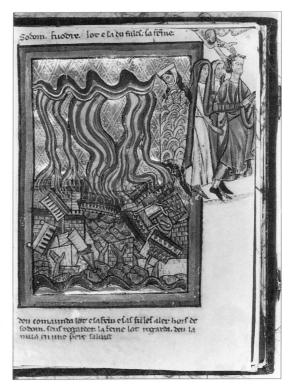

FIG. 41: Scenes from the Bible (de Brailes sheets). Baltimore, Walters Art Gallery, MS W. 106, fol. 4r: Lot leaving Sodom (Photo: Walters Art Gallery, Baltimore)

68. Fol. 11ᵛ (10ᵛJ), lower left: Lot's older daughter enters his bed. (Genesis 19. 33, pl. XXII)
DESCRIPTION: Lot and his daughters have arrived at the mountain (Genesis 19. 30), a blue-washed hill crowned by a lone flat tree with green top. An uncoloured area bounded above by a wavy line is the interior of the cave. The older daughter, a diminutive figure in a nightdress, steps into the bed of the slumbering father, who wears a nightcap. A wine vessel surmounted by an inverted bowl suggests his drunken state. The younger daughter sleeps under heavy drapery in a tilted bed at left.

The blue of the mountain and green of the tree are the only colour.

COMMENTS: This line drawing has little shading except for hair and beard. Here for the first time garments are shaded neither with wash, as in the two scenes immediately preceding, nor with penwork as in most previous images.

69. Fol. 11ᵛ (10ᵛJ), lower right: Lot's younger daughter disrobes and enters his bed. (Genesis 19. 35, pl. XXII)
DESCRIPTION: The same lone tree at the top of the jagged blue-washed hill, with wavy lower boundary, indicates the cave in the mountain again. At right the older daughter extinguishes a candle, mounted on a bracket by her bed. With lips pursed and cheeks puffed, she blows the flame leftward. At right, the second daughter removes her garment over her head as she enters the bed of the sleeping Lot. She slips into bed below Lot's naked arm which is above the coverlet. More of the wine carafe is visible than in the scene preceding. Penwork shades only the hair and beard.

COMMENTS: The motif of a figure disrobing by pulling a garment off over the head is common in English and Flemish manuscripts of the first half of the fourteenth century. Examples can be found in the Tickhill Psalter, New York Public Library, Spencer Collection, MS 26, fol. 16ᵛ, bas-de-page; in the Holkham Bible Picture Book, fol. 30ᵛ; and in Gl kgl. Saml. 3384,8°, fol. 57ʳ, right margin. The motif of a candle mounted on a wall bracket is found in the Tickhill Psalter, fol. 26ʳ, bas-de-page.

Folio 10ʳ (11ʳJ)

70. Fol. 10ʳ (11ʳJ), upper left: Sarah is brought before Abimelech. (Genesis 20. 1–2, pl. XXIII)
DESCRIPTION: Sarah looks back at Abraham. Her expression is less pained than before, in the similar narrative on fol. 7ʳ. Nor is Abimelech's expression as lecherous as that of the Pharaoh in the earlier episode. Abraham is dressed as a pilgrim with furry coat, purse, traveling hat, pilgrim staff, and bare feet. Abimelech, dignified, crowned, with upright posture and vertical sceptre, is elegantly drawn. He beckons Sarah in a calm but imperious manner. The courtier pulls her gently by her left wrist, from which her large hand droops limply, rather than roughly pushing, as on fol. 7ʳ, lower left. She holds the folds of her robe high in her right hand while looking back at Abraham with acquiescence. The setting is minimal, and the only

colour is the blue wash of the foreground. The fur coat, beards, and hair of Abimelech are heavily shaded with penstrokes.

71. Fol. 10ʳ (11ʳJ), upper right: Abimelech languishes. (Genesis 20. 3–7, pl. XXIII)
DESCRIPTION: Attended by Sarah, Abraham, courtiers, and physicians, Abimelech lies in bed under a coverlet, his head swathed in a cloth. Crouching on the far side of the bed, Sarah adjusts the bedclothes, a look of concern on her face. Abraham, crouching beside her, gestures prayerfully toward the Deity, whose face and hand emerge from a scalloped cloud at upper left. The heads of two grieving courtiers, one with tight curls and the other with fuzzy hair, appear at the foot of the bed. Below the scalloped cloud stand two tonsured physicians in long, hooded robes with bat-winged sleeves. One gestures toward a round-bottomed flask which the other holds aloft for the Deity's inspection. The bed is the sole indication of a setting. The drawing is monochromatic, save for the penwork shading of hair and beards.

COMMENTS: This scene suggests, but does not exactly correspond to, the dream of Abimelech in Genesis 20. 3–7; scripture mentions neither physicians nor the intercession of Abraham but rather the appearance of God to Abimelech in a dream by night. Peter Comestor does mention the despairing physicians.[68]

Randall notes many images of physicians with round-bottomed flasks, which she identifies as urine flasks, in the borders of French and Flemish manuscripts. Two of the many examples include a line-ending in Gl kgl. Saml. 3384,8° on fol. 86ʳ, right margin; and a long-legged grotesque in Walters 82, fol. 75ᵛ, upper margin. The bat-winged costume is worn by a cleric in a Bolognese Digest of the 1330s or 1340s, Vatican City, Biblioteca Apostolica Vaticana, MS Vat. lat. 1409, fol. 151ʳ;[69] and in an English Religious Miscellany that post-dates the Egerton Genesis, Hatfield House, MS CP 290, fol. 145ᵛ.[70]

72. Fol. 10ʳ (11ʳJ), lower left: Abimelech dismisses Abraham and Sarah. (Genesis 20. 8-16, pl. XXIII)
DESCRIPTION: At lower left, Abimelech, much improved in health and once more in command, is sitting up in bed. He is crowned with a carefully drawn diadem of matched stones. Behind him is the discarded headcloth of the previous scene. Pulling Sarah by her left hand, he returns her to Abraham. With his own left hand he gestures strongly toward the money being handed to Abraham. An intermediary, seen from the rear, reaches for Sarah's proffered hand while giving to Abraham the sack of a thousand pieces of silver mentioned in the text. Abraham receives the sack with his right hand while holding in his left hand three additional pieces. Sarah, the courtier, and Abraham have assumed a semi-kneeling posture. As before, this is an untinted line drawing with only beards and hair shaded by pen strokes. As in the scene preceding, the bed is the only indication of a setting.

73. Fol. 10ʳ (11ʳJ), lower right: Isaac is circumcised. (Genesis 21. 4, pl. XXIII)
DESCRIPTION: Sarah, eyes closed, lies inert in bed, her head at far right. Abraham holds the knife in his right hand and the child's penis in his left. Isaac, with a peaceful countenance,

faces forward. He is swathed in drapery and held by crossed straps in a rocking chair or cradle. A wet nurse—or possibly Sarah herself, if she appears twice—offers her breast with one hand while steadying the cradle with the other; she is ready to comfort the child, who will soon be in pain. This image, like the two preceding, is executed entirely as line drawing, except for the light penstrokes in Abraham's hair, which lies in parallel locks, and in his darker beard.

COMMENTS: The subject is unusual, though it is occasionally represented as a type of the circumcision of Christ, as it would seem to be in the Paduan Bible in Rovigo, fol. 12ᵛ, upper left. It is depicted on a late fourteenth-century misericord in Worcester Cathedral, on a boss at Salle in Norfolk, and in the east window of St Peter Mancroft, Norwich.[71] Anderson called attention to the inclusion of a related theme, Abraham's joy at the suckling of Isaac, on the subjects list of the now-lost roundels at Bury, transcribed by M. R. James.[72] Cox discussed the possible relation of this rare subject carved on the Worcester misericord to scenes on the twelfth-century Warwick Ciborium in the Victoria and Albert Museum and to its depiction in the thirteenth-century Apocalypse in Oxford, Eton College, MS 177.[73]

Folio 10ᵛ (11ᵛJ)

74. Fol. 10ᵛ (11ᵛJ), upper left: Ishmael attacks Isaac at the feast for the weaning of Isaac. (Genesis 21. 8–12, pl. XXIV)

DESCRIPTION: In the immediate foreground stand the children, Ishmael, in a short tunic, Isaac in a longer one. The slightly taller Ishmael strikes Isaac with his right fist and grabs food or a ball from the shorter child with his left. Six adults are seated along the far side of a long banqueting table behind the children. The table is cropped at both ends by the border of the image and is spread along its nearer side with vessels and bread in loaves and slices. Sarah, seated in the centre, turns toward Abraham, seated at her right, and vigorously points to the children, calling the patriarch's attention to Isaac's predicament. Abraham makes a gesture of disclaimer in response, while Hagar, seated left of Abraham, touches his shoulder with her right hand and holds up her left in intercession for Ishmael. A diner seated to the right of Sarah cranes his neck to peer around her, as if better to view interactions in progress; his head is presented in strong foreshortening. At the far right a banqueter drains a large goblet held in his right hand while grasping a slice of bread (?) with his left. A fourth man sits beside Hagar and watches. The Deity emerges from a four-tiered scalloped cloud at upper right, pointing to Abraham and directing him to do as Sarah asks. This scene has no colour apart from penwork darkening of hair and beards.

COMMENTS: The activity in the image goes beyond the scriptural version which simply reports that Sarah saw the son of the Egyptian woman playing with Isaac, her son. Though this scene bears no inscription, the violence of Ishmael toward Isaac reflects more nearly the account in the *Historia Scholastica* and in the *Histoire ancienne* Genesis, for which Peter Comestor

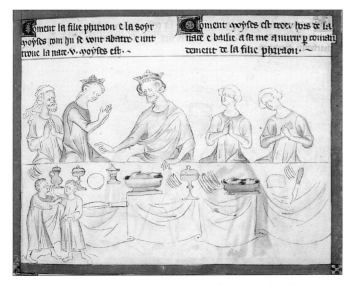

Fig. 42: Queen Mary Psalter. London, British Library,
Royal MS 2 B VII, fol. 23ʳ: Moses strikes Pharaoh's son at a
feast. (Photo: British Library, London)

is the source here. In these two texts, Sarah understood that there was persecution in Ishmael's
play.[74] The Egerton Genesis scene reflects the dramatic tension of the literary version.

This scene bears a close relationship to a legendary image on fol. 23ʳ of the Queen Mary
Psalter (fig. 42). Here the child Moses strikes the son of Pharaoh on the face with almost the
exact gesture of Ishmael's blow to Isaac in the Egerton Genesis miniature. The children are at
left in front of the dining table in both illustrations. The king points accusingly to the aggres-
sor, while his sister, who is raising the child, pleads for Pharaoh's indulgence. This scene in
the Egerton Genesis also suggests a conflation of two sequential scenes in Ælfric's Paraphrase
of the Hexateuch, fol. 35ᵛ (fig. 43). On the upper half of the folio, Isaac, holding a staff in his
right hand and bread (?) in his left is depicted as though levitated at left in front of the ban-
quet table. Below, in the second scene, the two children are playing. This time the taller child
holds the staff. Though no violence is depicted, the superior strength of the older child is
implied. The children appear to be juggling balls.

Resemblance between the Queen Mary Psalter and the Egerton Genesis was noted in the
scenes of the flood, fols 3ʳ and 4ʳ of the Egerton Genesis. The scenes of fighting children offer
another example of a common element in these two fourteenth-century works which illustrate
the Genesis, as well as a possible debt of both artists to Anglo-Saxon art. In the more abbre-
viated scene in the Isabella Psalter, fol. 28ᵛ, bas-de-page, Ishmael strikes Isaac with a whip as
a standing Sarah points out the mistreatment to Abraham.

93

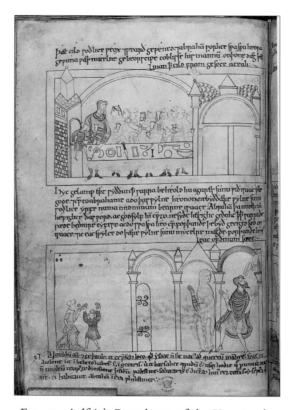

FIG. 43: Aelfric's Paraphrase of the Hexateuch.
London, British Library, Cotton MS Claudius B.
IV, fol. 35ᵛ: Abraham gives a feast (above) and
Sarah sees Ishmael playing with Isaac (below).
(Photo: British Library, London)

75. Fol. 10ᵛ (11ᵛJ), upper right: Hagar and Ishmael encounter the angel in the wilderness. (Genesis 21. 15–20, pl. XXIV)

DESCRIPTION: The weeping Ishmael, in a half-crouching position, holds one last crumb of bread between his thumb and forefinger. Beside him, hands clasped, kneels Hagar, listening to the angel who addresses her at right, not from a cloud but rather from the rounded top of the largest and tallest tree in a grove of six. Between mother and son lies the empty water jug, complete with strap and cork. Hagar does not yet see the well behind her. A second tree with five foliage balls bends over Hagar, as though attempting to attract her attention to the well at its base. The ground is washed in blue, and the leafless trees are tinted green.

COMMENTS: The setting is an elaboration on the biblical Genesis, which mentions only a bush. The mother is near the child, not at a distance, as stated in the Vulgate and in the *Historia*

Scholastica.[75] In the scene of Hagar and Ishmael by the well in the Queen Mary Psalter, fol. 10ʳ, the well is located on a tree-shaded hill and is shown in tilted perspective, as in the Egerton Genesis.

76. Fol. 10ᵛ (11ᵛJ), lower left: The marriage of Ishmael (Genesis 21. 20-21, pl. XXIV)
DESCRIPTION: Hagar gives Ishmael a bride from Egypt. As the Bible states, Ishmael has become an archer; he holds a bow, and his arrows are in a quiver at his side. He has the short hair and tunic of a youth. The tunic, pleated at the hip, has a fashionable wide collar; the shoes have long, pointed toes. His bride wears a fitted dress with sleeves puffed at the shoulder and a wreath of flowers over her veil. A partial band at the hem of her dress may be an underskirt. Seven trees are lined up in the background. They overlap, in the manner of the dozen super-posed children at lower left. The artist here has depicted the twelve sons of Ishmael, graded in size but identical in dress, all with their father's coiffure.

The ground is washed in blue; the trees, without articulated leaves, in green. There are no other hues. Hair is shaded with penwork.

COMMENTS: Though Ishmael's twelve sons are not mentioned in the Vulgate, Peter Comestor does mention them, calling six by name.[76] Josephus has a complete list of the twelve names.[77] The *Histoire ancienne* mentions the twelve sons but omits the names, saying they will be mentioned before the story is over.[78]

77. Fol. 10ᵛ (11ᵛJ), lower right: The agreement between Abraham and Abimelech (Genesis 21. 25–31, pl. XXIV)
DESCRIPTION: At right stands Abraham, wearing the costume of a gardener, laced boots, smock, and hat. He points with his right index finger to the seven lambs at his left, his gift to Abimelech which seals the agreement that Abraham has dug the well. Abraham has planted a grove by the well, as indicated by the eight small trees around the well and by the lopsided, iron-shod spade stuck in the ground beside them. At left the bearded Abimelech looks at Abraham and points to the well with his right index finger; his left hand rests on the shoulder of the beardless, frizzy-haired Phicol, who looks down while pointing to the well. Both men wear robes and cloaks. The well and the large tree beside it are much like those in the scene of Hagar and Ishmael in the wilderness, depicted directly above on this folio. The four branches of the large tree above the well are in virtually the same positions as in the well-sheltering tree above. The branch behind the head of Phicol is uncoloured, however. This tree, whose crossed branches visually unite Abraham and the two Philistines, seems to symbolise their agreement.

The green and blue washes used in the other two outdoor scenes on this folio appear here as well. As usual, hair and beards are pen-shaded.

COMMENTS: The story depicted is probably that of Peter Comestor who, however, quotes the biblical version; the grove around the well is mentioned only in the former.[79] The lopsided

spade appears in other approximately contemporary English manuscripts, such as the Holkham Bible Picture Book, fols 4ᵛ and 6ʳ, and much earlier in Ælfric's Paraphrase of the Hexateuch of the eleventh century, fols 17ʳ and 37ʳ.

Folio 13ʳ (12ʳJ)

78. Fol. 13ʳ (12ʳJ), upper left: God commands Abraham to sacrifice Isaac. (Genesis 22. 1–2, pl. XXV)
DESCRIPTION: At upper left God speaks from a three-tiered serrated cloud. He points to the young Isaac with his right hand and to Moriah with his left. Abraham, with his back to the viewer, shields his eyes from the brightness of the vision with his right hand. His left hand registers astonishment. He wears the robe and cloak of a dignitary. His head is depicted as a lost profile and his feet are awkwardly foreshortened. Clad in the tunic of a child, Isaac, with short curly hair and thick legs, plays with a tied, forked stick and a ball. He is unaware of the Deity's presence. In the background are two peaks of similar height and shape, the one at right, at whose base Abraham stands, overlaps the one at left. A total of nineteen small trees are sprinkled over their slopes. Many have pairs of heart-shaped foliage balls pointing in opposite directions; others are flat-topped.

The foliage is washed in green; leaves are not articulated in this scene, nor in the others on this folio. Hair and beard are shaded with pen strokes.

COMMENTS: This scene is the first of three devoted to the story of the sacrifice of Isaac. The trees, with divided, heart-shaped foliage balls, seem to manifest Abraham's predicament. The stick-ball game, which here emphasises the innocence of Isaac, is illustrated in many variants in early and mid-fourteenth-century manuscripts, as in the Queen Mary Psalter, fol. 4ᵛ, where Cain and Abel play stick ball; Douce 6, fol. 96ᵛ, bas-de-page; Gl kgl. Saml. 3384,8°, fol. 26ᵛ; Bodley 264, fol. 22ʳ, bas-de-page. The partially effaced left shoulder and arm of Abraham were smudged onto the page opposite.

79. Fol. 13ʳ (12ʳJ), upper right: Abraham and Isaac ascend the mountain. (Genesis 22. 6, pl. XXV)
DESCRIPTION: Isaac, depicted much as in the scene preceding, carries the wood for sacrifice in the shape of a cross. Abraham is presented again from behind in a lost profile view with awkwardly rendered legs and feet. He carries a torch in his raised right hand and wears over his shoulder a studded leather strap from which hangs a sheathed sword. He is dressed in a tunic rather than in the long robe and cloak of the previous scene. Near the summit of the taller hill is a bare altar, rendered in a tilted perspective with slightly divergent orthogonals.

The two peaks and the trees are depicted virtually as in the scene preceding, but here in addition to the green of the trees, the ground and hills are washed blue.

COMMENTS: The Vulgate says Abraham carried fire and a sword in his hands (*portabat in manibus ignem et gladium*). The crossed pieces of wood are one of the few typological references in the Egerton Genesis.

80. Fol. 13ʳ (12ʳJ), lower left: The angel halts the sacrifice of Isaac. (Genesis 22. 9–13, pl. XXV)

DESCRIPTION: This third scene of the sacrifice series is partially effaced, having been at one time stuck to fol. 12ᵛ (13ᵛJ) and severely damaged when detached. Tall flames rise from the top of the altar behind Abraham. The image of the child, whose head seems to be held down by Abraham's bent left arm, has been effaced. Abraham, with one foot braced to support his contrapposto stance, raises the sword with his right hand. He looks upward at the rescuing angel, which is in the form of a bird, complete with pinioned wings and a broad, blunt tail. His avian form has been modified by a human head and arms, capped and sleeved with feathers. One hand grasps the sword and the other points to the ram caught by his horns on two lopped branches of a tree below.

The hill is partially washed in blue, while the treetops, which replicate those of the two preceding scenes, are green.

COMMENTS: Like the sequential scenes in the story of the Drunkenness of Noah on fol. 4ᵛ, these three scenes of the sacrifice of Isaac have virtually the same background, as though successive episodes of the narrative take place on a stage setting. The appearance of the feathered, bird-like angel suggests parallels with the theatre. This scene differs from the more conventional imagery, in which Isaac is bound and is on the altar laid with wood. The Queen Mary Psalter, fol. 11ᵛ, and the Isabella Psalter, fol. 29ᵛ, lower margin, provide examples of the more usual iconography. In the effaced image of the Egerton Genesis, Isaac was either standing or kneeling. He was not on the altar, which is already ablaze in the background, a detail mentioned in Peter Comestor.[80]

81. Fol. 13ʳ (12ʳJ), lower right: The burial of Sarah (Genesis 23, pl. XXV)

DESCRIPTION: At right, Abraham, seen from behind with his face rendered as a lost profile, discusses with Ephron the Hittite the purchase of the burial place for Sarah. He points to the grave and communicates with the seller by a gesture of his right hand. He is at one end of Sarah's cloth-draped coffin, which has protruding wooden handles and rests on a four-legged stand. Garbed like Abraham in robe and cloak, Ephron thoughtfully considers the patriarch's offer. His left hand, held before his chest, is unfinished; the fingers are not differentiated. At centre, three tonsured clerics are ranged along the far side of the coffin, their bowed heads rendered in foreshortening. One holds an open book with his two long forefingers. At the far left, two gravediggers excavate with pick and shovel. The image has suffered some damage at the left border.

Behind the workmen is a cleft hilltop, washed in blue; the ground is likewise coloured, except for an uncoloured section in the area of excavation. Other sarcophagi are at bottom left. There is considerable shading of hair and beards here.

COMMENTS: The gravedigging differs from both the biblical account and that of the *Historia Scholastica*, which mention a cave as the burial site. Relatively rare in the margins of fourteenth-century manuscripts, gravediggers are found in the Tickhill Psalter, fol. 49ʳ, bas-de-page; in

Walters 82, fol. 164ᵛ, bas-de-page, at the beginning of the Offices of the Dead; and in the Gorleston Psalter, on fol. 89ᵛ.

Folio 13ᵛ (12ᵛ])

82. Fol. 13ᵛ (12ᵛ]), upper left: Abraham's servant is commissioned to seek a wife for Isaac. (Genesis 24. 1–10, pl. XXVI)

DESCRIPTION: Dressed as a knight in mixed plate and mail armour, Abraham's servant kneels before Abraham and swears not to choose a wife for Isaac from among the Canaanites (fig. 44). His left hand is under his master's thigh and his right raises the visor of his bascinet. Abraham, robed and barefooted, sits at the entry of a replica of the castle where he received the heavenly visitors (fol. 11ʳ (10ʳ]), upper left). Here the kitchen in the lower left foreground is less elaborate and the vaulted culvert is missing. Abraham holds the servant's arm with his right hand and with his left he points in the direction of the destination. A thick-legged, barefooted servant in a short tunic looks up with lost profile at the ten camels mentioned in the account and pictured here.

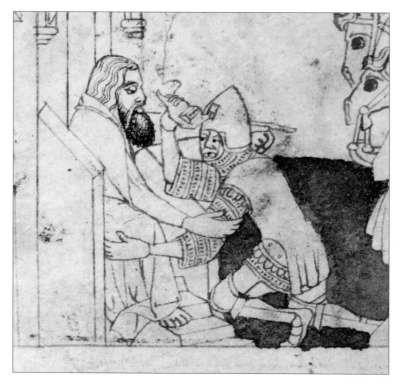

FIG. 44: Egerton Genesis. London, British Library, Egerton MS 1894, fol. 13ᵛ (12ᵛ]), upper left, detail: Abraham's servant in armour, kneeling before Abraham (Photo: British Library, London)

Beside the castle is a ball-topped tree washed in green. The ground is blue. Abraham's beard, the servant's hair, and the eyes of the animals are darkened with pen strokes.

83. Fol. 13ᵛ (12ᵛJ), upper right: Abraham's servant meets Rebecca at the well. (Genesis 24. 11–16, pl. XXVI)

DESCRIPTION: Seen from behind, his face a lost profile, Abraham's servant kneels beside the spring to ask divine guidance in choosing the young woman. He is no longer in armour but wears a long cloak and has black, frizzy hair and a long beard. Beside him are six of the camels who have assumed loading posture, their two small humps visible in profile. Rebecca, followed by three young women carrying vessels for water, braces herself with her right hand on the side of the well, while preparing to fill the bucket she carries in her left hand. The two girls with braids and the kerchiefed matron behind them are beautifully drawn, as are the bucket, basin, and jars they carry. The women wear dresses with fitted bodices and flared skirts. God looks down at Rebecca from the three-tiered serrated cloud at upper right, as though selecting her for Isaac.

The ground behind the spring is blue; the single tree, green. The coiffures of the women and the beard and hair of the servant are emphasised with pen-shading. The green paint of the scene on the recto of this leaf, the green of the trees on Moriah, has soaked while wet into the empty sky here.

COMMENTS: The artist appears to be following the story in both the *Historia Scholastica* and the Vulgate. Peter Comestor says simply that the servant prays, whereas in the Vulgate, the servant says he is standing (13: *'Ecce ego sto prope fontem aquae')*. He does not run to meet Rebecca, as in the biblical story. The water source in the image is a spring, rather than a well, although Peter Comestor uses *putento*, the word for well.

84. Fol. 13ᵛ (12ᵛJ), lower left: Rebecca waters the camels of Abraham's servant. (Genesis 24. 20–22, pl. XXVI)

DESCRIPTION: Rebecca pours water into the trough for the camels. Her midget-like figure is rendered from behind, in an unsuccessful attempt at foreshortening, and her head, viewed in lost profile, is turned to look at the ring and bracelet which Abraham's servant offers her. These ornaments are the same as those Judah offers to Tamar in a less honourable proposal at upper left on fol. 19ʳ. Five camels lean down to drink, while a sixth, upright, has turned its head to look behind. The three other women leave the scene at right. Two lean backward to balance heavy water containers on their heads. The matron, whose figure is sliced by the right margin, carries her water jar effortlessly with three fingers of her right hand.

The only colour is in the blue touches between the feet of the departing women. The usual pen-shading emphasises beard and hair, as well as the eyes of the camels.

COMMENTS: The ring is reminiscent of the ring offered to persuade the young girl in two similar fabliaux, *De Gombert et des .ii. clers* and *Le Meunier et les .ii. clers*.[81]

85. Fol. 13ᵛ(12ᵛJ), lower right: Rebecca takes leave of her family. (Genesis 24. 59–61, pl. XXVI)
DESCRIPTION: Rebecca is already beyond the pale, a wattled fence which surrounds the small house of her parents at left. The departing daughter kisses a young woman on the other side of the fence, while a young man in the doorway waves farewell. Beside the house at left, also behind the fence, a grieving older woman, the mother (?), blows her nose into a large handkerchief. She directs a sidelong glance toward the departing Rebecca. A second man on the opposite side of the house proffers a large travelling hat, the familiar hat of the pilgrim or the gardener which the artist has twice before depicted. Cloaked and hooded, Abraham's servant, demonstrating his impatience mentioned in Genesis 24. 56, points with his right hand in the direction of their impending departure. He wears spurs. A curious earthy touch is the defecating camel which the servant holds by a harness strap.

The ground is touched with blue. Penwork shades the servant's beard and the frizzy hair of the two young men.

COMMENTS: The artist gives free rein to his imagination in this scene, for there is little mention of Rebecca's departure in Genesis 24 or in the *Historia Scholastica*. The gratuitous image of defecation in a biblical scene is unusual and gives an unexpected comical touch. Images of defecation occasionally do appear in biblical illustration where specifically called for by the text, as in the scenes of King Saul relieving himself in the Tickhill Psalter, fol. 36ᵛ, lower margin. Images of defecating animals and humans are found frequently in the margins of northern French and Flemish manuscripts, less frequently in English manuscripts.[82] Walters 82, fol. 52ʳ, bas-de-page (fig. 45) depicts a man carrying a horse, whose feathery tail and stream of droppings, caught by a man following behind, are similar to the tail and droppings in the Egerton Genesis. Wattle-work fences suggest a connection with drama.

Folio 12ʳ (13ʳJ)

86. Fol. 12ʳ (13ʳJ), upper left: Abraham's servant presents Rebecca to Isaac. (Genesis 24. 66-67, pl. XXVII)
DESCRIPTION: Abraham's servant introduces Rebecca while telling the story of their journey. Isaac invites Rebecca into his 'tent', the same small cottage used in the Egerton Genesis to designate a dwelling. Here Isaac wears the brief garb and has the short curly hair of a youth or workman. Rebecca, her left hand upraised in greeting, doffs her travel hat with her right hand. Her long-sleeved costume is covered by a travel cloak which hangs heavily from the shoulders. Abraham's servant, greeting Isaac with his right hand, pushes Rebecca forward with his left hand, in a crudely familiar gesture. The camels at far right raise their cloven hooves. The only colour here is in the two touches of blue at the groundline.

COMMENTS: The story narrated by the illustrator is unlike that of the biblical Genesis or of Peter Comestor. The artist interprets the meeting of Isaac and Rebecca in his own way. Rather than descending from her camel upon sight of Isaac and covering her face with her veil, Rebecca doffs her travel hat. The servant's indecent gesture suggests a relationship on the jour-

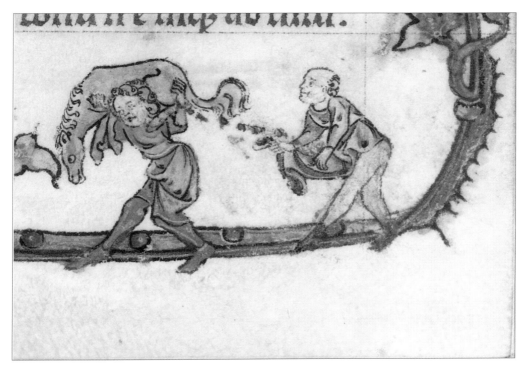

FIG. 45: Psalter-hours. Baltimore, Walters Art Gallery, MS W. 82, fol. 52ʳ, bas-de-page: Man carries a horse, followed by a second man who catches the droppings. (Photo: Walters Art Gallery, Baltimore)

ney inappropriate for that of future mistress and servant. This buffoonery is not a part of this scene in other manuscripts. In the Queen Mary Psalter, fol. 12ᵛ, the servant presents Rebecca to Isaac with a light touch on her upper arm.

87. Fol. 12ʳ (13ʳJ), upper right: Abraham welcomes Isaac and Rebecca while exiling Keturah and her children. (Genesis 25. 1–6, pl. XXVII)
DESCRIPTION: Abraham, the central figure, cavalierly dismisses with his left hand Keturah and their six small sons, while presenting with his right hand an elegant home to Isaac and his bride. Keturah's veiled figure is sliced by the right margin. The six children, scarcely graduated in height, are superposed in profile as replicas. Like the structures on fols 8ᵛ, lower left; 11ʳ (10ʳJ), upper left; and 13ᵛ (12ᵛJ), upper left, Isaac's new home features a corbelled short, square tower over the entrance. Access to the round-arched doorway is by a staircase with thirteen diminutive steps. The characteristic ball-topped tree is behind the structure. Isaac and Rebecca stand together behind the entrance to their new home. Their raised hands express surprise and gratitude. Isaac remains a curly-haired, short-gowned youth, but Rebecca has donned the kerchief of the married woman.

An expanse of blue wash, carelessly applied, stretches from the frontal picture plane to the ridge top where four small trees echo the procession of the departing children at right. Foliage balls are green. Hair and beard are pen-shaded.

COMMENTS: The biblical account and Peter Comestor make much of the descendants of Abraham through the children of his second wife Keturah. They are mentioned by name. However the image in the Egerton Genesis stresses the bounty of Abraham toward Isaac, his heir by Sarah, and gives short shrift to Keturah and her family. In the Paduan Bible in Rovigo, fol. 16ᵛ, upper left, the sons of Keturah, depicted as adults, are dismissed with a gesture of Abraham's left hand, as in the Egerton Genesis.

88. Fol. 12ʳ (13ʳJ), lower left: The burial of Abraham (Genesis 25. 9, pl. XXVII)
DESCRIPTION: The Bible states that Isaac and Ishmael buried their father. Here three young men place a shrouded body in a stone sarcophagus. Curves indicate a head, shoulders, knees, and feet under the drapery. The lid, embossed with a cross, is propped on the hill behind the figures. Three other sarcophagi lie behind that of Abraham. Single trees stand guard while double-branched trees bend, as though in respect, behind the shrouded figure. The green-tinted trees are curiously suspended just above the two jagged hills washed in blue.

COMMENTS: Sarah's double cave-tomb, mentioned in Peter Comestor, is not specified here, nor is the biblical statement that Abraham was buried with Sarah. This seems to be a generic burial scene which has relatively little to do with the Genesis text; it is virtually copied in the burial scene of fol. 18ʳ. The Egerton Genesis artist gives the trees an expressive role in the scene, as is repeatedly the case in this manuscript.

89. Fol. 12ʳ (13ʳJ), lower right: Rebecca consults God. (Genesis 25. 22–23, pl. XXVII)
DESCRIPTION: This image reflects the brief scriptural account of Rebecca's prayer and of God's explanation of the two races struggling within her. Right of centre is the figure of Rebecca kneeling on the hill, also used on fol. 14ʳ, upper right, to indicate the place where divine guidance is sought. The cylindrically draped kneeling leg characteristic of this artist has been noted before. Rebecca's mouth is open in prayer. The Deity points to her abdomen, as he explains about the coming dissension between her sons in adulthood.

The hill is a semi-circular blue mound, surmounted by a smaller one. At left is the simple structure repeatedly used in Egerton Genesis scenes. The blue-washed hill provides the only colour here.

COMMENTS: Peter Comestor mentions the mountain (Moriah) on which Rebecca prayed.[83] The use of a hill in drama to indicate a place of worship is discussed in Chapter 4.

Folio 12ᵛ (13ᵛJ)

90. Fol. 12ᵛ (13ᵛJ), upper left: The birth of Esau and Jacob (Genesis 25. 24-26, pl. XXVIII)
DESCRIPTION: Esau and Jacob, the twins, are being born, Esau first, with Jacob holding onto his foot. The baby Esau looks back at his brother. Only the baby Jacob's profile, sliced by the line of the bedclothes, and his hand holding Esau's foot are pictured. Rebecca is struggling to give birth to the second child. The midwife reaches under the coverlet, but not in the expected direction. The tight covering on her head and neck resembles that of Rebecca as traveller on fols 12ʳ (13ʳJ), upper left, and 13ᵛ (12ᵛJ), lower right, and that of the midwife on fol. 19ʳ, lower left. The bed is tilted toward the viewer. A small cradle at lower right awaits the babies. The bed covering is shaded in such manner as to emphasise the folds of the material, Rebecca's abdomen, and her raised knee.

91. Fol. 12ᵛ (13ᵛJ), upper right: Esau sells his birthright. (Genesis 25. 34, pl. XXVIII)
DESCRIPTION: Seated before the same small structure which twice appeared on the preceding folio, Jacob hands Esau a dish of potage ladled from a cooking pot set on a tripod above a fire. The story illustrated could be directly from the Vulgate. Esau, with a small head but large feet and legs, wears the brief tunic and has the short curly hair of a youth or servant. Jacob's destiny is implied in that he sits on the tiered stool similar to the seat of power of Pharaoh on fol. 20ʳ. He wears the robes characteristic of a person of importance. Esau, the hunter, holds his bow under his left wrist. His arrows are strapped to his waist. The ground is washed with blue.

92. Fol. 12ᵛ (13ᵛJ), lower left: Abimelech sees Isaac caressing Rebecca. (Genesis 26. 2–11, pl. XXVIII)
DESCRIPTION: The Deity looks down at Isaac from a notched cloud at the upper right corner of the scene, presumably directing Isaac to remain in Gerar. Isaac touches Rebecca's face with his right hand and gestures with his left hand while looking upward, though not directly at the divine face above his head. In this image Isaac appears more protective of his wife than was his father Abraham of Sarah (fols 7ʳ, upper left, and 10ʳ (11ʳJ), upper left), though he also called her his sister for self-protection, as in the earlier story. The crowned Abimelech, looking out of a window of his castle tower, sees Isaac caressing Rebecca and understands that she is his wife. He points to the couple either giving an order to two subordinates to bring Isaac before him or warning the people not to harm him. In all essentials the Vulgate explains this image. Isaac, though the father of Esau and Jacob, looks no older than his sons in the previous picture. For the first time, he is shown wearing the costume of a dignified adult. Abimelech's assistants wear the same costume. The hand of the man receiving orders below the tower replicates the pointing hand of Abimelech above.

The only colour is a narrow strip of blue behind the feet of the foreground figures who stand directly on the line of the lower border.

93. Fol. 12ᵛ (13ᵛ J), lower right: Isaac prospers. (Genesis 26. 12–14, pl. XXVIII)

DESCRIPTION: The picture is badly damaged, having once adhered to fol. 13ʳ (12ʳJ), from which it was subsequently torn, as already mentioned in the description of the sacrifice of Isaac. The top of Isaac's head (?) remains at left. At centre and right foreground are suckling lambs and the figures of three reapers harvesting full-headed ripe wheat. The faces and legs of three workers are sketched, though only two pairs of arms and one sickle are depicted. The harvesters wear shoes. One wears short, rolled stockings. Except for the pen-darkened hair of two persons, there is no colour .

COMMENTS: This scene, complete with flocks and servants harvesting wheat, is depicted in the Mosan Psalter fragment, fol. 3ʳ, in conflation with the confrontation between Isaac and Abimelech, depicted in the next image of the Egerton Genesis (fol. 14ʳ, upper left).

Folio 14ʳ

94. Fol. 14ʳ, upper left: Isaac's conflict with the Philistines over the wells, his subsequent alliance with Abimelech (Genesis 26. 15–22, pl. XXIX)

DESCRIPTION: A crowned Abimelech gives instructions to his workers to seal the wells, which had existed from the time of Abraham, by filling them with earth. With a gesture of his left hand he asks Isaac to leave. Isaac, repeating the gesture, complies with the request (verses 15-17). Four workers shovel vigorously. Two are standing within the two wells and two work behind the wells. Abimelech, Isaac, and the workmen wear shoes.

Fols 14 and 15, conjugate leaves with fols 8 and 9 respectively, have more colour and are more nearly finished than the previous four folios. Isaac's robe is lined with pink; Abimelech's cloak is lined in orange-gold; that of his attendant in green. Faces and hands have touches of orange. A gold-wash thread edges the cloak and tunic of Isaac and those of Abimelech. The king's crown is also gold wash. The ground is green with an overlay, in rows, of white vertical strokes which suggest blades of grass. This technique was used earlier, as on fol. 3ʳ, upper half.

COMMENTS: The simple biblical account seems to be illustrated here, rather than the more involved one of Peter Comestor. In the scene of stopping the wells in the Paduan Bible in Rovigo, fol. 18ʳ, lower left, four Philistines work at shovelling earth, as in the Egerton Genesis. The departure of Isaac is depicted in the scene following.

95. Fol. 14ʳ, upper right: Isaac is told of his future descendants; a well is excavated. (Genesis 26. 23–25, pl. XXIX)

DESCRIPTION: God appears to Isaac in Beersheba to reassure the kneeling patriarch of his blessing and of his progeny to come. At the top of a high, steep hill, Isaac kneels with hands together in prayer, looking up at the vision of the Deity, whose face appears from a two-tiered notched cloud in the upper right corner. The altar mentioned in verse 25 is partially depicted

in front of him. Below the hill, Isaac's servants sink a large well, already gushing with water. One wields a shovel; the other, depicted from behind with his face as a lost profile, holds up a flat-bottomed container. Both servants have hitched up their tunics for work, so that the bare buttocks of the second servant are comically revealed. A simple structure with two arched windows and a tall arched doorway stands at left.

The face of God is oxidised silver and his halo blue with a gold-wash cross. The two tiers of the notched cloud are washed with blue and red. Isaac's face and the shoulder of his cloak are touched with an opaque grey-gold, and his cloak, edged with a gold-washed thread, has a rosy pink lining. The nude buttocks of the servant at right are stained with pink. The roof of the structure at left is blue with a silver-washed ball above the gable.

COMMENTS: The source here seems to be the simple scriptural account. Nothing reflects Peter Comestor's more complicated explanation of events. The architectural structure at left is seemingly otiose here, as it is in scene 89, where it is in the same relation to Rebecca's hill. In Chapter 4 we discuss this repeatedly depicted structure as a possible stage prop. The episode of God's appearance to Isaac, including the bare, squarish altar, is depicted in the twelfth-century Mosan Psalter fragment, fol. 3ᵛ.

96. Fol. 14ʳ, lower left: Isaac's feast for Abimelech (Genesis 26. 29–30, pl. XXIX)
DESCRIPTION: The scene depicts the feast which Isaac gave for Abimelech after the two have agreed to live in peace. The crowned Abimelech, who has come to Beersheba to consult with Isaac, is the central figure at table. He is seated in front of an elaborately woven backdrop. To the immediate left, a person with caricatured face gestures toward the king, who glances in his direction; to the right, a man cranes his head forward and to the side to participate in the conversation. These two may be Ahuzzath and Phicol, who accompanied Abimelech from Gerar; or the man at left might be Isaac. Their avid attention to the ruler is comical. At far left, a person eats; at far right, a person drinks from a bowl.

The tapestry behind the king is beautifully painted. The blue squares with white cross-and-dot motif are enclosed by red vertical and horizontal bands dotted with white. The hanging rod and braces are brown. Abimelech's cloak has an orange lining and is edged with a gold-wash thread. The cloak of the attendant to the right of the king has a green lining, and those of the other diners are lined in low-intensity red. Grass in front of the table is green with an overlay of white strokes.

COMMENTS: This scene is illustrative of the Vulgate account. Peter Comestor does not mention the feast.

97. Fol. 14ʳ, lower right: The oath between Isaac and Abimelech and the discovery of water at Beersheba (Genesis 26. 31–33, pl. XXIX)
DESCRIPTION: The text for this story is in both the Vulgate and Peter Comestor. Isaac clasps right hands with Abimelech as the oath is sworn. Two bearded three-quarter faces of

witnesses are behind the face of Isaac, though only three feet are shown at ground level. Two advisors (Ahuzzath and Phicol?) stand as witnesses behind Abimelech. A small kneeling figure at left points with his left hand to the newly-found well behind him. He attempts to attract the attention of Isaac to his discovery by touching his cloak with his right hand. The flowing well behind the kneeling figure resembles the vaulted culvert on fol. 11ʳ (10ʳJ), upper left.

Here the green ground is much rubbed. The crown is washed in gold, and a gold-wash line edges Abimelech's mantle. The linings of mantles alternate in colour from left to right: green, red, green, red, green, red.

Folio 14ᵛ

98. Fol. 14ᵛ, upper left: Esau's Hittite wives (Genesis 26. 34–45, pl. XXX)
DESCRIPTION: A frontal Esau, now a long-robed, bearded person of importance, is shown with his wives, the two Hittite women, Judith and Basemath. The two women seem to be addressing Esau in a lively manner. They face him as mirror-image profiles, each gesturing toward him with one upraised hand, the other hand clasped by one of Esau's. Isaac, seated at the doorway of the familiar modest house so often used as scenic decor by this artist, gestures in disappointment. He has turned away from the three figures at his left.

Isaac's mantle is lined in pink; the mantle of the wife at left has a dark pink lining; Esau's is orange. The lining of the garment of the wife at right is not shown. Kerchiefs of both wives are cream-coloured and their faces and hands are splotched with orange. A gold-wash line partially edges the cloaks of Esau and his wives. The rooftop is blue, and the grass is green with an overlay of white strokes.

COMMENTS: This dramatic image includes more than the simple statements in the biblical text about Esau's marriage and the disappointment of his parents. Esau seems to be vaunting his own power in the power of his wives, a detail in Peter Comestor's account.[84] A sense that the women are offending the soul of Isaac and that he has made a decision to remain silent reflects the commentary in the *Historia Scholastica*.[85] The scenes on fol. 14ᵛ and the first three on 15ʳ seem to succeed one another as actions in a play.

99. Fol. 14ᵛ, upper right: Esau is sent to hunt game. (Genesis 27. 1–13, pl. XXX)
DESCRIPTION: Isaac, seated in the doorway of the familiar small structure, instructs Esau, now clad in the short costume of youth, with a gesture of his left hand, to hunt game for him to eat before he receives his blessing. The hairy Esau carries his bow and arrows. Rebecca, with her back turned toward Esau and Isaac, plots with Jacob so that he may receive the blessing which should be Esau's. She holds Jacob by his left arm while pushing him by his shoulder off-scene to the right. Jacob is still objecting (verses 11 and 12). Isaac's eyes are open, but weak. He does not look at Esau's face. The two sons wear shoes. Esau's commission to hunt is suggested by the hares in the ground holes at right.

The grass is green, overlaid by white strokes; the rooftop is blue and the bow, brown. Animals are orange-brown. Robe linings are orange for Isaac and dark pink for Rebecca, both of whose cloaks are outlined with a gold-wash thread. Rebecca's kerchief is a silvery-peach colour and there are splotches of an indeterminate colour on her robe, on her face and hands, and on those of Jacob.

COMMENTS: Here the artist closely follows the scriptural account. Peter Comestor's account is much slimmer, less vivid. Esau has been demoted from his dignity in the previous scene to the status of an unbearded, short-haired and extremely hairy youth wearing a brief dress. This seems particularly strange since the 'stage set' remains exactly the same. It is as though another differently costumed Esau, an actor, has entered the scene at the departure of the elegantly robed Esau as husband in the previous scene. The bristly Esau compares to the nude bristle-man on fol. 7ʳ of the St Omer Psalter (fig. 11). Hares or rabbits in their burrows are found in a number of English, Flemish, and Franco-Flemish manuscripts of the early fourteenth century, as witness the many examples in Randall's index.[86]

The story of Jacob's stealing Esau's blessing is told in five episodes—this scene and the four succeeding—in the Egerton Genesis. Lengthy treatment of this story is typical of fourteenth-century Genesis illumination.

100. Fol. 14ᵛ, lower left: Jacob approaches Isaac for the blessing. (Genesis 27. 16–19, pl. XXX)
DESCRIPTION: Isaac, now unmistakably blind, sits in the same position in the doorway of the little house at left. In front of him is a small table covered by a cloth; on it rest two triangular slices of bread. Rebecca pushes Jacob toward his father. His hands and neck are covered with the hairy animal skin which his mother has devised for him. He carries a bowl containing a rabbit whose ears are still perked up.

Grass and rooftop are coloured as in the scenes preceding. The tablecloth is a beigey-peach with light blue shading. The bread is golden yellow. Rebecca's kerchief is a silvery peach. Jacob's face, sleeves, and shirt are touched with a deeper peach colour. Isaac's and Rebecca's cloaks are edged with a gold-wash line.

COMMENTS: The rabbit, unlike the hare, was not indigenous to England. Introduced in the thirteenth century, rabbits were protected from an inhospitable climate in artificially created warrens in East Anglia. Considered a desirable gift, sixty rabbits were sent to Edward III by the Prior of Ely in 1345. Conversely, the hare, being pursued by Esau in the next image, was easily acquired game. After the Black Death, with the decline of agricultural acreage in use, the cultivation of rabbits was increasingly an alternate source of income on the poorer lands of East Anglia. It is interesting to speculate on the artist's choice of the more desirable gift at the hand of Jacob, seeking his father's blessing by stealth, whereas Esau hunts more ordinary game, the hare, for his offering.[87]

101. Fol. 14ᵛ, lower right: Esau hunting (Genesis 27. 5b, pl. XXX)

DESCRIPTION: Esau, his tunic hiked up to permit vigorous action, his hairy legs widespread, aims his arrow at a hare attempting to escape at right. A tree over Esau's head leans in the direction of the game, as though to encourage the hunter. Five ball-topped and two flat-topped trees seem to climb the hill. Hares appear and disappear in the ground.

Here the grass and trees are green. The bow is beige and brown. There are deep peach spots on Esau's arm and tunic.

COMMENTS: For hares and rabbits, see comments on the two preceding scenes.

Folio 15ʳ

102. Fol. 15ʳ, upper left: Jacob receives his father's blessing. (Genesis 27. 20–29, pl. XXXI)

DESCRIPTION: The setting is the same as in the first three scenes of fol. 14ᵛ; here, three legs of the small table are visible beneath the cloth. Jacob's gloved hands still hold the bowl which he has set on the table in front of Isaac. Around his neck is the goatskin mentioned in verse 16. He rests on one knee before his father who makes the sign of blessing over his head. Rebecca stands at right, her hands held out in a gesture of anxiety.

The bowl with the food is yellow, as are the two slices of bread beside it. The folds of the tablecloth are touched with peach and shaded with silvery grey. Blue is used for the lining of Isaac's mantle. Rebecca's kerchief is silver with peach touches; her cloak is lined in a bright orange. A gold-wash thread edges the cloaks of Isaac and Rebecca. The grass is green, overlaid with white strokes.

103. Fol. 15ʳ, upper right: Isaac refuses to bless Esau. (Genesis 27. 30–40, pl. XXXI)

DESCRIPTION: The setting is the same as in four of the five preceding scenes. In this highly theatrical scene the hairy Esau weeps bitterly to discover that Jacob has stolen his blessing. His contorted face and clasped hands express his despair. Jacob stands behind Esau. He turns his head to look at his mother at his left. Both Jacob and Rebecca point toward the scene of Esau's disappointment. Jacob's expression is one of comical uncertainty, while his mother's face displays satisfaction.

The tablecloth is a peachy beige; the bowl and bread are yellow. Flesh has peachy-beige touches. The twins' tunics and Jacob's legs have brownish beige touches. Rebecca's kerchief and the lining of her cloak are coloured as in the scene preceding.

COMMENTS: This scene in the Mosan Psalter fragment, fol. 4ʳ, shows Esau grimacing in distress, as in the Egerton Genesis.

104. Fol. 15ʳ, lower left: Isaac sends Jacob to Paddan-aram; Esau marries Mahalath. (Genesis 27. 46–28. 9, pl. XXXI)

DESCRIPTION: The setting is the same as before, minus the table. Two scenes are represented in this image. In the left half of this double scene, Rebecca, concerned for Jacob's safety,

brings him before his father with the complaint that he must not marry among the Canaanites. Isaac, with a gesture of his hands, agrees to send Jacob away to seek a wife among his mother's people. Rebecca, between the figures of the seated blind Isaac and the youthful Jacob, presses Jacob's shoulder with her right hand. She points to Isaac, who is blind as before and in the same seat in the doorway. Jacob listens obediently to his father's advice, his arms crossed before him in a gesture of filial respect.[88] Isaac's hands assume a speaking gesture.

The right half of this same quadrant illustrates Genesis 28. 9. Esau, no longer hairy, is marrying a third wife, Mahalath, daughter of Ishmael, who is more acceptable to Isaac than Esau's two Canaanite wives depicted at far right. He clasps hands with the young woman who wears the coiffure of an unmarried girl, while his first two wives gesture toward the event, one in curiosity, the other in surprise.

In this quadrant, Rebecca wears a pink veil. The kerchiefs of the three married women are peach in colour, and more touches of peach are found on faces, hands, and clothing of all figures in the scene. Isaac's mantle is lined with blue; Rebecca's with vermilion; those of the two wives with brownish gold and low-intensity red. The grass is green.

105. Fol. 15ᵛ, lower right: Jacob's ladder (Genesis 28. 12–14, pl. XXXI)
DESCRIPTION: This scene is badly damaged. A large part of the parchment at the edge is gone. The figure of Jacob, presumably asleep on his stone pillow at lower right, is completely lost. What appears to be the top of a bush or ball-topped tree is partially visible above the torn section of parchment. The image of the ladder which rises obliquely from lower left to upper right in the scene survives. Here two child-like angels climb the ladder. The lower one looks downward at the sleeping Jacob; the upper one looks at the Deity standing on a higher rung.

The Deity, whose face, hands, and feet are silvered, looks downward and points with his left hand, toward the sleeping Jacob. The silver, intended to brighten the scene, is now black. The angels' garments are a peachy silver colour with monochrome penwork shading. Their wings are a golden peach striped with green. Gold wash covers their hair; gold-wash threads are in their wings. Intense orange colours the faces and hands of both angels and the foot of the lower one. God's robe is the same cerulean blue as on fol. 1. His mantle is gold wash, shaded with red, and his nimbus has a red-orange cross with blue between the spokes. The ladder is orange-brown, and the grass and tree, both much rubbed, are green.

COMMENTS: It is odd that this badly damaged image is yet in possession of much of its original colouring of the figures. Henderson considered the figure of God to be headless, with a halo only.[89] However, the face and beard are represented, though they are obscured by the oxidised silver covering them. The angle of the halo's disk is confusing. Close examination eliminates the necessity of Henderson's hypothesis that the Egerton Genesis artist was using for this scene a Jewish model of the Deity without a head. Henderson stated that the presence of God on the ladder, unusual in the iconography for this scene, indicated that the Egerton Genesis artist copied this image from a similar one in the manuscript of Ælfric's Paraphrase of the Hexateuch.[90]

Folio 15v

106. *Fol. 15v, upper left: Jacob anoints the stone used for a pillow in the dream of the ladder. (Genesis 28. 18–22, pl. XXXII)*
DESCRIPTION: Jacob's face is intent and his mouth is open as he names the place Bethel and makes his vow to the Lord. Jacob pours thick oil from a carafe in a snake-like wave. The Deity looks down from a notched cloud of two tiers, at a lower level than usual, at the right side of the scene. Behind Jacob's back, taking up almost half of the quadrant, is a double-towered entrance to a walled city, within which the rooftops of four structures are visible.

There is more red in this scene than in any other picture of this manuscript. The lining of Jacob's ample mantle is vermilion. A gold thread edges Jacob's cloak and peachy smudges are on his face and cloak, and on the carafe. The halo of the Deity is blue with a silver cross, and his face is silvered. The rooftops are pink and blue, and the left tower has peachy-beige shading on its left side. The grass is green, overlaid with white strokes.

107. *Fol. 15v, upper right: Jacob at the well; Rachel's approach (Genesis 29. 1–10, pl. XXXII)*
DESCRIPTION: The well is in the centre, with three shepherds at the right and a single flock rather than the three mentioned in verse 2. Two young shepherds stand before a bearded figure who wears the now-familiar pilgrim's or traveller's hat and holds the knob-topped *bordon* which accompanies the traveller in this manuscript. This appears to be Jacob, suddenly transformed from his more youthful self of the preceding images, as Esau was on fol. 14v. The two shepherds in front are in serious discussion. They look one another in the eye. The shepherd at right, his tunic tucked into his waistband, places his hands on the shoulder and chest of his companion, who holds a curved stick. These young shepherds have the familiar stocky, thick-legged figure of the youth or worker, with short curly hair and short dress. A third shepherd, at far right, in dignified dress but with short hair listens as Jacob inquires about Rachel, who approaches with her sheep from the far left of the image.

Rachel wears a grey or silvered veil, a headdress unusual for an unmarried woman in the Egerton Genesis. The sheep on the left are beige, and the water is blue. Jacob's hat has a brownish-orange lining and his cloak is lined with a low-intensity red. A gold-wash thread lines his cloak. Rachel's face is touched with orange, as are those of the other figures, along with splotches of a darker colour. Grass is coloured as in the scenes preceding.

108. *Fol. 15v, lower left: Jacob greets Rachel. (Genesis 29. 10–11, pl. XXXII)*
DESCRIPTION: This scene is severely damaged by the loss of the lower edge, as mentioned above in the discussion of the recto of this folio. At centre is the stone which has been removed from the well. Laban's sheep, herded to the well by Rachel, are drinking at lower right. Above the torn lower edge, the upper part of the figures of Jacob and Rachel are visible. Jacob embraces and kisses Rachel.

Jacob's cloak, lined with brownish orange, has a gold-wash thread edging. Sheep are brownish grey, the water, blue-green, and the grass, green.

109. Fol. 15ᵛ, lower right: Jacob at Laban's house (Genesis 29. 16–19, pl. XXXII)
DESCRIPTION: At right, Laban stands in the doorway of a modest structure. A simple build-ing such as this often appears at left in Egerton Genesis scenes. Laban's two daughters stand before him. Jacob, dressed in long tunic, mantle, and shoes, raises his left hand as a signal to Laban. With his right index finger he points to Rachel, the shorter (younger) of the two daughters. Laban holds Rachel by her left arm, as though offering her to Jacob. Leah, the elder of the two, touches Rachel's right hand which is held out in a gesture of surprise. She seems to present her sister, along with Laban.

The lining of Jacob's cloak is vermilion. The kerchiefs of Leah and Rachel are brownish peach in colour; the same colour is used on projecting folds of the garments of all four figures and in touches on their faces. A gold-wash thread lines Laban's robe at the neck. Grass is green, and the rooftop blue.

Folio 16ʳ
(This final gathering of five folios consists of line drawings only.)

110. Fol. 16ʳ, upper left: The deception of Jacob with Leah (Genesis 29. 23, pl. XXXIII)
DESCRIPTION: Zilpah, bracing herself on the inner ruled margin of the scene, bends over the sleeping form of Jacob to cover Leah, on the viewer's side of the tilted bed. Both Jacob and Leah wear nightcaps. Zilpah has the kerchief of the married woman. Drawn at the foot of the bed, in front of a wattled enclosure, are numerous small sheep.

COMMENTS: The artist modifies the biblical account by having Zilpah, rather than Laban, bring Leah to Jacob. The artist's source here is probably the *Historia Scholastica* (ch. 74, col. 1115).

111. Fol. 16ʳ, upper right: Rachel is given to Jacob. (Genesis 29. 28b, pl. XXXIII)
DESCRIPTION: Laban gives his younger daughter to Jacob. Seated in the doorway of the familiar small house at left, Laban joins Jacob's hand with Rachel's hand. She still wears the maiden's coiffure. Jacob here wears the costume of the dignified older man. He touches his breast with his left hand in the gesture of blessing. Rachel raises her own left hand in acqui-escence. Visible behind Rachel, on the far side of the small house, is the upper part of the fig-ure of Leah, who is coiffed as a married woman.

112. Fol. 16ʳ, lower left: Rachel presents Bilhah to Jacob. (Genesis 29. 32–30. 3, pl. XXXIII)
DESCRIPTION: Leah stands at left, gesturing toward her children by her side. There are three visible children, though four are mentioned in the story. Jacob at centre gestures upward, as though to ask Rachel if he is God that he can give her children. Rachel, addressing Jacob with open mouth, presents to him her slave girl, Bilhah, that she may bear him a child in her (Rachel's) name. Bilhah, at far right, wears the coiffure of the childless concubine or the apparent prostitute. (See Chapter 4 on costumes.) No setting is indicated.

113. Fol. 16ʳ, lower right: Rachel, Leah, Jacob, and the mandrakes (Genesis 30. 14–16, pl. XXXIII)
DESCRIPTION: At left, Leah's oldest son, Reuben, having found mandrakes during the wheat harvest, holds them over his shoulder to present them to his mother. Leah looks at Jacob, the central figure. She points to the humanoid mandrakes with her left hand while holding Jacob by the wrist with her right hand. Jacob, in the tunic of a worker but with the long mantle of dignity, holds over his shoulder in his left hand a ploughshare, perhaps a phallic symbol and certainly indicative of his day spent in the fields (verse 16). Rachel, behind him with one hand on his waist and the other on his shoulder, pushes Jacob toward her sister. Curiously, Rachel once again wears the costume of the unmarried woman, a simple dress with bare head and braids over the ears, perhaps to suggest her childlessness. No setting is indicated.

COMMENTS: . The man-shaped roots of the mandrake are hanging downward here as in the marginal bestiary drawing on fol. 119ᵛ of the Queen Mary Psalter.

Folio 16ᵛ

114. Fol. 16ᵛ, upper left: Jacob's bargain with Laban (Genesis 30. 32–36, pl. XXXIV)
DESCRIPTION: Laban is seated at left in the doorway of the familiar small house. On the viewer's side of the house at far left stand Jacob's two wives and two concubines, all of whom wear the kerchief of a married woman. Jacob stands before Laban in a short tunic and a mantle. The artist has drawn a shoe on his right foot, while on the left foot he has mistakenly indicated toes, though he has attempted to correct the mistake. Laban holds up his right hand in a gesture of agreement with Jacob's proposal for dividing the herds and indicates the flocks behind Jacob with his left hand. Jacob points to Laban with his right hand and to the flocks behind him with his left. The flocks have been divided; one group faces to the right, in front of a group of eleven children, one girl and ten boys; the other group stands beside Jacob, facing him.

COMMENTS: This image is problematic, in part perhaps because the text is unclear, its ambiguities eliciting commentary from Comestor (*HS*, ch. 78, cols 1117, 1118) and even Jerome. According to the biblical text, Laban gave the black and speckled sheep to his sons and insisted that there be a three days' journey between himself and Jacob. The identity of the children is uncertain; are they the sons of Laban, accompanied by an unexplained girl, or are they ten of the sons of Jacob accompanied by his daughter Dinah?

115. Fol. 16ᵛ, upper right: The peeled rods and the mating animals (Genesis 30. 37–42, pl. XXXIV)
DESCRIPTION: Jacob, at centre, arranges the peeled wands in front of the sheep, who gather to drink. Two pairs mate. Jacob wears a robe of mid-calf length, a mantle, and shoes. A woman and three male figures stand behind him. Another flock, perhaps the weaker animals mentioned in the text, huddles in front of the woman.

COMMENTS: Scenes of copulating animals are usually in marginal illustration rather than in miniatures. Randall cites examples in the margins of fols 24ᵛ, 111ᵛ, 137ᵛ of Oxford, Merton College, MS O.1.3, a late thirteenth-century French copy of Aristotle's *De Historiis Animalium*;[91] Camille reproduces an example from fol. 84ᵛ of Paris, Bibliothèque Nationale, MS lat. 16169, a copy of Albert the Great's *De Animalibus*.[92] In Oxford, Exeter College, MS 47, the Psalter of Humphrey de Bohun, the first decorative campaign of which probably predated 1361,[93] this same scene is rendered in more abbreviated form in an initial on fol. 28ᵛ and includes a pair of copulating sheep. In the fourth bay of the nave of Norwich Cathedral, a roof boss depicts the seated Jacob peeling a wand while mating animals are at the water's edge on either side of him.[94]

116. Fol. 16ᵛ, lower left: Laban's search for his stolen gods (Genesis 31. 33–37, pl. XXXIV)
DESCRIPTION: Laban, looking for his gods, confronts Rachel who sits in front of her tent (the usual small structure). Seated on the concealed idols, she vigorously gestures toward her father with both hands, indicating that because of her menses she cannot rise to permit him to search for his gods. Laban, wearing a bascinet and chain mail camail, stands before her, raising his right hand toward her in an inquiring gesture. At far left are two or three helmeted soldiers, possibly the kinsmen of Laban mentioned in Genesis 31. 23. The foremost, who gestures with his hand on his chest, wears a *cyclas* over *haubergeon* and *hauketon*, and *jambarts*. The man behind him gestures toward Rachel. A river, the Euphrates mentioned in Genesis 31. 21, separates the soldiers from the group at right. Rachel's tent is on a grassy hillside, articulated in diagonals, perhaps the hill country of verse 25.

117. Fol. 16ᵛ, lower right: The division of Jacob's household (Genesis 32. 7–8, pl. XXXIV)
DESCRIPTION: Jacob is dividing his *ménage* into two groups in preparation for meeting his brother Esau. Jacob stands at far left, holding his staff with his left hand. His animals are in front of him, some facing him and some moving in the opposite direction. The two women at the centre, along with the two women at right, separate their children into two groups. Among the children of Jacob and his four wives is Dinah, his only daughter. The women at centre point to the two women at right, who gesture downward toward the children.

Folio 17ʳ

118. Fol. 17ʳ, upper left: Jacob wrestles with the angel. (Genesis 32. 22–26, pl. XXXV)
DESCRIPTION: The story of Jacob's family crossing the ford of Jabbok and of Jacob wrestling with the angel (man) is here depicted. At left, Jacob's two wives are labouriously traversing a deep and rushing stream. They carry or help four children to cross. The wife at far left is struggling with the help of a stout stick in her left hand, with a child under her right arm and another clinging to her neck from behind. The nearer mother carries a child on her back while another child, clutching his mother's garment, struggles across the water. Where the river curves at the bottom of the scene, eleven sheep swim or wade upward across the water. The women with their children and the sheep seem to be going in the wrong direction.

In the biblical account, verses 23, 24a, they cross the stream, leaving Jacob alone on the other side. At centre right, a wrestling match is in progress between the angel in a feathered suit and Jacob in his short tunic, leggings, and shoes. The setting is a grassy hillside articulated with grass in a diapered pattern, like that of fols 4ᵛ, upper left and right, and 14ʳ, upper right.

COMMENTS: Perhaps the artist took the liberty of having the women and children cross the ford toward Jacob for the sake of making a more compact and pleasing composition. In place of the shallow ford (*vadum*) mentioned in the Vulgate and in the *Historia Scholastica*, the body of water seems more like the rushing torrent (*torrentem*) of Josephus, which Peter Comestor mentions in his discussion of this text.[95] This image of the wrestling figures and the costume of Jacob's adversary has parallels in the medieval theatre.

119. Fol. 17ʳ, upper right: The reconciliation of Jacob and Esau (Genesis 33. 1–4, pl. XXXV)
DESCRIPTION: At centre, Esau embraces and kisses Jacob, who crosses his hands before him in a gesture of submission. At left, the handmaids and their children walk immediately after Jacob, while Leah and Rachel follow. Leah pushes one of the foremost women by the shoulder with her left hand; her right hand touches the head of a small child. A slice of the profile of Rachel is represented at far left. Fifteen crowded bodies and superposed heads suggest the four hundred followers of Esau.

COMMENTS: The two central figures of the twin brothers are particularly gracefully drawn. The heavy folds of Esau's voluminous gown and his gesture of forgiveness make him the strong figure of this image. The elaborate snood of the foremost woman is remarkable.

120. Fol. 17ʳ, lower left: Jacob buys land and builds an altar at Shechem. (Genesis 33. 18–20, pl. XXXV)
DESCRIPTION: The altar, mentioned in verse 20, is being built in this scene. A carpenter, with hammer and hatchet in his belt, constructs the arch above him. He is seen from the rear, with head turned back and arms upraised. At right in this scene, Jacob is buying the field in Shechem. He gestures with his left hand toward King Hamor of Shechem. With his right hand he offers the lambs at his feet in exchange for the ploughed field behind the two figures, depicted as if viewed from above. The figure of Hamor, a crowned king, stands superimposed upon the field indicated by wavy vertical lines behind him. He gestures toward the lambs huddled at Jacob's feet.

COMMENTS: The pose of the workman is similar to that of the sculptor at work on the tabernacle at lower right on fol. 8ʳ. Here, however, the altar's canopy is as yet a simple wooden frame and the workman is a carpenter rather than a mason.

The literary source for this scene in the Egerton Genesis is not readily identifiable. Confusion results from the translation or scribal transmission of the text in the Hebrew Bible. Both the Kohlenberger and Alter translations record that Jacob bought the land from the sons of Hamor,

called here the 'father of Shechem'.[96] Moreover, the Hebrew text uses the word *kesitah* as the medium of exchange, a term meaning measures of silver and gold weight or, by extrapolation, a unit for the barter of livestock from which the monetary term was derived.[97] Peter Comestor's Jacob purchases part of a field from Hamor and also purchases the 100 lambs from his sons.[98] In the Vulgate, Hamor is not mentioned as seller. Jacob purchases the part of the field from Hamor's sons for 100 lambs.[99] Thus, the Egerton Genesis artist shows Jacob purchasing the land from a different person and with a different medium of exchange from those described in the Hebrew text. In this scene in the Egerton Genesis, Jacob gestures toward Hamor with his left hand while pointing to the lambs at his feet. It is Peter Comestor who calls Hamor a king, *rege Sichimorum*. The Hebrew Bible and the Vulgate refer to him as the father of Shechem. In sum, the artist perhaps follows a version unknown to us. He may even offer his own personal version.

121. Fol. 17ʳ, lower right: Dinah visits the women of Shechem and is raped. (Genesis 34. 1–2, pl. XXXV)
DESCRIPTION: Dinah is represented three times in this miniature. In the central image, Dinah greets a Shechemite woman, a mirror image of herself. At right, a married woman leans into a small shop in which knives, purses, belts, and jewelry are displayed (fig. 46). She

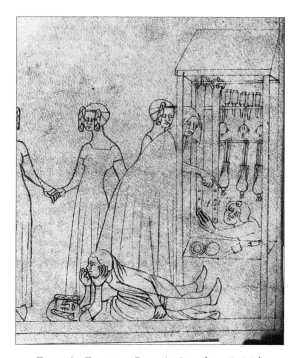

FIG. 46: Egerton Genesis. London, British Library, Egerton MS 1894, fol. 17ʳ, lower right, detail: Shop with purses, knives, and belts; rape of Dinah (Photo: British Library, London)

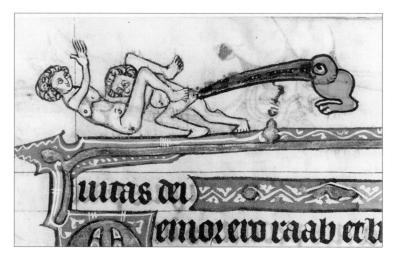

FIG. 47: Book of hours (partial). New York, Pierpont Morgan Library, MS M. 754, fol. 16ᵛ, detail, upper margin: Sexual intercourse (Photo: Pierpont Morgan Library, New York)

indicates what she wishes to buy, apparently dropping pieces of money into the hand of the shopkeeper who is seated behind his counter. Dinah stands behind this buyer, awaiting her turn. On the ground in front of the shop, the son of Hamor is in the act of raping Dinah, who tries to push his head away with both hands. At far left is the left half of the figure of Hamor. He looks downward, calmly witnessing the event.

COMMENTS: The biblical account does not mention that Dinah went into Shechem to shop during a festival to buy ornaments from the women of the region. This is a comment of Peter Comestor who refers to Josephus.[100] Knives and purses became fashionable presents in Norwich in the latter part of the fourteenth century. In the camera rolls of the *magister celarii* of Norwich Priory, knives, rings, brooches, purses, and occasionally buckles are listed among the expense records, almost certainly as gifts for ladies.[101] A similar shop is depicted in a copy of the *Vie de Saint Denis* of around 1317, Paris, Bibliothèque Nationale, MS fr. 2091, fol. 99ʳ. In the Paris manuscript, the shopkeeper shows a customer her wares, which include wallets and knives.[102] The rape scene in the Egerton Genesis is surprising. Such explicit treatment of sexual activity is to be found in borders of early fourteenth-century manuscripts, as in New York, Pierpont Morgan Library, MS M. 754 , fol. 16ᵛ, upper margin (fig. 47);[103] but usually rape and intercourse are treated less explicitly in miniatures, as in the version of this episode in the Paduan Bible in Rovigo, fol. 24ᵛ, upper left.

Folio 17ᵛ

122. Fol. 17ᵛ, upper left: The treacherous agreement with the Shechemites (Genesis 34. 6–24, pl. XXXVI)
DESCRIPTION: Hamor, his son, and an attendant emerge from the city gate. Hamor makes an agreement with Jacob that his son will marry Dinah on condition that all Shechemites be circumcised. Jacob at centre clasps right hands in this deceitful agreement with Hamor, who stands in an entranceway flanked by two round, crenellated turrets. The intended deception is reflected in the expression on Jacob's face and on the face of one of his sons who is greeting three Shechemites at right. Beneath the raised joined hands of Hamor and Jacob, a Shechemite is seated, in the act of circumcising himself.

123. Fol. 17ᵛ, upper right: The slaughter of the Shechemites (Genesis 34. 25–26, pl. XXXVI)
DESCRIPTION: The sons of Jacob take revenge for the rape of Dinah. The scene takes place within a circular battlemented enclosure, seen from above, flanked by twin towers. Two sons of Jacob in armour with dissimilar helmets hack at the heads of two Shechemites with sword and battle axe. The king is killed by a blow of the sword through his eyes. Behind are piled the mutilated dead. At the entrance to the left tower, Jacob witnesses the scene, his hands clasped in front of him.

COMMENTS: The twelfth-century Mosan Psalter fragment, fol. 5ᵛ, depicts this scene; as in the Egerton Genesis, the violence takes place within a crenellated enclosure flanked by towers. Depicted yet again within a crenellated enclosure, the scene appears in Oxford, Exeter College, MS 47, fol. 33ᵛ, at the bottom of the page.[104]

124. Fol. 17ᵛ, lower left: Jacob's altar at Bethel; the burial of the pagan gods (Genesis 35. 1–7, pl. XXXVI)
DESCRIPTION: At upper right in this quadrant, the Deity points to Jacob from a two-tiered notched cloud. Jacob kneels at the altar he was told to build in Bethel in verse 1 and which is mentioned again in verses 3 and 7. On and beside the altar are sacrificial animals, at least four in number. At left, members of Jacob's household are burying under a tall (terebinth) tree near Shechem the foreign gods which Jacob asked to be put away (verse 2). One man digs the earth under a large tree with a pick. Behind the digger, with his face looking downward, is a second man holding in his arms an idol which resembles a human baby.

COMMENTS: Peter Comestor mentions that Jacob made an offering on the altar at Bethel, a detail not in the biblical account.[105] Both the biblical account and Peter Comestor have Jacob himself, rather than assistants, hiding the gods under the terebinth tree near Shechem.

125. Fol. 17ᵛ, lower right: The death and burial of Rachel (Genesis 35. 16–19, pl. XXXVI)
DESCRIPTION: In this scene the artist represents the death of Rachel at the birth of Benjamin and her burial on the way to Bethlehem. The dead or dying Rachel is shown at left,

covered, in a bed tilted toward the viewer. At the foot of the bed, a midwife draws Benjamin out from under the bed covering, his head held in her two hands. At left, behind the bed, two mourners hold each other's hands, their faces contorted with grief. Jacob at centre, having turned away from the recumbent figure and the mourners, grieves with clasped hands. At far right, a workman stands between two mounds of earth in the grave he has dug. Seen from the rear, his face a lost profile, he continues to shovel earth from the grave.

Folio 18ʳ

126. Fol. 18ʳ, upper left: Reuben lies with his father's concubine. (Genesis 35. 22a, pl. XXXVII)
DESCRIPTION: Reuben lies with Bilhah, who is his father's concubine and Rachel's maid-servant. Though the biblical account and Peter Comestor suggest that Jacob learned about this affair indirectly, the Egerton Genesis drawing depicts Jacob himself witnessing the scene from the door of the small house at right. He expresses surprise with a gesture of his hands. The couple face each other in the tilted bed which lies between a tower at left and the small house at right in which Jacob stands.

127. Fol. 18ʳ, upper right: The burial of Isaac (Genesis 35. 29, pl. XXXVII)
DESCRIPTION: This scene is almost a replica of the Burial of Abraham on fol. 12ʳ (13ʳJ), lower left. Here as before, three figures are on the far side of the sepulchre. The background of sympathetic trees and sharp hills is the same in both pictures. In both scenes a line of tombs is at far left. Isaac's two sons, Jacob and Esau, lay his shrouded form in the sepulchre. They have become young men again. A mourning woman (Leah?) prays between the two sons.

COMMENTS: Rose, in speaking of the three burials and resurrections in the Hegge or N-Town plays says, 'From the similarity of the stage directions and from the references within the dialogue it is probable that each burial and resurrection was staged more or less the same way'.[106]

128. Fol. 18ʳ, lower left: The dreams of Joseph (Genesis 37. 5–9, pl. XXXVII)
DESCRIPTION: Joseph is asleep in the slanted bed to which we have become accustomed (fig. 48). The form of his body is clearly seen under the bed cover. His eleven brothers, eight of them as a row of overlapping heads and backs behind the bed, are at work binding sheaves of wheat. Joseph's sheaf is upright beside the head of his bed. The brother at centre, wearing sleeves with turned-back cuffs, seems to lay his sheaf down in front of that of Joseph. The second dream is represented at far left beside and above Joseph's head. Eleven stars are on his pillow while the sun and moon are represented above.

129. Fol. 18ʳ, lower right: Joseph's arrival in Dothan (Genesis 37. 17b–22, pl. XXXVII)
DESCRIPTION: Joseph, a small figure at lower right against a backdrop of ball-topped trees, arrives in Dothan where he sees his brothers from afar as they sit grouped together plotting

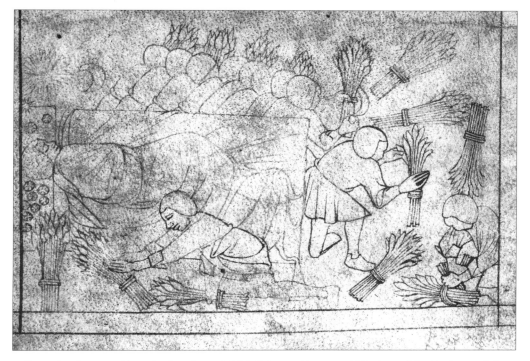

FIG. 48: Egerton Genesis. London, British Library, Egerton MS 1894, fol. 18ʳ, lower left:
Joseph's dream (Photo: British Library, London)

to do away with him. Gesturing with his right hand, he walks upward toward his huddled
brothers. He holds the handle of the knapsack over his left shoulder. Barefooted, he wears a
tunic with fringed braies. The herds are massed at the lower left. The brothers, wearing long
robes and with bare feet, are seated in a group on a hill. The three foremost centrally-placed
brothers converse seriously. The one at centre points toward Joseph, seemingly proposing that
they kill him. Reuben, at left, with hand raised in protest, pleads for Joseph's life. The flat-
topped tree behind the group seems to look upward.

COMMENTS: In the fifth bay of Norwich Cathedral, a roof boss depicts Joseph journeying
to Dothan to find his brothers. He holds a stick with a knapsack over his shoulder as in this
image of the Egerton Genesis.[107] The brothers are grouped here as in the comparable scene
in the Joseph cupola at San Marco, though the mosaic in Venice represents standing figures.[108]

Folio 18ᵛ

130. Fol. 18ᵛ, upper left: Joseph is stripped; his coat is stained. (Genesis 37. 23, 31, pl. XXXVIII)
DESCRIPTION: At centre, one brother is slitting the neck of a goat. He wears sleeves with
turned-back cuffs like those of the foremost brother in the image of Joseph's dream (fol. 18ʳ,

lower left, fig. 48). Another brother crouches, catching the blood in a dripping pan. A third brother, behind the two who draw the goat's blood, holds Joseph's long-sleeved coat on his left arm while pointing with his right to a large beast—curled up with snarling mouth, bat wings, a stump for a left paw, and a waving furry tail—behind him at far left. A fourth brother pulls off Joseph's outer garment over his head, thus revealing an elaborate pair of underdrawers with garters which hold up his fringed leggings. In the background is a large pit with a semi-circle of five trees at rear. Grass is articulated as vertical strokes in a diagonally oriented grid pattern, as seen in a number of scenes previously.

COMMENTS: Joseph's singular underclothing (gartered braies, pleated underdrawers) perhaps refers to his position as favoured child of the household. This pose of Joseph, who bends while his garment is pulled over his head, is represented on a roof boss in the nave of Norwich Cathedral, in the fifth bay of the nave.[109] The motif of the bent or crouched figure who disrobes by pulling a garment over his or her head is fairly common in manuscripts of this era. It occurs earlier in the Egerton Genesis on fol. 11v (10vJ), lower right, in the scene of Lot's younger daughter undressing; on fol. 30v of the Holkham Bible Picture Book; and on fol. 26r of the Tickhill Psalter. A Flemish example appears on fol. 57r, right margin, of Gl kgl. Saml. 3384,8°.

 The brother who points to the beast may be Reuben, attempting to call attention to his brothers' evil deed. The beast may represent their intention to deceive their father with the bloody coat. James asked whether this beast symbolised the devil inspiring the brothers.[110] Pächt interpreted this as 'nominalist representation', a literal portrayal of the words of the Genesis.[111] In the *plainte Jacob* of the *Histoire ancienne* Genesis, the beast is addressed in the second person as a real being: '*Bestes sauvage, por quoi devoras tu mon fiz Joseph e coment fus tu si creuse?*'.[112] This direct address illustrates Pächt's interpretation. However, other representations of the bat-winged snarling beast could illustrate James's interpretation or, perhaps more generally, the idea of imminent betrayal or treachery. On fol. 120r of the fifteenth-century Hours of Catherine of Cleves, (New York, Pierpont Morgan Library, MS M. 945), there is represented in the lower border a curled-up, large-headed bat-winged beast.[113] Being on the lower border of the scene of the Agony in the Garden, this beast could imply the evil of imminent betrayal, the next event in the biblical story. In a window at Gresford, a complete dragon, bat-winged and snarling, is inside Herod's crown as he witnesses Herodias' stabbing of the severed head of John the Baptist. A similar dragon emerges from the crown of Maximinus, before whom Saint Catherine stands, in an alabaster panel in the Roman Catholic Church at Lydiate in Lancashire. Anderson interprets this dragon as indicating the diabolical thoughts passing through the mind of the wearer. She relates this to a stage costume.[114] A snarling dragon in the grass occurs twice in the Netherlandish *Rijmbijbel*, in scenes with associations of treachery, in the miniature of the death of Absalom, fol. 61r and in the full-page illustration of the siege of Jerusalem, fol. 152v (fig. 49).

 The background of a pit surrounded by trees in this scene is repeated in the next two illustrations.

FIG. 49: *Rijmbijbel.* The Hague, Museum van het
boek/Rijksmuseum Meermanno- Westreenianum, MS 10 B
21, fol. 152ᵛ, detail: Snarling, dragon-like beast in the grass
(Photo: Museum van het boek/Rijksmuseum Meermanno-
Westreenianum, The Hague)

131. Fol. 18ᵛ, upper right: Joseph is sold to the Ishmaelites. (Genesis 37. 28, pl. XXXVIII)
DESCRIPTION: At centre, Joseph is drawn naked from the well by a brother who has looped
a rope around his midriff. Two Ishmaelite (Midianite) traders[115] wear stage-like costumes
which emphasise their exotic nature—tunic and short mantle with high collar fastened by four
buttons, hood surmounted by slightly domed conical helmets and spurred boots. The foremost
merchant hands a bag of money to a kneeling brother who receives the sack with his left hand
while pointing behind him toward Joseph with his right. At far right, two other brothers
empty and arrange on a square of cloth on the ground far more coins than the twenty shekels
of silver mentioned in the biblical text. The brother at far right, whose head and arms only are
shown, wears a turned-back tabbed stocking cap. Another brother bends down from behind
the camel of the traders, watching the transaction below.

COMMENTS: The domed conoid helmets of the traders may be copied from those of soldiers
in Bolognese manuscripts, as seen in an *Accursius* of the mid-1330s, Vatican City, Biblioteca
Apostolica Vaticana, MS Vat. lat. 1430, fol. 179ʳ, (fig. 50).[116] Also of interest is a miniature of
the brothers before Joseph on fol. 41ᵛ of an Italian manuscript of the *Histoire ancienne*,
Carpentras, Bibliothèque Inguimbertine, MS 1260, dating to the late thirteenth or early four-
teenth century.[117] In this image Joseph wears a domed conoid hat with a chin strap.

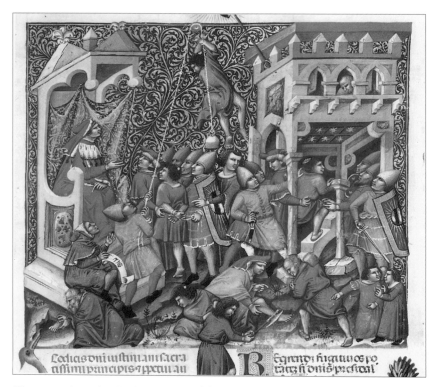

FIG. 50: *Accursius*. Vatican City, Biblioteca Apostolica Vaticana, MS Vat. lat.
1430, fol. 179ʳ, miniature: Punishment of the fugitive slaves (Photo:
Biblioteca Apostolica Vaticana, Vatican City)

132. Fol. 18ᵛ, lower left: Jacob learns the news of the loss of Joseph. (Genesis 37. 32–34, pl. XXXVIII)
DESCRIPTION: Jacob is seated in the familiar doorway at left, his hands clasped and his face
contorted in a grimace of grief. Two brothers give their version of what has happened. The
foremost son of Jacob holds Joseph's coat on his right arm while pointing to it with his left
hand. Open-mouthed, he speaks to his father. At right in the same scene are three figures; the
one at far left, beardless and wearing a mantle over a long robe or dress, is of indeterminate
sex; the other two are an older man in the clothing of a respected adult and a crouching youth
with clasped hands, bowed head, and closed eyes. The tree-encircled pit of the two preceding
scenes is partly visible behind this group of figures.

COMMENTS: The motif of a gesturing figure holding a drapery wrapped over one forearm
is found in the left margin on fol. 57ʳ of the Flemish Gl kgl. Saml. 3384,8°, immediately above
the disrobing figure mentioned as a parallel to the figure of Joseph stripped of his clothing in
the scene directly above this one in the Egerton Genesis.

The scene at the right in this quadrant is puzzling. James described this as 'Judah, Tamar behind him, approaches his son Er to betrothe him to Tamar'[118] (Genesis 38. 6). This identification is problematic because the figure whom James calls Tamar, though beardless, has the central forehead curl reserved for men in the Egerton Genesis, and because Er's grief-striken appearance is not accounted for in the text. One could identify the grieving figure as Reuben, who, on returning to the well, is distressed to receive the news that Joseph is gone (Genesis 37. 29–30). As a backdrop, the pit is more suitable for this subject, but the sudden change in appearance of the two standing brothers is surprising, and the chronology would be out of sequence, though neither of these aberrant conditions occurs here for the first time in this manuscript. This scene remains to be fully explained.

133. Fol. 18ᵛ, lower right: Tamar's exile upon the death of Judah's sons (Genesis 38. 6–11, pl. XXXVIII)
DESCRIPTION: At far left Judah, while looking at Tamar, points with his right hand to his two sons, Er and Onan, Tamar's successive husbands. They lie with naked torsos in bed together, one dead and the other dying. Judah's expression and his raised left hand express regret. Tamar emerges from the doorway, her face expressing grief and her gesturing hands surprise. Little Shelah, the third brother, who is too young to marry Tamar, is seen from the rear. His head in lost profile raised to her, he clings to her garment with his left fist. At far right, Tamar leaves the scene through an identical doorway to the one from which she entered the scene at left. She casts a glance at Shelah behind her.

Folio 19ʳ

134. Fol. 19ʳ, upper left: Judah takes Tamar for a prostitute. (Genesis 38. 12–18, pl. XXXIX)
DESCRIPTION: One of Jacob's sheepshearers at Timnath is working at centre. Four other sheep await their turn at right. In this sexually explicit scene, Judah has intercourse with his daughter-in-law Tamar, who has deceived him by disguising herself as a prostitute. Now beardless and with short hair and a loutish expression, Judah has lost all dignity; Tamar has exchanged the wifely kerchief for the face-framing braids of the unmarried woman. Judah's pledges—the signet ring, the cord, and the staff—lie beside her head. The background is diaper-patterned grass.

COMMENTS: On fol. 13ᵛ (12ᵛJ), lower left, Abraham's servant attracts the attention of Rebecca at the well by showing her similar ornaments. On fol. 131ʳ of the Ormesby Psalter there is a detail of a man offering a ring in exchange for a prostitute's favours, and on fol. 58ᵛ of the *Omne Bonum*, a young man offers the desired lady a large ring.[119]

135. Fol. 19ʳ, upper right: Tamar is saved by the articles of the pledge. (Genesis 38. 24–26, pl. XXXIX)
DESCRIPTION: At centre two men, on Judah's order, drag Tamar by a rope around her waist toward a blazing fire. She is still dressed and coiffed as an unmarried woman. She has been

deemed with child by harlotry. Upon being shown the cord, signet ring, and staff, the pledge objects, Judah, recognising the children as his own, intercedes to save Tamar. At far left, Judah gestures with his left arm to prevent the travesty, while his right hand is held up in surprise as he sees the objects which he had given the supposed prostitute, actually Tamar.

COMMENTS: The story of Tamar, not common in medieval Genesis imagery, is as graphically illustrated by the Egerton Genesis artist as is the rape of Dinah on fol. 17r.

136: Fol. 19r, lower left: The birth of Perez and Zerah, Tamar's twins (Genesis 38. 27–30, pl. XXXIX)
DESCRIPTION: Tamar's tilted bed has a striped coverlet. The kneeling midwife, whose head-cloth is secured with a knotted strip, dextrously ties the scarlet thread around the hand of Zerah. The Genesis story is that Zerah withdrew his hand and Perez was born first.

137. Fol. 19r, lower right: The sale of Joseph to Potiphar (Genesis 39. 1, pl. XXXIX)
DESCRIPTION: The artist returns to the story of Joseph. At right in this scene, a hooded figure in a long cloak points toward the central figure of Joseph with his left hand. He holds the bag of money, the price of Joseph. The Ishmaelite trader is dressed exactly as in the upper right scene of the purchase of Joseph on fol. 18v. At left Potiphar pulls Joseph by his left arm toward the doorway of the usual small structure, while motioning in that direction with his own left hand. Potiphar is stylishly dressed in a buttoned tunic with a long, fitted bodice, a short flared skirt, and a wide collar or shoulder cape. Joseph wears a tunic of medium length and a short mantle.

COMMENTS: The short, fitted costume began to replace looser dress as early as the 1330s in manuscript illumination. A number of figures wear variants of this modish apparel on fols 19 and 20 of the Egerton Genesis, giving these final pages the flavour of being latest in time. See Chapter 5 for a further discussion of these costumes.

Folio 19v

138. Fol. 19v, upper left: Joseph escapes from Potiphar's wife. (Genesis 39. 7–12, pl. XL)
DESCRIPTION: The seductress is seated before the same small stage-prop house so often seen in the Egerton Genesis. Her headdress with draped side panels is unique in this manuscript. She holds Joseph's cloak tightly with both hands, leaning backward as she exerts an effort to wrench the garment from the young man. Joseph walks from the scene at right, holding awkwardly to the garment with his left hand. He looks backward at the lady, while moving calmly but determinedly away from her.

COMMENTS: The seated Potiphar's wife is unusual; an early instance of this motif is in the Vienna Genesis (Vienna, Österreichische Nationalbibliothek, Cod. Th. Gr. 31, fol. 31r); one of several later instances is on fol. 5r of the Winchester Psalter. The expressive motif of the

stretched fabric is also found in the tightly held garment of the angel on fol. 11ʳ (10ʳJ), lower half, as Lot tries forcibly to make the visitors his guests. A similar motif is found on fol. 35ᵛ in the mid-fourteenth-century Zouche Hours (Oxford, Bodleian Library, MS Lat. liturg. e. 41), in the miniature of the Betrayal of Christ.[120]

139. Fol. 19ᵛ, upper right: Joseph is thrown into prison. (Genesis 39. 19–20, pl. XL)
DESCRIPTION: Potiphar, at right, with a commanding gesture, sends Joseph to prison. The bailiff, at left, forces Joseph toward the low door of a crenellated strong tower. His left hand is around Joseph's shoulders while in his right he holds a long-handled axe. Handcuffs hang from his right forearm. Joseph at centre, his hands bound before him, looks backward toward Potiphar. The bailiff wears a theatrical-looking costume—a backward-curved peaked cap with ornate cuffed brim, a tight-fitting tunic with puffed sleeves and a short, pleated skirt. A sword is strapped to his left side. Potiphar wears a variant of the costume he wore as purchaser of Joseph on fol. 19ʳ, lower right: a close-fitting garment with short, pleated skirt, wide collar, and long sleeves.

COMMENTS: Caps like those of the bailiff are found in manuscripts datable to mid-century or later. One such cap is worn by Pilate in the miniature of Christ before Pilate on fol. 51ᵛ of the Belknap Hours, in a private collection in Germany, dated c. 1385–1400 by Sandler.[121]

140. Fol. 19ᵛ, lower left: The dreams of the baker and the wine steward (Genesis 40. 9–17, pl. XL)
DESCRIPTION: The sleeping baker and wine steward are at opposite ends of a tilted bed with a striped coverlet. Grapes are being squeezed into a cup above the wine steward's head. At right lies the baker with bread baskets above his head. A bird is perched on the topmost basket.

COMMENTS: This badly worn scene is difficult to read.

141. Fol. 19ᵛ, lower right: The fulfillment of the dreams (Genesis 40. 20–22, pl. XL)
DESCRIPTION: At left, the baker, barefooted and dressed in a tunic, is hanging from a wooden gallows with his hands bound behind him. At centre kneels the steward, seen in partial profile from the rear. He hands a large cup to Pharaoh who is seated at table with an attendant at right who raises his right hand in a gesture of satisfaction or acknowledgement. The crowned king, the top of whose mantle is closed with a round brooch, reaches for the cup with his right hand. His left hand rests on the tilted table top, on which loaves and vessels are symmetrically arranged.

Folio 20^r

142. Fol. 20^r, upper left: The dreams of Pharaoh (Genesis 41. 1–7, pl. XLI)
DESCRIPTION: Pharaoh lies asleep, his head at the left end of a bed similar to that in the dream of the wine steward and baker on fol. 19ᵛ. He wears a nightcap, his crown placed beside him on the pillow. Wavy lines behind and at right below the cows represent the Nile from which the cows have come and beside which they stand (verse 3). The heads of seven fat cows have disappeared down the throats of seven thin ones. The second dream is represented at the foot of the bed. A field is indicated by vertical lines below the river. A stalk of grain with seven ears leans toward a straight stalk with seven thinner ears. The stem of the more luxuriant plant intrudes upon the margin at right.

143. Fol. 20^r, upper right: Joseph is prepared to appear before Pharaoh to interpret his dreams. (Genesis 41. 14, pl. XLI)
DESCRIPTION: Two courtiers prepare Joseph to appear before the Pharaoh. The crenellated tower into which Joseph was forcibly led in the upper right quadrant of fol. 19ᵛ appears in the same position at far left of this scene. Joseph is seated on a stone bench at centre with a peignoir over his shoulders and arms. His hair is being cut or combed by an attendant at centre. He is still barefooted. At right stands a second attendant, holding a clean garment over his left arm. The two servants of Pharaoh wear a simplified version of the modish costume which in this manuscript distinguishes a member of the household of an Egyptian aristocrat—a short, slim-waisted dress with a collar over the shoulders and a pleated skirt.

144. Fol. 20^r, lower left: Joseph's commission; Joseph in the chariot of honour (Genesis 41. 39–41, 43, pl. XLI)
DESCRIPTION: Two scenes are represented. At left and centre front, the enthroned king commissions Joseph commandant of Egypt. The crowned Pharaoh, on a three-tiered throne, is seated on a pillow tied at one end, with his feet resting upon another pillow. With his left hand he gestures toward the kneeling Joseph, now with a short, forked beard. Above, behind the kneeling figure, is a second related scene of the commissioned Joseph standing in a two-wheeled horse-drawn cart from which his new status will be proclaimed. The back legs and part of the body of the attached horse are at the right margin. Joseph looks at the Pharaoh whose right hand is at the level of the cart. Wearing his ring of authority, Joseph extends his right hand toward the king. With this gesture he accepts his assignment, to proclaim his ascendency by appearing before the people in the king's second chariot. In this scene, Joseph wears his costume as a dignitary for the first time, a costume which he continues to wear in two other scenes of the Joseph story. The robe is long, decorated with two rolls of fabric or metal rings around the neck and on the upper left arm.

COMMENTS: The sack on which Pharaoh sits and the one on which he rests his feet seem to be modelled on the wool sack on which the Chancellor sat to symbolise the power and wealth of the realm of England.[122]

145. Fol. 20ʳ, lower right: Simeon is held as hostage and the grain sacks are filled. (Genesis 42. 24b–25, pl. XLI)

DESCRIPTION: At lower right, Simeon, with bound hands, appears before the empowered Joseph. He will be held hostage until his brothers return with Benjamin. Nine brothers are kneeling at left. The heads of four horses are indicated behind them. Under the arched doorway of a shelter, three servants at right fill bags with grain. The shelter is crowned with a small polygonal tower. One servant faces the viewer. Only his fingers and his head are seen. The man at left is seen in profile. The third worker, at far right, is dimly seen but appears to be turned partially toward the viewer.

COMMENTS: This badly worn scene is very difficult to read.

Folio 20ᵛ

146. Fol. 20ᵛ, upper left: The brothers prepare to take Benjamin to Egypt. (Genesis 43. 13–15, pl. XLII)
DESCRIPTION: Jacob, seated in the doorway of the familiar little house, wears a doleful expression as he sends Benjamin away to Egypt with his brothers. His eyes are downcast. He gathers his robe around him as though seeking comfort in his bereavement. The nine older brothers and Benjamin, a tiny child mounted on the first horse, move off the scene to the right. To include the right number of human and equine legs has proven impossible for the artist. The foremost brother, probably Judah, who has pledged his own life to return the child safely (verse 9), looks back at Benjamin with his right arm around his shoulders. With his left hand he indicates the way forward.

147. Fol. 20ᵛ, upper right: The banquet for Joseph's brothers (Genesis 43. 31–34, pl. XLII)
DESCRIPTION: Joseph, whom the artist has given the appearance of the bearded Jacob, sits by himself at the head table. Likewise the brothers in the foreground are separated from the Egyptians on the far side of the table (verse 32). The brothers are seated according to age (verse 33), a detail which the artist has illustrated by graduating the size of the figures downward, from left to right. Each face in the sequence is depicted in slightly fuller profile than the one to its left. The four Egyptians at the far table are eating and drinking greedily. The meal includes bread and platters of chicken and ribs.

COMMENTS: This is the illustration which Pächt has called 'Giottesque'.[123] A sixteenth-century boss on the south transept roof of Norwich Cathedral represents a feast, perhaps Christ at the home of Mary and Martha; the solid backs of nine diners are very like these figures in the Egerton Genesis. Even their clothes are similar, with vertical pleats resembling those of the first two figures at left in this scene in the Egerton Genesis.[124] Could the ponderous diners seen from the rear have been commonly recognized in East Anglia during the Middle Ages? Could the Egerton Genesis have remained in the area for two centuries?

148. Fol. 20ᵛ, lower left: Joseph's cup is found in Benjamin's sack. (Genesis 44. 12–13, pl. XLII)
DESCRIPTION: The very elaborate cup, similar to that seen on the table beside Joseph in the preceding scene, is removed by Joseph's emissary from an enormous bag full of grain. The horses have already reversed direction to return to Joseph. Several of the brothers' faces indicate great distress. There is confusion among them, as some look forward and others face the rear.

COMMENTS: The sack of grain, with its rectangular shape and rolled neck, resembles those in the scenes of the hiding and discovery of Joseph's cup in the Paduan Bible in Rovigo, fol. 34ᵛ, upper left and lower left.

149. Fol. 20ᵛ, lower right: Judah pleads for Benjamin's life. (Genesis 44. 18–34, pl. XLII)
DESCRIPTION: Joseph at centre, in his dignitary's dress and once again with a short, forked beard, holds a long wand of authority over his shoulder. He raises his right hand in mock condemnation. His face is stern. Judah, the foremost of the eleven brothers crowded before Joseph, offers himself in Benjamin's stead. He pleads with both hands held out toward Joseph. Six Egyptians at right discuss the situation with gestures of shock and accusation. All figures are elongated, and all brothers and Egyptians wear long robes and mantles. The left arms of the figures behind Joseph are held in sling-like drapery. A small, ornate pepper-pot tower crowns the roof of the small house in front of which Joseph stands.

[It is regrettable that the story breaks off just as the climax of the Joseph story approaches. Six chapters of the biblical Genesis remain unillustrated. The Egerton Genesis artist would surely have treated the remaining six chapters of the narrative with his accustomed superb skill and dramatic panache.]

SUMMARY AND CONCLUSION

The questions posed at the beginning of this chapter now may be considered. A number of distinctive features of the iconography of the Egerton Genesis have been identified. First, it depicts human behaviour and reveals human character with expressive, dramatic force. As will be seen in Chapter 4, the artist probably knew and drew from the drama of his day. Second, it exhibits a Rabelaisian sense of humour. It lampoons the shortcomings of biblical characters; yet their nobler moments are also acknowledged, and the Deity is always respected. This humour is further discussed in Chapter 5. Third, it abounds in images of promises, pledges, agreements and transactions.[125] A number of weddings and agreements to marry are depicted.[126] Agreements are also established between men,[127] while the iconography of purchase, sale, and barter is notable as well.[128]

Nothing about the iconography hints at a royal or noble patron; the powerful and privileged are treated with scant respect. Rather, the patron was probably from the upper middle class. He may have had connections to the drama, perhaps as a sponsor or producer of some

sort. He may have been a merchant or someone with an interest in the law. He was someone to whom graphic sexual iconography was acceptable, probably a layman rather than a cleric. It is not impossible, as will be considered in Chapters 6 and 7, that he was a Flemish immigrant, for Flemings were more accustomed to bawdy imagery in manuscripts than were the English.

The Egerton Genesis shares certain significant iconographical elements with other fourteenth-century Genesis picture cycles in manuscripts: The death of Cain (fol. 3r, upper left) and the death of the boy guide (fol. 3r, upper right) are in the Holkham Bible Picture Book, the Isabella Psalter, and the St Omer Psalter. The manner of the embarkation (fol. 3r), the dragon in the debarkation (fol. 4r), the fight at the feast (fol. 10v (11vJ), upper left), and the mandrake (fol. 16r) appear in the Queen Mary Psalter. Tubal-cain and Naamah (fol. 2v, upper right) are depicted in the Isabella Psalter. The Tower of Babel (fol. 5v), the descendants of Adam (fol. 2r), and Hagar's encounter with the angel (fol. 9v, upper right) are in the Paduan Bible in Rovigo. Scenes from the stories of Hagar (fol. 9v, upper left) and Isaac (fol. 12v (13vJ), lower right), among others, are in the Mosan Psalter fragment. However, these are isolated vignettes which do not indicate a close overall relationship between the Egerton Genesis and any of these other Genesis picture cycles.

In the panorama of English fourteenth-century illumination, the Egerton Genesis is certainly distinctive, but it is not entirely an anomaly; the iconography has many motifs of common currency in both English and northern Continental books of the first half of the fourteenth century. These motifs include the following: hares in their burrows, fol. 14v, lower right; rams butting, fol. 4r; cooking pots on tripods, fol. 11r (10rJ) upper right and 12v (13vJ), upper right; disrobing figures, fol. 11v (10vJ), lower right; and scalloped clouds. The physician holding a urine flask, fol. 10r (11rJ), upper right, is found in many manuscripts from northern France and Flanders.

Among fourteenth-century English manuscripts that almost certainly post-date the Egerton Genesis, the Psalter of Humphrey de Bohun (Oxford, Exeter College, MS 47) is notable for iconographical connections with the Egerton Genesis; here the question arises of the Egerton Genesis's influence on later illumination. This is a matter for investigation in another context.

The question of ancient sources—Late Antique and Anglo-Saxon—has been considered by Pächt, Henderson, and Diebold, among others; but it seems that such sources, if they were used, were of minor importance in the overall picture of influences on the Egerton Genesis. We see little to indicate that the artist was directly acquainted with the Cotton Genesis or a close representative of this tradition, though this possibility cannot be entirely excluded. There is perhaps a little more evidence, in the scene of Jacob's ladder, that he was acquainted with the Anglo-Saxon Hexateuch or a similar manuscript.

There is the matter of North Italian influence. We find no compelling evidence of a trip to Italy by the artist. His Italianisms could have been assimilated through contemporary Italian manuscripts and possibly panel paintings, as the study of his style in Chapter 5 will indicate. Connections with the Paduan Bible in Rovigo are numerous, and it is possible that the artist had access to an unknown North Italian Bible like the Paduan Bible, itself too late to have served as

a source for the Egerton Genesis. Finally, elements in the iconography of the Egerton Genesis indicate that the artist had access to, and was extremely interested in, Bolognese manuscripts.

Much evidence suggests that the Egerton Genesis artist was thoroughly familiar with the contemporary theatre. Frequently and publicly staged, theatre was a major element in fourteenth-century visual culture. Chapter 4 deals at length with this aspect of the Egerton Genesis. Close similarities to the fifteenth- and sixteenth-century roof bosses in the nave and transepts of Norwich Cathedral suggest that the Egerton Genesis, in turn, was integrated into the visual culture of later centuries.

A number of motifs and subjects—the vaulted culvert (fol. 11r (10rJ), upper left), the wool sack (fol. 20r, lower left), the circumcision of Isaac (fol. 10r (11rJ), lower right), the embarkation (fol. 3r), the shop at Shechem (fol. 17r, lower right), and some Jacob iconography—relate the Egerton Genesis specifically to Norwich. It is noteworthy that the Egerton Genesis has much in common with the iconography of the St Omer Psalter, produced in Norwich.[129] The St Omer *Beatus* page, fol. 7r, has the scenes of the death of Cain, the death of the boy guide (fig. 11), and the drunkenness of Noah (fig. 17), also found in the Egerton Genesis, on fols 3r and 4v. The rare motif of animals carried bodily into the ark occurs on fol. 7r of the St Omer Psalter (fig. 13) and on fol. 3r, lower half, of the Egerton Genesis. The motif of a bristly wildman resembling the hairy Esau on fol. 14v, upper and lower right, of the Egerton Genesis, is found in the St Omer Psalter as well (fig. 11). The connection to Norwich will present itself again in Chapters 5 and 7. As noted above, the much later bosses of Norwich Cathedral raise the possibility that the manuscript may have remained in Norwich for a considerable time.

Numerous iconographical elements in the Egerton Genesis also link it to a group of manuscripts produced in Ghent and the area of St-Omer-Thérouanne in the third and fourth decades of the fourteenth century. Gl kgl. Saml. 3384,8°, Douce 5–6, Walters 82, the *Spiegel historiael*, and Additional MS 36684/Morgan 754 feature prominently in this group. The *Rijmbijbel* is another manuscript significantly related to the Egerton Genesis. Connections with the Low Countries are further strengthened by the many parallels with the twelfth-century Mosan Psalter fragment in Berlin. It is also noteworthy that the artist was apparently familiar with the legend of Mélusine (the debarkation, fol. 4r) which was known in French Flanders in the fourteenth century. The Egerton Genesis clearly was not produced in Flanders, yet its connections to Flanders are undeniable. It is therefore possible that the artist was of Flemish origin. Connections with Ghent resurface even more strongly in Chapters 5 and 6.

None of the Genesis material known to us seems to have served as a model for this manuscript in any comprehensive way. Rather, the artist seems to have proceeded largely by ad hoc composition and free adaptation from a wide variety of sources, some in illuminated manuscripts, some in other visual media, some in texts, and some from dramatic performances. The latter will be examined more closely in Chapter 4. Certainly the artist incorporated many observations from contemporary life. He had a thorough familiarity with the text of Peter Comestor's *Historia Scholastica*, as many of his iconographical references to it demonstrate. As Henderson has noted, the artist was 'a man gifted with a remarkably inquiring and acquisitive mind'.[130]

Notes

1 *Illustrations*, pp. 23–38.

2 All illustrations from the Paduan Bible in Rovigo are reproduced in Gianfranco Folena and Gian Lorenzo Mellini, *Bibbia istoriata padovana della fine del Trecento: Pentateuco-Giosuè-Ruth* (Venice: Neri Pozza, 1962). In addition, some are reproduced in Arensberg's study of the Paduan Bible.

3 All illustrations from Oxford, Bodleian Library, MS Junius 11 are in Israel Gollanz, *The Caedmon Manuscript of Anglo-Saxon Biblical Poetry* (London: Oxford University Press, 1927).

4 A date in the late 1330s to around 1340 is proposed by Hull, 'Douai Psalter', I, 190–193; Dennison, 'Stylistic Sources', p. 55 and n. 51, proposes a date around 1340, possibly as late as 1349.

5 Douce 5–6 will be further considered in Chapter 6. See Otto Pächt and J. J. G. Alexander, *Illuminated Manuscripts in the Bodleian Library, Oxford*, 3 vols (Oxford: Clarendon Press, 1966–73), I: *German, Dutch, Flemish, French and Spanish Schools*, p. 22. For discussions of this manuscript in contexts relevant to the Egerton Genesis, see Kerstin B. E. Carlvant, 'Collaboration in a Fourteenth-Century Psalter: the Franciscan Iconographer and the Two Flemish Illuminators of MS 3384,8° in the Copenhagen Royal Library', *Sacris Erudiri*, 25 (1982), 135–166; M. Alison Stones, 'Notes on Three Illuminated Alexander Manuscripts', in *The Medieval Alexander Legend and Romance Epic: Essays in Honour of David J. A. Ross*, ed. by Peter Noble, Lucie Polak, and Claire Isoz (Millwood, NY: Kraus International, 1982), pp. 193–241 (p. 206, n. 31). R. E. O. Ekkart, *De 'Rijmbijbel' van Jacob van Maerlant: een in 1332 voltooid handschrift uit het Rijksmuseum Meermanno-Westreenianum* (The Hague: Staatsuitgeverij and Rijksmuseum Meermanno-Westreenianum/Museum van het boek, 1985), p. 39; M. Alison Stones, 'Another Short Note on Rylands French 1', in *Romanesque and Gothic: Essays for George Zarnecki* 2 vols (Woodbridge, Suffolk: Boydell, 1987), I, pp. 185–192 (p. 188). Many illustrations from Douce 5–6 are included in Lilian M. C. Randall, *Images in the Margins of Gothic Manuscripts* (Berkeley: University of California Press, 1966); see p. 31 for a list of figures and additional bibliography.

6 All images from the Holkham Bible Picture Book are reproduced in Hassall, *Holkham Bible*.

7 All images from the Queen Mary Psalter are reproduced in Warner.

8 Reproduced in Lucy Freeman Sandler, *The Psalter of Robert de Lisle in the British Library* (London: Harvey Miller, 1983), pl. 2.

9 Alessandro Conti, *La miniatura bolognese: Scuole e botteghe 1270–1340*, Fonti e studi per la storia di Bologna e delle province emiliane e romagnole, 7 (Bologna: Alfa, 1981), p. 69. The Bolognese manuscripts relevant to this study are all discussed in Conti's book and/or in Elly Cassee, *The Missal of Cardinal Bertrand de Deux: a Study in 14th-Century Bolognese Miniature Painting*, trans. by Michael Hoyle, Istituto Universitario Olandese di Storia dell' Arte, 10 (Florence: Istituto Universitario Olandese di Storia dell'Arte, 1980).

10 For bibliography on this manuscript, see Martine Meuwese, 'Jacob van Maerlant's "Spiegel Historiael": Iconography and Workshop', in *Flanders in a European Perspective. Manuscript Illumination around 1400 in Flanders and Abroad*, ed. by Maurits Smeyers and Bert Cardon (Leuven: Peeters, 1995), pp. 445–450.

11 Reproduced in Randall, *Images*, fig. 140.

12 Pächt, 'Giottesque Episode', p. 59, n. 2, and Diebold, p. 8, noted the relationship to Jesse Tree iconography.

13 Spelling of names is that of *The Revised English Bible with the Apocrypha* (Cambridge: Cambridge University Press, 1996); however, quotations from other versions more appropriate to the image may be used, with parenthetical attribution.

14 Gl kgl. Saml. 3384,8° will be considered in Chapter 6. See Carlvant, 'Collaboration', for a discussion of this manuscript, and her notes for additional bibliography.

15 Many examples are listed in Randall, *Images*, p. 72.

16 Reproduced in Sydney C. Cockerell, *The Gorleston Psalter: a Manuscript of the Beginning of the Fourteenth Century in the Library of C. W. Dyson Perrins* (London: Chiswick Press, 1907), pl. XI.

17 All images from Bodley 264 are reproduced in M. R. James, *The Romance of Alexander: a Collotype Facsimile of Ms. Bodley 264* (Oxford: Clarendon Press, 1933). James rightly discerned more than one illuminator in this manuscript.

18 Reproduced in Randall, *Images*, fig. 724.

19 Randall, *Images*, p. 142. See Randall for bibliography as well as for reproductions from Additional MS 36684/Morgan 754. For numerous full-page reproductions and for description, see Mme. Th. Belin, *Les Heures de Marguerite de Beaujeu* (Paris: Madame Th. Belin, Librairie à l'Enseigne Notre Dame, 1925).

20 Pächt, 'Giottesque Episode', p. 59.

21 See E. M. Goulburn, *The Ancient Sculptures of Norwich Cathedral* (Norwich: Stacy, 1872), p. 38, and ills 8, 13.

22 Reproduced in Cockerell, *Gorleston Psalter*, pl. IX.

23 'Late Antique Influences', p. 189.

24 'Giottesque Episode', pp. 59–60.

25 Henderson, 'Late Antique Influences', pp. 188–190.

26 *Images*, p. 203.

27 The Lusignan family recognized Mélusine as an ancestor. See Louis-Ferdinand Alfred Maury, *Croyances et légendes du moyen age* (Paris: Champion, 1896), p. 24.

28 See Robert Nolan, 'The *Roman de Mélusine*: Evidence for an Early Missing Version', *Fabula*, 15 (1974), 53–58.

29 Paul-Yves Sébillot, *Le Folk-lore de la France*, 4 vols (Paris: Maisonneuve et Larose, 1907; repr. 1968), II, 66.

30 Fols 1–5 of the Ramsey Psalter are in New York, Pierpont Morgan Library, MS M. 302. For a reproduction of fol. 1r, see Lucy Freeman Sandler, *The Peterborough Psalter in Brussels and Other Fenland Manuscripts* (London: Harvey Miller, 1974), fig. 68.

31 James Mann, 'Appendix on the Armour', in Hassall, *Holkham Bible*, pp. 157–160 (p. 158).

32 Sandler, *Gothic Manuscripts*, II, 114.

33 W. 82 will be further considered in Chapter 6. For discussion and bibliography, see Lilian M. C. Randall, assisted by Judith H. Oliver, Christopher Clarkson and Claudia Mark, *Medieval and Renaissance Manuscripts in the Walters Art Gallery* (Baltimore: Johns Hopkins University Press in association with the Walters Art Gallery, 1989–), III: *Belgium, 1250–1530* (1997), pt. 1, 77–85.

34 Reproduced in *The Old English Illustrated Hexateuch: British Museum Cotton Claudius B IV*, ed. by C. R. Dodwell and Peter Clemoes, Early English Manuscripts in Facsimile, 18 (Copenhagen: Rosenkilde and Bagger, 1974).

35 Joslin, *Heard Word*, p. 106.

36 Pächt, 'Giottesque Episode', p. 62; and Henderson, 'Late Antique Influences', pp. 182–183.

37 Reproduced in Sandler, *Peterborough Psalter*, fig. 251.

38 We use the familiar names Abraham and Sarah throughout this discussion, even though the biblical names do not change until Genesis 17.

39 The text accompanying this image does not mention Shechem. See Warner, p. 58 and pl. 16.

40 See R. J. E. Tiddy, *The Mummers' Play* (Oxford: Clarendon Press, 1923), p. 72.

41 This *Rijmbijbel* will be further considered in Chapter 6. See P. C. Boeren, *Catalogus van de handschriften van het Rijksmuseum Meermanno-Westreenianum* (The Hague: Rijksmuseum Meermanno-Westreenianum/Staatsuitgeverij, 1979), pp. 50–51. See also Ekkart and *Scolastica willic ontbinden: over de Rijmbijbel van Jacob van Maerlant*, ed. by Jaap van Moolenbroek and Maaike Mulder, *Middeleeuwse studies en bronnen*, 25 (Hilversum: Verloren, 1991). Further bibliography may be found in the notes of these studies.

42 Pächt, 'Giottesque Episode', p. 63.

43 See M. R. James, *On the Abbey of S. Edmund at Bury: I, The Library, II, The Church* (Cambridge: Cambridge Antiquarian Society, 1895), p. 200.

44 For discussion, bibliography and reproductions of W. 88, see Randall, *Belgium*, pt. 1, pp. 67–72; pt. 2, figs 489–429.

45 See *Images*, pp. 160–161.

46 'Giottesque Episode', p. 59.

47 See François Avril, *Manuscript Painting at the Court of France: the Fourteenth Century (1310–1380)* (New York: Braziller, 1978), pl. 15 and p. 35.

48 Murray Roston, *Biblical Drama in England* (Evanston, IL: Northwestern University Press, 1968), p. 4.

49 Pächt, 'Giottesque Episode', p. 63.

50 For The Hague, Koninklijke Bibliotheek, MS 135 E 15, see J. P. J. Brandhorst and K. H. Broekhuijsen-Kruijer, *De verluchte handschriften en incunabelen van de Koninklijke Bibliotheek: Een overzicht voorzien van een iconografische index* (The Hague: Stichting Bibliographia Neerlandica, 1985), p. 88; Stones, 'Another Short Note', p. 189; and Carlvant, 'Collaboration', p. 162, n. 52. Both the *Rijmbijbel* and MS 135 E 15 have associations with Ghent and with the Diocese of Utrecht, as will be shown in Chapter 6.

51 James, *Illustrations*, p. 4.

52 See Klemm, fig. 2.

53 See Norman P. Tanner, *The Church in Late Medieval Norwich, 1370–1532*, Studies and Texts, 66 (Toronto: Pontifical Institute of Mediaeval Studies, 1984), p. 5; Giles Constable, 'Resistance to Tithes in the Middle Ages', *Journal of Ecclesiastical History*, 13 (1962), 172–185 (pp. 184–185).

54 W. N. Francis, ed., *The Book of Vices and Virtues: a Fourteenth Century English Translation of the 'Somme le Roi' of Laurens d'Orléans* (London: Oxford University Press, 1942; repr. 1968), pp. 37, 38. The sixth branch of *covetise* (*simonie*) mentions this vice.

55 Illustrations are in Sandler, *Peterborough Psalter*, figs 21, 116.

56 Conti, pp. 89–90.

57 James, *Illustrations*, p. 30.

58 See Klemm, pl. 4.

59 See Brian Ayers, *English Heritage Book of Norwich* (London: Batsford, 1994), p. 73, ill. 55.

60 See M. D. Anderson, *Drama and Imagery in English Medieval Churches* (Cambridge: Cambridge University Press, 1963), p. 127 and pl. 16c. She discusses a Hell-Mouth seen through a battlemented doorway depicted on an English alabaster, now at the Castle Museum at Carcasonne, as a possible reference to a mystery play.

61 See the adolescent couple in the *Omne Bonum*, fol. 58ᵛ, reproduced, as are all illustrations from this manuscript, in Sandler, *Omne Bonum*, and L. F. Sandler, 'A Bawdy Bethrothal in the Ormesby Psalter', in *Tribute to Lotte Brand Philip, Art Historian and Detective*, ed. by William W. Clark and others. (New York: Abaris, 1985) pp. 155–159 (p. 158).

62 Hull, 'Douai Psalter', I, 98–99.

63 See Randall, *Images*, pp. 69–70, for copious references.

64 'Late Antique Influences', pp. 192–193; n. 61; pl. 36c. Examples of a three-headed Trinitarian figure in a miniature illustrating the Heavenly Visitors story are on fols 9ʳ and 9ᵛ of a thirteenth-century psalter, St John's College, Cambridge, MS K. 26. See *English Illuminated Manuscripts 700–1500*, cat. by J. J. G. Alexander and C. M. Kauffmann (Brussels: Bibliothèque Royale Albert 1er, 1973), pp. 86, 87, pl. 28.

65 *Drama and Imagery*, p. 131.

66 M. D. Anderson, *The Imagery of British Churches* (London: Murray, 1955), p. 93, pl. 22.

67 Sandler, *Peterborough Psalter*, fig. 21.

68 *HS*, ch. 55, col. 1102.

69 Conti, fig. 272; see also p. 91, and Cassee, pp. 21–23, 26.

70 Reproduced in Sandler, *Gothic Manuscripts*, I, ill. 334.

71 Anderson, *Imagery*, pp. 19, 93, 107–108, pl. 16.

72 See Anderson's essay in G. L. Remnant, *A Catalogue of Misericords in Great Britain* (Oxford: Clarendon Press, 1969), p. xxx. Also James, *On the Abbey*, pp. 200–202. As noted in discussion of fols 7ᵛ and 8ʳ, this list also records two scenes of the separation of Abraham and Lot, as likewise found in the Egerton Genesis.

73 M. D. Cox, 'The Twelfth-Century Design Sources of the Worcester Cathedral Misericords', *Archaeologia* 97 (1959), 165–178 (p. 171, pl. LIV).

74 '*Dumque simul luderent Ismael et Isaac, major laedebat minorem. Et intellexit mater in ludo persecutionem*', HS, ch. 46, col. 1103. '*E tant cruit e esforsa (Ysaac) si com Deus la mouteplioit en tote bone maniere qu'il aloit joier e esbanoier avec Ismael, son frere. Ismael estoit plus grans e plus fors, quar il avoit plus d'aage. Si faisoit a Ysaac a la fiee aucune felonie dont molt grevoit a Sarram, sa mere*', Joslin, *Heard Word*, p. 158, ll. 29–33.

75 Ch. 56, col. 1103.

76 '*Et accepit ei mater uxorem de terra Ægypti, de qua nati sunt ei duodecim filii, principes, tribuum suarum*', etc., HS, ch. LVI, cols 1103–4.

77 *Antiquities*, I. xii. 4. All references to Josephus's *Antiquities* are from the Whiston translation.

78 Joslin, *Heard Word*, p. 160, ll. 21–25.

79 HS, ch. 57, col. 1104.

80 HS, ch. 58, col. 1105.

81 Anatole de Montaiglon, *Recueil général et complet des fabliaux des XIIIe et XIVe siècles*, 6 vols (Paris: Librairie des Bibliophiles, 1872–1890), I, 238–244 (p. 240) and V, 83–94 (p. 90). *De Gombert et des .ii. clers* is in Paris, Bibliothèque Nationale, MS fr. 837, fols 210ᵛ–211ᵛ; *Le Meunier et les .ii. clers* is in Bibliothèque de Berne, MS 354, fols 164ᵛ–167ʳ.

82 See the index of Randall, *Images*, pp. 192–194, for examples.

83 HS, ch. 66, col. 1110.

84 HS, ch. 71, end of col. 1112.

85 '*Quae cum ambae offendissent animum Isaac et Rebecca . . . tamen melius silere decrevit.*' HS, ch. 71, cols 1112–1113.

86 *Images*, p. 202.

87 See Mark Bailey, 'The Rabbit and the Medieval East Anglian Economy', *Agricultural History Review*, 36.1 (1988), 1–20 (pp. 1, 10, 19).

88 Jacob assumes this same gesture of obedience as he listens to his mother's urgent instructions for receiving Isaac's blessing in the miniature on fol. 43ᵛ of Paris, Bibliothèque Nationale, MS fr. 20125, a copy of the *Histoire ancienne*. See Mary Coker Joslin, 'The Illustrator as Reader: Influence of Text on Images in the *Histoire ancienne*', *Medievalia et Humanistica*, NS 20 (1993), pp. 85–121, (fig. 3).

89 'Late Antique Influences', p. 177, n. 27.

90 'Late Antique Influences', p. 177.

91 *Images*, pp. 94, 111.

92 Michael Camille, *Image on the Edge: the Margins of Medieval Art* (Cambridge, MA: Harvard University Press, 1992), p. 46, ill. 23.

93 Lynda Dennison, 'Oxford, Exeter College MS 47: The Importance of Stylistic and Codicological Analysis in its Dating and Localization', in *Medieval Book Production, Assessing the Evidence*, ed. by L. L. Brownrigg, (Los Altos Hills, CA: Anderson-Lovelace, 1990), pp. 41–59 (pp. 42–47, 57).

94 Martial Rose and Julia Hedgecoe, *Stories in Stone* (London: Herbert, 1997), p. 61.

95 HS, ch. 80, col. 1120.

96 John R. Kohlenberger III, ed., *The NIV Interlinear Hebrew-English Old Testament*, I: *Genesis-Deuteronomy* (Grand Rapids, Michigan: Zondervan, 1979), p. 92; Robert Alter, *Genesis, Translation and Commentary* (New York: Norton, 1996), p. 188.

97 Kohlenberger, p. 92, n. d19; Alter, p. 188, n. for Genesis 33. 19.

98 '*Porro Jacob emit juxta oppidum partem agri, ab Emor rege Sichimorum, et a filiis ejus centum agnis*' HS, ch. 82, col. 1122.

99 '*Emitque partem agri in qua fixerat tabernacula, a filiis Hemor patris Sichem centum agnis*', Genesis 33. 19.

100 HS, ch. 83, col. 1122. Josephus says Dinah went to see the finery of the women of Shechem, not to buy (*Antiquities*, I. xxi. 1).

101 H. W. Saunders, *An Introduction to the Obedientary and Manor Rolls of Norwich Cathedral Priory* (Norwich: Jarrold and Sons, 1930), pp. 81, 82, 119.

102 Reproduced in James Snyder, *Medieval Art: Painting, Sculpture, Architecture, 4th–14th Century* (Englewood Cliffs, NJ: Prentice Hall, 1989), fig. 563.

103 Reproduced in Camille, p. 49, ill. 24. For commentary on the rape of Dinah in the Egerton Genesis, see Diane Wolfthal, ' "A Hue and a Cry": Medieval Rape Imagery and its Transformation', *AB*, 75 (1993), 39–64 (pp. 45–46).

104 Reproduced in Eric G. Millar, *English Illuminated Manuscripts of the XIVth and XVth Centuries* (Paris: Van Ost, 1928), pl. 68.

105 *'Obtulit ei'*, *HS*, ch. 83, col. 1123.

106 Martial Rose, 'The Staging of the Hegge Plays', in *Medieval Drama*, Neville Denny, associate ed. (London: Arnold, 1973), pp. 197–209 (p. 209).

107 Reproduced in Goulburn, photograph #4 between pp. 120 and 121.

108 Reproduced in Otto Demus, *The Mosaics of San Marco in Venice*, 2 pts (Chicago: University of Chicago Press, for Dumbarton Oaks, 1984), II: *The Thirteenth Century*, vol. 2, black-and-white pl. 249.

109 Reproduced in Goulburn, photograph #7 between pp. 120 and 121.

110 *Illustrations*, p. 36.

111 'Giottesque Episode', p. 66.

112 Joslin, *Heard Word*, p. 225, ll. 19–20.

113 Reproduced in John Plummer, *The Hours of Catherine of Cleves* (New York: Braziller, 1966), pl. 16.

114 *Drama and Imagery*, p. 163, pls 23b and 16d.

115 Ishmaelites and Midianites in the Genesis 37. 28 text are identical or closely associated. There is no need to look for two sorts of traders. *Harper's Bible Dictionary*, ed. by Paul J. Achtemeier (San Francisco: Harper and Row, 1985), pp. 634, 432.

116 Conti, pp. 88–89.

117 Doris Oltrogge, *Die Illustrationszyklen zur 'Histoire ancienne jusqu'à César' (1250–1400)* (Frankfurt am Main: Lang, 1989). p. 240, pl. 80.

118 *Illustrations*, p. 36.

119 See note on Sodomite costume, comments for scene 65 in this chapter.

120 Reproduced in Sandler, *Gothic Manuscripts*, I, ill. 310.

121 Reproduced in Sandler, *Gothic Manuscripts*, I, ill. 411.

122 See G. M. Trevelyan, *English Social History* (London: Longmans, Green, 1961), p. 7. See also Eileen Power, *The Wool Trade in English Medieval History* (Oxford: Oxford University Press, 1941), p. 17.

123 'Giottesque Episode', pp. 67–69.

124 See C. J. P. Cave, 'The Roof Bosses of the Transepts of Norwich Cathedral Church', *Archaeologia*, 83 (1933), pl. XIV, 7.

125 God makes a promise to Noah (fol. 4r), a promise repeated on four occasions to Abraham (fol. 8r, upper right; fol. 9r, lower left; fol. 9v, lower left; fol. 11r (10rJ), upper left), and one to Isaac (fol. 14r, upper right). He makes a promise to Jacob (fol. 15r, lower right), and Jacob pledges to him in return (fol. 15v, upper left).

126 See fol. 6v, upper left; fol. 10v, lower left; fol. 14v, upper left; fol. 15r, lower left; 15v, lower right.

127 Images of agreements include Abraham's covenant with Abimelech (fol. 10v, lower right), the servant's pledge to Abraham (fol. 13v, upper left), Isaac's covenant with Abimelech (fol. 14r, lower right).

128 Abraham presents the tithe to Melchisedek and receives bread and wine in return, in an image with moralising overtones (fol. 9r, upper right). Leah exchanges mandrakes for a night with Jacob (fol. 16r, lower right). Jacob exchanges

sheep for the field at Shechem (fol. 17r, lower left). A woman makes a purchase from a shop displaying purses, knives, and belts (fol. 17r, lower right). Joseph is sold to the Ishmaelites (fol. 18v, upper right) and bought by Potiphar (fol. 19r, lower right).

129 Hull, 'Douai Psalter', I, 210.

130 'Late Antique Influences', p. 197.

Parallels With Medieval Drama

INTRODUCTION

James remarked how little the Egerton Genesis artist depends upon tradition, how he is so independent as hardly to have had a model.[1] Scholars have compared various scenes to Giotto, to Anglo-Saxon Genesis illustration, to Italo-Byzantine mosaics, to Jewish art, and to representatives of the Cotton Genesis recension. There is, however, another fourteenth-century phenomenon, one familiar to the English public, which can provide us with parallels. Close study of the finely wrought drawings narrating the biblical Genesis in Egerton 1894 reveals points of comparison with aspects of the English medieval drama. This idea is not new. In 1972 it was noticed that the sequence of episodes in the N-Town play of the Flood corresponds to the order of events in the Egerton Genesis narrative. In both, the legendary Lamech episode appears within the story of Noah's Flood.[2] A study of the Middle English drama in conjunction with a close look at the Egerton Genesis reveals other striking parallels. Proof of a definite connection between this curious Genesis picture book and the contemporary theatre is elusive. Did the illustrator expressly or inadvertently use elements reminiscent of familiar dramatic scenes? Is this another example in medieval culture of the amorphous sense of what was later to be called *genre*?[3]

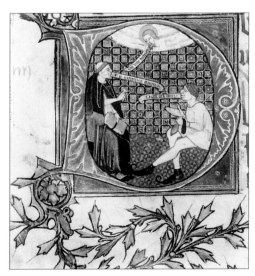

FIG. 51: Derby Psalter. Oxford, Bodleian Library, MS Rawlinson G. 185, fol. 43ᵛ: Initial D for Psalm 52, Augustinian remonstrating with Fool (Photo: Bodleian Library, Oxford)

There is evidence that the artist was interested in dramatic expression well before he undertook the commission of the Egerton Genesis. The initial for Psalm 52, fol. 43v in the Derby Psalter (fig. 51), is itself a little skit. The Augustinian corrects the fool who denies the existence of God, as God himself watches from above. Banners, emerging from their mouths, record their Latin conversation. On fol. 20r of the Fitzwarin Psalter, which includes illumination by the Egerton Genesis artist, Christ lowers the Pentecostal dove by ribbons from a towered superstructure. This probably reflects a dramatic device, one of several in this manuscript. Of the works we know to be by this artist, it is only in the Egerton Genesis, however, that multiple examples of parallels with the medieval drama attract the viewer's attention.

In this comparative study, we are hampered by the fact that only a remnant of the many plays widely enjoyed in medieval England have come down to us and that the date of their written record is later than that of the manuscript which seems to bear a dramatic stamp. In citing parallels, we are obliged to use written records which largely post-date the Egerton Genesis. These records are all we have. Why is the written record so late and why is there so little surviving testimony to what must have been a long and chiefly oral tradition? Gardiner suggests that during the Reformation the four great cycle dramas, having been heartily discouraged since early in the century, were put down through the intervention of authority between 1569 and 1580, during the reign of Elizabeth.[4] Johnston suggests the change in the status of communities in the 1370s, which instituted a new system of record keeping, as a reason why civic activities, including drama, remained unrecorded before that time.[5] Stevens proposes that the actual dramatic texts which have come down to us were never performed and that performances on which they are based may have taken place for many decades before the date of the literary record.[6] The surviving texts of mystery cycle plays are of a later date than that advanced by James for the Egerton Genesis (c. 1360).[7] Diller reminds us that 'hard evidence gathered from archives and manuscripts, especially by the powerful teams at Toronto and Leeds, has made it increasingly clear that the plays, as we have them, are products of the fifteenth and early sixteenth century. Any hopes of uncovering earlier textual strata which might take us back to the first beginnings of the cycles in the late fourteenth century or even earlier, must now be regarded as unfounded.'[8] However, evidence from literature and art and from contemporary written records testifies to the fact that theatre was popular much earlier than the demonstrable dates of existing texts. The so-called Cambridge and Rickinghall fragments of around 1300 bear lines in both French and English, presumed to be dramatic.[9] The 'Sacristan's Story', recorded by a continuator of the eleventh-century history of Saint John of Beverley, mentions a play performed in the first quarter of the thirteenth century in the churchyard of St John's Church in Beverley.[10] Chaucer's 'Miller's Tale' refers to religious plays, of both Old and New Testament.[11] The Holkham Bible Picture Book, produced earlier in the century than the Egerton Genesis, presents scenes similar to some which we encounter in later dramatic texts.[12] Documents exist from the twelfth, thirteenth, and early fourteenth centuries, which forbid or complain of the more raucous elements of drama in or near sacred places or which attest to the fourteenth-century performance of plays. The Bishop of Lincoln, Robert Grosseteste, and the Bishop of Worcester, Walter of Chanteloupe, issued prohibitions against

wrestling associated with the public drama in the thirteenth century.[13] A Wycliffite late four-teenth-century *Treatise against Miracle-Plays* sets out to answer five arguments used by those who seek to justify the playing of miracles.[14] A mid-fourteenth-century document records William de Lenne and Isabel, his wife, spending a mark '*in ludo filiorum Israelis*' in connection with a Guild of Corpus Christi at Cambridge.[15]

May there be visual evidence as yet unrecognised? Acquaintance with the mysteries would have enhanced the first viewer's appreciation of the Egerton Genesis. He or she would not have considered scenes reminiscent of the drama to be as 'curious', or as 'puzzling' as we do today. Contact with plays was a condition of public life. Scenes, types, action, and costumes in the Egerton Genesis communicate the Genesis story, often in a manner not inconsistent with dra-matic presentations recorded later. We may better understand this curious picture book and also gain glimpses of fourteenth-century drama by thinking of them in conjunction with each other.

Scholars have investigated the influence of medieval drama upon art for almost a century. Roy, Mâle, Prior, Cohen, Hildburgh, Pächt, and, more recently, Johnston have called attention to the all-pervasive drama as a source of ideas for the medieval artist from his own cultural milieu.[16] Nor has the converse, the influence of pictorial art on the drama, been neglected. Bonnell, Collins and Davidson have advocated turning our attention in that direction.[17] Certainly, there was a relationship between the dramatic and the visual arts, but establishing precedence of one or the other is neither demonstrable nor necessary. Gibson and Sheingorn advise looking at visual art and drama simultaneously.[18] Wickham writes of the influence that 'flows in both directions'.[19] Cohen, writing much earlier about art and drama, describes the situation of the medieval artist in a culture where drama was popular: 'The work of an artist is made up of so many subtle impressions, of so many sources of inspiration within himself that one no longer knows from whence they have come'.[20] Fourteenth-century English illus-trators were not ignorant of the productions taking place around them. The sacred, the secu-lar, the profane, the bawdy—all to be found in medieval religious drama—are observable in Egerton Genesis illustrations. Writers, artists, and players drew from a common tradition, that of the biblical narrative supplemented by apocryphal sources.

In many Egerton Genesis miniatures we encounter situations, scenes, characters, and costumes strongly suggestive of medieval drama. These examples speak clearly of the environment in which the artist lived and worked. All we have is the visual testimony of the manuscript itself. We offer, in the pages which follow, the artist's own pictorial evidence. Though no solid con-clusion based on proof is possible at this stage, this evidence so permeates this manuscript that the viewer is inevitably aware of the drama-drenched milieu in which the artist worked. We offer these examples as parallels occurring in two simultaneous societal phenomena.

OLD TESTAMENT PROCESSION AND SELF-INTRODUCTION

The Procession of Prophets in medieval plays allows smooth transition between Old and New Testament episodes. In the Egerton Genesis, the ancestral procession on fol. 2ʳ provides

a transition between the creative acts of God and the narrative of human events which God directs or oversees. On fol. 2ʳ, the descendants from Adam through Seth and Cain, elegantly robed and graceful, with bare feet, are aligned in genealogical order. Each introduces himself and, in an unbroken procession, gestures toward his direct ancestor or descendant. In the last quadrant, Irad stands alone. His three remaining descendants are related in pose and gesture, suggesting the completion of a pageant. These gesturing figures call to mind the prophets, conversing two by two, on the interior north portal at Reims Cathedral. Gestures are comparable in two cases. Also, like the Egerton Genesis figures, the Reims figures are clothed in ample robes covered by draped cloaks. Some are barefooted as well.[21] The elegantly costumed prophets of Claus Sluter's *Puits de Moïse*, the late fourteenth-century calvaire in the Chartreuse of Champmol near Dijon, also are comparable to the figures of fol. 2ʳ of the Egerton Genesis. Several scholars have associated these Burgundian sculptures of the late fourteenth century with the medieval theatre. Mâle associated the Dijon prophets with the mystery play, *The Judgement of Jesus*, in which some of the same prophets pronounce Christ's inexorable sentence using Latin quotations from their prophetic books, texts which correspond to inscriptions on phylacteries held by Sluter's prophets.[22]

The old liturgical *Ordo Prophetarum* was based on a pseudo-Augustinian sermon.[23] Owst has indicated the close relationship between the popular vernacular sermon and medieval religious drama.[24] In the Anglo-Norman *Jeu d'Adam* we have an example of a prophet's procession in a vernacular drama which pre-dates by centuries those preserved in the English mystery cycle texts.[25] Two Chester Plays, 5 of the H manuscript and 22 of the HM group, involve prophets.[26] Play 8 of the Wakefield Plays and Play 7 of the N-Town Cycle are prophet plays. In York pageant 12, there is a single speaker of prophecies, called 'Prologue', rather than a procession of prophets.[27] These prophetic scenes from cycle plays are not dramas, but mainly static series of declamations by self-introduced historic persons. The N-Town prophet's play, with its procession of twenty-seven individual speakers, offers a closer parallel with the figures on fol. 2ʳ of the Egerton Genesis than do those of Chester, Wakefield, or York, in that the genealogical dimension is added: royal ancestors of Christ speak along with the prophets. Bonnell has identified the Jesse Tree iconography of this play in which the ancestors of Christ are presented chronologically, along with those prophesying his birth.[28] On fol. 2ʳ of the Egerton Genesis, the lively figures have no role to play in a narrative. They stand without background as an abstract genealogical succession. As Gauvin remarked, the procession of kings and prophets of N-Town Play 7 requires no setting, no background or locus, but took place in the *platea*.[29]

The self-introduction of the central character of a scene, along with the presentation to the audience of accompanying family members, is found in both the Egerton Genesis and medieval drama. In the scene on fol. 2ᵛ, which extends uncharacteristically across the upper half of the page, we see Lamech at the central point where the frame should divide two scenes. His hand on his breast suggests that he is presenting himself to an audience. Adah, one of Lamech's wives, points left to her sons Jabal, ancestor of tent-dwellers and livestock owners, and Jubal, ancestor of those who play lyre and flute. Zillah, Lamech's other wife, while facing her husband, gestures over her shoulder toward her son Tubal-cain, the ancestor of metal-

workers, and toward her daughter Naamah at her loom. The viewer's impression is that the three central figures stand well in front of their offspring, seemingly upstaging them. Another example in the Egerton Genesis similar to a family introduction is to be found on fol. 14ᵛ. Here, Esau takes the hands of both his wives, Judith and Basemeth, while directly facing the viewer. This scene is theatrical, not merely a static introduction, for the women, daughters of Hittites, are in vigorous conversation with each other in front of their husband, who attempts to reconcile them. The distressed expression of Isaac, seated at the doorway, suggests his bitter disappointment about Esau's foreign wives, recorded in Genesis 26. 35.

Self-introduction of characters is not uncommon in medieval drama. In N-Town Play 4, after informing the audience of their own theological significance, Noah introduces his family standing beside him, while later, Noah's wife presents herself and their children to the audience.[30] Abraham introduces Isaac in Play 5. Noah's words and those of his wife imply a gesture toward figures facing the audience along with him, as do the words of Abraham.[31] Thus certain Egerton Genesis miniatures and N-Town Plays alike represent the individual introducing himself or herself, whether prophet or parent, along with family members, to the viewer.[32]

PASTORAL IMAGES

Two pastoral images, on fols 7 and 8 of the Egerton Genesis, are strikingly dramatic. In the first, at upper right on fol. 7ᵛ, the illustrator depicts three pairs of Abraham's and Lot's herdsmen in bodily struggle over grazing rights (Genesis 13. 4–7). The two pairs most clearly seen are locked in wrestling holds. The central two wear helmets and eye protectors, as though they have expressly prepared themselves for the rigors of the contest. These same wrestling helmets are worn also by the combatants as Jacob struggles with the angel in the image on fol. 17ʳ of the Egerton Genesis.

A second pastoral scene at lower left on fol. 8ʳ can be seen at a glance in conjunction with the wrestling shepherds, as the book lies open. Three men sit on a hill where there are three trees with flattened foliage. The face of the central figure is curiously foreshortened. With head thrown back, he tosses a ball upward from a three-pronged stick balanced on his nose (fig 24). His two companions, with eyes focused intently on the ball, watch his trick. Below these figures, at right, cattle are massed. On the lower left, a fourth person approaches. Wearing a hood and gloves, he is dressed differently from the other three. He carries his shepherd's crook in his right hand. His left hand shades his eyes from a brilliant vision somewhere at upper right. The suggestion here is that Abraham is obeying God's instruction to look over and travel through his future land (Genesis 13. 14, 17). Seeking to relate this scene to the biblical text, Pächt conjectured that the seated figures on the hill under the tree could represent the Amorite 'brothers', allies of Abraham—Mamre, Eschol and Aner, seated under the Oak of Mamre (Genesis 14. 13). The scene also suggested to him angels descending.[33] This miniature, though related to the Genesis narrative, is strongly reminiscent of iconography based on Luke 2, the angel's visit to the Shepherds.

Wrestling was a popular medieval sport. Fitzstephen refers to wrestling in his list of twelfth-century summer sports.[34] Robert de Brunne's *Handlyng Synne* attacks '"wrastlynges" and somour games' in church yards in 1303.[35] That wrestling was associated with the performance of plays in the early fourteenth century is evident from the petition of the Prioress of Clerkenwell for remedy from the desolation and destruction wrought by the people of London in connection with their miracles and wrestlings on her property. On Saturday, April 8, 1301, the Mayor and Sheriff of London issued a proclamation against *luctas et alias ludos* in the fields, meadows, and pastures of the offended Prioress.[36] Medieval spectators enjoyed wrestling, not only during interludes, but also as integral to the drama itself. In the Chester Shepherds' Play, each of the three shepherds is wrestled and thrown by the fourth character, Trowle.[37] A fragmentary Robin Hood play indicates that wrestling was a popular element in East Anglian drama in the fifteenth century.[38]

In the principal surviving medieval Shepherds' plays, the shepherds are well aware of the prophecies of the Old Testament, both before they are visited by the angel and before they see the star. They refer to the Trinity, the Christ, and the Cross before they receive the announcement of his birth. For example, in the first Wakefield Shepherds' Play, the third shepherd calls on the name of Christ before they settle down to sleep and before their vision of the angel.[39] Two of the shepherds in the Chester play have referred to the Cross and the Trinity before they hear the angel.[40] Greg writes of the 'prophetic principle' in the Old Testament sections of the miracle cycles, prophecies understood in relation to what follows.[41] Chronology of theological dogma bothered the medieval onlooker not at all. In the N-Town and York plays and in the *Prima* and *Secunda Pastorum* of the Towneley cycle, shepherds recall prophetic words.[42]

In all of these cycle plays which involve shepherds aware of prophecies, plus the Shearmen and Tailors' Play of the Coventry Cycle, there are three shepherds. Their role is symbolic as well as prophetic, for they represent both the Trinity and also the Magi, as they present gifts to the child after the vision. In the two Wakefield Shepherds' plays, a ball is a gift of one of the shepherds. We have already noted a ball as a source of amusement in the Egerton Genesis scene of the three shepherds on a hill, along with a fourth person on a lower level who gazes at something brilliant above and beyond the scene (fol. 8ʳ, lower left). It is interesting that Abel, the shepherd, holds a ball in the scene of Cain and Abel on fol. 4ᵛ of the Queen Mary Psalter. Before the annunciation, the three shepherds make crude complaints and bucolic jokes or share an uncouth feast. A balancing act would not be out of place in this scene. In three of the plays, a fourth person, one on a lower social scale, arrives to join the three shepherds: Trowle in the Chester play, Iak Garcio and Mak in the two Wakefield plays. Trowle of the Chester play is seemingly on a lower physical plane also, for the three shepherds who invite him to approach them are seated on a hill. The third shepherd asks for a helping hand to mount the hill with the others.[43]

Isaac was, to the medieval mind, the *sacrifice manqué*. Heavenly visitors announce his birth to Abraham. In the Brome *Abraham and Isaac*, Isaac, the beloved son, accepts his own sacrifice in obedience to his father.[44] Would the patron of the Egerton Genesis have at once

understood the prophecy of Isaac's birth on this folio as akin to the angel's announcement to the shepherds, so familiar in the popular civic drama?[45]

This complicated miniature on fol. 8[r], lower left, of the Egerton Genesis, reflects a melding of two divine commands to Abraham concerning his descendants: to count the stars, as a sign of his future progeny (Genesis 15. 5); to look over the landscape as far as he can see, as a sign of the extent of the territory which he and his children will possess (Genesis 13. 14). In addition, Abraham is invited to travel through the land (Genesis 13. 17). A typological association, rare for the Egerton Genesis, accompanies these details from Genesis—the prophecy of the birth of Isaac as a forerunner of Christ. Little wonder that the person assigned to write a text for this page, puzzled by the complicated iconography, skipped to fol. 9, leaving this page without inscriptions.

ABRAHAM AS PILGRIM

The twentieth chapter of Genesis narrates the story of Abraham's journey into the Negeb and eventually to Gerar where he settles as an alien. In the upper left quadrant of fol. 10[r] (11[r]J) of the Egerton Genesis, we see Abraham in the costume of a traveller or pilgrim. In this scene, Abimelech, King of Gerar, commands with an imperious gesture that Sarah be brought to him by an attendant, who pulls her away from a not unwilling Abraham. Abraham tries to protect himself at Sarah's expense, as he did in Egypt, by claiming that she is his sister. Abraham gestures toward Abimelech as Sarah turns back toward her husband in her reluctance to leave him.

Abraham wears a broad-brimmed hat turned up at the sides. His loose-sleeved fur coat reaches almost to his ankles. He carries a double-knobbed spiked walking staff, the *bordon*, which is often represented with a single-knobbed finial. A wallet hangs by a strap from the shoulder, or around the neck, and under the right arm. Abraham is barefooted and, as a patriarch, he is bearded.

This Egerton Genesis figure of Abraham the traveller is reminiscent of the iconography of Saint James as pilgrim to Compostela, a figure often depicted with bare feet, a satchel hanging from his shoulder and a hat turned up at the sides, either on his head or resting on his neck. He may even hold a double-knobbed *bordon*.[46] The pilgrim figure is not unfamiliar in medieval drama. There exist today several texts of *Peregrinus* liturgical plays in Latin or in the vernacular. Of the surviving texts, most originated in France. They were performed at Saintes, Rouen, Beauvais and Fleury (Saint-Benoit-sur-Loire) and probably elsewhere. One text of an Emmaus play is in the *Carmina Burana*. In the fifteenth-century Shrewsbury fragment, (fols 40[r] to 42[v]), is a *Peregrinus* one-part text in Middle English with Latin rubrics. This text may have been used in the diocese of Lichfield. [47]

In the Fleury *Peregrinus*, the rubrics indicate that an actor approaches in the semblance of the Lord, who himself is in the guise of a pilgrim. The Lord is described as carrying a purse or satchel and holding a long palm. He is clothed with a furry cloak and a tunic. He is barefooted. The two disciples carry staves.[48] A rubric in the *Peregrinus* play of Rouen tells us that

the two disciples are dressed as pilgrims, with staves and purses. Christ wears an alb and an amice; he carries a cross and is barefoot'. The Beauvais directions state that the disciples are to have 'caps on their heads and be bearded'.[49]

Mâle recognised these descriptions of Emmaus-play costumes and properties in the visual arts of the twelfth century: in a cloister bas relief at Silos in Spain, in miniatures of the St Albans Psalter and the Bury St Edmunds Gospels, in one of the small portals at Vézelay, in one of the pillars of the cloister of St Trophîmes at Arles, in the Passion and Resurrection window at Chartres, and in a capital of the cloister of La Daurade, a sculpture now at the Toulouse Museum.[50] Pächt expands upon this close connection between Emmaus imagery and the dramatised version of the narrative in his discussion of iconography in the St Albans Psalter.[51] The pilgrims to Emmaus on fol. 36 of the Holkham Bible Picture Book carry *bordons*, wear furry coats and are barefooted.

Abraham's costume, furry coat, hat, bare feet, purse, and staff in the Egerton Genesis miniature, while having attributes of the Santiago pilgrim, closely follows the Fleury play's rubric. This costume is one of several witnesses to the appearance of Emmaus pilgrims in a medieval drama of Christ's post-Resurrection encounter with his disciples. It is likely that the liturgical drama suggested to earlier medieval illustrators how the religious pilgrim could be depicted, as the visual arts certainly influenced the costuming for the contemporary dramatic presentations which the Egerton Genesis artist watched. With Abraham as pilgrim in an English Old Testament miniature of the mid-fourteenth century, this pictorial tradition is enriched and this cross fertilization illustrated.

GILDED OR SILVERED FACE AND HANDS OF THE DEITY

In all tinted representations in the Egerton Genesis, those illustrations which are completed or nearly so, the Deity who intervenes from a heavenly cloud to direct the actions of humans is distanced from earthly characters by silvered face and hands, sometimes over-washed with gold. The Egerton Genesis artist has distinguished with this silver paint the figure of God, or, in one case, that of an angel, in fifteen images.[52]

Dramatic literature and property inventories mention gilded masks for the actor representing the Deity or another painted celestial being. In a wardrobe account from Edward III's reign, there is a reference to silver heads of angels.[53] Anderson remarks a 'hierarchic gradation in the reflecting glory of stage masks for, at the Guildford Castle Christmas plays of 1348, the angels' masks were only silvered'.[54] The itemised gifts of Master Canynge's 1470 gift to St Mary's Church Redcliffe in Bristol include the 'crowne and visage' of the 'Fadre', probably a gilded mask.[55] Hildburgh, who believes English alabaster tables to have been influenced by the drama, remarks that the hair and beard of Christ are gilded on some of these tablets. He reports Coventry accounts which refer to 'payntyng and gyldyng of God's cote'.[56] Cohen directs our attention to the description in the *Passion of Jean Michel* of the Christ descending from the Mount of Transfiguration: 'the whitest robe which can be made and a face and hands

all of burnished gold'.[57] Mâle remarks this detail of the radiant face of the transfigured Christ after the late fourteenth century in French stained glass windows, as well as in precise indications for the performance of Passion plays, those of Gréban and Michel in particular.[58]

A rubric in the *Mystère de la Passion,* played at Mons in 1501, instructs an assistant to paint the face of Raphael red.[59] Red was the traditional colour for seraphim, though Chaucer describes the Summoner in the Prologue to the *Canterbury Tales* as having a 'fyr-reed cherubynnes face'.[60] A 1433 indenture of the York Mercer's *Last Judgement* play lists among its masks a gilded visor for God.[61]

Was the primary use of silver, rather than gold, to distinguish the Deity in the Egerton Genesis an economy measure? Is this an indication that the patron was of limited means? Did he or she lose interest in the project? In any event, the producer lacked the means or motivation to use luxury materials and to bring the book to completion.

THE ANGRY CHARACTER WHO STRIKES A WEAKER FIGURE

In three images of the Egerton Genesis, an angry individual strikes out with a weapon at a weaker individual. On fol. 9ᵛ, at upper left, Sarah attacks Hagar with the end of her distaff. Hagar is leaving the scene with her hands raised in protection. The giant Nimrod (Nembroth), on fol. 5ʳ at upper left, enforces his command that the people worship fire. He threatens to strike a group of suppliant figures, one of whom assumes exactly the same posture of self-defence with upraised arms which the illustrator gives Hagar on fol. 9ᵛ. The third example is on fol. 11ʳ (10ʳJ): In the lower half of the illustration, a Sodomite attempts to jab or strike two poor men, one of whom holds out a begging bowl toward his attacker (fig. 39).

In medieval drama, the individuals involved in personal violence are often husband and wife; the contest is usually on more-or-less equal terms. The Punch-and-Judy type of scene has long amused audiences. There are examples in medieval drama where the woman strikes out, seemingly with a distaff as her weapon. In the Wakefield Noah play, Uxor quarrels with her husband. Refusing to enter the ark, she tells him that he deserves to be clad in 'Stafford blew', thus indicating that she intends to administer bruising blows with her distaff. As she strikes him, she tells him to take a 'langett to tie up thy hose', presumably threatening him with the strap that binds her distaff's wool. She then resumes her spinning on a hill near the ark where she once again menaces Noah with a knock. The reluctant wife continues spinning as the other seven enter the ark.[62] Stevens says of Noah's wife in this play that she 'freely uses her cudgel in the form of a distaff'. In the Chester Noah's flood play, Noah's wife refuses to embark, even though she helped to build the ark by bringing timbers. She then boxes Noah's ears as she enters the boat.[63] It is interesting to note that only in the N-Town play, among the cycle plays of the Flood, is Noah's wife very helpful. The Egerton Genesis, also, portrays Noah's wife as a calm helper, whereas Nimrod, Sarah, and the Sodomites are shown as the aggressors.

In the 10th Chester Mystery Cycle play, the *Massacre of the Innocents*, the second mother tries to defend her baby, saying,

> Be thou so hardy, I thee behet
> to handle my son that is so sweet
> this distaff and thy head shall meet
> or we hethen gone.[64]

In the Digby Killing of the Children, the mothers beat Herod's messenger Watkyn with their distaffs.[65] In the biblical narrative, Hagar, as mother of Abraham's son Ishmael, torments her mistress Sarah, who is still barren. Sarah's violent reaction in the Egerton Genesis illustration calls to mind the treatment of the insolent servant who receives a beating in the English folk play, and husband-wife struggles in mummers plays.[66] As for domestic rivalry, the Mumming of Hertford (c. 1425) 'dispenses with allegory and presents rival sexes as speaking protagonists in the action. At least, the wives who enter armed with distaffs have their spokesperson'.[67] Images on the borders of late twelfth- and thirteenth-century manuscripts provide examples of the distaff as a feminine weapon.[68] A wood-carved miserere in the monastic stalls of Norwich Cathedral represents a woman driving away a fox with her distaff.[69]

The enraged tyrant of the early theatre was still a well-known character when Shakespeare's Hamlet instructed his players not to 'out-Herod Herod'. Pharaoh, Herod, and Pilate, all three, were given the comic role of outraged and violent despot in mystery plays. They are brought low after their prideful ranting. There are parallels to the stricken wicked tyrant in the sudden illness of the lustful Pharaoh and Abimelech (fols 7ʳ and 10ʳ (11ʳJ)), whom ineffectual priests and doctors cannot cure.[70] The diabolical figure, such as the Sodomite of the Egerton Genesis, sometimes rages irrationally. He becomes a buffoon, a comic figure. On fol. 11ʳ (10ʳJ), at left below, the Sodomite who pokes or strikes two beggars with a long stick reminds one of the violent tyrant or fool of the medieval drama. In the St Lawrence legend window at Ludlow (Shropshire), the frenzied emperor, reacting in anger to the Saint's advice that he give his wealth to the poor, beats an indigent subject with his staff. Anderson remarks that this scene 'recalls the comic tyrants of the mystery plays'.[71] It seems almost certain that the Egerton Genesis artist drew upon the idiom of theatre in depicting the behaviour of enraged individuals in Egerton Genesis images.

ANGELS IN FEATHERED SUITS

In the representation of the sacrifice of Isaac story on fol. 13ʳ (12ʳJ), at the point where the angel intervenes to prevent Abraham from killing his son (Genesis 22. 11), a small bird-like angel, with a tail, but with human face and hands, swoops down to stay Abraham's sword with his left hand, while pointing with his right to the ram caught in the lopped branches of a divided-heart tree below. Prior and Gardner thought the feathered angel could be considered a 'heavenly bird'.[72] There are records of artificially contrived stage angels during the period of the medieval theatre.[73] This bird-angel of the Egerton Genesis, who also has human attributes, suggests the awareness of a theatrical contrivance on the part of the Egerton Genesis artist.

On fol. 17ʳ, a winged, man-sized angel wrestles with Jacob, holding him by the belt and the

fabric of his short dress. The remarkable property of this angel is his costume, a tight-fitting suit of feathers reaching to his wrists and ankles. The two adversaries wear the caps we noted on the two fighting shepherds of fol. 7ᵛ, wrestlers who have prepared themselves in advance for the contest. These feather-suited angels, both bird and human, differ markedly in the Egerton Genesis from the authoritative angels: the robed and sometimes extravagantly winged angels outside the gates of Sodom (fol. 11ʳ (10ʳJ)) and the angel with unfinished wing in the scene of Sodom's destruction (fol. 11ᵛ (10ᵛJ)). Also different is the double-headed angel of fol. 11ᵛ (10ᵛJ) who stands inside the doorway of Lot's house, holding tightly by her garment one of Lot's daughters as the father offers them to the Sodomites. The little capped angels climbing Jacob's ladder, on fol. 15ʳ, differ still further from the wrestling adversary of Jacob on fol. 17ʳ. They more nearly resemble the choirboy angels of Fouquet in the miniature of the Martyrdom of Saint Apollonia, from the *Heures d'Etienne Chevalier* at Chantilly.[74] These angels of Jacob's ladder in the Egerton Genesis wear diminutive green-striped wings and enveloping robes, which seem to impede their ascent with the Deity up the ladder of Jacob's dream. The costume of the Egerton Genesis angel varies to fit the role he plays in the narrative.

Prior, Hildburgh, Anderson, Palmer, and others have noted the theatrical elements of feathered body-stockings in fourteenth-century carved alabaster tables, in glass and in fifteenth-century church art in Bordeaux, Warwick, and Yorkshire. All of these scholars consider these suits stage costumes. Prior saw evidence of the mystery play in such feather-bodied figures as those at the tomb of the Duchess of Suffolk at Ewelme and in the spandrel of the west door at Salle, in Norfolk.[75] Hildburgh has observed the feathered tights under the armour of Saint Michael in alabaster carvings. He sees in these garments evidence of influence of the drama.[76] Anderson remarks that the effect of stage costumes upon art is clearly indicated among angels. She calls attention to these costumes on the Beauchamp Chapel angels at Warwick.[77] Palmer gives ten examples of feathered angels in her study of items relevant to drama in the West Riding area of Yorkshire, an area of lively dramatic activity during the medieval period. [78]

OTHER COSTUMES AND POSSIBLE STAGE PROPERTIES

1. The fool-vice

In the images on fol. 11ʳ (10ʳJ) of the Egerton Genesis, Sodomites assault Lot's house, demanding to have their way with the visiting angels (Genesis 19. 6–11). The story is continued on fol. 11ᵛ (10ᵛJ). On the lower half of the recto, we see Lot pulling the two angels toward what appears to be the city gate of Sodom. The upper left quadrant of the verso illustrates the aggressive Sodomites at the door of Lot's dwelling. Lot offers his young daughters to a group of five of the intruders, in the attempt to appease their lust and protect his angelic guests. One of their group has already been stricken blind and is feeling his way along the wall of the house with his back toward the viewer.[79] The illustrator has clothed the Sodomite with a curious costume, a hood anchored by underarm straps, with a long tail or liripipe hanging to below the waist from the cap's peak, sleeves puffed to the elbow, and tights disappearing into

soft shoes with long pointed toes. Projections suggesting the aroused male sexual organ are attached to the tights. The blind Sodomite wears a sword. The aggressive Sodomite at left in the lower half of 11r (10rJ) violently wields a wooden staff.

We have already looked at the Sodomite striking a beggar as reminiscent of the dramatic tradition of the angry tyrant. How does this costume add to our understanding of the illustrator's characterisation of this personage? Does this character suggest the theatre? In Chaucer's *Hous of Fame*, Lady Fame addresses the self-proclaimed knaves who earn their living by wickedness as wearers of parti-coloured hose and bells. Chaucer implies that the antics of these fools represent the poorest form of human behaviour.[80] In fool-led dances, participants 'play at the staff', imitating bullying treatment between spouses, the favourite comic element, above-mentioned.[81] Violence is associated with the activities of the Morris fool.[82] Illustrations from early fourteenth-century psalters depict the fool in initials for Psalm 52 (53) which begins, as does Psalm 13 (14), with 'The impious fool says in his heart, there is no God'. Here, the semi-naked fool wears peaked cap with tippet or liripipe and eared hood. Hood, tunic and hose characterise the fool in illuminations after 1350.[83] William Langland, in *Piers Plowman*, links the fool and the devil, though he distinguishes between the natural witless person who is innocent and the artificial fool-mimic who is a professional.[84] The ornamental sword, often made of wood, was the hallmark of the fool in drama. In the manuscript of the Etymology of Exeter College (Oxford, Exeter College, MS 42, fol. 12r), circa 1300, the fool is naked, but for a sword and an eared hood. The fool often carries a phallic-shaped bauble. The sword here hanging between the legs of the Sodomites on fols 11r (10rJ) and 11v (10vJ) suggests the male sexual organ, as do the above-mentioned attachments on the costumes of the unarmed lustful figures at right on fol. 11v (10vJ).[85]

Stevens points to one model of the prime antagonist in the Corpus Christi drama, the devil as fool.[86] Tiddy, author of *The Mummers' Play* and student of English folk drama, expressed the idea that the fool-devil of the folk play and the vice are closely akin, 'essentially one and same'. The fool and the riotous man became associated as the vice of the morality play.[87] In early mummers' plays, there was a connection between Beelzebub and the fool. According to Mares, the vice was already a stage clown before the morality play became popular and already wore a fool's dress. The vice depended on abuse to make his effect, as did the fool.[88] Chambers mentioned a green and yellow hood as fool's costume in the sixteenth-century court revels.[89] Regrettably, these Egerton Genesis illustrations are not tinted, as the colour of the Sodomite costume, hose, or hood, for example, might have suggested a closer parallel with fool-vice dramatic tradition.

In depicting the fool-like costume for the Sodomite of Genesis 19 and his lustful and violent behaviour in the Egerton Genesis, the artist could count upon the contemporary viewer's awareness of the medieval dramatic tradition linking the fool with the violent man, who is later to become the personification of vice in the moralities. Violence toward the poor, recorded in art and drama, and perhaps observable in contemporary life, adds an element of black comedy to this biblical illustration in the Egerton Genesis.

2. Costumes and personae

The Egerton Genesis illustrator's use of costumes alerts the viewer to the status, function, and role in society of persons depicted. This is characteristic of the medieval theatre. The audience must be able immediately to identify the nature and function of the stage personage, whether human, diabolic, or angelic, at his appearance on the scene. We note the unmistakable costume of the divine Creator, the pilgrim, the potentate, the patriarch, the shepherd or workman, the matron, and the maid.

The standing figure of the Creator in the Egerton Genesis is easily identifiable, even apart from the cross-nimbus, by the colour of robe and cloak, and by the green ornate morse which clasps his outer garment at the neck. He is, of course, bearded and barefooted (fols 1ʳ, 2ᵛ). Anderson calls attention to the traditional long, draped mantle for Christ and the bare feet, which distinguish Christ and the apostles from other figures in medieval imagery.[90] Characters who are younger, or of inferior status, wear a tunic ending above the knee. The artist may exchange the costume of dignity for the simple costume according to the role of the character in the story. For example, Esau the husband, fol. 14ᵛ, upper left, wears a long robe and mantle, whereas Esau the hunter, in the adjacent quadrant, wears the short robe of youth.[91] Persons of lesser age or status may be bare-legged or wear what appear to be stirrup-footed trousers or leggings fringed at the ankle. They are usually without shoes (fols 3ʳ, 4ʳ, 5ᵛ, 7ᵛ, 13ʳ (12ʳJ)). Henderson remarked this distinction in the twelfth-century scene of the sacrifice of Cain and Abel on the painted nave vault of Saint-Savin-sur-Gartempe: 'Abel's head is surrounded by a nimbus and he wears a robe which reaches to his ankles . . . whereas Cain wears a short tunic'.[92]

The potentate is bearded and shod. If seated, he wears his crown and holds a fleur-de-lys sceptre, as on fols 7ʳ, 10ʳ (11ʳJ). If he is ill or dreaming, his crown lies beside him (fols 7ʳ, 20ʳ). He may wear the crown on his arm, as does Melchizedek (fol. 9ʳ, upper right), whom the author calls king as well as priest, and who needs his hands to present the bread and wine to Abraham and to receive his tithe of coins. If standing, or at table, the king is crowned and robed, usually with his outer garment clasped by a brooch which is smaller and less elaborate than that of the Creator (fol. 14ʳ).

Hairstyles play their role in character identification. Tightly curled hair indicates the workman or youth, as on fols 5ᵛ, 10ᵛ (11ᵛJ), 15ᵛ. Long, loose hair, with a forehead curl and a flowing beard, identify the patriarch or prominent older individual (fols 6ᵛ, 9ʳ). Noah is usually bald (fols 2ᵛ, 3, 4, 5); the priest is tonsured (fols 7ʳ, 9ʳ). The married woman usually wears a short white kerchief (fols 2ᵛ, 6ᵛ), whereas unmarried women or girls wear a coiffure with braids arranged vertically over the ear on each side of the head (fol. 11ᵛ (10ᵛJ)); fol. 13ᵛ (12ᵛJ)). In brasses of 1349 and 1364, St Margaret's, King's Lynn, the wives of Adam de Walsokne and Robert Braunch wear kerchiefs swathing the chin, such as those worn by Lamech's wives and Noah's wife on fol. 2ᵛ of the Egerton Genesis.[93] The woman's role may be delineated more precisely: the childless concubine (Hagar, Bilhah) wears braids crossed over the frontal crown (fols 9ᵛ, 16ʳ); the midwife wears a close-fitting kerchief, stretched under the chin and bound

at the forehead, with a length of cloth tied behind the head (fols 12ᵛ (13ᵛJ), 19ʳ). Even the child-less wife, Rachel on fol. 16ʳ, may have side braids rather than a veil.

A particular role in the narrative drama may have its own individual mark of identification. The bald Noah has one uncurled lock at the forehead (fols 2ᵛ, 3ʳ and 3ᵛ). Noah was represented as bald in the Cornish *Creacion*, where Jabal mocks him as 'old wretch, you baldpate'.[94] The Ishmaelite merchants who buy Joseph from his brothers and sell him to Potiphar are distinguished by cone-shaped hats worn over hooded cloaks, buttoned high at the neck. They wear gloves and soft boots to which spurs are attached by leather thongs around the ankle and under the arch of the foot (fols 18ᵛ and 19ʳ). The Sodomite, as noted previously, wears a costume resembling that of the fool, this costume being associated with vicious behaviour in the dramatic tradition (fols 11ʳ (10ʳJ) and 11ᵛ (10ᵛJ)).

The traveller's costume contributes to the viewer's easy reading of the narrative or immediate understanding of the drama. In addition to the traveller Abraham's pilgrim costume (fol. 10ʳ (11ʳJ)), which has a close parallel in drama, we find Abraham again in his wide-brimmed hat and laced boots at the well with Abimelech and Phicol (fol. 10ᵛ (11ᵛ J)). On fol. 15ᵛ, a herdsman, dressed in the same travel hat and cloak, and carrying the knobbed staff, points out Rebecca at the well to Jacob. Rebecca, as a traveller, is twice shown with the same hat which we have noticed before on the masculine traveller: once when she takes leave of her family to go with Abraham's servant (fol. 13ᵛ (12ᵛJ)); and again, when she arrives to meet her future husband Isaac at the door of his dwelling (fol. 12ʳ (13ʳJ)). This broad-brimmed travel hat becomes a familiar 'prop', having been used by the illustrator to signal the traveller or wanderer five times in all.

Potiphar or his agent and other minor officials of the Pharaoh wear short pleated skirts falling from a tight bodice, with a broad collar which covers the shoulders, and soft shoes, clothing reminiscent of the Greek royal guard costume (fols 19ʳ,19ᵛ, and 20ʳ). That this style was also fashionable among mid-fourteenth-century courtiers may be seen on fol. 51ʳ in a four-teenth-century copy of Guillaume de Machaut's *Le Remède de Fortune* (Paris, Bibliothèque Nationale, MS fr. 1586),[95] and also in Bodley 264, fols 59ʳ and 112ᵛ, among many other examples. Joseph's costume, after his elevation to Pharaoh's court, distinguishes him from the vulnerable youth of the earlier narrative. He wears a long-sleeved robe ornamented by a fabric roll or bracelet above each elbow, with another such roll or necklace at the throat (fols 20ʳ and 20ᵛ). Costume thus alerts the Egerton Genesis viewer, as it did the playgoer, to the role and function of the actor in this dramatically illustrated pictorial narrative.

3. Stage properties

On fols 1ʳ and 1ᵛ of the Egerton Genesis, the Deity sits upon a rainbow in six scenes of Creation.[96] The rainbow, in its more usual association with the Last Judgement, has its place in medieval drama. Roy associates the *arc-en-ciel* on which Christ and his apostles take their places in the *Last Judgement* at Lucerne with the scene of van der Weyden in the Polyptych at Beaune.[97] Cohen quotes a description from Roy of the Divinity in three persons seated on a rainbow in an elaborate *monstre* or preparatory procession for a representation of the 'Acts of

the Apostles' at Bourges in 1536.[98] Johnston and Dorrell record mention of 'a cloud and ii pieces of rainbow of tymber array' as properties related to the 1433 Doomsday pageant of the York Mercers.[99] The rainbow of Christ the Creator in the fourteenth-century Egerton Genesis is thus reminiscent of the rainbows of paintings and of drama properties in both England and on the Continent.

The entrance and exit of animals in the Noah's ark illustrations of fols 3 and 4 of the Egerton Genesis differ markedly from those in which the beasts mount or descend a ramp or ladder on their own power, as in the Sicilian mosaics at Palermo and Monreale, in the Oxford Moralized Bible and in a de Brailes illustration in the Walters Art Gallery.[100] The Egerton Genesis depiction differs even from other images in which animals are carried bodily into the ark.[101] On fol. 3r of the Egerton Genesis, Noah, his wife, and two sons carry on their backs inert figures of various animals: Noah's burden is a large ram, his wife's a bullock. One son transports on his shoulders two bears, another two monkeys. Noah's third son drags a reluctant lion toward his wife, who leans down to lift it into the ark. On fol. 4r, disembarking animals are considerably more active than those of the embarkation. However, Noah's wife, identifiable by her wimple, lowers from the side of the ark onto the grassy ground below a goat or ram very like one in the embarkation (fol. 3r).

The animals of the Egerton Genesis Flood scenes are represented largely in profile. Interestingly, some of the freed creatures, the bear, the bellowing bovine, and the determinedly advancing lion moving off to the left, are depicted in exactly the same postures as were their tiny counterparts at upper right in the Creation miniature of fol. 1v.

In the Chester Cycle *Noah's Flood*, beasts and fowl are described as painted on board. Stage directions for a late theatrical manuscript call for painted animals on boards which Noah's family swing upward to hang upon the ark.[102] Could the illustrator's recollection of wooden silhouettes of animals used in drama have inspired this curious representation of the rather stiff-bodied animals, depicted in profile, being carried into the ark?

The recurring use of the same element of 'scenery' in Egerton Genesis illustrations suggests a narrative played out on a stage. We mentioned previously the background in the drunkenness of Noah scenes (fol. 4v). Examples of what appear to the close observer as scenery are numerous. A few will suffice: the simple doorway of a box-like structure, usually at the left of the scene, often with a figure sitting before it, appears twenty-two times.[103] A crenellated entranceway to a castle or city gate appears at least twelve times. These more elaborate portals vary more among themselves than do the simpler cottage-like doorways, which are almost replicas one of another.[104] On fol. 15r, God and two angels ascend Jacob's ladder, reminiscent of the ascent to and descent from the locus of Heaven in the religious drama. The resemblance of these diminutive angels to the winged choirboys sitting on the ladder to heaven in Fouquet's scene of the Martyrdom of Saint Apollonia has been mentioned before.

A fence of curved reeds surrounds the house from which Rebecca takes leave of her family to become the bride of Isaac, lower right on fol. 13v (12v]). Anderson notes that Joseph builds an osier fence for the stable in the fifteenth-century mystère at Rouen. Roof bosses at Salle and Norwich show wattled fences associated with nativity scenes. Though no surviving English

play includes such a fence, its use in imagery suggested to Anderson that it was used dramatically in England.[105]

Sarah and Abraham prepare an altar with an elaborate Gothic superstructure on fol. 8r, at lower right. The Hull Noah play accounts for the years 1495–8 include an item for the painting of two tabernacles and for the 'bretesying over the table'. Bratticing or 'brattishing' refers to cresting or open carved work at the top of a shrine.[106] Rose hypothesises a dome on four slender legs, perhaps similar to the altar on fol. 8r of the Egerton Genesis, as somewhere in the *platea* of a group of N-Town plays.[107] Anderson calls attention to the use of a pinnacled roof with angled turrets, to indicate the building where a scene takes place. Norwich bosses, certain alabasters and an arched altar painted on a rood screen at Lodden, Norfolk, provide examples of this method of defining a scene. Anderson considers these as possible stage devices known to the artist.[108]

Sheingorn remarks on the tendency of staged journeys to move into the *platea* from the left and leave the scene at right, while entry from the right suggests a return.[109] This is the general rule for the travellers in Egerton Genesis pictorial narratives. Those entering the ark move from left to right (fol. 3r); Rebecca leaves with Abraham's servant from the left and arrives at Isaac's house from the right (fols 13v (12vJ) and 12r (13rJ)); Joseph's brothers move away from Jacob toward the right as they take Benjamin to Egypt at Joseph's command (fol. 20v). In the scene of the cup's discovery, the animals have already reversed direction to return to Egypt (fol. 20v).

The *platea* offered opportunity for actors to enter or leave the scene on horseback. In the *Conversion of St Paul*, Saul rides onto the scene with his servants. Again on the *platea*, he is stricken on the road to Damascus. Cain has a team of horses in the Wakefield play, and the magi enter on horseback. Horses are used in the Cornish *Life of St Meriasek*.[110] The defecation of one of Eliezer's camels as he prepares to leave the scene with Rebecca (fol. 13v (12vJ) of the Egerton Genesis) represents what must have been a frequent occurrence in religious drama where horses were used. A jester in Fouquet's theatrical scene, *The Martyrdom of Saint Apollonia*, distracts the crowd by lowering his hose, exposing his buttocks, presumably to prepare for defecation. This sort of coarse comic touch, though unexpected in the main scenes of biblical illustration, might not have surprised the early viewer of the Egerton Genesis, who was frequently reminded of the drama.

Hills are mentioned among the stage sets of the medieval religious plays.[111] Noah's wife sits on a hill to spin.[112] The Brome sacrifice of Isaac text refers to a hill.[113] In the Cornish plays *Origo Mundi* and *Passio*, a hill or high place is mentioned, as well as in the N-Town sacrifice of Isaac, the *Thrie Estaites*, and the *Life of St Meriasek*.[114] In the Chester Shepherds' Play, the hill, sometimes called 'the low', is mentioned at least four times.[115] Several scenes in the Egerton Genesis use this prominent mound iconographically. Both Rebecca (fol. 12r (13rJ)) and Isaac (fol. 14r) pray while kneeling on similar hills, with a simple dwelling indicated at the left of the scene. In both scenes, God looks down upon the petitioner from upper right. A hill is prominent in scenes of the destruction of Sodom (fol. 11v (10vJ)) and in the scenes of the sacrifice of Isaac (13r (12rJ)).

CONCLUSION

The Egerton Genesis scenes are often earthy. There is no sign, however, of the exaggerated coarseness or sadism of the Wakefield Master's plays of *Joseph's Trouble* and the *Buffeting and Scourging of Christ*. Cruel scenes, such as those found in Passion illustrations of the Holkham Bible Picture Book, are absent. However, a biting realism and the vital energy of visual narrative remind us of the drama in many scenes. In the Egerton Genesis, Noah's wife is not a rebellious shrew. But shepherds do wrestle, men graphically circumcise themselves and engage in sodomy, a woman is raped, the patriarch Judah has intercourse with an apparent prostitute, an animal in an image defecates. The flavour of the medieval English stage is strongly suggested, as one turns the pages of this slim codex. The earthy biblical stories are laid out for what they are, with few references to typology. The visual narratives of the Egerton Genesis are seldom touched by the courtly restraint often to be found in the main biblical scenes of fourteenth-century English manuscript illumination. Artist and patron have welcomed the ribald spirit of the drolleries and the civic drama into the central scene.

Would it be surprising if the fourteenth-century owner of this Genesis Picture Book found in his manuscript certain sequences, tableaux, properties, and costumes used in contemporary drama? Would he have associated wrestling figures with the summer games accompanying religious plays? Would the reiterated command in Genesis to count the stars have recalled to the viewer not only the prophecy of the Christ-type Isaac but also the announcement of Christ's birth in Luke's story as dramatised in the Shepherds' plays? Such an association would not have gone unnoticed. The medieval illustrator and his patron, the player and his audience would not always have adhered to the chronology we expect today. Christian symbols and figures of speech foreshadowing the Nativity were to be expected in Old Testament depictions, which unquestionably prefigured the Gospel events for the playgoer and for the manuscript viewer.

Costumes and actions identifying dramatic types or illustrative of roles in narrative were perhaps easily recognizable in both miniatures and dramatic performance, as they could indeed be seen in other visual arts. To understand contemporary reaction to manuscript illustration and to drama, we must assume the role of the English fourteenth-century viewer, familiar with biblical imagery and with Genesis tales. Like the Greek audience of Sophocles, the medieval bibliophile or playgoer usually knew the story's end before he or she ever settled down to relish its retelling, whether pictorially or dramatically, in terms both old and new.

Dramatic elements in manuscripts pre-dating the Egerton Genesis, such as the Fitzwarin Psalter and the Holkham Bible Picture Book, and in alabaster tablets, attest to use of the stage as a model for biblical realism commonly experienced and commonly understood. The influence of the theatre upon the imagination of the fourteenth-century visual artist is striking. Entire scenes seem theatrical, almost 'carnivalesque'.[116] Telling details recall the drama: bodily restraints are often absent; stage-like properties, gestures, and costumes abound. Even theatrical tricks may have served as models: board figures used in plays are suggested by ark

animals, seen in profile; the tailed and feathered angel who prevents the sacrifice of Isaac in the Egerton Genesis recalls birdlike angels pulled across upper stage space on a cord or wire.

This artist is prominent among those who turned to the drama as a source of realistic details. This skilful draftsman worked late in a well-established tradition of English artists who depended to some extent upon common knowledge of public drama to reinforce their intended realistic formulae, who drew but little upon the spatial illusionism of the early Italian Renaissance. In the East Anglian manuscripts, to be discussed in Chapters 5 and 6, there is realism in detail and some modelling, but no special concept of perspective. After mid-century, a change toward the influence of Italian art overlaps to some degree the dramatic realism of the Egerton Genesis. However, the Egerton Genesis remains a late witness to the staying power of theatrical realism in England, even as mid-century changes were underway.

Notes

1 *Illustrations*, p. 5.

2 Rosemary Woolf remarked the position of the Lamech episode within the N-Town narrative of the Flood. See *The English Mystery Plays* (London: Routledge and Paul, 1972), p. 135. Ellin M. Kelly first noticed the correspondence of this sequence with that of the Egerton Genesis. See ' "Ludus Coventriae" Play 4 and the Egerton "Genesis" ', *Notes and Queries*, 19 (1972), 443–444.

3 Harris compares the *Jeu d'Adam* and the *Holy Resurrection*, both in Norman French, to informative picture books with folk elements, intended to delight and inform. J. W. Harris, *Medieval Theatre in Context: an Introduction* (London: Routledge, 1992), pp. 49, 50.

4 Harold Charles Gardiner, *Mysteries' End: an Investigation of the Last Days of the Medieval Religious Stage* (New Haven: Yale University Press, 1946), ch.V, *passim*.

5 Alexandra Johnston, 'Chaucer's Records of Early English Drama', *REED*, 13.3 (1988), 13–20 (p. 18).

6 Martin Stevens, *Four Middle English Mystery Cycles* (Princeton: Princeton University Press, 1987), pp. 323, 325.

7 *Illustrations*, p. 6.

8 Hans-Jürgen Diller, *The Middle English Mystery Play: Great Britain*, trans. by Frances Wessels (Cambridge: Cambridge University Press, 1992), p. 4. For comments on dates of performances and manuscripts, see Stevens, ch. 1, *passim*.

9 See R. H. Robbins, 'An English Mystery Play Fragment ante 1300', *MLN*, 65 (1950), 30–35; Norman Davis, ed., *Non-Cycle Plays and Fragments*, EETS, SS 1 (Oxford: Oxford University Press, 1970), pp. cxiv–cxv; Ian Lancashire, *Dramatic Texts and Records of Britain: A Chronological Topography to 1558* (Toronto: University of Toronto Press, 1984), p. 20; Anna J. Mill, 'Miracle Plays and Mysteries', in *A Manual of the Writings in Middle English 1050–1500*, gen. ed., J. Burke Severs, 9 vols (New Haven: Connecticut Academy of Arts and Sciences, 1967–1993), V: *Dramatic Pieces*, Albert. E. Harting, gen. ed. (1975), pp. 1323–1324.

10 See Arthur F. Leach, 'Some English Plays and Players, 1220–1458', in *An English Miscellany Presented to Dr. Furnivall in Honour of his Seventy-fifth Birthday*, ed. by W. P. Ker, A. S. Napier, and W. W. Skeat (Oxford: Clarendon Press, 1901), pp. 205–234, (p. 206).

11 Of interest here is Roscoe E. Parker, 'Pilates Voys', *Speculum*, 25 (1950), 237–244.

12 Hassall, *Holkham Bible*, pp. 34–36.

13 See William Tydeman, *The Theatre in the Middle Ages: Western European Stage Conditions, c.800 to 1576* (Cambridge: Cambridge University Press, 1978), pp. 18, 19. See also Arthur Percival Rossiter, *English Drama from Early Times to the Elizabethans* (London: Hutchinson, 1950), pp. 56–57, for complaints from Wells and Exeter about raucous plays in the Church. For other early complaints about actors and plays, see John Wasson, 'Professional Actors in the Middle Ages and Early Renaissance', in *Medieval & Renaissance Drama in England: an Annual Gathering of Research, Criticism and Reviews*, J. B. Leeds, ed., P. Werstine, ass. ed., (New York: AMS Press, 1984–), I, pp. 1–12 (p. 2).

14 See Roger Sherman Loomis, *Medieval English Verse and Prose in Modernized Versions* (New York: Appleton-Century-Crofts, 1948), pp. 289–293 and p. 553, n. 32.

15 E. K. Chambers, *The Mediaeval Stage*, 2 vols (Oxford: Clarendon Press, 1903), II, 344. Chambers mentions this play on pp. 109 and 130 as well. On p. 190 he mentions Bishop Grandison's reference to mid-fourteenth-century theatre in Exeter. See also Roger Sherman Loomis and Gustave Cohen, 'Were There Theatres in the Twelfth and Thirteenth Centuries?', *Speculum*, 20 (1945), 92–98.

16 Emile Roy, *Le Jour de Jugement, Mystère français sur le grand schisme* (Paris: Bouillon, 1902; repr. Geneva: Slatkine, 1976); Emile Mâle, 'Le renouvellement de l'art par les "mystères" à la fin du moyen âge', *GBA*, 31 (1904), 90–96, 215 ff., 283 ff., 370 ff., (p. 289); E. S. Prior, 'The Sculpture of Alabaster Tables', in *Illustrated Catalogue of the Exhibitions of English Medieval Alabaster Works* (London: Society of Antiquaries, 1913), pp. 16–28; Gustave Cohen, *Histoire de la mise en scène dans le théâtre religieux français du moyen âge* (Paris: Champion, 1906; 2nd and 3rd edns, 1926, 1951); W. L. Hildburgh, 'English Alabaster Carvings as Records of the Medieval Religious Drama', *Archaeologia*, 93 (1949), 51–101; Otto Pächt, *The Rise of Pictorial Narrative in Twelfth–Century England* (Oxford: Clarendon Press, 1962); Alexandra Johnston, ' "All the World was a Stage": Records

of Early English Drama', in *The Theatre of Medieval Europe*, ed. by Eckehard Simon (Cambridge: Cambridge University Press, 1991), pp. 117–129.

17 J. K. Bonnell, 'The Source in Art of the So-called Prophet's Play of the Hegge Collection', *PMLA*, 29 (1914), 327–40; Patrick Collins, 'Narrative Bible Cycles in Medieval Art and Drama', *Comparative Drama*, 9 (1975), 125–146 (*passim*); Clifford Davidson, *Drama and Art: An Introduction to the Use of Evidence from the Visual Arts for the Study of Early Drama* (Kalamazoo, MI: Medieval Institute, Western Michigan University, 1977), p. 2.

18 See Gail McMurray Gibson, 'Long Melford Church, Suffolk: Some Suggestions for the Study of Visual Artifacts and Medieval Drama', *RORD*, 21 (1978), 103–115 (p. 103) and Pamela Sheingorn, 'On Using Medieval Art in the Study of Medieval Drama: an Introduction to Methodology', *RORD*, 22 (1979), 101–109 (p. 106).

19 Glynne Wickham, *Early English Stages, 1300–1660* (London: Routledge & Paul, 1959; repr. New York: Columbia University Press, 1980), p. 101.

20 'L'Oeuvre d'un artiste est faite de tant d'impressions subtiles, de tant d'inspirations qui se sont mêlées en lui, qui l'on ne sait plus d'où elles sont venues', *Histoire*, p. 115.

21 See Peter Kurmann, *La Façade de la Cathédrale de Reims: architecture et sculptures des portails*, 2 vols (Paris: Centre National de la Recherche Scientifique, 1987), II, pls 467, 473–475. Jaroslav Folda called our attention to a possible parallel between the Reims figures and those on fol. 2r of the Egerton Genesis.

22 Emile Mâle, *Religious Art in France: the Late Middle Ages* (Paris: Colin, 1908; Princeton: Princeton University Press, 1986, trans., rev., corrected, from 1949 edn), pp. 66–67. For another scholar's opinion as to the dramatic origin of the iconography of the *Puits de Moise*, see Aenne Liebreich, *Claus Sluter* (Brussels: Dietrich, 1936), pp. 80–81.

23 Robert A. Brawer, 'The Form and Function of the Prophetic Procession in the Middle English Cycle Play', *Annuale Mediaevale*, 13 (1972), 88–124 (p. 88). E. K. Chambers, *English Literature at the Close of the Middle Ages* (Oxford: Clarendon Press, 1945; repr. 1964), p. 6.

24 G. R. Owst, *Literature and Pulpit in Medieval England* (Cambridge: Cambridge University Press, 1933), p. 485 and *passim*.

25 *Jeu d'Adam*, ed. by W. Noomen (Paris: Champion, 1971), pp. 64–75.

26 Diller, p. 120, n. 48, calls attention to the term 'action-less' for these prophets.

27 Brawer, p. 115; L. T. Smith, ed., intro., gloss., *York Plays: the Plays Performed by the Crafts or Mysteries of York on the Day of Corpus Christi in the 14th, 15th and 16th Centuries* (Oxford: Clarendon Press, 1885; repr. New York: Russell and Russell, 1963), pp. 93–8.

28 See especially p. 332.

29 Claude Gauvin, *Un Cycle du théâtre religieux anglais du moyen âge: le jeu de la ville de 'N'* (Paris: Centre National de la Recherche Scientifique, 1973), p. 53.

30 Stephen Spector, *The N-Town Play, Cotton MS Vespasian D 8*, EETS, SS 11, 12, 2 vols (Oxford: University Press, 1991), I, 41, ll. 10–11 and 42, l. 40.

31 Spector, I, 50, ll. 13–16.

32 See Diller, p. 122, for other examples of self-introduction in medieval drama.

33 'Giottesque Episode', p. 59, n. 2. See our text comment for fol. 9r, upper left, in the Appendix.

34 Charles Read Baskerville, 'Dramatic Aspects of Medieval Folk Festivals in England', *Studies in Philology*, 17 (1920), 19–87 (p. 55).

35 Idelle Sullens, ed., *Robert Mannyng of Brunne, 'Handlyng Synne'*, Medieval and Renaissance Texts and Studies, 14 (Binghamton, NY: Medieval and Renaissance Texts and Studies, 1983), ll. 8991–8994.

36 W. O. Hassall, 'Plays at Clerkenwell', *MLR*, 33 (1938), 564–567 (pp. 565–567). For more on wrestling, see Diller, p. 243, n. 219, and Gail M.Gibson, *The Theatre of Devotion: East Anglian Drama and Society in the Late Middle Ages* (Chicago: University of Chicago Press, 1989), p. 114, n. 30. See also n. 13 above.

37 David Mills, *The Chester Mystery Cycle* (East Lansing, MI: Colleagues, 1992), Play 7, pp. 136 and 137.

38 Tydeman, *Theatre*, p. 19.

39 George England and Alfred W. Pollard, eds, *The Towneley Plays*, EETS, ES 71 (London: Paul, Trench, Trübner, 1897; repr. Millwood, NY: Kraus, 1975), p. 109, ll. 290–292.

40 Mills, *Chester Mystery Cycle*, p. 134, l. 236; p. 138, l. 347.

41 Walter W. Greg, *Bibliographical and Textual Problems in English Miracle Cycles* (London: Moring, 1914), pp. 16–17. See also William M. Manley, 'Shepherds and Prophets: Religious Unity in the Towneley *Secunda Pastorum*', *PMLA* 78.3 (1963), 151–155 (pp. 152–154).

42 The shepherds in the N-Town 'Adoration of the Shepherds', Play 16, cite prophecies of Balaam, Amos and Daniel. See Spector, I, 165. The first two shepherds of the York Angels and Shepherds, Play 15, refer to the prophecies of Hosea, Isaiah and Balaam. See Smith, ed., p. 118. In the *Prima Pastorum*, the shepherds recall the prophetic words of Isaiah, Jeremiah, Habakkuk, Elizabeth and Zechariah, among others who foresaw the Christ. See England and Pollard, pp. 111–112. The shepherds in the *Secunda Pastorum* recall the words of David and Isaiah after hearing the angel's message, England and Pollard, p. 138.

43 Mills, *Chester Mystery Cycle*, p. 130, ll. 93–4.

44 See Margery M. Morgan, ' "High Fraud": Paradox and Double Plot in the English Shepherds' Plays', *Speculum*, 39 (1964), 676–689 (p. 686).

45 In his introduction to Play 7 of the Chester Mystery Cycle, Mills calls the Shepherds' Play 'a popular piece, sometimes abstracted for performance before visiting dignitaries'. *Chester Mystery Cycle*, p. 125.

46 As examples, see English alabaster representations of St James in Francis Cheetham, *English Medieval Alabasters: with a Catalogue of the Collection in the Victoria and Albert Museum* (Oxford: Phaidon, Christie's, 1984), p. 105, fig. 34; and p. 106, fig. 35. In the fourth bay of Norwich Cathedral, a roof boss depicts Jacob walking to Paddan-aram with a double-knobbed staff. See Rose and Hedgecoe, p. 57. See also Goulburn, picture 4 between pp. 88 and 89.

47 See Karl Young, *The Drama of the Medieval Church*, 2 vols (Oxford: Clarendon Press, 1933; repr. 1951) I, 451–483; and II, 514–522.

48 Young, *The Drama*, I, 471. Otto Pächt translated this passage: *Rise*, p. 34. See pls 24, 25, and 27 in Pächt's book. Mary H. Marshall describes these costumes in 'Aesthetic Values of the Liturgical Drama', in *Medieval English Drama: Essays Critical and Contextual*, ed. by Jerome Taylor and Alan H. Nelson (Chicago: University of Chicago Press, 1972), pp. 28–43 (pp. 37, 38).

49 See David Bevington, *Medieval Drama* (Boston: Houghton Mifflin, 1975), p. 45, note for line 1 of the *Ordo ad Peregrinum* of Beauvais.

50 Emile Mâle, *L'Art religieux du XIIe siècle en France.* (Paris: Colin, 1924) pp. 137–9. For the Resurrection window at Chartres, see fig. 117.

51 See Otto Pächt, C. R. Dodwell and Francis Wormald, *The St Albans Psalter (Albani Psalter)* (London: Warburg Institute, University of London Press, 1960), pp. 74–78. For pilgrim costumes which bear a resemblance to that of Abraham on fol. 10r (11rJ) of the Egerton Genesis, see especially pls 38, 122a, 122f.

52 Silvered figures occur on the following folios: 1r, 1v, 4r, 6r, 8r, 9r, 9v, 14r, 15r and 15v.

53 Sir Nicholas Harris Nicolas, 'Accounts of the Great Wardrobe of King Edward the Third, from the 29th of September 1344 to the 1st of August 1345; and Again from the 21st of December 1345 to the 31st of January 1349', *Archaeologia,* 31 (1846), 1–163 (p. 37).

54 Anderson, *Drama and Imagery*, p. 165.

55 Anderson, *Drama and Imagery*, p. 27.

56 See Hildburgh, 'English Alabaster Carvings', p. 79, pl. XVIc. On this subject, see also Tydeman, *Theatre,* pp. 169–70.

57 See Cohen, *Histoire*, p. 222, n. 3 (Our translation). He quotes Vérard's edition of the *Passion of Jean Michel* of 1490 (Paris, Bibliothèque Nationale, Incunables, Y. K., 350). See also Anderson, *Drama and Imagery*, p. 164, n. 25.

58 *Late Middle Ages*, p. 64.

59 '*Nota d'ycy advertir ung paintre de aller en Paradis pour poindre rouge la face de Raphael*'. Gustave Cohen, *Le Livre du conduite du régisseur et le compte des dépenses pour le Mystère de la Passion* (Strasbourg: Librairie Istra, 1925), p. 410, n. 16.

60 See *The Riverside Chaucer*, 3rd edn, ed. by Larry D. Benson, (Boston: Houghton Mifflin, 1987), p. 822, n.). We are indebted to Dr. E. D. Kennedy for calling our attention to this ironic reference to the red-faced angel.

61 *York Mystery Plays: a Selection in Modern Spelling*, ed. by Richard Beadle and Pamela M. King (Oxford: Clarendon Press, 1984), p. xxv. For other late fifteenth- and sixteenth-century use of gilding for divine faces or masks, see *The Staging of Religious Drama in Europe in the Late Middle Ages: Texts and Documents in English Translation*, ed. by Peter Meredith and John E. Tailby, EDAM, Monograph Series, 4 (Kalamazoo, MI: Medieval Institute, Western Michigan University, 1983), pp. 109, 142, 145.

62 See A. C. Cawley, *The Wakefield Pageants in the Towneley Cycle* (Manchester: Manchester University Press, 1958), pp. 19–20, ll. 200–38 and ll. 340 ff.

63 Stevens, p. 170. See also P. W. Travis, *Dramatic Design in the Chester Cycle* (Chicago: University of Chicago Press, 1982), p. 100.

64 Mills, *The Chester Mystery Cycle*, Play 10, ll. 301–304.

65 See Claire Sponsler, *Drama and Resistance: Bodies, Goods and Theatricality in Late Medieval England* (Minneapolis: University of Minnesota Press, 1997), p. 145 and n. 40, for a discussion of the distaff as weapon of women in medieval drama. In the fourth bay of the east-walk of the Norwich Cathedral cloister (around mid-fourteenth century), seemingly, a comic actress raises her right arm to crown a thief with a blow. Since her sculpted arm is broken off at the wrist, her weapon, pan or rolling pin, must be conjectured. See Rose and Hedgecoe, pp. 13, 14.

66 For reference to the 'impudent servant' in folk drama, see Tiddy, pp. 104, 105, 111.

67 *Cambridge Companion to Medieval English Theatre*, ed. *by* Richard Beadle (Cambridge: Cambridge University Press, 1994), pp. 16, 17.

68 See figs 132, 190, 708 and 709 in Randall, *Images*, as examples.

69 See R. H. Mottram, *The Glories of Norwich Cathedral* (London: Winchester, 1948), p. 81.

70 William Tydeman mentions doctors and knights in his comment on the 'undermining and overthrow of pretensions . . . in English Cycle plays'. See 'Satiric Strategies of English Cycle Plays', in *Popular Drama in Northern Europe in the Later Middle Ages* (Odense: Odense University Press, 1988), pp. 15–39 (p. 31).

71 Anderson, *Drama and Imagery*, p. 201, pl. 20b. For the raging tyrants Herod and Pilate in the N-Town and Towneley Cycles, see Lawrence M. Clopper, 'Tyrants and Villains: Characterization in the Passion Sequences of the English Cycle Plays', *MLQ*, 41 (1980), 3–20 (pp. 9, 12).

72 E. S. Prior and A. Gardner, *An Account of Medieval Figure Sculpture in England* (Cambridge: Cambridge University Press, 1912), p. 516; also Hildburgh, 'English Alabaster Carvings', p. 67.

73 Tydeman writes of an artificially contrived angel flown in a sixteenth-century Canterbury pageant. See *Theatre*, p. 176. Beadle mentions 'carved angels designed to "run about the heaven when drawn on a cord" ', in *York Plays*, p. 36.

74 For comments on the relation of this well-known scene to a mystery play, see Henri Malo, *Les Fouquet de Chantilly: Livre d'Heures d'Etienne Chevalier* (Paris: Editions Verve, 1942), Introduction; also Germain Bazin, *Le Livre d'Heures d'Etienne Chevalier* (Paris: Somogy, 1990), p. 13.

75 Prior, ' Sculpture', p. 42.

76 See articles by W. L. Hildburgh for examples: 'Notes on Some English Medieval Alabaster Carvings', *Antiquaries Journal*, 3 (1923), 24–36 (p. 27, fig. 4); 'Further Notes on English Alabaster Carvings', *Antiquaries Journal*, 10 (1930), 34–45 (p. 37, fig. 9); 'Folk-Life Recorded in Medieval English Alabaster Carvings', *Folk-Lore*, 60 (1949), 249–265 (p. 257, pl. IV, fig. 8). For an excellent colour reproduction of an alabaster feathered St Michael, see Cheetham, pl. 3, figs 61, 63.

77 Anderson, *Drama and Imagery*, pl. 18a and b. Though she agrees that feathered angel costumes are theatrical, she stops short of assuming that they originated on the stage (p. 168).

78 Barbara D. Palmer, *The Early Art of the West Riding of Yorkshire*, EDAM, Ref. Ser., 6 (Kalamazoo, MI: Medieval Institute, Western Michigan University, 1990), pp. 29, 30.

79 Henderson remarked that this blind figure may record a missing portion of a source similar to the Cotton Genesis: 'Late Antique Influences', p. 194.

80 See Sandra Billington, *A Social History of the Fool* (Brighton, Sussex: Harvester, 1984), pp. 8–10; F. N. Robinson, ed., *The Works of Geoffrey Chaucer* (Boston: Houghton Mifflin, 1957) p. 145, ll. 421–435.

81 Billington, *Social History*, p. 10. She quotes Dan Lydgate on a mumming written for Henry VI's winter celebrations at Hertford in 1430.

82 Tiddy, *Mummers' Play*, p. 79.

83 Billington, *Social History*, pp. 4, 6–7.

84 E. Talbot Donaldson, trans.; ed., intro., and annot. by Elizabeth D. Kirk and Judith H. Anderson, *William Langland: Will's Vision of 'Piers Plowman'* (New York: Norton, 1990), p. 145, ll. 421–435, of Passus XIII.

85 See Chapter 3, comment on the Sodomite costume, scene 65, for similar suggestive images in other manuscripts.

86 Stevens calls the devil 'a pretender and shape shifter' in the Chester Cycle, p. 301.

87 See Tiddy, pp. 112, 113.

88 F. H. Mares, 'The Origin of the Figure Called "The Vice" in Tudor Drama', *Huntington Library Quarterly*, 22 (1958), 11–29 (pp. 11, 28).

89 Chambers, II, 387.

90 *Imagery*, pp. 83, 84.

91 For another example, see Lot the dignified herdsman and landowner, in long robe and mantle, fol. 7v, lower right, as compared with Lot, the prisoner, fol. 8v, upper right.

92 George Henderson, 'The Sources of the Genesis Cycle at Saint-Savin-sur-Gartempe', *Journal of the British Archaeological Association*, 26 (1963), 11–26 (p. 21).

93 Nikolaus Pevsner, *Northwest and South Norfolk* (Harmondsworth, Middlesex: Penguin, 1962), pp. 224, 225.

94 See Paula Neuss, ed., trans., *The Creacion of the World: a Critical Edition and Translation* (New York: Garland, 1983), l. 2319. The ultimate source of this insult for baldness may be in II Kings 2. 23, in which the boys of Bethel jeeringly address Elisha, 'Get along with you, bald head, get along'.

95 See Avril, *Manuscript Painting*, pl. 24.

96 See comments on the scene of the First Day of Creation, fol. 1r, in Chapter 3.

97 Roy, p. 112, n.1; p. 113, n.2.

98 Cohen, *Histoire*, p. 92, n. 1.

99 Alexandra Johnston and Margaret Dorrell, 'The Doomsday Pageant of the York Mercers, 1433', *LSE*, NS 5 (1971), 29–34 (p. 29).

100 See Otto Demus, *The Mosaics of Norman Sicily* (New York: New York Philosophical Library, 1950), pls, 31, 100 and 101; A. Laborde, *Etude sur La Bible moralisée illustrée conservée à Oxford, Paris et Londres*, 5 vols (Paris: Pour les membres de la Société, 1911–27), I, pl. for fol. 10.; Swarzenski, fig. 2.

101 See comments on the embarkation, fol. 3r, in Chapter 3 here.

102 For the Latin stage directions specifying animals *depicta in cartis* in a manuscript of 1607, see *The Chester Mystery Cycle: a Facsimile of British Library MS Harley 2124*, intro. by David Mills (Leeds: University of Leeds, LSE, 1984), fol. 14v. See also Kevin J. Harty, ed., *The Chester Mystery Cycle: a Casebook* (New York: Garland, 1993), p. xiv. For a discussion of representation of Noah's animals painted on board, see Tydeman, *Theatre*, p. 175, n. 34, and R. M. Lumiansky and David Mills, *The Chester Mystery Cycle*, EETS, SS 3, 9; 2 vols (London: Oxford University Press, 1974), I, 48 and note. See also Peter Meredith, ' "Make the Asse to Speak" or Staging the Chester Plays', in *Staging the Chester Cycle*, ed. by David Mills, ULTM, NS 9 (Leeds, 1985), pp. 49–76 (p. 66).

103 See fols 13v (12vJ), 12r (13rJ), 12v (13vJ), 14r, 14v,15r,15v, 16r, 16v, 18r, 18v, 19r, 19v, 20v.

104 For the more elaborate structure, see fols 8v, 11r (10rJ), 11v (10vJ), 13v (12vJ), 12r (13rJ) 12v (13vJ), 15v, 17v, 18r, 19v, 20r.

105 Anderson, *Drama and Imagery*, p. 124 and pls 10i and 17c. In Fouquet's painting, *The Martyrdom of St Apollonia*, a wattle fence separates the viewer from the dramatic scene depicted. See Beadle, ed., *Cambridge Companion*, p. 57, and Harris, p. 117.

106 Anna J. Mill, 'The Hull Noah Play', *MLR*, 33 (1938), 489–505 (p. 491, n. 4).

107 Rose, ' Staging', p. 208.

108 *Drama and Imagery*, p. 119.

109 Pamela Sheingorn, 'The Visual Language of Drama: Principles of Composition', in M. G. Briscoe and J. C. Coldeway, eds, *Contexts for Early English Drama* (Bloomington, IN: Indiana University Press, 1989), pp. 173–191 (pp. 178, 179).

110 For other references to horses in medieval drama, see Glynn Wickham, 'The Staging of Saint Plays in England', in *The Medieval Drama,* ed. by Sandro Sticca (Albany: SUNY Press, 1972), pp. 99–119 (pp. 107, 108); Tydeman, *Theatre*, p. 175; Rose, 'Staging of the Hegge Plays', p. 209; Richard W. Southern, *The Medieval Theatre in the Round* (London: Faber, 1957; New York, Theatre Art Books, 1975), fig. 21 and end fold-out.

111 See Alan H. Nelson, 'Some Configurations of Staging the Medieval English Drama', in *Medieval English Drama: Essays Critical and Contextual,* ed. by Jerome Taylor and Alan H. Nelson (Chicago: University of Chicago Press, 1972), pp. 116–147 (pp. 133, 134, 136).

112 Cawley, *Wakefield Pageants*, p. 23, ll. 336–343.

113 See Bevington, *Medieval Drama*, p. 309, l. 41.

114 See Southern, *The Medieval Theatre in the Round*, p. 130.

115 Mills, *The Chester Mystery Cycle*, p. 128, l. 47; p. 130, l. 94; p. 132, l. 171; p. 134, l. 216. Also, Harris, p. 130. See also L. Powlick, 'The Staging of the Chester Cycle', in *The Chester Mystery Cycle: a Casebook*, ed. by Kevin J. Harty (New York: Garland, 1993), pp. 199–230 (pp. 220–223).

116 Sponsler uses this term to describe unrestrained gluttony and references to buttocks, genitalia and excrement in medieval drama, *Drama and Resistance*, p. 79.

CHAPTER FIVE

—◆≥·≤◆—

Style

INTRODUCTION

IN recent years the study of style has played a relatively minor part in a number of scholarly works on manuscripts. Interest has often centred on the social, economic, and devotional contexts in which works were produced and used. There has been a tendency to regard style as a specialised, self-contained area of study which sheds little light on broader issues of patronage and function. The study of style has also been unfashionable because it was used in the past to establish hierarchical categories of importance based on judgements of quality.

However, there is intrinsic value in acquiring a thoroughgoing familiarity with qualities of line, shape, colour, and space, for these qualities constitute the language of visual art. In addition, the study of style gives valuable information about artists and chronology. An artist's style changes in some respects and remains the same in others. Artists often can be characterised, and hence differentiated, by constant features in their styles, but changes in style can help establish the relative chronology of the works they produce. The study of style produces evidence of the artist's interests and psychology, even of his biography, in a way that other types of analysis will not.[1] Finally, the study of style may provide information useful to the investigation of much broader questions and issues. Dennison's stylistic study of artistic hands has implications for study of such themes as the plague's effect on the production of books and the emigration of Flemings to England. The style of the Egerton Genesis provides evidence of the patronage and purpose of this curious manuscript.

In our study of style we used five of the six questions used in our study of the iconography, eliminating one on which style had little bearing and rephrasing another to narrow its scope. To these questions we added two more which the study of style is particularly helpful in answering. These are as follows: 1. What is distinctive about the style of the Egerton Genesis? 2. What can we learn from it of the artist's interests, personality, and psychology? 3. How does the Egerton Genesis fit into the broader picture of illumination, especially that of the first half of the fourteenth century? 4. When was the manuscript produced? 5. Where was this manuscript produced? 6. What does the style reveal about the patronage or purpose of this manuscript? 7. Where did the artist originate? These questions will be addressed in the conclusion to this chapter after a close look at the Egerton Genesis artist's style.

Both consistency and discrepancy mark the style of the Egerton Genesis, whether it is viewed among the English manuscripts of its era or whether it is considered alone. The

manuscript at first creates an impression of strong stylistic unity, manifested in the consistently excellent draughtsmanship and in the highly dramatic figures which enliven every page. These unifying aspects are so pronounced that the manuscript has always been considered the work of a single artist, and we agree with this view. As study progresses, however, the observer becomes increasingly aware of the heterogeneous elements in the manuscript. Parallels and possible sources, both English and continental, for a number of stylistic elements establish a stronger sense of context for this manuscript, so long considered a sort of dangling participle in the grammar of English fourteenth-century style. Many of the manuscripts which furnish iconographical parallels to the Egerton Genesis are also important as evidence of stylistic sources.

LINE AND THREE-DIMENSIONAL FORM

Perhaps the two most outstanding stylistic features of the Egerton Genesis are the fine quality of its drawing and its strong sense of three-dimensional form, which Pächt termed 'Giottesque' and identified as the primary distinguishing feature in the style of this manuscript.[2] These two aspects of style merge and overlap, as Pächt first noted, and hence are best discussed together. Figures on every page are drawn with line that is strong and assured, yet so precise and refined that detail cannot be fully read without magnification. This raises the possiblity that a lens was used during the drawing. The figure of Zillah (Sella), fol. 2ᵛ, upper right, has a sense of bulk that derives not only from the breadth of silhouette and the spare but judicious modelling, but also from the monumental outline, a tight curve that shapes and contains from shoulder to ankle. Bodily members defined by line have an almost geometric perfection of shape coupled with an organic fullness of form. The hand of Abimelech on fol. 10ʳ (11ʳJ), upper left (fig. 52), is an example. The geometric is manifested in thinness and uniformity of line, in the careful control of the width of each digit, in the taut, subtle curves that define the back of the hand and the bulge at the base of the thumb. The very slight convex arc of these lines is both geometric in its regularity and organic in imparting a sense of fullness and structure to the form. The organic is also communicated in the varying lengths of the four overlapping fingers and in their optically suggestive foreshortened alignment. Throughout this manuscript, tight, controlled curves tend to replace the looser more flexible curves often characteristic of earlier English illumination. This alteration renders the figures of the Egerton Genesis less willowy than those of many earlier manuscripts and also plays a significant role in generating the sense of sculptural form.

Abimelech's eye likewise combines a geometric two-dimensional shape with a sense of organic form (fig. 52). The basic design is of a circle halved by a horizontal line to delineate the half-closed lid, and surmounted by a section of a triangle which defines the socket and eyebrow. However, this geometry is altered by a second geometry of subtle curvature, manifested in a slight flattening of the frontal surface of the eye circle to suggest the profile view, by a slight upward curve at the tail of the bisecting horizontal, and by slight convex and con-

FIG. 52: Egerton Genesis. London, British Library, Egerton MS 1894, fol. 10ʳ
(11ʳJ), upper left, detail: Head and hand of King Abimelech (Photo: British
Library, London)

cave curves to the socket and brow lines respectively. These features give an organic sense of animation and expression to the eye. This second geometry is thus a sort of medium through which the geometric merges with the organic.

The circumflex eye, as it may be termed, which is only one type of several in the artist's repertoire, has antecedents in manuscripts from the region of Ghent and the Franco-Flemish border. In earlier Flemish manuscripts, such as the *Spiegel historiael* (The Hague, Koninklijke Bibliotheek, Koninklijke Akademie MS XX), a similar, though less rounded, eye is often used on faces distorted by strong emotion, or those of figures engaged in violent action, as in the face of Peter, fol. 64ʳ (fig. 53). In the Egerton Genesis the circumflex eye is abstracted from that context of emotion or action and is used to impart an expression of the grotesque or of the comical.

Refinement of line is among the major features which distinguish English illumination of about 1320 to 1340. In the Psalter of Robert de Lisle it is coupled with control and precision;[3] in manuscripts of the Queen Mary Psalter group, with freedom, delicacy, and variety of effect.[4] The Egerton Genesis shares this refinement yet it alone 'establishes a system of stereometric simplicity', as Pächt wrote.[5]

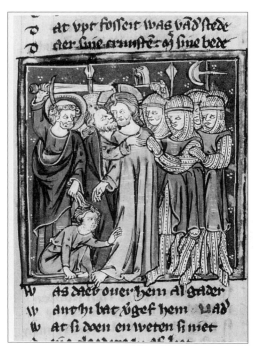

FIG. 53: *Spiegel historiael.* The Hague, Koninklijke Bibliotheek, Koninklijke Akademie MS XX, fol. 64ʳ, miniature: Arrest of Christ (Photo: Koninklijke Bibliotheek, The Hague. Copyright: Koninklijke Bibliotheek, The Hague)

Line is also used in penwork shading. This technique occurs in a number of variations, as is the case for many aspects of style in the Egerton Genesis. Most commonly the shading is in black ink, applied with a very fine nib. Multitudinous lines, so closely spaced and so fine that they are usually hard to distinguish individually, model figures throughout the first gathering and on about half the pages of the second gathering. In this technique the graphic becomes almost equivalent to a tonal wash. The goal was seemingly to combine the subtlety and control afforded by fine line with the strong sense of plastic form generated by the range of values in tonal modelling. The penwork technique is found in earlier East Anglian manuscripts such as the Gorleston Psalter; black penwork shading is clearly visible in the garments of a soldier on fol. 69ʳ (fig. 54). In one variant in the Egerton Genesis, fine-line penwork shading may be applied also in one hue over a different hue: the gold wash mantle worn by the Deity is often shaded with red or orange penwork, as on fol. 1ᵛ, lower right, and fol. 15ʳ, lower right. Like that of the circumflex eye, this treatment of the garment has antecedents in the *Spiegel historiael*, in which red is used to shade gold-wash garments, as in the cloak of John in the Crucifixion on fol. 64ʳ.

Yet another variant of the penwork technique occurs in hair and beards, which may be rendered as soft fluffy or kinky masses composed of innumerable fine, wavy penwork lines which function to model the form even as they define it, as in the beards of Abimelech and Abraham and the hair of the beardless Phicol, on fol. 10ᵛ (11ᵛJ), lower right. This technique seems to originate in Italy, probably Siena,[6] though it may have been mediated to England through

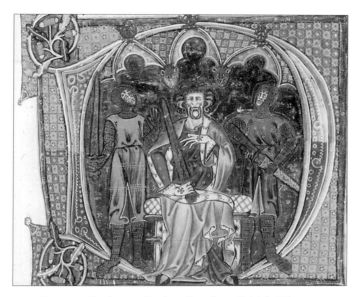

FIG. 54: Gorleston Psalter. London, British Library,
Additional MS 49622, fol. 69ʳ: Initial D for Psalm 52, detail:
Armed knight (Photo: British Library, London)

Flemish manuscripts. In a liturgical psalter produced for Louis de Male, probably in Ghent, and dated by Dennison 1345–1350 (Brussels, Bibliothèque Royale Albert 1er, MS 9427),[7] the treatment of hair in some figures approaches that in the Egerton Genesis. On fol. 43ʳ of this Flemish manuscript, articulation with many fine black penstrokes defines the beard of the kneeling layman in the initial D and the beards of several grotesques in the borders. In England, the Douai and St Omer Psalters include many figures, such as the nude bishop and the man with the foreshortened head in the St Omer Last Judgement (fig. 5), with this soft, kinky hair.

Beards and hair are also rendered as the traditional northern (English, French, Flemish) wavy locks, examples of which are multitudinous in manuscripts of the late thirteenth and early fourteenth centuries, as in the Queen Mary, Isabella, and Ormesby Psalters; the *Somme le Roy* (London, British Library, Additional MS 54180); and Bodley 264, to name only a very few. The hair of Nimrod, fol. 4ᵛ, lower right, and that of Abraham, fol. 12ʳ (13ʳJ), upper right, illustrate this type in the Egerton Genesis.

The artist's eclecticism is exemplified by his treatment of the three heads of hair in the miniature of the death of Cain, fol. 3ʳ, upper left. The boy guide's hair is treated as an Italianate fuzzy cap, modified in the direction of regularity and also hardening. Cain's hair is the traditional northern wavy locks. Lamech's hair is a pattern of tight, overlapping ringlets, each with a dark centre. The precedent for this treatment is the rather schematic curls which often appear framing the face in early fourteenth-century English manuscripts, but the curls are more

numerous and more regularly patterned than those of the prototypes and suggest a different model, that of scale armour, found in the battle scenes of some Flemish manuscripts such as the *Spiegel historiael*, fol. 214r, or in the Massacre of the Innocents in Oxford, Bodleian Library, MS Douce 5, fol. 15v (fig. 55). Once again, the radical recontextualization of a motif suggests a creative and adventurous artistic sensibility.

Modelling in the Egerton Genesis is primarily by means of penwork shading but is also through the modulation of value and saturation in brushed colour, as in the garment of the figure of Nimrod on fol. 5r, upper left, or the lining of the garment of Ham on fol. 5r, upper right. On fol. 11v (10vJ), upper right, in the incompletely coloured section of the second gathering, a grisaille effect is obtained not by penwork but with a light wash of ink in the midsection of Lot's garment. In the sequence of production of the manuscript, this page marks the beginning of a sharp curtailment in the use of penwork shading, as though the artist were running out of time or money. The figure of Lot may have been a brief experiment with a method of shading quicker than the penwork technique, just before shading was largely discontinued. Often the linings of garments, whose touches of colour are one of the beauties of the manuscript, are not shaded but are applied as areas of flat colour, in contrast with the penwork shading of the outer surface of the garments. Multiple approaches to shading are evidence of the Egerton Genesis artist's flexibility and breadth, characteristics manifested in many other aspects of his work as well.

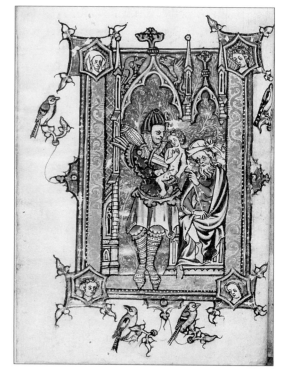

Fɪɢ. 55: Psalter. Oxford, Bodleian Library, MS Douce 5, fol. 15v: Massacre of the Innocents (Photo: Bodleian Library, Oxford)

If line, as penwork shading, is used to model, modelling also produces line, in another convergence of the two- and three-dimensional. In fol. 5ʳ, upper left, the folds just above Nimrod's waist are linear ridges outlined at their lower edges but defined above by a reserve technique of highlighting, in which strips of the ground are left bare, untouched by the modelling in lower value of adjacent areas. A similar technique produces highlights as linear strips on the mantle of Ham's companion, in the scene of Ham's descendants just to the right. On fol. 8ʳ, upper right, several such strips edge the vertical pleats in the mantle of the kneeling Abraham. These meander in decorative loops over the lower leg. Shading has a dichotomous effect. It produces a sense of three-dimensional form but also produces these linear strips, which have a two-dimensional life of their own. A full integration of line and shading is not achieved. Though the Egerton Genesis artist absorbed much from Italian sources, he always retained much of the northern line-oriented approach to form.

Highlighted strip folds not unlike those in the Egerton Genesis are found in earlier East Anglian manuscripts like the Ormesby Psalter, the Bromholm Psalter (Oxford, Bodleian Library, Ashmole MS 1523), and the Gorleston Psalter.[8] Highlighted convex strips of even width, rounded profile, and firm definition are found in the Ormesby and Bromholm Psalters; in the Gorleston Psalter the profile of the strip is flatter. These strips are less common in manuscripts which were made in the area of London, such as the Psalter of Robert de Lisle and the Queen Mary Psalter. This distinction suggests, as do other factors, that the Egerton Genesis artist worked in East Anglia, probably in Norwich, in which city Hull has recently located the production of a number of the major East Anglian manuscripts.[9]

The Egerton Genesis is perhaps best known for its abundant and masterful use of three-dimensional and illusionistic effects in rendering the human figure. These effects have been taken as evidence that the artist was trained in Italy and that he worked in part from models of early Christian date.[10] However, neither training in Italy nor use of sixth-century models is necessary to account for the manuscript's spatial qualities, which could have been learned in a northern milieu. Furthermore, it is equally apparent, though less frequently mentioned, that many scenes which are traditionally northern in the arrangement of their figures exist side by side with more Italianate images and that even the latter have many essentially northern elements.

It is true that the Egerton Genesis shows a remarkable degree of understanding of the Italianate concept of the body as a cylindrical solid. This concept was manifested in much early fourteenth-century Italian painting by consistently highlighting the main axis of the body and by rendering folds primarily as convex ridges, themselves seemingly almost solid, on the solid surface of the body. Northern artists of the same era, by contrast, conceived of the body not as an inviolable solid but rather as a brittle surface into which spatial cavities could be excavated by concave folds. Their techniques of highlighting generally focused on folds at the expense of the body as a whole, and concave folds were as important as convex. These concepts and techniques are operative even in northern images which exhibit strong Italian influence, such as the added Crucifixion in the Gorleston Psalter, fol. 7ʳ (fig. 56). In the figure of the Virgin, the long fold running from her left ankle to her right hip is highlighted at the expense of the groin and upper left thigh, so that her body in that area seems excavated;

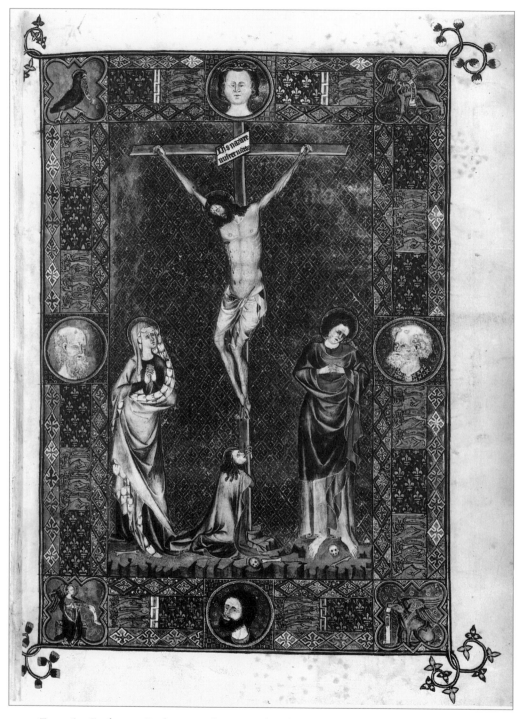

FIG. 56: Gorleston Psalter. London, British Library, Additional MS 49622, fol. 7ʳ:
Crucifixion (Photo: British Library, London)

and the sense of the body as a rounded solid, which is conveyed by the highlighting of chest and abdomen, is sacrificed to a Gothic elegance of stance and line, imparted by the emphasis on the diagonal sweep of the fold.

The Italianate concept of the solidity of the body is far more consistently and strongly articulated in the Egerton Genesis than in most English manuscripts of this era, the Egerton Genesis artist's earlier English work excepted. By consistently raising the overall value of highlighting and shading along the main axis of the body and by lowering it along the edges, regardless of the shape and direction of folds, the artist imparts a sense of cylindrical form to the figures. The four figures in the departure of Terah and Abraham, fol. 6v, upper right, exemplify his technique. Shading and highlighting of individual folds, most sweeping in curves across the body, are subordinated to the highlighting of the body's longitudinal axis. Though the folds are strongly modelled, the sense of the body's overall cylindrical form is not sacrificed in order to define them.

However, in shifting from a consideration of the body to a consideration of the folds that articulate it, one encounters a disjunction. The Italianate sense of the body as a whole contrasts with predominately northern techniques in the articulation of the folds. The crescent-shaped arcs of drapery, the passages of irrational complexity in the relations of folds to each other and to the hemlines, and the inclusion of deep, if narrow, cavities in the drapery between the legs, these witness to the basically northern conception of the folds. Thus the Egerton Genesis artist weds the Italianate to the northern in combining these concepts of the body and its covering, and in places the two conceptions conflict.

The solid, substantial figures of the Egerton Genesis relate to Flemish as well as Italian traditions. In the Egerton Genesis there are curious figures with elephantine legs, such as Esau on fol. 12v, upper right, or Canaan on fol. 4v, lower left. These are best explained by Franco-Flemish antecedents, as will be seen below.

ILLUSIONISTIC EFFECTS IN THE TREATMENT OF THE HUMAN FIGURE

The many back views in the Egerton Genesis are of figures in a variety of positions and activities. There are standing figures, such as Methuselah on fol. 2r, upper right; Lamech on fol. 3r, upper left; Abraham on fol. 13r (12rJ), upper left; climbing figures, such as the workmen ascending the ladder on fol. 5v and Abraham on fol. 13r (12rJ), upper right; kneeling figures, such as Abraham's servant on fol. 13v (12vJ), upper right; crouching figures, such as Abimelech's attendant on fol. 10r (11rJ), lower left; seated figures, such as the brothers of Joseph on fol. 20v, upper right; even a reclining figure, that of Lamech's stricken boy guide on fol. 3r, upper right. A number of back views are of figures engaged in strenuous activity, such as the two stone carvers on fol. 8r, lower right; and the wrestling Jacob, fol. 17r, upper left.

Many heads are rendered as lost profiles: Heber, on fol. 6r, upper right; the second well-digger on fol. 14r, upper right; and several of the brothers harvesting grain on fol. 18r, lower

left (fig. 48), to name only a few. Perhaps most striking of all are the many heads and figures rendered in numerous variations of foreshortening. On fol. 5v at bottom left is a standing figure, bent forward at the waist, whose upper body and head are drastically foreshortened. The shortest of the wrestling shepherds on fol. 7v, upper right, is similarly depicted. Seated figures with heads tilted forward in strong foreshortening include the centre figure in the circumcision of Abraham, fol. 9v, lower right; and the large Sodomite on the roof on fol. 11r (10rJ), lower half. On fol. 14r, lower left, the figure seated fourth from the left is shown with his head turned in profile and tilted forward, in an unusual, if not entirely successful, rendering. Even bolder is the figure examining a plumb bob at the top of the Tower of Babel on fol. 5v (fig. 22). Here the tilted profile is attempted as *di sotto in su*.[11] On fol. 8r, lower left, the shepherd balancing a three-pronged stick on his nose is rendered with head tilted strongly backward (fig. 28). Bug-eyed and flat-faced, the head is again less than completely successful. In the image of the building of the altar at Bethel, just to the right on the same page, a workman is shown from the back, with head tilted backward toward the viewer, in a far more accomplished effort at a foreshortened face.

Other parts of the body are depicted in foreshortening also. Though there are no strongly foreshortened arms, legs are rendered in strong foreshortening in the figure of Abraham's kneeling servant, fol. 13v (12vJ), upper right. Hands are masterfully presented in foreshortened side views in a number of elegant examples. In addition to the hand of Abimelech on fol. 10r (11rJ), upper left (fig. 52), the left hand of Sarah is similarly depicted in the same image. Other examples include Cain's left hand on fol. 3r, upper left, and the left hand of Abraham, fol. 9r, lower left. Foreshortened curled fingers are skillfully presented on fol. 8v, lower left, on the right hand of the kneeling messenger. Almost all hands which are foreshortened or are shown with fingers in unusual configurations are in the first two gatherings. In the final gathering, hands are more often formulaically depicted as a summary outline in the shape of a tapered oval within which fingers are differentiated with several parallel strokes. The left hand of Jacob on fol. 18r, upper left, the right hand of the brother at the foot of Joseph's bed on the same folio, lower left (fig. 48), and the left hand of Rachel on fol. 16r, lower right, are three of many examples. This type of hand, which also occurs in some Flemish illumination, probably originates in Bolognese manuscripts. It is visible in several instances on the left side of the image of the Elevation of the Host in a book of Decretals of Giovanni Andrea datable to the early 1350s, Vatican City, Biblioteca Apostolica Vaticana, MS Vat. lat. 2534, fol. 1r (fig. 57).[12] The drawing of the hand in the Bolognese manuscripts, in its suggestion of three-dimensional curvature, is more successful than that in the Egerton Genesis.

The sources for the back views, foreshortenings, and other illusionistic features in the Egerton Genesis are, in our estimation, somewhat different than those proposed in previous scholarship. Though the Egerton Genesis artist may have seen an early Christian manuscript of the Cotton Genesis recension, this is not necessary to explain either the style or the iconography of his book. Furthermore, there is no need to assume that the artist saw wall painting in Italy. Sources closer to the artist in time and place explain the Classical and Italianate elements in his work at least as well as, and often better than, early Christian works or fourteenth-

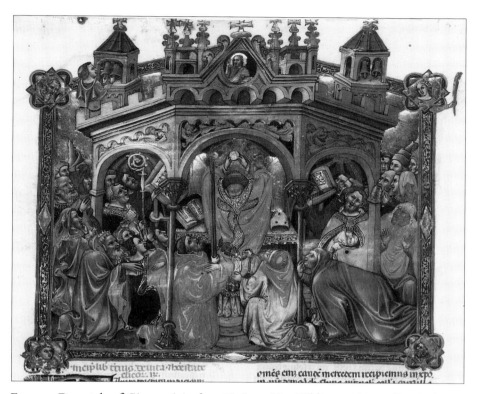

FIG. 57: Decretals of Giovanni Andrea. Vatican City, Biblioteca Apostolica Vaticana, MS Vat. lat. 2534, fol. 1r, miniature: Elevation of the Host (Photo: Biblioteca Apostolica Vaticana, Vatican City)

century Italian wall painting. As Sandler has pointed out, some of these elements in fact have antecedents, if not exact parallels, in English manuscripts.[13] Many can be found in Flemish illumination as well, and almost all elements, including those without parallel in English and Flemish works, can be found in either Italian manuscripts of the 1320s, 1330s and 1340s, or in Italian panel painting.

Back views of standing figures are common enough in English and continental manuscripts of the mid-fourteenth century, as on fols 164v and 173v of the Luttrell Psalter (London, British Library, Additional MS 42130),[14] and were not unknown even decades earlier, as on fol. 64r of the Canticles, Hymns and Passion of Christ, in Cambridge, St John's College, MS 262 (K. 21), of c. 1280–1290.[15] The shield-bearers with bare buttocks on fols 6r and 6v of a fragmentary book of hours London, British Library, Harley MS 6563, of c. 1320–1330, resemble the well-digger on fol. 14r, upper right, of the Egerton Genesis.[16] Perhaps under the corrective influence of Italian manuscripts, back views in the Egerton Genesis depict shoulders, torso, and legs more convincingly than do similar images in earlier English manuscripts and avoid the common earlier tendency to splay one of the legs, unless the iconography specifically

requires it, as in the figure of Lamech as archer, fol. 3r, upper left. It should be noted that back views of standing figures also occur in some Liège and Flemish manuscripts and in some from northeastern France of the late thirteenth and early fourteenth centuries, as in the Annunciation to the Shepherds on fol. 6v of a psalter, London, British Library, Additional MS 28784B, and in the figure of the dancing fool in the initial to Psalm 52 of a psalter, Baltimore, Walters Art Gallery, MS W. 112, fol. 83r.[17]

Rear views of seated figures can be found in English manuscripts of the early and mid-fourteenth century also, including seated riders, as in the Luttrell Psalter, fol. 159r, right margin, and in the Holkham Bible Picture Book, fol. 13v, upper right, as well as seated listeners in the same manuscript, fol. 26v, upper middle. More immediately relevant as antecedents for the row of diners seated on a long bench on fol. 20v, upper right, in the Egerton Genesis are images in North Italian manuscripts of rows of seated figures seen from the rear, as on fol. 120r of a miscellany in Florence, Biblioteca Riccardiana, MS 1538, of the 1320s, or possibly earlier (fig. 58).[18] Perhaps Giotto's fresco of the Last Supper in the Arena Chapel is the ultimate source for these rows of figures seen from the rear, but the crowding of the figures and the use of vertical drapery folds in the Egerton Genesis relate more to the image in the Riccardiana manuscript than to the fresco, in which figures are allotted more space and folds are diagonal rather than vertical.

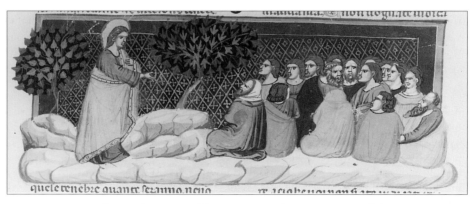

FIG. 58: Miscellany. Florence, Biblioteca Riccardiana, MS 1538, fol. 120r: Christ preaching (Photo: Biblioteca Riccardiana, Florence)

The back views of kneeling and reclining figures in North Italian manuscripts are likewise more common and often more specifically relevant to the Egerton Genesis than are those in English manuscripts. Somewhat comparable to the figure of a crouching attendant on fol. 10r (11rJ), lower left, of the Egerton Genesis, is a supplicant figure kneeling on one knee in an illustration in Vatican City, Biblioteca Apostolica Vaticana, MS Vat. lat. 1389, fol. 97r, a book of Decretals of Gregory IX, of the early 1340s.[19] A similar figure appears as a censing attendant in the miniature of the Elevation of the Host in Vat. lat. 2534, fol. 1r (fig. 57). Kneeling figures seen from behind with both legs foreshortened, comparable to the kneeling servant on fol. 13v

(12ᵛ]), upper right, of the Egerton Genesis, are often depicted in Bolognese manuscripts, as in the miniature of the Papal Consistory on fol. 3ᵛ of Vat. lat. 1389, or in that of the adoration of the Trinity on fol. 4ʳ of the same manuscript (fig. 37). English examples of rear-view kneeling figures, such as the man pumping the bellows of the organ on fol. 66ʳ, bas-de-page, of the Peterborough Psalter in Brussels, tend to sidestep the difficulty of foreshortening the legs by attaching the feet directly to the back of the garment.[20]

A reclining figure seen from the rear and closely comparable in both motif and meaning to the figure of the stricken boy guide on fol. 3ʳ, upper right, of the Egerton Genesis, is the fallen Abel on fol. 3ᵛ in the Paduan Bible (fig. 12). Though later than the Egerton Genesis, this Bible probably reflects earlier North Italian imagery.

The radical lost profile, in which the head is viewed three-quarters from the rear and eye, nose, and mouth are absent from the silhouette, is found occasionally in earlier English manuscripts, as on fol. 89ᵛ of Baltimore, Walters Art Gallery, MS W. 102, a psalter-hours of c. 1300.[21] This view was used more often in Flanders, northern France, and the Mosan area in the early fourteenth century. Examples can be found on fol. 82ᵛ of Walters 88; on fol. 16ᵛ of a book of hours London, British Library, Stowe MS 17,[22] and on fol. 12ʳ of the Breviary of Marguerite de Bar (Verdun, Bibliothèque Municipale, MS 107).[23] Less radical views of the head seen three-quarters from behind, with one eye and nose partly visible, appear in East Anglian manuscripts, as in the prophet figure at upper right, fol. 9ᵛ, in the Ormesby Psalter. However, lost profiles are most common in Italian manuscripts. Whatever the Egerton Genesis artist may have learned from English, French, or Liège sources was probably reinforced and further developed by Italian examples, such as the seated figure in the front row, second from the left, on fol. 120ʳ of Riccardiana MS 1538 (fig. 58); or on fol. 53ᵛ of a Digest in Turin, Biblioteca Nazionale, MS E. I. 1, of the 1340s.[24]

Foreshortened heads which are tilted back, seen from the front, like that of the seated figure on fol. 8ʳ, lower left, of the Egerton Genesis (fig. 28), are hardly to be found in English manuscripts of the first half of the fourteenth century other than in those associated with the Egerton Genesis artist. These are, however, quite common in Bolognese manuscripts, such as the head of the kneeling figure in the centre of the initial *P*, fol. 1ʳ, of a manuscript of collected writings in Bologna, Collegio di Spagna, MS 2, datable to the second or third decade of the 14th century.[25] Another such head is that of a figure in the initial at the *Incipit* of a register of commodities in Bologna, Museo Civico, MS 633, dated 1328 (fig. 59).[26] This second example is especially striking because the Italian figure, like that in the Egerton Genesis, balances something on its nose. Another North Italian example, an early fourteenth-century copy of the *Histoire ancienne*, Vienna, Österreichische Nationalbibliothek, Cod. 2576, fol. 19ʳ, is striking because the foreshortening is applied to the face of Abraham in the scene of Abraham and the stars, the same scene as on fol. 8ʳ, lower left, in the Egerton Genesis.[27]

Heads tilted forward, seen in foreshortening from the front, and heads tilted backward, seen in foreshortening from the rear, are found occasionally in East Anglian manuscripts, such as the St Omer Psalter and the Luttrell Psalter. On the *Beatus* page, fol. 7ʳ, of the St Omer Psalter, in the left margin, a standing figure bends slightly forward and peers downward, so that the

FIG. 59: Register of commodities. Bologna, Museo Civico , MS 633: Initial I, with standing figure (Photo: Museo Civico, Bologna)

head is seen foreshortened from the front.[28] A seated archer in the margin of fol. 54r of the Luttrell Psalter presents a similar, though less radical, view of the head, with a slightly foreshortened torso as well. Such views are precedents for the forward-bending figures with foreshortened heads on fol. 5v and fol. 7v, upper right, in the Egerton Genesis. The figure seen from the rear, with head bent backward, in the Last Judgement of the St Omer Psalter, fol. 120r (fig. 5), is likewise a precedent for the figure of the workman on fol. 8r, lower right, of the Egerton Genesis.

Once again, however, it is North Italian manuscripts that provide the best comparisons and most abundant examples of views similar to those in the Egerton Genesis. The scene of the building of the Tower of Babel on fol. 7r, upper left, in the Paduan Bible, (fig. 23) has a forward-bending figure which is strikingly similar to the workman in the same scene on fol. 5v in the Egerton Genesis. In the Paduan Bible, the figure, even more drastically foreshortened than its English counterpart, holds a basin of stones rather than a basin of mortar, as in the Egerton Genesis. In other respects the two figures are closely comparable. Likewise the carver in the scene of the building of the altar at Bethel, fol. 8r, lower right, in the Egerton Genesis is most closely parallelled in Bolognese manuscripts by the many rear-view figures with raised arms and heads bent backward. These include praying figures and celebrants of the Mass with raised arms, such as the hooded figure before the altar on fol. 4r of Vat. lat. 1389 (fig. 37), and

the caryatid figures which support miniatures, as on fol. 6r of a book of Decretals, Weimar, Thüringische Landsbibliothek, MS Fol. max. 10, of the 1340s.[29]

Finally, the foreshortened hands have closer antecedents in Bolognese manuscripts than in English ones. The hand which Abraham lays on his head on fol. 9r, bottom left, in the Egerton Genesis compares to that of Christ in the *Noli me tangere* on fol. 111r of Bologna, Convento di San Domenico, graduale 21, datable to the 1320s (fig. 7). In both images, fingers are together and the hand is seen from the side and slightly from above. The curled, foreshortened fingers of the kneeling messenger on fol. 8v, lower left, of the Egerton Genesis are like those of the figure seated in the centre margin below the miniature on fol. 5r of Vatican City, Biblioteca Apostolica Vaticana, Vat. lat. 1430, dated to the mid 1330s.[30] Nevertheless, we find nothing in Italian or northern manuscripts, or even in the work of Giotto, to compare with the hand of Abimelech on fol. 10r (11rJ), upper left, in the Egerton Genesis (fig. 52). The hand is angled and the fingers aligned so as to provide the most possible information about all dimensions, relative positions, and structure of the palm and digits with a minimal number of penstrokes. It is an unsurpassed small masterpiece of foreshortening in its era and serves as a caution against assumptions that northerners were incapable of a profound understanding of Italian spatial concepts.

Thus, back views and foreshortenings in the Egerton Genesis have antecedents in a variety of sources. For some there were English models or models from manuscripts of Flanders and the nearby Mosan area. Often these motifs seem to have been corrected toward greater realism under the influence of Italian models. Other motifs apparently had few or no antecedent examples in northern manuscripts and were probably picked up directly from Italian sources, especially Bolognese manuscripts, among which those of the 1320s through the 1340s provide the most relevant visual material. Illuminations by an artist of vigorous narrative style, who is variously designated the *'Illustratore'*, 'Pseudo-Niccolò', or Andrea da Bologna and who worked in the 1330s and 1340s and into the 1350s,[31] repeatedly supply close comparisons for motifs in the Egerton Genesis. Capable in some respects of surpassing his models on their own grounds, the Egerton Genesis artist had an open-minded, opportunistic attitude, learning and borrowing from whatever could teach him.

One notes a variety of physical types among the figures in the Egerton Genesis. Patriarchs, persons of rank, and women are generally tall and relatively slender. Youths, male servants, and men of lower rank are often shorter and more squatly proportioned, with thick legs and large feet. Canaan, on fol. 4v, lower left, the workmen on fol. 5v, Lot's small companion on fol. 8v, upper right, the youthful Esau on fol. 12v (13vJ), upper right, and the figure grasping Tamar on fol. 19r, upper right, are a few examples of this figure type. Usually male figures of the first type are bearded and long-haired, and are clothed in long robes, while figures of the second type are beardless with frizzy, short hair and are clothed in knee-length tunics. Figures of the first type are traditional and generic in northern manuscript illumination. Those of the second type are of more specific derivation. Figures of squat proportions are found in some Bolognese manuscripts. Even more germane are marginal figures in Franco-Flemish manuscripts, such as those in Walters 88, from the Diocese of Cambrai, on fol. 53v, and in a book of hours for use

in St Omer-Thérouanne, Baltimore, Walters Art Gallery, MS W. 90, on fol. 145ᵛ.³² Figures in both miniatures and margins of another manuscript from this region, the Canticles of the Virgin, Paris, Rothschild Collection, as on fols 113ᵛ (miniatures), 182ʳ, and 186ᵛ (margins), often have short bodies with thick legs and feet.³³ Thick legs and feet are also found on marginal apes and hybrids with spaniel-like or leonine hindquarters, as on fols 81ʳ and 97ᵛ of Copenhagen, Kongelige Bibliothek, Gammel kongelig Samling, MS 3384,8° and fol. 190ʳ of Walters 82.

EXPRESSION

Dramatic expression permeated with a coarse comic sensibility that verges on the burlesque is one of the most pronounced stylistic qualities of the Egerton Genesis. Gestures, facial expressions, and bodily movements are all strongly expressive. The four scenes on fol. 7ʳ depicting episodes from Abraham and Sarah's sojourn in Egypt are illustrative. Pointing hands, some enlarged and with exaggeratedly long index fingers, are depicted eight times in these scenes. On fol. 7ʳ, upper right, the tense rhythmic patterns of the draperies and hands of the courtiers convey their excitement over the beauty of Sarah, to which Pharaoh responds with a buffoonish leer. Below at left, Sarah is literally shoved into Pharaoh's presence; and she protests with 'groundelande contenance' (fig. 25), hands flung up and out, her body and draperies curved in lines of strong resistance. On fol. 15ʳ, upper right, in the scene of Esau's discovery of Jacob's theft of his blessing, the helpless surprise of the blind Isaac, the grief and dejection of Esau, the conspiratorial mockery of Rebecca and Jacob are all played to the hilt with gestures and expressions, as though this were an episode from a comic drama quoted with relish by the artist. Unlike almost all other illustrations of biblical material from this era, the Egerton Genesis's imagery does not present idealised biblical protagonists. Biblical characters can hardly be termed heroes in these stories, which exaggerate their weaknesses and poke fun at their predicaments. Esau, played for a fool in the scene just described, is a case in point. On fol. 2ᵛ, upper centre, Lamech, comically directing his eyes toward the viewer as he is caught between his two insistent wives, is another foolish figure. Rebecca is the sly trickster as she deceives Laban on fol. 16ᵛ, lower left; Judah is a lecherous lout as he has intercourse with Tamar on fol. 19ʳ, upper left.

Strong expression which often borders on the grotesque is a common feature in English works of the mid-fourteenth century. It characterises not only other works assigned to the Egerton Genesis artist, such as the James Memorial and Derby Psalters, but also the illuminations by the main artist of the Fitzwarin Psalter, and those of the Zouche Hours and an hours of the Virgin, London, British Library, Egerton MS 2781.³⁴ The Egerton Genesis thus participates in a general trend, yet in the sexual dimension of this expression it surpasses these other manuscripts.

In virtually unprecedented fashion, the Egerton Genesis exploits the sexual implications of many biblical scenes. In Abraham's circumcision on fol. 9ᵛ, lower right, the patriarch's large

sexual organs are prominently displayed, trumpeting the physical prowess of this progenitor of many nations. The circumcision is graphically depicted with the knife in mid-cut, a thread of red blood emerging from the wound and Abraham grimacing in pain. Unlike the same scene on fol. 9ᵛ of the Paduan Bible, in which Abraham modestly circumcises himself in solitude, behind a building, here the circumcision is a communal affair, in which three men expose their genitals and two others wield the knives. On fol. 4ᵛ, upper left and right, in the scenes of Noah's drunkenness, his sexual organs are fully visible and are carefully rendered; and Ham, with leering, toothy giggle, enjoys the sight to the fullest. On fol. 11ʳ (10ʳJ), in the lower image, two male Sodomites on the rooftops prepare to engage in sexual activity, an image so shocking that the sexual organs were later erased. Shechem rapes Dinah, who resists with a blow of her fist to his face, on fol. 17ʳ, lower right (fig. 46). In the story of Isaac and Rebecca the artist invests the story with sexual implications that the text does not warrant. On fol. 12ʳ (13ʳJ), upper left, Abraham's servant pats Rebecca on the rump as he presents her to Isaac, implying the development of unsuitable intimacy between the two travellers during the long journey from Harran.

The Egerton Genesis's only scatological image is depicted at the beginning of this same trip, on fol. 13ᵛ (12ᵛJ), lower right. A camel defecates, its droppings depicted in mid-fall, as Abraham's servant urges Rebecca to finish her leave-taking. Here again one suspects the influence of the drama, in which the inclusion of live animals in the performances must have led to diverting comical occurrences of just this sort. It should be noted that this unusual image has a precedent in the Flemish Walters 82, in another context. On fol. 52ʳ, in the *bas-de-page*, a young man carries a defecating horse, its green droppings caught in a cloth held by an older man (fig. 45).

Though English manuscripts of the first half of the fourteenth century have sexual and scatological imagery in the margins, on the whole this imagery is more restrained in quantity and in character than that of the Egerton Genesis. Traditions of Ghent and the Franco-Flemish border are more helpful to one seeking parallels for the scene in the Egerton Genesis. The margins of a number of manuscripts from this region, works such as Additional MS 36684/Morgan 754 and Walters 88, are heavily salted with imagery of this sort. Occasionally even biblical miniatures include elements of bold sexual imagery. One example is the reclining Adam, depicted with enlarged genitalia in the creation of Eve on fol. 4ᵛ of the *Spiegel historiael* (fig. 18).

The Egerton Genesis has no marginalia, but its main scenes incorporate material that might have been in the margins in earlier manuscripts. It is as though the psychological and social constraints which maintained the boundaries between marginal and main imagery have collapsed. Not only has the marginal material moved into the centre, but it has been radically integrated into the biblical stories, in virtually unprecedented fashion. Biblical patriarchs and their wives frequently behave almost like the apes and grotesques in the margins of earlier manuscripts. Only God is respected. He is not mocked, does not mock others, and does not play the buffoon. His gestures are dignified and restrained, and his figure is spared the more drastic experiments in foreshortening to which others are subjected. (The only exception is in

the two scenes with the three heavenly visitors, on fol. 11r (10rJ), at top. The two visitors, each without nimbus, one with hooded eyes and a five o'clock shadow in the scene at left, both displaying questionable table manners in the scene at right, are treated with some comic elements. The nimbed figure, however, is dignified.)

SPACE

The Egerton Genesis artist apparently had less interest in Italian ideas about space and the placement of figures within space than in Italian concepts of the human figure. Space in the Egerton Genesis is essentially northern and planar. Figures' gestures, movements, and interactions are usually parallel to the picture plane. Depth is achieved primarily through multiplying the number of planes and placing them one behind the other. Examples of these planar compositions are multitudinous. Often the alignment of figures in a row has a stage-like quality, as in the descendants of Adam in all quadrants of fol. 2r, or the scene of Lamech and his wives and offspring which covers the upper half of fol. 2v. The battle scenes on fol. 8v, upper left and lower right, though densely packed with figures, are composed using the same spatial principle. Horses, lances, axes, and swords are aligned in parallel planar layers which contain and orient their movements. Likewise the multi-figured scenes from the Jacob story in all quadrants of fol. 16v and those of the Joseph story in all quadrants of fol. 20v are planar in their organization. In the scene of Joseph feasting with his brothers on fol. 20v, upper right, the table tops are tilted in compliance with the demands of this planar spatial system rather than subjected to any serious attempts at foreshortening, as in Bolognese manuscripts. In the building of the Tower of Babel, fol. 5v, one of the most Italianate compositions in terms of figure design, the space is still largely planar. The ramp, which an Italian artist might have rendered as a diagonal in three dimensions, is here forced into two.

However, at least one compositional device, most clearly presented on fol. 5r, lower left, represents a step toward a more nearly three-dimensional design in multi-figure groups. On fol. 5r, lower left, the descendants of Japheth are depicted in animated conversation. In the centre of the group, under the inscription *Japheth*, a figure in three-quarters view points to his left at another gesturing figure depicted in profile. In the space that separates their heads is the full-view face of a figure behind them. A party to their conversation, this man directs his eyes toward the profile discussant. A little of his lower body, including one foot, is visible between the robes of the two primary figures. Here, the planar grouping of the two-way conversation is modified, by the addition of a third person, toward a semicircle in depth. Similar groups of full-view heads between facing profiles or three-quarters views can be seen in the scene of the descendants of Ham in the upper right of the same folio and in the scene of Hiron, Ham, and Nimrod on fol. 4v, lower right.

Northern antecedents for this grouping are rare, but at least one can be found from the Mosan area. On fol. 198v of Stowe 17, lower margin, four figures standing in a cart are grouped in a spatial circle. On the other hand, Bolognese manuscripts of the first half of the

fourteenth century are amply supplied with well-defined conversational groups of figures in threes, arranged in three-dimensional semicircular groups. The *Liber primus decretalium*, Vatican City, Biblioteca Apostolica Vaticana, Vat. Lat. 1456, depicts such a group at the lower left of fol. 179ʳ. Another example is in the Missal of Cardinal Bertrand de Deux (Vatican City, Biblioteca Apostolica Vaticana MS Cap. 63 B), fol. 239ᵛ. In these Italian examples, the groups are spatially and psychologically integrated. In the example in Vat. Lat. 1456, the full-view figure directs his eyes to the side to follow the gestures and words of the figure to his left, as did also one of the conversationalists in the Egerton Genesis. In the example from the missal, the three figures are isolated within an initial as a self-contained unit.

Elements of both northern and Italian traditions for figural groups are used in the Egerton Genesis. The two flanking members of each conversing group might still be read as belonging to a different row than the figure or figures behind them, and yet there is an attempt to integrate the three figures spatially and psychologically. Once again, apparently, the Egerton Genesis artist produced, in consultation with Italian manuscripts, a more fully spatial version of a motif that had antecedents of some sort in northern traditions. This interest in producing lively, interacting spatial arrangements may also reflect the drama, in which groups of figures in expressive conversation could serve as models for the artist. The artist was not merely a passive recipient of tradition nor a transmitter of prototypes but rather an active seeker of imagery and ideas, eager to create a sense of the lifelike from whatever visual sources were available, regardless of their origin or medium.

ARCHITECTURE

Primarily secular rather than ecclesiastical, the architecture of the Egerton Genesis derives from English, Flemish, and Italian sources. Many elements in the architecture of the Egerton Genesis are very common in the castles depicted in northern manuscripts of the first half of the fourteenth century and require no comment. These include portals flanked by turrets, fol. 11ʳ (10ʳJ), lower half; fol. 17ᵛ, upper left; portcullises, fols 5ᵛ, 6ʳ, left; and 11ʳ (10ʳJ), lower half; walls crowned by battlements, fol. 8ᵛ, lower left; fol. 11ʳ (10ʳJ), upper left and lower half; and slender attached buttresses, fol. 11ʳ (10ʳJ), lower half; fol. 17ᵛ, upper right. Other features, though somewhat less common, have antecedents of some sort in English and Flemish works. These elements include corbelled polygonal bay windows, fol. 11ʳ (10ʳJ), upper left and right, and fol. 13ᵛ (12ᵛJ), upper left; roof ventilators, fols 8ᵛ, lower left and 12ᵛ (13ᵛJ), lower left; entrances crowned by cantilevered short towers, fol. 11ʳ (10ʳJ), upper left and right; fol. 13ᵛ (12ᵛJ), upper left; walled rooftop areas within which are structures and human activities, as on fol. 11ʳ (10ʳJ), upper left and lower half.[35]

Many close parallels for individual motifs, as opposed to the overall appearance of the architecture, are to be found in the secular Bodley 264, which manifests some significant stylistic advances, of French and Italian origin, over Flemish psalters of the 1320s and 1330s. The corbelled polygonal bay windows on fol. 167ʳ, the roof ventilators and short towers supported

on corbelled vaults on fol. 51v, and the view of rooftops and soldiers within the city wall on fol. 82v are all suggestive of the Egerton Genesis, though none is an exact parallel. However the architecture of Bodley 264 is far more Italianate than that of the Egerton Genesis. Architecture is in fact the most Italianate feature of this book, whose slim, elegant figures look very French and whose foliate borders are traditionally Flemish.

The castle-like compounds in the Egerton Genesis bear some resemblance to those in French works of the mid-fourteenth century, such as that on fol. 23r in Guillaume de Machaut's *Le Remède de Fortune* (Paris, Bibliothèque Nationale, MS fr. 1586), of about 1350.[36] Shared features include blue roofs, white masonry with inky black doorways and windows, staircases, conical turrets, and battlements enclosing gabled roofs. However, examination reveals that the French structure has numerous complexities, elegant slim proportions, and intricate traceried windows lacking in the Egerton Genesis. Moreover, unlike the artist of the Guillaume de Machaut and other French artists of his era, the Egerton Genesis artist had little interest in depicting architectural interiors. In its architecture, as in other respects, the Egerton Genesis affords scant evidence of direct influence from French manuscripts.

Buildings of simple articulation whose corbelled upper stories are wider than their lower stories are found on fol. 11v (10vJ), upper left and right. These may reflect Sienese painting. Ambrogio Lorenzetti's fresco *Allegory of Good Government* in the Palazzo Pubblico, Siena, depicts relatively simple volumetric structures whose projecting upper stories are braced or corbelled. Similar features appear in the architecture of Sienese panel paintings, as in *The Miracle of Agostino Novello* in Simone Martini's altarpiece of *The Blessed Agostino Novello and Four of His Miracles* in S. Agostino, Siena. Though architecture in Bolognese manuscripts also features cantilevered upper stories, the characteristic busy symmetries of these structures are very different from the asymmetry and relative simplicity of the architecture in the Egerton Genesis and in Sienese painting.

Italian influence, perhaps Sienese, is possible for the Tower of Babel, depicted on fols 5v and 6r. Its monumental, volumetric form and its simplicity of articulation and detailing relate to Sienese traditions. In this regard it is worth noting that Lorenzetti's fresco in the Palazzo Pubblico shows a scene of workmen on cantilevered wooden scaffolding, not unlike that in the Egerton Genesis. However, it should also be noted that the walls of fourteenth-century English cities were fortified with relatively unadorned cylindrical towers. In Norwich, where the city walls were under construction in the 1340s, at least two of the fourteenth-century towers are still standing, the Black Tower on Carrow Road and another between Ber Street and the river.[37]

The one ecclesiastical structure in the Egerton Genesis is the altar at Bethel on fol. 8r, lower right. The architecture is that of a freestanding Gothic tabernacle. It bears comparison to the Bishop's throne at Exeter Cathedral, begun in 1312, with its ogival arches, foliate finials, battlemented wall, and superstructure of towers and pinnacles,[38] and also to the painted architecture enclosing Queen Philippa and her daughters in St Stephen's Chapel, Westminster, whose pictorial decoration was begun in 1350.[39]

In the Egerton Genesis the underside of the vaulted canopy is shown with ribs diverging from the top of one of the four columnar supports, a view which would be more realistic for a structure with multiple bays. In the St Omer Psalter, fol. 70ᵛ (fig. 33), there is a more structurally accurate view, in which ribs are depicted converging to a keystone. The undersides of vaults are depicted in many images in the Fitzwarin Psalter, as on fols 7ʳ and 15ʳ (fig. 32), but here they are quite flat. They may be read as projections of ribs converging to a keystone or diverging from a corbel, or in some cases even as flat screens of tracery.

Vaults are similarly depicted, with more or less facility, in Flemish manuscripts of the second quarter of the fourteenth century, as on fol. 48ʳ of the *Rijmbijbel* (The Hague, Museum van het boek/Rijksmuseum Meermanno-Westreenianum, MS 10 B 21) (fig. 30); similar views of vaults appear on fols 143ᵛ and 151ʳ of The Hague, Museum van het boek/Rijksmuseum Meermanno-Westreenianum, MS 10 A 14, a missal completed in Ghent, much of whose illustration has been dated 1345–50,[40] and in Bodley 264, as in the architectural frames of the full-page miniatures on fols 101ᵛ and 188ᵛ.

Some structures in the Egerton Genesis are complex; others are simple. Abraham's dwelling on fol. 11ʳ (10ʳʹJ) upper left, includes multiple levels, planes, and types of fenestration. It has a spring issuing from a culvert, an oven, and a two-storey square tower. By contrast, a very simple type of structure occurs repeatedly in the second half of the manuscript. A one-storey building with a pitched roof and round-arched doorway, sometimes also with two windows and a moulding, appears over and over again like a reusable stage prop. Quite possibly its multiple appearances reflect the practices of theatrical staging, as well as a quickening pace of work in the latter folios of the manuscript.

In the architecture of Bolognese manuscripts, symmetrical complexes, sometimes reminiscent of Roman wall painting, often display the artist's mastery of the concept of a more or less fixed eye level (fig. 50). Contracting orthogonals may be rendered with some degree of success (fig. 37). Italianate perspective was not substantially assimilated by the artist of the Egerton Genesis, who, for architectural compositions as well as for the figural compositions discussed above, primarily used a rationalised version of the northern system in which space is constructed by the layering of planes. The strongly rational dimension of his version of the northern system is evident in complexes such as Abraham's dwelling on fol. 8ᵛ, lower left, of the Egerton Genesis. Here as many as nine distinct sequential spatial layers are defined by walls, roofs, and towers. However, the artist was far less successful in fixing eye level and in coordinating the contracting orthogonals and the tilted horizontal planes of architectural perspective. On fol. 12ʳ (13ʳʹJ), upper right, one looks up at the corbels beneath the tower but views the tower itself straight on. On fol. 11ʳ (10ʳʹJ), bottom, the relatively lucid series of planes in the towered entrance contrasts with the skewed overall perspective of the rooftop structure and encircling battlements. Orthogonals often fail to contract, as in the altars on fol. 6ᵛ, lower left, and fol. 13ʳ (12ʳʹJ), upper right, and horizontal planes are sharply tilted, as in the beds on fols 12ᵛ (13ᵛʹJ), upper left, and 18ʳ, upper left. Pächt cited this tilting as evidence of Late Antique influence,[41] but in fact projection of horizontal surfaces in such a manner is quite common in English manuscripts of the era. The Luttrell Psalter affords a number of examples.

LANDSCAPE

As is the case for architecture, the conventions for rendering landscapes in the Egerton Genesis are primarily northern. Italianate rocky cliffs do not appear. On the whole, landscape is flat rather than illusionistic, but it is depicted with a variety of conventions, as noted earlier in this chapter. Many images, such as the two at the bottom of fol. 16r, have no indication of setting. On fol. 2v, upper half, the scene of Lamech with his two wives and their offspring has no ground plane but includes elements that suggest variously the indoors (the loom) and the outdoors (the blacksmith's anvil and shepherd's cart). The ambiguous setting as well as the pageant-like display of activities and the wheeled cart suggest the theatre. Elsewhere the outdoors is clearly specified, with grass, trees, and hills. In earlier English and Flemish manuscripts, grassy ground is most commonly rendered as green wash overlaid with short black vertical strokes in irregular rows or clusters (figs 5, 6). Black strokes over green wash appear in the Egerton Genesis, as on fol. 4v, all quadrants, and fol. 9r, lower left, but the strokes are usually arranged in a diagonal grid, resembling, on an enlarged scale, the diapered pattern of decora-

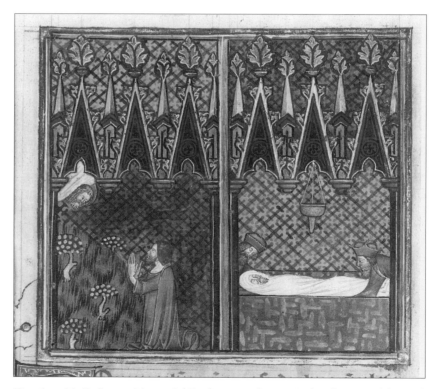

FIG. 60: M. R. James Memorial Psalter. London, British Library, Additional MS 44949, fol. 6v, double miniature: Gethsemane, Entombment (Photo: British Library, London)

tive backgrounds in many contemporary and earlier manuscripts. In the James Memorial Psalter, diapered backgrounds are found in conjunction with grass treated in this fashion in the Crucifixion, fol. 5v, and in Gethsemane, fol. 6v (fig. 60).[42] The effect, as in the Egerton Genesis, is greatly to flatten the space. Although black strokes are arranged in diagonal or zigzag patterns in the grass of a number of earlier manuscripts, we have not encountered elsewhere grass articulated as such regularly diapered grids.

Grass as a green wash overlaid with regular rows of white vertical strokes is very common in the Egerton Genesis, as on fols 3r, upper left and right, 4r, 9v, upper left and right, and 14r, upper left. This treatment can be related to the Gorleston Psalter, where white is brushed over green between rows of black vertical strokes on fol. 125r, and to the use of both black and white vertical strokes over green wash on fol. 72r of the *Histoire del Saint Graal et de Merlin*, London, British Library, Additional MS 10292, a work of Franco-Flemish or Flemish origin.[43]

On fols 10 (11J) through 13 (12J), the ground is blue wash rather than green and is incomplete, without any articulation of the blades of grass. At first it seemed to us that this change of colour might indicate a second colourist at work on these pages, especially given the other anomalies exclusive to these four leaves—the trees which lack articulated foliage, the lack of any colour in garments and architecture, and the reversed order of the two bifolios in question. However, on closer reflection, it seems more likely that there was no change of artistic hand here and that the anomalies must be otherwise explained, perhaps by a pressing deadline, which could not be met in the end. Blue ground is not a novelty. It was used earlier, on fol. 1v, lower right, and the pattern of inkblot transfers of both blue and black ink indicates that the reversal of the leaves occurred before the ink was dry on either the reversed folios or the folios immediately preceding and following them.

In many English, French, and Flemish manuscripts of the first half of the fourteenth century, ground is rendered in painterly fashion with many small hillocks and hollows, often without grass. These conventions would seem to derive from Parisian and northern French manuscripts of the era of Master Honoré. (An example can be seen in the British Library *Somme le Roi*, illustrated by Master Honoré, fol. 5v). On fol. 161r of Gl kgl. Saml. 3384,8°, these hillocks appear in a particularly curvilinear variant (fig. 61), and they appear in similar form in other Flemish and Franco-Flemish manuscripts such as the *Saint Graal* from Thérouanne, London, British Library, Royal MS 14 E III, on fol. 43r.[44] Manuscripts of the Queen Mary Psalter group in England often employ this landscape convention in a more understated fashion, with emphasis on the hollows rather than the hillocks, as in the image of the Creator, fol. 2r of the Queen Mary Psalter. In the Egerton Genesis this convention appears only once, on fol. 7v, upper right. Above the sheep appears a small tree-crowned hill on which, in a more two-dimensional version, are angular hillocks like those in the Parisian and Franco-Flemish examples mentioned above. Perhaps closest to the rendering in the Egerton Genesis are the hillocks in the *Rijmbijbel*, as in the miniatures of the first and second days of creation, fol. 1v (fig. 26).

Undoubtedly the most expressive elements of landscape in the Egerton Genesis are the trees. Trees are of both traditionally northern and Italianate types. On fol. 7v, trees with lopped branches and individual blade-shaped leaves drawn on a green ground, uniform in hue, are

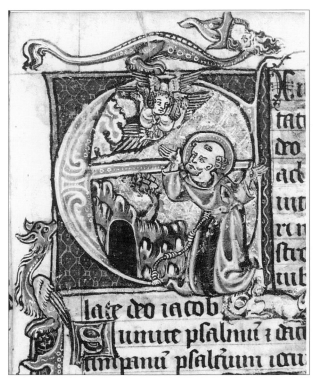

FIG. 61: Psalter. Copenhagen, Kongelige Bibliotek,
Gammel kongelig Samling, MS 3384,8°, fol. 161ʳ:
Initial E for Psalm 80, with St Francis receiving the
stigmata (Photo: Kongelige Bibliotek, Copenhagen)

like those found in numerous earlier northern manuscripts. Trees with balls of foliage articu-
lated with individual leaves, shaded dark green along the edges and highlighted golden
orange at the centre, like many on fol. 1ᵛ, lower left and right, and fol. 4ʳ, are of Italian deri-
vation.[45] They can be compared to those in the Bolognese gradual, fol. 111ʳ (fig. 7). Trees often
articulate the mood or underscore the significance of a scene. On fol. 3ʳ, upper right, the tan-
gled trunks above the figure of the child murdered by Lamech express the chaos and horror
of the moment. On fol. 7ᵛ, lower right, a tree with forked trunk bends its foliage to the left
and right, as though to emphasise the parting of Abraham and Lot, depicted on either side of
it. Again on fol. 13ʳ (12ʳJ), in the three scenes of the story of Abraham's sacrifice of Isaac, the
many divided trees with heart-shaped foliage balls suggest that Abraham feels his own heart
divided between obedience to God and love for Isaac. This reflective and ever sympathetic role
of trees in the manuscript manifests the creative whimsy of the artist.

As is often the case in northern manuscripts, clouds figure chiefly in the Egerton Genesis as
heavenly loci from which the Deity or his angelic messengers communicate with the men and
women in the biblical stories. In the first gathering clouds are scalloped and are arranged in

diagonal or concentric rows. In the second and third gatherings they are likewise in concentric rows, but the edges are serrated and notched, a change perhaps made with a view to saving time, because the second style, lacking the extensive subtle shading of the first, could be more quickly executed. The number of rows in concentric alignment steadily diminishes from eight on the first page of the second gathering (fol. 8ʳ) to two on the last page of the gathering (fol. 15ᵛ), again suggesting that corners were cut to save time or money. In the final gathering the Deity appears only thrice, on each occasion in a small serrated cloud of two tiers. Clouds may be silvered, as on fols 4ʳ and 6ʳ, upper left, shaded with penwork, as on fol. 6ᵛ, lower left, or coloured with red and blue, as on fol. 9ʳ, lower left. Many variants of both scalloped and serrated clouds are common in earlier English and Flemish manuscripts. One precedent for clouds of both types in the same manuscript is in the Ormesby Psalter, in which serrated clouds appear in the two-line initial on fol. 72ʳ and scalloped clouds in the five-line initial on fol. 131ʳ.

CLOTHING AND ARMOUR

Fashion changed radically during the fourteenth century. The fitted garments which were the ancestors of modern dress began to replace the loose ones as early as the 1330s, and male costume seems to have become progressively shorter and tighter over the course of two or three decades.[46] In English illumination, tunics with fitted bodices and flared skirts, some of above-knee length, made their appearance in the men's garments of the St Omer Psalter of the late 1330s. The tormentors of Christ in the roundels of the Flagellation and Christ Carrying the Cross on fol. 120ʳ clearly wear the new clinging costumes.[47] The Smithfield Decretals of c. 1340 and the Luttrell Psalter of c. 1335 depict similar male costume. The famous miniature of the mounted Sir Geoffrey Luttrell accompanied by his ladies shows the latter in modish dress with fitted bodice and off-shoulder sleeves.[48] About the same time, in the Flemish Bodley 264, illuminated 1339–1344, the new costume, complete with fashionable parti-colouring, is the usual rather than the occasional. In the Fitzwarin Psalter the new costume appears in the work of the main artist but not in the two illustrations of this MS assigned to the artist of the Egerton Genesis, whose subjects hardly provide opportunity for its depiction.

Most men and women in the Egerton Genesis wear the traditional loosely fitting robes and mantles and the sleeveless *surcot* is rare. Tunics are sometimes worn over stirrup pants or leggings, as on fol. 3ʳ, upper left, and fol. 8ʳ, lower left. More fitted attire appears frequently in the final gathering. Potiphar on fol. 19ʳ, lower right, Potiphar and the jailer on fol. 19ᵛ, upper right, and Joseph's attendants on fol. 20ʳ, upper right, all wear the garb of mid-level courtiers—fashionable tunics with fitted bodices and short flared skirts. On fol. 19ʳ Potiphar's bodice is fastened with a long row of buttons, a prominent feature of the new styles. Most of the new garments have wide collars. The dress of young women becomes more stylish in the final gathering as well. In the second gathering, Hagar wears a dress with bloused waist on fols 9ʳ, lower right, and 9ᵛ, upper left, while in the third gathering, Rachel's maid wears a dress with fitted bodice

on fol. 16r, lower left. Dinah and her companion on fol. 17r, lower right, wear dresses with off-shoulder sleeves as well as fitted bodices (fig. 46). On the whole, costume in the Egerton Genesis, with its mix of old and new styles tilted in favour of the older ones, suggests a date closer to 1350 than 1360. Some clothing in the Egerton Genesis is almost certainly inspired by theatrical costume—as for example, the attire of the Sodomite, the Ishmaelite, and the angel.

Knights and foot soldiers in precisely rendered armour appear on several folios of the Egerton Genesis, always in the mixed chain-and-plate mails of c. 1320 to c. 1380.[49] The men-at-arms at left and right on fol. 7v, upper left, and at left on fol. 16v, lower left, each wear a chain mail *haubergeon*, under which is visible the vertical stitching of a quilted undergarment (*hauketon* or *gambeson*) and over which is a fitted *surcot*, shorter in front than in back. Abraham's servant, fol. 13v (12vJ), upper left (fig. 44), also wears this style of *surcot*, termed a *cyclas*, featured on brasses of the second quarter of the fourteenth century. Its predecessor before 1320 was a longer, looser *surcot*, and its successor, around mid-century, a shorter one. The knight at left on fol. 7v, upper left, and Laban on fol. 16v, lower left, wear a chain mail hood (*camail*) beneath the helmet.

On fol. 9r, upper right, the kneeling Abraham appears in a slightly different style of armour (fig. 36). Around his neck is a collar of plate mail, and he wears metal-studded leather *cuisses*, or thigh protectors. He wears a hip-length, fitted garment with a scalloped lower border and below this, draped across his thighs, is the thin material of a short skirt. The plate collar appears on the brass of Sir Hugh Hastings, in Elsing, Norfolk, dated 1347, as does a flared skirt of thin material.[50] Hastings's skirt is that of an updated *cyclas*, which is shortened to above-knee length behind as well as before. In the manuscript, however, the hip-length garment whose scalloped edge ends above the skirt resembles rather a slightly later garment, the fitted leather *jupon*, which was worn over a short mail *haubergeon* and first appears in brasses on that of John de Cobham, Cobham, Kent, in 1354.[51] Abraham wears plate *rerebraces* and *vambraces* (upper and lower arm protectors), *jambarts* (shin protectors), as well as roundels at the shoulder and presumably at the elbow (here covered by drapery but visible on his armour in the preceding illustration) and *genouillières* at the knees. As reinforcement over chain mail these pieces of plate are all commonly seen in brasses which date to the second quarter of the fourteenth century. Abraham's helmet, a pointed bascinet of the type that appears on brasses from around 1330 until the end of the century, is held by the mounted soldier behind him. Most of the knights on fols 8v and 9r wear variants of Abraham's armour. Their outer garments, short like the *jupon* but laced up the sides like the *cyclas*, suggest a garment transitional between the two, as does Abraham's skirted *jupon*.

What are the implications of the styles of armour for the dating of the Egerton Genesis? Macklin puts the appearance of the short, fitted leather *jupon*, worn without outer garment, to the years between the Battle of Crécy in 1346 and the Battle of Poitiers in 1356.[52] As noted above, the first brass which depicts the new *jupon* is the Cobham brass of 1354. Given that the most advanced outer garments of the *jupon* type in the Egerton Genesis still seem to include features of the earlier *cyclas* and that Abraham's steel-plate collar appears in a brass of 1347, a date of about 1350 seems most likely, but a date as late as 1360 might be possible.

SYSTEMS OF DRAPERY FOLDS

Relatively little in English mid-century manuscript illumination is directly comparable to the rich, sophisticated drapery of the Egerton Genesis. Many manuscripts of the 1340s and 1350s (the Egerton Genesis artist's earlier work excepted) are in a simpler style, Sandler's mid-century vernacular,[53] and employ fold systems which are much simpler than those of the Egerton Genesis. Even the artist's own earlier work does not approach the Egerton Genesis in its wealth of fold types and dense, complex patterns. However, many of the Egerton Genesis artist's folds can be seen as developments of simpler motifs already present in earlier English illumination, especially that of East Anglia, with only a few motifs adapted from Italian manuscripts.

In certain respects his drapery is comparable to that of other artists of his era, featuring long robes with vertical pleats over which are worn mantles, the folds of which fall in diagonals, and short tunics, frequently bloused at the waist. Extremely fine penwork shading combined with very fine linear detail defines folds. A mannerism found in all English works by the artist of the Egerton Genesis is the use of a teardrop-shaped fold at the elbow. Curiously, in the last few images in the Egerton Genesis, this teardrop sometimes becomes a tri-lobed pattern, as in the left sleeve of Joseph's coiffeur, fol. 20r, upper right, or at the right elbow of Pharaoh and the left elbow of Joseph, fol. 20r, lower left. The introduction of this motif is a concrete manifestation of stylistic development in process.

Long robes usually hang in a few broad, parallel vertical folds which are treated by modelling to emphasise their projection from the surface of the body. The shaded, narrow creases between folds are treated as secondary, so that a sense of bulk is generated. Hems which clear the ground are almost always plain and straight, only rarely having the decorative butterfly or bowtie treatment common in English manuscripts of earlier decades and still found in the James Memorial Psalter. Robes treated in a similar fashion are to be found in many earlier English manuscripts, but those in the Egerton Genesis and in other English works generally ascribed to the Egerton Genesis artist bear comparison especially with those in earlier East Anglian manuscripts such as the Ormesby and Bromholm Psalters. All feature a few broad folds, powerful but subtle modelling, and linear strip highlights, discussed earlier, at the edges of folds and at the waist.

However, the realistic note imparted by the plastic and sober treatment of garments in the Egerton Genesis gives way to rich invention when hemlines of robes or mantles touch the ground and break into pleats and folds of an almost baroque abundance and variety: deep loops, S-curves, curving teardrop indentations (hems of Melcha, fol. 6v, upper left, and of Sarah and Terah, fol. 6v, upper right), stacked curving knife-pleats (Sarah, fol. 7r, lower left, fig. 25), plastic pyramidal folds that project like ledges toward the viewer (Sarah, fol. 8r, lower right) and tilted T-shaped linear patterns (Sarah, fol. 9r, lower right). These latter are sometimes treated three-dimensionally, as in the hems of Zillah, fol. 2v, upper right, and Hagar, fol. 9v, upper right, so that the pattern appears as a bifurcation in a large fold, creating a triangular pocket of space which is all the more noticeable because of the generally restricted

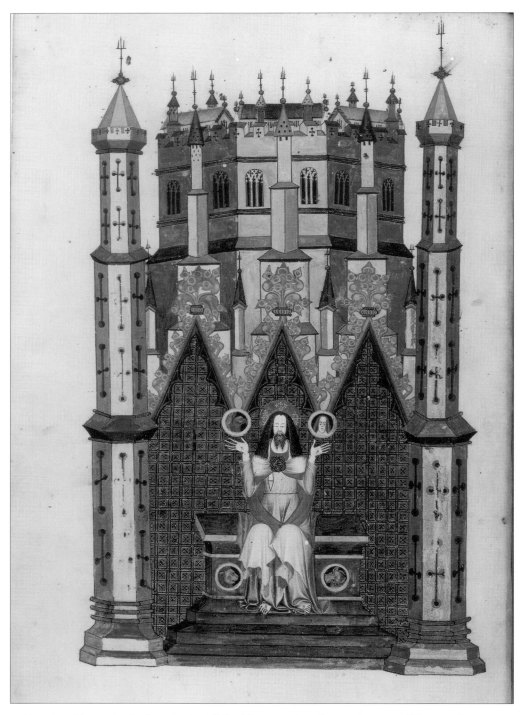

FIG. 62: Fitzwarin Psalter. Paris, Bibliothèque Nationale, MS lat. 765, fol. 21ᵛ: Christ in Majesty (Photo: Bibliothèque Nationale, Paris)

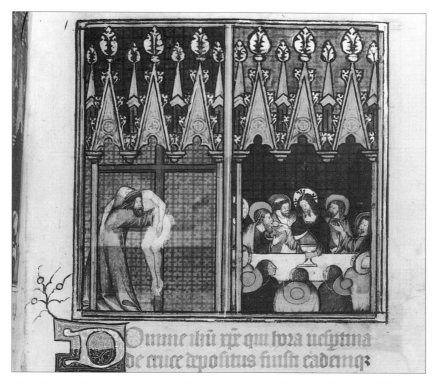

FIG. 63: M. R. James Memorial Psalter. London, British Library, Additional
MS 44949, fol. 6ʳ, double miniature: Descent from the Cross, Last Supper
(Photo: British Library, London)

use of crevices and cavities. Additional three-dimensional effects are created with folds that
bulge out toward the viewer, then double back into the picture plane, sometimes turning out
yet again, in effect a C-curve or S-curve rotated 90° from its customary angle of view. The fold
behind Sarah's right foot on fol. 9ᵛ, upper left, and the central fold of Sarah's dress on fol. 6ᵛ,
upper left, are examples. Similar in their three-dimensional effect are the triangular folds that
arc out toward the viewer as they pass over the lower leg of a kneeling figure, like that of
Abraham on fol. 8ʳ, upper right. A vertical series of short horizontal lines above the hem of a
floor-length garment suggests stiff fabric resistant to fluid curves, as in the mantle of Rebecca
on fol. 14ᵛ, upper right.

Illuminations in the Fitzwarin, James Memorial, and Derby Psalters have been assigned,
correctly in our view, to the Egerton Genesis artist, as noted in Chapter 1 and as further
explained in Chapter 6. Hems in these illuminations include loops and teardrops, as in Christ
in Majesty, fol. 21ᵛ of the Fitzwarin Psalter (fig. 62), the standing figure in the Descent from
the Cross, fol. 6ʳ of the James Memorial Psalter (fig. 63), and above the right foot of the
enthroned Christ in the initial on fol. 20ʳ of the Derby Psalter. The hem of the Fitzwarin
figure also includes a projecting, three-dimensional pyramidal fold. Tilted T-shaped folds and

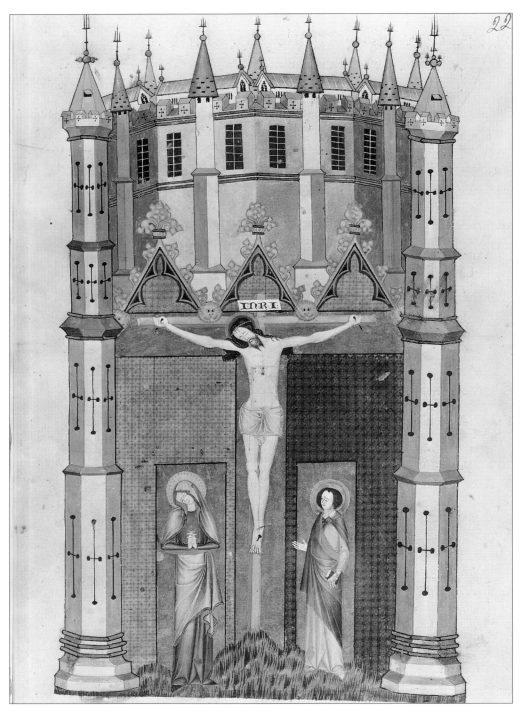

FIG. 64: Fitzwarin Psalter. Paris, Bibliothèque Nationale, MS lat. 765, fol. 22ʳ: Crucifixion
(Photo: Bibliothèque Nationale, Paris)

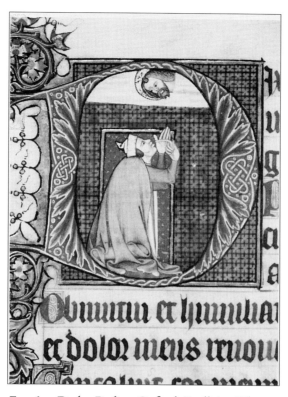

FIG. 65: Derby Psalter. Oxford, Bodleian Library,
MS Rawlinson G. 185, fol. 32ᵛ: Initial D for Psalm
38, with praying man (Photo: Bodleian Library,
Oxford)

folds that bifurcate to produce a pocket of space are found in the hems of both standing
figures in the Fitzwarin Crucifixion, fol. 22ʳ (fig. 64), in the hem of the Virgin in the
Crucifixion on fol. 7ʳ of the James Memorial Psalter, and in the cloak of the praying man in
the initial on fol. 32ᵛ of the Derby Psalter (fig. 65). Triangular folds that bulge out as they tra-
verse the lower leg of a kneeling figure are found on the figure of Christ in Gethsemane, fol.
6ᵛ, of the James Memorial Psalter (fig. 60), and in the cloak of the praying man on fol. 32ᵛ of
the Derby Psalter (fig. 65). Horizontal lines marking a crease in stiff fabric occur in the folds
of the standing figure in the Descent from the Cross, fol. 6ʳ of the James Memorial Psalter (fig.
63). Thus most of the motifs appear in the Egerton Genesis artist's earlier work. The stiffest
versions are in the Fitzwarin Psalter and the most fluid in the Derby Psalter. Antecedents for
many of these fold types can be found in a number of English manuscripts of the 1320s to
1350s, especially in those with East Anglian associations. The garments of David in the *Beatus*
initial, fol. 7ʳ, of Oxford, All Souls College, MS 7,⁵⁴ a psalter of the 1320s of possible East
Anglian destination, have both loops at the hem and a series of projecting, knife-like pleats
below the hip. A bifurcated fold marks the garment of Christ's tormentor at the right side of

the Arrest, fol. 35ᵛ in the Zouche Hours, a manuscript whose Sarum calendar has some Ely variants.[55] Small triangular pockets of space, in conjunction with pronounced modelling, mark the hem of David in the *Beatus* initial, fol. 7ʳ, of a psalter in New Haven, Yale University Beineke Library, MS 417, dated to the 1320s and having an East Anglian destination.[56] However in these manuscripts, the treatment of folds is less refined and less fully articulated than in the works of the Egerton Genesis artist.

A recurrent mannerism in the treatment of mantles is an elongated, curved fold, triangular in shape and positioned at knee-level or slightly above. The upper edge of this fold curves upward, while the lower edge curves downward, as in the garments of Jacob and his two wives on fol. 16ᵛ, lower right. This same mannerism appears in all the Egerton Genesis artist's earlier English works, as in the mantle of the Virgin in the Crucifixion, fol. 22ʳ of the Fitzwarin Psalter (fig. 64) and in the mantle of Christ in the *Noli me tangere*, fol. 4ʳ of the James Memorial Psalter. This fold and the others tend to cling to the body rather than break the silhouette with angular projections and thereby help create the effect, reinforced by modelling, of a voluminous, substantial body beneath drapery.

Fabric may cascade over an arm in stairstep pleats, as on fol. 16ʳ, lower right, or in more three-dimensional patterns involving 360° spirals, as in the drapery of Noah and that of Cain on fol. 2ʳ, lower left. Patterns are enriched by multiple reversals between the fabric and its lining, as in the mantle of Jabel on fol. 2ᵛ, upper left, and that of Lot on fol. 11ʳ (10ʳJ) lower centre. The richness of effect and the three-dimensionality created by complete spirals have few parallels in English manuscripts of the mid-fourteenth century. In many earlier English manuscripts, including the Fitzwarin Psalter, the Gorleston Psalter, and manuscripts of the Queen Mary Psalter group, as well as in some Flemish illumination, such as Gl kgl. Saml. 3384,8°, the idea of a complete spiral is present, but in simpler form, as in the mantle between the legs of the seated Christ on fol. 21ᵛ of the Fitzwarin Psalter (fig. 62). More fully comparable is drapery by the Majesty Master in the Psalter of Robert De Lisle, such as the complex fold hanging from the arm of Christ on fol. 130ʳ. This fabric incorporates multiple reversals, full spirals and ornamental S-curves.[57] Images in the De Lisle Psalter are far larger than those of the Egerton Genesis. The comparison offers to the viewer an impression of monumentality which the Egerton Genesis artist is able to achieve on a small scale.

It seems that the artist was influenced, either directly or indirectly, by Sienese panel painting in which an unbroken silhouette and clinging folds are also featured. In the Egerton Genesis artist's Crucifixion in the Fitzwarin Psalter (fig. 64), which predates the Genesis, the drapery of John and the Virgin is even more Sienese in its soft, clinging form with understated folds that respect the body's unity of silhouette. Closer than either Simone Martini or the Lorenzettis in style to the Egerton and Fitzwarin drapery is perhaps the style of an artist such as Lippo di Benivieni, a Florentine whose work combines Sienese elegance and fluidity with Florentine monumentality.[58] In the Gorleston Psalter, flat-topped ridges had already signalled a trend toward less projecting drapery, perhaps one of many manifestations of the Italian and Franco-Italian influence which was percolating into English illumination during the first half of the fourteenth century. The Egerton Genesis can be seen as representing yet another step

in the assimilation of this influence, which is further integrated after the middle of the century in the style of the Bohun manuscripts. Hull raised the possibility that a Sienese panel painting may have been on display in a church in Norwich.[59] However, the question of Tuscan panel painting in Norwich and its influence on illumination in the 1330s and 1340s certainly needs further investigaton.[60]

The fold patterns on the garments of a few kneeling figures, like the positions of the figures themselves, show the influence of Bolognese illumination. The slender curved folds, descending alternately from left and right and patterning the lower garment of the crouching shepherd on fol. 7[v], lower left, are comparable with those on the garments of similar crouching figures on fol. 199[r] of a book of Decretals, Munich, Bayerische Staatsbibliothek, MS lat. 23552,[61] and fol. 151[r] of Vatican City, Biblioteca Apostolica Vaticana, Vat. lat. 1409, both probably from the second quarter of the fourteenth century.[62]

Drapery and costume in the Egerton Genesis relate primarily to English traditions, but also to Italian ones. There are many shared elements with East Anglian manuscripts of the 1320s through the 1350s. There are also some, though fewer, traits in common with London-area manuscripts and with mid-century English manuscripts in the vernacular style. Tuscan panel painting and Bolognese illumination of the second quarter of the fourteenth century were also important sources for the Egerton Genesis artist. Perhaps drapery in the Egerton Genesis is best understood as a sort of elaboration of the traditional East Anglian fold systems, modified by Italian motifs to accommodate a substantially more Italianate concept of the body than that which appears in earlier East Anglian work. Not only the fold systems but also the attitude of openness to Italian influence seems to link the Egerton Genesis to East Anglian traditions, for in earlier fourteenth-century England, works of East Anglian origin manifest the most elements of Italian origin. The artist may well have had some acquaintance with high-quality manuscripts of the London area, but the connections to London traditions are fewer than to those of East Anglia.

Drapery in the Egerton Genesis, unlike architecture and iconography, has relatively little to connect it specifically with Flemish manuscripts. The strong interest in modelling and the interest in three-dimensional spirals are shared by Gl kgl. Saml. 3384,8°, but the fold systems in the two manuscripts and their respective concepts of the relationship of the drapery to the body are different. Gl kgl. Saml. 3384,8° still belongs conceptually to the era of Master Honoré, and the Egerton Genesis belongs to the epoch of post-Pucellian Italianism. Yet there are clear differences in drapery with post-Pucellian Flemish works, as a comparison with Bodley 264 reveals. Its plethora of fashionable, up-to-date costumes coupled with very simple fold patterns is the opposite of the Egerton Genesis, characterised by a preponderance of old-fashioned dress and highly complex fold systems. Bodley 264's combination, however, was to characterise works of the era following the Egerton Genesis in England, that is, manuscripts of the Bohun group, whatever their stylistic sources.

COLOUR

The Egerton Genesis has been considered a work largely in grisaille. This assessment is not entirely inaccurate but has been overstated because much of the manuscript's paint has been rubbed. Opaque peachy pinks and beigey oranges, originally represented in abundance on garments and skin, remain only as traces. Lighter washes of blue, red, green, and ochre, used to line garments and to colour elements in the landscape and architecture, have fared better. Much of the green used in colouring landscape elements has bled through the sheets. Sienna or ochre also survives fairly well where used on furniture and on wooden structures like the ark on fols 2ᵛ through 4ʳ. Both silver and gold, the former opaque and the latter a wash, seem to have survived rubbing somewhat better than the shades of orange. Silver often covers the face and hands of the Deity, and gold wash appears on his mantle and also as a very thin thread lining the edges of robes and mantles of important persons. God is the only figure whose garments are completely coloured. Under the gold mantle he wears a robe of intense cerulean blue. Touches of a luminous white survive as well, on some faces and hands, as at the bottom of fol. 2ʳ, as a thread lining the edges of some garments, and occasionally on kerchiefs, like that of the woman next to Nimrod on fol. 4ᵛ, lower right. Often translucent colour was applied over penwork shading, which seems to have survived relatively undamaged.

Only in the first gathering was the application of colour completed. On fols 10 (11J) through 13 (12J) of the second gathering, the trees and ground are coloured, while the figures and architecture, for which colour was presumably intended, are entirely in penwork. The final gathering, least finished, consists of outline drawings with very little shading and no colour at all.

Some indication of the original appearance of many figures in the first two gatherings of the Egerton Genesis may be given by the two angels in the scene of Jacob's Ladder, on fol. 15ʳ, lower right. Bright orange paint still colours their faces and hands, not uniformly but with gradations in intensity that function as modelling. Their garments are completely coloured a translucent greyed pink, a wash applied over penwork shading, and the wings, of a slightly more orange shade, are striped with green. Hair, a close-fitting cap of unmodelled gold wash, would not have been typical of other figures. In the adjacent scene of Esau with his parents and three wives, the colour of the figures is rubbed to a degree typical of much of the manuscript. A beigey peach colour remains in some quantity on the three kerchiefs and in spots on hands, faces, legs, and garments. The red wash lining of Rebecca's cloak and the rosy pink lining of the cloak of the wife at the far right are the brightest surviving touches of colour. The green of the grass has flaked away in spots at the bottom.

If the garments and skin were largely coloured, as the surviving touches would indicate, then originally the image would have been much more peach than in its present state. In fact, shades of orange and peach would have keyed the colour for much of the first gathering and for many images in the fully coloured folios of the second gathering (fols 8ʳ–9ᵛ and 14ʳ–15ᵛ), for touches of peach or orange can be found on the skin or garments of figures on almost all the fully coloured folios. The opaque colour probably did not extensively overlay

the penwork shading. It survives mostly on unshaded garments such as kerchiefs, and on unshaded areas of other garments. On fol. 5r, lower left, for example, orange was applied in long strips on the vertical folds of many garments. These strips are applied to unshaded areas and function apparently as highlights. The receding, shaded areas between folds have no traces of an overlay of colour. Some garments, like most of those on fols 6v and 7r, are without any traces of opaque orange or peach, though translucent orange or sienna is used on the linings. These garments may have been originally as they now appear—grisaille with coloured linings.

The many coloured linings are one of the chief beauties of the Egerton Genesis. Translucent blues, rosy pinks, greens, and ochres are the colours most frequently used. An intense vermillion red appears less often. These accents of colour with their highly variable shapes and sizes greatly enliven the manuscript's visual patterns and are all the more noticeable against the large areas of blank parchment which constitute much of the background throughout the manuscript. The colour may be modelled with highlights in white paint, as in the lining of Sarah's mantle, fol. 6v, lower right, or with variations in the saturation of hue, as in the mantles on fol. 5r upper right. It may be applied flatly, with no modelling, as in the lining of Jacob's mantle on fol. 15v, upper left.

Variety characterises the application of colour in the Egerton Genesis as it does so many other aspects of the manuscript. Skin may be left as uncoloured parchment, as in most figures on fol. 9r, upper right. It may be modelled with orange, as in the angels in the scene of Jacob's ladder, fol. 15r, lower right. It may be coloured with an ochre wash, apparently in an attempt to represent persons of African or Asian descent, as in many of the descendants of Ham on fol. 5r, upper right. It may be silvered, as on the face and hands of God, or, oddly, on the face and hands of the workmen at the top of the Tower of Babel, fol. 5v. Hair, which can be either traditionally English or Italianate in its appearance, may be in black penwork with no overlay of colour wash or may be overlaid with blue or orange, as on fol. 5r, upper right. It may be in blue penwork, as in the figure of Abraham, fol. 7r, upper left, or it may be a cap of unarticulated gold wash, as on fol. 15r, lower right.

A semi-grisaille tonality characterises the decoration of a number of English manuscripts dated between about 1330 and 1360, including two psalters, Oxford, Bodleian Library, MS Douce 131[63] and Brescia, Biblioteca Queriniana, MS A.V. 17,[64] and the earliest illustrations in the Carew-Poyntz Hours (Cambridge, Fitzwilliam Museum, MS 48).[65] The form and application of this technique vary from manuscript to manuscript, but in a general way the Egerton Genesis can be seen as participating in a trend toward the use of grisaille in English manuscripts of the middle decades of the century.

The preference for grey coupled with shades of pink and orange, to which are added lavender and dull green, along with blue, red, and gold in the backgrounds, is evident in the Fitzwarin Psalter's two illuminations generally assigned to the Egerton Genesis artist. The strong colour gives a harsh, expressionistic feel to the illumination. The James Memorial Psalter and the Derby Psalter are more nearly balanced. An almost total absence of grey marks the James Memorial Psalter, in which the palette is slightly weighted toward warm colours—red, red-orange, and

gold; but these colours are nearly balanced by rich, deep green and blue. Sustained intensity of colour in a sequence of many large miniatures helps create an emotional charge, but the effect is of integrated, rather than distorted or expressionistic, emotion. This psalter's long prefatory cycle is old-fashioned in England in the 1340s, as are its architectural frames, and the intense, jewel-like colour also is reminiscent of an earlier era. Conjoined with these elements, in a manner typical of the Egerton Genesis artist, is the thoroughly modern Italianate realism of the figure design. The overall effect is of a poignant human drama in which grief, love, betrayal, surprise, are all deeply felt in turn. Colour in the Derby Psalter is altogether softer and less emotionally engaging, harmonising orange, pink, gold, grey, green, blue, and maroon. This shift accords with the iconography, which is more whimsical and humorous, less pathetic, than is that of the James Memorial Psalter. It is interesting that the largest figure in the manuscript, the monumental Jesse at the bottom of fol. 1r, is entirely in pink, orange, and grey.

INKBLOT TRANSFERS

As described in Chapter 2, the Egerton Genesis has several instances of inkblot transfers. It appears that the artist sometimes worked quickly during the finishing stages of a folio. He overlaid a page whose final overdrawing in black ink was still wet with another parchment sheet, so that an impression was transferred from one page to another. Yet this final phase of hasty execution is accompanied by the consistent employment in the English works of the very time-consuming technique of penwork shading.

It may be noted that, although inkblot transfers are found in the work of a number of other artists as well, many artists produced illumination without transfers. This phenomenon, in which working methods and quality of materials both play a part, could be the subject of further profitable study.

SUMMARY AND CONCLUSION

The most striking feature of the Egerton Genesis's style is a consistently high quality of draughtsmanship. This drawing successfully integrates Flemish firmness of line with English sensitivity and refinement. Also distinctive is the concept, articulated by penwork shading, of the substantial, solid human body. This concept weds the Italian idea of the body as a cylindrical, three-dimensional solid to the Flemish presentation of full-bodied and firmly defined human figures. The penwork shading technique is adopted from East Anglian manuscripts produced in Norwich. Thus, two conceptual traditions merge and a third tradition is tapped for the technical means to express the hybrid concept.

Drawing and solidity of form reflect the fundamental concern of the artist to create expressive and realistic human figures. To this end he employs a broad range of methods from different sources, a potpourri of concepts, of motifs, and of systems for organising motifs to

express concepts. For example, drapery organised in systems of predominantly English origin (more expressive than those of Italy) clothes bodies of Italo-Flemish design (more realistic than those of England). The result is indeed powerfully expressive, but not entirely harmonious. Space constructed as northern layered planes is interrupted by Italianate pockets of three-dimensional space which allow the artist to create realistic conversational groups. Motifs or conventions for rendering eyes, hands, hair, drapery, and bodily poses are variously drawn from Flemish, Liègois, English, and Italian sources, and perhaps indirectly from French sources. This multiplicity of sources supplies the artist with the means to characterise all social classes of humanity, from the elegant noble to the rustic peasant, and all types of emotion, from grave reserve to unbridled buffoonery. Disparities in the resulting richness of effect are, if not harmonised, at least contained by the consistencies of line, three-dimensional form, and expressive purpose. Yet, while some disparate elements coexist, others are merged with extraordinary nuance and finesse. A geometry of subtle curvature fully merges organic and geometric elements in the use of line. Line and form merge in the penwork modelling of figures.

Variety also marks the treatment of landscape elements such as grass, trees, and architecture. Here variety is not wholly the servant of expression but seems to exist for its own sake. New elements and fresh combinations of established elements are always cropping up in the Egerton Genesis, as though to obviate the artist's boredom with the repetitive aspects of his work.

The artist who produced, within this unity, such varied and sophisticated effects of line and form was a man of remarkable technical and conceptual abilities. A mature and experienced illuminator, he was curious, observant, and eager to learn, as is apparent from his close attention to numerous and varied visual sources. He had a distinctive sense of humour—bold and coarse, caricaturing all sorts and conditions of humankind with an evenhanded disrespect, yet showing reverence for the Deity. He was a keen observer of human behaviour, noting both the virtuous and the base, and marking especially the contradictory and the inconsistent.

Looking beyond the unities of line and three-dimensional form, the viewer realises that disparities and discontinuities are in fact everywhere in the Egerton Genesis. In addition to the many disjunctions generated by the juxtaposition of heterogeneous motifs and concepts, there are also disjunctions between origins and uses of motifs. Notable among these is the circumflex eye, abstracted from Flemish sources, where it expresses strong emotion or violent action, and used in the Egerton Genesis to convey a sense of the comical. The ability to recontextualise a motif suggests a creative mind; to do so in such a radical fashion, converting violence to humour, suggests an attempt to cope with pain through laughter.

There are also disjunctions in techniques of execution. Among these is the use of meticulous and time-consuming penwork shading along with the practice, indicative of haste, of overlaying a still-damp page with another sheet, creating inkblot transfers. This use of seemingly incompatible techniques is puzzling. Neither artistic sources nor artistic goals entirely suffices to explain why the artist apparently contravened his own efforts in these cases.

The possibility of a psychological dimension to the many discontinuities in the manuscript should be considered. The plague is one possible source of psychological trauma. For a time, the pestilence destabilised the behavior of individuals, pushing them toward extremes of libertinism

or asceticism.[66] It also disturbed the normal functions of society—lands had no tenants, and parishes no clergy. Such conditions might have encouraged the artist to produce the extremes and disruptions of the Egerton Genesis. Working in a painfully ruptured world, the artist may have expressed, perhaps not entirely consciously, his own sense of derangement through the employment of mutually incompatible elements in the style and execution of the manuscript.

However, to view the plague as sole cause of this phenomenon of style may oversimplify matters. The disjunctions also suggest a conflict or division of some sort in the artist's personality, perhaps with roots in much earlier life. The plague and its unsettling aftermath may have re-energised an unresolved inner conflict of some significance, with resultant effects in the artist's work. As will be seen in the next chapter, the artist was a Flemish immigrant, and immigration may have been a third factor contributing to an inner sense of dislocation, outwardly expressed in the style of the manuscript.

The style of the Egerton Genesis, far from being an isolated and self-contained domain of study, has connections in many directions. Multiple factors, including the artist's training, his personal history and psychology, and the history and conditions of his times converge and find expression in style.

In some ways the Egerton Genesis is quite in step with major trends of book illumination at the time. Its refinement of line, its strong element of expression, its semi-grisaille technique are all representative of major aspects of English illumination of its period, though in the Egerton Genesis each of these features is developed in ways that are unique. Even its striking heterogeneities are not an exclusive feature. In fact, Sandler designates the taste for the heterogeneous as the most universally shared proclivity among fourteenth-century English illuminators. She cites striking disparities of scale and juxtapositions of the plastic and the two-dimensional as typical of English, especially East Anglian, work throughout the century, and such disparities and juxtapositions are certainly found in the Egerton Genesis.[67] However, in the Egerton Genesis, heterogeneous elements exceed in quantity and often differ in quality from those which are found generally in English fourteenth-century illumination. Heterogeneity is not only a principle of design, as is often the case in English illumination of the era, but permeates concepts and conceptual systems.

Connections of style are numerous between the Egerton Genesis and East Anglian manuscripts from the 1320s through around 1340—including the Ormesby, the Gorleston, the Douai, and, especially, the St Omer Psalters. Connections to the Fitzwarin, James Memorial, and Derby Psalters, all of which contain illumination by the Egerton Genesis artist in years prior to his work on Egerton 1894, are many and close. North Italian and Tuscan sources are also important for the style of the Egerton Genesis, as noted above. Bolognese manuscripts, especially those with work by the *Illustratore*, furnished many expressive elements for the design of figures, including models for back views and foreshortenings. A North Italian Bible, like the Paduan Bible in Rovigo, and Tuscan panel painting (this latter possibly mediated through other sources) very likely influenced the artist also.

The years immediately following the plague, those between about 1350 and 1353, seem most likely to be those in which the Egerton Genesis was produced, for several reasons. First, the

styles of armour and clothing point to these years, as demonstrated above. Second, if the fold systems of the Egerton Genesis are, to a considerable degree, baroque derivatives of those in East Anglian manuscripts, then the Egerton Genesis succeeds the latter, but probably not by a lengthy interval. The Douai and St Omer Psalters and the added Crucifixion in the Gorleston Psalter, among the latest of the East Anglian works and those most relevant as sources for the Egerton Genesis, have been dated 1335–40 by Hull.[68] The dates may be a few years later, given their stylistic connections to the Ghent manuscripts associated with Louis de Male, a group dated 1345–1350 by Dennison.[69] Dennison proposed that the St Omer Psalter may date in the late 1340s.[70] If so, a date of 1350–1353 seems reasonable for the Egerton Genesis. Third, the *Illustratore*, the Bolognese illuminator whose figure style offers the most comparanda to the figure style of the Egerton Genesis, was active from the 1330s into the 1350s. Presumably the Egerton Genesis artist would have been attracted to the most up-to-date Italian models, among which, in the early 1350s, the *Illustratore*'s works would be counted. In the 1360s or 1370s these works would be outdated; in the 1330s and 1340s the *Illustratore*'s illumination might have been accessible to English artists, but no one has ever suggested such an early date for the Egerton Genesis. Fourth, the years 1350–1353 are within that brief window of time, approximately 1348–1355, during which, as a result of the plague, men and women exhibited the most extreme behaviours and society suffered the most critical disruptions. By the mid-1350s recovery was underway,[71] though, of course, some effects of the plague lasted for decades, even centuries, and periodic recurrence of the pestilence introduced further complications.

The many connections to manuscripts such as the Ormesby, Gorleston, Douai and St Omer Psalters, produced in Norwich, as opposed to the relatively few to those, like the Queen Mary and de Lisle Psalters, made in London, make it likely that Norwich was the site of production of the manuscript. Stylistic elements noted above as common to the Norwich manuscripts and to the Egerton Genesis include those used in the rendering of hair, drapery, architecture, and landscape.

Insofar as materials are an aspect of the style of the manuscript, the absence of gold leaf and the rather sparing use of gold wash, reserved for the cloak of the Deity and applied as a thin line to the necklines, edges of sleeves, and hems of the garments of the most important persons, indicate that the patron may have had limited means. The unbridled buffoonery of expression is very different from the courtly reserve of a manuscript made for the royal family, such as the Queen Mary Psalter, and again suggests a middle class patron, lay rather than clerical. This colourful, dramatic expression suggests that the manuscript was for entertainment rather than for pious instruction or devotional meditation. The many connections with Flemish manuscripts, especially those from the region of Ghent and St-Omer-Thérouanne of the 1320s and 1330s, raise the possibility of a Flemish origin for the artist.

Evidence derived from the study of style tends to support the same conclusions as evidence derived from the study of iconography. Though style and iconography are artificially separated for purposes of study, they are aspects of the same whole in the process of production. Whatever visual sources the Egerton Genesis artist observed and learned from, whatever experiences he had of life, affected, in various ways, all aspects of his art.

Notes

1 Dennison writes in the introduction to her dissertation, a study of style in manuscripts of the Bohun workshop: 'Concentrated iconographic discussion, though intrinsically valuable, would not have yielded the answers I was seeking, namely where, at what dates and for whom were the various Bohun manuscripts produced, how many illuminators participated, what were their specific origins and how might their development be defined?' ('Stylistic Sources', p. 36).

2 'Giottesque Episode', pp. 67–68.

3 Sandler, *Psalter of Robert de Lisle*, p. 17.

4 Sandler, *Gothic Manuscripts*, I, 19.

5 'Giottesque Episode', p. 69.

6 Hull, 'Douai Psalter', I, 186–189.

7 'Stylistic Sources', pp. 116–129 (p. 129). See the section on the Fitzwarin Psalter in Chapter 6 for further discussion of the style of Brussels, Bibliothèque Royale Albert 1er, MS 9427.

8 For reproduced examples, see Sandler, *Gothic Manuscripts*, I, ill. 99 (Bromholm Psalter, fol. 65ʳ); Sydney Carlyle Cockerell and Montague Rhodes James, *Two East Anglian Psalters at the Bodleian Library, Oxford* (Oxford: Oxford University Press, for the Roxburghe Club, 1926), pl. VIII (Ormesby Psalter, fol. 71ᵛ); Richard Marks and Nigel Morgan, *The Golden Age of English Manuscript Painting 1200–1500* (New York: Braziller, 1981), pl. 19 (Gorleston Psalter, fol. 8ʳ).

9 'Douai Psalter', I, 221; see also Sandler, *Gothic Manuscripts*, I, 28, for manuscripts linked to Norwich.

10 Pächt, 'Giottesque Episode', pp. 63–64; Simpson, p. 115.

11 Pächt, 'Giottesque Episode', p. 63.

12 Cassee, pp. 27–28.

13 Sandler, *Gothic Manuscripts*, II, 143.

14 Reproduced in Janet Backhouse, *The Luttrell Psalter* (London: British Library, 1989), fig. 68, p. 58; fig. 29, p. 30.

15 Sandler, *Gothic Manuscripts*, I, ill. 20; II, 18.

16 Sandler, *Gothic Manuscripts*, I, ills 232, 233; II, 98.

17 Judith H. Oliver, *Gothic Manuscript Illumination in the Diocese of Liège (c. 1250–1330)*, Corpus of Illuminated Manuscripts from the Low Countries, 2 (Leuven: Peeters, 1988), pl. 69; Randall, *Medieval and Renaissance Manuscripts*, I: *France, 875–1240* (1989), fig. 78.

18 Conti, p. 67.

19 Conti, p. 90.

20 Reproduced in Sandler, *Peterborough Psalter*, fig. 52.

21 Randall, *Images*, p. 38.

22 Oliver, fig. 33 and p. 269.

23 Randall, *Images*, fig. 716 and p. 37.

24 Reproduced in Conti, figs 183 and 233. See p. 84 for date of MS E. I. 1.

25 Conti, pl. XXIII, pp. 70–72.

26 Conti, p. 82.

27 See Joslin, 'The Illustrator as Reader', pp. 102, 105, and fig. 10.

28 Reproduced in Randall, *Images*, fig. 140.

29 Conti, pl. XXX and p. 95. See also F. Saxl and R. Wittkower, *British Art and the Mediterranean* (London: Cumberlege, Oxford University Press, 1948; repr. 1969), no. 33, fig. a.

30 Conti, fig. 264 and p. 89.

31 Cassee, pp. 14–16, 20–32.

32 Randall, *France, 875–1240*, p. 138.

33 Jeffrey F. Hamburger, *The Rothschild Canticles: Art and Mysticism in Flanders and the Rhineland circa 1300* (New Haven: Yale University Press, 1990), pp. 12–14, and figs 65, 86, 89.

34 See Kathryn A. Smith, 'Canonizing the Apocryphal: London, British Library MS Egerton 2781 and its Visual, Devotional and Social Contexts', (unpublished doctoral dissertation, Institute of Fine Arts, New York University, 1996), pp. 42–80 (p. 42); Sandler, *Gothic Manuscripts*, II, 127–129.

35 English antecedents for the following: Corbelled polygonal bay windows: the projecting semicircular elements on upper walls in a psalter, Oxford, Bodleian Library, MS Douce 131, fols 119ʳ and 126ʳ. Roof ventilators: Smithfield Decretals, London, British Library, Royal MS 10 E IV, fol. 95ʳ; Holkham Bible Picture Book, fol. 12ᵛ; entrances crowned with cantilevered short towers: Holkham Bible Picture Book, fol. 15ᵛ, upper centre; Gough Psalter, Oxford, Bodleian Library, Gough MS Liturg. 8, fol. 11ᵛ; upper stories wider than lower: Brescia, Biblioteca Queriniana, MS A.V. 17, fol. 7ʳ; walled rooftop areas within which are structures and human activity: Fitzwarin Psalter, fols 20ʳ, 15ʳ. (Here the activity is by demons.)

36 Reproduced in Avril, *Manuscript Painting*, p. 84 and pl. 23.

37 For this information we thank Mr Brian Ayres, Principal Field Archeologist of the Norfolk Archeological Unit. Another round, unadorned tower, much earlier in date, is the Saxo-Norman tower of St Mary Coslany, Norwich. A photograph of the latter is reproduced in Susanna Wade Martins, *A History of Norfolk* (Chichester, Sussex: Phillimore, 1984), pl. 15, after p. 48.

38 Reproduced in Sandler, *Psalter of Robert de Lisle*, fig. 8.

39 Tancred Borenius and E. W. Tristram, *English Medieval Painting* (New York: Hacker Art Books, 1976; first published, Florence, 1927), p. 22.

40 Dennison, 'Stylistic Sources', p. 124. See Boeren, *Catalogus*, pp. 17–18, for a description of and bibliography on Museum van het boek/Rijksmuseum Meermanno-Westreenianum MS 10 A 14.

41 'Giottesque Episode', p. 64.

42 For description of and bibliography on the James Memorial Psalter, see Sandler, *Gothic Manuscripts*, II, 141.

43 Stones, 'Notes', pp. 199–200; 'Another Short Note', p. 189.

44 Royal 14 E iii is included among mss discussed by Stones, in 'Another Short Note', pp. 187–188.

45 Pächt, 'Giottesque Episode', p. 63, mentions the trees rendered according to the 'Trecento formula'.

46 H. M. Zijlstra-Zweens, *Of His Array Telle I No Lenger Tale: Aspects of Costume, Arms and Armour in Western Europe, 1200–1400* (Amsterdam: Rodopi, 1988), pp. 27–28.

47 Reproduced in Marks and Morgan, pl. 21.

48 Reproduced in Backhouse, fig. 1, p. 6.

49 For definition of terms and for discussions of the changing styles of armour in the middle decades of the fourteenth century as evidenced in brasses, see Herbert Druitt, *A Manual of Costume as Illustrated by Monumental Brasses* (London: Moring, De la More, 1906), ch. III, especially pp. 147, 151–152, 154, 158–159; and Herbert W. Macklin, *The Brasses of England* (New York: Dutton, 1907), chs II and III, especially pp. 15–16, 22–23, 48, 50.

50 Reproduced in Macklin, p. 49; and in Druitt, ill. I facing p. 154.

51 Macklin, p. 52.

52 p. 50.

53 Sandler, *Gothic Manuscripts*, I, 34.

54 Sandler, *Gothic Manuscripts*, I, fig. 209 and II, 89–90.

55 Sandler, *Gothic Manuscripts*, II, 133.

56 Sandler, *Gothic Manuscripts*, II, 121.

57 Reproduced in Sandler, *Psalter of Robert de Lisle*, pl. 23.

58 See illustration in Norman E. Land, 'Petrarch's Eye and a *Crucifixion* by Lippo di Benivieni', *Southeastern College Art Conference Review*, 12.5 (1995), 391–401 (fig. 1, p. 391).

59 'Douai Psalter', I, 186–189.

60 For another possible example of a Tuscan panel as a model for English painters, see Paul Binski and David Park, 'A Ducciesque Episode at Ely: the Mural Decorations of Prior Crauden's Chapel', in *England in the Fourteenth Century: Proceedings of the 1985 Harlaxton Symposium*, ed. by W. M. Ormrod (Woodbridge, Suffolk: Boydell, 1986), pp. 28–41.

61 Reproduced in Cassee, fig. 115.

62 Conti, pp. 91–92 and fig. 272.

63 Sandler, *Gothic Manuscripts*, II, 117–118.

64 Sandler, *Gothic Manuscripts*, II, 121–122.

65 Sandler, *Gothic Manuscripts*, II, 143–145.

66 For a discussion of the disruptive consequences of the plague, see Robert S. Gottfried, *The Black Death: Natural and Human Disaster in Medieval Europe* (New York: Free Press, 1983), especially ch. V. See also *The Black Death*, trans. and ed. by Rosemary Horrox (Manchester: Manchester University Press, 1994).

67 Sandler, *Gothic Manuscripts*, I, 16.

68 'Douai Psalter', I, pp. 191–192.

69 'Stylistic Sources', pp. 124–129.

70 'Stylistic Sources', p. 55 and n. 51.

71 Horrox, trans. and ed, p. 239; W. M. Ormrod, 'The English Government and the Black Death of 1348–49', in *England in the Fourteenth Century: Proceedings of the 1985 Harlaxton Symposium*, ed. by W. M. Ormrod (Woodbridge, Suffolk: Boydell, 1986), pp. 175–188 (pp. 187).

CHAPTER SIX

—⇒·◦·⇐—

Origins, Identity, Early Work, and Career of the Artist

INTRODUCTION

Much evidence indicates that the Egerton Genesis artist was Michiel van der Borch, a Fleming whose early place of work was probably in Ghent. Van der Borch's hand can be identified in at least five manuscripts from the Low Countries. The calendars of two of these indicate use in the region of Ghent, while another is for the diocese of Utrecht in the northern Netherlands. All were probably produced in the 1330s. The Hague, Museum van het boek/Rijksmuseum Meermanno-Westreenianum, MS 10 B 21, which is signed by van der Borch and dated 1332, consists of the text of the Middle Netherlandish *Rijmbijbel* by Jacob van Maerlant to which is added a shorter work, *Die Wrake van Jerusalem,* based on Josephus's *De Bello Judaico.*[1] The remaining four works are devotional: The Hague, Koninklijke Bibliotheek, MS 135 E 15,[2] Oxford, Bodleian Library, MSS Douce 5–6,[3] and Copenhagen, Kongelige Bibliotek, Gammel kongelig Samling, MS 3384,80[4] (all psalters), and Baltimore, Walters Art Gallery, MS W. 82 (psalter-hours).[5]

In this chapter, we will consider, first, the evidence which favours attribution of the above-named Flemish manuscripts to van der Borch and, second, the evidence which connects these Flemish works to the Egerton Genesis and the English manuscripts associated with it, namely the Fitzwarin, James Memorial, and Derby Psalters. The critical link is the second. Other scholars have already remarked on connections between the style of van der Borch and that of manuscripts of Ghent and the Franco-Flemish border region. A considerable body of literature in recent decades associates various ones of the Flemish manuscripts mentioned above either directly or indirectly with van der Borch. However, to our knowledge no scholar has yet assigned a Flemish origin to the Egerton Genesis artist nor identified him with Michiel van der Borch.

Evidence for our attribution is compiled from the study of style, iconography, techniques of execution, and penwork flourishing in the relevant manuscripts. A thorough search of archives in Norwich and Ghent might yield additional evidence, though our preliminary archival work has not brought to light any documents naming van der Borch.

It is not our intention here to present a full description of, nor a comprehensive study of any aspect of, the manuscripts in question. They are chiefly of interest in this study for what they reveal about the origins of the artist of the Egerton Genesis. We also do not undertake to establish van der Borch's complete oeuvre but rather to identify a basic core of work from

which we can derive a definition of his style. MS 135 E 15 and Walters 82 have received relatively little attention in scholarship; Douce 5–6 and Gl kgl. Saml. 3384,8°, somewhat more, and the *Rijmbijbel*, considerably more. It is to be hoped that all these manuscripts will be studied further in the future.

FLEMISH MANUSCRIPTS WITH ILLUMINATION BY MICHIEL VAN DER BORCH

1. Rijmbijbel, *The Hague, Museum van het boek/Rijksmuseum Meermanno-Westreenianum, MS 10 B 21 (figs 26, 30, 66, 67, 68)*

> '*Doe men scref int iaer ons heren Mᵒ.CCC.ᵒXXXᵒII. verlichte mi. Michiel van der borch. Bit uoer hem dat ghod sijns ontfarmen moete'*: 'When it was the year of Our Lord 1332 Michiel van der Borch illuminated me. Pray for him that God may have mercy on him'.[6]

This inscription in Middle Netherlandish, below the full-page miniature of the Siege of Jerusalem on fol. 152ᵛ of the *Rijmbijbel* (fig. 66) happily provides the date of 1332 as well as the artist's name. Measuring 345 × 235 mm and comprising 194 folios,[7] this manuscript is the largest of the five Netherlandish books associated with van der Borch. Fol. 1ᵛ has an additional full-page miniature, actually a composite of six small scenes (fig. 26), and there are sixty-two smaller miniatures (figs 30, 67), some with partial borders (fig. 68), placed mostly at the beginnings of divisions of the text. The text in this manuscript has no penwork flourishing. The manuscript may have been produced in the northern Netherlands, perhaps in the diocese of Utrecht, though this is by no means certain—it could also have been produced in the southern Netherlands for a patron in the north.[8] Since the text is in Middle Netherlandish, the language of the artist's inscription, it is clear that the artist could have read the text he was illustrating.

2. The Hague, Koninklijke Bibliotheek, MS 135 E 15, a psalter (figs 69, 70, 82, 85; pl. Ia)

This is a small and little-known biblical psalter, measuring 117 x 85 mm and comprising 246 folios.[9] The calendar is of the diocese of Utrecht.[10] The *Beatus* page and three additional leaves are missing from the first gathering.[11] The manuscipt has no full-page illuminations but has eight historiated psalm initials, with partial borders, attributable to van der Borch on the basis of style. Iconography is of the standard literal type. However, the artist seems to have transposed the very similar images for Psalms 26 and 38. In the initial for Psalm 26, fol. 38ʳ, the kneeling David points to his mouth to illustrate '*Dominus illuminatio mea*' (fig. 69); and in the initial for Psalm 38, fol. 59ᵛ, he points to his eyes to illustrate '*Dixi custodiam vias meas*', in a reversal of the usual iconography for these psalms. (The same transposition occurs in Baltimore, Walters Art Gallery, MS W. 68, a psalter from Hainault of about 1265–75.)[12]

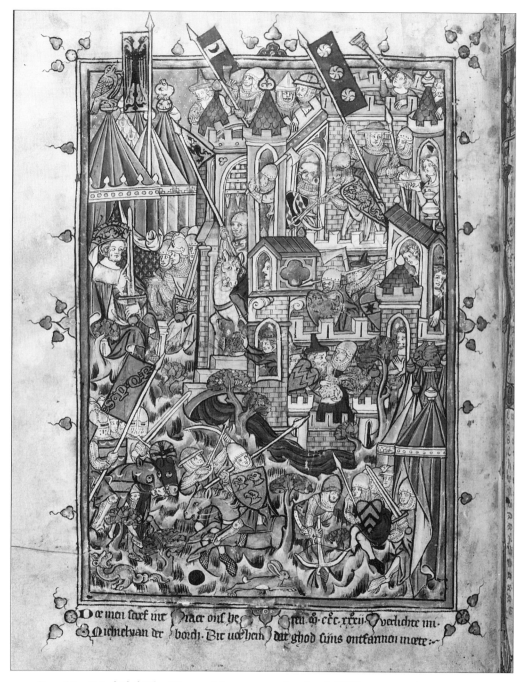

FIG. 66: *Rijmbijbel.* The Hague, Museum van het boek/Rijksmuseum Meermanno-
Westreenianum, MS 10 B 21, fol. 152ᵛ: Siege of Jerusalem (Photo: Museum van het
boek/Rijksmuseum Meermanno-Westreenianum, The Hague)

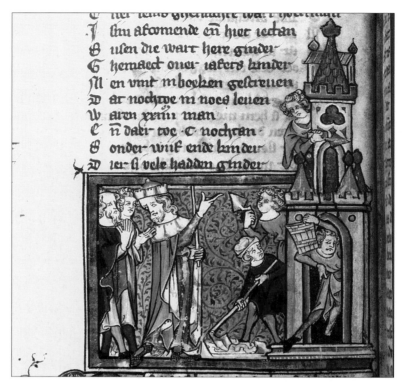

FIG. 67: *Rijmbijbel.* The Hague, Museum van het boek/Rijksmuseum
Meermanno- Westreenianum, MS 10 B 21, fol. 9ᵛ, miniature: Building
the Tower of Babel (Photo: Museum van het boek/Rijksmuseum
Meermanno-Westreenianum, The Hague)

The leaves of the first gathering (through fol. 16ᵛ) are flourished in a different style, more
rectilinear in design and with larger loops, than are the leaves of succeeding gatherings (fig.
70). If the change in flourisher was coupled with a change in illuminator, as is the case in
Douce 6, then perhaps the missing *Beatus* page, which belonged to the first gathering, was dec-
orated by an artist other than van der Borch. The last leaf of the manuscript bears the date
'Mcccxxxiii' in a poor script which, it has been suggested, may be that of an early owner.[13]
Of the four devotional manuscripts, this one is closest in style to the *Rijmbijbel* of 1332, so 1333
is possible as the date of this psalter's execution.

3. Baltimore, Walters Art Gallery, MS W. 82, a psalter-hours (figs 21, 45, 71, 72, 73; pl. Ib)

The largest (173 × 124 mm) of the four devotional works, Walters 82 comprises 213 folios and
has the calendar of St-Bavo, Ghent.[14] It has no full-page illuminations but contains
thirty-three historiated initials whose depictions include Davidian subjects (fig. 71), the

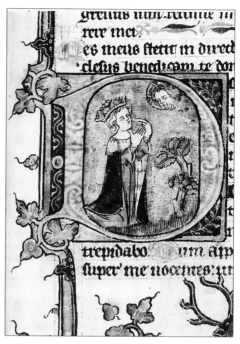

FIG. 68: *Rijmbijbel*. The Hague, Museum van het boek/Rijksmuseum Meermanno-Westreenianum, MS 10 B 21, fol. 153ʳ (Photo: Museum van het boek/Rijksmuseum Meermanno-Westreenianum, The Hague)

FIG. 69: Psalter. The Hague, Koninklijke Bibliotheek, MS 135 E 15, fol. 38ʳ: Initial D for Psalm 26, with kneeling David pointing to mouth (Photo: Koninklijke Bibliotheek, The Hague. Copyright: Koninklijke Bibliotheek, The Hague)

Infancy and Passion of Christ, and a series of seated apostles or prophets displaying scrolls.[15] The borders feature a variety of activities by humans, animals, and grotesques (figs 45, 72, 21). The style of the illuminations is that of van der Borch, with the exception of the nude trumpeter and jousting knights in the bas-de-page of the *Beatus* page, fol. 15ʳ.[16] This image is by an illuminator with a much lighter touch than van der Borch's. One-line initials are flourished throughout (fig. 73), except in the texts of the Office of the Dead and Commendation of Souls (fol. 164ᵛ, line 12, through fol. 170ᵛ), presumably in acknowledgement of the gravity of subject-matter in these sections. Flourishing (fig. 73) is congruent in style with much of that in the texts of the other devotional manuscripts.

4. Oxford, Bodleian Library, MSS Douce 5–6, a psalter (figs 2, 6, 20, 40, 55, 74–76, 80, 95)

Small (95 × 70 mm) but lavishly illustrated and decorated, Douce 5–6 has the calendar of St-Pierre, Blandigny, near Ghent.[17] Douce 5 comprises 226 fols; Douce 6, 207 fols. This

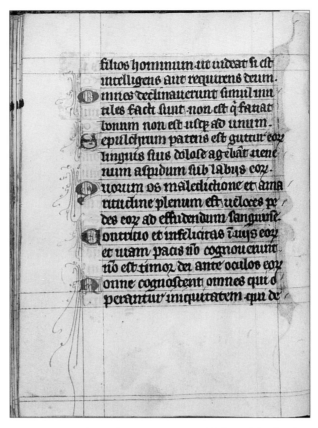

FIG. 70: Psalter. The Hague, Koninklijke Bibliotheek,
MS 135 E 15, fol. 20ᵛ (Photo: Koninklijke Bibliotheek,
The Hague. Copyright: Koninklijke Bibliotheek,
The Hague)

two-volume work has seventeen full-page miniatures of the life of Christ, eight as a prefatory cycle in Douce 5 (figs 55, 74, 75), and eight historiated psalm initials with borders on three or four sides (fig. 6). Borders are replete with busy humans, animals, and grotesques, and there are many figural line-endings as well. To van der Borch can be attributed seven of the prefatory miniatures in Douce 5 (those on fols 10ᵛ–16ᵛ, figs 55, 74, 75), and in Douce 6 all decoration on fols 48ʳ to end, including the full-page miniature of the Last Judgement on fol. 78ᵛ (fig. 6). This manuscript is flourished more elaborately than the other devotional manuscripts. The style of flourishing, like that of illumination, changes on fol. 48ʳ of Douce 6, as discussed below. Flourishing from fol. 48ʳ to end (figs 2, 76) shares many characteristics with that in van der Borch's sections of the other devotional manuscripts. Each artist probably flourished his sections of this psalter.

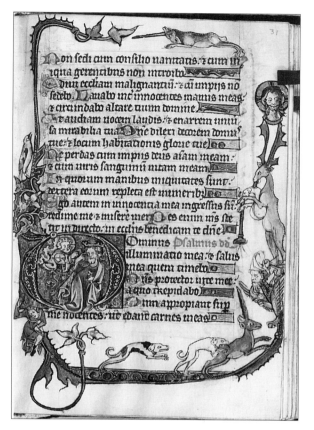

Fig. 71: Psalter-hours. Baltimore, Walters Art
Gallery, MS W. 82, fol. 31ʳ: Psalm 26 (Photo:
Walters Art Gallery, Baltimore)

5. Copenhagen, Kongelige Bibliotek, Gammel kongelig Samling, MS 3384,8°, a psalter (figs 10, 19, 24, 38, 61, 77, 78; pl. II)

Like Douce 5–6, Gl kgl. Saml. 3384,8°, comprised of 352 folios, is small (92 x 62 mm)[18]. It has lost its original calendar and original litany, and its destination cannot be localised from liturgical evidence. It has been assigned to Ghent on the basis of close stylistic connections to Douce 5–6, Walters 82, and other manuscripts assignable to Ghent.[19] Gl kgl. Saml. 3384,8° has ten full-page miniatures, three as a prefatory series. Eight full-page illuminations (fig. 10, pl. II) and seven of nine psalm initials (fig. 61) are in the style of van der Borch, as are borders, figural line-endings, and the abundant marginalia on all but nine bifolios through fol. 192ʳ (figs 19, 24, 38, 77, 78)[20] These nine bifolios and fols 192ᵛ to the end of the manuscript are illuminated by a second artist. Most full-page illuminations depict pairs of standing saints. The psalm initials illustrate the life of St. Francis.

FIG. 72: Psalter-hours. Baltimore, Walters Art Gallery, MS W. 82, fol. 193ᵛ, bas-de-page: Crawling beggar (Photo: Walters Art Gallery, Baltimore)

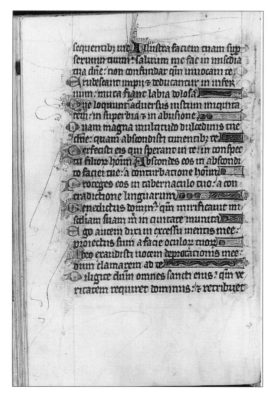

FIG. 73: Psalter-hours. Baltimore, Walters Art Gallery, MS W. 82, fol. 34ᵛ (Photo: Walters Art Gallery, Baltimore)

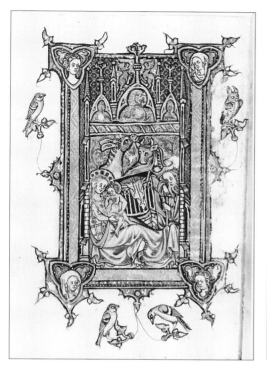

FIG. 74: Psalter. Oxford, Bodleian Library, MS Douce 5, fol. 14ᵛ: Nativity (Photo: Bodleian Library, Oxford)

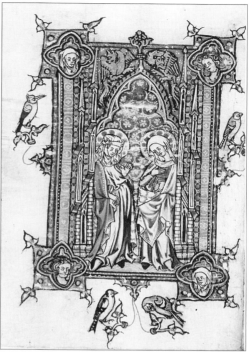

FIG. 75: Psalter. Oxford, Bodleian Library, MS Douce 5, fol. 11ᵛ: Visitation (Photo: Bodleian Library, Oxford)

Notably absent from this manuscript is the sexual and scatalogical imagery which is so abundant in the margins of Douce 5–6. The patron's strong interest in Franciscan subject matter may be indicative of a pious attitude coupled with a distaste for fleshly vulgarities.

Changes in patterns of penwork flourishing (figs 79, 80) in this manuscript are coordinated with changes in artistic hands, as discussed below. Flourishing on sheets with illumination by van der Borch (fig. 79) is in a style related to that of Walters 82 and Douce 6.

In recent decades some attempts have been made to determine the stylistic connections of the art of Michiel van der Borch and his geographical origins, the latter with less success than the former. In her study of Gl kgl. Saml. 3384,8°, Carlvant attributes to van der Borch only the illumination in MS 135 E 15 in addition to that in the *Rijmbijbel*.[21] These two manuscripts are similar in style to Douce 5–6, Walters 82, and Gl kgl. Saml. 3384,8°, in which she sees, however, not the work of van der Borch but of a closely related artist, whom she designates the Copenhagen Master.[22] The Copenhagen Master is characterised by his use of vividly descriptive detail, by his understanding of religious symbolism, and by his practice of redrawing contours with strong black lines over coloured surfaces. His drawing is 'fluid and forceful', and his work is of consistently high quality in the prefatory miniatures but is uneven in

FIG. 76: Psalter. Oxford, Bodleian Library, MS Douce
6, fol. 62ᵛ (Photo: Bodleian Library, Oxford)

the copious marginal illustrations.[23] She dates the Copenhagen Master's illumination to the 1320s. We believe that her Copenhagen Master and van der Borch are one and the same. The work she assigns to the Copenhagen Master is later, stylistically more developed work by van der Borch.

Though he does not assign Douce 5–6 and Gl kgl. Saml. 3384,8° to van der Borch, Ekkart remarks on the close stylistic connections between the *Rijmbijbel* and these two West Flemish manuscripts, both of which he dates to the first quarter of the fourteenth century. He specifies the Franco-Flemish border area as the region in which the roots of van der Borch's style might be sought.[24] As seen in the *Rijmbijbel*, van der Borch uses heavy black outlines around frames and in the design of miniatures and creates shallow, restricted spatial compositions.[25] The artist is a captivating storyteller, one who includes a quantity of telling detail in his miniatures and who compensates with this liveliness for his technical deficiencies.[26]

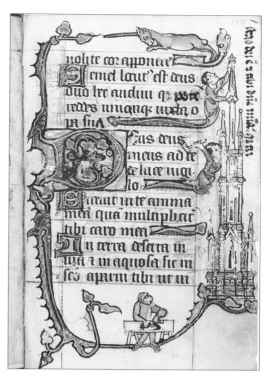

FIG. 77: Above: Psalter. Copenhagen, Kongelige Bibliotek, Gammel kongelig Samling, MS 3384,8°, fol. 37ʳ, detail, upper left margin: Grotesque with circumflex eye (Photo: Kongelige Bibliotek, Copenhagen)

FIG. 78: Right: Psalter. Copenhagen, Kongelige Bibliotek, Gammel kongelig Samling, MS 3384,8°, fol. 114ʳ (Photo: Kongelige Bibliotek, Copenhagen)

Stones accepts the illumination of the *Rijmbijbel* and that of MS 135 E 15 as van der Borch's work and extends this oeuvre with the addition of other secular and religious books not considered here. She sees in his style a distinctive looseness and fluidity of drawing and a largeness of figures and foliage motifs.[27] Like Carlvant, Stones attributes to a different, but stylistically related, artist the illumination of Walters 82, Douce 5–6, and Gl kgl. Saml. 3384,8°. To this oeuvre she adds other manuscripts, including a prose Lancelot, London, British Library, Additional MSS 10292–4.[28] Manuscripts in these two groups have a broad range of connections, with Ghent, Utrecht, Cambrai, St-Omer-Thérouanne, Liège, perhaps Tournai, and even Italy.[29] They include both sacred and secular texts and are written in Flemish and French as well as in Latin.

The five manuscripts we assign to van der Borch are thus divided between two related artists by both Carlvant and Stones, and Ekkart also sees four of the five as stylistically related. Lively narrative style, the use of strong, dark contours (which Carlvant correctly notes are often redrawn), a fluidity of execution which can be hasty and uneven—these are features of style all three scholars associate with the group of manuscripts linked directly or indirectly to van der Borch. Shallow space and a feeling for largeness of form are noted as well.

When considering works related in style to van der Borch's, all three scholars reserve a prominent place for The Hague, Koninklijke Bibliotheek, Koninklijke Akademie MS XX, the only known illustrated copy of Jacob van Maerlant's *Spiegel historiael*. This manuscript

FIG. 79: Psalter. Copenhagen, Kongelige Bibliotek,
Gammel kongelig Samling, MS 3384,8°, fol. 175ᵛ
(Photo: Kongelige Bibliotek, Copenhagen)

probably originated in Ghent or St-Omer-Thérouanne.[30] We agree that this manuscript is sty-
listically similar to van der Borch's. As will be demonstrated below, there is reason to believe
that the artist of the *Spiegel historiael* was an early co-worker with van der Borch, perhaps even
a master under whom he trained.

It is clear that van der Borch was connected with the growing trade in the illumination of
vernacular texts through his work on the *Rijmbijbel* (Middle Netherlandish), through his asso-
ciation with the artist of the *Spiegel historiael* (Middle Netherlandish), and through his connec-
tions, whether direct or indirect, with the prose Lancelot (French). He also worked on Latin
liturgical texts. He was thus situated within a nexus of languages, literary genres, and geo-
graphical connections which might encourage freedom and breadth of artistic development.
This background is one key to the extraordinary stylistic development he was to undergo in
the course of his career. We agree with Ekkart that van der Borch's stylistic roots are to be

sought in the area of Ghent and west to St-Omer-Thérouanne on the Franco-Flemish border; most of the manuscripts in the stylistic group with which he is closely associated originated in that area.

STYLE AND TECHNIQUE IN VAN DER BORCH'S FLEMISH MANUSCRIPTS

1. Solidity of form, outlining

A pronounced plumpness of form characterises figures in all manuscripts, a full-bodied softness in faces and hands and a breadth of silhouette that does not sacrifice articulation of the body. This feeling for form is reinforced by the strong black outlines which impart structure and strength to the body without flattening it. Van der Borch avoids flattening by

FIG. 80: Psalter. Oxford, Bodleian Library, MS Douce 5,
fol. 59ʳ (Photo: Bodleian Library, Oxford)

incorporating breaks in the outlines, as between chin and neck, at the corners of eyes, in the internal fold systems of draperies. Van der Borch's strong modelling likewise augments the sense of form, adding plasticity and a sense of the three-dimensional. This feeling for plump, solid form is perhaps in part a legacy of the perennial Classicism of the nearby Mosan region.

Very close to van der Borch in the handling of form is the illumination in the *Spiegel historiael*, which features substantial figures and strong black outlines (figs 18, 34, 53, 81). If anything, line is even stronger, but here it has a harshness lacking in van der Borch's work and incorporates fewer breaks, so that line has a greater tendency to flatten figures. Eyes are often drawn without breaks at the corners, and the line of the chin is often continuous across the neck, as in the figures of Cain and Abel, fol. 5ʳ (fig. 81). This stridency of line reinforces the emotional quality, harsher than that of the *Rijmbijbel*, of illumination in this work.

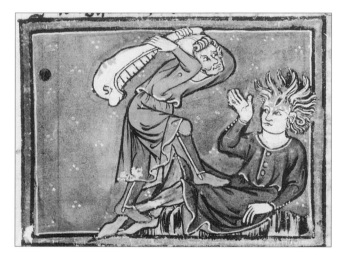

FIG. 81: *Spiegel historiael*. The Hague, Koninklijke
Bibliotheek, Koninklijke Akademie MS XX, fol. 5ʳ, minia-
ture: Cain slays Abel. (Photo: Koninklijke Bibliotheek,
The Hague. Copyright: Koninklijke Bibliotheek,
The Hague)

2. Expression

In all the manuscripts we attribute to van der Borch, figures are expressive, using gestures, facial expressions, and poses to communicate. Most restrained in expression is MS 135 E 15. Yet hand gestures and poses are adroitly nuanced, and expressions, though subdued, are carefully observed. In the initial for Psalm 51 on fol. 79ʳ of MS 135 E 15, the figure of David, shrinking from the Devil while confronting him with both glance and gesture, is a small masterpiece of expressive understatement (fig. 82).

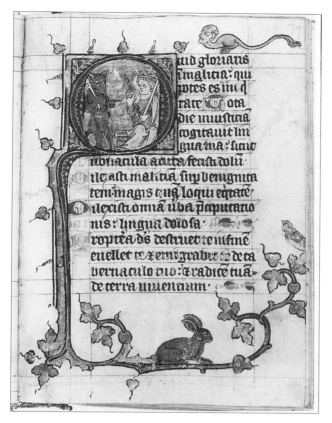

FIG. 82: Psalter. The Hague, Koninklijke Bibliotheek, MS
135 E 15, fol. 79ʳ: Psalm 51 (Photo: Koninklijke
Bibliotheek, The Hague. Copyright: Koninklijke
Bibliotheek, The Hague)

Expression of all kinds is stronger in the *Rijmbijbel*. In the six scenes of Creation on fol. 1ᵛ
the Creator's varied swaying poses and reaching gestures, together with the in-and-out flow
of his draperies, express the energy of creation (fig. 26). In the full-page miniature of the Siege
of Jerusalem, fol. 152ᵛ (fig. 66), faces and poses express anxiety, conspiratorial thought, rage,
determination, surprise. A group of knights remonstrates with the emperor. Men prepare to
shoot bows and to hurl spears and large rocks, while exchanging words or glances. This is not
the conventional battle scene of death and carnage but rather explores the human drama, the
psychology and busy-ness of war. Even a horrifying episode recounted by Josephus, in which
Mary of Bethezuba presents her fellow citizens with her roasted child, is depicted not in grue-
some detail but with an interest in psychology, as revealed by the grimacing soldier who views
the dish.[31] In the grass at lower left lurks a snarling dragon-like beast, a warning of imminent
treachery and disaster (fig. 49).

The secular and narrative character of the *Rijmbijbel* no doubt in part accounts for the expressiveness of its illumination, but in Walters 82, Douce 5–6, and Gl kgl. Saml. 3384,8° expression is also emphasised to the extent that formulas for psalter illustration permit. In Walters 82, which lacks full-page illustrations, the initial for Psalm 26, fol. 31r, shows a kneeling David in a strongly twisting pose, pointing to his eyes with his right hand (fig. 71). His gesture with extended index finger exactly duplicates that of the Deity, whose right hand of blessing, as he emerges from a cloud, is closely juxtaposed to David's. Heads as well as hands are in close proximity, heightening both the sense of intimacy and the contrast between divinity and humanity. In the prefatory cycle of Douce 5–6 the miniature of the Massacre of the Innocents on fol. 15v (fig. 55) presents a gripping juxtaposition of evil and innocence. The oversized armoured soldier, his face animated with an evil grin, cradles a nude child in his left arm, in a grotesque parody of Mary's traditional pose. With his right hand he plunges his sword into the child's bowels. The child holds his right hand to his heart in a touching gesture of purity, the very same gesture as that of the Christ Child in the Nativity miniature on fol. 14 v, the folio immediately preceding (fig. 74). The exaggerated swaying stances of Mary and Elizabeth in the Visitation, fol. 11v (fig. 75), their inclined heads and exchanged glances, intensify the expression in this conventionalised format of paired standing saints. In the full-page miniatures of paired standing saints in Gl kgl. Saml. 3384,8 ° (pl. II, fig. 10), extreme hip-shot stances, tilted heads with sidelong glances, exaggerated modelling, and a heavy palette of hot orange and pink cut by cool greys create a strongly baroque sense of the physical as a vehicle for the spiritual.

The intensity of expression in van der Borch's manuscripts relates them to other manuscripts from the area of Ghent and St-Omer-Thérouanne. In the *Spiegel historiael*, violence and gore are depicted with highly graphic realism, both in the biblical scenes such as Cain and Abel, fol. 5r (fig. 81) and in battle scenes, as in the Battle between Hannibal and the Romans, fol. 42r (fig. 34). This same manuscript includes a startling image of the slumbering Adam, with prominent genitalia, in the scene of the creation of Eve, fol. 4v (fig. 18). To another artist working in the same region may be attributed Additional MS 36684/Morgan 754 (figs 47, 83, 84),[32] which is as extreme in its depiction of the sexual and scatalogical as the *Spiegel historiael* is in its depiction of violence.

3. Mannerisms

A recurrent mannerism in these manuscripts is a notched wrist, as in the figure of David in the initial for Psalm 68 in MS 135 E 15, fol. 99r (fig. 85), in the figures of Micah praying, fol. 48r (fig. 30) and of the directing figure (Nimrod?) in the scene of the building of the Tower of Babel, fol. 9v, in the *Rijmbijbel* (fig. 67), in the right hand of St Michael on fol. 97r, and the right hand of the bishop saint on fol. 126v of Gl kgl. Saml. 3384,8°. Even more in evidence is an exceptionally long, pointing index finger, such as that of David in the initials for Psalms 26 (fol. 38r) and 38 (fol. 59v) of MS 135 E 15, that of the angel in the scene of Noah and the ark, fol. 8r, and of the emperor in the miniature of the siege of Jerusalem, fol. 152v of the

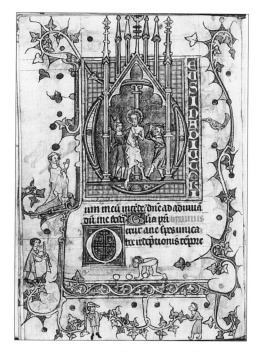

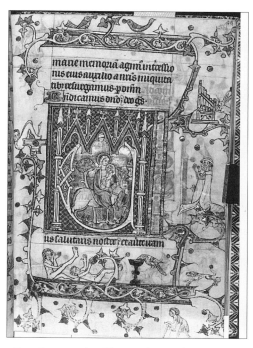

FIG. 83: Book of hours (partial). New York, Pierpont Morgan Library, MS M. 754, fol. 65ᵛ (Photo: Pierpont Morgan Library, New York)

FIG. 84: Book of hours (partial). London, British Library, Additional MS 36684, fol. 56ʳ (Photo: British Library, London)

Rijmbijbel (fig. 66), that of the figural line-ending in the lower right margin of fol. 64ʳ of Douce 6; the figure of St Paul, fol. 42ᵛ of Gl kgl. Saml. 3384,8°. In this last manuscript, the circumflex eye, which originates in Flemish works such as the *Spiegel historiael*, as described in Chapter 5, is abstracted from its original context of strong emotion or violent action and is used to impart an expression of the grotesque or the comical (fig. 77).

Another expressive mannerism is the repetition of gestures. Figures which converse or interact, or which are symbolically linked, are often depicted with identically configured hands, as though to indicate a mutual understanding. On fol. 31ʳ of Walters 82 (fig. 71), David's right hand, with pointing index finger, duplicates the gesture of the Lord, to whom he prays. On fol. 161ʳ of Gl kgl. Saml. 3384,8° (fig. 61), St Francis and the seraph appear with identically positioned right hands, suggesting the transfer of the stigma from angel to man. In Douce 5, the gesture of hand to heart, made first by the Christ Child on fol. 14ᵛ and repeated by the slaughtered infant on the next leaf (figs 74, 55), suggests a shared purity and innocence.

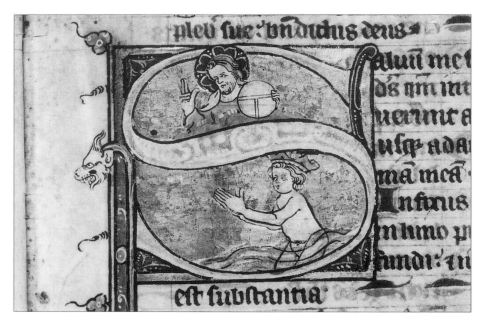

FIG. 85: Psalter. The Hague, Koninklijke Bibliotheek, MS 135 E 15, fol. 99ʳ: Initial S
for Psalm 68, with nude David in the waters (Photo: Koninklijke Bibliotheek, The
Hague. Copyright: Koninklijke Bibliotheek, The Hague)

4. Space

Van der Borch's work shows a strong preference for aligning objects or structures in space in
rising and receding planes parallel to the picture plane. The simple designs of the initials of
MS 135 E 15 are mostly uniplanar. In the third, fourth, and fifth Creation scenes of the
Rijmbijbel, fol. 1ᵛ (fig. 26), small plants are aligned in one planar row and trees in another
behind them. In the miniature of the siege of Jerusalem (fig. 66), the city is designed as rising
and receding layers of walls, towers, and buildings, almost all parallel to the picture plane.
There are only a few diagonally aligned structures, one of which, the section of wall at the top
centre of the image, causes the artist considerable difficulty. Most other structures, such as the
the house of Micah, fol. 48ʳ (fig. 30), the city of Jerusalem in the scene of entry, fol. 140ʳ, the
city of Jericho, fol. 38ʳ, the city of Bethel, fol. 80ᵛ, have this planar organization. In the scene
of Antiochus Epiphanes in bed, fol. 115ᵛ, a section of the castle aligned on an advancing diag-
onal again causes the artist problems. In Douce 5, fol. 14ᵛ (fig. 74), the manger in the Nativity
is oriented diagonally to the picture plane, resulting in a confused perspective. Otherwise in
this manuscript, as in Walters 82 and Gl kgl. Saml. 3384,8°, structures are mostly simple and
parallel to the picture plane. Of course, many northern artists of his era rendered diagonals in
an awkward perspective. Van der Borch is perhaps distinguished only in that he attempts devi-
ations from parallel alignment infrequently and is less successful in his handling of them than
many artists of comparable abilities. A comparison of the siege of Jerusalem in the *Rijmbijbel*

(fig. 66) with a walled city on fol. 20ᵛ of Bodley 264 (fig. 86), a Flemish manuscript of the same decade as the *Rijmbijbel*, reveals how few are the diagonal elements in van der Borch's architecture.

5. *Borders*

All five manuscripts share a common repertoire of elements in their border decoration (figs 6, 40, 68, 71, 78, 82). The character of these borders is worth noting, though border elements described below are not unique to this group of manuscripts but rather draw from a repertoire common to many West Flemish manuscripts of the era.[33] Border bars lined with tendrils, or tendrils alone, are used in various ways on pages with large decorated or historiated initials. The bar and tendril, or tendril alone, usually extend from the initial into the margins of two, three, or even four sides of the page. Emphatic cusping is applied where the tendrils bend around corners. In the *Rijmbijbel,* the initials and miniatures at the beginnings of important divisions of the text are accompanied by a border bar lined with a tendril that expands into the lower margin and usually into the upper as well (fig. 68). Since the text is in two columns per page, the border bar may occupy either the left margin or the space between columns. Tendrils are ornamented with balls and sprout trilobate leaves in various colours.

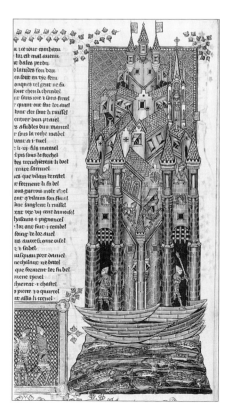

Fig. 86: *Romance of Alexander*. Oxford, Bodleian Library, MS Bodley 264, fol. 20ᵛ, miniature: A Greek fort on boats before Tyre (Photo: Bodleian Library, Oxford)

In MS 135 E 15 and the *Rijmbijbel*, the rectangular border bars are used more extensively, the tendrils are thinner, and cusping is used less than in the other manuscripts, suggesting, as do other factors, that these two works are the earliest of the group. MS 135 E 15 has a single animal in the bas-de-page of each of its surviving eight psalm initial pages (fig. 82), and in the upper margin a bird or a grotesque, or both (fol. 144ʳ). Borders in the *Rijmbijbel* likewise are inhabited mostly by animals or grotesques alone or in pairs; the last bordered page, fol. 153ʳ, (fig. 68) is more populous. In Walters 82, Douce 5–6, and Gl kgl. Saml. 3384,8°, borders are liberally salted with grotesques, animals, and vignettes involving both humans and animals in a wide range of activities. Douce 5–6 and Gl kgl. Saml. 3384,8°, have figural line-endings as well. Thus the tendency is to load the borders with ever more figures and activity.

Among the manuscripts whose border decoration bears comparison to that in van der Borch's manuscripts, several of early fourteenth-century date from Ghent or St-Omer-Thérouanne may be noted. Those of the *Spiegel historiael* bear resemblance to the borders of the *Rijmbijbel* (cp. figs 68, 87); Meuwese has also noted 'remarkable similarities in the marginal designs' between the *Spiegel historiael* and Walters 82.[34] Comparable to van der Borch's later Flemish manuscripts, especially Walters 82, are the borders of Baltimore, Walters Art Gallery, MS W. 90[35] and Additional MS 36684/ Morgan 754 (figs 83, 84). The vine tendrils and cusping bear comparison with these elements in van der Borch's manuscripts, as do the inventive and freely arranged figural scenes in the borders.

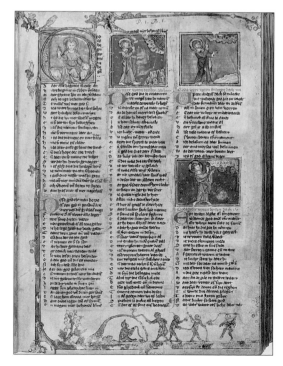

FIG. 87: *Spiegel historiael*. The Hague, Koninklijke Bibliotheek, Koninklijke Akademie MS XX, fol. 4ʳ (Photo: Koninklijke Bibliotheek, The Hague. Copyright: Koninklijke Bibliotheek, The Hague)

6. Colour

All five manuscripts are close in colour. Oranges, blues and greys, pinks and maroons predominate, generally with fluid modelling applied as variations in value. Green and brown occur in minor amounts, and gold occurs as both leaf and, less often, as wash. The colour is expressive, often strong, rather than lushly decorative. The artist's primary interest is in telling the story and in communicating his insights into human nature. Perhaps the decorative possibilities of colour are kept in check to avoid competing with, or diluting, this overriding interest.

Colour is handled, nevertheless, with thoughtfulness and subtlety. A hint of iridescence is introduced into the foliage of MS 135 E 15 through mixing some pigments with a little silver or gold wash. In the full-page miniature with the six days of Creation in the *Rijmbijbel*, fol. 1ᵛ (fig. 26), the Creator never wears the same colour combinations twice, despite the limited palette. Likewise, in Gl kgl. Saml. 3384,8°, many colour combinations are created for tunics and cloaks from a few hues in van der Borch's full-page miniatures. Modelling in value is least developed in MS 135 E 15 (pl. Ia) and the *Rijmbijbel*, somewhat further developed in Walters 82 (pl. Ib), and most developed in Douce 5–6 and Gl kgl. Saml. 3384,8° (pl. II). These differences suggest that the *Rijmbijbel* and MS 135 E 15 are earliest in date, that Walters 82 is next, and that Douce 5–6 and Gl kgl. Saml. 3384,8° are the latest of the group.

Palettes of a number of early fourteenth-century West Flemish and Franco-Flemish manuscripts are similar to van der Borch's, but there are distinguishing nuances and variations. Work by van der Borch's fellow illuminator in both Gl kgl. Saml. 3384,8° and Douce 5–6 features more green than van der Borch's, and in Gl kgl. Saml. 3384,8° the co-worker employs a bright golden orange which is entirely absent from van der Borch's palette. A beautiful cerulean blue found sparingly in van der Borch's Flemish work is used copiously in Baltimore, Walters Art Gallery, MS W. 95, a book of hours from the region of Ghent of about the same date as Walters 82.[36] Additional MS 36684/Morgan 754 is illuminated in the same basic colours as are van der Borch's manuscripts but in overall higher values, so that this book has a distinctive pastel tonality.

7. Inkblot transfers

One of van der Borch's final acts as he finished a page was to re-outline, in black ink, the major contours of some figures or border elements, as Carlvant has noted.[37] Yet he then did not wait for the ink to dry before overlaying the still-wet folio with his next sheet, or placing the wet folio on top of another sheet. The result is that in each of these manuscripts there are inkblot transfers, impressions of still-damp contours blotted from one sheet onto the facing page. Occasionally impressions transfer from wet paint, especially blue, and from damp penwork, apparently also the work of the artist. Some examples of inkblot transfers in each of the five manuscripts under consideration are listed below. In the earlier manuscripts these transfers are fewer and less pronounced; in the case of Douce 5–6 and Gl kgl. Saml. 3384,8°, the re-inking

was very heavy, and examples of transfers could be multiplied many times over. (It should be noted that inkblot transfers are not unique to the manuscripts of van der Borch. Further study of this feature of many early fourteenth-century manuscripts might reveal much about working practices of scribes and illuminators.) Details of inkblot transfers are as follows:

The *Rijmbijbel*, The Hague, Museum van het boek/Rijksmuseum Meermanno-Westreenianum, MS 10 B 21

> fol. 45r onto 44v: penwork of initial
>
> fol. 48r onto 47v: outlining of the grotesque at bottom
>
> fol. 49v onto 50r: outlining of tendril at upper left
>
> fol. 104r onto 103v: outline of bar in top margin

The Hague, Koninklijke Bibliotheek, MS 135 E 15

> fol. 24r to fol. 23v: tail of border bar at top
>
> fol. 41v onto 42r: outline of border bar at centre
>
> fol. 47v onto 48r: outline of three-line initial at top

Baltimore, Walters Art Gallery, MS W. 82

> fol. 42r onto 41v: black ink at bottom
>
> fol. 62v onto 63r: inside and outside borders
>
> fol. 100r onto 99v: outlining of cusping at inner left
>
> fol. 208v onto 209r: outlining and black ink of tower in margin

Oxford, Bodleian Library, MS Douce 6

> fol. 48r onto 47v: outline of cusping, foliage, and figures from bottom and right margins
>
> fol. 108v onto 109r: outline of cusping on tendril at left and bottom margin and ink from blackened doorway of building in bas-de-page
>
> fol. 110v onto 111r: outline of cusping around bishop in left margin
>
> fol. 111r onto 110v: outline of cusping in lower right margin (fig. 40)

Copenhagen, Kongelige Bibliotek, Gammel Kongelig Samling, MS 3384,8°

> fol. 37v onto 38r: outline of figural line-ending in bottom right margin
>
> fol. 38r onto 37v: impression of penwork flourishing in left margin
>
> fol. 47r onto 46v: outline of cusping around tendril in lower right margin
>
> fol. 60r onto 59v: outline of cusping around tendril in lower left margin

8. Penwork flourishing

The *Rijmbijbel* lacks penwork flourishing, but the three psalters and the psalter-hours are flourished, and with similarities in style that would indicate the same flourisher at work in all four manuscripts (figs 70, 73, 76, 79). The flourishing shows a tendency toward the use of multiple free, sweeping diagonals that terminate in slightly flattened or irregular loops. These contrast with the more uniformly right-angle directionality and more regular curves characterising the penwork in a number of other Ghent-area manuscripts, such as The Hague, Museum van het boek/Rijksmuseum Meermanno-Westreenianum MS 10 A 14 (fig. 88),

FIG. 88: Missal. The Hague, Museum van het boek/
Rijksmuseum Meermanno- Westreenianum, MS 10 A 14,
fol. 155r (Photo: Museum van het boek/ Rijksmuseum
Meermanno-Westreenianum, The Hague)

Brussels, Bibliothèque Royale Albert 1er, MS 9217, and Brussels, Bibliothèque Royale Albert
1er, MS 6426. The pinwheel configurations that dominated border design in earlier Flemish
manuscripts seemingly left a structural legacy in much of the penwork flourishing of these
Ghent manuscripts of the 1330s and 1340s. Van der Borch's penwork escapes, to a greater
degree than most, this domination by a paradigm from the past.

The decorative vocabulary of the penwork in van der Borch's four flourished manuscripts
includes pearls and corkscrews or squiggles. The short crossed lines and hatched lines, often
occurring in pairs or triplets, that intersect long flourishes at intervals in penwork elsewhere,
as in Additional MS 36684/Morgan 754 (fig. 89) and the psalter Copenhagen, Kongelige
Bibliotek, Ny kongelig Samling, MS 41, occur much less frequently in van der Borch's work
and are generally placed near curves so that they do not break the quick movement of a long
line. MS 135 E 15 (fig. 70) is the most understated of the four devotional manuscripts in its
flourishing, as it is in many other respects. Douce 5–6, by far the most elaborate in its pen-
work decoration, includes tendrils with a feathery foliage, five-petalled flowers, four-pointed
floating stars, and floating balls.

FIG. 89: Partial book of hours. London, British
Library, Additional MS 36684, fol. 54ᵛ (Photo:
British Library, London)

Evidence that the artist was the flourisher is afforded by the fact that the major changes in the style of penwork are coordinated with changes in artist in those manuscripts of van der Borch's group which contain work by more than one artist. In Douce 5–6, those folios illuminated by van der Borch's colleague (fols 17ᵛ to end of Douce 5 and fols 1ʳ–47ᵛ of Douce 6, fig. 80) are flourished in a stiffer, more regular style, with fewer foliate and floral elements than are the folios illuminated by van der Borch (fig. 76). This flourisher frequently uses a large five-pointed star enclosed in an open loop, a motif absent from van der Borch's repertoire. In Gl kgl. Saml. 3384,8°, the folios illuminated by van der Borch's colleague (fol. 192ᵛ to end, plus 9 additional bifolios) are all unflourished, whereas those illuminated by van der Borch, with the systematic exception of those bifolios having either full-page miniatures or eight-line initials, are all flourished and in a uniform style.[38] With the exception of the vignette at the bottom of the *Beatus* page, fol. 15ʳ, Walters 82 appears to be illuminated solely by van der Borch;

its flourishing is also in his style. The first sixteen folios of MS 135 E 15 are flourished quite differently from, and hence probably by a different hand than, the rest of the manuscript. The penwork style of these folios is more rectilinear than that of later folios and uses hatched lines. Whether this change in penwork style is coordinated with a change in artist cannot be determined, since fols 7ʳ through 9ᵛ of this manuscript, including the *Beatus* page, are missing, and there is thus no illumination through fol. 16ᵛ. The change in penwork style occurs at fol. 17ʳ, where a new gathering commences.

From the above study of the five Flemish manuscripts we reach three conclusions. First, the many shared elements in style, penwork, and techniques of execution are evidence that all these manuscripts do indeed contain work by Michiel van der Borch. Second, a consistent development in many aspects of style and execution, toward heavier, richer, more fully articulated effects, strongly suggests a relative chronology: The *Rijmbijbel* and MS 135 E 15 are the earliest of the group; Walters 82 was executed next; Douce 5–6 and Gl kgl. Saml. 3384,8° are the latest. Third, the artist was the flourisher. Patterns of change in the style of flourishing are so consistently coordinated with patterns of change in the style of illumination that it is hard to reach any other conclusion on this point.

We differ from previous scholars, who generally have dated Walters 82, Douce 5–6, and Gl kgl. Saml. 3384,8° to the 1320s, or earlier.[39] Van der Borch's inscription firmly dates the *Rijmbijbel* 1332, and MS 135 E 15 may date to 1333. We conjecture that Walters 82 was probably executed three or four years later and that Douce 5–6 and Gl kgl. Saml. 3384,8° date to the very end of the decade. None of these manuscripts reflects the French and Italianate novelties of costume and architecture which abound in the Flemish Bodley 264, the illumination of which was executed between 1339 and 1344, probably in Tournai, nor does their style reflect contact with Brussels, Bibliothèque Royale Albert 1er, MS 9217, Brussels, Bibliothèque Royale Albert 1er, MS 6426, Brussels, Bibliothèque Royale Albert 1er, MS 9427, or The Hague, Museum van het boek/Rijksmuseum Meermanno-Westreenianum MS 10 A 14, all probably produced in the 1340s in Ghent.

ENGLISH MANUSCRIPTS RELATED TO THE EGERTON GENESIS

Evidence indicates that in the late 1330s or early 1340s van der Borch emigrated to England, probably Norwich, and established himself as a major artist in the English milieu. He was not the only Flemish artist who crossed the Channel to become a successful manuscript illuminator in England during this period of especially close relations between Flanders and England. Dennison has identified one, and possibly two, such Flemish emigrant artists.[40] Van der Borch worked in England for about ten or fifteen years.

Similarities in style, penwork, and idiosyncrasies of execution, as well as many repetitions in iconography, link the Flemish manuscripts discussed above with the four English manuscripts containing illumination generally assigned to the Egerton Genesis artist, who was in fact Michiel van der Borch. Textual evidence affords none of the English manuscripts a

certain date or place of origin. We offer below a brief description of the illustration of each manuscript along with comments on the work attributable in each to van der Borch and to some of his colleagues.

All of these English psalters are considerably larger than the Flemish psalters and psalter-hours.

1. Fitzwarin Psalter, Paris, Bibliothèque Nationale, MS lat. 765 (figs 32, 62, 64)

The Fitzwarin Psalter, 315 × 210 mm,[41] has a prefatory cycle of sixteen full-page miniatures (fols 7r–22r).[42] The first miniature, of the Education of the Virgin, fol. 7r, includes a donor portrait, the next thirteen, fols 8r–20r, are of the Passion, Resurrection, Ascension, and Pentecost, and the final two are a diptych of Christ in Majesty, fol. 21v (fig. 62), and the Crucifixion, fol. 22r (fig. 64). The *Beatus* page, fol. 23r, has a seven-line historiated initial. Eight additional initials are decorated with foliage. The Egerton Genesis artist is generally assigned, correctly we believe, only the illumination of the two final full-page miniatures, namely the diptych of Christ in Majesty (fig. 62) and the Crucifixion (fig. 64), on a single bifolium. Sandler concluded that this diptych was added around 1370, perhaps twenty years after the other full-page miniatures, and Dennison likewise considered it a post-plague addition to the manuscript.[43] We agree instead with Wormald that all the full-page miniatures were approximately contemporary.[44] The images of the diptych have a meditative, iconic quality quite distinct from the more narrative character of the other miniatures. A possible difference in function may thus explain the inclusion of the diptych.

Van der Borch's Crucifixion should be considered with the added Crucifixion of the Gorleston Psalter (fig. 56) and the Douai Psalter Crucifixion, both of which it resembles stylistically and upon which it was quite possibly modelled. Both the Gorleston Psalter and the Douai Psalter were probably illuminated in Norwich,[45] and there is evidence that the Fitzwarin Psalter was as well. Not only would it have been the most likely place for van der Borch to have seen the manuscript models for his Crucifixion, but the iconography of some of the miniatures by the main artist of the Fitzwarin Psalter have strong Norwich connections. The scenes of the Descent into Limbo (fig. 32) and the Resurrection are very like those carved on two bosses in the vault of the north end of the east walk of the Norwich Cathedral cloister. This walk is dated to the first half of the fourteenth century.[46]

The illumination of the psalter Oxford, Bodleian Library, MS Liturg. 198 has been attributed to the main artist of the Fitzwarin Psalter.[47] We propose that he was also a Fleming, and that he had worked previously in Ghent, on Brussels, Bibliothèque Royale Albert 1er, MS 9427, a liturgical psalter produced in that city for Louis de Male and dated by Dennison to around 1345.[48] A number of features in the Fitzwarin Psalter—drawing practices (outlining figures in red ink), figure style and costume, iconography, architecture, border treatments, line-endings and penwork—connect his work in the Fitzwarin Psalter to work in the liturgical psalter.

One more connection of the main Fitzwarin artist to Ghent may be noted here. The Ascension in the Fitzwarin Psalter, fol. 19r,[49] is closely related to the same scene in the initial

on fol. 33[r] of Brussels, Bibliothèque Royale Albert 1er, MS 9217, a missal of about the same date as Brussels, Bibliothèque Royale Albert 1er, MS 9427 and probably produced in Ghent.[50] The scene depicts the 'Disappearing Christ', whose legs and feet are still visible while his upper body has vanished into the scalloped cloud above (fig. 90). In the architectural super-structure, a woman's head peeks from a window above Christ's legs, and on the same axis. In the Fitzwarin Psalter, fol. 19[r], this motif of the head in the superstructure appears to have been adopted, and then transformed by conflation with the figure of Christ. Christ's feet appear below the scalloped cloud, his upper legs, through the tracery screen beneath the arch, and his hands and face in openings of the superstructure. The connection between the two Ascensions becomes clearer in light of the fact that the artist of Brussels, Bibliothèque Royale Albert 1er, MS 9217 worked with the main Fitzwarin artist on Brussels, Bibliothèque Royale Albert 1er, MS 9427.[51]

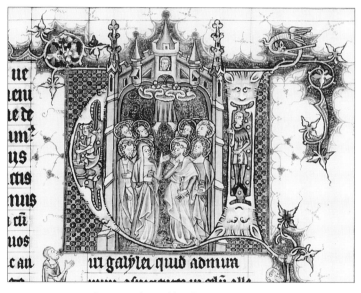

FIG. 90: Missal. Brussels, Bibliothèque Royale Albert 1er, MS 9217, fol. 33[r]: Initial Q, with Ascension (Photo: Bibliothèque Royale Albert 1er, Brussels)

The Fitzwarin Psalter has other connections to this region, specifically to the Mosan area. In London, British Library, Stowe MS 17, a book of hours from Liège, the grotesque, dark-faced tormentors in some of the Passion scenes are reminiscent of those in the Fitzwarin Psalter.[52]

The fact that van der Borch's colleague in the Fitzwarin Psalter was of Flemish origin is sig-nificant in a number of ways. Most importantly for our purposes, it indicates that Flemish artists who emigrated to England, probably Norwich, stayed in close touch for a time after

their arrival and suggests that some of them may have emigrated together. If the Fitzwarin Psalter and Oxford, Bodleian Library, MS Liturg. 198, as well as most of the James Memorial Psalter, much of the Derby Psalter, and the entire Egerton Genesis are the work of Flemish immigrants, it becomes clear that the larger picture of East Anglian illumination in the decade before the plague and in the years immediately afterwards must be re-evaluated to take account of a significant Flemish contribution.

The two illustrations in the Fitzwarin Psalter are probably the earliest of the English works generally attributed to the Egerton Genesis artist. They indicate that he had assimilated Sienese influence, either directly through Sienese panel paintings or manuscripts, or indirectly through the Sienese-influenced work of other artists in Norwich, such as that of the main artist of the St Omer Psalter. Sienese elements include the soft, fuzzy hair and the thin, smooth fabric with low-relief folds. By contrast, Bolognese influence is absent. Van der Borch's work in the Fitzwarin Psalter has none of the foreshortenings and back views which appear in his later manuscripts. A likely date for the Fitzwarin Psalter is the early 1340s, and it is likely that the two Flemings worked together or in close sequence on this project.

2. James Memorial Psalter, London, British Library, Additional MS 44949 (figs 60, 63, 91, 96)

Next in van der Borch's surviving English oeuvre was probably the James Memorial Psalter, which is the smallest of the three English psalters, measuring 258 × 175 mm.[53] The James Memorial is prefaced on fols 3v–7r with a series of eight almost-square miniatures of events from the life of Christ, each miniature occupying about two-thirds of the page (figs 60, 63, 91). Each of the first seven illuminations accompanies a prayer at one of the canonical hours, while the eighth accompanies a prayer to Christ on the cross. All but the last are subdivided into two events which happened at the hour of the prayer. The last miniature of the series illustrates a single scene, the Crucifixion.

The first miniature in the sequence is not by van der Borch, but rather appears to be the work of an artist stylistically connected to the Bohun manuscripts, perhaps the artist Dennison identifies as Hand D, the English artist.[54] In this first miniature, skin is very white and unmodelled, and the eyes are little more than black dots. Clothes are modelled mainly with white highlights. The gables of the arched frame are decorated with black, and the corbels are flat-bottomed. The panel enclosing the initial below the miniature features blue above red and the initial is unflourished. In all other miniatures of the manuscript, skin has a more pinkish colour, eyes are detailed with lids, and there is shading around lids and nose. Modelling of the clothing is primarily with penwork shading. Architecture lacks black details in the gables, and corbels are round-bottomed. The enclosing panels of the initials below the miniatures are all coloured with red above blue, and are all flourished with black squiggles and gold balls. The palette in this manuscript is more keyed to red, blue, and gold, less to grey and orange, than are the palettes of the Fitzwarin Psalter, the Derby Psalter, or the Egerton Genesis. Perhaps the colours initially selected by the first artist were inherited by van der Borch, who continued to use them.

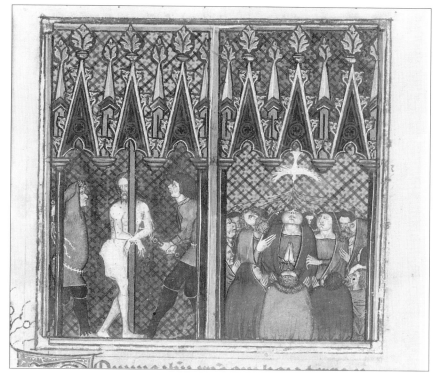

FIG. 91: M. R. James Memorial Psalter. London, British Library, Additional
MS 44949, fol. 4ᵛ, double miniature: Flagellation and Pentecost (Photo:
British Library, London)

The James Memorial Psalter shows the influence of Bolognese illumination. Back views, lost profiles, foreshortened heads, and circular grouping, all features the artist might have seen in Bolognese manuscripts, are boldly, if not entirely successfully, attempted (cp. figs 37 and 58 with fig. 91). A trip to Italy seems unnecessary as a means of explaining these and later Italianisms in van der Borch's work.[55]

3. Derby Psalter, Oxford, Bodleian Library, MS Rawlinson G. 185 (figs 51, 65, 92, 93, 94)

A folio volume measuring 398 × 253 mm, the Derby Psalter is the largest of the three English psalters.[56] It has no full-page illuminations but has eight historiated psalm initials on pages with borders on three or four sides. Though all the illumination of the Derby has usually been ascribed to a single artist, evidence indicates that van der Borch in fact worked with a collaborator on this manuscript. On the *Beatus* page, fol. 1ʳ (fig. 92), he probably had little to do with the border, a very stiff, repetitive climbing vine, or the figures it encloses. The large hands, small heads, and often brushy hair bear little resemblance to his work elsewhere.

FIG. 92: Derby Psalter. Oxford, Bodleian Library, MS Rawlinson G. 185, fol. 1ʳ: Psalm 1 (Photo: Bodleian Library, Oxford)

The monumental reclining Jesse (fig. 93) on this page is probably, for the most part, his work. As in the Egerton Genesis, the shading of the garments is applied to this figure to emphasise the main axis of the body and its three-dimensional form. The contour of the back side of the figure was redrawn from hips to knee, and the folds and hemline of the garment over them was altered, apparently in order to make the figure more ample in conception. These features suggest that perhaps van der Borch altered the initial drawing of his assistant and then

FIG. 93: Derby Psalter. Oxford, Bodleian Library, MS Rawlinson G. 185, fol. 1ʳ, detail: Reclining Jesse (Photo: Bodleian Library, Oxford)

completed the figure. If so, this would not be the only instance of collaborative work on a *Beatus* page in the manuscripts under consideration. In the *Beatus* page of Walters 82, fol. 15ʳ, the bas-de-page vignette of a nude trumpeter and jousting knights is the work of an assistant, but the initial is the work of van der Borch.

Van der Borch can be assigned the initials, but not the borders, on fols 20ʳ and 32ᵛ (fig. 65). The small, stiff sprays of foliage in these borders contrast with the more largely conceived full borders and initials, both probably executed by van der Borch, on fols 43ᵛ (fig. 51), 54ᵛ (fig. 94), 68ᵛ, and 81ᵛ. On these folios, at both the top and bottom of the page, long tendrils sweep in from the sides, intertwine, and return to the sides. A few dragons, grotesques, masks, and other leaf forms occur as accents in the left and right marginal bars. The effect is simple and monumental, quite in accordance with the figure style. On fols 1ʳ (fig. 92) and 97ʳ the assistant was responsible for both borders and initials, which are less plumply rounded than those

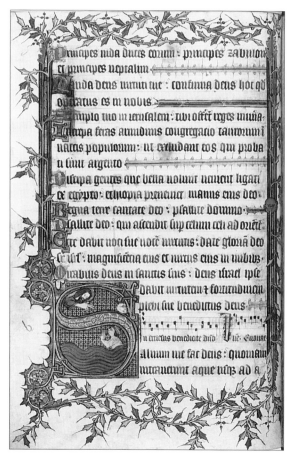

FIG. 94: Derby Psalter. Oxford, Bodleian Library,
MS Rawlinson G. 185, fol. 54ᵛ: Psalm 68
(Photo: Bodleian Library, Oxford)

by van der Borch and contain figures drawn in monochrome in the staves. Here it may be noted that many of Dennison's comparisons between the Derby Psalter and a late fourteenth-century psalter, Norfolk, Holkham Hall, Earl of Leicester MS 26, the illustration of which she assigns to the artist of the Egerton Genesis, are made with portions of the Derby Psalter which we assign not to van der Borch but to the assistant.[57] Perhaps this second artist was the illuminator of Norfolk, Holkham Hall, Earl of Leiscester MS 26 and related manuscripts; we see no evidence that van der Borch himself worked on these manuscripts.

In the initials illuminated by van der Borch in the Derby Psalter, the figures have a greater solidity and three-dimensionality than do those of the James Memorial Psalter and the Fitzwarin Psalter. There are fewer foreshortenings and back views than in the James Memorial Psalter, but they are handled more proficiently.

A striking feature of the Derby Psalter is its unusual series of two-line initials decorated with a head of Christ. Stephen of Derby, who commissioned the manuscript, became Prior of Christ Church Cathedral, Dublin, in 1348. If, as seems possible, he ordered this splendid psalter soon after his installation as prior, then its execution could well have been underway during the years of the plague, 1348–49. The initial heads of Christ may have been intended as visual prayers to the Saviour for deliverance from the pestilence.

STYLISTIC CONNECTIONS BETWEEN THE FLEMISH MANUSCRIPTS OF VAN DER BORCH AND THE ENGLISH MANUSCRIPTS OF THE EGERTON GENESIS ARTIST

The four English manuscripts considered above can be connected by elements of style and iconography and by shared techniques of execution with the Flemish manuscripts by Michiel van der Borch.

1. Solidity of form

The interest in solidity of form which marked the Flemish manuscripts and which was articulated with painterly modelling is continued in the English series, but with modifications which reflect the artist's exposure to both English and new Italian influences. In accordance with the English preference for the linear, modelling is by means of refined penwork shading. Italian, particularly Sienese influence, is manifested in the change to a thinner, more clinging drapery which gives a stronger sense of the underlying body than does the heavy fabric with strongly projecting folds which is found in the Flemish manuscripts (cp. figs 64, 75). The interest in Italianisms is not in itself new, however. In the Flemish manuscripts this interest is manifested mostly in the iconography, while in the English manuscripts it is manifested in stylistic elements, first Sienese, then Bolognese, as noted above.

The strong black outlines which reinforce the feeling for solidity of form in the Flemish manuscripts become the firm, assured, and more refined outlines of the English manuscripts.

As Pächt noted in his discussion of the Egerton Genesis, 'the line drawing, despite the absence of any modelling, is hardly less successful than the finished picture in creating the illusion of solid, bodily forms or three-dimensional space. The reason for this surprising fact is this: in the Egerton Genesis lines or curves do not mark the end of a flat surface or describe a linear form. They are always silhouettes of a stereometric world.'[58] Flemish-Italianate sources explain this feeling for three-dimensional form, so surprising in an English manuscript.

Proportions are slim in van der Borch's illuminations in the Fitzwarin Psalter, perhaps reflecting the elegance of Sienese art; but figures grow thicker in the succeeding manuscripts, as the artist's Flemish feeling for earthbound figures re-emerges, probably under the influence of the squat proportions typical of Bolognese figure style.

2. Expression

In the Egerton Genesis the artist's primary interest is in the human drama and in the exploration of character and personality. This theme has been brought to the reader's attention repeatedly in preceding chapters; it need not be recapitulated here.

The four English manuscripts, no less than the Flemish ones, are marked by a strong feeling for expression. The mood and the emotions of the characters are communicated through gestures, poses, and facial expressions, always with the dual purpose of colourful, forceful storytelling and the probing of human character, in which the artist sees the grotesque as well as the noble. In the Fitzwarin Psalter's Crucifixion, fol. 22r (fig. 64), the exaggerated angles of the Virgin's elbows and head are tensely contained by an almost Byzantine mannered formality to produce a strong sense of emotion. In the James Memorial Psalter, Christ is depicted with great dignity and pathos in the miniatures of the Trial, fol. 4r, Gethsemane and the Entombment, fol. 6v (fig. 60), the Flagellation, fol. 4v (fig. 91), and the Descent from the Cross, fol. 6r (fig. 63). The disciples, on the other hand, are fair game for caricature and burlesque. Their distorted faces and bulging eyes in the Ascension, fol. 5v, and Pentecost, fol. 4v (fig. 91), have a distinctly comic aspect. The Derby Psalter also has a strong component of expression and caricature. The initial for Psalm 52 on fol. 43v (fig. 51) is virtually a little skit, in which the fool and the Augustinian remonstrate as God watches, and each actor says his lines, recorded on a speech scroll beside his mouth. In the initial for Psalm 97, fol. 81v, the coarse-featured, rotund clerics, intently focused on song, are mimicked by two equally earnest hybrids whose faces closely resemble those of the human singers. In the Derby Psalter, a number of faces, including that of Stephen of Derby, in both the initials and in the margins have expressions verging on caricature.

3. Mannerisms

The English manuscripts share a number of mannerisms with the Flemish manuscripts, including those in the rendering of wrists and fingers already noted in the Flemish examples, and one in the drawing of eyes. The manneristic notched wrist occurs in the figure of

Christ on fol. 21v in the Fitzwarin Psalter (fig. 62), in the figure of Christ in Gethsemane, fol. 6v of the James Memorial Psalter (fig. 60), in the figure of David on fol. 54v of the Derby Psalter (fig. 94), and in the figure of Nimrod, fol. 4v, lower right, of the Egerton Genesis. Also found is the elongated, pointing index finger, as that of the angel on fol. 5r of the James Memorial Psalter, that of the kneeling man in the initial for Psalm 38, fol. 32v of the Derby Psalter (fig. 65), and, in the Egerton Genesis, that of the third figure from the right on fol. 7r, upper left, and that of Abraham on fol. 12r (13rJ), upper right. The circumflex eye, discussed in Chapter 5, appears not only in legion figures in the Egerton Genesis, such as those of Zillah and Naamah, fol. 2v, upper right, and that of Abimelech, fol. 10r (11rJ), upper left, but also in the artist's other English manuscripts. Examples include the tormentor to the right of Christ in the Flagellation, fol. 4v of the James Memorial Psalter (fig. 91), and some of the singing monks and mimicking grotesques in the initial for Psalm 97 on fol. 81v of the Derby Psalter. As already noted, this eye is of Franco-Flemish or Flemish origin and appears in Gl kgl. Saml. 3384,8° (fig. 77).

The mannerism of repeated, identical hand gestures, noted in the Flemish manuscripts, is even more common in the Egerton Genesis. As in the Flemish manuscripts, these gestures denote shared understanding, joint action, or symbolic connection. On fol. 7r, upper right, two of Pharaoh's courtiers indicate Sarah with virtually identical pointing gestures which bespeak a shared eagerness. On fol. 10v (11vJ), lower right, Abimelech at left and Abraham at right make similar gestures as they seal their pact concerning the well. On fol. 11r, upper left, two members of the Trinitarian group visiting Abraham point to him with curiously crooked wrists and spreading fingers, gestures which are, again, closely similar. On the verso of this leaf, fol. 11v (10vJ), upper left, Lot and one of the costumed Sodomites point in the same direction and with identically flexed digits as Lot offers, and the Sodomites consider, his daughters. Examples could be multiplied.

4. Space

The treatment of space as an arrangement of planes parallel to the picture plane has been noted in the discussion of space in the Flemish manuscripts. This treatment is also a hallmark of the Egerton Genesis, as is discussed at length in Chapter 5. For example, the dwelling of Abraham on fol. 11r (10rJ), upper left, can be read as a series of eight planes parallel to the picture plane: the oven, the lean-to wall, the crenellated wall, the upper wall, the chimney, two rows of small roofed buildings, and a final row of chimneys. The rationally organised architecture in the two illuminations by van der Borch in the Fitzwarin Psalter is similar in character (figs 62, 64). Both English examples bear comparison with the city of Jerusalem on fol. 152v of the *Rijmbijbel* (fig. 66). In the latter example the city is laid out in five rising and receding spatial planes marked by crenellated walls, interspersed with other planar elements. Diagonals are relatively few and are less rationally handled, in both the Egerton Genesis and the *Rijmbijbel*, than are elements parallel to the picture plane.

5. Colour

The palette of the Egerton Genesis is weighted to greys, pinks, and oranges, the latter orig-
inally even more than is now apparent because much opaque peachy-pink and orangey-
beige pigment has flaked off the parchment. These colours, along with blue, dominate the
palettes of the Flemish manuscripts (pls Ia, Ib, II). In the Egerton Genesis, blue is used in
touches throughout, and quite extensively in the landscapes on fols 10r (11r J) through 13v
(12vJ). Gold and silver washes also occur in the Flemish manuscripts and are used in the
Egerton Genesis manuscript as well. The Egerton Genesis includes much more green than
the Flemish manuscripts, primarily in the trees and grass of its landscapes, and it has touches
of many shades of various hues, but the colouristic keynotes of the Egerton Genesis and
Flemish manuscripts are very similar. Grey and orange are the predominant colours in the
monumental architecture, and hence of the entire image, on van der Borch's pages of the
Fitzwarin Psalter. Probably coloured by van der Borch, the monumental figure of Jesse on
the *Beatus* page, fol. 1r of the Derby Psalter is almost entirely in pink, grey, orange, and blue,
which are, together with maroon, gold wash, and green, the main colours in this manuscript.
Only the James Memorial Psalter has a very different palette, of blue, red, gold, and green.
As noted above, the first illumination in this manuscript is not by van der Borch; the
Mocking of Christ and the Resurrection on fol. 3v are by an artist closely related to (perhaps
identical with) the English Bohun artist. The colours chosen by the first artist are used by
his successor as well.

6. Inkblot transfers

On at least two pages in the James Memorial Psalter, fols 3v and 5r, there are inkblot transfers
from the black penwork of the squiggles and outlining of the balls on the page facing.[59] In
the folios of the Egerton Genesis, the black ink of outlining or detailing, apparently applied
in the final stages of work on a folio, frequently left an impression on the facing page, as
though one sheet were laid upon the other before the ink dried. On fol. 3v, bottom centre,
there are impressions of foliage balls from fol. 4r, and at top left, both to the right of Noah
and below him, there are impressions of the black doorways of the ark. On fol. 6v, upper right,
a smudge between the heads of Lot and Sarah is seen to be a transfer from the hair of the dark-
skinned man beside Abraham on fol. 7r, upper left. Many more examples are noted in Chapter
2. Numerous inkblot transfers have been noted on the pages of the Flemish manuscripts, espe-
cially Douce 6 and Gl kgl. Saml. 3384,8°.

7. Penwork flourishing

The line initials of the Egerton Genesis are flourished throughout the first gathering, which
ends with fol. 7. On fol. 2r the flourishing is elaborate (figs 1, 3), as though in an attempt to
compensate with decoration for the repetitive sequence of figures. The flourishing on this page

has much in common with that of Douce 6 (figs 76, 2), the most highly flourished of van der Borch's Flemish manuscripts. Some of the common features are the following:

a. A decorative vocabulary which prominently features pearl strings, spirals, corkscrews, floating circles, and plant forms. In the Egerton Genesis pearl strings are longer than in Douce 6. Streamers in both manuscripts may terminate in foliage, corkscrews, or loops, the latter often becoming small spirals in the Egerton Genesis. Foliage is more feathery in Douce 6, more precisely defined as trilobate leaves in the Egerton Genesis. However, the line-ending above the head of Cain, third figure from the left, lower left on fol. 2r of the Egerton Genesis (fig. 1), employs the same feathery forms as the foliage in Douce 6. Floating flowers also appear in Douce 6; in the Egerton Genesis there are floating flower-like forms composed of several circles (fig. 3).

b. Compressed vertical loops whose knobbed tips bend, usually to the left. In Douce 6 these are not nested, as they are in the Egerton Genesis, but they often occur in pairs.

c. Spirals bordered by pearl strings (figs 1, 2).

d. Spirals within line initials (figs 1, 76).

e. A preference for streamers with closed forms and vertical-horizontal orientation above the text and for streamers with open forms and diagonal orientation below the text.

In comparing the flourishing in the Egerton Genesis with that on pages illuminated by van der Borch in Douce 6, one has the impression that things have crystallised and come into sharper focus in the English manuscript. This difference closely parallels that in figure style between these two manuscripts. However in both manuscripts penwork curves are easy and graceful, and designs are richly nuanced. Flattened passages are opposed to more strongly curved ones, the two mediated by smooth transitions; diagonals are used with horizontals and verticals, the latter decorating spaces both above and below initials; clockwise spirals alternate with counterclockwise. These features contrast markedly with the stiffer, less varied, and more patternised penwork by van der Borch's colleague in Douce 5 (fig. 80).

In Chapter 2 above, we conclude that the two scribes are the flourishers in the Egerton Genesis. In Douce 6 the artists are the flourishers. If, as is now apparent, van der Borch is artist and flourisher in both Douce 6 and the Egerton Genesis, then we may conclude that he is the first scribe in the Egerton Genesis.

ICONOGRAPHICAL CONNECTIONS BETWEEN THE ENGLISH AND THE FLEMISH MANUSCRIPTS

The Egerton Genesis contains many iconographical quotations and paraphrases from van der Borch's Flemish manuscripts. Many of these iconographical connections have already been noted in the discussion of each scene of the Egerton Genesis in Chapter 3. Here they will be summarised. The other English manuscripts with illumination by van der Borch have far fewer of these references but are related iconographically to Flemish traditions in other ways. Some of these relationships will be noted.

1. Fitzwarin Psalter

The illumination of Christ in Majesty, fol. 21ᵛ, by van der Borch, can be connected to the full-page illumination of the Last Judgement on fol. 78ᵛ of Douce 6 (figs 6, 62). Both show Christ enthroned and displaying his wounds. He is seated beneath an architecture of three gables and four pinnacles, the gables decorated with crockets and fleshy acanthus finials, backed by a crenellated wall. This wall is low in Douce 6, but in the Fitzwarin Psalter it is part of a tall structure of walls, pinnacles, and rooftop buildings reminiscent of the architecture in Douce 131.[60]

In the Last Judgement of Douce 6, cusped quatrefoil medallions, each containing a trumpeting angel, are found in the four corners of the illumination. These resemble, and may help explain, the four rather oddly placed medallions enclosing the evangelists' symbols in the Fitzwarin Majesty. Two of these are corbels for the gabled frame, and the other two decorate the front of the throne.

2. James Memorial Psalter

The prefatory programme of this psalter, consisting of pairs of miniatures of events from Christ's life in conjunction with prayers at the canonical hours with which each pair of events is associated, is rare in English psalters of the first half of the fourteenth century.[61] It may relate to the Flemish and Liège practice of prefacing divisions of the text, in psalters and books of hours, with pairs of Christological and hagiographical images.[62]

3. Derby Psalter

Three of the six initials by van der Borch in the Derby Psalter, those for Psalms 38, 68, and 97, are illustrated with subjects used in MS 135 E 15, where, as noted above, the artist seems to have transposed the very similar images for Psalms 26 and 38. In both manuscripts the kneeling supplicant points with a long, curving forefinger and holds up his other hand (cp. figs 65, 69). The face of God emerges from a cloud above him and to the right. In the Derby Psalter, on fol. 32ᵛ (fig. 65), the curving forefinger, gesturing hand, kneeling posture, and face of God also appear. Here the man is not crowned. At Psalm 68, fol. 54ᵛ, of the Derby Psalter (fig. 94) and fol. 99ʳ of MS 135 E 15 (fig. 85), the nude crowned David, hands together in prayer, appears in the waters of the lower section of the S, and God emerges from a cloud to bless in the upper section. At Psalm 97, fol. 81ᵛ of the Derby and fol. 144ʳ of MS 135 E 15, tonsured clerics or monks sing from an open book displayed on a lectern.

4. Egerton Genesis

Masons are observed with especial interest in the Egerton Genesis and in van der Borch's Flemish manuscripts. They are shown working with a distinctive triangular trowel with angled

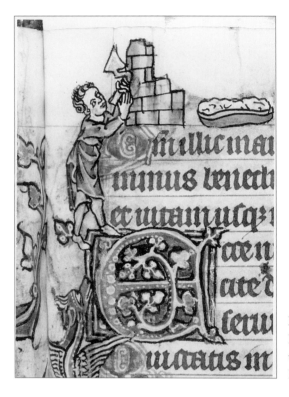

FIG. 95: Psalter. Oxford, Bodleian Library, MS Douce 6, fol. 129r, detail, upper left margin: Mason at work (Photo: Bodleian Library, Oxford)

handle in the Egerton Genesis on fol. 5v (fig. 22), in the *Rijmbijbel* on fol. 9v (fig. 67), in Douce 6 on fol. 129r (fig. 95), and in Gl kgl. Saml. 3384,8° on fol. 36r (fig. 24). Masons also work stone by carving, chiselling, or hammering: in the Egerton Genesis on fol. 8r, lower right; in Douce 6 on fols 84v, 95r, and 197r; in Gl kgl. Saml. 3384,8° on fol. 114r (fig. 78).

Also of particular interest to van der Borch are beggars, whom he observes with sympathy, realism, and humour. In the Egerton Genesis, fol. 11r (10rJ), bottom, a Sodomite brutally beats two beggars in ragged fur garments (fig. 39); in Walters 82, on fol. 193v, bas-de-page, a foot-less beggar holds a bowl in his mouth (fig. 72); in Douce 6, on fol. 110v, upper margin, a beg-gar with stumps for fingers and legs crawls with his bowl in his mouth (fig. 40); in Douce 6, on fol. 98v, a woman drops a coin into a blind beggar's bowl, held in the mouth of his guide dog, while Christ, in a cloud above, blesses this act of charity; in Gl kgl. Saml. 3384,8°, on fol. 126v, St Elizabeth of Hungary gives alms to a beggar on crutches. Examples could be multi-plied.

Interest in the sexual and scatological is strong not only in the Egerton Genesis but also in van der Borch's work in Walters 82 and Douce 6. The Egerton Genesis includes scenes of rape, fol. 17r, lower right (fig. 46); fornication, fol. 19r, upper left; incest, fol. 11v (10 vJ), lower left and right; and sodomy, fol. 11r (10r J), lower half. In Walters 82, lovers and a bathhouse scene appear on fol. 100r (pl. Ib); in Douce 6, lovers appear on fols 79r, 106v, 138r, and 160v. In the Egerton Genesis, Abraham's large genitals are prominently displayed on fol. 9v; in Walters 82,

in the initial on fol. 52r, a fool shows his genitals; on fol. 62v of Walters 82 is a ram with large golden testicles. A remarkable repetition is the image of a horse defecating, depicted in the Egerton Genesis on fol. 13v (12vJ), lower right; and in Walters 82, on fol. 52r (fig. 45). In Douce 6, fol. 181v, a seated demon defecates. Again, examples of the sexual and the scatalogical in both Walters 82 and Douce 6 could be multiplied. By contrast MS 135 E 15, the *Rijmbijbel*, and Gl kgl. Saml. 3384,8° contain relatively little of the scatological and sexual (though Gl kgl. Saml. 3384,8° does have images of bodily functions—men vomiting, fols 54r and 82r). Perhaps the interests and attitudes of the patron in some measure directed the selection of subjects for the margins in each manuscript.

A fringed altar cloth with two fringed panels is found on fol. 8r, lower right, of the Egerton Genesis; on fol. 147r of MS 135 E 15 (pl. Ia); on fols 31r and 48r (fig. 30) of the *Rijmbijbel*; on fol. 2v of Gl kgl. Saml. 3384,8°. This type of cloth appears in manuscripts of the 1340s produced in Ghent, as is noted in Chapter 3 in the comments on fol. 8r, lower right, of the Egerton Genesis. A dragon-like beast in the grass is found on fol. 18v, upper left, of the Egerton Genesis and on fols 61r and 152v of the *Rijmbijbel* (fig. 49). In each image it is associated with treachery or disaster. The motif of a soldier slicing with his sword through the helmed head of an enemy is found on fol. 8v, lower right, of the Egerton Genesis and on fol. 49r of the *Rijmbijbel*. An enclosure with crenellated walls anchored by cylindrical towers with conical roofs is found on fol. 17v, upper right, of the Egerton Genesis and on fol. 96v of the *Rijmbijbel*. Blacksmiths with tongs and hammer appear on fol. 2v of the Egerton Genesis and on fol. 60r of Gl kgl. Saml. 3384,8°. Dark-skinned men, perhaps African, appear on fol. 5r, upper right, of the Egerton Genesis; in Douce 6 on fols 63r (fig. 20) and 68r; in Gl kgl. Saml. 3384,8° on fol. 69r; and (with dark face only) in Walters 82 on fol. 197r (fig. 21). In the Egerton Genesis on fol. 11r, upper right, a kneeling servant blows on the fire under a pot resting in a tripod frame; in Gl kgl. Saml. 3384,8° a figure blows through a tube on a fire under a similar pot (fig. 38).

As is noted in Chapters 2 and 3, the illuminations of the Egerton Genesis show that the artist was familiar with the content of Comestor's *Historia Scholastica*, on which he often drew for iconographical material when composing images, even when the accompanying inscriptions refer to Comestor not at all. Michiel van der Borch, literate in Middle Netherlandish, illustrated the *Rijmbijbel*, a free adaptation of Comestor in Middle Netherlandish, and would have had an acquaintance with Comestor by way of Jacob van Maerlant's work.

SUMMARY AND CONCLUSION

Although it is certainly singular in many respects, the Egerton Genesis is not an entirely isolated work, neither stylistically nor iconographically. In various ways and with varying degrees of closeness, it is related to many other manuscripts. Its connections to the three English psalters and to the Flemish manuscripts by van der Borch are numerous. Members of this group of manuscripts are embedded in a matrix of interconnections which include stylistic concepts, techniques of style, iconographical elements, techniques of execution, and

Italianisms. Most importantly, these manuscripts manifest an interest in strongly modelled human figures and in dramatic human expression.

A second group of manuscripts to which the Egerton Genesis is related are those with which its connections are, in the main, unusual iconographical vignettes or discrete elements of style, sometimes numerous but not constituting the dense web which connects members of the first group. The manuscripts in this group, not consistently interrelated among themselves, are from three regions: Ghent and St-Omer-Thérouanne (the *Spiegel historiael*, Walters 88, Additional MS 36684/Morgan 754), Norwich (Ormesby, Gorleston, Douai, and St Omer Psalters), and Italy (Bolgnese manuscripts and the Paduan Bible). The St Omer Psalter shares with the Egerton Genesis a number of unusual iconographical vignettes, as noted above. In addition there are in the St Omer Psalter iconographical and stylistic parallels with the Fitzwarin Psalter. The straight, stiff body of Christ on fol. 120r of the St Omer Psalter is in both Crucifixion scenes in the Fitzwarin (fols 14r and 22r). The St Omer Psalter's stylistic Italianisms provide some of the best English antecedents for those in the Fitzwarin Psalter. Perhaps the artist of the St Omer Psalter was a friend or acquaintance of van der Borch, who certainly knew his work. The *Spiegel historiael* and the Paduan Bible also provide many striking similarities among the Flemish and Italian works respectively.

Finally there is a third group of manuscripts, connections to which tie the Egerton Genesis into the mainstream of English, Flemish, and northern French illumination of the first half of the fourteenth century. A number of these similarities are noted in the conclusion to Chapter 3.

There is no other group of manuscripts which affords the sheer number of iconographical parallels to the Egerton Genesis that van der Borch's Flemish books provide. To these connections may be added the parallels in style, working methods, penwork flourishing, and interest in plastic form, expression, and human character. All this evidence indicates that the Fleming Michiel van der Borch was in fact the artist of the Egerton Genesis.

'Unless it is acknowledged that illuminators at this date were especially keen to experiment, even to the point where their styles become transformed, vital links between manuscripts, and indeed workshops, might be overlooked'.[63] We concur with Dennison's view that profound stylistic transformation was indeed possible for these fourteenth-century manuscript illuminators. In van der Borch's case, the assimilation of new techniques, the development of techniques new and old, and an ever-expanding repertoire of motifs and iconography resulted in profound changes in his art across two decades. Yet his overriding concerns remained the same, as did certain fundamental artistic preferences. He was consistently interested in the human drama and in the articulation of human character and personality. He always preferred solid, weighty figures and set them in spaces constructed primarily as planar layers. His reverence for Christ and Mary and his respect for the Creator were always touched with a feeling of human tenderness. Many idiosyncratic motifs and mannerisms used in works of the earlier years reappeared in those of the later years. The changes in his style generated stronger, more effective means for the expression of these unchanging interests and attitudes.

Notes

1 See Chapter 3, n. 41.

2 See Chapter 3, n. 50.

3 See Chapter 3, n. 5.

4 See Chapter 3, n. 14.

5 See Chapter 3, n. 33.

6 We wish to thank Mr Erik Geleyns of the Koninklijke Bibliotheek in The Hague for this translation, and Dr Anne S. Korteweg, Curator of Medieval Manuscripts, Koninklijke Bibliotheek, for securing his assistance on our behalf.

7 Boeren, p. 50.

8 Ekkart, pp. 33–34; Peter van Dael, 'De illustraties bij de proloog en het scheppingsverhaal in de "Rijmbijbel" van Jacob van Maerlant: woord en beeld', in *Scolastica willic ontbinden*, p. 105 and p. 106, n. 11; various scholarly opinions on the origins of van der Borch are summarised on pp. 120–121.

9 Brandhorst and Broekhuijsen-Kruijer, p. 88.

10 H. P. Kraus, *Catalogue 115* (New York: Kraus, 1966), p. 13.

11 See Kraus, pp. 13–14.

12 Randall, *Belgium*, pt. 1, p. 9.

13 Kraus, p. 13.

14 Randall, *Belgium*, pt. 1, p. 77. Stones, 'Another Short Note', p. 188, writes that 'the calendar points to a Benedictine house dedicated to St. Lawrence in the docese of Cambrai'.

15 Randall, *Belgium*, pt. 1, p. 77.

16 We differ from Randall, *Belgium*, pt. 1, p. 82, who sees in Walters 82 'workmanship by several artists working in related style, figures in larger initials and margins more ably rendered, different pair of collaborators beginning f. 171'.

17 Randall, *Images*, p. 31; Pächt and Alexander, I, 22.

18 Carlvant, 'Collaboration', p. 164.

19 Carlvant, 'Collaboration', pp. 135, 145–147.

20 Carlvant, 'Collaboration', p. 143 and n. 11, first distinguished the two hands in this manuscript.

21 Carlvant, 'Collaboration', p. 162, n. 52.

22 Carlvant, 'Collaboration', pp. 140–145.

23 Carlvant, 'Collaboration', p. 145.

24 Ekkart, p. 39.

25 Ekkart, pp. 37.

26 Ekkart, pp. 37, 39.

27 Stones, 'Another Short Note', p. 189.

28 Stones, 'Another Short Note', p. 188.

29 Stones, 'Another Short Note', p. 188–89.

30 Carlvant, 'Collaboration', pp. 145–146; Ekkart, p. 39; Stones, 'Another Short Note', p. 188. For possible origin of the *Spiegel historiael* in Ghent, see Meuwese, pp. 448, 450.

31 See Smith, 'Canonizing the Apocryphal', pp. 358–392, for discussion of this episode, which is depicted in Egerton 2781. She discusses the miniature in the *Rijmbijbel* on pp. 368–370.

32 Scatalogical imagery from Morgan 754 is reproduced in Camille, p. 50, ills 25–26. More such imagery in Additional MS 36684 is found on fols 14ʳ, right margin, 28ʳ, right margin, 38ʳ, top of page, 51ᵛ, right margin, 56ʳ, left margin. A number of similar marginal images have been whited out, presumably by an owner who found this imagery objectionable.

33 Stones, 'Notes', p. 197.

34 p. 449.

35 See Randall, *France, 875–1420*, fig. 113, for illustration.

36 Randall, *Belgium*, pt. 1, p. 85.

37 'Collaboration', p. 141.

38 See Carlvant, 'Collaboration', p. 143, n. 11, for the folios with work by the assistant.

39 Randall, *Belgium*, pt. 1, p. 77, dates Walters 82 1315–1325; Pächt and Alexander, I, 22, date Douce 5–6 c. 1320–1330; Carlvant, 'Collaboration', p. 135, dates Gl kgl. Saml. 3384,8° to the 1320s.

40 'Stylistic Sources', pp. 95, 108–116.

41 Measurements for all three English psalters are from the respective catalogue entries in Sandler, *Gothic Manuscripts*, II.

42 For description of, and bibliography on, the Fitzwarin Psalter, see Sandler, *Gothic Manuscripts*, II, 133–135. See also Isa Ragusa, 'A Gothic Psalter in Princeton: Garrett MS. 35' (unpublished doctoral dissertation, New York University, 1966), p. 101, and Dennison, 'Stylistic Sources', pp. 59–79.

43 *Gothic Manuscripts*, II, 134; 'Stylistic Sources', pp. 65–66.

44 pp. 73–74.

45 Hull, 'Douai Psalter', I, 210.

46 C. J. P. Cave, *Roof Bosses in Medieval Churches: an Aspect of Gothic Sculpture* (Cambridge: Cambridge University Press, 1948), p. 12.

47 Wormald, see especially p. 74.

48 'Stylistic Sources', pp. 124–129; see p. 115, n.2, for bibliography on this psalter and pp. 115–126 for a discussion of style and identification of artistic hands in this and related manuscripts.

49 Reproduced in Sandler, *Gothic Manuscripts*, I, 33.

50 See Dennison, 'Stylistic Sources', p. 115, n. 3, for bibliography on this missal.

51 See Dennison, 'Stylistic Sources', p. 116, n. 6, for the division of work in Brussels, Bibliothèque Royale Albert 1er, MS 9427.

52 Reproduced in Oliver, *Gothic Manuscript Illumination*, pl. 129.

53 For description and bibliography, see Sandler, *Gothic Manuscripts*, II, 141.

54 Wormald, p. 74, n. 1, noted a similarity to the Bohun style in this miniature. See Dennison, 'Stylistic Sources', p. 114, for Hand D.

55 Pächt, 'Giottesque Episode', p. 68, and Simpson, p. 115, proposed training in Italy.

56 For description of and bibliography on the Derby Psalter, see Sandler, *Gothic Manuscripts*, II, 142.

57 Dennison, 'Stylistic Sources', pp. 220–222.

58 'Giottesque Episode', p. 68.

59 The Fitzwarin Psalter, with only one bifolium by the Egerton Genesis artist, has not been examined for inkblot transfers.

60 Sandler, *Gothic Manuscripts*, II, 134.

61 See Ragusa, pp. 101–102. For poetry on the canonical hours in the fourteenth century, see Carleton Brown, ed., *Religious Lyrics of the XIVth Century*, 2nd edn, rev. by G. V. Smithers (Oxford: Clarendon Press, 1957), pp. 39–44, 50–51, 69–70.

62 Carlvant, 'Collaboration', p. 138; and Kerstin Birgitta Elisabet Carlvant, 'Thirteenth-Century Illumination in Bruges and Ghent' (unpublished doctoral dissertation, Columbia University, 1978), pp. 273–304. This system is used in Liège books of hours such as Stowe 17 and Baltimore, Walters Art Gallery, MS W. 37. For the latter, see Randall, *Belgium*, pt. 1, pp. 56–64.

63 Dennison, 'Stylistic Sources', p. 48. See also p. 38.

CHAPTER SEVEN

<div align="center">—◈◆◈—</div>

General Conclusion: An Interpretation from the Evidence

CAREER AND TIMES OF MICHIEL VAN DER BORCH

Our study suggests the following reconstruction of van der Borch's life.

1. Surroundings and early work in Flanders

Michiel van der Borch was a native of Flanders, a multilingual bourgeois society with an econ-omy heavily dependent on wool trade and on manufacture of cloth. He probably worked early in his career with or under the supervision of the artist of The Hague, Koninklijke Bibliotheek, MS Koninklijke Akademie XX in Ghent, a city in which were illuminated a variety of texts, sacred and secular, traditional and newly composed, in several languages. The senior artist's illuminated oeuvre included not only the Middle Netherlandish *Spiegel historiael* but also Arthurian romances in the French vernacular. His work had connections to illumination in Latin devotional books produced in the Mosan region, as the similarities to Stowe 17 and Additional MS 28784 indicate. In this bourgeois environment, lacking some of the restraints and refinements of taste and manners of a more aristocratic ambience, there was an unusual openness toward subject matter, as exemplified by the older artist's depiction of extreme vio-lence and sexuality. This unusually free artistic environment helped form van der Borch's potential ability and willingness—only fully realised years later—to go beyond the conven-tions in his subject matter.

Van der Borch may have travelled to the northern Netherlands for work on the *Rijmbijbel* and the psalter The Hague, Koninklijke Bibliotheek, MS 135 E 15 in the early 1330s. If so, he had returned to Ghent by the mid-to-late 1330s, as the style and destination of his three heav-ily illustrated psalters indicate. On at least two of these five commissions he worked with another artist; he was not an artistic loner.

2. The decision to emigrate

Ghent was a centre of the cloth industry, which was the basis of its prosperity. The industry declined as English manufacture and trade in woven cloth grew. Unemployment, even famine, resulted from interruption of wool supply. Weaving centres in the Low Countries were so dependent on English wool that a threat to deprive Flemish looms of English wool was

enough to weaken Flanders's traditional alliance with France. Edward III attempted to manipulate trade with the Low Countries to finance the early period of the Hundred Years' War.[1] Van der Borch would have known of the prolonged visits of Edward III, Queen Philippa, and several powerful English noblemen to Ghent and other Flemish cities in the late 1330s and early 1340s. He would have been aware that the English king encouraged Flemish weavers to enter England as a boost to the developing English cloth industry and that Queen Philippa had established a colony of Flemish weavers in Norwich.[2] Perhaps he knew that she visited them during the 1340s to see them at work when her travels permitted.[3] He might have known Flemish artists who illuminated manuscripts commissioned by English visitors to Flanders, of which Bodley 264 may have been one. Thus, economic and psychological conditions were in place to encourage emigration to England.

Hopeful of finding work in East Anglia, centre of the expanding English wool trade, the artist left Flanders, crossing the North Sea, perhaps landing at Yarmouth, the closest English harbour. Thence, he reached Norwich, a commercial and cultural centre where he found himself among compatriots. He quickly learned that Flemish aliens, who kept to themselves and did not submit to control of the guild of native weavers,[4] were subject to harassment by hostile native clothworkers, and that his compatriots had been forced to seek the protection of the king.[5] As an accomplished illuminator, perhaps at times itinerant, and not a commercial threat to competitors, van der Borch was probably better received. At any rate, he sensibly set himself to learn English style.

Van der Borch was not among the first Flemish artists to seek work in England.[6] He probably did not have to seek work long. The busy trade between Low Country provinces and East Anglia and the resulting prosperity of merchants, monks, and land owners would have encouraged him to try his luck among wealthy aristocratic and ecclesiastical manuscript patrons. His obvious skill opened doors for him.

3. Surroundings and initial years at Norwich

Arriving in East Anglia as an alien craftsman, probably in the early 1340s, van der Borch found Norwich to be a cosmopolitan city in which Flemish, Italian, and English tradesmen were much in evidence. He found in Norfolk a population of sheep-owners and other wealthy agricultural producers, both lay and monastic. Local resentment against the wealth and privilege of monastic establishments, with their large land holdings and great herds, providing wool preferred by foreign buyers, did not escape his notice. Friction over grazing rights rankled in English towns.[7] Disputes frequently occurred about boundary lines and the number of sheep allowed in designated areas. Serious infraction of rights to the use of priory lands could be settled by appeal to the king, who usually took the side of the prior, thus fuelling resentment against the priory. Van der Borch heard grumbling about the elegant way of life of the monks, the isolation of the priory from public concerns, the prior's constant pious demands upon the local citizenry. Tales of the violence of the 1272 uprising, when the townspeople burned the priory, were legendary. The artist sensed the unresolved tensions in

mid-fourteenth-century Norwich.[8] He may have noticed growing resentment against the obligation to pay tithes.[9]

Civic religious plays were an element of public life much to the taste of this artist. He likely carried with him to England interest in such popular Low Country drama as the 'ingenious plays' and farces (*abele spelen* and *sotternieën*).[10] He would have witnessed periodic visits of Christmas, Easter, and Plough Monday mummers in East Anglia, with their use of bawdy language and their death-and-resurrection sequences, which represented (and were even originally designed to effect) the rebirth of life after winter.[11] He witnessed and survived, unlike many artists, the devastating loss of life in 1349, when the Black Death reached Norwich. He noted unsuccessful attempts to heal the sick.

The spectacle of eager exchange of money—the bargaining, contracts, and financial compromises of a busy market town—were evident on every hand. Trade in local artefacts during the prosperous years before and after the plague met his eye as part of the city and its environment. He noticed with interest the activities and products of stone carvers in Norfolk, as well as the weavers and craftsmen in cutlery and leather in Norwich.[12]

Initially, van der Borch worked in Norwich with at least one of his countrymen. Commissions were somewhat different in England than in Flanders. English patrons, aristocratic or ecclesiastical, preferred psalters larger in size than the small devotional books used by the bourgeois of Ghent. The secular literary texts composed in the vernacular, so popular in Flanders, were rarely commissioned in England. Royal and aristocratic tastes introduced into the artistic milieu of England an element of refinement and restraint.

At first van der Borch seems to have set aside much that was Flemish in order to assimilate new artistic resources and to adapt his style to the tastes of English patrons. He absorbed English linearity, which refined his already assured draughtsmanship and hardened his style. The fluid, painterly modelling of the Flemish manuscripts was translated into a highly refined and accomplished penwork shading, a form which he might have seen in works like the Gorleston Psalter. Van der Borch's interest in solid, three-dimensional form did not change, but the means of articulating that interest changed radically. The rigidity and control of his style in the Fitzwarin Psalter suggest a sort of initial hesitancy in his work in England, as though he were trying to orient himself in a new artistic environment.

In England he began incorporating into his art elements of Sienese origin, such as fuzzy hair and refined plastic figure style. Were these elements recalled from Sienese works seen in Ghent, or were they derived directly from Sienese works in England, such as a panel painting displayed on an altar or chapel accessible to the artist, or in the shop of a local merchant,[13] or were they borrowed indirectly from manuscripts in the Norwich area? However he came into contact with Sienese painting, he absorbed elements of Sienese figural and hair style. The Fitzwarin Psalter shows his assimilation of these features. In addition, in Bolognese works he remarked backviews and foreshortening. These stylistic elements, which he began to incorporate in the James Memorial Psalter, he could have seen in decretals in the library of the civic law courts,[14] or in works owned by law students who had studied in Bologna, or in books introduced by one or more of the Italian merchants in Norwich. The depiction of lively fig-

ural activity in Bolognese miniatures influenced his work in the Egerton Genesis. He must also have seen and learned from a North Italian Bible. Any of these sources or still others could have introduced him to Italian characteristics which he eagerly absorbed into his own work.

Within a few years, gaining confidence in the English artistic environment, van der Borch began to reintroduce more Flemish elements, without fear that they would somehow compromise the quality or desirability of his work. In the James Memorial and Derby Psalters, the Flemish feeling for heavy form, suppressed in the Fitzwarin Psalter, reappeared, articulated now with refined English techniques. These two manuscripts may have been produced at sites other than Norwich. The Derby Psalter may well have been under production during the years of the plague, which spared the life of van der Borch and that of his English collaborator, whose work appears in manuscripts of later decades.

THE EGERTON GENESIS

1. Artistic character

Though van der Borch may have travelled in order to execute the commissions for the James Memorial Psalter and the Derby Psalter, he returned to Norwich to work on the Egerton Genesis. Stylistically and iconographically there is much to connect the manuscript with that city. The Egerton Genesis represents van der Borch's most successful synthesis of Flemish, English, and Italian features of style. The Flemish feeling for heavy form merges with Italian plasticity, and both are articulated with consistently exquisite English linear refinement. This latter feature strongly unifies the manuscript. Throughout, the artist keenly observes and expressively renders his human characters, with an eye for the humour in their weaknesses.

At the same time, the Egerton Genesis manifests enormous diversity. Graceful Gothic figures coexist with bulky Flemish-Italianate ones on almost every page. Hair, eyes, clothing, grass, and trees are rendered with a potpourri of conventions reflective of van der Borch's richly varied artistic sources. Flemish motifs re-emerge *en masse*, making this in many ways the most Flemish of his English manuscripts. Everywhere there are disjunctions and discontinuities. If the unity and synthetic mastery of his style speak of a highly capable and mature artist, the vast reservoir of motifs speaks of a widely experienced one. Contradictions in working practices suggest that disjunctions, in places jarring, may have had a psychological dimension. Hasty, final outlining and hasty collating create unsightly inkblot transfers, which repeatedly compromise the beauty and elegance of painstaking draughtsmanship and time-consuming penwork shading.

2. Textual character

The text of the Egerton Genesis, imposed after the completion of the images, is sometimes completely harmonious with the image, at other times only partially relates to the image, or differs radically from the visual image it purports to explain. Where the text is purely factual,

as on folio 2ʳ, the first scribe, whom we identify as Michiel van der Borch, the artist, tends to stick to the biblical Genesis as his source. This may be because he is illustrating the days of Creation or early genealogy. In his final inscription (fol. 2ᵛ, upper right), where he is training his successor and where the more interesting narrative begins, he launches into Peter Comestor's version of the biblical story.

The second scribe, responsible for fol. 2ᵛ, upper left and the remainder of the inscriptions in the manuscript, continues to rely heavily on Peter Comestor's text, even to the point of including much more material than is pertinent (fols 9ʳ, lower left, and 9ᵛ, upper right). He may also tell the story related to the scene in his own words, using remembered material not positively identifiable in any source (fols 7ʳ and 7ᵛ). The text is thus dependent, not only on the writer's assessment of the scene, but also on his own familiarity with the story elsewhere encountered and his willingness to veer from the source. This second writer uses the French imaginatively, sometime failing to explicate the image accurately, but at other times enlivening the reader's enjoyment with his own flights of fancy.

3. Social document

The shock of the social disruption caused by the Black Death and its immediate aftermath may have prompted van der Borch to introduce into his scenes something of the uninhibited spirit of the fabliaux and of Reynard the Fox, oral forms familiar in the culture from which he came.[15] A temporary collapse of social norms precipitated or was paralleled by a collapse of the conceptual boundaries between margins and centre in illumination.[16] This brief episode of radical instability allowed him room to depart from a traditional interpretation of the biblical Genesis expected by theologians and devout laymen—to introduce into many of his Genesis scenes indecencies usually relegated to border images, even in manuscripts he knew in his native Flanders. Van der Borch may have responded to the request of a patron, perhaps himself a Fleming by background, who had found social conditions in East Anglia after the plague suitable enough to permit him to request and accept a highly unconventional book.[17] The Egerton Genesis's designer-artist felt free to paint with stark realism the human foibles of revered biblical personages. Figures of powerful persons resented by the public—selfish tyrants, ineffectual monks and doctors, venal priests, greedy traders, quarrelling sheep herders—all appear in his visual narrative of Genesis scenes.

4. Evidence of origin in the manuscript

Close observation of scenes in the Egerton Genesis itself discloses many threads tying this manuscript to Norwich. Multiple clues present themselves. Having left a land of weavers for another weaving centre, the designer-artist would have been partial to the figure of Naamah, the daughter of Lamech, with whom weavers traditionally associated themselves (fol. 2ᵛ).[18] In his adopted town, van der Borch observed the sale of locally produced brooches, knives, gloves, belts, and leather aprons, articles in practical use or distributed as gifts (fols 1, 8ʳ, 11ʳ

(10ʳJ), and 17ʳ).¹⁹ Everywhere the artist watched money changing hands, between merchant and producer, foreigner and native, or simply distributed as largesse. The eager counting of money must have been a fascinating sight in prosperous urban centres such as fourteenth-century Ghent or Norwich (fols 10ʳ (11ʳJ), 17ʳ and 18ᵛ). Walking the streets of Norwich, the artist would have seen multiple examples of simple round towers (fol. 5ᵛ). He could have observed the vaulted culverts which served for water supply or drainage (fol. 11ʳ (10ʳJ)).²⁰ He had depicted similar vaulted conduits in Flanders and was reminded of them again in Norwich. Whether or not hostile wrestling was the result of disputes over grazing rights, the artist certainly noticed and represented vividly in his Genesis Picture Book the popular wrestling contests associated with public entertainment or with the religious drama (fol. 7ᵛ). Lack of respect for the bishops of Norwich, who often took royal service more seriously than their duties as churchmen or the affairs of their urban neighbours, did nothing to ease disputes between the city and the priory, which controlled large areas of ecclesiastical lands.²¹ The bitter continuing struggle between lay- and priory-managed access to disputed grazing lands in the environment of Norwich is reflected in this artist's unusually full treatment of such a dispute which resulted in the parting of Abraham and Lot (fol. 7ᵛ, 8ʳ). The artist, even while living in Flanders, and certainly in Norwich, recognised wool as the source of power in England. He thus found it appropriate to pose his imperious Pharaoh on a woolsack, the seat and symbol of power of the royal chancellor and of the judges of parliament (fol. 20ʳ).²² Scenes in mummers' plays of resuscitation of the suddenly stricken by the comic doctor could be related ironically to the helplessness and incompetence of those attempting to effect cures, so obvious to all during 1349, the year of the Black Death. These ineffectual cures are reflected in the visual narratives of the suffering Pharaoh with his clerical advisers (fol. 7ʳ), and of the stricken Abimelech with his powerless would-be healers, so deftly sketched in their sartorial splendour, holding aloft or pointing to their urine flask (fol. 10ʳ (11ʳ J)). Elements of the dramatic tradition, reflected in the N-Town plays, which have been associated with Norwich, such as the placement of the Lamech scenes within the flood story and the helpful behaviour of Noah's wife, are paralleled in the Egerton Genesis (fols 2ᵛ, 3ʳ). As to the text, there are at least three words used in common in the English N-Town plays and the Norman-French Egerton Genesis, as noted in our Glossary: *cosin*, *happa*, and *purpose*. The designer seems to comment upon the resented practice of tithing in the scene in which Abraham kneels before Melchizedek to offer a cloth full of coins in exchange for the elements of the Eucharist (fol. 9ʳ).²³ These and other vignettes germane to this monument, itself our primary source, must speak for themselves in the absence of all but general historical and cultural testimony.

THE BIBLICAL GENESIS AS SUBJECT

The elemental reality of the biblical Genesis tales themselves invited the designer-artist to give expression to uninhibited exuberance. He was commissioned to produce a secular picture book for the pleasure of his patron and all to whom the owner chose to show it. The very

content of Genesis narratives, revelatory of human weakness as well as strength, which by long tradition had frequently been treated in typologically significant illustration cycles, offered the visual artist an opportunity to discard old patterns, to shake off didactic prudery in depicting human behaviour, and, not infrequently, to introduce elements of comedy. At times he depicted the honoured patriarchs and matriarchs in their all-too-human behaviour. The Egerton Genesis designer judged this to be the taste of his patron. At the same time, the artist treated noble impulses of certain Genesis characters with the greatest respect, even with tenderness: Sarah prays compassionately for the ill Abimelech (fol. 7r); Abraham, followed by his cross-bearing child, slowly climbs the hillside of Mount Moriah through trees with foliage suggestive of divided hearts (fol. 13r (12rJ)); Jacob's courageous wives, carrying and pulling their children, struggle across the raging waters of Jabbok (fol. 17r). The Creator, though usually speaking from a heavenly cloud, is gently brushed with humanity in the figure who lies exhausted on the grass of Paradise after his fatiguing work of the previous six days (fol. 1v). One of the Heavenly Visitors, who apparently represent the Trinity, eats greedily at Abraham's table (fol. 11r (10rJ)). Even these mild comments on the humanity of the Deity would have surprised viewers accustomed to traditional iconography. Previous representations of Genesis, however inclusive as narrative, had not presented biblical characters in so human a light as does this gifted artist, and certainly not with his comic touch. He was an original.

Could this manuscript have been meant as a parody of the Genesis? This is a remote possibility. But even if so, the artist's mockery is selective: it spares the Divine Being and, though it mocks the foibles of worthy patriarch and matriarch, it also credits their nobler moments. It may reflect acquaintance with some forgotten drama based on Genesis narratives. Certainly the Egerton Genesis is a commentary on the contemporary cultural milieu. That the stories are depicted both ruthlessly and respectfully at the same time is to be expected of an artist whose work is characterised by many discontinuities, who readily shifts from one view of a character to a vastly different depiction of the same character, in both behaviour and appearance, even in contiguous scenes on the same folio (fol. 14v).

THE QUESTION OF THE PATRON

The manuscript itself informs us that the patron was neither royal nor extremely wealthy. The commissioner certainly did not intend the manuscript for the Norwich priory library, since the books given to the library after the fire[24] were largely traditional and the collection had been virtually completed, often by lavish gifts, by the time he ordered his Genesis Picture Book.[25] Certainly, its contents would have been inappropriate.

The patron was not interested in owning this book as a display of wealth, as evidenced by the absence of gold leaf and the spare use of gold wash. However, he was sufficiently well off to order from a seasoned artist a manuscript to his taste. That the first owner could have been a master weaver or cloth manufacturer is suggested by the unusual figure of Naamah, the patron of weavers (fol. 2v).[26]

The commissioner may have offered work to an artist who shared his background and tastes. It is not out of the question that this manuscript's patron was a Flemish immigrant or alien living in East Anglia. If he was an export merchant, he could have been granted as an alien the right to pay customs at native rates.[27] Such a benefit may have helped him to afford a book of his own. A Flemish population of some means in East Anglia in the mid-fourteenth century suggests that an investigation of Flemish manuscript patrons could prove fruitful.

From the worn condition of this unfinished manuscript, one judges that a custodian, perhaps not its commissioner, undervalued his treasure. He afforded his codex little protection, allowing its pages to be roughly turned by many hands. The owner may have used his picture book to surprise and amuse friends and acquaintances with its impertinence.

There is no doubt that the patron wanted the biblical narrative in pictures and probably requested brief inscriptions in French. The artist whom we judge to be identical with the first scribe, came from a bilingual region, as did possibly the patron. The second scribe, who wrote in a legal book-hand, was certainly at home with the French language of the courts.[28]

Enthusiasm for drama is apparent in the many visual references to the civic religious theatre, so popular in East Anglia. The patron and artist, as part of the Norwich cultural scene, were surely aware of the town's long dramatic tradition. They may have known of the Noah play in the N-Town collection which, as before mentioned, ordered scenes in the same sequence as does the Egerton Genesis.[29] Was the patron's association with the theatre closer than that of an amateur, a spectator? That he relished the ribald spirit of the civic religious theatre is evident from the representation of unbridled behaviour. Undertaken during the years of recovery after the Black Death of 1349, the Egerton Genesis was abandoned unfinished. At the time of its discontinuance, its artist was not young. He was at the height of his skill. He necessarily ceased work which he obviously relished and which he seems to have been hastening to complete. We can only guess the reason why. Did the patron find it impossible to pay scribe, painter and initialler sufficiently and long enough to accomplish the completion of this book? Many landowners and even mid-level merchants were plunged into heavy debt because of the king's relentless demands for money to finance his war with France.[30] Extreme fluctuation characterised mid-century East Anglian economy. Did the modest wealth of the commissioner, apparent in the completed portion of the work, diminish while the work was in progress? Did the death of the patron or illness and death of the artist himself prevent the completion of this work? Did the periodic persecution of Flemings affect the patron or the artist? Perhaps most likely, the artist was pressured by a deadline, which was impossible for him to meet. Why did painting, inscription and initialling all cease at different points in *medias res*?

HISTORICAL AND METHODOLOGICAL PERSPECTIVES

In a larger art historical context, how can we see the style of this manuscript and of the artist? In a limited sense it is indeed the product of Panofsky's 'lonely Italianist',[31] in that it shows assimilation of more Italianate elements than does any other English manuscript of its era, the

artist's earlier works included. Alternatively, it could be seen as a unique surviving product of the brief but cataclysmic social and psychological disruptions in the wake of the Black Death, when many working artists died.[32] But it might also be seen as the culmination of a tradition, as the final great exemplar of East Anglian figure style, because its modelling of the figure reflects developments that go back to the Ormesby Psalter, and its drapery systems are partly rooted in earlier East Anglian ones. The attitude of openness to Italian influence also has strong precedents in East Anglian illumination, and in a number of cases the iconography has East Anglian connections.

Van der Borch's emigration from Flanders to England can be viewed in the light of the constant artistic interchange between England and the Channel area of France and Flanders throughout the Middle Ages and beyond. Van der Borch was only one of several Flemish illuminators to arrive in England in the decade preceding the Plague. The artists involved in this particular episode of immigration had a major impact on English illumination of the succeeding decades. Much work could be done to identify these men, to establish their careers in Flanders and in England, and to assess fully their contribution to English fourteenth-century art.

In the context of broad currents in fourteenth-century art, this manuscript can be viewed as a harbinger of the International Gothic Style, which was only to emerge fully toward the end of the century. The mixture of Italian, Flemish, and English elements in the Egerton Genesis marks an early, and not entirely successful, attempt at synthesis of northern and Italian elements, which the Bohun artists would attempt again, before the most successful formulas were developed at the Burgundian court. In both the Bohun and Burgundian workshops, Flemish artists were of the first importance. Van der Borch, no less than these other Flemings, can be seen as an exemplar of the Low Countries' artistic tradition of synthesising the northern and the Italian, a tradition with beginnings at least as early as eleventh-century Mosan Classicism and extending to the time of Rubens. Low Country artists with an interest in the earthy and the grotesque include not only van der Borch but, in succeeding centuries, Bosch and Breugel as well.

Often, in identifying artistic hands in medieval manuscripts, each small difference in style is assigned to a different hand, as though the artist, once trained, were constrained to follow set patterns without the possibility of variation or growth. This approach to identifying artists owes much to the Morellian method, which accords great significance to variation in minor details. Respectful attention to detail is a valuable legacy of the Morellian method, one which should be integrated into a larger and more flexible conception of artistic identity. Van der Borch had a repertoire of motifs and mannerisms; moreover, his repertoire was not static, but changed by accretion and deletion and by internal development. What is unchanging in his art, its benchmark, is his interest in depicting the human drama vividly, realistically, and humorously, and in rendering figures with three-dimensional solidity as a way of anchoring them in the real.

Van der Borch is not necessarily to be taken as a paradigm, but more broadly applicable principles are implicit in the case of his work. One principle is a reaffirmation of the value of

the concept of the artist as an individual. The validity of the study of the individual artist is sometimes lost from view when art is regarded primarily as an artefact or as a social construct. But these views—anthropological, sociological, and individualistic—might be regarded more profitably as complementary rather than as competitive. A correction to the Morellian concept of the artist as an individual is allowing for the possibility of ruptures and discontinuities as part of the experience and artistic style of a single individual. A second correction relates to the linear concept of development. Van der Borch's development involved rupture followed by the assimilation of totally new material and techniques, and finally reintegration; returning artistically to his Flemish roots late in his career, he moved in a fractured spiral rather than in a straight line.

Scrutiny of details of artistic production, of codicology and palaeography, the study of larger artistic concerns, and the investigation of broad social trends and historical circumstances—all may be undertaken profitably in attempting to identify medieval artists and to define and understand their styles. Ultimately, all these approaches interconnect and shed light on each other. A manuscript is all things: a product of culture and society and a product of an individual's conscious and subconscious life, an artefact, and a being with its own vital force.

The personality and career of Michiel van der Borch have begun to take shape. He may even have left us his self-portrait, in the scene of the Flagellation of Christ on fol. 4v of the James Memorial Psalter (fig. 96). The tormentors in the James Memorial Psalter adhere to none of

FIG. 96: M. R. James Memorial Psalter. London, British Library, Additional MS 44949, fol. 4v, miniature of the Flagellation, detail: Flagellator at left, possible self-portrait of van der Borch (Photo: British Library, London)

the usual iconographies.[33] The flagellator at left, at whom Christ gazes sorrowfully, is short, paunchy, middle-aged. He has a shock of unruly salt-and-pepper hair, which grows in a widow's peak at the forehead, small deep-set eyes with bushy eyebrows, and a double chin. Could this be van der Borch? If so, why would he choose to depict himself as a torturer of Christ? A familiar passage from Isaiah may shed some light on the iconography of the James Memorial Psalter: 'He was wounded for our transgressions, he was bruised for our iniquities: the chastisement of our peace was upon him; and with his stripes we are healed'.[34] If this flagellator is van der Borch, he depicts himself as quite literally inflicting his transgressions upon Christ. His choice then may be an act of humility and unsparing honesty in the admission of guilt for personal sin. In this image he visually repeats the request he wrote in the *Rijmbijbel* many years before: 'Pray for him that God may have mercy on him'.[35]

Notes

1 For the politics and economics of the wool and cloth trade between the Low Countries and England, see E. M. Carus-Wilson, *Medieval Merchant Ventures* (London: Methuen, 1954), pp. xvi, 241–249; Power, *The Wool Trade*, pp. 16–18; H. L. Gray, 'The Production and Export of English Woollens in the Fourteenth Century', *English Historical Review*, 39 (1924), 13–35 (p. 23 and passim); T. H. Lloyd, *The English Wool Trade in the Middle Ages* (Cambridge: Cambridge University Press, 1977), p. 134; Mary Lyon, Bryce Lyon, Henry S. Lucas, and Jean de Sturler, *The Wardrobe Book of William de Norwell, 12 July 1338 to 27 May 1340* (Brussels: Palais des Académies, 1983), p. liii.

2 For Edward III and Queen Philippa as promoters of Flemish weavers in England (Norwich), see Bryant, p. 198; E. Lipson, *A Short History of Wool and its Manufacture, Mainly in England* (Melbourne: Heinemann, 1953), pp. 57–58; May McKisack, *The Fourteenth Century: 1307–1399* (Oxford: Clarendon Press, 1959), pp. 366–7.

3 Michael Packe, *King Edward III*, ed. by L. C. B. Seaman (London: Routledge & Kegan Paul, 1983), p. 77.

4 Lipson, *Short History*, p. 59.

5 McKisack, p. 368; W. Hudson and J. C. Tingey, *The Records of the City of Norwich* (Norwich: Jarrold and Sons, 1906, 1910), II vols (1910), lxvii.

6 See Dennison, 'Stylistic Sources', pp. 95, 109–116, cited in Ch. 6 here.

7 Tanner discusses confusion over boundaries granted by charters to citizens and earlier, twelfth-century charters giving to the priory lands in Norwich, liberties still confirmed by the Crown. Tanner, *The Church,* 144, 145. Though these conflicts were evident in other towns, none resulted in violence as severe as that of 1272 in Norwich. For conflict in other towns, see William Savage, *The Making of our Towns* (London: Eyre & Spottiswoode, 1952), pp. 97–101.

8 For the common people's resentment of the clergy of the larger religious houses in East Anglia and friction between the townspeople of Norwich and the priory, see Edgar Powell, *The Rising in East Anglia in 1381* (Cambridge: Cambridge University Press, 1896; repr. Ann Arbor, MI: University Microfilms, 1980), p. 34; Tanner, ch. 4, pp. 141–54.

9 Constable, p. 185.

10 For Low Country drama, see E. Strietman, 'The Low Countries', in *The Theatre of Medieval Europe: New Research in Early Drama*, ed. by E. Simon (Cambridge: Cambridge University Press, 1991), pp. 225–252 (pp. 226, 230); P. M. King, 'Morality Plays', in Beadle, ed., *Cambridge Companion*, pp. 240–64 (p. 255); D. Beecher, D. Campbell and M. Ciavolella, gen. eds; trans. intr., notes by T. de Vroom, *Netherlandic Secular Plays from the Middle Ages: the Abele Spelen and the Farces of the Hulthem Manuscript* (Ottawa: Dovehouse, 1997), Introduction.

11 For Mummers plays, see Alan Brody, *The English Mummers and their Plays* (Philadelphia: University of Pennsylvania Press, 1970), passim; Gomme, pp. 175–177; Tiddy, passim.

12 See text comments for fol. 17ʳ, lower right, in ch. 3 for discussion of articles made in Norwich. Of the 134 trades and occupations recorded for bustling Norwich during the last half of the thirteenth century, at least 25 find counterparts later in the Egerton Genesis. These trades are reflected as products used for producing the codex itself or as activities in process of production or use in the scene: armourer, axe-maker (axsmith), boatman, book-binder, bridle-maker, carpenter, candle-maker, cutler, draper, dyer, harper, hatter, knife-handle-maker, leather cutter, limner, mitten-maker, painter, parcheminer, sadler, scrivener, sculptor, smith (fevre), tailor, weaver: Hudson and Tingey, II (1910), xxvi.

13 Hull, 'Douai Psalter', I, 186–189.

14 For law courts at Norwich, see Hudson and Tingey, I (1906), cxxiii–cxli.

15 For Reynard the Fox in the Low Countries; Reynard and Flemish names, see E. Colledge, ed., A. J. Barnouw, trans., *Reynard the Fox and Other Mediaeval Netherlands Secular Literature* (Leiden: Sijthoff, 1967), pp. 145–165; James, *Romance*, p. 4.

16 For the plague and its immediate aftermath, see Horrox; Goulburn, p. 437; Colin Platt, *King Death: the Black Death and its Aftermath in Late-Medieval England* (Toronto: University of Toronto Press, 1996); James W. Thompson, 'The Aftermath of the Black Death and the Aftermath of the Great War', *American Journal of Sociology*, 26 (March, 1920), 565–72 (pp. 565, 569); Philip Ziegler, *The Black Death* (Harmondsworth: Penguin, 1969).

17 Flemish immigrants were not all impoverished workers. Successful masters of the trade were courted and well received. John Kempe, a well-established weaver, had settled in Norwich in 1331 under letters of protection of Edward III. He brought with him his men, servants and apprentices. See Lipson, p. 57; G. W. Morris and L. S. Wood, *The Golden Fleece: an Introduction to the Industrial History of England* (Oxford: Clarendon, 1922), p. 25.

18 For Naamah and the weavers, see Lipson, *Short History*, p. 49.

19 For products of Norwich, see Ayers, pp. 67–68; James Wentworth Day, *Norwich through the Ages* (Ipswich, Suffolk: East Anglian Magazine, 1976), p. 39; For gifts from the priory, see Saunders, p. 81. See comments on the shop at Shechem, fol. 17ʳ, lower right, Chapter 3, and n. 12 above.

20 For a vaulted culvert excavated in Norwich in 1993, see Ayers, p. 73, illustration 55.

21 Martins, p. 36.

22 For the woolsack as seat of power, see Morris and Wood, p. 13; Power, p. 17.

23 See Chapter 3 above, comments on fol. 9ʳ, upper right.

24 The townspeople burned the priory and its library in the uprising of 1272.

25 For the Norwich Priory library, see Tanner, pp. 35–42; also H. C. Beeching, 'The Library of the Cathedral Church of Norwich', *Norfolk Archaeology*, 19 (1917), 67–116.

26 Norwich was admitting weavers and fullers to the freedom by 1317. The proportion of burgesses to other citizens was increasing in many provincial towns after the mid-century. See A. R. Bridbury, *Economic Growth: England in the Later Middle Ages* (London: Allen and Unwin, 1962), pp. 58, 59, 62. See also comments for fol. 2ᵛ, upper half, on Naamah the weaver, in Chapter 3.

27 Carus-Wilson uses the term 'denizen' to include, along with native merchants, alien merchants who were granted this privilege. See E. M. Carus-Wilson and Olive Coleman, *England's Export Trade 1275–1547* (Oxford: Clarendon Press, 1963), p. 11 and Appendix IV.

28 For Anglo-Norman as living language, see Helen Suggett, 'The Use of French in England in the Later Middle Ages', in *Essays in Medieval History*, ed. by R. W. Southern (London: McMillan, 1968), pp. 213, 231, 235; G. M. Trevelyan, *History of England* (London: Spottiswoode, Ballantyne, 1958), p. 224.

29 Some scholars have suggested that the collection of plays called N-Town or *Ludus Coventriae* may have been copied in Norwich. See Jacob Bennett, 'The Language and the Home of the "*Ludus Coventriae*"', *Orbis*, 22. 1 (1973), 43–63; Chambers, II, 421; E. J. Dobson, 'Etymology and the Meaning of Boy', *Medium Aevum*, 9.3 (1940), 121–154 (pp. 147, 153); J. Dutka, 'The Lost Dramatic Cycle of Norwich and the Grocers' Play of the Fall of Man', *The Review of English Studies*, NS, 35 (1984), 1–13; M. Eccles, '*Ludus Coventriae*: Lincoln or Norfolk?', *Medium Aevum*, 4 (1971), 135–141; H. S. Sherman, '*Ludus Coventriae* and the Bosses of the Nave of Norwich Cathedral: the Christian History of Man in Two Disciplines' (unpublished doctoral dissertation, Michigan State University, 1976), passim. The identification of Norwich as the home of the N-Town plays, or even where they were copied, remains controversial.

30 For an example of an estate ruined by financial service to Edward III, see Edward Miller and John Hatcher, *Medieval England: Towns, Commerce and Crafts, 1086–1348* (London: Longman, 1995), p. 341 and n. 43. A merchant who lost out in the course of the king's wool dealings refused to contribute to a loan being raised by the town of Norwich in 1351. See W. Ormrod, *The Reign of Edward III: Crown and Politcal Society in England, 1327–1377* (New Haven: Yale University Press, 1990), p. 185, n. 91.

31 Erwin Panofsky, *Early Netherlandish Painting: its Origins and Character*, 2 vols (Cambridge, MA: Harvard University Press, 1953; repr. New York: Harper and Row, 1971), I, p. 26.

32 Dennison gives clear evidence of interruption by the pestilence of work on Vienna, Österreischische Nationalbibliothek, Cod. 1826*, when between the years 1347 and 1350 three successive artists undertook the illumination: 'Stylistic Sources', pp. 39, 91.

33 Frequently in scenes of the Flagellation, the tormentors of Christ are depicted with visages grotesquely distorted, as in the Peterborough Psalter in Brussels, fol. 48ʳ, the Ramsey Psalter, fol. 2ᵛ, or with violently contorted poses, the St Omer Psalter, fol. 121ʳ, lower margin; or with both, as in the Fitzwarin Psalter, fol. 12ʳ. Other artists have chosen to include themselves in scenes of the Passion: Rembrandt depicted himself as the sorrowful youth receiving the body of Christ in his Descent from the Cross of 1634.

34 (Isaiah 53. 5, King James Version).

35 '*Bit uoer hem dat ghod sijns ontfarmen moete*'.

Appendix Text: Transcription and Translation, Comments on Sources and Relation Between Image and Text

[We present the text basically as it is written. Abbreviations are expanded in the conventional manner. Parentheses enclose lacunae where words are illegible or where dim text requires a probable reading. They are also sometimes used to clarify meaning. Notes indicate readings which differ from those of James.]

Folio 1ʳ, upper left (Scribe I wrote all inscriptions on fols 1ʳ, 1ᵛ, and 2ʳ.)

TRANSCRIPTION: Coment dieux le pier primerement creat ciel et terre et la terre et tretoutz les ele/mentz estoient adonc en graunt oscurete avaunt qe dieux ordeinat lumer.

TRANSLATION: How God the father first created heaven and earth, and the earth and all the elements were then in great obscurity before God ordained light.

COMMENTS: This text is more like Genesis 1. 1–2 than Peter Comestor.[1] The inscription is by the first Hand, which continues through fol. 2ʳ and is also responsible for the upper right quadrant of fol. 2ᵛ. The text and the scene are harmonious.

Folio 1ʳ, upper right

TRANSCRIPTION: Comment dieux ordeinat la secunde iour un firmament **lusaunt**[2] qi departi les eau(x) / desoutz le firmament et les eaux qeux sunt sour le firmament et apella le firmament (ciel).[3]

TRANSLATION: How God ordained the second day a firmament, so placing it that it divided the waters below the firmament and the waters above the firmament and he called the firmament heaven.

COMMENTS: The text is more like Genesis 1. 6–8 than Peter Comestor. There is an indication of the semi-circular firmament with waters above and below. The text reflects the image.

Folio 1ʳ, lower left

TRANSCRIPTION: Coment dieux ordeinat le tierz iour touz les eaux qeux furrunt desouz le firmament dasem/bler en un lieu qe la terre purreit estre veu et commaunda la terre de verder et porter arbr(es) et frut.

TRANSLATION: How God ordered the third day all the waters that were beneath the firmament to come together in one place so the earth could be seen and ordered the earth to become green and bear trees and fruit.

COMMENTS: The source is not specifically Peter Comestor. It is more like the Vulgate, a paraphrase or shortening of Genesis 1. 9–12. Birds and fish in abundance make the illustration appropriate for the text.

Folio 1ʳ, lower right

TRANSCRIPTION: Coment diex ordeina le quart iour le solail et la lune et les esteilles et les comaunda / denluminer et governer la terre et toutz les elementz et toutz chose qex sunt **eneanz**.

TRANSLATION: How God ordained the fourth day the sun and the moon and the stars and commanded them to enlighten and govern the earth and all things which are therein.

COMMENTS: This text is more like Genesis 1. 14–19 than the *Historia Scholastica*. The created circle here seems almost a replica of the scene at lower left. The sun, moon and stars are not apparent. Presumably, they were once represented, but have been erased by rubbing, as has much of the colour of the Creator figure. The scene is badly worn and torn at the right corner.

Folio 1ᵛ, upper left

TRANSCRIPTION: Coment diex ordeina le quint iour touz les oiseaus de mound et touz les pessouns de la ma/re et fist **dens** grauntz peissouns qez furrent apelleez .**cees**. et les commaunda multiplier.

TRANSLATION: How God ordained the fifth day all of the birds of the world and all the fish of the sea and made therein the great fish called whales and commanded them to multiply.

COMMENTS: This is more like Genesis 1. 20–23 than Peter Comestor. In the *Historia Scholastica*, ch. 7, col. 1061, Peter Comestor uses the word *cete* for enormous sea creature, as does the Vulgate. Birds and fish in abundance make the illustration appropriate for the text.

Folio 1ᵛ, upper right

TRANSCRIPTION: Coment diex ordeina le **syme** iur toutz les bestes de terre et les fist a nostre profist / et les commaunda multiplier a vere[4] cops et donk forma adam a vauls debron.

TRANSLATION: How God ordered the sixth day all the animals of the earth and made them for our profit and commanded them to multiply in great abundance and then made Adam in the Hebron Valley.

COMMENTS: The text seems to come from Genesis 1. 24–31 except for the reference to the Hebron Valley. In ch. 13, col. 1067, Peter Comestor says 'Did Adam remain in the place where he was created, to wit, in the Damascene field? No'. James mentions this text as source for the Hebron Valley reference.[5] The identity of the two locations is doubtful. There may be another source. The Egerton Genesis author refers to the Hebron Valley on fol 2ʳ, at upper left, as the dwelling place of Adam and Eve, near where Cain killed Abel, the Vale of Tears.[6]

The artist depicts a rich variety of animals, but not the Creation of Adam. The text partially describes the miniature, while adding extra information.

Folio 1ᵛ, lower left

TRANSCRIPTION: Come le **syme** iour diex vist qe tot soun overaigne estoit trebone. donc forma il adam / a sa ymage **demeigne** et lui amena en paradis et laa forma il eve de une coste de son cost.

TRANSLATION: How the sixth day, God saw that all of his work was very good. Then he formed Adam in his own image and led him into Paradise and there he formed Eve of a rib from his side.

COMMENTS: Eve's creation is in Genesis 2. 18–23. The scribe again uses the language of the second Creation story here (Genesis 2. 8), perhaps to adapt his text to the scene of paradise, a garden with trees. The Creation of Adam is not shown.[7] The Creator, a standing figure, coaxes Eve forth from Adam's side as he blesses her with his right hand. Adam sleeps at the Creator's feet. The iconography does not reflect the rib mentioned in the text. The writer here refers to Adam's Creation for the second time. Is the artist-scribe's repetition intended to compensate for his failure to include Adam's Creation in either image? The text is not well adapted to the scene.

Folio 1ᵛ, lower right

TRANSCRIPTION: Come le septisme iur deux reposa de tout soun overayn qil fist et cele iour benesqi / oue toutz ses overaignes qil fist et acompli. qaar cele iour acomplist tot son overaygn.

TRANSLATION: How the seventh day God rested from all his work which he did and this day blessed this, all his works, because this day he finished his work.

COMMENTS: From Genesis 2. 1–3. The setting is a wooded garden as before, with flowered grass not observable in the previous damaged illustration. The influence of the Tree of Jesse iconography is notable. In the image, the recumbent Deity is resting, seemingly because he is tired. The scribe emphasises another point which we find in Genesis and Peter Comestor— that God rested because the work was finished. The text does not fully explicate this unusual scene.

Folio 2ʳ, upper left: (The first Hand has written all of fol. 2ʳ. An explanatory inscription introduces the page, followed by text in four columns, one above each figure.)

TRANSCRIPTION: Cest tut la generacioun de Adam. Adam avoit en tut xxxij filz et xxx filles et vesquist (adam) / noef cent anz mais cent anz avantqe Seth fut nee si manout[8] Adam et Eve en la / vale de lermes iuste ebron mais a fontaine la ou Cain oscit Abel et laa fust il et Eve (establi).

TRANSLATION: This is all the generation of Adam. Adam had in all thirty-two sons and thirty daughters and Adam lived nine hundred years, but a hundred before Seth was born. Thus lived Adam and Eve in the Valley of Tears near Hebron at the fountain where Cain killed Abel and there he and Eve dwelled.

COMMENTS: The scribe may have derived his information from different parts of the *Historia Scholastica*. James points out that Peter Comestor mentions the number of sons and daughters of Adam and Eve in the *Additio* to chapter 29 (col. 1080).[9] In ch. 25, col. 1076, Peter Comestor says that Adam and Eve grieved for Abel 100 years. In the *Additio* to chapter 25, the place where they grieved was called the Vale of Tears, next to Hebron, though a fountain is not mentioned. The first scribe has thus referred to Hebron as both the place of Creation of Adam and Eve (fol. 1ᵛ, upper right) and as their later dwelling place, near the site of the fratricide. Only the first sentence applies to the scenes on fol. 2ʳ.

Still folio 2ʳ, upper left: (text in four columns)

TRANSCRIPTION: Adam vesquist cent / trente anz et engendra / Seth et puis vesquist il / .viii. centz anz et morust.

Seth vesquist cent / .v. ans et engendra / Enos et puis vesquist / il .viii. centz et .vij. / anz et avoit filcz et fil/les et morust.

Enos vesquist / lxxxx anz et engendra / Cainan. et puis ves/quist .viij. cent anz / et engendra filcz et fil/les et morust.

Cainan vesquist .lxx. / ans et engendra Ma/laleel puis vesquist / .viii. centz et .xl. anz et en/gendra filcz et filles et / puis morust.

TRANSLATION:

Adam lived a hundred and thirty years and begat Seth and then lived eight hundred years and died.

Seth lived a hundred and five years and begat Enos and then lived eight hundred and seven years and had sons and daughters and died.

Enos lived ninety years and begat Kenan and then lived eight hundred years and begat sons and daughters and died.

Kenan lived seventy years and begat Mahalalel. Then he lived eight hundred and forty years and begat sons and daughters and then died.

COMMENTS:

Genesis 5. 4–5.

Genesis 5. 6–7.

Genesis 5. 9–11. The Bible has eight hundred and fifteen years for the length of Enos's life after the birth of Kenan, whereas this inscription has eight hundred. Four *erratum* points under the numeral lxxxx suggest that the writer knew one number to be wrong. However, he marked the first rather than the second number as being erroneous.

Genesis 5: 12–14.

Folio 2ʳ, upper right

TRANSCRIPTION:

Malaleel vesquist / .lxv. anz et engendra / .iareth. et puis vesquist / .viij. cent et .xxx. anz et / engendra filcz et filles / et puis morust.

Iareth vesquist cent / .lxii. ans et engendra / Enoc. et puis vesquist / .viij. centz anz et engen/dra filz et filles et morust.

Enoc vesquist .lxv. / ans et engendra ma/tusalem. et puis vesquist / .iii. centz anz et engen-dra / filcz et filles et morust.

Matusalem vesquist / .clxxxvii. ans et engen/dra lamech. et puis / vesquist .vii. cent anz / .lxxxii. et engendra filclz / et filles et puis morust.

TRANSLATION:

Mahalalel lived sixty-five years and begat Jared and then lived eight hundred years and thirty and begat sons and daughters and then died.

Jared lived one hundred and sixty-two years and begat Enoch and then lived eight hundred years and begat sons and daughters and died.

Enoch lived sixty-five years and begat Methuselah and then lived three hundred years and begat sons and daughters and died.

Methuselah lived one hundred and eighty-seven years and begat Lamech and then lived seven hundred and eighty-two years and begat sons and daughters and then died.

COMMENTS: The material comes from Genesis 5. 15–26. Verse 24 about Enoch's walking with God and being taken by God is omitted. The dry genealogical text explains the relationships so well represented visually by gesturing hands.

Folio 2^r, lower left

Lamech vesquist cent / .lxxxij. anz et engendra / Noe et puis vesquist (cinq) / cent .lxxxxv. anz et en/gendra filcz et filles et morust.

Noe vesquist v / centz anz et engendra / Sem et Caam et Iaph/eth et puis vesquist .iiii. centz et .xl.[10] / anz et engendra filcz et filles et morust.

La generacioun de Cain (above the text over Cain)

Cain engendra / Enoc et puis / orgina une / cite qe fut apellee / apres le noun de soun ficlz / enoc.

Enoc (engendra) / Irad.

TRANSLATION:

Lamech lived one hundred and eighty-two years and begat Noah and then lived (five) hundred and ninety-five years and begat sons and daughters and died.

Noah lived five hundred years and and begat Shem, Ham and Japheth and then lived four hundred and forty years and and begat sons and daughters and died.

The descendents of Cain

Cain begat Enoch and then founded a city, which was called after Enoch's name.

Enoch begat Irad.

COMMENTS:

Genesis 5. 28; 30–31.

Genesis 5. 32. The detail about Noah's living after the birth of Shem, Ham and Japheth to

produce more sons and daughters is not in the Bible. Perhaps the scribe is thinking of the text he later quotes from Peter Comestor about Noah's descendants through his sons.[11]

Genesis 4. 17. A larger initial begins the line of Cain. James attributes the 'city' reference to Peter Comestor, who himself quotes the biblical text.[12] The descendants of Cain appear earlier than the descendants of Seth in the biblical Genesis.

Enoch begat Irad. This and the following three figures are explained by three words. They are mentioned thus briefly in Gen. 4: 18.

Folio 2ʳ, lower right

Irad engendra / Mauiael.

Mauiael engen / dra Matusahel.

Matusahel / engendra Lamech.

Lamech qestait / le septisme apres adam / estoit tresmauvais / premerement fist / bigamie (qar) il avoit / .ij. femes contre (nature).

TRANSLATION:

Irad begat Mehujael.

Mehujael begat Methushael.

Methushael begat Lamech.

Lamech who is the seventh after Adam was evil. He first committed bigamy for he had two wives, contrary to nature.

COMMENTS:

Genesis 4. 18.

Genesis 4. 19. The information that Lamech was evil, committing bigamy and adultery against nature is in the *Historia Scholastica*, ch. 27, col. 1078, as James points out.[13]

This entire page is reminiscent of a theatrical prophets pageant, as is noted in Chapter 4 here. Pen flourishes decorate this page, as discussed in Chapter 2.

Folio 2ᵛ, upper left: (Upper left and right are one scene. Scribe II has written the inscription for the left side of this image.)

TRANSCRIPTION: Cestui Iabel founda primerment remurement as **faudes** / et severi primes compaignies en deux. et Iubal son frere / fu le premere mestre de musyke en harpe et en orgens. quel mu/syk il controva de la proporcion des coups queux son frere Tubal/caym dona a la forge. ces deux freres engendra Lamek de / Oda sa femme.

TRANSLATION: This Jabal founded first the movement of the folds (movable sheepfolds) and first divided the companies into two. And Jubal, his brother, was the first master of music in harp and organ, which music he contrived according to the proportion of the beats which his brother Tubal-cain gave at the forge. These two brothers Lamech begat of his wife Adah.

Folio 2ᵛ, Upper right: (Scribe I has written the inscription for the right side of this image.)

TRANSCRIPTION: Cestui Lamech out deux femmes: la une out noun Oda. lautre out noun Sella / Sella avoit un fille et un filcz. cestui filcz fust **faeure** de tote manere de / ferre et darrein et primerement trova cele arte et out a noun Tubalcayn. et la seur / Tubalcayn (out) noun Noemma quele primerement trova larte de diverse tiseure.

TRANSLATION: This Lamech had two wives, one had the name Adah and the other had the name Zillah. Zillah had a daughter and a son. This son was a worker of all manner of iron and bronze and first established this art and had Tubal-cain for a name. And the sister of Tubal-cain was called Naamah, she who started the art of making various fabrics.

COMMENTS FOR UPPER HALF OF PAGE:

This elaboration of the material in Genesis 4. 19–22 comes from ch. 28, col. 1079 of Peter Comestor's *Historia Scholastica*. Interestingly, the text at right, written by the first hand, begins with information which precedes it in the source. The text at left, is written by the second hand. See Chapter 2 for discussion of the possibility that the text at right was a demonstration to the new scribe and Chapter 3 for the significance of the weaver, Naamah. The text well reflects this scene. (The Lamech story, interrupted by the Noah story, follows on the next folio. The second hand returns here and continues to the end of the manuscript.)

[Above the figures, left to right: Jubal, Jabel, Oda, Lamech (rubbed, almost illegible), Sella, Tubalcayn and Noemma. The names Oda and Sella are decorated with a double-bordered cartouche with corner flowers. Their names, plus the dim name of Lamech, are written in lighter ink than the names Jubal, Jabel, Tubalcayn and Noemma.]

Folio 2ᵛ, lower left: (Scribe II has written this and all subsequent inscriptions.)

TRANSCRIPTION: Quant Noe fu cynk centz anz il engendra trois fitz Sem / Cam et Iapheth. adonqes dieu counta a Noe coment il de/veroit defaire tote la nature de hom par eawe pro cause de lecherie / et lui commanda qil devereit faire un nief en la quele lui, sa / femme Phuarphara, ses trois filz et lour trois femmes, Parfia, Ceta/fluia et Fluia. de bestes nient nettes deux de mal et deux de / femmale, de bestes nettes sept de lun et sept de lautre purroi/ent estre sauves. bestes nient nettes sont ceux qe ne sont / pas mangeables. et counta dieu a Noe la fourme coment / la nief seroit fair (fait) en longeur en leure et hautesse / come apres enorrez.

TRANSLATION: When Noah was five hundred years old, he begat three sons, Shem, Ham and Japheth. Then God recounted to Noah how he must do away with all nature of man by water because of lechery and commanded him that he must make a ship in which he, his wife Phuarphara, his three sons and their three wives, Parfia, Cetafluia and Fluia, of beasts not clean, two males and two females;[14] of clean beasts, seven of one and seven of the others could be saved. Unclean beasts are those which are not edible. And God told Noah the form in which the ship should be made in length, width and height, as you will afterward hear about. [Above the figures: Noe, puarphara]

COMMENTS: The language is a distillation of information from chs 31–33, cols 1081–1084 of the *Historia Scholastica*. The text begins on the central horizontal dividing line, as if the scribe feared lack of space for his text or as if he confused the border for a ruled line. The use of the word *enorrez* (will hear about) suggests that the writer was familiar with an oral presentation of the Genesis, such as that in the *Histoire ancienne*.

Only the last part of the text seems to fit this illustration, which depicts God instructing Noah as to how to build the ark. Details earlier in the text are not represented.

Folio 2ᵛ, lower right

TRANSCRIPTION: Adonqes fist Noe la nief en la manere come dieu lui avoit / commande cest **assaver** trois centz cubitz en longeure. cynkante / cubitz en leeure et trente cubitz en hautesce. et chescun cubit de / lour a ce temps amounte sys cubitz de noz que sont noef pies. car / chescun cubit de nostre contient un pie et demy.

TRANSLATION: Then Noah made the ark in the manner that God had commanded him, that is to be exact three hundred cubits in length, fifty cubits in height, and each cubit of theirs at that time amounted to six cubits of ours which are nine feet, because each of our cubits contains a foot and a half.

COMMENTS: The text comes from ch. 32 of the *Historia Scholastica*, but the information is not consecutive. The first part, the dimensions of the ark, is found in col. 1082. Comparison of 'their' and 'our' cubit size, in col. 1083. The Egerton Genesis has a six-to-one ratio, whereas the Migne edition has seven-to-one. Noah is working with the axe. His son brings nails in a basket on his head. Very little of the text corresponds to the illustration.

Folio 3ʳ, upper left: (Here the Lamech legend is introduced into the Flood narrative)

TRANSCRIPTION: Lamek pur ceo qil feut veugles il avoit un enfaunt / de li mener. quel enfaunt deveroit **eymer** sa mein / quant il devereit trere a nul beste. e ensi **happa** il qil ferri / Kaym dun saete en lieu dun autre beste et lui occi: adonc / quaunt il fut seu de la mort de Cain soun **cosin** a poi qil / ne fust forcener pur dolour.

TRANSLATION: Lamech, because he was blind, had a child to lead him. This child was supposed to aim his hand when he had to draw the bow to any beast. And thus he happened to strike Cain with an arrow in place of another beast and killed him. Thus, when he was informed of the death of Cain, his kinsman, he was almost overcome with grief. [Above the figures: Lamec, Cam]

COMMENTS: This legendary episode interrupts the Flood story here, as is also the case in the N-Town Flood Play.[15] In the *Historia Scholastica*, the Lamech story, ch. 28, col. 1079, appears considerably before the Flood story, even before the birth of Seth. Peter Comestor is more interested in explicating the one obscure verse (Genesis 4. 23) than in recounting the legend. As mentioned in our discussion of text sources in Chapter 1 above, the *Histoire ancienne's* Genesis has in common with the Egerton Genesis text a mention of Lamech's grief for what he had done. The Egerton Genesis text reflects the scene.

Folio 3ʳ, upper right

TRANSCRIPTION: Adonqes Lamek pur corouce de la mort Kaym baty len/fant qe lui menoit **issint q**il morust et ensi occit / il deux; et pur ceo estoit il en graunt dolour long temps / apres.

TRANSLATION: Thus Lamech, for anger at the death of Cain, beat the child who led him with the result that he died; and thus he killed two; and for this he was in great grief a long time afterward. [Above the figure: Lamec]

COMMENTS: This text differs from the *Historia Scholastica*. Again there is a parallel with the *Histoire ancienne* as to the two-fold grief of Lamech.[16] The writer may be drawing from familiar remembered material. The text is in harmony with the scene.

Folio 3ʳ, lower half

TRANSCRIPTION: En le sys cent an le diseptisme iour du moys de may Noe entra la nief oue touz ceus qe dieu lui commanda / mais oysealx et autres bestes vindrent a lui en la nief molt plue par la volonte de dieu qe par arte ou force de / hom et quant touz feurent dedeinz la nief qe deveroient adonqes pleut il quarant iours et quarant nuytz (autant / qe)[17] leawe feut plus haut qe nul mountein par quinz cubite et ensi endura par un an entier.

TRANSLATION: In the six-hundredth year, the seventeenth day of the month of May, Noah entered the ark with all those which God had commanded him (to take), but birds and other beasts came to him in the ark, more by the will of God than by skill or force of man, and when all were inside the ark who should be there, then it rained forty days and forty nights so that the water was higher than any mountain by fifteen cubits and thus it endured for an entire year. [Above the figures: puarphara, Noe]

COMMENTS: This text is from Peter Comestor, ch. 23, col. 1084, who says they were led by the divine will (*nutu*, nod) and the ministration of angels (*angelorum ministerio adducta*). The scribe omits two details, however: that this was the six hundredth year of Noah's life and that angels administered God's command. The illustration shows Noah and his family members actually carrying or dragging animals into the ark. The scene in the Egerton Genesis thus bears little relation to the inscription.[18] The *Histoire ancienne* implies that Noah was to *put* the animals into the ark. (*car tu i metras de totes manieres de bestes avec toi, masle e femele*). The same verb (*metras*) is used for provisioning the ark.[19] These words more nearly describe the Egerton Genesis Master's scene than does the text beside it.

Folio 3ᵛ, upper left

TRANSCRIPTION: Adonqes apres quarant iours noe lessa passer hors de la / nief un corf. liquel retourna a noe pur ceo qil ne trova / nulle place seke come dit Josephus. le mestre de estoris dit qe / par aventure ou il fut nee en leawe. ou il trova un caroyne / flotant sur quel il demurroit. et ne retourna mie a la nief.

TRANSLATION: Then after forty days Noah released a raven from the ark, which returned to Noah because he found no dry place, as Josephus says. The Master of History says that by chance either he was drowned in the water or he found carrion floating on which he remained and did not return to the ark.

COMMENTS: Although he quotes both Josephus, III. v, and the biblical Genesis, 8. 6–7, Comestor alone of these three sources mentions the floating cadaver: 'Noah opened the window and sent out a raven, but it did not return, perhaps having been prevented from landing on the water or finding a cadaver floating on the surface of the water, was enticed by it' (ch. 34, col. 1085). The text is more elaborate than the scene, which simply shows Noah releasing the raven.

Folio 3ᵛ, upper right

TRANSCRIPTION: Apres cele corff noe lessa passer un columbe la quele / retorna a noe pur ce qil ne trova nulle place seke sur quele / il purra reposer (pur) eauwe.

TRANSLATION: After this raven, Noah released a dove, which returned to Noah because it found no dry place on which it could rest because of the water.

COMMENTS: In the *Historia Scholastica*, ch. 34, col. 1085, Peter Comestor merely quotes the Vulgate, Genesis 8. 8. The miniature shows Noah releasing the dove only. It does not depict the first return of the dove indicated in the text.

Folio 3ᵛ, lower half

TRANSCRIPTION: Apres cella le septisme iour noe lessa hors mesme la columbe la quele countre la vespree lui apporta un braunche / de olyve ou foiles verts et le septisme iour apres il lessa hors mesme la columbe la quele ne retourna mie a / noe par quei il savoit certeinement qil y avoit terre seke iadumeins noe nala mie hors de la nief avant qil avoit commandement de dieu.

TRANSLATION: The seventh day after that, Noah released the same dove from the ark who at evening brought him a branch of olive or green leaves. And the seventh day afterward he let out the same dove which did not return to Noah. For that reason he knew certainly that there was dry land; nevertheless, Noah did not go out of the ark before he had God's command.

COMMENTS: This text comes from the *Historia Scholastica*, ch.34, col. 1085, which closely follows Genesis 8. 10–11. The image shows the dove twice—at left perched on the right branch of a curiously shaped tree and at right returning to Noah on the ark with an olive sprig in his beak.[20] The first part of the Egerton Genesis text applies to the scene depicted.

Folio 4ʳ, full page

TRANSCRIPTION: Mesme le iour en un an qe Noe entra la nief dieu lui commanda daler hors de la nief / tous ceus qe furent dedeinz et les commanda qils deveroient crestre et mul-

tiplier. adonqes fi(st il) / un auter al honor de dieu et offri sur ce le septisme beste de touz nettes bestes et pur ce qils furent / doutifs qatant de bestes purroient defaire si pou come ils furent dieu lour dona seignourie de(ux) / et de tote chose en terre. et mist lark du ciel en le firmament en signe qe nulle tiel **flume** dev(eroit) / iames ester. car ce dutoient ils **sovereinement.**

TRANSLATION: The same day that Noah entered the ship, a year later, God commanded him (to cause) to go out of the ship all those who were within and commanded them that they should grow and multiply. Then he made an altar to the honour of God and offered on this the seventh beast of all the clean beasts, and because they were worried that so many beasts would conquer so few as they were, God gave them lordship over them and of all things on earth. And he put the rainbow in the firmament as a sign that no such torrent would ever again be, because they supremely feared this.

COMMENTS: The text is derived from various elements of Peter Comestor's *Historia Scholastica*, ch. 35, col. 1086. God commands at upper left, above the rainbow. The actual descent of the animals is not included in the text. The animals do not appear threatening in the illustration, as the text suggests. The escaping dragon below the rainbow is not mentioned. It calls to mind the popular medieval legend of Mélusine, as well as the symbolic evil, which the Flood did not quench.[21] No altar or sacrifice is shown. This scene suggests the active verb *metre* as used in the *Histoire ancienne*: '*et met avec toi fors sor terre totes les creatures qui salvées ont lor vies en l'arche*'.[22] Noah's wife lowers a ram by its hind legs over the side of the boat. The text and image differ radically.

Folio 4ᵛ, upper left

TRANSCRIPTION: Adonqes apres ce noe plaunta vins et fu yvres du vine / pur ce qil navoit conissance de la fortresce du vine et **issint qe** / come il dormist pur ce qe Cam son filz vist ses membres . . . / .[23] (il) moka son piere et ala counter a ses freres et les am/ena pur veoir. mais il ne voldroient regarder pur hount / ainz mistrent lour mains entre lour oeux et le privetee de / lour pier.

TRANSLATION: Thus, after this, Noah planted a vineyard and was drunk on the wine because he did not have knowledge of the strength of the wine and thus, as he slept, Ham his son saw his private parts . . . / . he mocked his father and went to tell his brothers and bring them to look. But they did not wish to see for shame; thus they put their hands between their eyes and the private parts of their father. [Above the figures: Sem, Caam, Noe]

COMMENTS: Ch. 36, col. 1087 of Peter Comestor tells of Noah's not knowing the strength of the wine and of Ham's mocking his father: '*sed ignorans vim ejus, inebriatus est . . . Sed cum Cham verenda patris vidisset nudata, irridens, nuntiavit hoc fratribus*'.[24] There is only one brother with the laughing Ham in the image. This brother does put his hand before his eyes. The text here is fairly well adapted to the image.

Folio 4ᵛ, upper right

TRANSCRIPTION: Les freres avoient hount et pristerent draps et tournerent / lour dos devers lour piere et lui coٰcoٰ coٰverent **issint** qil semble / aussi come dit le mestre de estoiries qe a celle hure homs / ne usoient point de brays: devaunt la deluvie et long/temps apres.

TRANSLATION: The brothers were ashamed and took a cloth and turned their back toward their father and covered him; thus it seems, as also says the Master of History, that at this time men did not use underpants, before the Flood and for a long time afterward. [Above the figures: Cam. Sem. Noe]

COMMENTS: The text is from Peter Comestor, ch. 36, col. 1087. Only one brother backs up toward his father with the cloth. The laughing Ham is depicted in this scene also. The text well describes the scene, while adding Peter Comestor's explanatory remark on undergarments: '*Patet quia nondum homines utebantur femoralibus*'.[25]

Folio 4ᵛ, lower left

TRANSCRIPTION: Adonqes noe ce veilla et qant il oy qe cam son filz lui \ moska il maudia canaan le fitz cham. le quel mau/diement faut qil deveroient estre serf a sem. souvent et plu/sours foicz avient qe les culpes de piere sont venges sur / les enfantz moundeinement. aussi come dit le mestres / destoirs purce il ne maudia mie son filz mais le filz / son filz. aussi come hom purroit dire. si come **ios** nai nulle / ioie de vous onkes mon filz ensi neiez vous ioie de toun filz / noe estoit del age de noef centz et cynkant ans quant il mo/roust.

TRANSLATION: Then Noah woke up and when he heard that Ham his son mocked him, he cursed Canaan, the son of Ham, which curse provided that he should be a servant to Shem. Often and several times it happens that the sins of the fathers are avenged on the children everywhere. Also, as the Master of History said, so that he cursed not his son, but his son's son. Also as one could say, if I have no joy of you ever, my son, neither have you joy of your son. Noah was nine hundred years and fifty when he died. [Above the figures: Japheth, Cam, Sem, Canan, Noe]

COMMENTS: These ideas are from ch. 36, col. 1087 of Peter Comestor. As in the two top pictures, the figure of Noah is the same. The text here presents more information than the illustration warrants. However, drooping vegetation and drapery seem to reflect the shame verbally implied.

Folio 4ᵛ, lower right

TRANSCRIPTION: De Cam le fitz Noe vint Nemroth si com dit le mestre / destorys. mais Metodie dit sicome mesme le mestre **re/herce** qe cestui Nemroth vint de hiron le filz Sem: de le quel sem / com dit Alquyn avindrent vint et sept parenties et il oue / les soens occupia asie la tierce partie du siecle.

TRANSLATION: Of Ham, the son of Noah, came Nimrod, as the Master of History shows. But Methodius says, as also the Master quotes, that this Nimrod came from Aram, the son of Shem. From this Shem, as Alcuin says, came twenty-seven generations and he or his people occupy Asia, the third part of the world. [Above the heads of the figures and at far right: Hiron, Cam, Nemrot, *lacus*]

COMMENTS: Peter Comestor and this writer acknowledge the biblical origin of Nimrod through Ham, but they quote Methodius (the Pseudo-Methodius) as saying that Nimrod descended from Shem through Hiron (Aram) (ch. 37, col. 1088). The Comestor also quotes Alcuin as saying that Shem occupied Asia (col. 1087). In the *Historia Scholastica*, col. 1088, we learn that the sons of Shem dwell apart in Asia, beginning from the Euphrates. Is this the river depicted at right in the miniature? The miniature shows the descendants of Hiron and the descendants of Ham discussing Nimrod's ancestry beside a river, as though suggesting the controversy mentioned in Peter Comestor, the source. The image provides more information than does the text. For comment on the puzzling spaces left for names in the background of fol. 4v, see Chapter 3, comment for scene 26.

Folio 5r, upper left

TRANSCRIPTION: Cestui Nemroth creust molt fors et usa venerie et (par) / cause de coveitise de seignurie fist a plusours gentz / grantz duresces. et les fist honurer fu. et dist qe la feu fust / dieux. et cestui Nembroth primierement prist seignurye / sur la terre et nomement sur cele lignage de qi il / vint.

TRANSLATION: This Nimrod grew very strong and practised hunting and because he coveted lordship he made great hardship for several peoples. And he made them honour fire and said that the fire was God. And this Nimrod first took lordship on the earth and especially over the lineage from which he came. [Above the figure: Nembroth]

COMMENTS: This text seems based on sentences in the *Historia Scholastica*, ch. 37, col. 1088.[26] The illustration shows Nimrod forcing his grovelling underlings to worship fire. The text, though in harmony with the visual representation, lacks the dramatic vigour of the miniature. The figure of Nimrod resembles the caricature of a raging tyrant of the medieval theatre, as is discussed in Chapter 4. [Above the head of the large figure, the word Nembroth]

Folio 5r, upper right

TRANSCRIPTION: De Cam vindrent trente parenties. et il oue soens / occupia affrike: lautre tierce partie du siecle.

TRANSLATION: From Ham came thirty generations and he or his people occupied Africa, the other third part of the world. [Above the figure: Cam]

COMMENTS: This sketchy information is in ch. 37, col. 1087 of the *Historia Scholastica*. Twelve figures are represented in the image. Some faces are darker, suggesting persons of

African descent. There seems to be an effort to represent African features as well. The text is appropriate to the scene.

Folio 5ʳ, lower left

TRANSCRIPTION: De Japheth vindrent quinze parenties. li quel Japheth / oue les soens occupia europe lautre tierce partie du / siecle. Philo dit qe de Noe trois filz vivant Noe vindrent / vint et quatre mil et cent hom forspris femmes.

TRANSLATION: From Japheth came fifteen generations; this Japheth or his people occupied Europe, the third part of the world. Philo says that of Noah's three living sons came twenty-four thousand and one hundred men, excepting women. [Above the figure, center left: Japheth]

COMMENTS: This material comes from ch. 37, cols. 1087 and 1088 of Peter Comestor.[27] There are fourteen (or fifteen) figures in the scene. The text is not fully descriptive of the lively scene in which the conversing figures gesture with one hand and hold their cloaks with the other.

Folio 5ʳ lower right

TRANSCRIPTION: Adonqes Jonitus qe fu le filz Noe si come Metodie dit / fu sachant en astronomie et le primer (qe fust onques)[28] / ce a qui Nemroth vint pur savoir de les seignuries et roi/almes qe deveroient venir apres. et Jonitus lui counta qe / de sa linage deveroit primerment regner le primer / home du cecle et pur ceo fust Nembroth plus **ebaignie**.

TRANSLATION: This Jonitus, who was the son of Noah, as Methodius says, was learned in astronomy and the first one to whom Nimrod came to learn of the lords and realms which would come afterward. And Jonitus told him that from his lineage would first reign the Prince of the world and for this was Nimrod very desirous. [Above the figures: Noe, Jonitus, Jonitus, Nembroth]

COMMENTS: This material is from ch. 37, col. 1088 of the *Historia Scholastica*. Peter Comestor's text fits the miniature better than does that of the Egerton Genesis. The Master of History says that Noah sent his son Jonitus ('*dimisit eum*') into the land of Ethan as far as the Eastern sea called Elioschora and that here Jonitus received from the Lord the wisdom to discover astronomy.[29] On the left side of this miniature are two figures with a stream between them. Noah indicates to Jonitus with a gesture of his thumb his gift of land. His son, on the other side of the stream points inquiringly in the same direction. The river, which Jonitus has already crossed, is depicted in the image. The *Histoire ancienne* states that Jonitus received the land of Euconie from his father Noah, a land in the East beside the Euphrates River.[30] The illustrator could have remembered a source similar to the *Histoire ancienne* in depicting the water as a river, though it is called the Eastern sea in Peter Comestor (*ad mare orientis*, col. 1088) and in Peter Comestor's source, the Pseudo-Methodius.[31] Livesey and Rouse recognised this illustration on fol. 5ʳ of the Egerton Genesis as depicting the material in Peter Comestor

(cols 1087–89) on Jonitus as Nimrod's teacher of astronomy.[32] The source of the text well describes the right half of the scene. That Jonitus received from the Lord the wisdom to discover astronomy, a detail in the source, is suggested by the scalloped clouds and the hand of God depicted above the teacher and student.[33] The Egerton Genesis text only partially explicates the rich scene below it.

Folio 5ᵛ, full page

TRANSCRIPTION: Adonqes sassemblerent le plus **rour** du saunk Noe en les chaumps de sennaar. et pur doute de fluvie / qe porroit apres avenir par **looement** de Nemroth qi coveita a regner ilz firent la toure / (de)[34] babiloigne de teules et de bitume qest trove flotans en les (**lais**) de Jude. Mais en / (syr)ie il est trouve buillant hors de la tere la quele tour estoit large et haute.
TRANSLATION: Then there assembled the leading men of Noah's lineage in the fields of Shinar and for fear of a flood which could come afterward, because of the wish of Nimrod, who coveted ruling, they made the Tower of Babel of tiles and of bitumen / which was found floating in the (lakes) of Judea. But in Syria it is found coming out of the ground. This tower was wide and high. [Left of the tower, above the figure: La tour de babilon, Nembroth]
COMMENTS: The text up to the slash in the translation comes from ch. 38, col. 1089 of the *Historia Scholastica*. In ch. 32, col. 1083, Peter Comestor, in writing about Noah's ark, tells of bitumen floating on the surface of lakes in Judea, but heaving on the earth in Syria, a detail extraneous to the scene. We have filled in the blank space in the text with the word *lais* (lakes) which appears thus earlier in the source. The scene at lower right suggests Nimrod in consultation with his distinguished kinsmen. Though they assemble and help him build the tower in the Egerton Genesis text, here they seem to speak with Nimrod to advise him against building the tower, as do '*li sage home dou lignage*' in the text of the *Histoire ancienne*.[35] The text is not closely adapted to the illustration.

Folio 6ʳ, vertical left half

TRANSCRIPTION: Adonqes dieu oue / ses angles suf/flirent et abatirent la / tour oue grant vent et / tempest et ensi devisa / la parlance de ceux / qe lovrient[36] qe nul entendi autre et pur ce / fu la tour apelle babel qest tant / a dire come confusioun ou ho/nisement des launges qar / adonqes furrount toutz les launguages chaun/ges et pus **esparpoiles** par / le secle.
TRANSLATION: Then God or his angels blew and battered the tower with a great wind and tempest and so divided the speech of those who were working that none understood the other and for that reason was the tower called babel which is to say confusion and dishonour of tongues, for thus were all the languages changed and then dispersed throughout the world. [At right above tower: La tour de babilon]
COMMENTS: Peter Comestor, ch. 38, col. 1089, quotes Josephus who says the gods sent the winds to overturn the tower.[37] In the text of the Egerton Genesis, God or his angels blew and battered the tower. The scribe has called the winged winds angels. The tower is not overturned,

but rather crumbles from the blast from above. Neither the artist nor the writer of the Egerton Genesis chooses to attribute the winds to a pagan source, as do Peter Comestor and his source, Josephus. The artist represents God directing the four destroying angels with silvered wings. The text here partially accomodates the picture, rather than slavishly quoting its non-biblical source.

Fol. 6ʳ, upper right

TRANSCRIPTION: Qant Sem le filz noe estoit cent ans engendra Ar/faxath. Arfaxath engendra Salem. Salem engen/dra Heber. Heber engendra Phaleth. Phaleth engendra / Ragan. Ragan engendra Sarug. Sarug engendra Na/chor. Nachor engendra Thare. et quant Thare estoit cessant et / dys ans il engendra Habram. Nachor. et Aram. come / apiert desoutz.

TRANSLATION: When Shem Noah's son was one hundred, he begat Arphaxad. Arphaxad begat Shelah. Shelah begat Eber. Eber begat Peleg. Peleg begat Reu. Reu begat Serug. Serug begat Nahor. Nahor begat Terah. And when Terah was seventy years old, he begat Abram,[38] Nahor and Haran, as appears below. [Above the figures; Sem, Arfaxat, Salem, Heber, Phaleth, Ragan, Sarug, Nacor, Thare]

COMMENTS: This genealogy is in Genesis 11. 10–26 and also in ch. 41, cols 1090–91 of the *Historia Scholastica*, though Comestor's comments are omitted. Fifteen heads are depicted, six more than the persons named. The last three mentioned names (Abram, Nahor and Haran) are not written above the heads in this picture, but rather appear in the image directly below, as the inscription tells us. The final three words, '*come apiert desoutz*' are in darker ink like the names below. They were probably inserted later, as were perhaps these names over the heads of figures. The text reflects the scene.

Folio 6ʳ, lower right

TRANSCRIPTION: Aran engendra Loth et Jescan et morust (avant) / Thare son piere en hur qe fu une citee (entre les) / Caldeis come dit Josephus.

TRANSLATION: Haran engendered Lot and Iscah and died before Terah his father in Ur which was a city among the Chaldeans, as Josephus says. [Above the figures: Abraham, Nacor, Aran, (Lot), (Iscah)]

COMMENTS: This is almost a direct translation from ch. 41, col. 1091 of the *Historia Scholastica*, though a few words are omitted. The picture does not fit the text, as Abram and Nahor, whose names appear above the figures, are not mentioned in the Comestor's text. They are mentioned, however, on fol. 6ʳ, upper right, above.

Folio 6ᵛ, upper left

TRANSCRIPTION: Adonqes Thare quoi pur doel de la mort son fils Aran / qe pour tortz qils lui firent en cel pays pur ce qils lui / vorroient avoir fait honourer fu; il sen parti dilloeqes / et dona a Nachor son filz Milcah a femme et[39] a Habra/ham son autre filz Sarai a femme qele fust baray/gne long temps apres.

TRANSLATION: Then Terah, for the grief about the death of his son Haran, as well as for the injustice they did him in that they wanted him to worship fire, he left from there and he gave Nahor, his son, Milcah for a wife and Abram, his other son, Sarai, who would remain barren for a long time afterward. [Above the figures: Nacor, Milcah, Abram, Sarai]

COMMENTS: This text is from ch. 41, col. 1091 of Peter Comestor's *Historia Scholastica*, though the words, 'for a long time afterward' are added by the writer at the end. Two marriages are depicted. The text tells of the reasons for Terah's move: his grief for his son Haran, and the injustice of being forced to worship fire. We are told also that Sarai will be barren. A portion of the text fits the scene, the detail of the two marriages. However, there is more in the text than depicted here.

Folio 6ᵛ, upper right

TRANSCRIPTION: Et en le lieu de Aran il prist Loth, le fils Aran le / frere Sarai come pur son filz, car Sarai feut baraigne / et ensi vindrent ils ensemble a la citee de Aram. en / la quele citee. Thare morust quant il estoit del age / de deux centz et cynkante ans.

TRANSLATION: And in the place of Haran he (Terah) took Lot, the son of Haran, the brother of Sarai as his son because Sarai was barren and thus they came together into the city of Harran in which city Terah died when he was two hundred and fifty years old. [Names above the heads: Loth, Sarai, Abraham, Thara.]

COMMENTS: The text of fol. 6ᵛ seems to be more nearly a paraphrase of Genesis 11. 31–32 than of the *Historia*'s ch. 41, col. 1091, though Peter Comestor twice quotes the biblical Genesis. Both possible sources say, unlike this text, that Terah died at two hundred and five years. It is not clear who 'they' are in the *Historia Scholastica*. The Vulgate (Genesis 11. 31) says '*et eduxit eos de Ur Chaldaeorem*' after spelling out the four persons, Terah, Abram, Lot and Sarai. However, Peter Comestor identifies Lot as Sarai's brother, a detail not in the biblical account. The writer is drawing from both sources. In the image, Terah is leading Abram by the hand. The text, though including more than is represented in the scene, is appropriate to this theatrical scene of figures moving off to the right.

Folio 6ᵛ, lower left

TRANSCRIPTION: Adonqes parla dieux a Habram et / lui commanda qil devereit aler / hors de sa terre et hors de sa conissance / et hors de la meson son piere.
adonqes / prist Habram Sarai sa femme et Loth le / frere Sarai oue lour enfantz et autres cho/ses qils avoient et vindrent a sichem / en la terre de Canaan ou il leva un auter al ho/nur de dieux en la quele terre avint merveilleus/ment molt grant feime qe dura grant piece.

TRANSLATION: Then God spoke to Abram and commanded that he should go out of his land and away from those he knew and out of the house of his father. Thus Abram took Sarai his wife and Lot, Sarai's brother, with their children and other things that they had and came to Shechem in the land of Canaan where he raised an altar to the honour of God. In this land came a very great famine which lasted a long time.

COMMENTS: The Vulgate (Genesis 12. 1–7, 10) seems a more likely source than Peter Comestor's *Historia Scholastica*. The biblical source is succinct, whereas the information presented in the *Historia* (ch. 43, one sentence; ch. 44, scattered bits; ch. 45, first sentence) is interrupted by lengthy commentary. The speaking Deity and the altar and worshippers are shown in the scene. The text contains more of the story than the image.

Folio 6ᵛ, lower right

TRANSCRIPTION: Par cause de quele feime Habram oue Sarai sa / femme alerent vers egypt et pur doute qe les egypci/ens lui vodroient avoit occis sils eussent sceu qele / estoit sa femme par ce qele estoit si beale par cause qils / estoient molt licherous homs. il la commanda dire / qele estoit sa soer a chescun qe ele demandra et ensi / dist ele tote voies a chescum.

TRANSLATION: Because of this famine, Abram with Sarai, his wife, went toward Egypt, and for fear that the Egyptians would want to have him killed if they should know that she was his wife, because she was so beautiful, because they were very lecherous men, he commanded her to say that she was his sister to each one who will ask and thus to say this always to everyone. [Above figures: Sarai, Abraham]

COMMENTS: The word '*licherous*' (*libidinem Ægyptiorum*) seems to indicate that this text is based on the *Historia Scholastica* (ch. 45, col. 1093). However, the information is expanded over the source and is not in the same order. In the image, Abram and Sarai are walking forward. They hold double-knobbed *bordons*. Abram is ahead. He turns to look at Sarai. She gives a consenting gesture with her right hand. With his palm toward Sarai, against her walking stick, Abram seems to arrest her progress in order to call her complete attention to his instructions. The text is well adapted to the image.

Folio 7ʳ, upper left (The upper half is one continuous scene, even though the crowd of figures is cut off at the central margin)

TRANSCRIPTION: Adonques les gentz Pharao qestoit roi de egypte virent / Sarai et sassemblerent entour ele de lavoir amene / au Roi par cause qele estoit si beale. qar ils ne virent / si beale femme en cele terre et pur ceo ils **vioient** davoir / grauntz mercies du roi par cause de ele et ensi fut il.

TRANSLATION: Then, the people of Pharaoh, who was king of Egypt, saw Sarai and assembled themselves around her to have her taken to the King because she was so beautiful, for they did not see such a beautiful woman in this land and because they expected to have great favors from the King on her account and thus it was. [Above the figures: Sarai, Abraham]

COMMENTS: This text is not precisely like that of Genesis 12. 15. Nor does it seem to come from the *Historia Scholastica* (ch. 45, col. 1093). It seems more like a sentence from the Latin translation of Josephus's Antiquities (I.viii). The writer may be telling the well-known story for himself. The text does not reflect the illustration, in that Abram, using the same gesture toward Sarai as in the previous quadrant on fol. 6ᵛ, appears to be telling the admiring

Egyptians that the lady is his sister. One individual at right has turned to take the news about Sarai to the King.

Folio 7ʳ, upper right

TRANSCRIPTION: Adonqes alerent acun de eux au Roi et lui cunte/rent dune tiele beale femme qestoit venuz et / les commanda de la faire venir a lui entote **maner** si / el vodroit ou noun. qar il **via** de lavoir a amie mais / dieux pensa aultrement et lui fist failir de sa **purpose**.

TRANSLATION: Then some of them went to the King and told him of such a beautiful woman who had come and he commanded them to have her come to him by any means, whether she was willing or not, because he wanted to have her as a lover, but God thought otherwise and caused his purpose to fail. [Above the figure: Roi Pharao]

COMMENTS: As in the previous scene, the text cannot be traced to a direct source, in the Vulgate, Peter Comestor or Josephus. Indeed, it has elements in common with the embellished narrative of this event in the *Histoire ancienne* Genesis[40], where Pharaoh is so enthusiastic about what he has heard about Sarai that he goes out of the city to meet her for himself. As in the previous scene, the writer may be continuing to tell the story in his own way. Five figures facing Pharaoh gesture vigorously. The dramatic quality of this and the previous scene is evident.

Folio 7ʳ, lower left

TRANSCRIPTION: Adonqes amenerent ils Sarai a Pharao le Roy oue / **groundelande** contenance. de qi venue le Roi es/toit lees et vorroit avoir pecche ovesqs ele mais dieux / ne lui lessa de honir la prodefemme en tiele manere.

TRANSLATION: Then they brought Sarai, with a grumbling countenance, to Pharaoh the King. At her arrival the King was happy and wanted to have sin with her, but God did not let him dishonour this noble woman in such a manner. [Above the figures: Abram, Sarai, Roi Pharao]

COMMENTS: The text seems more like the embroidered versions in Josephus and in the *Histoire ancienne*, for which Josephus was the source, than like the spare account of the *Historia Scholastica*.[41] As in the *Histoire ancienne*, God is given the credit for protecting the noble Sarai's honour. The scene is dramatic. The illustration shows Abram taking no responsibility for his wife's protection. In using the expression '*groundelande contenance*', the writer aptly describes Sarai's expression as she is pushed toward the Pharaoh, who grasps her by robe and wrist. Speaking mouths and speaking gestures characterise the figures. The text adapts the source to the image, but does not approach the vitality of the artist's visual representation.

Folio 7ʳ, lower right

TRANSCRIPTION: Iadumeins dieu lui mist en maladie **issint** (qe il)⁴² / estoit distourbe de sa volonte. et quant prestres qe (offri)/rent pur lui avoient conissance par la monstrance de / dieu qe Sarai estoit la femme Habram et qe ce feut la / cause de la maladie le roi. ils lui counterent et / donqes le roi commaunda de faire venir Abram devaunt / lui.

TRANSLATION: Furthermore, God put him into sickness with the result that his will was thwarted, and when the priests who sacrificed for him became aware by the revelation of God, that Sarai was the wife of Abram and that this was the cause of the sickness of the king, they told it to him and then the king commanded that Abram be brought before him. [Above the figures: Sarai, Roi Pharao]

COMMENTS: The words are essentially those of Peter Comestor, ch. 45, col. 1093. In the image, three priests inform the stricken King that Sarai is Abram's wife and that this has caused his illness. The King reclines with his crown removed. Neither the writer nor the source mentions the striking central figure of the compassionate Sarai who, grateful for her deliverance, prays for the King's recovery. The text does not adequately describe the scene.

Folio 7ᵛ, upper left

TRANSCRIPTION: Adonqes manda Pharao le Roi apres Habram et lui / blama pur ce qil dist qele estoit sa soer et lui deli/vera sa femme et commanda ses gentz qils deveroient con/dure Habram et sa femme ou qils **vorroient** hors de sa / terre en saufe conduit sauntz ascune desturbaunce / et donqes **launt** Abraham vint hors de Egipt oue sa femme / et Loth et aultres choses. si vindrent a un lieu qe fust / apellee Sichim iuste la contree de Sodom qore est mort mer / et illoeqes firent lour mansioun ensemble Abraham et / Lot oue lour bestes et aultres biens tanqa un iour qe (incomplete).

TRANSLATION: Then Pharaoh the King commanded Abram to be brought near him and blamed him because he said that she was his sister and he delivered his wife to him; and he commanded his people that they should conduct Abram and his wife where they would like to go outside of his land, in safe conduct without disturbance and then Abram went out of Egypt together with his wife and Lot and other possessions. Thus he came to a place which was called Shechem beside the country of Sodom which now is the dead sea and there they made their dwelling together, Abram and Lot with their beasts and other goods, until one day that (the text is incomplete here). [Above the figures: Pharao, Sarai, Abram]

COMMENTS: The first half of this text uses the version of Peter Comestor, ch. 45, col. 1093. However Shechem, the destination of Abram upon leaving Egypt, was mentioned previously in ch. 44, col. 1092. In the Egerton Genesis text, Abram did not teach the Egyptians before he left, as we are told in Josephus, Peter Comestor and at length in the *Histoire ancienne*.⁴³ In the image, Pharaoh's health has improved. He is seated and crowned. By his gesture, he seems to indicate both disapproval and dismissal. The entire Egyptian adventure in the Egerton Genesis text is an important dramatic enlargement over any of the sources we can identify. There are

five illustrations of the episode (six, if one includes their progress toward Egypt at the beginning of the story on 6ᵛ, lower right). These images constitute a unified visual narrative, an independent dramatic episode.

Folio 7ᵛ, upper right

TRANSCRIPTION: Come les pastours de Abraham et de Loth estriverent / entre eaux et firent grant debate par cause de la pasture / de lour bestes qeux furrount ensemble. qare la pasture / estoit moult **scarce** pur eaux et pur ceo Abraham fut corouce / grevousement quaunt il le sceut.

TRANSLATION: As the shepherds of Abram and of Lot strove among themselves and made great argument because of the pasture of their beasts which foraged together, for the pasture was very scarce for them; and for this reason Abram was greatly vexed when he knew it. [Above the figures: Les pastours]

COMMENTS: The text seems more nearly from the biblical account (Genesis 13. 5–7) than from Peter Comestor's narrative, which gives only passing reference to the shepherds' quarrel (ch. 45, col. 1093). Abram's anger seems to be an addition of the writer. There are three couples of struggling shepherds in the image. Beasts are massed at right. Abram's anger is not illustrated, even in the scene below where he receives the news of the conflict. The text does not closely reflect the scene.

Folio 7ᵛ, lower left

TRANSCRIPTION: Adonqes vindrent les pastours Habram et firent / pleint qe les pastours Loth lour avoient mesfait / pur la pasture de lour bestes qestoit moult **scarce** pur / lour bestes et pur ceo Abraham estoit coroucee grevouse/ment qar il dotout qascun debate **sourdereit** entre / lui et Loth son **cosin** pur la debate qe fut entre lour / pastours pur la pasture et pur ceo il pensa aultrement / faire et donc il fist venir Loth devount soi et lui are/sona en consaillaunt moult bealement et bonement.

TRANSLATION: Then the shepherds came to Abram and made complaint that Lot's shepherds had wronged them because of pasture of their animals which was very scarce for their animals; and for this reason Abram was greatly vexed because he feared that some quarrel would arise between him and Lot, his kinsman, because of the dispute that was going on between their shepherds for the pasture. And for that reason he thought of an alternate plan; and thus he made Lot come before him and reasoned with him, advising him beautifully and well. [Above the figures: Sarai, Abram, Lour pastours]

COMMENTS: The text here is much expanded over the story in the Bible, in the *Historia Scholastica*, in Josephus or in the *Histoire ancienne* Genesis. None of these texts speak of the shepherds' going to Abram to complain, or of Abram's summoning Lot, or of his fear of a rift with Lot. Abram's anger upon hearing the news, already mentioned in the text on the previous scene, is not pictured. He receives the news calmly. The word *scarce* is used twice on this

page. Only the first part of the text reflects the scene. But the writer includes more than the artist depicts: Abram's fear of a rift with his nephew and his courteous interview with Lot.

Folio 7ᵛ, lower right

TRANSCRIPTION: Adonk Loth et Abraham departirent pur la debate qestoit par/entre lour pastours par cause de la pasture de lour bestes / dist Abraham a Loth qestoit filz de Nachor soun friere. nous / **sum** frieres et nous ne **volom** mye estre en debate par nule voie / et pur ceo elisez vous daler vers cele parte de la contre oue vooz bes/tes et **ioe** demorai ici. ou demoretz vous ici et ioe men irrai vers / cele partie de la contree qare mies est destre en pees qen con/tetz et issint **poms** estre en pees **sauntz** contec desormes / adonc ala Loth oue ses bestes et aultre biens a la contre / de Sodom et illeoqes demorra tanqe la cite de Sodom estoit / foundree pur lour pecches come apres ennoretz.

TRANSLATION: Then Lot and Abram separated because of the quarrel between their herdsmen about the pasture of their beasts. Abram said to Lot who was the son of Nahor, his brother: 'We are brothers and we do no more want to be in hostility for any reason and for this you choose to go toward that part of the country with your animals and I will remain here, or you rest here and I will go away toward that part of the country, for it is better to be in peace than conflict, and so we can be in peace without disagreement henceforth.' (Blacker ink begins here.) Thus Lot went with his animals and other possessions to the country of Sodom and there dwelt until the city of Sodom was melted down (foundered) because of their sins, as you will henceforth hear. [Left, above heads: Loth oue sa femme et sa megnee; Right, above heads: Abram oue sa feme et sa **meins**]

COMMENTS: This account is much fuller than that of Peter Comestor. It is as though the text concerning the separation of Abram and Lot had to be spun out among four scenes, three on fol. 7ᵛ and one on fol. 8ʳ (where text is missing). These four scenes deal with the shepherds' quarrels, which caused the separation of Abram's people from those of his nephew. The biblical account is fuller than that of Peter Comestor. But this text is more like that of Josephus (I.viii.3) who, in mentioning Sodom, adds that the city was destroyed and that he will tell about it in its proper place. The *Histoire ancienne* also has this conversational tone.[44] The tale of the separation of Abram and Lot is an important narrative sequence for both illustrator and scribe, as is also the adventure of the beautiful Sarai with the lecherous Pharaoh immediately preceding. The illustration communicates less than the lengthy text. It includes, however, the regretful faces and farewell gestures, which enliven the separation narrative for the viewer. A second scene of this narrative, on fol. 8ʳ at upper left, treats the actual parting of Abram and Lot.

Folio 8ʳ and 8ᵛ: There are no inscriptions. In two of the verso scenes, there is little space for an inscription. Having the inscriber's view of its meaning would have helped in interpreting the enigmatic scene of 8ʳ, lower left. It is possible that the difficulty of interpretation influenced the decision to omit text for this page, at least temporarily.[45]

Folio 9^r, upper left

TRANSCRIPTION: Qant Abram fut repeiree de lestour le roi de Sodome / lui encontra et lui pria corteisement de lui doner / les homs quex il avoit restoures et faire des altres cho/ses ceo qil vodroit et Abram lui respount qe de toutes / choses rien voldroit aver, fors qe ataunt come ils avoi/ent espendu en vitailes, et les trois partes partenauntz / a les trois friers avauntditz qe vindrent en aide de lui.

TRANSLATION: When Abram had returned from the battle, the King of Sodom encountered him and courteously offered to give him the men whom he had surrendered and to do other things that he wanted, and Abram answered that, of all the things, he wanted nothing but as much as they had spent on food and the three parts belonging to the three before-mentioned brothers who came to his aid.

COMMENTS: The source is largely Peter Comestor, ch. 46, col. 1094. The Egerton Genesis writer paraphrases as indirect address the *Historia Scholastica*, which quotes the Vulgate directly, presenting the King of Sodom's proposal as a conversation, (Gen. 14. 21–25). Pächt has suggested that *'les trois friers avaunditz'* of this text may refer to the three figures on the hill of the pastoral scene on fol. 8^r, lower left.[46] However, these words are found in the *Historia Scholastica* (*tres praedictos fratres*). Comestor himself had mentioned the brothers in the previous column, just as they are twice mentioned in Genesis 14. The scribe, then, is simply quoting Comestor as part of his narrative of Abram's settlement with the King of Sodom, without reference to any image. A tiny q directs the initialer who never completed initials for the remaining text. Five more lines than required are ruled for the text.[47] In the image, Abram meets the King of Sodom, who courteously doffs his crown. Although the scene probably represents Abram's first meeting with the King of Sodom, the Egerton Genesis scribe uses the text of his second meeting with this King which occurs after the encounter with Melchizedek in the biblical narrative. The writer thus adapts the sequence of his text to that of the image and that of Peter Comestor by placing the second meeting of Abram with the King of Sodom (Genesis 14. 21–24) before his encounter with Melchizedek (Genesis 14. 18). He changes the biblical order, probably for the reason that the first meeting is so briefly mentioned in the Vulgate (Genesis 14. 17b). The Egerton Genesis images distinguish between the two kings.

Folio 9^r, upper right

TRANSCRIPTION: Adonqes lui encountra Melchisedech qestoit prestre / et roi de jerusalem et lui offera pain et vyn et dona a / les soens grauntz douns come dist Josephus et benesqui diex / qi lui dona victorie de ses enemys. a qi Abram dona / disme primierment. Les Hebreus diount come dist Josephus / qe cestui Melchisedech estoit Sem le filtz Noe. et diount qe a / ceste victorie commencea laane de grace. qest le cinkantime / ane car adonqes estoit loth cinkaunt ans come ascuns / diount. ou pur ceo qe adonqes estoit le cinkantime ans de coe / qe diex parla ovesk Abram en la chemine alaunt vers / Sodome.

TRANSLATION: Then Melchizedek met him, (Melchizedek) who was a priest and the King of Jerusalem, and offered him bread and wine and gave to his people great gifts, as Josephus says, and blessed God who gave him the victory over his enemies, to whom Abram previously had given a tribute of a tenth. The Hebrews say, as Josephus said, that this Melchizedek was Shem, the son of Noah and they say that at this victory begins the year of grace which is the fiftieth year, for then was Lot fifty years old, as some people say, or for this that then it was the fiftieth year that God spoke with Abram on the road going toward Sodom.

COMMENTS: The wording of this inscription is essentially that of Peter Comestor, ch. 46, col. 1094, for the reference to Melchizedek as Shem, and col. 1095, for mention of the fiftieth anniversary. Peter Comestor quotes Josephus, I.x.2, about Melchizedek's generosity to Abram. The text follows the image in that Melchizedek is both priest and king. Here, there is more information in the text than is implied in the illustration. However, the artist follows his own bent, by coupling his reference to the Eucharist as a known type with a sly social commentary on the mandatory tithe.[48]

Folio 9r, lower left

TRANSCRIPTION: Adonqes pramist diex a Abram heir de soun corps / en qi serroient toutz gentz beneqis / et lui dona tote la terre qil porroit vere / entoure. et lui dist qe sicome nul porra / noumbrer les esteiles de ciel. **issint** nul / porroit noumbrer sa linage. et Abram lui / demanda signe. et diex lui comanda de / prendre une vache. une chevre. et / une tope. chescune de trois ans. une tourtre. et une co/lumbe et Abram severa les trois bestes chescune parmi / et miste chescune parte encountre aultre mes les oisels / ne severa mie. et puis countre **ceyr** qant le solail fut co/chee vindrent fu et fumer de ciel et degasteirent trestote / par qel signe Abram savoit qe verroiment avendreit ceo / qe diex lui pramist.

TRANSLATION: Then God promised to Abram an heir of his body in whom all people would be blessed and he gave him all the surrounding land that he would be able to see. And he said to him that, just as no one will be able to number the stars of the heaven, thus no one would be able to number his lineage. And Abram asked a sign of him. And God commanded him to take a cow, a goat and a ram, each three years old, and a dove and a pigeon. And Abram cut the three beasts, each one in two, and put each half over against the other, but the birds he did not sever. And then toward evening, when the sun was set, fire and smoke came from the sky and destroyed (consumed) all, by which sign Abram knew it would truly come to pass what God promised.

COMMENTS: The text conflates information from Genesis 15 and 13. Some of the text of Genesis 15. 4–10, 17 is omitted. The expression, 'Land as far as he could see' is from the first promise in Genesis 13. 15. The detail about the flame consuming the divided animals is mentioned only in Peter Comestor, where the flame is described as both passing between the divided parts and consuming them (ch. 48, col. 1095). The biblical account says only that 'a smoking furnace and a firebrand went between the halves'. Remarkably, there is little in the miniature which corresponds to the long text. The illustration shows Abram, seated on the

ground, looking at the Deity in the cloud at right above. Gestures of the patriarch with right and left hand protect his ear from sound and his eyes from the strong light suggested by the whitened face and hand of the speaking Deity. The text is far more comprehensive than is the illustration, which deals with one verse, Genesis 15.1.

Folio 9ʳ, lower right

TRANSCRIPTION: Mes pur ceo qe Sarai la femme Abram bien savoit qe ele estoit / baraigne ele congea Abram de conustre charnelment / Agar sa auncele. pur ceo qe ele estoit **ieovenes**, et **issint** fist / Abram. et donc fust Agar enceintes dun enfaunt qe fut / apellee ysmael par langel avant qi fu nee. donc Agar des/pisa Sarai sa dame. et Sarai se pleina a Abram son baroun / et Abram le dist qe ele devereit faire de sa auncele ceo qe ele / pleroit. car il ne lui voldroit medler entre lui et sa ser/vaunte.

TRANSLATION: But for the reason that Sarai Abram's wife well knew that she was barren, she authorised Abram to know carnally Hagar, her servant, for she was young. And thus Abram did and thus was Hagar pregnant with a child who was called Ishmael by the angel before he was born. Thus Hagar despised Sarai, her mistress. And Sarai complained to Abram, her husband, and Abram told her that she should do with her servant as she pleased, for he did not wish to meddle between her and her servant.

COMMENTS: The detail about the angel's naming Ishmael before he was born is in Genesis 16. 11. That Abram did not wish to meddle and that Hagar was young are neither in Genesis, nor in the *Historia Scholastica*, nor in Josephus. The writer probably here interjects his own comments. The writer adapts well his text to the illustration, as the gestures of all three figures could include both parts of the text: a reaction to Sarai's advice to her husband to take Hagar and a reaction to her suggestion that Hagar be banished. Sarai's pose could imply both suggestion and complaint about Hagar's scorn of her. Abram's hands and expression suggest both his acceptance of Sarai's advice and his refusal to meddle in her affair. Hagar expresses more surprise at being chosen than shock and dread at the prospect of abandonment.

Folio 9ᵛ, upper left

TRANSCRIPTION: Mes qant agar oia qe ele fu misse en la **baundoun** / Sarai sa dame, et savoit bien qe Sarai lui avoit / sovent grevee devaunt. ele fua en egipte. car ele / estoit nee de cel pais.

TRANSLATION: But when Hagar heard that she had been delivered to the power of Sarai, her mistress, and she knew well that Sarai had often tormented her before, she fled into Egypt, for she was born in that country.

COMMENTS: The detail about Hagar fleeing to Egypt comes from the *Historia Scholastica*, ch. 49, col. 1096. In Genesis 16. 6, Sarai deals harshly with Hagar and Hagar flees, but there is nothing about Egypt. The author himself introduces Hagar's remembrance of her previous torment by Sarai. The text does not suit the illustration, which depicts Sarai beating Hagar with

a distaff. This scene recalls a farcical episode in medieval drama, as is discussed in Chapter 4, herein.

Folio 9ᵛ, upper right

TRANSCRIPTION: Et si come el fu encheminaunt vers / egipt en le desert de sur un / angel de ciel lui commanda retourner / et servir sa dame come adevant et lui / dist qe ele deveroit enfanter. et ele lui / deveroit apeller ysmael car sa mayn / serreit a contre totz et les mains de / totz encontre lui, qe tant amount come dist le / maistre des estoires qe les saracienes qex vendre(r)unt / de lui tuerunt prestres en leues seyntz: et illeoqes coche/rount oue femmes et lierount lour chivals a les sepulcres / des seyntz pur peches de christiens qa donqes serrount.

TRANSLATION: And thus, as she was on the way toward Egypt, in the desert of Shur, an angel from heaven commanded her to return to serve her mistress as before and told her that she would bring forth a child and she should call him Ishmael, for his hand would be against all and the hands of all against him to such an extent, as says the Master of History, that the Saracens who would come from him would kill priests in the holy land and there sleep with women and tie their horses to the tombs of saints, because of the sins of the Christians who would live then.

COMMENTS: The source here is Peter Comestor. In ch. 49, col. 1096, the Comestor quotes liberally from Genesis 16. 7–12. Here, both in the biblical text and in the *Historia Scholastica*, the angel announces to Hagar the coming birth of her son, who shall be called Ishmael.[49] In ch. 49, col. 1097, Peter Comestor quotes the Pseudo-Methodius on the behavior of the Saracens, who would descend from Ishmael. There is much more in the text than is suggested by the image. The scene relates well to the first part of the inscription. The angel in the image indicates with a gesture that Hagar should return to her mistress. The inscription is closely fitted around the angel at upper right. One has the impression that the writer is carried away by his source and that only lack of space in the quadrant has prevented him from continuing his account taken from the *Historia Scholastica*.

Folio 9ᵛ, lower left

TRANSCRIPTION: Habram estoit octant et sept ans / qant Iysmael fut nee. et apres ceo qant / il fust nonaunte et noef ans diex lui pra/mist de multiplier sa engendrure et / lui nomaa Habraam qest a dire pier / de meint gentz. car avant estoit apelle / Habram, cest a dire hault pier, et lui com/manda nomer sa femme Sara, qest adire / princesse, car devant estoit apelle Sarai / cest a dire ma princesse. et lui pramist daver / un filtz de ele qi serroit apelle Ysaac qest adire / **riaunce** pur ceo qe habraam son pier adonqes rist qant / diex lui enparla.

TRANSLATION: Abram was eighty-seven years old when Ishmael was born.

And after that, when he was ninety-nine years old, God promised him to multiply his descendants and called him Abraham, which is to say father of many people, because before he was called Abram, which is to say high father, and commanded him to name his wife Sarah which

is to say princess, because before she was call Sarai, which is to say my princess, and promised him to have a son of her who would be called Isaac, that it to say laughter, because Abraham, his father, laughed when God spoke to him about it.

COMMENTS: This text comes from the end of ch. 49 and from ch. 50, both in col. 1097, of Peter Comestor, who quotes the Vulgate liberally, (Genesis 16 and 17). However, Genesis 16. 16 gives Abram's age as eighty-six at the birth of Ishmael, whereas the *Historia Scholastica* and the Egerton Genesis have his age as eighty-seven. The detail of Abraham laughing is in Genesis 17. 17. In this image we see a scene similar to that of Abraham's encounter with the speaking Deity on the previous page, but here the posture of the patriarch is abject. The writer takes liberties with the story in Genesis. The lengthy text about name changes, has little relation to Abraham's posture of awe before the vision at upper right. The text is poorly adapted to the illustration on which it appears. Here two and one-half ruled lines remain unfilled.

Folio 9ᵛ, lower right

TRANSCRIPTION: Mesme le iour diex lui commanda de circumcidre / sey mesmes et totz les altres qe furrount ou de sa / lignage ou de sa menage ovesqe lui **madles issint** qils / porraient estre conutz pur especial gentz de diex severi / par cest signe de totz aultres gentz et **issint** fist il.

TRANSLATION: The same day God commanded him to circumcise himself and also all the others who were either of his lineage or of his household with him. In this manner they would be known as special people set aside by God by this sign from all other people, and thus he did.

COMMENTS: This is from Genesis 17: 23–27. God's order refers back to Gen. 17. 10–13. However, the biblical text stresses the covenant, whereas Peter Comestor, ch. 50, col. 1097 and this inscription explain circumcision as a means of identification. 'The same day' is only in Genesis 17. 23. The author is going back to circumcision material skipped in the previous discussion of names. The image graphically depicts circumcision. The short text is more applicable to the image it accompanies than is the previous longer one.

Folio 11ʳ (10ʳJ), upper left

TRANSCRIPTION: Apres ceo un iour avint qe Habraam sist en le huis de sa / meisoun et vist treis damisels venir vers lui les qeux / furent treis angels, des qeux lun fust misse de nouncier a Ha/braam de son filcz qil dust avoir. et les altres deus furrount misse / pur la citee de Sodome enfoundrer come dit Josephus. mes Eusebi / dist qe lune apparust en fourme de nostre seignour et pur ceo habra/ham lui fist honurer et les requist de demorer a manger oue / lui et issint fierunt.

TRANSLATION: After this, one day it happened that Abraham was seated at the doorway of his house and saw three young men coming towards him who were three angels. Of these one was sent to announce to Abraham about the son he would have. The others were sent by God to destroy the city of Sodom, as Josephus says. But Eusebius says that one appeared in the form

of our Lord and thus Abraham honoured him and invited them to stay to dinner with him, and thus they did.

COMMENTS: This material is largely from Genesis 18. The first sentence, that Abraham was seated at his doorway, is in the Genesis only. In the *Historia Scholastica*, ch. 51, col. 1098–1099, where Peter Comestor quotes Josephus, the three visitors are called angels, a detail not depicted in this scene, in which the visitors have human form. Peter Comestor quotes both Josephus and Eusebius in ch. 51, as does the Egerton Genesis writer. This text on fol. 10r upper left of the Egerton Genesis seems to be a freely woven combination of the biblical account and that of the *Historia*. The artist shows Abraham humbly welcoming the visitors, one of whom has a cross nimbus. The text and image here are in harmony.

Folio 11r (10rJ), upper right (This is the final inscription in the manuscript.)

TRANSCRIPTION: Adonqes habraam les dona a manger et a boivre. mes la / viaunde estoit consumee en lour bouche come leawe / est consumee par chalour de la feu com dist le meistre des / estoires. et celui qi apparust principal de eax pramist de reve/nire a habraam mesme cet temps au chef del ane le quel / temps il lui pramist qe Sara sa femme enfantereit: et donc pur / cele parole sara rist, pur ceo qils estoierent treveux.

TRANSLATION: Then Abraham gave them to eat and to drink. But the food was consumed in their mouth as water is consumed by heat of the fire, as the Master of History says. And the one who seemed first among them promised to return to Abraham at the same time at the end of a year at which time he promised him that Sarah would have a child. And thus, because of this statement, Sarah laughed, for they were very old.

COMMENTS: The source is Peter Comestor, ch. 51, col. 1099. Though the image depicts a real meal, where the guest at right drinks from a bowl in a normal manner, the text describes the food as consumed like vapour. The visitors, depicted as wingless men, are seated at table, while a servant crouches to blow upon the fire under the cooking pot. Sarah turns away, her hand before her face. The text does not fit the picture.

Notes

1 All references to Peter Comestor's *Historia Scholastica* will be indicated by the chapter and the number of the column. See Peter Comestor, *Historia Scholastica. Patrologia Latina*, 198, ed, by J. P. Migne (Paris: Migne, 1885).

2 Bold type indicates words included in the Glossary.

3 Parentheses surrounding a French text indicate a probable reading. Both eau(x) and (ciel) have been cropped off in binding.

4 James does not resolve the abbreviated word, *v're*. We are resolving it as *vere*, true, and translating it as 'great'. The weak *e* disappears in Anglo-Norman. See E. Einhorn, *Old French: A Concise Handbook* (London: Cambridge University Press, 1974), p. 141.

5 *Illustrations*, p. 9.

6 See comments for fol. 2r, upper left, explanatory text, this chapter.

7 James thought that this scene portrayed the Creation of Adam (*Illustrations*, p.23). Pächt, 'Giottesque Episode', p. 62, noted that this damaged image portrays the Creation of Eve.

8 This is difficult to read. There may possibly be a faint abbreviation indicating third person plural: *manouient*.

9 *Illustrations*, p. 10: '*triginta habuisse filios, et totidem filias*'. In a note for II.3 of his translation of Josephus's *Antiquities,* Whiston notes that thirty-three sons and twenty-three daughters is the tradition. See *Josephus*, Whiston, p. 27.

10 This age of Noah after birth of his three sons is a doubtful reading. James, *Illustrations*, p. 10, reads it differently: '*viij* (!) *centz et lxx*'.

11 See text, comments and note for fol 5r, lower left, below.

12 *Illustrations*, p. 11.

13 *Illustrations*, p. 11.

14 The scribe doubles the number of unclean beasts over the number in his source, Peter Comestor, who specifies two beasts '*combinata . . . secundum genus suum*' (ch. 33, col. 1083).

15 The N-Town play is also called *Ludus Coventriae*. See Chapter 4 herein for more on this episode.

16 Joslin, *Heard Word*, p. 92, ll. 15–17.

17 James, *Illustrations*, p. 13, reads this *ass . . ke,* with *erratum* points under the *k* and *e*.

18 The de Brailes illustration in Baltimore, Walters Art Gallery MS 106, fol. 2, shows an angel directing the entry of the animals after Noah and his family are already in the ark. See Hanns Swarzenski, 'Unknown Bible Pictures by W. de Brailes and Some Notes on Early English Bible Illustration', *JWAG* I (1938), 55–69 (fig. 2). Thus, the Egerton Genesis uses the partial text of Peter Comestor without corresponding iconography, whereas de Brailes depicts the scene described by Peter Comestor, with a prominent angel directing the entry of the animals, while the text below the miniature is unrelated to the image. An approximate translation of the de Brailes text is that God commanded Noah to make an ark of three stories and to put therein himself and his wife and his three sons and their wives and the beasts and the birds. There is no mention of God's will being accomplished through the ministration of the large angel prominently depicted in the right border.

19 Joslin, *Heard Word*, p. 95, ll. 19–21.

20 See comments for this scene in Chapter 3.

21 See Chapter 3, comments for fol. 4r.

22 Joslin, *Heard Word*, p. 98, ll 3–5. 'And take (or put) out with you all of the creatures who have had their lives saved on the ark'.

23 Ellipsis designates an illegible word.

24 But, being ignorant of its strength, he became inebriated. . . .But Cain, seeing the nude pudenda of his father, mockingly announced this to his brothers.

25 It is obvious that men were not yet using thigh-coverings.

26 In the *Additio* below on col. 1088, there is another reference to the Chaldeans who were wont to worship fire.

27 James says that Peter Comestor's quotation of Philo was incorrect—that he was quoting another writer whose text was included in the manuscript with Philo. See M. R. James, trans., *The Biblical Antiquities of Philo*, Translations of Early Documents, Series 1 (New York: Ktav, 1971), p. 10.

28 These words are now illegible. We take James' reading, though he leaves one blank space.

29 Jonitus, as noted by Steven J. Livesey and Richard H. Rouse, 'Nimrod the Astronomer' *Traditio*, 37 (1981), 203–6 pp. 213, 214), was known to the West by the Syrian tradition, an important source being the *Revelations* attributed to St. Methodius.

30 Joslin, *Heard Word*, p. 104, ll. 15–25.

31 Quoted in Ernst Sackur, *Sibyllinische Texte und Forschungen: PseudoMethodius, Adso und die Tiburtinische Sibylle* (Halle: Niemeyer, 1898; repr. Turin: Bottega d'Erasmo, 1963), pp. 63–64..

32 Livesey and Rouse, p. 233, n. 78.

33 Ch. 37, col. 1088: '*hic accepit a Domino donum sapientiae, et invenit astronomiam*'.

34 The letters in parentheses here and below have been cropped at left margin. We propose (*de*). James, *Illustration*, p. 16, omits the *de*.

35 Joslin, *Heard Word*, p. 106, ll. 20–24.

36 *loui*: In resolving the abbreviation, James reads *loth* (*loueri?*), *Illustrations*, p. 16. We are making it plural.

37 '*Dii vero ventos immitentes everterunt turrim*', ch. 38, col. 1089. Josephus (I. iv. 3) himself is quoting the Third Book of the Sibylline Oracles (iii. 101). See James, *Illustrations*, p. 27.

38 For the sake of consistency, we use the names Abram and Sarai in the translations and comments on the text up to fol. 9ᵛ, lower left, when the name change to Abraham and Sarah occurs in the biblical Genesis, Chapter 17. We use the names Abraham and Sarah, however, for titles of plates and figures and for general comments, such as those in Chapter 3 and 4.

 In the text and in figure titles of the Egerton Genesis Abraham story (fols 6ʳ through 11ʳ (10ʳJ)), the names Abram/Abraham, or Habram/Habraam and Sarai/Sara occur 68 times. The writer's use of names is not haphazard. For the most part, he uses the names correctly with respect to the name changes narrated in the lower left scene of fol 9ᵛ. In 10 instances, the scribe uses a name incorrectly with respect to the story. This is not surprising in view of the variable orthography of the time.

39 James has the *erratum* points under *e* and *t*. This indication of error is not in the text. The word is necessary.

40 Joslin, *Heard Word*, p. 135, ll. 20–23.

41 Comparable material: Genesis 12. 15; *HS*, ch. 45 col. 1093; *Antiquities*, I.viii.1; Joslin, *Heard Word*, p. 135.

42 The words at the end of lines one and two are now illegible. We take James's reading.

43 Information that Abraham instructed the Egyptians is in Josephus I.viii.2, Peter Comestor ch. 45, col. 1093 and the *Histoire ancienne*. See Joslin, *Heard Word*, p. 138, ll. 8–10.

44 Joslin, *Heard Word*, p. 139, ll. 26–28.

45 See comments on this image in our Chapters 3 and 4.

46 'Giottesque Episode', p. 59.

47 Extra lines are ruled on the other three quadrants of fol. 9ʳ as well. Either the scribe expected from the outset to write longer texts, or he was unclear as to what he intended to write.

48 See comment on this scene in Chapter 3.

49 The angel who announces Ishmael's birth was already mentioned in the text on fol. 9ʳ, lower right. See above.

Bibliography

Achtemeier, P. J., ed., *Harper's Bible Dictionary* (San Francisco: Harper and Row, 1985)

Alexander, J. J. G. and P. Binski, eds, *The Age of Chivalry: Art in Plantagenet England, 1200–1400* (London: Royal Academy of Arts, 1987)

Alexander, J. J. G. and C. M. Kauffmann, cat., *English Illuminated Manuscripts* (Brussels: Bibliothèque Royale Albert Ier, 1973)

Alter, R., *Genesis: Translation and Commentary* (New York: Norton, 1996)

Anderson, M. D., *Drama and Imagery in English Medieval Churches* (Cambridge: Cambridge University Press, 1963)

Anderson, M. D., *History and Imagery in British Churches* (London: Murray, 1971)

Anderson, M. D., *The Imagery of British Churches* (London: Murray, 1955)

Arensberg, S., 'The Padua Bible and the Late Medieval Biblical Picture Book' (unpublished doctoral dissertation, Johns Hopkins University, 1986)

Avril, F. Ier, and P. D. Stirnemann, *Manuscrits enluminés d'origine insulaire, VIIe–XXe siècle* (Paris: Bibliothèque Nationale, 1987)

Avril, F., *Manuscript Painting at the Court of France: the Fourteenth Century (1310–1380)* (New York: Braziller, 1978)

Ayers, B., *English Heritage Book of Norwich* (London: Batsford, 1994)

Backhouse, J., *The Illuminated Page: Ten Centuries of Manuscript Painting in the British Library* (Toronto: University of Toronto Press; London: British Library, 1997)

Backhouse, J., *The Luttrell Psalter* (London: British Library, 1989)

Bailey, M., 'The Rabbit and the Medieval East Anglian Economy', *Agricultural History Review*, 36.1 (1988), 1–20

Baskerville, C. R., 'Dramatic Aspects of Medieval Folk Festivals in England', *Studies in Philology*, 17 (1920), 19–87

Bazin, G., *Le Livre d'Heures d'Etienne Chevalier* (Paris: Somogy, 1990)

Beadle, R. and P. M. King, eds, *York Mystery Plays: a Selection in Modern Spelling* (Oxford: Clarendon Press, 1984)

Beadle, R., ed., *Cambridge Companion to Medieval English Theatre* (Cambridge: Cambridge University Press, 1994)

Beadle, R., ed., *The York Plays* (London: Arnold, 1982)

Beecher, D., D. Campbell, and M. Ciavolella, gen. eds; trans., intro., notes by T. de Vroom, *Netherlandic Secular Plays from the Middle Ages: the* Abele Spelen *and the Farces of the Hulthem Manuscript* (Ottawa: Dovehouse, 1997)

Beeching, H. C., 'The Library of the Cathedral Church of Norwich', *Norfolk Archaeology*, 19 (1917), 67–116

Belin, Mme Th., *Les Heures de Marguerite de Beaujeu* (Paris: Mme Th. Belin, Librairie à L'Enseigne Notre-Dame, 1925)

Bennett, J., 'The Language and the Home of the *"Ludus Coventriae"* ', *Orbis*, 22.1 (1973), 43–63

Benson, L. D., ed., *The Riverside Chaucer*, 3rd ed. (Boston: Houghton Mifflin, 1987)

Berger, S., *La Bible française au moyen âge* (Paris: [n. pub.], 1884; repr. Geneva: Slatkine, 1967)

Bettini, S., *Mosaici antichi di San Marco a Venezia* (Bergamo: Istituto Italiano d'Arti Grafiche, 1944)

Bevington, D., *Medieval Drama* (Boston: Houghton Mifflin, 1975)

Billington, S., *A Social History of the Fool* (Brighton, Sussex: Harvester, 1984)

Binski, P. and D. Park, 'A Ducciesque Episode at Ely: the Mural Decoration of Prior Crauden's Chapel', in *England in the Fourteenth Century: Proceedings of the 1985 Harlaxton Symposium*, ed. by W. M. Ormrod (Woodbridge, Suffolk: Boydell, 1986), pp. 28–41

Blatt, Franz, ed., *The Latin Josephus*, 2 vols (Copenhagen: Munksgaard, 1958)

Block, K. S., *'Ludus Coventriae' or the Plaie called 'Corpus Christi'*, EETS, ES 120 (Oxford: Oxford University Press, 1922; repr. 1960, 1974)

Boeren, P. C., *Catalogus van de handschriften van het Rijksmuseum Meermanno-Westreenianum* (The Hague: Rijksmuseum Meermanno-Westreenianum/Staatsuitgeverij, 1979)

Bonnell, J. K., 'The Source in Art of the So-called Prophet's Play of the Hegge Collection', *PLMA*, 29 (1914), 327–340

Borenius, T. and E. W. Tristram, *English Medieval Painting* (New York: Hacker Art Books, 1976; first published, Florence, 1927)

Brandhorst, J. P. J. and K. H. Broekhuijsen-Kruijer, *De verluchte handschriften en incunabelen van de Koninklijke Bibliotheek: een overzicht voorzien van een iconografische index* (The Hague: Stichting Bibliographia Neerlandica, 1985)

Brawer, R. A., 'The Form and Function of the Prophetic Procession in the Middle English Cycle Play', *Annuale Mediaevale*, 13 (1972), 88–124

Bridbury, A. R., *Economic Growth in England in the Later Middle Ages* (London: Allen and Unwin, 1962)

Brody, A., *The English Mummers and their Plays* (Philadelphia: University of Pennsylvania Press, 1970)

Brown, Carleton, ed., *Religious Lyrics of the XIVth Century*, 2nd edn, rev. by G. V. Smithers (Oxford: Clarendon Press, 1957)

Brown, M. P., *A Guide to Western Historical Scripts from Antiquity to 1600* (London: British Library and Toronto: University of Toronto Press, 1990)

Bryant, A., *The Medieval Foundation of England* (Garden City, NY: Doubleday, 1967)

Buchthal, H., *Miniature Painting in the Latin Kingdom of Jerusalem* (Oxford: Clarendon Press, 1957)

Buschhausen, H., 'Die Fassade der Grabeskirche zu Jerusalem', in *Crusader Art in the Twelfth Century*, ed. by J. Folda, BAR, International Ser. 152 (Oxford: British School of Archaeology in Jerusalem, 1982), pp. 71–96

Byvanck, A. W., *De middeleeuwsche boekillustratie in de Noordelijke Nederlanden*, Maerlantbibliotheek, 10 (Antwerp: De Sikkel, 1943)

Camille, M., *Image on the Edge: the Margins of Medieval Art* (Cambridge, MA: Harvard University Press, 1992)

Carlvant, K. B. E., 'Collaboration in a Fourteenth-Century Psalter: the Franciscan Iconographer and the Two Flemish Illuminators of MS 3384,8° in the Copenhagen Royal Library', *Sacris Erudiri*, 25 (1982), 135–166

Carlvant, K. B. E., 'Thirteenth-Century Illumination in Bruges and Ghent' (unpublished doctoral dissertation, Columbia University, 1978)

Carus-Wilson, E. M. and Olive Coleman, *England's Export Trade 1275–1547* (Oxford: Clarendon Press, 1963)

Carus-Wilson, E. M., *Medieval Merchant Ventures* (London: Methuen, 1954)

Cassee, E., *The Missal of Cardinal Bertrand de Deux: a Study in 14th-Century Bolognese Miniature Painting*, trans. by M. Hoyle, Istituto Universitario Olandese di Storia dell'Arte, 10 (Florence: Istituto Universitario Olandese di Storia dell'Arte, 1980)

Cave, C. J. P., 'The Roof Bosses in the Transepts of Norwich Cathedral Church', *Archaeologia*, 83 (1933), 45–65

Cave, C. J. P., *Roof Bosses in Medieval Churches: an Aspect of Gothic Sculpture* (Cambridge: Cambridge University Press, 1948)

Cawley, A. C., *The Wakefield Pageants in the Towneley Cycle* (Manchester: Manchester University Press, 1958)

Chambers, E. K., *English Literature at the Close of the Middle Ages* (Oxford: Clarendon Press, 1945; repr. 1964)

Chambers, E. K., *The Mediaeval Stage*, 2 vols (Oxford: Clarendon Press, 1903)

Cheetham, F., *English Medieval Alabasters: with a Catalogue of the Collection in the Victoria and Albert Museum* (Oxford: Phaidon Press, Christie's, 1984)

Clopper, L. M., 'Tyrants and Villains: Characterization in the Passion Sequences of the English Cycle Plays', *MLQ*, 41 (1980), 3–20

Cockerell, S. C., *The Gorleston Psalter: a Manuscript of the beginning of the Fourteenth Century in the Library of C. W. Dyson Perrins* (London: Chiswick Press, 1907)

Cockerell, S. C. and J. Plummer, *Old Testament Miniatures: a Medieval Picture Book with 283 Paintings from the Creation to the Story of David* (New York: Braziller, 1969)

Cockerell, S. C. and M. R. James, *Two East Anglian Psalters at the Bodleian Library, Oxford* (Oxford: Oxford University Press, Roxburghe Club, 1926)

Cohen, G., *Histoire de la mise en scène dans le théâtre religieux français du moyen âge* (Paris: Champion, 1906; 2nd and 3rd edns, 1926, 1951)

Cohen, G., *Le Livre du conduite du régisseur et le compte des dépenses pour le Mystère de la Passion* (Strasbourg: Librairie Istra, 1925)

Colledge, E., ed., A. J. Barnouw, trans., *Reynard the Fox and Other Mediaeval Netherlands Secular Literature* (Leiden: Sijthoff, 1967)

Collins, P., 'Narrative Bible Cycles in Medieval Art and Drama', *Comparative Drama*, 9 (1975), 125–146

Constable, G., 'Resistance to Tithes in the Middle Ages', *Journal of Ecclesiastical History*, 13 (1962), 172–185

Conti, A., *La miniatura bolognese: scuole e botteghe 1270–1340*, Fonti e studi per la storia di Bologna e delle province emiliane e romagnole, 7 (Bologna: Alfa, 1981)

Corfis, I. A., ed., *Historia de la linda Melosina* (Madison, WI: Hispanic Seminary of Medieval Studies, 1986)

Cox, M. D., 'The Twelfth-Century Design Sources of the Worcester Cathedral Misericords', *Archaeologia*, 97 (1959), 165–178

D'Ancona, P. and E. Aeschlimann, *The Art of Illumination: an Anthology of Manuscripts from the Sixth to the Sixteenth Century* (London: Phaidon Press, 1969)

Dael, P. van, 'De illustraties bij de proloog en het scheppingsverhaal in de "Rijmbijbel" van Jacob van Maerlant: woord en beeld', in *Scolastica willic ontbinden: over de 'Rijmbjibel' van Jacob van Maerlant*, ed. by J. van Moolenbroek and M. Mulder, Middeleeuwse studies en bronnen, 25 (Hilversum: Verloren, 1991) 105–125

Davidson, C., *Drama and Art: an Introduction to the Use of Evidence from the Visual Arts for the Study of Early Drama* (Kalamazoo, MI: Medieval Institute, Western Michigan University, 1977)

Davis, N., ed., *Non-Cycle Plays and Fragments*, EETS, SS 1 (Oxford: Oxford University Press, 1970)

Day, J. W., *Norwich through the Ages* (Ipswich, Suffolk: East Anglian Magazine, 1976)

Delaporte, Y., *Les Vitraux de la Cathédrale de Chartres*, histoire et description par Y. Delaporte, reproductions par E. Houvet (Chartres: Houvet, 1926)

Demus, O., *The Mosaics of Norman Sicily* (New York: New York Philosophical Library, 1950)

Demus, O., *The Mosaics of San Marco in Venice*, 2 pts (Chicago: University of Chicago Press, for Dumbarton Oaks, Washington, D. C., 1984)

Dennison, L., 'Oxford, Exeter College MS 47: the Importance of Stylistic and Codicological Analysis in its Dating and Localization', in *Medieval Book Production: Assessing the Evidence*, ed. by L. L. Brownrigg (Los Altos Hills, CA: Anderson-Lovelace, 1990), pp. 41–59

Dennison, L., 'The Fitzwarin Psalter and its Allies: a Reappraisal', in *England in the Fourteenth Century: Proceedings of the 1985 Harlaxton Symposium*, ed. by W. M. Ormrod (Woodbridge, Suffolk: Boydell, 1986), pp. 42–66

Dennison, L., 'The Stylistic Sources, Dating and Development of the Bohun Workshop, ca. 1340–1400' (unpublished doctoral thesis, Westfield College, University of London, 1988)

Diebold, W., 'The Egerton Genesis' (unpublished paper read at Dumbarton Oaks, Washington, D. C., 1980)

Diller, H.-J., *The Middle English Mystery Play: Great Britain,* trans. by F. Wessels (Cambridge: Cambridge University Press, 1992)

Dobson, E. J., 'The Etymology and Meaning of Boy', *Medium Aevum* 9.3 (October, 1940), 121–154

Dodwell, C. R. and P. Clemoes, eds, *The Old English Illustrated Hexateuch: British Museum Cotton Claudius B IV*, Early English Manuscripts in Facsimile, 18 (Copenhagen: Rosenkilde and Bagger, 1974)

Donaldson, E. T., trans., *William Langland: Will's Vision of 'Piers Plowman'*, ed., intro., and annot. by E. D. Kirk and J. H. Anderson (New York: Norton, 1990)

Druitt, H., *A Manual of Costume as Illustrated by Monumental Brasses* (London: Moring, De la More, 1906)

Dutka, J., 'The Lost Dramatic Cycle of Norwich and the Grocers' Play of the Fall of Man', in *The Review of English Studies*, NS 35 (1984), 1–13

Eccles, M., ' "*Ludus Coventriae*": Lincoln or Norfolk?', *Medium Aevum*, 4 (1971), 135–141

Einhorn, E., *Old French: a Concise Handbook* (London: Cambridge University Press, 1974)

Ekkart, R. E. O., *De 'Rijmbijbel' van Jacob van Maerlant: een in 1332 voltooid handschrift uit het Rijksmuseum Meermanno-Westreenianum* (The Hague: Staatsuitgeverij and Rijksmuseum Meermanno-Westreenianum/Museum van het boek, 1985)

England, G. and A. W. Pollard, eds, *The Towneley Plays*, EETS, ES 71 (London: Paul, Trench, Trübner, 1897; repr. Millwood, NY: Kraus, 1975)

Fawtier, R., *La Bible Historiée toute figurée de la John Rylands Library* (Paris: Pour les Trustees et Gouverneurs de la John Rylands Library, 1924)

Folda, J., *Crusader Manuscript Illumination at Saint-Jean d'Acre* (Princeton: Princeton University Press, 1976)

Folena, G. and G. L. Mellini, *Bibbia istoriata padovana della fine del Trecento: Pentateuco-Giosuè-Ruth* (Venice: Neri Pozza, 1962)

Francis, W. N., ed., *The Book of Vices and Virtues: a Fourteenth Century Translation of 'Somme le Roi' of Lorens d'Orléans*, EETS, OS 217 (London: Oxford University Press, 1942; repr. 1968)

Gardiner, H. C., *Mysteries' End: an Investigation of the Last Days of the Medieval Religious Stage* (New Haven: Yale University Press, 1946)

Gauvin, C., *Un Cycle du théâtre religieux anglais au moyen âge: le jeu de la ville de N* (Paris: Centre National de la Recherche Scientifique, 1973)

Gibson, G. M., *The Theatre of Devotion: East Anglian Drama and Society in the Late Middle Ages* (Chicago: University of Chicago Press, 1989)

Gibson, G. M., 'Long Melford Church, Suffolk: Some Suggestions for the Study of Visual Artifacts and Medieval Drama', *RORD*, 21 (1978), 103–115

Gollanz, I., *The Caedmon Manuscript of Anglo-Saxon Biblical Poetry* (London: Oxford University Press, 1927)

Gomme, L., 'Christmas Mummers', *Nature*, 57 (Nov. 1897–Apr. 1898; Dec. 23, 1897), 175–177

Gottfried, R. S., *The Black Death: Natural and Human Disaster in Medieval Europe* (New York: Free Press, 1983)

Goulburn, E. M., *The Ancient Sculptures of Norwich Cathedral* (Norwich: Stacy, 1872)

Gray, H. L., 'The Production and Export of English Woollens in the Fourteenth Century', *English Historical Review*, 39 (1924), 13–35

Greg, W. W., *Bibliographical and Textual Problems in English Miracle Cycles* (London: Moring, 1914)

Greimas, A. J. *Dictionnaire de l'ancien Français jusqu'au milieu du XIVe siècle* (Paris: Jarousse, 1968)

Hamburger, J. F., *The Rothschild Canticles: Art and Mysticism in Flanders and the Rhineland circa 1300* (New Haven: Yale University Press, 1990)

Haney, K. E. H., *The Winchester Psalter* (Leicester: Leicester University Press, 1986)

Harris, J. W., *Medieval Theatre in Context: an Introduction* (London: Routledge, 1992)

Harty, K. J., ed., *The Chester Mystery Cycle: a Casebook* (New York: Garland, 1993)

Hassall, W. O., 'Plays at Clerkenwell', *MLR*, 33 (1938), 564–567

Hassall, W. O., *The Holkham Bible Picture Book* (London: Dropmore, 1954)

Haussherr, R., comm., *Faksimile-Ausgabe im Originalformat des Codex Vindobonensis 2554 der Österreichischen Nationalbibliothek,* 2 vols (Graz: Akademische Druck, 1973)

Henderson, G., 'Late-Antique Influences in Some English Mediaeval Illustrations of Genesis', *JWCI*, 25 (1962), 172–198

Henderson, G., 'The Sources of the Genesis Cycle at Saint-Savin-sur-Gartempe', *Journal of the British Archaeological Association*, 26 (1963), 11–26

Henryson, R., *Testament of Cresseid*, ed. by D. Fox (London: Nelson, 1968)

Hildburgh, W. L., 'English Alabaster Carvings as Records of the Medieval Religious Drama', *Archaeologia*, 93 (1949), 51–101, pls XI–XXI

Hildburgh, W. L., 'Folk-Life Recorded in Medieval English Alabaster Carvings', *Folk-Lore*, 60 (1949), 249–265

Hildburgh, W. L., 'Further Notes on English Alabaster Carvings', *Antiquaries Journal*, 10 (1930), 34–45, pls V–X

Hildburgh, W. L., 'Notes on Some English Medieval Alabaster Carvings', *Antiquaries Journal*, 3 (1923), 24–36

Holy Bible, Authorized Version (Philadelphia: Holman, n.d.)

Holy Bible, Revised Standard Version (New York: Nelson, 1952)

Horrox, R., trans. and ed., *The Black Death* (Manchester: Manchester University Press, 1994)

Hudson, W. and J. C. Tingey, *The Records of the City of Norwich*, 2 vols (Norwich: Jarrold and Sons, 1906, 1910)

Hull, C. S., 'Rylands MS French 5: the Form and Function of a Medieval Bible Picture Book', *BJRL*, 77.2 (1995), 3–24

Hull, C. S., 'The Douai Psalter and Related Manuscripts', 2 vols (unpublished doctoral dissertation, Yale University, 1994)

James, John, *History of the Worsted Manufacture in England* (London: Cass, 1857; repr. New York: Kelley, c. 1968)

James, M. R., 'An English Bible-Picture Book of the Fourteenth Century', *Walpole Society*, II (1922–23), 1–27

James, M. R., *Illustrations of the Book of Genesis: Being a Complete Reproduction in Facsimile of the Manuscript British Museum, Egerton 1894* (Oxford: Oxford University Press, Roxburghe Club, 1921)

James, M. R., *On the Abbey of S. Edmund at Bury: I, The Library, II, The Church* (Cambridge: Cambridge Antiquarian Society, 1895)

James, M. R., *The Romance of Alexander: a Collotype Facsimile of Ms. Bodley 264* (Oxford: Clarendon Press, 1933)

James, M. R., trans., *The Biblical Antiquities of Philo*, Translations of Early Documents, Series 1 (New York: Ktav, 1971)

Jean D'Arras, *Le Roman de Mélusine, ou, l'Histoire des Lusignan, mis en français modern par M. Perret* (Paris: Editions Stock, 1979)

Jerusalem Bible, gen. ed. A. Jones (Garden City, NY: Doubleday, 1966)

Jeu d'Adam, ed. by W. Noomen (Paris: Champion, 1971)

Johnson, C. and C. H. Jenkinson, *English Court Hand, AD 1066 to 1500*, 2 pts (Oxford: Clarendon Press, 1915)

Johnston, A., ' "All the World was a Stage": Records of Early English Drama', in *The Theatre of Medieval Europe*, ed. by Eckehard Simon (Cambridge: Cambridge University Press, 1991), pp. 117–129

Johnston, A., 'Chaucer's Records of Early English Drama', *REED*, 13. 3 (1988), 13–20

Johnston, A. and M. Dorrell, 'The Doomsday Pageant of the York Mercers, 1433', *LSE*, NS 5 (1971), 29–34

Josephus, F. *The Works of Josephus*, trans. by W. Whiston (Lynn, MS: Hendrickson, 1980; repr. 1981)

Joslin, M. C., 'The Illustrator as Reader: Influence of Text on Images in the *Histoire ancienne*', *Medievalia et Humanistica*, NS 20 (1993), 85–121

Joslin, M. C., 'Women Characters in the *Histoire ancienne* Genesis of Rogier, Chastelain de Lisle, from the Text of Paris BN fr. 20125', in *Court and Poet*, ed. by G. S. Burgess (Liverpool: Cairns, 1981), pp. 207–214

Joslin, M. C., *The Heard Word: a Moralized History*, Romance Monographs, 45 (University, MS: Romance Monographs, 1986)

Jusserand, J. J., 'A Note on Pageants and "Scaffolds Hye" ' in *An English Miscellany presented to Dr. Furnivall in Honour of his Seventy-fifth Birthday*, ed. by W. P. Ker, A. S. Napier, and W. W. Skeat (Oxford: Clarendon Press, 1901), 183–195

Kelly, E. M., ' *"Ludus Coventriae"* Play 4 and the Egerton Genesis', *Notes and Queries,* 19 (1972), 443–444

King, P. M., 'Morality Plays', in *The Cambridge Companion to Medieval English Theatre*, ed. by R. Beadle (Cambridge: Cambridge University Press, 1994), pp. 240–264

Klamt, J. C., Review of Johannes Zahlten, *Creatio Mundi: Darstellungen der sechs Schöpfungstage und natur-wissenschaftliches Weltbild im Mittelalter* (Stuttgart: Klett-Cotta, 1979), *Simiolus* 12 (1981–82), 77–84

Klemm, E., *Ein romanischer Miniaturenzyklus aus dem Maasgebiet* (Vienna: Holzhausens, 1973)

Kohlenberger, J. R. III, ed., *The NIV Interlinear Hebrew-English Old Testament*, I: *Genesis-Deuteronomy* (Grand Rapids, MI: Zondervan, 1979)

Kraus, H. P., *Catalogue 115* (New York: Kraus, 1966)

Kurmann, P., *La Façade de la Cathédrale de Reims: architecture et sculptures des portails*, 2 vols (Paris: Centre National de la Recherche Scientifique, 1987)

Laborde, A., *Etude sur la Bible moralisée illustrée conservée à Oxford, Paris et Londres*, 5 vols (Paris: Pour les membres de la Société, 1911–27)

Lancashire, I., *Dramatic Texts and Records of Britain: a Chronological Topography to 1558* (Toronto: University of Toronto Press, 1984)

Land, N. E., 'Petrarch's Eye and a *Crucifixion* by Lippo di Benivieni', *Southeastern College Art Conference Review*, 12 (1995), 391–401

Leach, A. F., 'Some English Plays and Players 1220–1458', in *An English Miscellany Presented to Dr. Furnivall in Honour of his Seventy-fifth Birthday*, ed. by W. P. Ker, A. S. Napier, and W. W. Skeat (Oxford: Clarendon Press, 1901) 205–234

Leveen, J., *The Hebrew Bible in Art* (London: Milford, 1944)

Liebreich, A., *Claus Sluter* (Brussels: Dietrich, 1936)

Lipson, E., *A Short History of Wool and its Manufacture, Mainly in England* (Melbourne: Heinemann, 1953)

Lipson, E., *The Economic History of England*, 3 vols (London: Black, 1959–61), I: *The Middle Ages* (1959)

Livesey, S. J. and R. H. Rouse, 'Nimrod the Astronomer', *Traditio*, 37 (1981), 203–266

Lloyd, T. H., *The English Wool Trade in the Middle Ages* (Cambridge: Cambridge University Press, 1977)

Longnon, J. and R. Cazelles, pref. by M. Meiss, *The Très Riches Heures of Jean, Duke of Berry* (New York: Braziller, 1969)

Loomis, R. S. and G. Cohen, 'Were There Theatres in the Twelfth and Thirteenth Centuries?', *Speculum*, 20 (1949), 92–98

Loomis, R. S., *Medieval English Verse and Prose in Modernized Versions* (New York: Appleton-Century-Crofts, 1948)

Lowden, J., 'Concerning the Cotton Genesis and Other Illustrated Manuscripts of the Genesis', *Gesta*, 31 (1992), 40–50

Lumiansky, R. M. and D. Mills, *The Chester Mystery Cycle*, EETS, SS 3, 9; 2 vols (London: Oxford University Press, 1974)

Lyon, Mary, Bryce Lyon, Henry S. Lucas, and Jean de Sturler, *The Wardrobe Book of William de Norwell, 12 July 1338 to 27 May 1340* (Brussels: Palais des Académies, 1983)

Macklin, H. W., *The Brasses of England* (New York: Dutton, 1907)

Mâle, E., 'Le renouvellement de l'art par les "mystères" à la fin du moyen âge', *GBA*, 31 (1904), 90–96, 215 ff., 283 ff., 370 ff.

Mâle, E., *L'Art religieux du XIIe siècle en France* (Paris: Colin, 1924)

Mâle, E., *Religious Art in France: the Late Middle Ages* (Paris: Colin, 1908; Princeton: Princeton University Press, 1986, trans., rev., corrected from 1949 edn)

Malo, H., *Les Fouquet de Chantilly: Livre d'Heures d'Etienne Chevalier* (Paris: Editions Verve, 1942)

Manley, W. M., 'Shepherds and Prophets: Religious Unity in the Towneley *Secunda Pastorum*', *PMLA* 78.3 (1963), 151–155

Mann, J., 'Appendix on the Armour', in W. O. Hassall, *The Holkham Bible Picture Book* (London: Dropmore, 1954), pp. 157–160

Mares, F. H., 'The Origin of the Figure Called "The Vice" in Tudor Drama', *Huntington Library Quarterly*, 22 (1958), 11–29

Marks, R. and N. Morgan, *The Golden Age of English Manuscript Painting 1200–1500* (New York: Braziller, 1981)

Marshall, M. H., 'Aesthetic Values of the Liturgical Drama', in *Medieval English Drama: Essays Critical and Contextual*, ed. by J. Taylor and A. H. Nelson, (Chicago: University of Chicago Press, 1972), pp. 28–43

Martins, S. W., *A History of Norfolk* (Chichester, Sussex: Phillimore, 1984)

Matějcěk, A., *Velislavova Bible* (Prague: [n. pub.], 1926)

Maury, L.-F. A., *Croyances et légendes du moyen âge* (Paris: Champion, 1896)

McCulloch, F., *Mediaeval Latin and French Bestiaries* (Chapel Hill: University of North Carolina Press, 1960)

McGerr, R. P., 'Guyart Desmoulins, the Vernacular Master of Histories, and his *Bible historiale*', *Viator*, 14 (1983), 211–244

McKisack, M., *The Fourteenth Century: 1307–1399* (Oxford: Clarendon Press, 1959)

Meiss, M., *French Painting in the Time of Jean de Berry* (London: Phaidon Press, 1967)

Meredith, P. and J. E. Tailby, eds, *The Staging of Religious Drama in Europe in the Late Middle Ages: Texts and Documents in English Translation*, EDAM, Monograph Ser. 4 (Kalamazoo, MI: Medieval Institute, Western Michigan University, 1983)

Meredith, P., ' "Make the Asse to Speak" or Staging the Chester Plays', in *Staging the Chester Cycle*, ed. by D. Mills, ULTM, NS 9 (Leeds: University of Leeds, LSE, 1985), pp. 49–76

Meuwese, M., 'Jacob van Maerlant's "Spiegel Historiael": Iconography and Workshop', in *Flanders in a European Perspective: Manuscript Illumination around 1400 in Flanders and Abroad*, ed. by M. Smeyers and B. Cardon (Leuven: Peeters, 1995)

Michael, M. A., 'A Manuscript Wedding Gift from Philippa of Hainault to Edward III', *Burlington Magazine*, 127 (1985), 582–598

Mill, A. J., 'The Hull Noah Play', *MLR*, 33 (1938), 489–505

Millar, E. G., 'The Egerton Genesis and the M. R. James Memorial MS.', *Archaeologia*, 87 (1938), 1–5

Millar, E. G., *English Illuminated Manuscripts of the XIVth and XVth Centuries* (Paris: Van Oest, 1928)

Miller, E. and J. Hatcher, *Medieval England: Towns, Commerce, and Crafts, 1086 – 1348* (London: Longman, 1995)

Mills, D., *The Chester Mystery Cycle* (East Lansing, MI: Colleagues, 1992)

Mills, D., intro., *The Chester Mystery Cycle: a Facsimile of British Library MS Harley 2124* (Leeds: University of Leeds, LSE, 1984)

Mills, D., ed., *Staging the Chester Cycle: Lectures Given on the Occasion of the Production of the Cycle at Leeds in 1983*, ULTM, NS 9 (Leeds: University of Leeds, LSE, 1985)

Montaiglon, A. de, *Recueil général et complet des fabliaux des XIIIe et XIVe siècles*, 6 vols (Paris: Librairie des Bibliophiles, 1872–1890)

Morgan, M. M., ' "High Fraud": Paradox and Double Plot in the English Shepherds' Plays', *Speculum*, 39 (1964), 676–689

Morris, G. W. and L. S. Wood, *The Golden Fleece: an Introduction to the Industrial History of England* (Oxford: Clarendon Press, 1922)

Mottram, R. H., *The Glories of Norwich Cathedral* (London: Winchester, 1948)

Nelson, A. H., 'Some Configurations of Staging the Medieval English Drama', in *Medieval English Drama: Essays Critical and Contextual*, ed. by J. Taylor and A. H. Nelson (Chicago: University of Chicago Press, 1972), 116–147

Neuss, P., ed., trans., *The Creacion of the World: a Critical Edition and Translation* (New York: Garland, 1983)

Nickson, M. A. E., *The British Library: Guide to the Catalogues and Indexes of the Department of Manuscripts* (London: British Library, 1978)

Nicolas, N. H., 'Accounts of the Great Wardrobe of King Edward the Third, from the 29th of September 1344 to the 1st of August 1345; and Again from the 21st of December 1345 to the 31st of January 1349', *Archaeologia*, 31 (1846), 1–163

Nolan, R., 'The *Roman de Mélusine*: Evidence for an Early Missing Version', *Fabula*, 15 (1974), 53–58

Oliver, J. H., *Gothic Manuscript Illumination in the Diocese of Liège (c. 1250–1330)*, Corpus of Illuminated Manuscripts from the Low Countries, 2 (Leuven: Peeters, 1988)

Oltrogge, D., *Die Illustrationszyklen zur 'Histoire ancienne jusqu'à César' (1250–1400)* (Frankfurt am Main: Lang, 1989)

Ordish, T. F., 'English Folk-Drama', *Folk-Lore*, 4 (1893), 149–175

Ormrod, W. M., 'The English Government and the Black Death of 1348–49', in *England in the Fourteenth Century: Proceedings of the 1985 Harlaxton Symposium*, ed. by W. M. Ormrod (Woodbridge, Suffolk: Boydell, 1986), pp. 175–188

Ormrod, W. M., *The Reign of Edward III: Crown and Political Society in England, 1327–1377* (New Haven: Yale University Press, 1990)

Owst, G. R., *Literature and Pulpit in Medieval England* (Cambridge: Cambridge University Press, 1933)

Pächt, O. and J. J. G. Alexander, *Illuminated Manuscripts in the Bodleian Library, Oxford*, 3 vols (Oxford: Clarendon Press, 1966–73)

Pächt, O., 'A Giottesque Episode in English Mediaeval Art', *JWCI*, 6 (1943), 51–70

Pächt, O., C. R. Dodwell, and F. Wormald, *The St. Albans Psalter (Albani Psalter)* (London: Warburg Institute, University of London Press, 1960)

Pächt, O., *The Rise of Pictorial Narrative in Twelfth-Century England* (Oxford: Clarendon Press, 1962)

Packe, Michael, *King Edward III*, ed. by L. C. B. Seaman (London: Routledge & Kegan Paul, 1983)

Palmer, B. D., *The Early Art of the West Riding of Yorkshire*, EDAM, Ref. Ser. 6 (Kalamazoo, MI: Medieval Institute, Western Michigan University, 1990)

Panofsky, E., *Early Netherlandish Painting: its Origins and Character*, 2 vols (Cambridge, MA: Harvard University Press, 1953; repr. New York: Harper and Row, 1971)

Parker, R. E., 'Pilates Voys', *Speculum*, 25 (1950), 237–244

Parkes, M. B., *Pause and Effect: an Introduction to the History of Punctuation in the West* (Berkeley: University of California Press, 1993)

Peter Comestor, *Historia Scholastica, Patrologia Latina*, 198, ed. by J. P. Migne (Paris: Migne, 1885)

Pevsner, N., *Northeast Norfolk and Norwich* (Harmondsworth, Middlesex: Penguin, 1962)

Pevsner, N., *Northwest and South Norfolk* (Harmondsworth, Middlesex: Penguin, 1962)

Pfaff, R. W., *Montague Rhodes James* (London: Scolar Press, 1980)

Pickering, F. P., *Literature and Art in the Middle Ages* (Coral Gables, FL: University of Miami Press, 1970)

Pickering, F. P., *The Anglo-Norman Text of the Holkham Bible Picture Book* (Oxford: Blackwell, for the Anglo-Norman Text Society, 1971)

Platt, C., *King Death: the Black Death and its Aftermath in Late-Medieval England* (Toronto: University of Toronto Press, 1996)

Plummer, J., *The Hours of Catherine of Cleves* (New York: Braziller, 1966)

Powell, E., *The Rising in East Anglia in 1381* (Cambridge: Cambridge University Press, 1896; repr. Ann Arbor, MI: University Microfilms, 1980)

Power, E., *The Wool Trade in English Medieval History* (Oxford: Oxford University Press, 1941)

Powlick, L., 'The Staging of the Chester Cycle' in *The Chester Mystery Cycle: a Casebook*, ed. by K. J. Harty (New York: Garland, 1993), 199–230

Prior, E. S. and A. Gardner, *An Account of Medieval Figure Sculpture in England* (Cambridge: Cambridge University Press, 1912)

Prior, E. S., 'The Sculpture of Alabaster Tables', in *Illustrated Catalogue of the Exhibitions of English Medieval Alabaster Works* (London: Society of Antiquaries, 1913), 16–28

Ragusa, I., 'A Gothic Psalter in Princeton: Garrett MS. 35' (unpublished doctoral dissertation, New York University, 1966)

Randall, L. M. C., assisted by J. H. Oliver and others, *Medieval and Renaissance Manuscripts in the Walters Art Gallery* (Baltimore: Johns Hopkins University Press in Association with the Walters Art Gallery, 1989–), I: *France: 875–1420* (1989); III: *Belgium, 1250–1530*, 2 pts (1997)

Randall, L. M. C., *Images in the Margins of Gothic Manuscripts* (Berkeley: University of California Press, 1966)

Remnant, G. L., *A Catalogue of Misericords in Great Britain*, intro., essay by M. D. Anderson, (Oxford: Clarendon Press, 1969)

Revised English Bible with the Apocrypha (Cambridge: Cambridge University Press, 1996)

Rickert, M., *Painting in Britain: the Middle Ages* (Baltimore: Penguin, 1954)

Rickert, M., *The Reconstructed Carmelite Missal* (London: Faber and Faber, 1952)

Robbins, R. H., 'An English Mystery Play Fragment ante 1300', *MLN*, 65 (1950), 30–35

Robinson, F. N., ed., *The Works of Geoffrey Chaucer* (Boston: Houghton Mifflin, 1957)

Roesner, E. H., F. Avril, and N. F. Regalado, intro., '*Le Roman de Fauvel' in the Edition of Mesire Chaillon de Pesstain: a Reproduction in Facsimile of the Complete Manuscript Paris, Bibliothèque Nationale fonds fr. 146* (New York: Broude Brothers, 1990)

Rose, M. and J. Hedgecoe, *Stories in Stone* (London: Herbert, 1997)

Rose, M., 'The Staging of the Hegge Plays', in N. Denny, associate ed., *Medieval Drama* (London: Arnold, 1973), pp. 197–222

Rossiter, A. P., *English Drama from Early Times to the Elizabethans* (London: Hutchinson, 1950)

Roston, M., *Biblical Drama in England* (Evanston, IL: Northwestern University Press, 1968)

Roth, C., text, *The Sarajevo Haggadah and its Significance in the History of Art* (New York: Harcourt, Brace & World, 1963)

Roy, E., *Le Jour de Jugement: études sur le théâtre français au XIVe siècle* (Paris: Bouillon, 1902; repr. as *Le Jour de Jugement: Mystère français sur le Grand Schisme,* Geneva: Slatkine, 1976)

Sackur, E., *Sibyllinische Texte und Forschungen: PseudoMethodius, Adso und die Tiburtinische Sibylle* (Halle: Niemeyer, 1898; repr. Turin: Bottega d'Erasmo, 1963)

Sagher, H.-E. de, 'L'Immigration des tisserands flamands et brabançons en Angleterre sous Edouard III', in *Mélanges d'histoire offerts à Henri Pirenne par ses anciens élèves et ses amis à l'occasion de sa quarantième année d'enseignement à l'Université de Gand, 1886–1926,* 2 vols (Brussels: Vromant, 1926), I, 109–126

Sandler, L. F., 'A Bawdy Betrothal in the Ormesby Psalter', in *Tribute to Lotte Brand Philip, Art Historian and Detective,* ed. by W. W. Clark and others (New York: Abaris, 1985), pp. 155–159

Sandler, L. F., *Gothic Manuscripts 1285–1385,* 2 vols, in *A Survey of Manuscripts Illuminated in the British Isles,* V (London: Harvey Miller, 1986)

Sandler, L. F., 'Notes for the Illuminator: the Case of the *Omne Bonum*', *AB,* 71 (1989), 551–564

Sandler, L. F., '*Omne Bonum*: a Fourteenth-Century Encyclopedia of Universal Knowledge, British Library MSS Royal 6 E VI–6 E VII,* 2 vols (London: Harvey Miller, 1996)

Sandler, L. F., *The Peterborough Psalter in Brussels and Other Fenland Manuscripts* (London: Harvey Miller, 1974)

Sandler, L. F., *The Psalter of Robert de Lisle in the British Library* (London: Harvey Miller, 1983)

Saunders, H. W., *An Introduction to the Obedientiary and Manor Rolls of Norwich Cathedral Priory* (Norwich: Jarrold and Sons, 1930)

Savage, William G., *The Making of our Towns* (London: Eyre & Spottiswoode, 1952)

Saxl, F. and R. Wittkower, *British Art and the Mediterranean* (London: Cumberlege, Oxford University Press, 1948; repr. 1969)

Scolastica willic ontbinden: over de 'Rijmbijbel' van Jacob van Maerlant, ed. by J. van Moolenbroek and M. Mulder, Middeleeuwse studies en bronnen, 25 (Hilversum: Verloren, 1991)

Scott-Fleming, S., *The Analysis of Pen Flourishing in Thirteenth-Century Manuscripts* (Leiden: Brill, 1989)

Sebillot, P. -Y., *Le Folk-lore de la France,* 4 vols (Paris: Maisonneuve et Larose, 1907; repr. 1968)

Severs, J. B., gen. ed., *A Manual of the Writings in Middle English 1050–1500,* 9 vols (New Haven: Connecticut Academy of Arts and Sciences, 1967–1993), V: *Dramatic Pieces,* A. E. Harting, gen. ed. (1975), 'Miracle Plays and Mysteries', by A. J. Mill, pp. 1323–1324.

Shapiro, M., *Words and Pictures: on the Literal and Symbolic in the Illustration of a Text* (The Hague: Monton, 1973)

Sheingorn, P., 'On Using Medieval Art in the Study of Medieval Drama: an Introduction to Methodology', *RORD,* 22 (1979), 101–109

Sheingorn, P., 'The Visual Language of Drama: Principles of Composition', in M. G. Briscoe and J. C. Coldeway, eds, *Contexts for Early English Drama* (Bloomington, IN: Indiana University Press, 1989), pp. 173–191

Sherman, H. S., '*Ludus Coventriae* and the Bosses of the Nave of Norwich Cathedral: the Christian History of Man in Two Disciplines' (unpublished doctoral dissertation, Michigan State University, 1976)

Simpson, A., *The Connections between English and Bohemian Painting during the Second Half of the Fourteenth Century* (New York: Garland, 1984)

Smith, K. A., 'Canonizing the Apocryphal: London, British Library MS Egerton 2781 and its Visual, Devotional and Social Context' (unpublished doctoral dissertation, Institute of Fine Arts, New York University, 1996)

Smith, L. T., ed., intro., gloss., *York Plays: the Plays Performed by the Crafts or Mysteries of York on the Day of Corpus Christi in the 14th, 15th, and 16th Centuries* (Oxford: Clarendon Press, 1885; repr. New York: Russell and Russell, 1963)

Snyder, J., *Medieval Art: Painting, Sculpture, Architecture, 4th–14th Century* (Englewood Cliffs, NJ: Prentice-Hall, 1989)

Southern, R. W., *The Medieval Theatre in the Round* (London: Faber, 1957; New York: Theatre Art Books, 1975)

Spector, S., ed., *The N-Town Play, Cotton MS Vespasian D.8*, EETS, SS 11, 12, 2 vols (Oxford: Oxford University Press, 1991)

Spiegel, G. M., *The Past as Text: the Theory and Practice of Medieval Historiography* (Baltimore: Johns Hopkins University Press, 1997)

Sponsler, C., *Drama and Resistance: Bodies, Goods and Theatricality in Late Medieval England* (Minneapolis: University of Minnesota Press, 1997)

Stanton, A. R., 'The "Queen Mary Psalter": Narrative and Devotion in Gothic England' (unpublished doctoral dissertation, University of Texas at Austin, 1992)

Stejskal, K., ed., *Velislai Bibbia picta*, 2 vols (Prague: Pragopress, 1970)

Sterling, C., pref., C. Schaefer, intro., legends, *The Hours of Etienne Chevalier [by] Jean Fouquet* (New York: Braziller, 1971)

Stevens, M., *Four Middle English Mystery Cycles* (Princeton: Princeton University Press, 1987)

Sticca, S., ed., *The Medieval Drama* (Albany: SUNY Press, 1972)

Stones, M. A., 'Another Short Note on Rylands French 1', in *Romanesque and Gothic: Essays for George Zarnecki, 2 vols* (Woodbridge, Suffolk: Boydell, 1987), I, pp. 185–192

Stones, M. A., 'Notes on Three Illuminated Alexander Manuscripts', in *The Medieval Alexander Legend and Romance Epic: Essays in Honour of David J. A. Ross*, ed. by P. Noble, L. Polak, and C. Isoz (Millwood, NY: Kraus International, 1982), pp. 193–241

Stones, M. A., 'Secular Manuscript Illumination in France' in *Medieval Manuscripts and Textual Criticism*, ed. by C. Kleinhenz, North Carolina Studies in the Romance Languages and Literature, 4 (Chapel Hill: University of North Carolina Press, 1976), pp. 83–102

Strietman, E., 'The Low Countries', in *The Theatre of Medieval Europe: New Research in Early Drama*, ed. by E. Simon (Cambridge: Cambridge University Press, 1991), pp. 225–252

Suggett, H., 'The Use of French in England in the Later Middle Ages', *Essays in Medieval History*, ed. by R. W. Southern (London: McMillan, 1968), pp. 213–239

Sullens, I., ed., *Robert Mannyng of Brunne, 'Handlyng Synne'*, Medieval and Renaissance Text and Studies, 14 (Binghamton, NY: Medieval and Renaissance Text Studies, 1983)

Swarzenski, H., 'Unknown Bible Pictures by W. de Brailes and Some Notes on Early English Bible Illustration', *JWAG*, 1 (1938), 55–69

Tanner, N. P., *The Church in Late Medieval Norwich, 1370–1532*, Studies and Texts, 66 (Toronto: Pontifical Institute of Mediaeval Studies, 1984)

Taylor, J. and A. H. Nelson, *Medieval English Drama: Essays Critical and Contextual* (Chicago: University of Chicago Press, 1972)

Thomas, M., *Le Psautier de Saint Louis* (Graz: Akademische Druck, 1972)

Thompson, J. W., 'The Aftermath of the Black Death and the Aftermath of the Great War', *American Journal of Sociology*, 26 (March, 1920), 565–572

Tiddy, R. J. E., *The Mummers' Play* (Oxford: Clarendon Press, 1923)

Travis, P. W., *Dramatic Design in the Chester Cycle* (Chicago: University of Chicago Press, 1982)

Trevelyan, G. M., *English Social History* (London: Longmans, Green, 1961)

Trevelyan, G. M., *History of England* (London: Spottiswoode, Ballantyne, 1958)

Tristram, E. W., *English Wall Painting of the Fourteenth Century* (London: Routledge & Paul, 1955)

Tydeman, W., 'Satiric Strategies in the English Cycle Plays', in *Popular Drama in Northern Europe in the Later Middle Ages* (Odense: Odense University Press, 1988), pp. 15–39

Tydeman, W., *The Theatre in the Middle Ages: Western European Stage Conditions c. 800–1576* (Cambridge: Cambridge University Press, 1978)

Vocel, J. E., *Welislaws Bilderbibel aus dem dreizehnten Jahrhunderte in der Bibliothek Sr. Durchl. des Fürsten Georg Lobkowic in Prag* (Prague: Verlag der königl böhm. Gesellschaft der Wissenschaften. Druck von Dr. Eduard Grégr, 1871)

Warner, G., *Queen Mary's Psalter: Miniatures and Drawings by an English Artist of the 14th Century* (London: British Museum, 1912)

Wasson, J., 'Professional Actors in the Middle Ages and Early Renaissance', in *Medieval & Renaissance Drama in England: an Annual Gathering of Research, Criticism and Reviews,* J. B. Leeds, ed., P. Werstine, ass. ed., (New York: AMS, 1984–), I, 1–12

Weitzmann, K. and H. L. Kessler, *The Cotton Genesis, British Library Codex Cotton Otho B VI* (Princeton: Princeton University Press, 1986)

Wentersdorf, K. P., 'The Symbolic Significance of *Figurae Scatologicae* in Gothic Manuscripts', in *Word, Picture and Spectacle*, ed. by C. Davidson, EDAM, Monograph Ser. 5 (Kalamazoo. MI: Medieval Institute, Western Michigan University, 1984), 1–19

Wickham, G., 'The Staging of Saint Plays in England', in *The Medieval Drama*, ed. by S. Sticca (Albany: SUNY Press, 1972), 99–119

Wickham, G., *Early English Stages, 1300–1660* (London: Routledge & Paul, 1959; repr. New York: Columbia University Press, 1980)

Woledge, B. and H. P. Clive, *Répertoire des plus anciens textes en prose française depuis 842 jusqu'aux premières années du XIIIe siècle* (Geneva: Droz, 1964)

Wolfthal, D., ' "A Hue and a Cry": Medieval Rape Imagery and its Transformation', *AB*, 75 (1993), 39–64

Woodforde, C., *The Norwich School of Glass-Painting in the Fifteenth Century* (London: Oxford University Press, 1950)

Woolf, R., *The English Mystery Plays* (London: Routledge and Kegan Paul, 1972)

Wormald, F., 'An English Eleventh-Century Psalter with Pictures', *Walpole Society*, 38 (1960/62), 1–13, pls 1–30

Wormald, F., 'The Fitzwarin Psalter and its Allies', *JWCI*, 6 (1943), 71–79

Young, K., *The Drama of the Medieval Church*, 2 vols (Oxford: Clarendon Press, 1933; repr. 1951)

Zahlten, J., *Creatio Mundi: Darstellungen der sechs Schöpfungstage und naturwissenschaftliches Weltbild im Mittelalter* (Stuttgart: Klett-Cotta, 1979)

Ziegler, P., *The Black Death* (Harmondsworth, Middlesex: Penguin, 1969)

Zijlstra-Zweens, H. M., *Of His Array Telle I No Lenger Tale: Aspects of Costume, Arms and Armour in Western Europe, 1200–1400* (Amsterdam: Rodopi, 1988)

Glossary

amount [f.9ᵛ ˙lower right]: adverb; to such a degree that.

assaver [f.2ᵛ, lower right]: infinitive; 'that is to say'.

baundoun [f.9ᵛ, upper left]: noun; power, authority; *bandon*—liberty, licence; *metre a bandon*—to deliver, sacrifice, condemn.

cees [f.1ᵛ, upper left]: noun; great fish, whale.

ceyr [f.9r, lower left]: noun; evening.

cosin [f. 3ʳ,upper left]: noun; kinsman. (*Cosyn* is used in N-Town Play 11—208, 255, 310; Play 26,—196, see Spector.)

deluive, deluvie [f.4ᵛ,upper right]: noun; flood.

demeigne [f. 1ᵛ, lower left]: adverb; 'a *sa ymage demeigne*'—according to his personal image.

dens [f. 1ᵛ, upper right]: preposition; derived from *dedenz—dans, dedans*.

ebaignie [f. 5ʳ, lower right]: adjective; greatly desirous of; related to *baer, baier, beer*—aspirer ardemment (Greimas).

eneanz [f.1ʳ, lower right]: adverb; therein.

esparpoiles [f. 6ʳ, lower]: past participle; dispersed.

eymer [f. 3ʳ, upper left]: infinitive; to aim.

faeure [f. 2ᵛ, upper right]: noun; maker, creator author (from *faitre, faiseor*).

faudes [f. 2ᵛ, upper left]: noun; folds, sheepfolds.

flume [f.4ʳ, full page]: noun; flood.

groundelande [f. 7ʳ, lower left]: adjective; grumbling.

happa [f. 3ʳ, upper left]: verb; 'It happened that'. (The noun *hap(p)* is in the N-Town compilation as lot or fortune—Play 2, 313; Play 38, 217, 225; or as misfortune—Play 12, 181. See Spector, Glossary, p. 593.)

ieovenes [f. 9ʳ, lower right]: adjective; young.

ios, ioe [f. 4ᵛ, lower left; f. 7v, lower right]: pronoun; Anglo-Norman forms of *je*.

issint [f. 9r, lower left and lower right; 11r (10ʳJ), upper left]: adverb, thus.

issint qe [7r,lower right; 9v, lower right]: adverb; with the result that.

lais [f. 5ᵛ, full page]: noun, pl.; lakes.

looement [f. 5ᵛ, full page]: noun; probably related to *loiemier*, desirous of.

launt [f. 7ᵛ, upper left]: adjective; united, together.

lusaunt [f. 1ʳ, upper right]: adjective; from *lus* and *seant*, place; 'situated in a manner that'.

madles [f. 9ᵛ, lower right]: adverb; in such a manner that; *modle—manière* (Greimas).

maner [f. 7ʳ, upper right]: noun; manner (*manière*).

meins [f. 7ᵛ, lower right]: noun; family, household suite; form of *mesniee* (See right border of scene).

poms [f. 7ᵛ, lower right]: first person plural (pouvons).

purpose [f. 7ʳ, upper right]: noun; purpose. (Purpos(e) is used as a noun in N-Town Play 14, 223, Play 24, 46, Play 26, 46, 250. It is also used as a reflexive verb elsewhere in N-Town. See Spector, Glossary, p. 622.)

reherce [f. 4ᵛ, lower right]: third person singular; recounts.

riaunce [f. 9ᵛ, lower left]: noun; laughter; *riace—rieuse* (Greimas).

rour [f. 5ᵛ, full page]: adjective, nominal use; authoritative; may be related to *robor*, force, authority.

sauntz [f. 7ᵛ, lower right]: preposition; without.

scarce pur [f. 7ᵛ, upper right, lower left]: adjective; lacking for, scarce.

sovereinement [4r, full page]: adverb; supremely, powerfully.

sourdereit [f. 7ᵛ, lower left]: third person singular, conditional; would break out.

sum [f. 7ᵛ, lower right]: first person plural, *être*.

syme [f. 1ᵛ, upper right; lower left]: adjective, means sixth here. sisme—*septième* (Greimas); (The Egerton Genesis scribe uses *septième* for seventh.)

via [f.7ʳ, upper right]: third person singular, form of *envier*.

vioient [f. 7ʳ, upper left]: third person plural, probably a form of *veor* or *veoir*.

volom [f. 7ᵛ, lower right]: first person plural, *vouloir*.

vorrient [f. 7ᵛ, upper left]: third person plural, conditional of *voloir*.

Gorleston

journey to Harran, 60; Third day of Creation, 33; Three heavenly visitors dine and promise a son to Abraham and Sarah, 84; The Tower of Babel, 12 The treacherous agreement with the Shechemites, 117; Tubal-cain and Naamah, 129
misbinding of, 14, 15
mise-en-page, 24–5
missing folios in, 15, 16, 18
moralist scrapers of, 6
origin of, 250–1
palaeography, 20
parallels with medieval drama, 137–60
 Abraham as pilgrim, 143–4
 angels in feathered suits, 146–7
 the angry character who strikes a weaker figure, 145–6
 costumes and possible stage properties, 147–52
 fool-vice, 147–8
 gilded or silvered face and hands of the Deity, 144
 Old Testament procession and self-introduction, 139–41
pastoral images, 141–3
patron of, 9, 128, 142, 143, 145
penwork in, 21, 22, 24
 line-fillers, 24
 pearl strings, 21, 22, 238
 spirals, 21, 22, 24, 238
phallic imagery in, 87, 88
provenance of, 1
purchase by British Museum, 14
relation to manuscripts of Low Countries, 3
Roxburghe Club facsimile of, 1, 2
scholarship on, 2, 3, 4, 5
scribal additions, 7
scribes of, 7, 15
 Scribe I, 16, 17, 20, 21, 24
 Scribe II, 16, 17, 19, 20, 21, 24, 25, 27, 40
as a social document, 250
sources of, 129, 130, 167, 179, 198
 textual sources of, 25–7, 69
 visual sources of, 69, 70
style of, 161–202
 antecedents of, 163, 169
 architecture, 179–81
 circumflex eye, 163
 clothing and armour, 185
 colour, 194–6
 expression, 176–8, 235
 geometry, 162–3
 illusionistic effects in the treatment of the human figure, 169–76
 Italianate, 167, 169
 landscape, 182
 line and three dimensional form, 162–9
 modelling, 166, 167
 penwork shading, 164, 194, 195
 space,178–9
 systems of drapery folds, 187–93
textual character of, 249–50
transcription of, 259–88

translation of, 259–88
unillustrated chapters in, 128
working practices in, 16–19

Egypt, 126, 127, 143, 152, 276, 277, 278, 279, 283, 284
Elioschora, Eastern sea, 272
Elizabeth I, Queen, 138
Elizabeth, St, 87
Elsing, Norfolk, 79, 186
Ely, Prior of, 107
England, 5, 79, 107, 126, 164, 165, 196, 197, 227, 229, 247, 248, 251, 254
 Religious Miscellany from, 91
 wool industry in, 46, 246–247, 257
Enoch, 37, 263
Enos, 262
Enosh, 37
Ephron the Hittite, 97
Epiphanes, Antiochus, 220
Er, 123
Esau, 103, 106, 107, 108, 110, 113, 114, 118, 130, 141, 169, 176, 194
Eschol, 69, 141
Ethan, land of, 272
Etymology of Exeter College, *see* Index of Manuscripts Cited *under* Oxford, Exeter College, MS 42
Euconie, land of, 272
Euphrates, 51, 113, 271, 271, 272
Europe, 54, 272
Eusebius, 285, 286
Eve, 16, 35, 36, 260, 261, 262
Exeter, 155
 Exeter Cathedral, Bishop's throne, 180

Fame, Lady, character in Chaucer's *Hous of Fame*, 148
Farnborough Fund, 2
Fitzwarin Psalter: *see* Index of Manuscripts Cited *under* Paris, Bibliothèque Nationale, MS lat. 765
Flanders, 2, 130, 173, 227, 246, 247, 254
Fleury, 143
Fluia, 265
Fool-vice, 147–8
 Morris Fool, 148
Fouquet, *The Life of Saint Apollonia*, 152
France, 79, 143
Frankfurt-am-Main, 2

Garcio, Iak, character in Wakefield Plays, 142
Genesis manuscripts, 4
Georges Wildenstein Collection, 3
Gerar, 105, 143
Ghent, 4, 24, 34, 38, 177, 181, 199, 203, 206, 207, 209, 213, 214, 215, 218, 227, 228, 242, 246, 247, 248, 251
Giotto, 3, 137, 175
 Last Supper, fresco, 172
God, 59, 60, 61, 68, 79, 81, 84, 91, 92, 96, 99, 102, 103, 104, 105, 109, 110, 117, 135, 138, 140, 141, 144, 147, 150, 152, 164, 177, 194, 199, 218, 235, 239, 251, 259, 260, 261, 265, 266, 267, 268, 269, 273, 274, 275, 277, 278, 282, 283, 284, 285, 286

Gorleston Psalter: *see* Index of Manuscripts Cited *under* London, British Library, Add. MS 49622
Gough Psalter: *see* Index of Manuscripts Cited *under* Oxford, Bodleian Library, Gough MS liturg. 8
gravediggers, in fourteenth-century manuscripts, 97
Gregory IX, Decretals of: *see* Index of Manuscripts Cited *under* Vatican City, Biblioteca Apostolica Vaticana, MS Vat. lat. 1389
Gresford, 120
Grisaille, 3
 in Egerton Genesis, 194, 195
de Grise, Jehan, 39
Grosseteste, Robert, Bishop of Lincoln, 138

Habakkuk, 155
Hagar, 15, 81, 82, 92, 94, 95, 129, 145, 146, 149, 185, 187, 283
Haggadah, of mid-fourteenth century, 13
Hainault, 204
Ham, 48, 49, 50, 51, 166, 167, 177, 178, 263, 265, 269, 270, 271
Hannibal, 75, 218
Haran, 60, 274, 275
Hares, 107
Harran, city of, 61, 275
Hastings, Sir Hugh, 186
 brass of, Elsing, Norfolk, 79, 186
Heber, 169
Hebron, 262
Hebron Valley, 260, 261
Herod, 120, 146
Herodias, 120
Heures d'Etienne Chevalier, 147, 151
Higden, *Polychronicon*: *see* Index of Manuscripts Cited *under* Oxford, Bodleian Library, MS Bodley 316
Hiron, 178
Histoire ancienne: *see* Index of Manuscripts Cited *under* Carpentras, Bibliothèque Inguimbertine, MS 1260 *and* Vienna, Österreichische Nationalbibliothek, MS 2567
Histoire del Saint Graal et de Merlin: *see* Index of Manuscripts Cited *under* London, British Library, Add. MS 10292
Hittites, 141
Holkham Bible Picture Book: *see* Index of Manuscripts Cited *under* London, British Library, Add. MS 47682
Honoré, Master, 183, 193
Hosea, 155
Hours of Catherine of Cleves: *see* Index of Manuscripts Cited *under* New York, Pierpont Morgan Library, MS M. 945
Hours of Jeanne de Navarre: *see* Index of Manuscripts Cited *under* Paris, Bibliothèque Nationale, MS Nouv acq. lat. 3145

iconoclasts, 6
iconography
 connections between English and Flemish Manuscripts, 238–241